Fabric Reference

FOURTH EDITION

MARY HUMPHRIES, B.A., M.A.

Fellow, Institute of Textile Science

Upper Saddle River, New Jersey Columbus, Ohio Humphries, Mary
Fabric reference / Mary Humphries.— 4th ed.
p.cm.
Includes bibliographical references and index.
ISBN 978-0-13-158822-6 (alk paper)
1. Textile fabrics. I. Title.
TS1445. H85 2009
677—dc22

2007048578

Editor in Chief: Vernon R. Anthony

Editor: Jill Jones-Renger

Editorial Assistant: Doug Greive Production Editor: Kevin Happell Design Coordinator: Diane Ernsberger Cover Designer: Kellyn E. Donnelly Cover Art: Rose E. Dee International Production Manager: Deidra Schwartz Director of Marketing: David Gesell Marketing Manager: Leigh Ann Sims Marketing Coordinator: Alicia Dysert

This book was set in Souvenir by Laserwords. It was printed and bound by Bind-Rite Graphics. The cover was printed by Phoenix Color Corp.

Copyright © 2009, 2004, 2000, 1996 by Pearson Education, Inc., Upper Saddle River, New Jersey 07458. Pearson Prentice Hall. All rights reserved. Printed in the United States of America. This publication is protected by Copyright and permission should be obtained from the publisher prior to any prohibited reproduction, storage in a retrieval system, or transmission in any form or by any means, electronic, mechanical, photocopying, recording, or likewise. For information regarding permission(s), write to: Rights and Permissions Department.

Pearson Prentice Hall™ is a trademark of Pearson Education, Inc. **Pearson®** is a registered trademark of Pearson plc **Prentice Hall®** is a registered trademark of Pearson Education, Inc.

Pearson Education LTD.
Pearson Education Singapore, Pte. Ltd
Pearson Education, Canada, Ltd
Pearson Education–Japan

Pearson Education Australia PTY, Limited Pearson Education North Asia Ltd Pearson Educaçion de Mexico, S.A. de C.V. Pearson Education Malaysia, Pte. Ltd

10 9 8 7 6 5 4 3 2 1 ISBN-13:978-0-13-158822-6 ISBN-10: 0-13-158822-2

Brief Contents

	•				
SECT	TION ONE INTRODUCTION 1	SECTION FIVE FINISHING OF FABRICS 197			
	Fabrics and Your Career 2 Basic Terms Used with Fabrics and Fibers 8	5—1 Role of Fabric Finishing 198 5—2 Other General and Basic Finishes 203 5—3 "Added Value" and Special Purpose Finishes 208			
	TION TWO TEXTILE FIBERS 13 What Is a Fiber? 14	5-4 Application of Color 219 5-5 Printing 227 5-6 Other Applied Design 232			
2-2 2-3	Fiber Properties and Amounts Used 20 Natural Fibers 27				
	Manufactured Fibers 56	SECTION SIX CARE OF FABRICS 238			
	Modifications of Manufactured Fibers and Blending 79 Fiber Identification 91	6–1 Home Care 239 6–2 Commercial Cleaning 257			
	TION THREE	6–3 Dyes and Colorfastness 263 6–4 Care Labeling 267 6–5 Storage of Textile Articles 273			
YARI	NS-FROM FIBER TO FABRIC 103				
3–1 3–2 3–3	Yarn Types, Classifications, Notation 104 Spun Yarns 108 Filament Yarns 114	SECTION SEVEN FABRICS AND ECOLOGY 278			
3-4	Novelty (Fancy or Complex-Ply) Yarns 117 Thread and Cordage 120	7–1 Clothing as Environment 2797–2 Textiles and Environmental Concerns 29	2		
	TION FOUR	SECTION EIGHT FABRIC ASSESSMENT 3	01		
FABI	RIC CONSTRUCTIONS 123	8–1 Fabric Assessment—How It's Done 302			
4-2		8–2 Nontechnical Fabric Tests 307			
	Basic Weaves 134	SECTION NINE			
4–4 Complex Weaves 142 4–5 Knitting 154		METRIC IN TEXTILES USE 313			
	Other Construction Methods Using	24			
1 7	Yarns 169	9–1 The Metric System 314 9–2 Metric in Textiles Use 316			
	Fabrics Without Yarns; Fabrics Without Fibers 178 Leather, Fur 183	3-2 Metric III Textiles Use 310			
	Compound Fabrics 190	REFERENCES AND RESOURCES 323			

Contents

Properties in Relation to Use 21

General Advantages of Natural Fibers 21

Preface xiii General Advantages of Manufactured Fibers 23 General Advantages of Cellulosic Manufactured SECTION ONE: INTRODUCTION 1 (CMF) Fibers 24 General Advantages of Synthetic Fibers 1-1 Fabrics and Your Career 2 (and Some Drawbacks) 24 How Much Do You Need to Learn about (Static) Textiles? 2 Fibers—Relative Position in World Everyday 21st-Century Textiles Production 25 Are Extraordinary 2 Review Questions 2-1, 2-2 26 What Do We Want from Textiles? 5 2-3 Natural Fibers 27 Fabric Definition 6 Cellulosic Natural Fibers 27 Fabric Production: Overview of Process and Cellulose 27 Timing 6 Cotton—A Seed Fiber 27 1-2 Basic Terms Used with Fabrics (Production, Properties, Quality) and Fibers 8 Other Seed Fibers 30 Aesthetic Characteristics 8 (Kapok, Coir) Comfort Characteristics 9 Flax (Linen)—A Bast (Stem) Fiber 30 Performance Characteristics 9 (Production, Properties, Quality) Other Basic Terms 10 Other Bast Fibers 33 Review Questions Section One 11 (Jute, Hemp, Ramie, Kenaf, Roselle, Sunn, Investigations to Do with Introduction: A "Baseline" Urena, etc.) for Your Studies 11 Leaf Fibers 34 (Sisal, Henequen, Abaca, New Zealand "Flax," New Zealand "Hemp," Yucca, Raffia, Piña) **SECTION TWO: TEXTILE FIBERS 13** Minor Bast and Leaf Fibers 36 Other Miscellaneous Cellulosic Natural Fibers 36 2-1 What Is a Fiber? 14 (Bark Fiber Cloth (Tapa), Spanish Moss, Sacaton) Fibers Are Fundamental 14 Inorganic (Mineral) Natural Fibers 36 Textile Fibers Are Special 14 Asbestos 36 What's in a Name? Fiber Generic Names 14 Protein Natural Fibers 36 Fiber Content Labeling 16 Wool—The Major Hair Fiber 37 What Is a Trademark Name? (Production, Structure, Properties, Quality, Legal Framework of Trademarks 19 Products Labeling Act) 2-2 Fiber Properties and Amounts Specialty Hair Fibers 42 Used 20 (Horsehair, Mohair, Cashmere, Cashgora, Camel Hair, Hair of Camelids, Angora, Qiviug, Other Properties of Major Fiber Groups—Important Relationships and Summaries 20 Specialty Hair Fibers)

Plumage—Feathers, Down 47

Silk Filament 47

(Production, Properties, Quality) Staple Silk (Spun) 52 (Cultivated Silk Waste, Wild Silk, Thai Silk and Indian Silk) Spider Silk 53

Link 2-3 with Files in Fabric Glossarv 53 Review Questions 2–3 55

2-4 Manufactured Fibers

Spinning Manufactured Fibers 56 Spinning Methods 56 Spinneret Types 58 Drawing Manufactured Fiber Filaments Cellulosic and Minor Natural Polymer Manufactured Fibers 59 Reconstituted Cellulose Fibers 60 (Rayon, Lyocell, Minor Reconstituted Cellulose Fibers) Cellulose Acetate Compounds 62 (Cellulose Acetate and Triacetate) Minor Natural Polymer Manufactured Fibers 63

(Azlon (Protein), Alginate Fiber, Chitin Fiber) Synthetic Manufactured Fibers 64

Nylon (Polyamide)—The First Synthetic Fiber 65

(Production, Properties,)

Polyester—The Most-Used

Synthetic Fiber 66

(Production, Polyester, Aromatic Polyester (PTT),

Other Types of Polyester) Acrylic Fibers 69

(Production, Properties)

Fibers Related to Acrylic 70

(Vinyon and Saran (Chlorofibre), Modacrylic.

Vinal (vinylal, also given as PVA.

polyvinylalcohol), Nytril)

Olefin Fibers: Polypropylene, Polyethylene,

Subgroup Lastol 71

(Olefin Subgroup, Lastol,

Elastomers 72

(Rubber, Spandex (Elastane), Elastoester

Flame- and Heat-Resistant Organic Fibers and

Other High Performance Fibers 74 (Aramid, Novoloid, PBI (Polybenzimidazole))

Other Minor Organic Synthetic Fibers 75

(Fluoropolymer (fluorofibre), Sulfar,

Melamine, Carbon)

"Bio-Based" Synthetic Fibers—From Annually Renewable Raw Materials 76 Inorganic Manufactured Fibers 77 (Glass, Metallic Fibers, Miscellaneous) Review Questions 2–4 77

2-5 Modifications of Manufactured Fibers and Blending 79

Manufactured Fiber Modifications 79 Specialized Physical Modifications 79 (Solid Fibers with Nonround Cross Section, Morpho-structured Fiber, Flat Filament or Tapelike Fiber, Air Spaces Incorporated into Manufactured Fibers, Microfibers and Nanofibers) Physical or Chemical Properties Modified 84 (High-Tenacity (High-Strength) Fibers, Low-Pilling Fibers or Fibers to Be Sueded, More Dyeable Fibers. Antistatic Fibers) Additions to Manufactured Fibers before

Spinning 84

(Dulling or Delustering Agent, Ultraviolet Resistant, Light Stabilized, Colored Pigment. Flame Retardant, Bioactive Agent, Cut-Resistant Particles)

Bicomponent Fibers 86 (Fibers (a), Fibers (b))

Blending of Fibers 86

Reasons for Blending Fibers 87 (Economy, Quality, Fashion, and Comfort, Dyeing Effects, Safety and Hygiene (Flame Resistance, Anti-Microbial Action), Improved Performance in Wear and Care)

Link 2-4, 2-5 With Files in Fabric Glossary 90 Review Questions 2–5 90

2-6 Fiber Identification

Fiber Identification Methods 91 Textile Flammability 92 Burning Behavior 93 (Fiber Type and Fire Safety, Fabric Construction and Fire Safety, Garment Design and Construction and Fire Safety, Other Fire Hazards) Fiber Identification Burning Test 94 Microscopic Fiber Examination 94 Typical Features 96

Solubility or Chemical Tests 99

Review Questions 2–6 99

Investigations to Do with Textile Fibers 100

SECTION THREE: YARNS—FROM FIBER TO FABRIC 103

3-1 Yarn Types, Classifications, Notation 104

Yarn Types and Constructions 104
Spun Yarns Compared to Filament Yarns 104
(Look, Hand, Comfort, Durability, Strength, Cost)
Yarn Classification 105
Yarn Classified by Ply 105
Yarn Classified by Twist Direction 105
Yarn Classified by Amount of Twist 105
Yarn Classified by Linear Density (Count or Number) 106
(Indirect Yarn Number, Direct Yarn Number)
Yarn Notation 107

3-2 Spun Yarns 108

Conventional Processing 108

Main Conventional Processes 108

Types of Conventional Spinning Frames 108

Carded versus Combed Yarn 109

(Yarn, Yarn)

Some Twists on Conventional Processing 111

Compact Spinning 111

Sirospun and Solospun 111

Optim™ Technology for Wool 111

Unconventional Processing 112

Open-End, Rotor, or Break Spinning 112

Air-Jet Spinning 112

Vortex Spinning 112

Direct Spinning 112

3-3 Filament Yarns 114

Textured Manufactured Filament Yarns 114
Stretch Texturing 114
(False-Twist, Coil, Step-by-Step, Twist-Heat Set-UFntwist, Knit-Deknit, Edge-Crimp, Textured Set)
Crimp Texturing 116
Air Texturing or Interlacing, Air-Jet Texturing,
Loop Texturing 116
Spun-like Effect 116

3-4 Novelty (Fancy or Complex-Ply) Yarns 117

Main Types of Novelty Yarns 117 Loop Yarns 117 Nub Yarns 117 Slub Yarns 118
Wrapped Yarns 118
Metallic Yarns 118
Chenille Yarn 118
Link 3–1, 3–2, 3–3, 3–4 With Files in Fabric Glossary 118

3-5 Thread and Cordage 120

Types of Thread 120
Cotton Thread 120
Spun Polyester 120
Filament Threads 120
(Monofilament, Multifilament, Bulked or Textured Filament)
Specialized Threads 120
Cordage 121
Review Questions Section Three 121
Investigations to Do with Yarns 122

SECTION FOUR: FABRIC CONSTRUCTIONS 123

4-1 Fabrics-Two Sides 124

Fabric Right Side versus Wrong Side,
Face versus Back 124
General Guides to Fabric Right Side
and Face 124
Particular Guides to Fabric Right Side
and Face 124
(Twill Line, Stitch Side)

4-2 Weaving—General 125

Speed in Weaving: Notation 125
Types of Looms (Weaving Machines) 125
Shuttle Looms 125
Shuttleless Looms 127
Selvage 128
Warp versus Weft in a Weave 128
Thread or Cloth Count 130
Point Diagrams, Notation of Weaves 132

4-3 Basic Weaves 134

Plain Weave 134
Balanced Plain Weaves 134
Unbalanced Plain Weaves 134
Other Plain Weave Variations 135
Twill Weave 135

Twill Direction 136 Angle of Twill 136 Satin Weave 137 Comparisons Among Plain, Twill, and Satin Weaves 138 Link 4–2, 4–3 with Files in Fabric Glossary 139 Review Questions 4–1, 4–2, 4–3 140 4-4 Complex Weaves 142	(Machine-Made Lace Types, Handmade Lace Types, Lace Forms and Terminology) Tufting 173 Braiding 175 Stitchbonded 175 Embroidered, Base Dissolved 176 4-7 Fabrics without Yarns; Fabrics without Fibers 178		
Harness Control of Complex Weaves	Fabrics without Yarns 178		
(Dobby) 142 Jacquard Control of Complex Weaves 144 Leno Weave 145 Surface Figure Weaves 146 Swivel 146 Clip-Spot 146 Lappet 147 Pile Weaves 147 Warp Pile Weaves 148 (Carpet Quality, Other Pile Terms, Fabrics)	Felt 178 Nonwoven 178 (Bonded Fiber Web, Needled, Stitchbonded No Yarns, Spunbonded (Flash Spun), Meltblown, Spunlaced (Hydroentangled), Steam Heat + Jet Blasts, Combinations of Nonwoven Methods) Fabrics without Fibers 181 Film 181 Foam 182 4-8 Leather, Fur 183		
Weft Pile Weaves 151	Leather 183		
Link 4–4 with Files in Fabric Glossary 152 Review Questions 4–4 152	Sources of Leather 184		
	Tanning 184		
Investigations to Do with Fabric Constructions 195	Leather Properties 186		
4–5 Knitting 154 Knitted versus Woven 154 In Character 154 In Use 155	Fur 186 Fur Quality/Price 186 Construction of Fur Garments 186 Glossary of Fur Terms 188		
(Comfort ., Wear, Care)	4-9 Compound Fabrics 190		
Handling in Garment Construction 155 (Pattern, Layout, Marking and Cutting, Lining,	Vapor-Permeable/Water-Resistant (VPWR) Fabrics 190		
Stitching, Fasteners) Knitting Terms, Knitting Action, Types of Needles 156	Fabric System with Impact-Hardening Layer 191		
Some Other Knitting Terms: 156	Link 4–5 to 4–9 with Files in Fabric Glossary 193		
Types of Knits 157	Review Questions 4–6, 4–7, 4–8, 4–9 194		
Weft (Filling) Knitting 157			
(Single Weft Knits, Doubleknits, Weft Knit Stitch	SECTION FIVE: FINISHING		
Variations, Seamless Garment Knitting) Warp Knitting 162	OF FABRICS 197		
(Tricot, Raschel, Minor Warp Knits)	OF TABRICS 177		
Other Knitted Fabrics and Terms 165	5-1 Role of Fabric Finishing 198		
(Two Face Fleece Knit)	Finishing the Natural Fibers 198		
Knitting with Weft or Warp Insertion 166	Wool 198		
Review Questions 4–5 168	(Scouring, Bleaching, Carbonizing, Fulling)		
4-6 Other Construction Methods Using	(Decating and Crabbing, Mothproofing)		
Yarns 169 Twisting /Knotting) 160	Silk 199		
Twisting (Knotting) 169 Net 169 Lace 169	Cotton 200 (Scouring, Bleaching, Mercerizing) Flax (Linen) 200		

(Bleaching, Beetling) Link 5–1 with Files in Fabric Glossary 201 5–2 Other General and Basic	Screen Printing 228 Jet Printing 228 Transfer Printing 230 Photographic Laser Printing 230			
Finishes 203 Heat Setting of Thermoplastic MF Fibers 203 "Three Dimensional" or "3-D" Surfaces 203 Singeing or Gassing 204 Calendering 204 Creping 204 Crinkle Sheeting 205	Photographic, Laser Printing 230 Engineered Prints 231 Blotch Print 231 Resist Printing 231 Discharge Printing 231 Duplex Printing 231 Block Printing and Stencil Printing 231			
Stiff or Crisp Finish 205	5-6 Other Applied Design 232			
Softeners 205 Mill Washing 205 Other Regular Finishing Processes 205 Link 5–2 with Files in Fabric Glossary 207	Printing Other than Color 232 Burned-Out 232 Plissé or "Crinkle Crepe" 232 Flocked 232			
5-3 "Added Value" and Special Purpose	Mechanically Applied Design 232			
Finishes 208 Coatings 208 Encapsulation Technology 209 Micro-encapsulation 209 (Temperature Regulation or Thermal Comfort Management, Body Interactive Encapsulations) Other Approaches to Encapsulation 211 Water Repellent, Stain Repellent, Soil Release, Moisture Management 211 Bioactive Agents 212 Stain Repellent, Bioactive and UV Protective 213 Other Special Finishes 213 Flame Retardant 213 Wrinkle Resistant or Crease Recovery 213 Durable Press (DP) 214 Dimensional Stability, Including Shrinkage Control 214	Embossed 232 Sculptured or Carved Design 232 Moiré 232 Embroidery 233 (Other Stitching) Pleating 233 Miscellaneous Effects 234 Link 5-4, 5-5, 5-6 With Files In Fabric Glossary 234 Review Questions 5-4, 5-5, 5-6 235 Investigations to Do with Finishing of Fabrics 236 SECTION SIX: CARE OF FABRICS 238 6-1 Home Care 239			
Carpet Shading Prevention 215	Where Are the "Knows" of Yesteryear? 239 Fiber Properties and Care 239			
Link 5–3 with Files in Fabric Glossary 217	Heat in Fabric Care 239			
Review Questions 5–1, 5–2, 5–3 217	Water and Mechanical Action			
5-4 Application of Color 219	in Fabric Care 240			
What Is Color? 219 Application of Color to Textiles 219 Dyeing 220 (Types (Classes) of Dyes, Dyeing Stages, Methods, and Effects)	Home Care—Washables 240 General Method for Machine Washing in the Home 240 Tender, Loving (Home) Care (TLC) 241 Silk 241			
5-5 Printing 227	Linen 242 Cotton 242			
Printing Methods and Effects 227 Sliver or Top Printing 227 Warp Printing 227 Roller Printing 227	Lace 242 Pile Fabrics 242 Upholstery Fabrics 243 Wool and Hair Fibers 243			

Down 244 Pillows with Synthetic Fiber Filling 244 Suede and Leather 244 Fur 245 Care of Special Items 246 TLC or Beware: High Fashion Specialties 246 Potential Troublemakers in Fabrics and Garments 247 Laundering 248 Water—The Basic Cleansing Agent 248 (Water "Hardness," Iron, Water Softeners, Water Pollution) Detergents and Detergency 249 (Soap, Synthetic Detergents) Other Laundry Agents 251 (Water Softeners, Builders, Bleaches, Disinfectants, Enzymes, Fabric Softeners) Home Dryer "Freshening" of Non-Washable Articles 252 Home Treatment of Spots and Stains 253

6-2 Commercial Cleaning 257

"Dry" Cleaning? 257 What Happens in a Dry Cleaning Plant? Dry Cleaning Solvents 257 (Synthetic Solvents, Hydrocarbon Solvents) Other Dry Cleaning Solvents 258 (Silicone-Based Solvent, CO2-Based Solvent, Glycol Ether Solvents, n-Propyl Bromide-Based (NPB) Solvents) Commercial Wet Cleaning 259 Ultrasonic Cleaning 259 How to Rate Cleaning 259 Quality Checklist 259 When You Need the Best Cleaning 260 (Tough Stain Removal, Finishing) How to Select a Dependable Cleaner 260 6-3 Dyes and Colorfastness

What Can We Deduce about Colorfastness? 263 Acetate 263 Acrylic 263 Cellulose Fibers 263 Nylon 264 Polvester 265 Silk 265 Triacetate 265 Wool and Specialty Hair Fibers 265 Home Dyes 265 Brighteners: What to Expect of "Whiter Than White" 265

6-4 Care Labeling 267

U.S. Care Labeling Rule 267 Canadian Standard Care Labeling 270 Care Labeling—International Symbols 271 Care Labeling in the United Kingdom—HLCC System 271 Private Sector Labeling with Implications for Care 272 Trade Associations 272 Individual Companies 272

6-5 Storage of Textile Articles 273

Basic Home Storage Procedure 273 Major Hazards to Textiles 273 Storing Vintage Textiles 275 Review Questions Section Six 276 Investigations to Do with Care of Fabrics 276

SECTION SEVEN: FABRICS AND ECOLOGY 278

7-1 Clothing As Environment 279

Comfort in Clothing 279 Basic Principles of Physiological Comfort in Clothing 280 Permeability to Water Vapor 280 Head and Hands 281 Water Conducts Heat 281 Insulation 282 Heated Air Rises 283 Circulation of Blood 283 Density 283 Basic Principles Applied: Traditional Inuit Clothing 283 Clothing Developed by Arctic Peoples 283

Fashion and Energy 285 Cold Weather Tactics 285 (Clothing for Cold Weather, Furnishings to Retain Warmth) Warm Weather Tactics 287 (Regulation of Body Temperature, Clothing for Warm Weather, Furnishings to Keep Out the Heat) Sun Hazards 289

7-2 Textiles and Environmental Concerns 292

Eco Concerns—How Green? 292 Textiles' Impact on Water and Air 293 Water Pollution 293

Loss of Fresh Water 294
Air Pollution 294
Recycling 295
Unusual Fabrics of the 21st Century 296
Biotechnology 296
Other "Forward" Developments 297
(Light, "Smart Fabrics")
Review Questions Section Seven 299
Investigations to Do with Fabrics
and Ecology 299

SECTION EIGHT: FABRIC ASSESSMENT 301

8-1 Fabric Assessment—How It's Done 302

Standard Tests and Rating 303
Some Standard Methods Sources 303
Colorfastness Tests and Ratings 303
Absorbency or Wicking 305
Thermophysiological Comfort 305
Protection from Ultraviolet (UV) Rays 305
Other Tests with Ratings for Interiors
Fabrics 305
Resistance to Abrasion 305

8-2 Nontechnical Fabric Tests 307

Not Requiring a Sample 307 Crease Resistance, Wrinkle Recovery 307 Appearance, Drapability 307 Closeness of Construction 307 Wind Resistance 307 Stretch and Recovery 307 Colorfastness to Crocking or Rubbing Off of Color 307 Seam Slippage 308 Seam Stretch 308 Nap—Especially Wool Fabrics 308 Quality of Felt 308 Requiring a Sample to Do the Test 308 Colorfastness to Cleaning 308 Shrinkage 308 Seam Raveling 309 Seam Slippage 309 Sagging, Bagging 309 Snag Resistance 309 Review Questions Section Eight 310 Investigations to Do with Fabric Assessment 310

SECTION NINE: METRIC IN TEXTILES USE 313

9-1 The Metric System 314

Origin of Metric Measurement 314 SI Usage 314

9-2 Metric in Textiles Use 316

Metric in Sewing 316 Piece Goods (Rather Than "Yard Goods") 316 Sewing Machine Needle Sizes 316 Stitch Length 316 Seam Allowance 317 Sewing Thread Length 317 Thread Size 317 Measuring Tapes 317 Hem Markers, Gauges, Scissors, Blades Slide Fasteners (Zippers, Coil Fasteners) Buttons 317 Craft Yarn (Knitting, Needlework, etc.) 317 Knitting Needle, Crochet Hook Sizes 318 Metric in Home Furnishings 318 Metric in Miscellaneous Textile Articles Metric in Home Maintenance of Textile Articles 318 Washing Machines 318 Pressing and Ironing 319 Home Tinting 319 Metric in Textiles Study or Laboratory Testing 319 Staple Fiber Length 319 Filament Fiber Length 319 Fiber "Thickness" (Diameter) 319 Fiber Bale Weight (Mass) Fiber Tenacity (Tensile Strength) 319 Linear Density of Fibers (Hair Weight per Centimetre) 320 Yarn Linear Density (Yarn Count) 320 Yarn or Fabric Thickness 320 Woven Fabric Thread Count 320 Knitted Fabric Stitch Density 320 Fabric Area 320 Fabric Weight (Mass) 320 Carpet Pile Height and Density 320 Thermal Insulation 320 Color; Dyeing, Color Matching 321 Investigations to Do With Metric Measurement 321

Review Questions Section Nine 321

REFERENCES AND RESOURCES 323

References 323
References of Historical Importance 326
Publications—Catalogs, or Online 326
Periodicals 326
Associations 327
Teaching Aids and Resources 328
Printed and Internet 328
Storage and Conservation of Textiles
and Vintage Articles

Resources Including Fabrics 329 Equipment Helpful in Textiles Study 329

APPENDIX 331

INDEX 335

Preface

Innovation is bringing what were once "far-forward" developments in textiles involving highly complex technology, into mainstream consumer goods. This fourth edition of Fabric Reference emphasizes, to students as well as instructors, the relevance of this innovation to their fields. I shall return to this theme shortly in "Focus on Today's Exciting Fabrics." But first, a general indication of what this book is about.

Fabric Reference is a guide for anyone who needs accessible information on today's fabrics—how they behave and why. The study of textiles represents a highly technical, complex, and rapidly developing field, yet one that attracts and interests most students with its direct impact on all our lives. What is learned about fabrics in an introductory course will usually be applied in careers involving many other skills as well, such as those offered in programs of textile, fashion, or interior design; apparel and furnishings merchandising; costuming; or communication in various media.

The student more often than not comes to textiles without a background in the disciplines that underlie the information offered (particularly organic chemistry and physics). This book is aimed to serve the needs of such students, for whom textile science is a significant component of their programs but not the entire focus. This is accomplished by following the most up-to-date technical information, but condensing the essentials—distilling the main points without "watering them down."

Study of the Fabric Reference is greatly assisted by the material in its companion book, Fabric Glossary, which describes by name and characteristics most of the fabrics we deal with in apparel, interiors, and other consumer goods. In this way, while studying a certain weave structure, for example, the student can also absorb details of major fabrics made that way, see closeup photos or scans of the materials, and even handle many of them through a swatch set of fabric samples designed to be mounted in this fabric dictionary. Use of the two books together is

facilitated by tables in the Fabric Reference that provide links with the names in the Fabric Glossary. In addition, the comprehensive index of the Fabric Reference also lists the pages in the Fabric Glossary that contribute to that subject and indicates where an item is illustrated in either book.

Presentation and Organization

Fabric Reference first discusses all the elements that go together to make a fabric, with sections on textile fibers; all kinds of yarns; fabric constructions, including weaving, knitting, lace, tufting, nonwovens, leather, and furs; and finishing, including coloration. This basic information is presented in a condensed format; data are summarized, and elements that are often confused one with another—such as raw silk and wild silk—are clarified. The book offers full coverage of the rapidly increasing special modifications of manufactured fibers, high-performance materials, specialized finishes, and leading-edge printing methods. All of this is laid out clearly, with many excellent illustrations including specially executed graphics.

Following the sections just outlined, much fuller treatment is given of many areas of applied textile knowledge that are dealt with only sparsely in other textbooks, plus some aspects that are virtually ignored. I believe these areas of knowledge to be among the most useful in many fabric-related fields.

Fabric Reference includes an expansive section on the care of fabrics, a subject that other texts treat more briefly. Home care instructions according to the approved symbols used in the United States are compared with those of other countries. I also discuss the far-reaching changes in commercial cleaning, which include wet cleaning as well as dry cleaning solvent use. I have included insights gained from my work with textiles testing, quality control, and extensive experience in dyeing. Anyone buying fabric will do so

with more confidence if the basic colorfastness to be expected has been clarified, as it is here.

Because students should understand the importance of standard tests, I have included a brief section on fabric assessment. For those in interior design, the special tests routinely used for upholstery fabric, carpets, and other materials have been added, along with the significance of the rating scores (suitable for light use, contract use, etc.) in selecting fabrics. Students, retail buyers, designers, fabric buyers for garment houses, or home sewers and dressmakers can apply nontechnical assessments to get valuable information about a fabric's likely performance, or provide practical and revealing investigations of fabric properties. There is also a unique Fabric Case History record sheet to encourage those actively working with fabrics to develop a routine of keeping samples of and full data on materials used. This has proven to be a vital asset to many designers—an "archive" with a record of fabrics used, not only during makeup of the article, but also behavior in use. This applies to designers of anything from theater costumes, to high-performance sportswear, or interiors.

As befits a fabric reference, this text includes a full section on use of the metric system in textiles, recording almost every aspect imaginable—the result of my work as the "textiles person" on a metric committee of the Canadian Home Economics Association. When we deal with most of the world, we encounter metric units, and people in laboratory work use them all the time.

The extensive section on fabrics and ecology is unique among current texts. It addresses such issues as how we can keep warm in cold weather with the least impact on the environment; how we can keep cool in hot, sunny conditions, and relatively safe from ultraviolet radiation at any time; what is happening to combat pollution or promote recycling; and finally, where some of the most forward and exciting developments are leading.

Online Supplements

An online Instructor's Manual is available to instructors. To access the online Instructor's Manual, go to **www.prenhall.com.** Instructors can search for a text by author, title, ISBN, or by selecting the appropriate discipline from the pull down menu at the top of the catalog home page. To access supplementary

materials online, instructors need to request an instructor access code. Go to www.prenhall.com, click the Instructor Resource Center link, and then click Register Today for an instructor access code. Within 48 hours of registering you will receive a confirming e-mail including an instructor access code. Once you have received your code, go to the site and log on for full instructions on downloading the materials that you wish to use.

Focus on Today's Exciting Fabrics

The extent of change and development in textiles available to the public has been so great since the third edition of *Fabric Reference* that I rewrote most of my introduction. I tried to describe some of the profoundly different materials we are using or are close to being able to use for consumer products that were "ivory tower" research destinations not long ago. I think it is important that today's students get exposure to this in even an introductory course in textiles, or they will neither understand the choices that are possible nor recognize when a product is radically different from a seemingly similar traditional one.

An open mind is needed to explore the unfolding opportunities, and also to keep delight in and respect for ages-old fabric favorites as well, often enhanced by ultra-modern yarn styles, machine construction, or possibly new printing or surface embellishment methods.

There is very little looking back in this edition of Fabric Reference;* instead I have emphasized today's and tomorrow's fabrics—the products of leading-edge technology that produces more and more astounding results. In previous editions I paid tribute to microfibers much finer than the wispy filaments from the spinnerets of a caterpillar (silk). We are already becoming blasé about these fibers, but they are wonders nonetheless. Now we are using nanotechnology, on a thousand times smaller scale, and in digital printing, electronic control is creating patterns with drops of ink on a scale a thousand times smaller again (picoliter). We are seeing more "smart" textile products engineered to play an active part under specific conditions.

Fabric Reference is the result of a distillation of my nearly sixty years' experience in the textiles, communications, and education fields, and a desire to present the information gleaned from this experience as succinctly and clearly as possible. It is a culmination of wide-ranging research into the field's fast-moving technology to record the latest developments in an accessible format. I hope this text offers a lifeline to (a) students of textiles who are trying to grasp the essentials of this demanding subject and hoping to work in one of the areas where knowledge of fabrics is crucial; (b) those who are already involved in a textiles or clothing field but have no formal training; and (c) educators dedicated to leading students through this complicated, rapidly developing, but deeply rewarding and satisfying subject.

Fields of Application

The information in this text applies to many fields:

- Design and manufacture of fibers, yarns, or fabrics and various aspects of finishing, including dyeing and printing
- Design and production of garments or accessories, whether in business and industry or by an

* The history of textiles has been my extracurricular passion for many years, taking me as an amateur member into spinning and weaving guilds and as a very active member into costume societies. However, it is modern fabrics I have dealt with all my working life, first in the textiles industry—running a small research, development, and testing laboratory while at the same time presenting information to consumers through print, radio, and television—and later teaching college fashion students.

- individual in couture, commercial dressmaking, or home sewing
- Design and furnishing of interiors
- Quality control of fabrics, garments, or other consumer textiles products
- Any phase of merchandising of fabrics, garments, accessories, or home furnishings, including wholesale, retail, and display, plus staff training
- Fabric care—laundering, commercial cleaning (dry or wet), repair, storage, or conservation
- Design and production of costumes, whether for theater in its many guises or for "living museums" where authentic reproduction costumes are desired
- Preservation and display of historic costumes
- The myriad forms of textile crafts, including spinning, weaving, dyeing, surface embellishment, and needlework
- Communications in all media concerning any of these areas

To guide you into and through the exciting, fascinating, colorful world of textiles, I offer the *Fabric Reference*. May it prove a good companion.

Acknowledgments

Revising a book like Fabric Reference involves gathering information on developments that are highly technical, yet move ever more rapidly beyond applications such as industrial or aerospace textiles to become part of the consumer market, often carrying trademark names to single out the result of a great deal of research. I prefer to get my information from those who deal in the terminology of physics, organic chemistry, or whatever the basis is of a particular product, and to do this I often contact professionals who might not be expected to give their time helping me make a link between the underlying scientific discipline and those who will use this textbook. It is a process I delight in: "translating" data to make it clear while keeping it accurate.

Particular thanks go again this edition to Rose E. Dee (International) Ltd., for providing their newest registered designs to grace the covers of both *Fabric Reference* and *Fabric Glossary*, as well as others for

the title and section heading pages, all sent by their Head of Design, Michelle Miller. My daughter, Nina Scott-Stoddart, revised four key graphics, and piloted me through the process of receiving and organizing images.

The reviewers of the third edition were particularly helpful for this revision, and I sincerely appreciate their contribution. On a very few points I went my own way, but almost all of the critiques zeroed in on areas that I had missed, or they reinforced my belief that certain areas were much more important this time around. Thanks to those reviewers: Brian George, Philadelphia University; Marguerite Reed-Brooke, Philadelphia University; and Robyne Carol Williams, North Dakota State University.

I have had the special guidance of Joanne Vickers again for preparing the revision for production, and it is a privilege to work with her. We had excellent rapport with Vern Anthony, Editor-in-Chief of Careers, for Pearson/Prentice Hall, and also with the Editor for Fashion, Jill Jones-Renger, Assistant Editors Doug Grieve, ReAnne Davies, and Yvette Schlarman, and Project Manager Kevin Happell during the preparation period.

The outstanding skill and precision of my copyeditor, Rebecca M. Bobb, was deeply appreciated—indeed, enjoyed deeply. There has been considerable effort in this edition to lay out and separate the condensed information so that it can be "taken in" more easily.

In sifting through the masses of information in this very fast-moving field, I have had delightful and fascinating exchanges with many busy experts who so generously gave their time to provide me with technical information, wonderful new images, and the essential letters of permission to publish. I thank them all, listed here alphabetically by company or organization:

Academic School for Interior Design, Jo Woodworth; AGP & Associates, Inc., Nancy Collins for Dow Corning; Americas International Consultants Inc., Bob Hardy; Clean Concepts Technology, Inc., John Tipps; DuPont Sorona, Dawson Winch; Ellis Developments Ltd., Julian G. Ellis, OBE; Fashion Innovation Service, MP3Blue, Oliver Stollbrock; Fiber Economics Bureau Inc., Stanwood Snowman; Fleissner GmbH, Sascha Berk; GINETEX, Trudy Lüthi; Interactive Wear, Andreas Röpert; Invista, Valerie A. Mackie; Malden Mills Industries/Polartec®, Joanna Collar; Karl Mayer Maschinenfabrik GmbH, Petra Arnold; Nano-Tex, LLC, Tom Stenzel; Optimer Performance Fibers, Inc., Karen Deniz; Rose E. Dee,

Michelle Miller; Sport Hotel Lorünser, Gebhard Jochum; Thomson Research Associates, Dr. Laval Yau; Vintage Fabrics on www.fabrics.net, Joan Kiplinger; Weave Corporation, Sarah Berkley.

Acknowledgments-Third Edition

Significant help was received from each of the following:

American Fibers & Yarns Co., Nicolette Rainey; Angora Rabbit Breeder, Lil Peck; Bodycote Ortech Inc., Jerry Bauerle; Canadian Textile Journal, Roger LeClerc; Consoltex Inc., Esther Bensusan; Crossley Carpet Mills, Gerry Newell; DanRic Marketing, Paul Beacock; Lindauer DORNIER GmbH, Mr. E. Wirth; DuPont Canada Inc., Adelina Tiberio; Dupont Ink Jet, Adrian F. Newell; Federal Trade Commission, Consumer Protection, Steve Ecklund; Fiber Economics Bureau Inc; (Textile Organon), Stan J. Snowman. The John Forsyth Shirt Company, Phyllis Gordon; Frisbie Technologies, Doug McCrosson; Gaston County Dyeing Machine Company, Sally S. Davis: The Lace Merchant, Elizabeth M. Kurella; 3M Canada Company (Thinsulate™), Inge Pudelek; Karl Mayer Textilmaschinenfabrik GmbH, Ulrike Schlenker; Miele Appliances Limited, Sally McClelland; A. Monforts Textilmaschinen GmbH & Co., K. A. Heinrichs: National Cotton Council of America, Cotton Nelson; Nest Builder, Barbara Hord; Nextec Applications Inc... Victoria Cabot; Rieter Machine Works Ltd., Kathrin Mähliss; Rose E. Dee (International) Ltd., Rhoda Cooper; Seneca College Fashion Resource Centre, Bev Newburg; SunSense, Cindy Legare; Textile Human Resources Council, Alan Athey: USMA (United States Metric Association), Dr. Don Hillger; Zellweger Uster, Peter Mock; Wacker Chemical Corporation, Wm. J. Toth. Wellman, Inc., Judith Langan; WestPoint Stevens, Alan Kennedy; The Woolmark Company, Sue Tolson; WRONZ (Wool Research Organisation of New Zealand [Inc.]), Dr. Errol Wood.

Acknowledgments-Second Edition

The shared enthusiasm of so many diverse people makes a revision like this exciting and a joy. Those who helped me most are listed here, arranged alphabetically by company or organization:

Akzo Nobel Fibres, Graham Allen; American Textile Manufacturers Institute, Inc., Caroline Bruckner. Communications; Amoco Fabrics & Fibers Co., David B Gray; BASF, Andy Buffam; The Bata Shoe Museum, Susana Petti; Canadian Apparel Magazine, Hedi Badakhsham; Canadian Textile Journal, Roger Leclerc; Celanese via Eileen Brown Associates, Eileen Brown, Consoltex Inc., Tim Colburn-Corterra via BRSG, Inc., Sarah Semple; B. A. Crosbie, Consultant; C-Shirt Canada; Jeanne Boldt; DanRic Marketing, Paul Beacock; Doubletex, Cory W. Havnes; The DuPont Company, Adelina Tiberio; Martine Thériault, John Burn; Fabricare Canada, Marcia Todd; Federal Trade Commission, Steve Ecklund; Fiber Organon, Fiber Economics Bureau, Stan Snowman; FoxFibre (Natural Cotton Colours, Inc.), Sally Fox; W. L. Gore & Associates; Inc., Cynthia Amon; Michael Graves, Architect Michael Graves; Hempline Inc., Geoffrey Kime; Hoechst NA Holdings; Inc., Vicki Bousman; Industry Canada, Chris Chiba; Intera Corporation, Jim Klopman; Betty Issenman (re, Sinews of Survival); JABA Associates, J. A. B. Athey: The 3M Company, D. Christine Shumsky; Meadowbrook Inventions; Inc., Roberta M. Ruschmann: Micro Thermal Systems: Ltd., Philip Johnson; Milliken & Company, Timothy Monahan: Department of Entomology, Mississippi State University, Dr. Gerald T. Baker; National Cotton Council of America, T. Cotton Nelson; Outlast Technologies, Inc., John Erb; Dana Rogers (MPH); Park B. Smith; Inc., Valborg Linn; Picanol of America, John Vanbee; PTFE® llc, Robert Gunn; Amy Mansfield; Raven Marketing Services, Ltd., Lisa Chum-Seneca College of Applied Arts and mun; Technology, Bev Newburg; Solutia Inc; (re: Monsanto) Joan Murcar; Sulzer-Rüti AG, René König; Sulzer-Rüti USA, Heidi M. Jameson; Tencel Fibres Europe, Caroline Crouch; Textiles Magazine, Jack Smirfitt; Textile World, John W. McCurry, Jim Morrissey; T.G.I. Fabrics, Paul Triska; United Media; United Feature Syndicate, Anna Soler; University of British Columbia Press, Marnie Rice; School of Textile Industries; University of Leeds, Jill Bullock; Uvex Toko Canada Ltd., Andrew Murdison; Catherine Vernon; Textile Conservator; The Woolmark Company, Kate Sumptner, Heather Stuart, Kirsten Mogg; Wordcrafters Editorial Services, Laura Cleveland.

Acknowledgments-First Edition

As I worked on the manuscript for this book, I often looked forward to preparing some record of thanks to the many who helped me. I realize now that

countless others will not be formally acknowledged, starting with my instructors and colleagues over the years. However, a key influence and guide was Jessie Roberts Current, who directed my graduate work and later managed to get me to take over from her the National Textiles Committee of the Consumers Association of Canada, in its heyday of volunteer consumer advocacy. Perhaps most of all I owe a great debt to my students, who have led me first to try to digest and keep current the sprawling body of information to do with textiles, and then to compress and highlight it for those who do not have the time or opportunity to absorb all the detail behind the working guides and conclusions presented here. Their questions, comments, challenges, and responsiveness have helped shape this presentation of Fabric Reference.

Of individuals directly connected to production of this book, I wish to thank Paul Beacock, my computer graphics wizard (who had not been familiar with textiles before!), and the stalwart "home team" of my daughter Nina Scott-Stoddart, my sister Lucy Noble, and my good friend Rosemary Webber for endless hours of effort. Support came also from Bev Newburg of Seneca College, Cathy Bell of St. Lawrence College, and Alistair Stewart, expert and patient photographer. Claire Becker shared fur expertise over the years in Seneca textiles classes. My reference on silk production was obtained for me by Debbie Boedefeld Cowan, a former student now living in Japan, and the essential translations from the Japanese were by Hiroshi Yamamoto. Critical appraisal of the jacquard loom diagram was made by Marceline Szpakowski:

So many more gave of their time and expertise, and often lightened the job with enthusiasm and humor. I hope most of these are in the following listing, arranged alphabetically by company or organization,

Akzo Nobel Textile Technical Institute, Wolfgang Luft; American Sheep Industry Association, Ron Pope; American Textile Manufacturers Institute Gail Raiman; Anne Schmitz; Amoco Fabrics & Fibers Company, M. Normand Joly; BASF Canada, Owen Bird; Bayer Corporation, Ben Bruner; Bayer Faser GmbH, Dr. Türck, Dr. Reinehr; R. Dohm; Canadian General Standards Board, Ginette Chalifoux; Christina Canada Inc., Myriam Cook; Ciba-Geigy Limited, Peter Warne; Cluett International (Sanforized), Andrew Gryszkiewicz; Coats Patons Karen Glover, John Laurie; Cocoon World photographers Shigeki Furukawa and Masahisa Furuta; Consoltex

Inc., Paul Pinsler; Consorzio Merletti di Burano, Dott; Annibale Tagliapietra; Cotton Incorporated, Bill Daddi, Courtaulds Fibers Inc., Don Vidler; Courtaulds Fibres, S. A. Frankham Cranston Print Works Company, George W. Shuster, Christine Navarette; Dahlbrook Farm, Lars Dahl; Denver Museum of Natural History, Dr. Richard S. Peigler; Dominion Textile Inc., Sylvain Dufort; Dorothea Knitting Mills Ltd., Beryl Borsook; Down North, Wendy Chambers: DuPont Canada, Wolfe Brehme, Elizabeth Lam; Eco Fibre Canada Inc., Judy Heifetz, eco-tex consortium, Christel Beuth; E. I. DuPont de Nemours and Company, Karen Galbraith; Environment Canada; Climate Information Branch, Gary Teeter and M. S. Webb; Fabricare Canada Magazine, Marcia Todd; Federal Trade Commission, Steve Ecklund, Bret Smart; Gateway Technologies, Inc., Bernard T. Parry; GINETEX Secretariat, Nathalie Gamet; W. L. Gore & Associates, Inc., Lisa Wyre; Hafner Inc., M. Adrian Spoerry. Shirley Horner; Health Canada, Product Safety, Kathy Wick; Hoechst AG, H. Dilley and Robert Jarausch; Hoechst Celanese, Maxine Speakman. Ellen Sweeney; Hoechst Celanese Canada Inc., Wilma Wiemer; Home Laundering Consultative Council, Richard Crooks; Industry Canada, Consumer Products, Chris Chiba, Kathy Dobbin, Francine Chabot-Plante; International Fabricare Institute, Jill Handman; International Wool Secretariat (IWS), Rachel McCluskey; IPL Ingenieur-planung Leichtbau GmbH, Dr. Harmut Ayrle; ISO Central Secretariat, Anke Varcin; Italian Cultural Institute (Istituto Italiano di Cultura di Toronto), Dr. Francesca Valente;

Kanebo New York, H. Jindo; Kuraray Company Ltd., Junko Mon Lenzing AG, Dr. Dieter Eichinger; Linda Lundström Ltd., Linda Lundström; 3M Canada Inc., D. Christine Shumsky; Malden Mills Industries. Inc., Kelly Raadmae, Ernst B. Weglein; Malimo, c/o Karl Mayer Textile Machinery Corp., W. Poenite; Masters of Linen/USA, Pauline V. delli-Carpini; McCord Museum of Canadian History, Nicole Vallières; Merrow Publishing, Dr. J. G. Cook; Messe Frankfurt Techtextil-Team, Michael Jännecke: Metropolitan Toronto Zoo, Toby Styles; Mohair Council of America, Christie Ingrassia; Monsanto Canada Ltd., Joan Murcar, Dragana Zivanovic; Morrison Textile Machinery Co., James Hamilton; National Cotton Council of America, T. Cotton Nelson; Polywert Faserrecycling GmbH, Katrin Näser; J. C. Rennie & Co., Dr. J. Lawrence; Rhône-Poulenc, Textile Performance Chemicals, Jack Bennett; Arthur Sanderson & Sons, Tony Tenkortenaar; SATRA Footwear Technology Centre, Peter Larcombe; Sears Canada, Shirley Baker; Sears Roebuck, Nancy Pauer; Seneca College Fashion Resource Centre, Claire Becker; Shima Seiki U.S.A. Inc., Anthony McBryan Speizman Industries (Jumberca), Bob Speizman; Statistics Canada, Margaret Parlor; Sulzer Canada Inc., Gary Zimmermann; Sunsoakers, Inc., Sheryl Barber; Teijin Limited, S. Tsuji; The Textile Institute, Paul Daniels; Tribune Media Services, Mary Beth Pacer; Universal Press Syndicate, Carla Stiff; Valley-Tex Inc., David Huffman; Wool Bureau of Canada Ltd., Heather Stuart.

Mary Humphries

About the Author

Mary Humphries has nearly 60 years of experience in the textiles field, from the basis of an Honor B.A. (Household Economics), then an M.A. in textiles research, both at the University of Toronto. Two of her papers (then Mary Murdison) were published on her M.A. work in the *Journal of the Textile Institute*, Manchester, U.K. She is a Charter Member and Fellow of the Institute of Textile Science. Mary worked in textiles testing, in research and development, as head of a small laboratory for more than 10 of her 13 years

there. Some work involved referee reports on dry cleaning. During that time, she was National Textiles Chair for the Consumers' Association of Canada, and she did extensive radio and television broadcasting, as well as speaking to consumer and industry groups. She was a Professor of Textile Science at Seneca College in Toronto for 23 years and at Ryerson Polytechnic University for $1\frac{1}{2}$; years. She is a past Chair of the Costume Society of Ontario, and for nearly 10 years was Editor of their thrice-yearly $Costume\ Journal$.

SECTION ONE

Introduction

1-1 FABRICS AND YOUR CAREER

How Much Do You Need to Learn about Textiles?

Most of you are planning to work in a field involving fabrics, and that field covers a wide and wonderful range of occupations: design of textiles, interiors and furnishings, apparel, or costumes; merchandising of apparel, furnishings, even appliances; communication in various media; museum and conservation specialties; education; or (for new possibilities open as the field expands) working in a team with engineers. chemists, electronics experts, and others. To do any of these jobs effectively and to get joy from such work, it is essential to understand the fine points of what you are dealing with, and that involves technical complexities as well as beauty of color or textures. attractiveness, or correct period of design. So you now find yourself taking an introductory course in textile science, which this text will make as accessible as possible, both now and when you need to look something up later, as you follow your career.

Humans have made and delighted in textiles for many thousands of years, and we still do. Fabrics are all around us, literally wrapping us in clothing or bedding, under us as we sit, and in sight at our windows; we call these domestic or residential fabrics. Then we meet more in transport, at work, or in public places; these are known as contract textiles. There are many others not at all familiar, with specialized applications and properties. These are usually classified as industrial, or more often now, technical textiles.

In each of the preceding editions of Fabric Reference, attention was focused mainly on fabrics used in consumer goods. Industrial textiles were in the background because they represent materials, techniques, or components suitable for specialized applications: geotextiles such as liners for highway beds, or essential to filter, drain away, or hold out moisture in buildings; space suits; "smart textiles" that can monitor a soldier's or healthcare patient's vital signs, such as pulse and blood pressure; specialized "high performance" types, used by firefighters, police, or astronauts for extreme conditions.

Now the line is disappearing between the properties of those materials far from the experience of the ordinary public, and those that form consumer products. These novel constructions or characteristics may inspire new items that often become "must haves" for home or apparel fashion, or perhaps for those enjoying a demanding sport or leisure activity—and this transformation is moving more quickly than anyone expected. This underlying message of this edition has been summarized by a wide variety of observers or communicators, but Matilda McQuaid says it most dramatically: *Textiles can be anything*.¹

Everyday 21st-Century Textiles Are Extraordinary

Today, most definitions of what a textile is, as well as most listings of the applications of various fabrics, are obsolete. You have already been selecting and using textiles that are truly 21st-century creations. The result of this innovative thinking is development of materials with amazing properties. And the flip side of that development is that we have more and more extraordinary fabrics in everyday use that are very unlike what was used just a few years ago.

To accomplish this, research and development personnel in textile firms have been working with those in other companies with special technological skills or knowledge in electronics, engineering, physics, chemistry, medicine, and many more areas of expertise. In this way, some outstanding North American and European firms have been able to meet the challenge of losing markets for their more conventional products to textiles made abroad, often in countries with much lower labor costs. These firms may and do source materials, have products made, and otherwise operate globally, but their *innovation* is the thing that is keeping them in business.

So there are many exciting developments involved, but the basics are still here and need to be understood to give an updated general introduction to textiles science as it applies to consumer goods. In apparel, household furnishings, and contract work, we still live with much that is familiar, and treasure established fine design as well as high quality traditional constructions.

Some of the most intriguing or significant developments in their appeal to consumers are admittedly complex, involving plasma treatments, nanoscience, or other processes that sound a bit other-worldly. (Some, indeed, originated in the needs of the space program.) However, other aspects of textiles study have been simplified in this edition, particularly the recording of trademarks. (See discussion of "What Is a Trademark Name?" in Section Two.) Parts of Section Seven, "Textiles and Ecology," have been shortened because "going green" has become more a part of fabric production in the Western World and there is pressure to cut back pollution worldwide. The basics of keeping warm in cold weather are now well established. Almost all discussion of "smart" textiles and components has been moved to earlier sections, as part of the mainstream.

A few of the developments that have moved rapidly from extraordinary to (or towards) ordinary features of the fabrics we use in clothing, domestic furnishings, and sportswear or gear are shown here. One with this kind of immediate appeal is

Figure 1.1 Wearable electronics with Rosner MP3Blue, dubbed a "multimedia lifestyle jacket." (Courtesy of Fashion Innovation Service GmbH)

"electronic clothing," which allows wired and wireless control of various items of equipment to be built into an article of clothing. Figure 1.1 demonstrates the concept of "wearable electronics" as a fashion sportswear reality, made possible by developments of Interactive Wear AG. This company brings together the specialties and expertise of various firms to provide integration of electronic functions, components, and systems into textile products. The basis here is an MP3 player with a Bluetooth interface. In the case of the Rosner MP3Blue jacket shown in Figure 1.1, a cell phone and the MP3 player are controlled by "soft switches" on a fabric keypad integrated into the sleeve. There will be more discussion of such "smart textiles" in Section Seven.

Figure 1.2 shows a very special material used in windsurfing. Its silicone rubber finish makes it stronger and also repels liquids such that it can resist water hitting it with great force. The material also filters out UV rays for a long life in this sport.

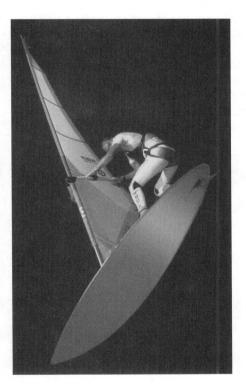

Figure 1.2 Textile products are used extensively in sports, not only in clothing but in the sport's gear. Windsurfer sail-fabric is an example of specially treated material for marine use. (Courtesy of Wacker Chemical Corporation)

What is generally termed biotechnology is illustrated in Figure 1.3, with textiles the "wearer" never sees, for they are surgical implants. The tube (stent) shown in photo (a) is used to hold an artery open. It has been embroidered with wire, so that no matter how sharply it is bent, the central canal (lumen) stays open.² In this case, the fabric base is still there, but for other purposes, if the fabric base for the embroidered material is dissolved away, an openwork structure results, a technique used for years to make Schiffli lace.

But with innovations in materials used, and computer-aided design and manufacture (CAD-CAM), many other bioimplantable devices can now be made—and very quickly. For an example of the super-practical yet wondrous results this can give, see "Embroidered, Base Dissolved" and Figure 4.78 in Section Four. Figure 1.3 (b) shows replacements for human arteries by sophisticated fabric tubes.

Figure 1.4 reflects the likely experience of almost anyone who has had a spill on clothing or furnishings. This shows a shirt with one of the Nano-TexTM finishes, in this case resulting in liquids just rolling off. This is the result of nanotechnology (definition coming up under "Basic Terms" in this section). Such stain repellency is durable, yet it is achieved without changing the aesthetics of the fabric. This is good news for anyone, but especially here, where it is part of a travel wardrobe (more on Nano-TexTM finishes in Section Five).

There are also developments for the many applications where standards must be met for flame retardancy, antibiotic action, or such—textiles in hospitals, schools, offices, theaters, and other places where contract textiles are involved, plus protective clothing for firemen, police, miners, and many occupations where textiles contribute to safety. If you go into contract work in interior design, these are textiles you need to know about.

Having taken a quick look at some unusual fabrics, let us list a few in use all the time, but to which we give little thought as textiles. Consider the canvas behind an oil painting, the tape in a cassette, the stadium's "grass" carpet as you watch a game on TV, the "enhancement" by synthetic fibers of the turf on a horseracing track, the teabag you used for

Figure 1.3 (a) Embroidered stent, as used for repair of abdominal aneurysms. (Courtesy of Ellis Developments Limited) (b) Tubes of expanded polytetrafluoroethylene replace human arteries in Gore-Tex[®] fabric vascular grafts. (Courtesy of W. L. Gore & Associates, Inc.)

Figure 1.4 Spills roll off shirt with Nano-TexTM Resists Spills finish. (Courtesy of Nano-Tex, Inc.)

your "cuppa," the filter in your air conditioner, the cover for your pickup truck, undeployed inflatable airbags, the cords in the tires, the belts and hoses under the hood, fibers in car brake linings and clutch facings. If a handsome balloon floats overhead, that's more fabric—also lines (ropes), not unlike the combination of canvas and lines still so important to sailing. You may have been in a structure with a fabric roof (and not just a pup tent, either)—perhaps a sports dome that opens in good weather and retracts in bad. It takes the mind's eye to see the fiber optics core your telephone message flashes along, the miles of electrical cables hidden in any town or city.

Now we need to focus on some of the basics of all these amazing entities that are part of the field of textiles. To begin, we should clarify what we expect of fabrics.

What Do We Want from Textiles?

In apparel and household furnishings, to say nothing of offices and autos, we want fabrics that make us look and feel good! This is not just good appearance, the right color, texture, or scale of design. Today's consumer should get physiological comfort from clothing (and furnishings should contribute to it). Such aspects as softness and drape, as well as absorbency in clothing, are necessary for this comfort. Apparel must fit the body and move well with it. Where relevant to the prevailing climate, fabrics should keep us warm in cold weather and relatively cool in hot weather. Consumers also respond to developments that discourage growth in fabrics of bacteria (which cause odor when they break down perspiration), or fungi that cause mold, or dust mites in bedding or carpets, which can cause allergic reactions.

As consumer lifestyles and leisure activities have changed, usually to a more active mode even with increasing lifespan, all of these aspects have become more significant, and that is a main reason why the 21st-century developments described so far are of such importance in our study of fabrics.

For most of us, part of comfort is also what might be termed psychological comfort, the wearing of apparel or furnishing of a home to feel "right," whether according to the latest fashion interest or to individual taste. This has always been apparent with clothing, but now seems much more so with our homes. There has been for some time a sharply increasing interest in personal surroundings as very important to well-being, a retreat from the world at large, or in some cases, also one's workplace: fabrics play a great part in this. Finally, today's consumer has extended the sense of rightness to include environmentally friendly—more on this in Section Seven.

We have also come to expect that fabrics will be easy to look after—that it will not be hard to restore them to a neat, clean state, and that they will go on looking good even after considerable wear.

Safety is another of our expectations concerning fabrics—we expect that they do not contain toxic substances, and are not highly flammable.

This is true not only for our clothing, but also for the textiles in our homes, offices, and public buildings, to say nothing of transport, such as automobiles. As in clothing, we look for attractive materials, with pleasing hand, that are easy to care for, wear well, and are safe to use.

In almost every application, then, fabrics must serve useful as well as decorative functions, and our newest developments often contribute greatly. In order to select fabrics that are suitable to a particular end use, method of care, or price range, we must have an understanding of how they behave and why—and that is the answer to the opening question: "How much do you need to learn about textiles?"

Groups of fabrics and fibers react differently from one another: these differences have affected the choice of textiles throughout history. With the introduction of manufactured fibers and complex finishing materials. the choice is much wider, but it is still governed by the behavior properties of:

Fibers Yarns **Fabric constructions** Coloration and finishes

All of these will be examined in this Reference, but first we should define what a fabric is.

Fabric Definition

Fabric is known to us under several other names: textile, cloth, material, dry goods, and stuff. The derivations of these names are as follows:

fabric. (Latin fabrica) Workshop.

textile. (Latin textilis) Woven.

cloth. (Old English) Piece of woven, felted, or otherwise formed stuff.

(dry) goods. Manufactured soft wares (merchandise) as compared to hardware. ("Software" has a very different meaning now!)

stuff. (archaic) Woven material of any kind.

So a regular dictionary definition of a fabric or textile usually includes woven, knitted, braided. twisted, or felted fabrics, but will not cover many materials we use as fabrics today, such as shower curtains of film or interfacings of nonwoven fabric. Similarly, leather and fur are included in this text. although they are outside this formal definition of fabric, since they are not manufactured. They are presented here as being like "natural fabrics," since we certainly use them for clothing and interiors.

An informal, more inclusive definition of fabric would be more cumbersome than the narrow, "official" one:

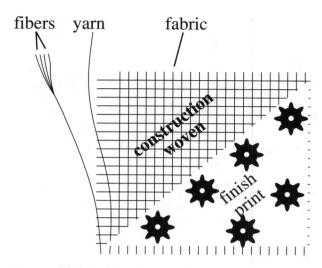

Figure 1.5 Most fabrics can be unraveled to varns, which can be untwisted to fibers.

a thin, flexible sheet of material with sufficient strength and tear resistance (especially when wet) for clothing; interior fabrics; and other protective, useful, and decorative functions.

Most fabrics are manufactured. Nearly all can be unraveled into yarns, and these further taken apart (untwisted) to give fine, hairlike fibers. (See Figure 1.5.)

Fabric Production: Overview of Process and Timing

Anyone dealing with textiles in business should be familiar with the processes undergone to bring them to market. Figure 1.6 gives a flowchart of the timing and paths taken to produce fabrics and bring them to various end uses.

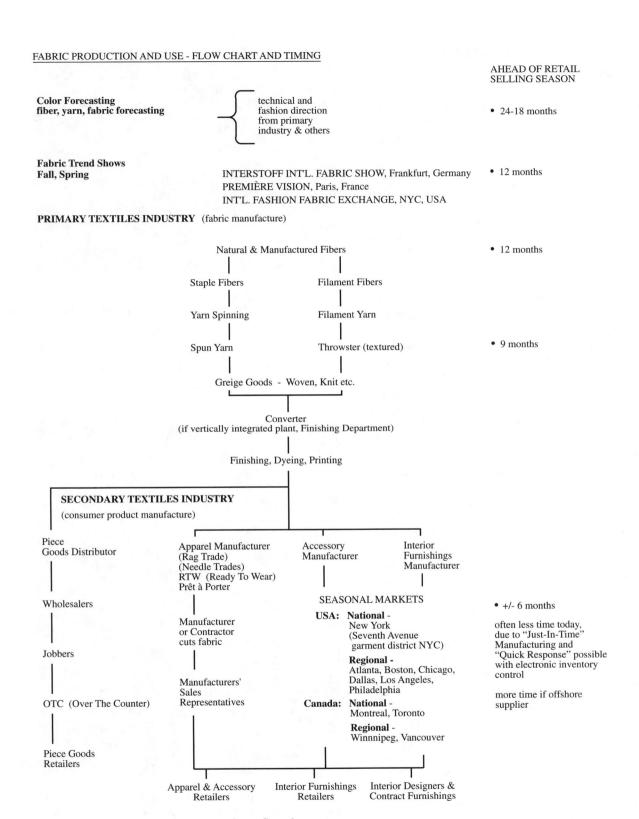

Figure 1.6 Fabric production and use flowchart.

1-2 BASIC TERMS USED WITH FABRICS AND FIBERS

Before using this *Reference*, you need to know some basic terms and special vocabulary used to describe fabrics and particularly to compare the character and performance of fibers.

Aesthetic Characteristics

hand. Feel or handle. It may be warm and dry or cool; smooth and slippery or fuzzy, rough, bumpy; soft or firm; "sleazy" or with good body; supple and drapable, even limp, or crisp, stiff, wiry.

flexibility. Suppleness, pliability; important to draping ability. Drapability as well as softness is related to fiber diameter (fineness); a fine staple fiber allows a fine, even, smooth, lustrous, strong yarn. Terms used for fineness are usually derived from yarn count (see Section Three), such as *denier* or *decitex* and wool quality numbers. The current term *microfiber* represents a fiber with a diameter less than that of silk, which is approximately 1 denier or decitex or less.

luster. Subdued, pleasing shine or sheen; related to the fiber surface (smooth or rough) plus the shape of a cross section of the fiber. A round cross section will yield shine; a nonround or lobal cross section will yield luster. Manufactured fibers as made are bright; with the addition of a delustrant (white pigment) they are delustered or dull. Luster is also affected by the type of yarn, the fabric construction, or the finish. Smooth yarn has more luster than bumpy (especially smooth, low-twist filament yarn), as does a construction such as a weave with such yarns lying on the surface, as occurs in satin. Finishing, such as pressing the surface flat or adding a smooth coating, contributes to luster.

pilling. Fibers, worked out of a fabric, roll up into small balls on the surface. All staple fibers in spun yarns can form pills. Stubborn pilling, i.e., pills that cannot easily be brushed off, is a problem. This occurs with very strong fibers. (See Figure 1.7.)

oleophilic. "Oil-loving" or having a tendency to hold oily stains. See *Detergents and Detergency*, Section Seven, on removal of oily soil.

Figure 1.7 Pilling on a woven polyester fabric. (Courtesy of the Textile Institute [Shirley Institute photo])

cover (opacity). Ability to create a dense surface covered in yarn. (See Figure 1.8.) **sound.** As in the rustle ("scroop") of silk.

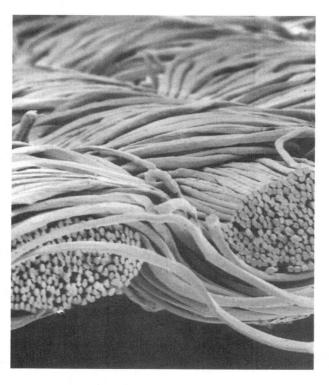

Figure 1.8 Illustrating the concept of cover: Trevira Finesse® microfibers provide good cover to this fabric surface; the fabric also keeps out wind and rain. (Courtesy of Trevira GmbH)

Comfort Characteristics

absorbency. Ability to take up water. Hydrophilic or "water-loving" fabric takes up moisture: **hygroscopic** fabric takes up and holds moisture: hydrophobic or "water-hating" fabric absorbs little; hygral expansion is the increase in fabric size with more humidity; reversible. Absorbency is of primary importance to comfort, for perspiration is a main body temperature control mechanism. We pass off about a liter (quart) a day of "insensible perspiration" as vapor; it is only when perspiration forms as water drops that we are aware of it as sweat.

Absorbency also affects collection of static electricity—electrostatic charges formed when two materials come into contact and are then separated. Moisture will conduct or "bleed" charges away, if present in a fabric; a fiber's electrical resistivity increases when dry. Olefin fiber (polypropylene) is an exception in that it absorbs almost nothing but does not tend to collect or build up static; it wicks moisture (see wicking). Further discussion of static buildup is presented under Properties in Relation to Use (Synthetic Fibers) in Section Two.

adsorbency. Moisture taken up on the surface, varies with the surface area available.

wicking. Passing moisture along the length of the fiber, whether or not it absorbs. Because olefin fiber wicks well, it can be made into comfortable underwear or sportswear although it absorbs almost no moisture. Flax fiber both absorbs and wicks well; this is the reason linen has long been preferred for clothing in hot, humid climates.

resiliency. Ability to spring back when crushed. This most obviously affects crush or wrinkle resistance. (What is measured in testing is wrinkle recovery.) Resiliency of the fiber also affects the insulative property of a fabric. If a fabric with air spaces in it for insulation is made of resilient fibers, the air spaces will not be lost by the fibers "packing down." Such a fabric will prevent loss of body heat and be a good insulator, because one of the best insulators known is a layer of still air (the same principle used in double- or tripleglazed windows).

loft. The volume or amount of space taken up by a given weight of fiber. It is related to low specific gravity or, more simply, to low density, but is not equivalent to weight alone. A lofty fiber such as wool will give a thick material, for example, a heavy coat fabric, that is not nearly so heavy as one made of a denser fiber such as cotton.

crimp. Waviness along a fiber. The finest wool fibers have a great deal of crimp.

elongation. Ability of a fiber to stretch before it breaks; the amount it "gives." (See also modulus.)

elasticity. Elastic recovery is the relative ability to return to original length after stretching. A truly elastic fiber (an elastomer) can be stretched to several times its original length, with immediate and complete recovery, time after time.

skin irritation. Rough fibers, such as coarse wool, can cause itchiness and feel prickly.

Performance Characteristics

strength. Strength, which affects durability, is of several kinds:

- tensile strength (termed tenacity for fibers). Resistance to pulling or tearing.
- resistance to abrasion. Resistance to rubbing or scraping.
- *flex strength.* Resistance to bending.
- modulus. Resistance to stretching. High modulus is little stretch for a given pulling force.
- wet modulus. Ratio of wet strength to wet breaking elongation.

reaction to heat and flame. Fabrics vary in their reaction to heat and to flame.

- thermoplastic. Becoming soft and eventually melting when heated, allowing molding and heat setting. Fibers that do not melt will char with heat. Most major manufactured fibers, except reconstituted cellulose fibers, are thermoplastic.
- heat sensitive. In this Reference, taken to indicate a fiber that would soften in home washing, a hot dryer, and at any but the lowest setting of an iron.

- very heat sensitive. Indicates a fiber that must be kept away from dryers, hot radiators, and even a low setting of an iron.
- flameproof (nonflammable, noncombustible). Will not burn.
- flame resistant. Can burn, but extinguishes when not in contact with flame (self-extinguishing).
- *flammable*. Can ignite and burn.

felting. Matting together of wool and hair fibers: the result in fabric is thickening and shrinkage.

dimensional stability. Ability to keep size, neither shrinking nor stretching.

wet press retention. Ability to hold a press if damp or wet.

Other Basic Terms

polymer. Having many parts: the submicroscopic structure of all fibers. Long molecular chains of small units (monomers) join together like a string of pop beads to make a high polvmer, macromolecule, or "giant molecule." To give an idea of molecular size scale, G. R. Lomax of the Shirley Institute, Manchester, U.K., explained that "a 1 cm cube of polyethylene contains approximately one million, million, million molecular chains, each consisting of some twenty thousand monomer units."3

A copolymer has two units repeating throughout (can be in different proportions). An oligomer has a small number of repeating units. crystalline. Structure of a solid aligned into a repeating pattern. It is hard to realize that a fiber (think of one of your own hairs) is a crystal, just as a diamond is. This paradox can be explained.4 but here it is simply recorded, since the more (perfectly) crystalline a fiber is (molecular chains closely packed), the stronger it is. Less well organized parts of a fiber are called amorphous and are usually more absorbent. The names come from Greek: crystal meaning "clear ice"; amorphous meaning "having no shape." A fiber may have some areas more crystalline, others more amorphous. Only two fiber types have no crystallinity: novoloid and glass.

orientation. Another term having to do with organization of a fiber's molecular chains; in this

case, how nearly parallel they lie to each other. The more oriented a fiber, the stronger it is. If the long chains lie at all angles to each other, it is called a random arrangement. Again, a fiber may have more- and less-oriented parts. The chief method of orienting manufactured fibers is by drawing, and filaments not fully drawn are called POY-partially oriented yarn. (See Synthetic Manufactured Fibers in Section Two.)

plasma. Plasma as used in textile applications is what has been described as the fourth state of matter (after solid, liquid, gas); it is the result of passing electricity through a gas, resulting in "a mixture of positive and negative ions, electrons, free radicals, ultraviolet radiation, and many different electronically excited molecules."5 The definition is doubtless off-putting to those interested mainly in consumer goods, and just beginning an introductory study of textiles! But what can be accomplished with textiles by plasma treatments has already shown very practical and worthwhile results. By working on the fabric surface with such tiny elements, there can be changes unknown before. For example, the hand, luster, or drape of the material is not changed, as it is with most finishes, especially coatings. And there seem to be ever more possibilities in this relatively new way of treating fibers and fabrics. Further, the application of finishing treatments in plasma processing does not involve water or chemicals as most conventional finishes do, thus avoiding pollution.

nanoscience, nanotechnology. These terms represent working with very small units. We are accustomed to microfibers (at or smaller than 1 dtex. a term for fineness), and the wonderful hand or feel they give fabrics, as well as their value in insulation, as in Thinsulate®. Technology has already given us ultra-microfibers down to 0.1 dtex or 3 micrometers (3 µm) in diameter (1 micrometer is a millionth of a meter (about a yard). A nanometer is a thousand times smaller still; 1 nm = 1 billionth ofa meter.

Now fibers called "nanowhiskers" are produced which are in the order of 0.001 micrometer (1 nm) in diameter; in comparison, a human hair is about 20,000 nm wide. One application of these nanofibers is to make filters that can work wonders in separating unwanted materials out of a liquid.

A fiber with a diameter in the range of a nanofiber was developed in Taiwan by San Fang Chemical, aimed for use in an artificial leather. The fiber was reported as so fine that 42 grams of it (under $1\frac{1}{2}$) ounces) would reach the moon 384,000 km away. Such very fine fibers contribute enormous surface area and covering power with very low weight.6

Nanoparticles are the size of molecules or atoms, one million times smaller than a grain of sand (see Relative Size Chart, Figure 5.13 in Section Five). They are worked with in biotechnology a good deal, but with fabrics, particles like this are very useful in finishing treatments (see Figure 1.4, Section One, for one application). The small size allows a desirable property in a textile finish to be permanently attached to the fibers, so it lasts, and moreover, does not affect aesthetics such as the

hand, luster, or drape of the material. Most coatings or other finishing treatments to make a fabric water or oil repellent, or wrinkle resistant, do change these characteristics, and few if any can be said to last the life of the fabric.

Working with very small units, fibers can be made to dye more rapidly, with the colors lasting better in laundering, or to absorb and transport moisture better, a great factor in comfort of fabrics made of them, since evaporation of perspiration is one of the body's principal temperature regulators. In nanoscience, textile technologists, usually in a team with experts in other fields, are working at the level of manipulating atoms and molecules, with wonderful and practical results. There will be more discussion of these in Section Five, Finishes, as well as in Section Two under Microfibers and Nanofibers.

REVIEW QUESTIONS SECTION ONE

- 1. Name one typical end use situation where each of a residential, contract, or industrial textile would be appropriate.
- 2. List three materials we use as fabrics that do not conform to a "dictionary definition."
- 3. How far ahead of a retail selling season does the process of fabric production begin? Name two factors that can allow the shortest time between producing the fabric and offering an item made of it for retail sale.
- 4. Can you suggest three factors that contribute to
- 5. What is the difference between absorbency and adsorbency? Between absorbing and wicking?

- 6. What important role does resiliency play besides resistance to wrinkling?
- 7. For what end use is a lofty fiber well suited, and whu?
- 8. List and define three different kinds of strength in a fabric.
- 9. Clarify the terms: thermoplastic, flameproof, flame resistant.
- 10. What two factors to do with arrangement of the long molecular chains in a fiber contribute to strength?
- 11. What are two factors pulling high performance developments in fibers, fabrics, and finishes into consumer goods?

INVESTIGATIONS TO DO WITH INTRODUCTION: A "BASELINE" FOR YOUR STUDIES

- 1. Select one article of high quality, specialized outerwear, such as high performance sportswear. List all the information given about it (advertisements, labels, hang tags, counter cards), including what salespeople give as the reasons for various construction features, finishes, the price, and such.
- 2. Do the same for a high end textile item of household furnishings: bedding, upholstery, carpet, drapes.
- 3. Keep These Preliminary Records. Critique the information you have gathered or been given when you have completed Sections 2–5, noting what points have been clarified, or where you received misleading or confusing information in the marketplace.

NOTES SECTION ONE

- 1. Matilda McQuaid, editor, Extreme Textiles (New York: Princeton Architectural Press, 2006): 30.
- 2. "Embroidery Technology for Surgical Implants," The Textile Journal, November–December 2006: 30.
- 3. G. R. Lomax, "Polymerization Reaction," Textiles, 1987, Vol. 16, No. 2: 50.
- 4. "Crystal Gazing," New Science, The Ontario Science Centre, May 1991: 1.
- Ian Holme, "Nanotechnologies for Textiles, Clothing, and Footwear," *Textiles Magazine*, 2005, No. 1: 10. (The entire article, pp. 7–11, covers the field with Dr. Holme's special clarity.)
- 6. "Taiwan: Ultra-Thin Fibre Unveiled After \$60m Investment," http://just-style, 16 May 2002.

2-1 WHAT IS A FIBER?

Fibers Are Fundamental

Most basic of all in selecting fabrics is the behavior of the **fibers**, the smallest visible components of most fabrics.

The two main divisions in textile fibers are **natural** and **manufactured** (see Figure 2.1). Natural fibers are those found in nature already usable to make fabrics. The two main sources are plants (with the fibers called cellulosic from the main building material, cellulose), and animals (with the fibers called protein from the main building material). Manufactured (MF) fibers (formerly termed "man-made") are formed from a suitable raw material as a thick, sticky liquid, which is "spun" or extruded through spinneret holes, forming streams that are solidified into fibers. The raw material for MF fibers may be itself a natural substance, or it may be synthetic (synthesized from basic chemical units), but it is converted into textile fibers by a manufacturing process. While there are MF fibers made of natural rubber (as well as of synthetic rubber), there is no such thing as a natural rubber fiber. Similarly, Tencel® lyocell is not a natural fiber; it is an MF fiber made of a natural material, cellulose.

Textile fibers may be staple or filament. **Staple** fibers are relatively short, measured in millimeters or inches. **Filament** fibers are relatively long, measured in meters or yards. Most natural fibers are staple; the only natural filament fiber is reeled or cultivated silk. On the other hand, all MF fibers can be staple or filament; they begin as filament, and in this form can give silky or (reeled) silk-like fabrics. They can also be cut or broken into staple to give fabrics that look and feel more like wool, cotton, or linen.

Textile Fibers Are Special

Many fibrous materials are not suitable to make into fabrics, e.g., corn silk or wood slivers. Textile fibers must have certain properties: flexible, thin (but not too thin), long (enough), cohesive, and strong (enough).

Textile fibers must be flexible. Wood fibers (unless processed, as into pulp) do not bend easily—you can-

not make fabrics from slivers! Textile fibers are also very thin—long in relation to diameter. To be mechanically spun into yarn—drawn out and twisted—staple fibers must have sufficient length, strength, and cohesiveness (fiber-to-fiber friction). Many seed fibers are too short, weak, and slippery to spin into yarn; kapok, for instance, can be used only for stuffing.

Of course, for a fiber to be used a great deal, there must be a reasonable supply and price.

What's in a Name? Fiber Generic Names

Fibers are classified into groups, each of which is given a **generic** name or "generic." For natural fibers, this generic is the name of the plant (cotton) or animal (camel) from which the fiber comes, or an accepted name, such as wool or mohair. For MF fibers, the generic name is given to a family of fibers of similar chemical makeup and is defined in textile labeling regulations in the United States, Canada, and many other countries (see also "Fiber Content Labeling," which follows. Definitions to be used in the United States may be found in full in the Appendix to Fabric Reference, which shows all of 16 CFR Part 303 of Rules and Regulations Under the Textile Fiber Products Identification Act¹ [TFPIA, often called "Textile Rules"]).

A listing of generics and their relationships is shown graphically as a textile fiber "family tree" in Figures 2.1 and 2.2, and as flowcharts in Figures 2.3 and 2.4. Only a few of these are used extensively by consumers; these *major generics* are shown in Figure 2.2 as a "pruned" textile fiber family tree. All are summarized and discussed in this section.

Note that some generic names legitimate in Europe or Canada are not recognized by the United States in its Textile Fiber Products Identification Act (16 CFR Part 303), although they are allowed to be used if recognized by the International Organization for Standardization (ISO-2076-1999). Some of these are: alginate, carbon, chlorofibre, cupro, elastane, elastodiene, fluorofibre, metal fibre, modal, polyamide, polyethylene, polyimide, polypropylene, vinylal, viscose. Conversely, ISO rejected rayon as a generic name in 1971, although it remains a legitimate generic name in the United States and Canada.

Some names are not official in the United States or Canada:

polynosic (a term for one type of High Wet Modulus [HWM] viscose rayon)

fibranne (a term for viscose rayon used in France)

PVC (an acronym for polyvinyl chloride, United States generic vinyon)

PVA (an acronym for polyvinyl alcohol—vinal) polyacrylonitrile (PAN) or polyacryl (terms for acrylic)

Fiber Content Labeling

In the United States, the Textile Fiber Products Identification Act² (TFPIA), enforced by the Federal Trade Commission, specifies requirements for labels, invoices, or advertising for most textile fiber consumer products (there are some exemptions); in Canada, the Textile Labelling and Advertising Regulations made under the Textile Labelling Act, administered by Industry Canada, give similar specifications.3 Labels should state in English (Canada: English and French) the content by generic name (not capitalized) of each fiber present in an amount of 5 percent or more, listed in descending order of percentage. A fiber present as less than 5 percent, unless it clearly has functional significance, and excluding decoration, is labeled "other fiber." Generic names are defined in the regulations. A trademark name (see the next section) may be added in immediate conjunction with and in type of roughly equal size and prominence to the generic. When the fiber content cannot be determined, terms such as "unknown fibers" and their origin, such as "waste materials" are allowable. A company name or registered identification number must also appear on the label, and each act details declaration of the country where the textile product was processed or made.

What Is a Trademark Name?

With many fashion-forward, "high tech," or "Space Age" articles, consumers are more familiar with trademark names than those of the maker, in many cases, or the generic type of a fiber. A few for examples: Fortrel[®], a polyester fiber; Supplex[®], a textured yarn; Ultrasuede[®] or Gore-Tex[®], fabrics; and Scotchgard[™], a finish.

Trademarks (brand, house, or trade names) are names or symbols given to a product by a company or association that has registered and owns the name. Many names we use indiscriminately for any of similar products are actually trademarks of wellknown products, such as Coke, Kodak, and Kleenex.

These are powerful promotional tools, especially when they include or use a memorable logo (word in distinctive type) or symbol (such as the interlocking rings of the Olympic games). An example is shown in Figure 2.1: the Seal of Cotton symbol (a stylized cotton boll) plus the logo used by the trade association Cotton Incorporated.

DuPont, a company that owned some of the most famous trademarks in textiles, guided by market research, in 2000 "restructured" the definitions of some of its brands, including one of the best-known in the world, Lycra[®] (see Figure 2.68), which originally meant the first spandex (elastane) fiber. Because of that restructuring, the name Lycra, now owned by Invista, does not necessarily connote a spandex fiber, but is attached to fabrics promising freedom of movement in clothing, no matter how achieved. Some others no longer associated with a particular generic, type of varn, or finish are: Coolmax[®], Supplex[®], and Thermolite[®], all now owned by Invista.

Considerable emphasis in Fabric Reference has formerly been placed on trademark names as carriers of specific information, with the generic or chemical makeup most basic of all, but this shift has brought listing of all names into question, and in this edition, many trademark names have been removed, and virtually all information on names that are obsolete.

A great deal of money can be invested in establishing a trademark with positive connotations; manufacturers naturally wish these to remain distinctive but part of their corporate image, rather than drifting into the dreaded area of a generic name, as aspirin has done. In this text, every effort has been made to add the appropriate symbol and give the name of the company that owns a trademark in brackets immediately after, at least for the first use on a page; in

Figure 2.1 The "Seal of Cotton" is a registered servicemark/trademark of Cotton Incorporated. (Courtesy of Cotton Incorporated)

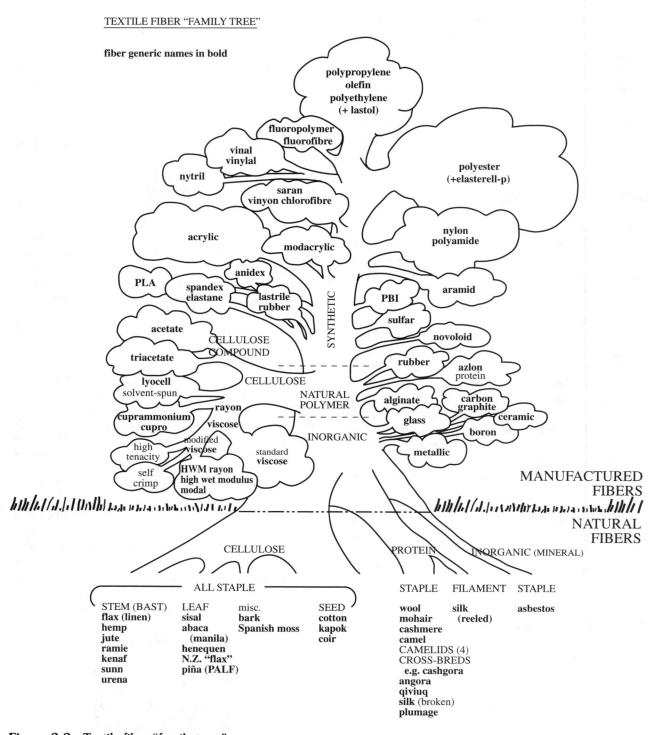

Figure 2.2 Textile fiber "family tree."

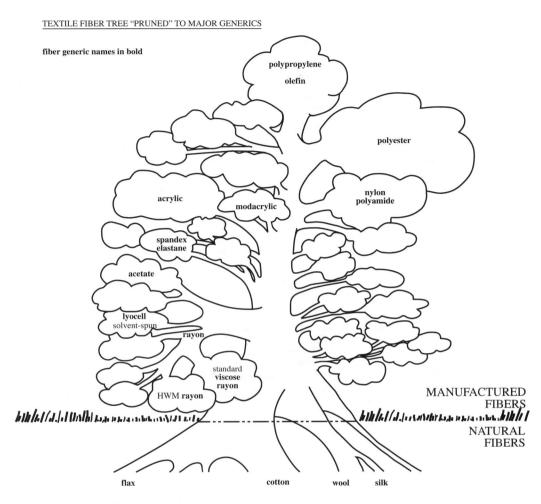

Figure 2.3 Textile fiber family tree "pruned" to major generics.

advertisements you will usually find a footnote used to denote ownership, such as "Abcd is the Registered Trademark of Wxyz Company." Such well-known trademarks carry a definite promise of quality to the consumer; see "Private Sector Labeling with Implications for Care" in Section Six.

Fibers or fabrics sold without a trademark name or end product certification are termed commodity fibers or commodity goods.

Legal Framework of Trademarks

The symbol for a registered trademark is [®] (TM if pending), and for a certification mark, ©. Such a trademark is owned as "intellectual property" and may legally be used exclusively by the company that applied for it.

The owner may license others to use the mark, within provisions of legislation in each country. In the United States, this falls within the jurisdiction of the Department of Commerce, through the Patent, Trademark and Copyright Information Office. A trademark, if for interstate commerce, may be registered with the federal Patent and Trademark Office. In Canada, the governing legislation is the Trade Marks Act.

Since trademarks or brands are such an important factor in advertising and hence in competition, governments handle registrations but leave policing of the system to those who own the trademarks. Infringement of trademark rights is pursued through the courts.

A few words and symbols cannot be used (e.g., United Nations; national, territorial, or civic flags; and the Red Cross symbol).

NATURAL FIBERS

fiber generic names in bold

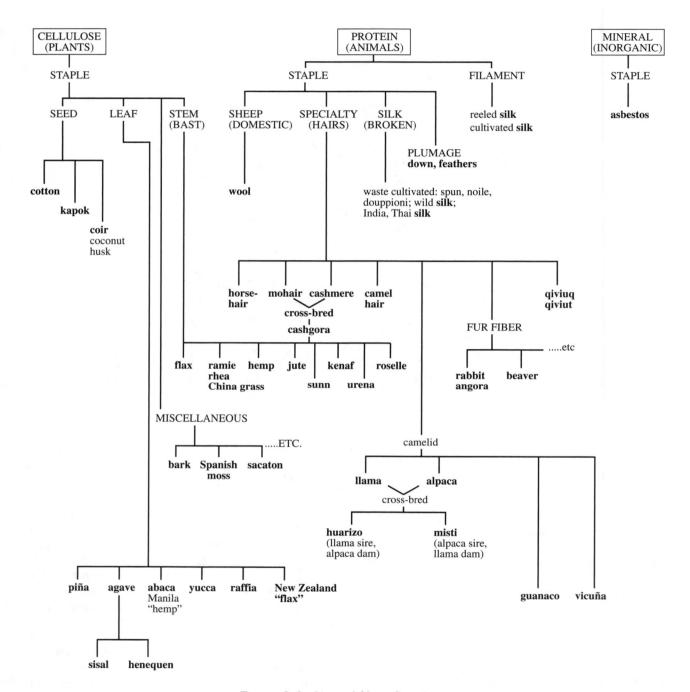

Figure 2.4 Natural fibers flowchart.

MANUFACTURED FIBERS

fiber generic names in bold

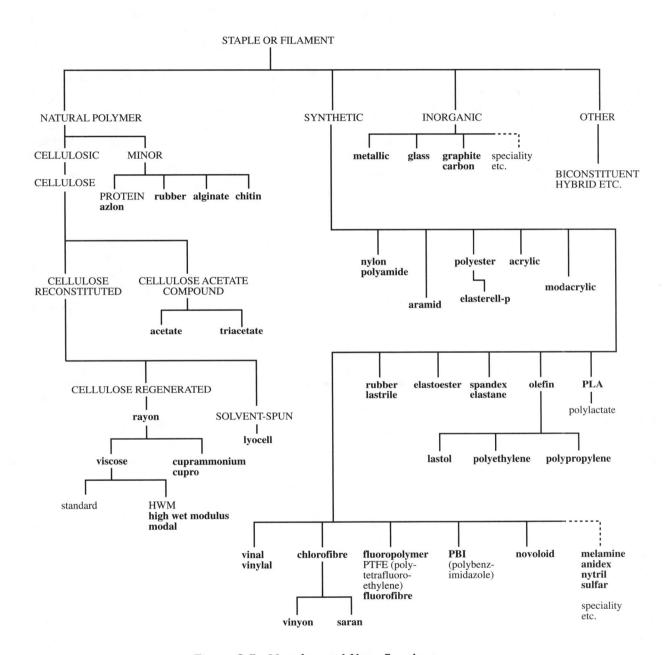

Figure 2.5 Manufactured fibers flowchart.

2-2 FIBER PROPERTIES AND AMOUNTS USED

Section One listed the various properties by which a fabric or fiber may be evaluated; Table 2.1 gives the specifics of these properties for each fiber group.

Properties of Major Fiber Groups— Important Relationships and Summaries

Table 2.2 gives the outstanding advantages and significant drawbacks of each of the major generic fiber groups. The following summarizes the properties of fiber groups and indicates relationships among the groups:

hand (feel):

cool: Cellulose fibers, especially flax (linen) woolly (soft, warm, and dry): Wool; acrylic; modacrylic

silky (smooth, drapable, lustrous): Silk (cultivated or reeled); filament acetate; fine and/or lobal forms (e.g., nylon; polyester)

absorbency:

most (comfortable, nonstatic): Protein natural; cellulose natural; reconstituted cellulose MF

least (less comfortable, collects static [except olefin], dries quickly): Synthetics

wicking: Flax among natural fibers; olefin among MF fibers

resiliency (wrinkle and crush resistance, good insulation): Protein (wool especially); polyester; acrylic; modacrylic

loft (helps air-trapping or insulation with light weight, good cover): Olefin (lightest); polyester; acrylic; wool

strength (resists rubbing wear or abrasion and tearing, but stubborn pilling with staple fibers): Nylon; polyester; olefin

wet strength:

greater than dry: Cotton; flax (linen)

less than dry: Wool; silk; cellulosic MF fibers (includes viscose, lyocell, acetate)

no significant change: Synthetics

thermoplastic (softens, then melts on application of heat; moldable; can be heat set): All major MF fibers except reconstituted cellulose fibers

Table 2.1 Fiber Properties

Fiber Group	Tenacity (Tensile Strength)	Abrasion Resistance	Absorbency	Static Resistance	Bulk and Loft
cotton	++(+)	++	+++	++++	+
flax	+++(+)	+/-	+++(+)	++++	_
wool	_	+++	++++	++	+++(+)
silk	+++(+)	*	+++	++	*
viscose rayon	+	+	++++	++++	+
HWM rayon	++	+(+)	++++	++++	+
lyocell	+++(+)	++	++++	++++	+
acetate	_	_	++	+	++
triacetate			+	+	++
nylon (polyamide)	++++	++++	+	+/-	++(+)
polyester	+++(+)	+++(+)	_	_	++(+)
acrylic	++	++	_	+/-	++++
modacrylic	++	++	_	+/-	+++(+)
olefin (polypropylene)	+++(+)	+++(+)	_	++++	++++
glass	++++	_	0	als:	_

++++ excellent +++ good ++ fairly good + fair +/- fair to poor — poor or deficient

Permanent heat set in this Reference means that a yarn or fabric made 100 percent of that fiber can be set at a high enough temperature into crimps, pleats, smoothness, etc., that these will not alter in normal use and care (hot water, high dryer heat [not hot ironing!]) for the life of the article. (Care related to fiber content is discussed in Section Six.)

heat set permanent: Nylon; polyester; triacetate heat set durable: Other major thermoplastics

heat sensitive (can be damaged or affected by heat, e.g., dryer set on high): Standard olefin; modacrylic; acetate; acrylic

heat resistance: Cellulose natural and reconstituted cellulosic MF fibers (there are other heatresistant fibers, but these are special synthetic or minor generics)

flame resistance (self-extinguishes): Modacrylic (there are other special or minor generics that are flame resistant); wool has a degree of flame resistance if air is not dry

light (UV) resistance: Acrylic, modacrylic, polyester

economy to produce: Cotton among natural fibers; cellulosic MF fibers among all MF fibers; olefin among synthetic fibers

expense to produce, limited supply: Silk; specialty hairs; finest (Merino) wool; flax among natural fibers

expense to produce: Spandex (elastane) among MF fibers

produced from renewable resource(s): Cellulosic MF; elasterell-p; PLA

Properties in Relation to Use

General Advantages of Natural Fibers

From prehistory to almost A.D. 1900 fabrics were made of natural fibers, the major ones being cotton, wool, flax, and silk. These and minor naturals are shown in Figure 2.3 as the roots of a textile fiber family tree. In our marketplace today, they are used to make the fabric for most of the top-quality and top-price consumer textile goods. We still value them, then-why? They are all absorbent, comfortable to

Wrinkle			100	276
and Crush Resistance	Wet Press Retention	Resistance to Heat	Resistance to Sunlight	Other Sensitivities
_	_	+++	++	Mildew, acid
_		+++	+++	Mildew, acid
++++1	+/-	+	*	Insect larvae, alkali, bleach ²
+++		+		Perspiration, alkali, bleach ²
		+++	++	Mildew, acid
	_	+++	++	Mildew, acid
	_	+++	++	Mildew, acid
+	+/-	+	+/-	Acetone dissolves
++(+)	++++	++(+)	+/-	Acetone disintegrates
++(+)	++++	+	3	Strong acid
++++	++++	+	+++	Strong alkali
+++	++	+	++++	Strong alkali, steam
+++	++	+	++++	Warm acetone
+++	*	4	3	Oxidizing agents, chlorinated solvents
++++	*	++++	++++	None

^{*}Data either not relevant or not available.

¹When dry.

²Hypoclorite or "chlorine."

³Without UV light stabilizers.

⁴Unless modified.

Table 2.2 Outstanding Advantages and Significant Drawbacks of Major Fiber Generics Used in Clothing and Household Textiles¹

Group	Advantages	Drawbacks
cotton	Absorbent; strong wet; ample supply; soft (fine); cool hand	Wrinkles; swells in water (fabric shrinks); mildews
flax (linen)	Absorbent; strong dry and wet; wicks; smooth; lustrous; cool hand	Wrinkles; limited supply; mildews
wool	Absorbent; soft, warm, dry hand; moldable; elastic recovery; lofty	Felts; weaker wet; eaten by insect larvae; limited supply; can irritate skin
silk	Absorbent; lustrous; smooth; soft, dry hand; drapes well; strong; good elastic recovery	Weakened by light and perspiration; limited supply
viscose rayon (cupro less important)	Absorbent; economical to produce	Wrinkles; swells in water (fabric shrinks or stretches); mildews; fair strength; much weaker wet
HWM rayon (modal)	Absorbent; economical to produce; dry strength fairly good—better than that of standard viscose; loses less strength wet	Wrinkles; swells in water (fabric shrinks); mildews
lyocell	Absorbent; good strength	Wrinkles; swells in water (fabric shrinks); mildews; loses some strength wet
acetate (as filament)	Drapes well; soft, silky hand; smooth; economical to produce	Weak; low abrasion resistance; fairly heat sensitive; much weaker wet
triacetate	Economical to produce; permanent heat set	Weak; much weaker wet; low abrasion resistance
nylon (polyamide)	Greatest strength and resistance to abrasion; permanent heat set	Collects static; low UV light resistance (can be stabilized); stubborn pilling (staple)
polyester	Good strength and resistance to abrasion; permanent heat set; resilient.	Collects static and oily stains; low per- spiration absorbency; stubborn pilling (staple)
acrylic	Soft, warm hand; resilient; lofty	Collects static; low perspiration absorbency; somewhat heat sensitive
modacrylic	Soft, warm hand; resilient; flame resistant	Collects static; low perspiration absorbency; heat sensitive
olefin (polypropylene)	Strong; lofty; static resistant; wicks; most economical synthetic; almost no absorbency (stain resistant); sunlight resistant if stabilized	Very heat sensitive unless modified; low resistance to oxidizing agents; low resistance to UV light (can be stabilized)
spandex (elastane)	Elastic; up to 10 times the strength of rubber; can be used uncovered; more resistant to oil and dry heat than rubber; takes dye	Yellows in chlorine bleach

¹References are to standard (unmodified) forms of fibers (except HWM rayon); special forms of various generics are discussed under "Modifications of Manufactured Fibers" later in this section.

wear, and collect little static. All have a pleasing hand, texture, and appearance, although they differ a great deal one from another. Our standards of comfort and aesthetics are therefore still set by the natural fibers, which are also a renewable resource.

General Advantages of Manufactured **Fibers**

As the bar graph of world fiber production (Figure 2.6) shows, we use more and more MF fibers, especially synthetics, which have different characteristics from the CMF fibers. However, all MF fibers have the tremendous advantage of being free from most of

the hazards of agriculture that affect production of natural fibers: seasonal variations of weather (sun, wind, rain, floods) and variations of nutrients, with the addition of disease and infestations (sheep tick, boll weevil).

MF fibers are produced all year around and indoors, and require less labor and relatively little space. (One of the reasons for the limited supply of wool is the amount of pasture needed for flocks of sheep, even when otherwise arid land is reclaimed.) Production, and so quality, is controlled with MF fibers, much more so than with natural fibers.

The other main advantage stems from this control-the versatility of MF fibers. MF fibers can be

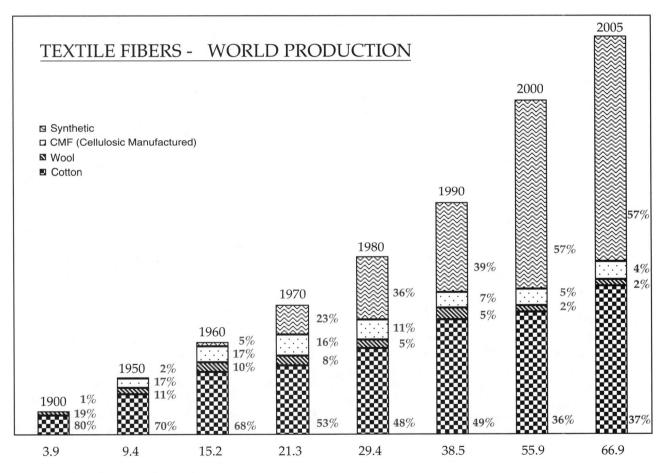

Total in millions of (metric) tons (figures for many years converted from billions of pounds)

Figure 2.6 Bar graph of world textile fiber production, excluding jute, ramie, flax (linen), and silk. Amounts for year 2005 from Fiber Organon, June 2006: 95. (Courtesy of Fiber Economics Bureau, Inc.)

any length (staple or filament); even, or thick and thin; any diameter (fish-line coarse or microfiber fine). The cross-sectional shape of the fiber can be altered; variations of chemical makeup can be made; and materials can be added to the fiber.

General Advantages of Cellulosic Manufactured (CMF) Fibers

The raw material for the first MF fibers was cellulose, which is obtained from wood, a renewable resource in large supply (though there is concern about de- and reforestation these days). Cellulose is a long-chain polymer, one of the main materials of plant structures. It comes to us, then, ready-made, a natural high polymer, and this is the most economical way to make a fiber. It is more expensive to synthesize such a polymer, by building small units and joining them together into very long chains, as we do to make a synthetic fiber.

CMF fibers have all the general advantages listed for MF fibers, but the two types within this grouping, reconstituted cellulose fibers and cellulose acetate compounds, cannot be described together beyond their economy of production from a renewable base. See the discussion of each or the summaries in this section for the specific advantages of each type.

General Advantages of Synthetic Fibers (and Some Drawbacks)

Synthetic fibers have the general advantages listed for MF fibers, but their special properties relate mainly to good performance. Because many are thermoplastic, synthetic fibers can be molded and heat set to give durable or permanent pleats or creases, garment shape, filament yarn texture, surface smoothness or texture, good wet press retention, and dimensional stability. Most have fairly good to excellent resistance to abrasion and tensile strength or tenacity (spandex is an exception), and their wet strength is much the same as dry. Because synthetics absorb little moisture, they do not swell and distort as easily as natural fibers or reconstituted cellulose fibers, and they dry quickly.

It is this superior performance that makes synthetic fibers so important in consumer goods today, especially polyester, now the most-used synthetic.

There is no such thing (so far) as a *miracle fiber*, however, and there are drawbacks to the synthetics, as with natural and CMF fibers. They have required a

finite resource, petrochemicals, for raw materials, although it is worth noting that only about 5 percent of the oil used worldwide goes to make chemicals, plastics, *and* fibers. Now renewable resources such as corn and soy are providing the raw material for synthetic polymers.

There are other sides to many of the properties valued for performance—durability and ease of care—that must be seen as disadvantages. The flip side of high strength is stubborn pilling, a problem met when staple fibers roll into balls on a fabric surface and are too strong to be brushed off easily. Low absorbency gives us quick drying, but makes for less comfortable fabrics that also tend to collect static electricity; a notable exception is the group of olefin fibers that absorb almost no moisture but exhibit wicking of moisture to a high degree, leading to transfer of perspiration away from the skin and a low tendency to collect static.

Static

Static is a pervasive problem with most synthetics, and in dry air it makes fabrics cling to the body, crackle with sparks, and attract bits of lint and other airborne particles such as soot.

A charge is built up when fabrics are brought together and separated, e.g., as a person moves, so that layers of clothing rub against each other and the body. This is called tribocharging, and it happens when electrons transfer between layers, leaving the one with the added electrons negatively charged, the one with lost electrons positively charged. The material in most clothing, footwear, and furnishings does not conduct electricity well, while the body is a good conductor but is often insulated so that charges do not escape gradually. Then, when a conductor is touched, the discharge can be great enough to give an electric shock or a spark. Static is also generated as fabrics are tumble dried. A triboelectric series can be made to show what type of charge is induced on various materials when they are rubbed together; one such series is shown in Figure 2.7.

Static is usually simply annoying, but in medical or industrial situations, it can be very dangerous (if flammable or explosive materials are around) or damaging (to delicate electronic equipment, either as it is assembled or in operation). Buildup of static is especially common in winter conditions, when cold air holds little moisture, and humidifiers are not operational in many buildings.

positive

wool nylon viscose ravon cotton silk human skin acetate polvester acrylic polypropylene vinyon modacrylic polyethylene **PTFE**

negative

Figure 2.7 Triboelectric series. (From N. Wilson, Shirley Institute, "Fabric Cling: The Problem and Some Remedies," Textiles 7/2, 1978: 54; and "Static Electricity and Textiles," Textiles 16/1, 1987: 18)

Fibers—Relative Position in World Production

World textile fiber production is shown in the bar graph in Figure 2.6; note that this excludes coarse fibers such as jute (which, in 2000, would have represented about 6 percent). It also ignores flax (linen), which that year was about 1 percent; silk production is relatively small so it does not make it into the figures at all.

In 1900, 80 percent of this was one fiber, cotton! Although more and more cotton was grown, with total fiber use expanding, cotton's portion fell to 50 percent in 1975. In the 1990s, it fell gradually to below 40 percent, and the total amount used also fell slightly in some years, but it still undeniably earned its name of "King Cotton," as the most-used single fiber in the world. By 2005, it still accounted for over onethird of all fibers, but so did polyester. So in the 21st century, the "King" has had to share the throne, if not actually step down!

It may be hard for us to realize that in 1800, at least in European countries, cotton accounted for only 4 percent of fiber use, with wool at 78 percent and flax at 18 percent. (Silk, then as now, was a luxury fiber only, at less than 1 percent.) Cotton did not become "king" until after the Industrial Revolution got well underway in the 19th century, after beginning in the 18th century with machine spinning of cotton yarn. This explains why a fabric such as lawn, originally made of flax and so historically of the flax or linen family, is today definitely considered a "cotton," since it has long been made predominantly of cotton.

The total amount of textile fibers used worldwide since 1900 increased tenfold by 1990, and reached just over fourteenfold by the end of the 20th century. The beginning of that century had marked the earliest stages of use of MF fibers, those from cellulose: reconstituted, as in rayon, or cellulose compounds, as in acetate. In 1938, the first synthetic fiber—nylon—was introduced, and synthetics established themselves after World War II, in the 1950s. Textile fiber consumption increases almost directly with development of countries and the rise in standard of living. So, while some fierce competition between fibers for certain end uses exists, seldom does one major fiber drive another from the marketplace.

Of the MF fibers, it is the synthetic fibers that have shown the most notable growth in amount used; compare 1950 to 2005 in Figure 2.6. Among the synthetics, nylon led in growth and amount used until 1972, when polyester took the lead; by 2000, polyester represented 60 percent of all synthetics, and accounted for over a third of all fibers used—on a par with cotton, or just slightly ahead. Nylon, at 8 percent of synthetics, was in a distant second place. Polypropylene (olefin) which has long been a dark horse in this fiber steeplechase, has moved rapidly into prominence, especially for activewear, industrial floor coverings, and disposable nonwovens; it is now, at 6 percent, third in use of synthetics. Acrylic has regained ground, at 6 percent of synthetics. Spandex, although present in small amounts in most applications, gains steadily in importance, and a specialized fiber, aramid, has also found many uses for its flame and heat resistance. The early 2000s saw development of a type of synthetic fiber that is bound to be very important in the future, headed by the generic PLA (polylactate—see Figures 2.1 and 2.4), with excellent properties, and deriving its carbon from starch, an annually renewable resource, rather than a hydrocarbon such as oil; it is also biogradable.

Cellulosic MF (CMF) fiber production has been far out-distanced by the synthetics, especially polyester, and use of CMF fibers decreased from 1980 to 2000, with the (HWM) rayons (high wet modulus rayons—see Figures 2.1 and 2.2 and Tables 2.1 and 2.2) never reaching their full stride. However, in the 21st century, the closely related CMF fibers of the lyocell type, led by Tencel® (staple, originally from Courtaulds) and Newcell® (filament by Acordis), can deliver excellent properties and performance, are environmentally acceptable in raw material and process used (solvent spinning), and may register an increase.

The tremendous rise in production of synthetics from 1980 to 2005 (and continuing) is truly startling. It should be kept in mind by any student of textiles, as a verifier of the importance of the advantages of the synthetics discussed in this section. A major advantage is the specialized forms and modifications that have multiplied since 1990, many of them suitable for the myriad industrial and technical applications or consumer gear that use "high tech" materials. The growth also reflects hugely increased MF production in areas other than the United States, Western Europe, and Japan, what are called "emerging markets,"—especially Taiwan, China, South Korea, and India.

REVIEW QUESTIONS 2-1, 2-2

- 1. What is a textile fiber? How would you demonstrate this with a piece of woven fabric?
- 2. What is wrong with the statement: "textile fibers are either natural or synthetic"?
- 3. What are the two main sources of natural fibers, and what is the name of the main material of which each is made?
- 4. What are the two main terms to do with length of fibers?
- Name five properties necessary for a textile fiber. Name three fibrous materials from which you cannot make a fabric, i.e., they are not textile fibers.
- 6. Name five generic names for natural fibers, and five for manufactured fibers. Will you find these names on labels? Why or why not?
- Find five examples of textile trademark names, and record if you also found the fiber generic group identified.
- 8. Of the major generic fiber types, which is the only one not ever used as 100 percent of a fabric?

- 9. What two properties have most to do with comfort in apparel? Which property most affects smoothness retention? What two properties have most to do with creating fabrics that insulate well? How is permanent heat set defined in this text? Can a fiber be both heat sensitive and flame resistant?
- 10. List three important advantages of natural fibers over MF. List four significant advantages of MF fibers over natural. What are four main advantages of the major synthetic fibers among the MF types? What are four disadvantages?
- 11. What was the first manufactured fiber? What was the first synthetic fiber? What is the difference?
- 12. Give three main reasons for the huge increase in use of cotton in the 19th century. Give three main reasons for the huge increase in use of synthetic fibers from the middle of the 20th century, and still continuing in the 21st.

2-3 NATURAL FIBERS

Cellulosic Natural Fibers

Cellulose

Cellulose is a main building material of plants, likened to the (protein) flesh of animals. The woody plant material lignin, found in the stiffer plant parts, especially in trees, acts like bone, while binders such as plant pectins act like animal ligaments.

Cellulose is a carbohydrate, composed of carbon (C), hydrogen (H), and oxygen (O), making simple sugar units (β - Δ -glucose). These polymerize: that is, they join together, with water (H2O) given off, to form very long molecular chains of 2,000 units or more; this makes cellulose a polysaccharide.

A representation of this unit commonly used for many years is shown in Figure 2.57 under Cellulose Acetate Compounds; the more modern "puckered ring" diagram for the structure of these units is shown in Figure 2.8. It is interesting to note that the unit of starch, another very large carbohydrate molecule, is also a glucose but in a slightly different form; it produces long chains, but is less suitable for a textile fiber.4

Cellulose is sensitive to mineral (strong) acids, but not to alkali or chlorine bleach; it can be attacked by mildew growth (fungi), rot (bacteria), and silverfish. It has a cool hand (conducts heat well) and good heat resistance (cellulose fiber fabrics scorch only under a hot iron). Cellulose is fairly rigid or stiff (not resilient). Cellulose fibers swell in water, and, although they return to their original size when dry, fabrics made of them shrink when the fibers are wet and swollen. Cellulose is flammable, burning quickly with the familiar odor of burning plant material, such as wood or leaves, and glows for some time after a flame is extinguished.

Cotton—A Seed Fiber

Cotton still accounts for about a third of all fiber use (when coarse fibers such as jute are excluded). It certainly has desirable properties, but the success of "King Cotton" lies in production: the fiber is readily available from the plant.

Cotton Production

Cotton production requires a semitropical climate (nearly 200 days frostfree), with sun and water needed to produce the best fiber. Principal cottonproducing countries with percentage of world production in 2005 were: China (24%); the United States (21%): India (17%): Pakistan (9%): Republic of Uzbekistan (5%); Brazil (4%); Turkey (3%); Australia (3%); Greece (2%); with a total for these countries of 88% of world production. Many (22) other countries made up the other 12%; a number of these were republics which had been part of the USSR, so if their production, along with that of Uzbekistan, had been under that former entity it would have added up to a more significant figure.5

Cotton is in the mallow family (Malvaceae). genus Gossypium, and there are many species. The best types for textiles develop fibers called mature cotton or lint, which can be spun into yarn; other types produce only immature cotton or linters, also called fuzz, that cannot be spun into yarn.

By far the predominant type of textile cotton grown in the Americas is G. hirsutum. This species produces both mature cotton and fuzz. The longest types (long staple), such as Sea Island, Pima, and Egyptian, are varieties of G. barbadense and G. peruvianum: these produce no fuzz but account for only a small percentage of production. The Old World species are mostly the short-staple types grown in Asia and Africa: G. arboreum and G. herbaceum. All wild cottons produce only fuzz. See also "Cotton Quality".

Figure 2.8 Unit of cellulose: two β-Δ-glucose residues in 'puckered ring" structure.

There has been considerable work on *hybrid cottons*, crossing species. One breakthrough to offer higher quality and shorter time to market was Hazera Hybrid CottonTM (by Hazera Genetics). This crossed a *G. hirsutum* (Acala) with a *G. barbadense* (Pima).

Cotton seed is planted, weeded, and cultivated during an 8- to 12-week period until the plant, grown to a height of 1–2 m (3–6 ft.), forms flowers. These are cream colored at first, then, over 3 days, turn to deep red and the petals fall, leaving the seed pod or boll, which is about the size of an egg. A boll contains about 30 seeds, and fibers (each a single cell) grow out on the surface of each seed. (See Figure 2.9.)

During the first 24 days after pollination, a fiber develops only in length, folding back on itself inside the closed boll and reaching a length up to 1,000 times its diameter (see Figure 2.10). During this time, the fiber has only a thin *primary wall*, lying under

the very thin, outer, waxy cuticle. Fibers that start to grow in the first 2–3 days after flowering will go on to develop the *secondary wall* of mature (lint) fibers; those that start to grow later never develop more than the primary wall and are called immature cotton, linters, or fuzz. They cannot be spun into yarn for textiles, but are used for cotton batting or as a cellulose base for manufacture of rayon.

After 24 days, then, a fiber does not grow longer but begins to thicken, maintaining a central canal (*lumen*) carrying the plant juices that nourish it. Each day, a layer of cellulose is laid down in the fiber in a spiral arrangement that reverses each day; this thickening of the secondary wall continues for about 24 days more, when the boll opens. The fibers, which have been almost cylindrical in shape, dry, flatten, and twist to form the reversing convolutions so typical of cotton seen under the microscope (see "Fiber Identification"

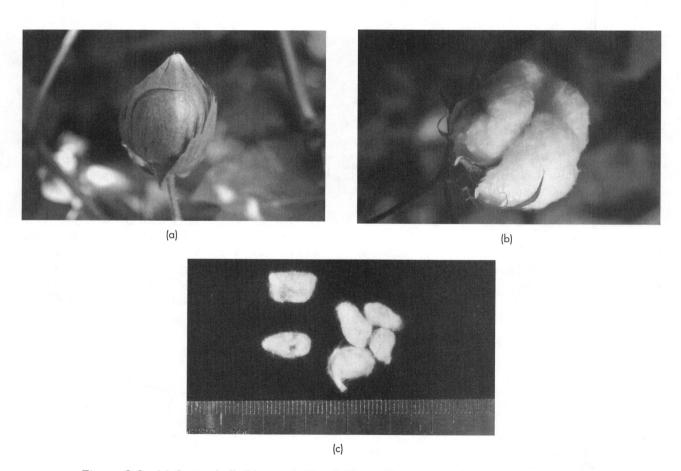

Figure 2.9 (a) Cotton boll; (b) open boll with fibers; (c) cotton seeds. (Courtesy of National Cotton Council of America)

Days after Pollination	4	12	24	36	48 -
Boll	Q				
Fiber (Lint) Length	_	Ш			
Fiber Wall Thickness	0	0	0	0	8

Figure 2.10 Growth of the cotton fiber. (Courtesy of Ciba Review)

later in this section and Figure 5.4a). These folds and twists are very important in spinning fine yarns, and are one of the main reasons why such a (relatively) short fiber can be spun into yarn—the only seed fiber that provides a textile fiber among so many thousands of types.

Cotton in the open boll is almost pure cellulose available for use. While some waxes and pectins, protein, coloring matter, and minerals are present, only 4–12 percent of the fiber is anything other than cellulose! It needs only to be picked (mostly by machine today) and separated from the seed, a process carried out in the cotton gin. This is the reason cotton is "king" (along with its excellent properties, of course).

The cotton gin pulls the fibers from the seed and carries them away, but there is also quite a lot of other plant matter picked up by mechanical harvesters which has to be eliminated at some stage. Some gins do this by passing cotton through a huller front, but in newer gin stands, the seed cotton drops directly into a roll box (follow the arrow in Figure 2.11 [a], where the seed is separated from the mature cotton fiber [lint]). When all the long fibers are removed, the seeds slide down the face of the ginning rib between the saws, and are taken away on a conveyor. Revolving circular saws pull the lint through closely spaced ribs that do not allow the seed through. Lint is removed from the saw by a rotating brush (or a blast of air) and goes on to Figure 2.11 (b), the lint cleaner. Here immature seeds (motes) and bits of plant matter (trash) are removed. The lint cleaner also blends and aligns the fibers.

Cotton seeds are pressed to give an important polyunsaturated oil, while their hulls are used for

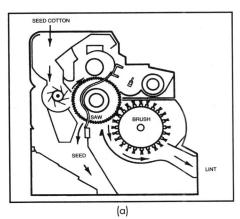

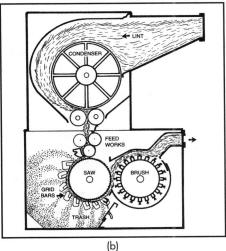

Figure 2.11 (a) A modern, high capacity gin stand without a huller front. (b) A typical saw-type lint cleaner, which removes trash, and blends and aligns the fiber. (Courtesy of U.S. Department of Agriculture and National Cotton Ginners Association)

animal feed or fertilizer. Some trash gets in with the usable lint fibers, and can be seen in a fabric such as unbleached muslin (see "Finishing the Natural Fibers" in Section Five).

Cotton Properties

Cotton properties, when summarized, do not seem to account for its status as "king" of textile fibers. It is used, however, for bulky household textiles, such as towels and sheets, and for workwear and summer wear, when we want a fiber that

- is absorbent, comfortable, with a cool hand and good static resistance; and
- · withstands vigorous machine washing and drying, using effective alkaline builders and even bleaches with detergents.

As well as resisting alkaline agents, cotton, which has good strength when dry, gets about 25 percent stronger when it is wet. However, cotton is certainly not easy care without special Durable Press treatment, since it wrinkles readily, swells in water so that fabrics made of it shrink, and can mildew, as anyone knows who has left a damp towel lying about. Cotton fabrics also lose a crisp press when damp (poor wet press retention).

Cotton Quality

Cotton quality is based largely on length. As mentioned, lint cotton is the only seed fiber long, strong, and cohesive enough to be spun into fine yarn.

- Short-staple, coarser cotton is 10–25 mm ($\frac{1}{2}$ –1 in.) long. It is grown in China, India, South Africa, and southeastern Europe.
- Medium-staple cotton is 25-35 mm (1-1 $\frac{1}{2}$ in.) long. These varieties are mostly American Upland. It is interesting that the Shankar variety of Indian cotton is called ESL or extra-long staple, but at 28-32 mm in length, would be classed as only medium-staple by these measures.
- Long-staple cotton is the highest quality: 35 up to 60 mm $(1\frac{1}{2}-2\frac{1}{2})$ in.) long, and are the varieties with no fuzz: Sea Island, Pima, and Egyptian (see "Cotton Production"). These are not only the longest, but the finest, softest, and strongest; plus. when mercerized, as much top-quality cotton is,

these give the most luster. The best long-staple cotton grown in the United States is labeled Supima®, now generally called ESL, for "extralong staple." It is grown in the "Pima Belt": Arizona, New Mexico, Texas, and the San Joaquin Valley of California; in 1999 it was 3 percent of the U.S. cotton crop. These long-staple cotton fibers will be spun as fine, combed yarn; made into top-quality fabric with "silky" look and drape; given the most careful, artistic finish, coloring, and trims; ready to be turned into well-designed, bestmade articles carrying the name of a designer or established firm: the top of the market.

A similar litany of factors contributing to the highest-quality, usually most expensive textile articles. both clothing and fabrics for interiors, can be repeated for every fiber, natural and MF. When the very best fiber is selected, it will almost always be used to make a superior product, with the concomitant expenditure on quality at the level of yarn preparation, fabric construction, finishing, coloring, trim, design, and manufacture of the final garment or home furnishing article, and culminating in the labels, tags, and promotional material.

Other Seed Fibers

Kapok

Kapok, from the seed pod of a tropical tree (Ceiba pentandra), is a soft fiber that is buoyant because it is hollow; it is used for stuffing in furnishings and life jackets, largely replaced now by foam or polyester fiberfill.

Coir

Coir, from the husk of the coconut (Cocus nucifera), is coarse, stiff, and strong even when wet; it is used for rough matting and cordage (twine, rope), and in geotextiles, as it is biodegradable.

Flax (Linen)—A Bast (Stem) Fiber

Flax or linen is one of the oldest and most-prized of natural fibers. In textiles study, the fiber is termed flax, while the fabric made of it is called linen; however, both are legitimate fiber generic names. The fiber bundles lie between the outer bark and the core

of the stem of Linum usitatissimum (the meaning of the Latin is "the most useful linum"; many of the Linum genus grow wild). As mentioned, linen is a legal name for the fiber; it is *flachs* in German, giving the English name flax. (See Figure 2.12.)

Flax has been in limited supply and expensive because processing the fiber from the plant to get top-quality fiber is long and labor intensive, and fine yarns could not be spun with any but top-quality fiber until relatively recently.

Flax Production

Flax grows in temperate climates, the best quality coming from the moist area of northwestern Europe: France, Belgium, the Netherlands, and Ireland; coarser flax from eastern Europe, New Zealand, and Australia. Another variety of flax is grown for oil from its seeds; linseed oil has long been used as a quickdrying oil base for paints.

It takes 100 days for the plant to grow from seed to its height of 80-120 cm (2-4 ft.); while the stem is still pliable, the plant is pulled and dried (see Figure 2.13[a]). Rippling removes the seeds.

Next comes the central process, retting, which is really rotting—a natural breakdown of the stem materials and pectins that bind the fiber bundles to the stem. Dew, pool, or river retting takes 4-6 weeks. Lukewarm water retting in tanks takes 3–5 days, after which the bundles are dried for 1-2 weeks. Chemical retting speeds up the process, but when the stem materials are so attacked, the fibers are also weakened and harshened. Top-quality fibers today are often still dew retted, where the cut flax is left in the fields to let the action of moisture from dew and the action of microorganisms break down the outer stem.

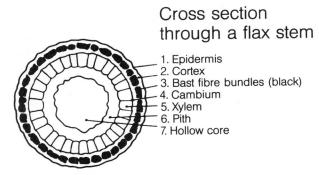

Figure 2.12 Cross section of flax stem. (Courtesy of Masters of Linen/USA)

(a)

(b)

Figure 2.13 (a) Flax harvested with pulling machine. (b) Worker at flax scutching machine, where stems are broken up. (Courtesy of Masters of Linen/USA)

After retting and drying, the stems are broken up by scutching with wooden breaker rollers (see Figure 2.13[b]), then the straw is beaten out as waste or shivs for use in chipboard. The fibers, separated into "hands," are then hackled or combed to take out short waste fibers called tow and to lay parallel the long fibers called line: these may reach 500 mm (20 in.) long. (See Figure 2.14.)

Wet spinning of flax (immersed in hot water) is done for the finest yarns, to soften the natural gums holding fibers together; dry spinning is used for other qualities.

Some short flax fibers can be spun as cotton would be for high-value textiles. The very short tow fibers have been used to replace glass fiber in composites, e.g., for automotive use.

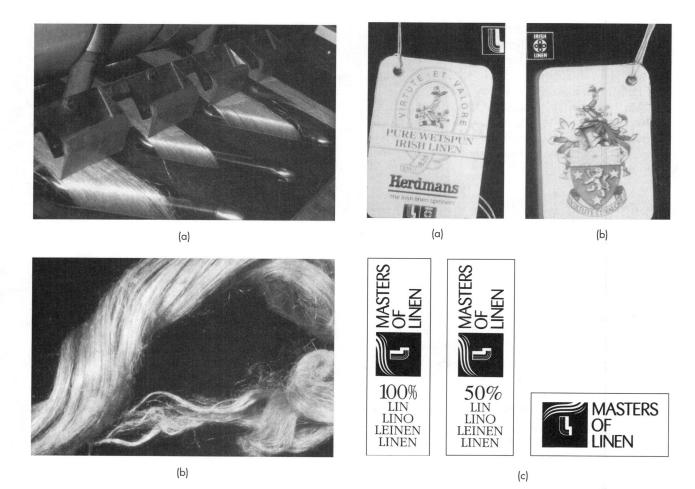

Figure 2.14 (a) Hackled (combed) flax ready for spinning. (b) Line flax. (Courtesy of Masters of Linen/USA)

Flax Properties

Flax properties are outstanding—it is a fiber that is still valued after some 10,000 years. It has better dry strength than cotton, and like cotton it gets 25 percent stronger when wet. It absorbs more moisture (for comfort and static resistance), and it wicks; it is longer, smoother, and more lustrous than cotton.

A number of symbols are used to identify the top quality of this prestigious fiber and its fabrics; some are shown in Figure 2.15. Masters of Linen is the promotional arm of the European Flax and Hemp Confederation. An old, well-known trademark name in Irish linens is Moygashel.

Linen has been enjoying an upsurge in popularity as technological developments have reduced spinning costs by achieving fine yarns with middle-quality

Figure 2.15 Tags and logos identifying high-quality linen: (a) wet spun tag, (b) Irish Linen Guild logos, (c) Masters of Linen labels identifying products using West European quality 100 percent linen and blends with minimum 50 percent linen (flax). (Courtesy of Masters of Linen/USA)

flax, and also by allowing blends of flax with other fibers, on spinning machines that can handle long-and short-staple fibers together. Although linen is a legitimate name for flax fiber, and bedding or table fabrics made of any fiber may be called "linens," there is a definite profile of the apparel fabric *linen*: traditionally bottom weight, with slubs in both warp and weft yarns, in a balanced plain weave.

Flax (Linen) Quality

Flax quality is well established with consumers. The best long, smooth, lustrous line fibers give us strong and beautiful fabrics with a cool hand that absorb

and wick moisture well, so that clothing is comfortable in hot, humid weather, while dish towels or handkerchiefs, after absorbing well, dry quickly without linting.

An old-fashioned test to distinguish linen from cotton was to drop water on the fabric; if it spread quickly along the yarns, it was (probably) linen. Linen fabric is noted for slubs, since the fibers are bundles of cells and vary in thickness. These bundles of cells can be affected more easily than cotton by chlorine bleach; bleaching of linen should be carried out less vigorously than with cotton.

Fine table linen (e.g., damask) seems to get softer and more lustrous as it is used, laundered, and ironed. And ironed it must be! Linen fabrics do wrinkle badly, and are the opposite of "easy care." In apparel a small amount of spandex blended with flax helps avoid some wrinkling—more under 2-5, "Blending of Fibers." Care of linen including bleaching, ironing, and storage is discussed in Section Six.

Other Bast Fibers

A number of fibers from plant stems are used in considerable amounts, and to get at the fiber, all are retted in much the same way as flax (see Figure 2.16). These fibers are not included in the figures on the world fiber production chart in Figure 2.6, as they are considered to be "coarse fibers," hitherto used mostly for sacking, carpet and linoleum backing, and cordage (twine, cord, and rope). The only one not considered coarse is ramie, and because it has been expensive to produce, it has been used in small amounts. Many minor bast

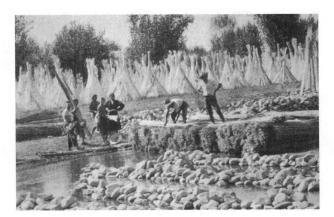

Figure 2.16 Retting hemp—"rafts" submerged with rocks. (Courtesy of Ciba Review)

and leaf fibers are being investigated as a renewable resource. They will be discussed briefly here, at the end of the discussion of major bast and leaf fibers.

Jute

Jute is one of the most easily spun and cheapest fibers but is also one of the weakest, most brittle, and least durable. It comes from plants of the Corchorus genus (C. capsularis, C. olitorius), grown mainly in India and Bangladesh, but also in China, Nepal, and Thailand. Fibers range in length from shorter than 25 mm (1 in.) to about 300 mm (12 in.). Retting takes 2-3 weeks, and fiber yield is less than 10 percent of the total stem weight. We have used a great deal of jute for coarse twine and cordage and as burlap in sacking and carpet and linoleum backing. World production in 2000 was 26 percent of all fibers, although this is not counted in Figure 2.6. Jute cannot be used in water (e.g., for fish nets) as it deteriorates (rots) quickly when wet.

The International Jute Organization is promoting jute bags for the food industry, produced using a vegetable jute batching oil instead of a petroleum-based oil. Further, as the use of jute in sacking, cordage, and especially carpet backing has been replaced extensively by polypropylene, other uses for it have been actively sought, especially in geotextiles, such as fabrics used to prevent erosion on hillsides.

Hemp

Hemp is an old bast fiber of the Mulberry family Moraceae, and like flax, the fibers are removed from the plant stems by retting (see Figure 2.16). Hemp has many of the good properties of flax, and is one of the strongest natural fibers, even when wet. It has been used mostly for coarser products, such as strong twine and other cordage, fish nets, canvas, and a better quality of burlap. It can give a fabric hard to tell from linen, and historically, fine fabrics as well as good paper have long been made from hemp in China. Hemp seed oil compares in yield to rape or sunflower oils, and the woody core of the stem can be made into building materials as well as paper, so there are nontextile uses as well. Hemp is seen as "eco-friendly." Plants grow quickly in temperate climates with minimal rainfall, to heights of some 4 m (10-14 feet) in 3 months, resist weeds, and need little application of pesticides or agrochemicals. The large root system aerates the soil it grows in. (See Figure 2.17.)

Figure 2.17 Hemp for fiber may now be legally grown in Ontario, Canada. (Courtesy of Hempline Inc.)

However, hemp has more lignin than flax, and the fiber bundles are harder to separate to give fine yarns. More significantly, in some countries and at various times, hemp growing has been prohibited under narcotics control legislation because it is of the genus and species *Cannabis sativa*—the same as marijuana and hashish. Today, varieties low in the hallucinatory substance tetrahydrocannabinol (THC) can be grown for textile use, but production difficulties seem to keep this fiber in a minor place for finer fabrics. However, it is being used in Europe in blends with flax, as the processing equipment is similar.

Ramie

Ramie (China grass, rhea) is a minor fiber but can rival linen in strength, beauty, and absorbency. It is a nonstinging nettle of the Uticaceae family, genus Boehmeria (B. nivea and B. tenacissima), is stiffer than flax, and is even more difficult than flax to loosen from the plant stems without chemical treatment, which harshens the fiber. The ramie called China grass is grown in China, while the type called

rhea comes from Malaysia, Africa, and Mexico. A good deal of ramie appeared on the North American market in the 1980s, blended, usually with cotton, in both knit and woven fabrics. This influx was a result of its exemption, as a minor fiber, from the duties and quotas put on cotton in the Multifibre Arrangements; blends of ramie (often just over 50 percent) with cotton could be imported at an advantage from low-cost sources: India, China, and Southeast Asian countries.

Kenaf, Roselle, Sunn, Urena, etc.

Kenaf, roselle, sunn, and urena are minor bast fibers used for the same purposes as jute. Kenaf (*Hibiscus cannabinus*) is grown in India, Bangladesh, China, Thailand, and other parts of Southeast Asia. Other minor bast fibers are roselle (*Hibiscus sabdariffa*), sunn (*Crotalaria juncea*), and urena (*Urena lobata*). As the uses of jute rise or fall, so will those of these fibers.

Leaf Fibers

Textile fibers are obtained from the long, fleshy leaves of tropical plants and trees. These are usually removed not by retting, as bast fibers are, but by *decorticating*—ripping out the cortex cells that lie in the center of the leaf (see Figure 2.18).

Sisal

Sisal, family Amarylklidaceae or Agavaceae, is one of the best known of the *Agave* genus of plants (*A. sisalana*) (see Figure 2.19). The bundles of fibers,

Figure 2.18 Decorticating leaves for fiber. (Courtesy of *Ciba Review*)

Figure 2.19 Sisal growing, (Courtesy of Ciba Review)

which are coarse and woody, may be up to 1 m (3 ft.) in length, held together by resin. Sisal is used for totebags, summer handbags, matting carpets, cordage, and bristles. The plant is a native of Mexico, but 80 percent is now grown in East African countries, as well as Brazil, Mexico, and Central America. These fibers cannot be used for fish nets, as saltwater degrades them.

Henequen

This is another of the Agavaceae family, used mostly for twine.

Abaca

Abaca, Manila "hemp," "sisal hemp," "sunn hemp," or manila is a fiber from the leaves of a member of the banana family (Musa textilis), used for cordage, matting, and some clothing.

New Zealand "Flax," New Zealand "Hemp"

New Zealand "flax" (Phormium tenax) is a leaf fiber of the Liliaceae family, and is similar to abaca.

Yucca

Yucca is in the Agavaceae family, genus Yucca. The most common in northern Mexico and the southwestern United States is Yucca cassava. Fibers from the rigid, sword-shaped leaves have been used for a long time. The Anasazi people who lived from approximately A.D. 1 to 1300 in the region known as the Four Corners-Utah, Colorado, Arizona, New Mexico—produced footwear by weaving, plaiting, and twining yucca plant fibers into sandal soles and binding them to their feet with cordage ties. (See Figure 2.20.)

Raffia

Raffia (rafia) is a type of palm of the genus Raphia, a soft fiber from the leaves of R. ruffia and R. taedigera. Often used for craft work, raffia can be dued to many colors. It is typical of many minor fibers and other plant materials like reeds and even paper, made into yarn and used to make chair seats, rugs, and wall or window coverings.

Piña

This is the fiber (known as PALF for pineapple leaf fiber) from the leaf of the pineapple plant, a member of the Bromeliaceae family. There are many species of the genus Ananas, such as A. sativa. This is the only fine leaf fiber, giving exquisite fabrics, crisp and sheer, or soft and flexible. It is usually hand stripped from the leaves, but is also retted. This fiber has not been produced in commercial amounts but rather as a boutique or craft material, for example as a base for craft embroideries. Designer Romeo Gigli used gauzy woven material of piña in couture designs for summer 1991, and a cottage industry in the Philippines has produced jusi cloth, made with piña and silk. India in the 1990s has concentrated on its possible commercial use in textiles.

Figure 2.20 Anasazi sandals, pre-Columbian, circa 1300, yucca fiber soles. (Courtesy of the Bata Shoe Museum)

Minor Bast and Leaf Fibers

The waste of many plants gives short fibers which have been found especially useful, as mentioned regarding flax tow, in composite nonwoven materials, since many combine "relatively low cost and excellent technical characteristics." Banana stems and corn husks, for example, have been used in this way.

Bamboo, a very fast-growing plant, yields a fiber by steaming and boiling that is rather coarse for many apparel uses. However, the fiber has an interesting cross section that shows spaces, which may explain its very good moisture absorption and ability to make fabrics that feel cool to wear in hot weather. It is also reported to have natural antibacterial and ultraviolet-protective properties. To make finer fibers, it is converted to liquid form and regenerated as a manufactured cellulosic fiber. It is this form that is used in the Dri-release® fabric blends discussed under "Blending of Fibers" in this section.

The stinging nettle, *Laportea canadensis*, gives an ancient, slightly hairy, very strong bast fiber. It is used in furnishings, workwear, and automotive fabrics for its high performance, but is not very comfortable next to the skin! Fibers from lotus stems are again being made into fabric in Burma by villagers, encouraged by their cooperative association. This is a rare cloth, with some 220,000 stems needed to make fabric for a set of monk's robes.⁹

Other Miscellaneous Cellulosic Natural Fibers

Bark Fiber Cloth (Tapa)

Bark fiber cloth (tapa) is made using fibers from the inner bark of the paper mulberry tree (*Brousonnetia papyrifera*), pounded into bark cloth (tapa) in the Pacific islands, to give a kind of "natural nonwoven" fabric (see Figure 2.21). The bark cloth is decorated with designs handpainted, stencilled, or transferred from an incised piece of wood.¹⁰

Spanish Moss

Spanish moss, a relative of the pineapple, has been used in the southern United States as an alternative to horsehair for stuffing.

Sacaton

Sacaton, a root fiber from Mexico, has been used as a stiff bristle in brushes.

Figure 2.21 Bark fiber cloth (tapa).

Inorganic (Mineral) Natural Fibers

Asbestos

Asbestos, or "rock wool," is a fiber formed in rocks, which can be spun and made into fabrics. It has been known from ancient times because it is flameproof: the name comes from the ancient Greek, meaning "will not burn." Asbestos can melt, but only at 1450-1500°C (2580-2670°F), the temperature of lava in a volcano. There are various types of asbestos, hydrated silicates of magnesium and calcium, with other minerals; the best fibers for textiles come from chrysotile asbestos, much of it mined in the Eastern Townships of Quebec, Canada. The fibers subdivide to fibrils and, since they never rot, are very harmful if breathed into the lungs; mining and use of asbestos today are therefore carried out much more carefully than in the past. It is used only where it is not exposed to air, e.g., sealed in cement. Unfortunately, it is still exported to countries which may not take such care.

Protein Natural Fibers

Protein

Protein is a major building material of animals; flesh, skin, hair, antlers, plumage, and spider webs are all proteins, differing from one another according to their function and the creature that made them.

Proteins are *polypeptides*, and have the most complex makeup of any fiber polymer. The units are

amino acids, joined together with amide or peptide linkages (see the discussion under Nulon, later in this section). Long chains are formed, some folded, others lying in spirals or helixes. The protein of silk (fibroin) is folded: that of wool (keratin) is a single spiral or helix, with some cross-links (see Figure 2.22); while the collagen of leather is a triple helix (see Figure 4.88).

Each type of protein has its own assortment of amino acids made up of carbon (C), hydrogen (H), oxygen (O), and nitrogen (N), plus, in some units of hair fibers, sulfur (S); these last two (N and S) account for the different burning smell of wool from cellulose fibers, which are made up only of C, H, and O.

Protein fibers have a dry, warm hand, are weaker wet, and are sensitive to alkali and chlorine bleach, but not to acid.

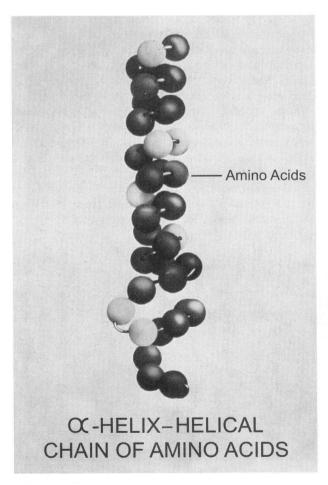

Figure 2.22 The α -helix form of wool keratin. (Courtesy of the Woolmark Company)

Wool—The Major Hair Fiber

Wool is taken in this Reference to be the hair of the domestic sheep; what we will call specialty hair fibers, such as camel hair, are not usually termed wool in textiles or fashion. Domestic sheep raised for wool have been bred with less and less guardhair, the coarse outer coat that protects wild animals and is found on all fur-bearers, even domestic cats. This layer is distinct from the fine, insulating undercoat called "down." Wool from most breeds of sheep contains a portion of guardhair as coarse white fibers called kemp that do not take dye; they may be used as effect fibers in fabric such as tweed.

Wool Production

Production of wool involves many breeds of sheep all over the world and requires a great deal of grazing land, although in many key sheep-raising areas, formerly unproductive land has been reclaimed for grazing pasture. Australia raises the most sheep and is by far the foremost wool-producing country. Since over 90 percent of its exported wool is the finest of all, Merino, it also dominates production of fine wool. Figures for 2000 showed that Australia's yield was 33 percent of worldwide raw wool production. New Zealand was in second place (14 percent), and China third (11 percent). After these came Eastern Europe, Turkey, the U.K., Argentina, Uruguay, South Africa (most of this Merino), the U.S., and various others. 11, 12

Sheep are sheared once a year in most countries, and the wool just shorn from a living sheep is called a fleece (see Figure 2.23). (Wool from the skin of a dead sheep is called *pulled wool*.) With such a valuable crop,

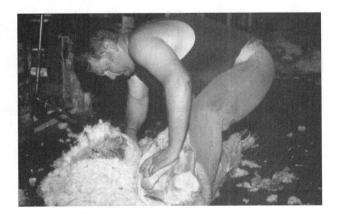

Figure 2.23 Shearing the fleece from a sheep. (Courtesy of the Woolmark Company)

research is intensive and unending for improvements, some of which involve treating sheep to repel pests such as blowflies or to produce mothproof wool.

Wool is only a portion of each fleece, with up to half the weight made up of wool grease (more accurately, wax, and known as lanolin in purified form), suint (perspiration), and all kinds of dirt and plant matter (twigs, burrs), especially with the Merino (see Figures 2.24 and 3.8). Wool is generally washed (scoured) and treated to remove plant matter (carbonized); for details, see "Finishing the Natural Fibers" in Section Five.

The Merino sheep is the ultimate wool producer (see Figures 2.24, 2.25), with no kempy wool in its fleece and an annual yield of greasy wool up to 4.4 kg (9.7 lb.), compared to 1 kg (2.2 lb.) from some types of sheep in China or India. Merino wool has all the qualities we rank as best in wool for finer fabrics—a fine fiber with scales tightly packed, which gives a soft hand, plus lots of crimp. The finer the wool, the finer the yarn that can be spun from it. The Merino as raised today, especially in Australia, is descended from a type of sheep that was prized from Roman times, developed in Spain, and taken by a circuitous route to Holland, South Africa, and eventually the emerging British colony in Australia. Just under 30 percent of the world's fine clothing wool comes from there now. The Rambouillet, developed in France and raised prominently in the United States, also produces very fine wool.

Coarser wools have their place, too, and are better for very hard wear, as in carpets or for a sturdy, sporty fabric such as tweed (see "Wool Quality" and Figures

Figure 2.24 Coat of a Merino sheep parted showing close, crimped fibers. (Courtesy of the Woolmark Company)

Figure 2.25 Group of Merino sheep. (Courtesy of the Woolmark Company)

2.32, 2.33). Sheep in New Zealand have been bred as "dual-purpose," for meat and wool production (they may be called Crossbred). Those bred from English Romney have been most successful, with many other breeds based on it, the Drysdale, a specialty carpet wool type, and the Corriedale (the first indigenous New Zealand breed) giving medium-fine wool.¹³ Hair from mountain sheep is shaggy and coarse as well, to protect them from inclement weather (see Figure 2.26). Some special wools come from sheep living in unique conditions, such as Iceland or the Shetland Islands, an island group northeast of Scotland. The number of fibers in the coat of one sheep varies from 10 million for coarse wool to 100 million for fine wool.¹⁴

Figure 2.26 Sheep with coarser wool than Merino. Left to right: Scottish Blackface, Welsh Mountain, Lincoln Longwool. (Courtesy of the Textile Institute)

Wool Structure

Wool protein is keratin, of which our fingernails as well as our hair are also made. The molecular chains of joined amino acid residues lie in alpha-helix coils (see Figure 2.22); some sulfur-containing amino acids can form custine cross-linkages between chains, and side chains on others can give salt bridge links. The result is a springlike coil, giving wool and hair fibers resilience and elastic recovery (springiness).

The outside layer (cuticle) has overlapping scales in three layers (Figure 2.27), the outermost being thin and porous. The edges of the scales project, so that the fiber is rougher from tip to root than from root to tip. When fibers are moved about, there is a kind of ratchet effect, so they move in the direction of their root ends; the fibers tangle together, a process called felting, discussed further under Wool Properties.

Under the cuticle is the cortex, made up of spindle-shaped cortical cells, which can take up and hold moisture (Figure 2.28). Wool is the most absorbent fiber of all, and is also hygroscopic takes up moisture without feeling wet. The cells are of two types, ortho-cortex and para-cortex, twisted together along the length of the fiber, making it bicomponent (Figure 2.29); the two sides behave differently as a wet fiber dries, one shrinking more than the other, resulting in a spiral crimp (Figure 2.30). The cortical cells are made up of microfibrils, which are finally composed of the coiled molecular chains. In the center of some coarser wools is a medulla with air spaces.

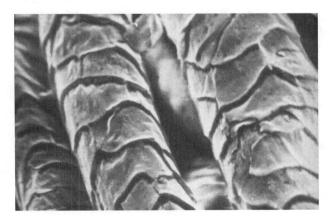

Figure 2.27 Wool fibers with outer scale covering. (Courtesy of the Woolmark Company)

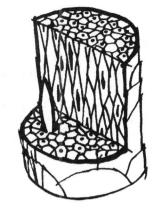

Figure 2.28 Wool fiber structure: cuticle with scales, cortical cells. (Courtesy of the Woolmark Company)

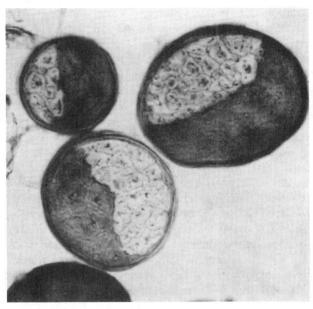

Figure 2.29 Cortex of wool stained to show the bicomponent nature of the cells. (Courtesy of the Woolmark Company)

Figure 2.30 Threedimensional wool crimp. (Courtesy of the Woolmark Company)

Wool Properties

The properties of wool result from its structure, adding up to a fiber that makes up into fabrics well suited to keep us warm in cold weather and comfortable under many other conditions.

First, wool has a dry and warm hand because it is protein material, and it is light (low specific gravity). Next, it is very resilient, so wool fabrics insulate well; this, along with great loft, allows warmth with little weight. The resilience plus good elastic recovery mean wrinkle recovery. Wool can have a luster, but the finer the scales, the duller the fiber. However, when fine fibers are spun into worsted (combed) yarns, with fibers laid nearly parallel, we see the quiet luster evident in fine suitings.

Wool has low tenacity (tensile strength); pilling is not a great problem in wool fabrics. Pills can be removed with a stiff bristle brush, and so are not classed as "stubborn." However, wool does make very durable fabrics, with good abrasion resistance, which can be restored to good looks over a long wear life.

All hair fibers (and leather), because they are protein, can be molded or shaped with steam. A good example is the shaping of wool felt hats. This is also used in tailoring to give a temporary set, and is an important adjunct to shaping apparel in hard tailoring, where interlinings such as tailor's or hair canvas hold the structured shape of a jacket or coat. It is, of course, lost if a cheaper tailor's canvas of tapelike rayon fiber (cellulose) is used instead of a wiry hair fiber and wool.

Wool has natural flame resistance unless humidity is very low or the fabric is very open. The coarser the wool, the more prickly it will be; this can cause itching and redness that is often taken for an allergic reaction. Since wool is the same protein as our own hair, a truly allergic reaction is rare, and most people can wear fabrics made of fine wool in finer, smoother yarns without discomfort.

Hair fibers (sulfur-containing protein) are eaten by some insect larvae, notably those of the clothes moth and various carpet beetles. Materials can be treated to be mothproof; this is especially important with articles such as carpets and valuable or seasonal clothing (see Section Five). Details and directions for home storage protection are given in Section Six.

In caring for any protein fiber, treat it like your own hair: wool is harmed by alkali and chlorine bleach, is harshened by heat, and is also weaker when wet. Care procedures are discussed in Section Six.

Felting of wool previously described under "Wool Structure" is looked on as a disadvantage insofar as it is produced by machine washing and drying of wool articles with resulting matting and shrinkage, unless they have been given an antifelt treatment (see Section Five). However, it is often done on purpose, e.g., to make *felt* (see Section Four). In finishing, gradual felting is called *fulling*, giving closer, warmer fabrics—a definite advantage in uses such as winter coats (see Section Five).

Wool Quality

Wool quality is related to wool grade, and this is linked to fineness. There is not only a considerable range of quality (fineness) among various breeds of sheep, but there is a difference from one part to another of the fleece from one animal. Fineness also varies with year of growth and health of the animal (food, weather, etc.). Although the finest, softest wool is taken to be the highest quality, we must realize that this is not the strongest type; what we want for slacks or a dress is not best for a long-wearing overcoat or for carpet.

Fineness of wool is expressed in science as the diameter of the fibers in millionths of a meter, termed a micron (symbol μ) or in international metric usage a micrometre (μ m or 0.001 mm—see Section Nine, "Metric in Textiles Use"). Figure 2.31 records various

Wool Grade	Diameter (μm; μ)	Length (mm; inches)	Uses	Sheep Breeds
Superfine	12–18	<40; <1½	apparel	Merino, some Rambouillet
Fine	18–24	40–110; 1½–4½	apparel	Merino, Rambouillet, most lamb's wool
Medium	24–31	110–150; 4½–6	apparel (coats, tweeds)	Crossbred, e.g., Corriedale
Coarse	31-40 (most), can go to 70	150 up; 6 up	carpet	Romney, Lincoln

Figure 2.31 Wool quality by grade, related to fineness.

wool qualities by grade, related to diameter (fineness), uses, and various sheep breeds. For Superfine wool, in previous editions the range shown for diameter was 15-18 um. It is extremely rare to have finer than that in even one fleece, yet in 1996, enough 13.3 µm diameter wool for a bale was produced, and brought \$1.2 million. Then in 2004, a 90 kilogram bale of Australian Merino wool was sold certified as 11.9 µm diameter—a record, and the heading on this column has been changed to 12-18 µm.

Wool fineness in commerce is more commonly related to the old British worsted yarn count numbers, such as 50s, 70s, and so on; the higher the number, the finer the wool. Figure 2.32 shows the length and crimp of various wool qualities by number. Fine wools have shorter fibers, 40-110 mm $(1\frac{1}{2} - 4\frac{1}{2}$ in.), with the most crimp; coarser wools have longer fibers, $110-150 \text{ mm} + (4\frac{1}{2}-6 \text{ in.+})$, with less crimp.

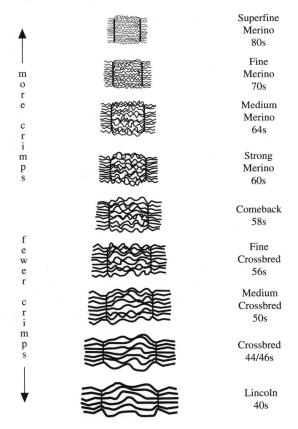

Figure 2.32 Wool quality by number—note length, degree of crimp.

Most terms for high quality wool relate to fineness: low micron figure (diameter), high number (fine varn = fine fiber), botany, lamb's wool, or Merino. (See also Optim™ Technology for wool, Section Three.)

botany. 60s or better quality wool, in a worsted varn; all Merino wool is 60s or finer.

Superfine. 80s or better quality wool (some may give a higher number, such as Super 100s); this term may be woven into the selvage in some worsteds (see Figure 2.33). There is a very limited supply of these very finest fibers, and they amount to a kind of modern "golden fleece" (see "Golden Bale," Section Three). The finest and rarest, Super 170s, is "1PP" wool, highest of the Australian Wool Trading Authority's 975 grades, and would represent only 0.0002 percent of the annual Australian wool production (see note on Superfine wool of 12 um diameter or less, earlier in this discussion of "Wool Quality"). The limited supply of these finest wool fibers is being extended by judicious blending (see "Blending of Fibers") and by new spinning techniques (more on these and ultrafine wool as part of the cost of combed yarns in Section Three).

"Medium micron" is a somewhat confusing term for Merino wools that fall at the coarse end of the Merino scale but are still very high quality! Since there is a larger supply of these than of the Superfine, spinning technology has concentrated on producing fine yarns with them to give lightweight worsteds that are more affordable (see "Compact Spinning," Section Three).

Figure 2.33 Worsted suiting made of Superfine wool may have the word woven into the selvage.

lamb's wool. The first clip of a young sheep (6–8 months old), with each fiber tapering to a tip—finer and softer than wool from adult sheep. It is accepted in the trade that an article labeled "lamb's wool" should contain about a third of this first-clip wool.

The Woolmark[®], with its famous logo (see Figure 2.34[a]), is an overall assurance of the quality of the article, which must be of 100 percent pure new wool.

Figure 2.34 (a) The Woolmark[®], (b) Woolmark[®] Blend, and (c) Wool Blend are trademarks of the Woolmark Company. (Courtesy of the Woolmark Company)

The mark is licensed by the Woolmark Company, with strict quality standards laid down. The Woolmark® Blend (b) is licensed for certain products made with 50–99 percent new wool, and the Wool Blend logo (c) for 30–49 percent blends; both are also trademarks of the Woolmark Company.

The New Zealand Wool Board promotes highquality but sturdier (coarser) wool through its Wools of New Zealand brand, launched in 1994 for carpets. These growers separated from the Woolmark Company, which does not allow country of origin to be indicated in use of its Woolmark.

Wool Products Labeling Act

The United States passed the Wool Products Labeling Act in 1939 to clarify descriptions of the stage of use of this fiber:

virgin wool, new wool. Wool that has never been previously manufactured or used, never reclaimed from any woven or felted wool product. recycled wool. Wool reclaimed from new fabric or fabric used by the ultimate consumer. Until the July 1980 Amendment to the act these were called reprocessed and reused wool, respectively.

These terms, while informative, do not relate to quality, which can vary widely within either category. Fiber is reclaimed by garnetting, a process in which textile material is torn apart to fiber. Garnetted fiber has usually sustained some damage, but could still be higher-quality fiber than some virgin wool; it may be termed "shoddy," or "mungo."

Specialty Hair Fibers

We use hair from many animals besides domestic sheep; most cost more than wool and all have special advantages or properties for them to be used instead of wool—this is what we will concentrate on. See the summary of information in Table 2.3, a comparison of specialty hair fibers.

Horsehair

Horsehair (from the mane and tail) is very wiry, and has been used to stuff sofas or for millinery and hem braid; it is now used mainly in tailor's canvas to help in garment shape retention.

Table 2.3 Comparison of Specialty Hair Fibers

Fiber/Animal	Major Geographical Source	Special Property or Advantage vs. Wool
horsehair/horse (mane & tail)	Worldwide	Wiry, smooth, coarse
mohair/Angora goat	United States, South Africa, Turkey	Wiry, smooth (large scales)—lustrous, dirt- shedding, long, strong
cashmere/cashmere goat	Kashmir, Himalayan Mountains, white from Mongolia (China), brown or gray from Iran or Tibet (China)	Undercoat very fine, buttery soft, rather dull
camel/two-humped Bactrian camel	Mongolia (China), mountains and desert	Distinctive tan color, thermostatic, makes very warm fabric
Camelids:		
llama/llama	Peru, Chile, Andes Mountains	Various natural shades from cream to dark brown
alpaca/alpaca	Peru, Chile, Andes Mountains	Same shades as llama, long, lustrous, soft
vicuña/vicuña	Peru, Chile, Andes Mountains	Cinnamon-color undercoat finest, softest, rarest hair
angora/Angora rabbit	China, France, Chile	Limply soft, lustrous, smooth, slippery, lofty
qiviuq or qiviut/musk ox	Northwest Territories, Alaska, Yukon, Nunavut, Greenland, Russia	Undercoat very lofty, fine, soft, shades of taupe (gray/brown), makes very warm fabric

Mohair

Mohair comes from the Angora goat, thought to originate in Asia; the name for the goat comes from Ankara, Turkey, also (confusingly) the origin of the name of the rabbit (with hair called angora). Mohair grows very long, up to 200–300 mm (8–12 in.), if the animal is sheared once a year, but shearing is usually done twice annually (see Figure 2.35[a]). The United States is the leading mohair producer in the world; two million Angora goats are raised on 23 million acres, 85 percent in southwestern Texas. Almost all of this production is exported. South Africa is also a major producer. The logo of an international association and the Mohair Council of America (Figure 2.35[b]) reflects the length of the fibers in mohair fleece. Mohair has relatively large, platelike scales that give a smooth, lustrous, dirt-shedding surface; it is still used for paint roller covers because it releases the paint. It is stronger than wool and gives very durable fabrics (e.g., upholstery); however, when used in crisp worsteds, creases should not be pressed hard over and over in the same place, or the fabric can split. This fiber is often used in bouclé loop yarn to give a light, airy, but warm fabric. For its wiry property, like horse-hair it is used in braids and tailor's canvas.

Cashmere

Cashmere, as used in sweaters, is the very fine, soft underhair of the cashmere (Kashmir) goat, combed out as the animal molts; coarser hairs are used in overcoats (see Figure 2.36). Most white cashmere, needed for light-colored articles, is from Mongolia (China): natural colors, such as brown or gray, come from Iran or Tibet (China).

Articles of widely different prices can be 100 percent cashmere, but the more expensive will be made of the (hand-sorted) longest underhair, spun into worsted yarn, which pills less. These will probably be of 2-ply yarns for better wear, and the fibers will be the finest and softest as well. Finally, when this much care is taken in selection of the raw materials and spinning of the yarn, the same high quality will be built in with the knitting, color selection, finishing, trim, findings—all aspects of the finished article.

The name pashmina has appeared in marketing of recent years as if it were a separate fiber, always superfine, or in a blend with silk. Pashmina comes from the Persian word for wool, and is applied to the softest undercoat of the Himalayan cashmere (Kashmir) goat. Today the term has been linked to fine cashmere from Nepal, where the goats also live high in the Himalayas, and in that climate would produce an especially fine undercoat. However, there is no guarantee

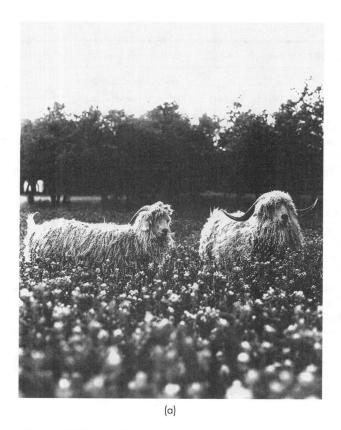

Figure 2.35 (a) Angora goats, source of mohair. (b) Mohair logo. (Courtesy of the Mohair Council of America)

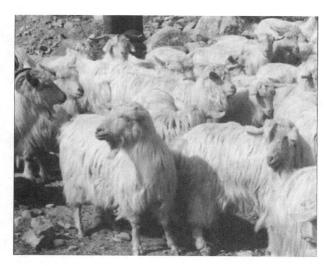

Figure 2.36 Cashmere goats. (Courtesy of the Textile Institute)

as to fineness or even origin for the fibers in a shawl or sweater marked "pashmina," and the only legal name is cashmere. Caveat emptor—let the buyer beware!

Cashmere was the fiber originally used (sometimes with silk) to make the elaborately patterned Kashmir shawls that were prized in Europe from the mid-18th century. The basic design motif, which we call *paisley*, has been widely developed and used from the 19th century on.

Cashgora

This is the long yet soft hybrid fiber produced by a cross between an Angora goat sire (the source of mohair) and a cashmere goat dam.

Camel Hair

Camel hair is obtained from the two-humped Bactrian camel of Asia, of which only about 1,000 have been estimated to be living wild in a remote part of

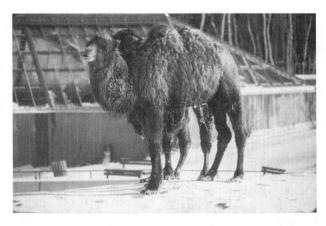

Figure 2.37 Bactrian camel of Asia. (Courtesy of the Metropolitan Toronto Zoo)

northwestern China. 15 However, this animal has long been domesticated and used as a beast of burden on ancient caravan routes over mountains and across deserts (see Figure 2.37). Its coat therefore protects it from both heat and cold—a thermostatic property, keeping temperature constant. It makes fabrics that keep us very warm. It is a distinctive tan color.

The fiber is gathered in the molting period, the coarse guardhairs separated by hand from the fine, soft undercoat. As with cashmere, the coarser hair will be used for overcoats; the finer, usually in a worsted yarn, for knitwear and lighter wovens.

Hair of Camelids

Camelids, living in the Andes Mountains of South America, are believed to be the originals of the camel family, which crossed to Asia when there was a land bridge between Alaska and Russia; the Bactrian camel and the one-humped dromedary of the Middle East developed from these. They became extinct in North America some 10,000 years ago, with llamas reintroduced in the late 1800s.

Llama and alpaca are domesticated camelids used to carry burdens in the mountains, the alpaca being more important commercially for fiber (see Figures 2.38 and 2.39). The hair on the alpaca is very long, with properties as listed in Table 2.3.

Vicuña and guanaco are wild camelids, living very high in the Andes. The vicuña is much prized for its undercoat, often listed as the finest, softest, rarest hair fiber (however, this was before giving entered the fringes of the commercial fiber supply). Vicuña were

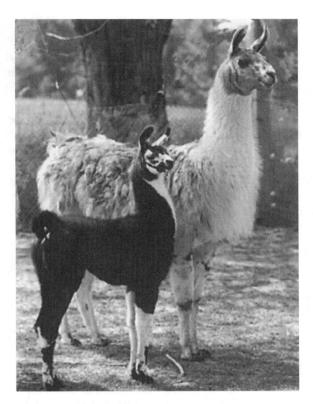

Figure 2.38 Llama and young (cria). (Courtesy of Lars Dahlberg, Dahlbrook Farm, for the Ontario Llama and Alpaca Club)

Figure 2.39 Alpaca. (Courtesy of the Metropolitan Toronto Zoo)

almost extinct, having been hunted and killed to get the small amount of hair from each. They have been strictly protected for some years, and there has been some success in "ranching" them in order to take hair without harm to the animal. Guanaco hair is not much used in textiles. Vicuña and alpaca have been cross-bred to obtain soft hybrid fiber of greater length; see the natural fibers flowchart (Figure 2.3) earlier in this section.

In Geelong, Australia, the Elite Fibre spinning factory was funded by a group of alpaca breeders to process this and other specialty hair fibers such as cashmere, which need special treatment. It also takes colored and white wool, and for any of these, specializes in small runs. So Elite is not the name of a fiber, but of this spinning mill.

Angora

Angora fiber comes from either the French or the English Angora rabbit. The French Angora is a large rabbit, with a longer, muscular body, and is more active: the English rabbit (Figure 2.40) is small to medium, with a short, stocky body, and a docile personality. With the French Angora, most of the hair is on its back and sides, with more guard hairs and somewhat coarser hair in general, whereas with the English type, the hair is very fine and silky, and grows all over its body, on the ears and paws, and even right down its nose. 16 The hair is combed at molting time, and although there are many natural colors, white-haired types are needed for fabrics that will be dyed pastel shades. Angora is really a fur fiber, with air cell spaces in the center of the fiber. visible under the microscope. The rabbits are raised today in China, France, and Chile.

Figure 2.40 English Angora rabbit. (Courtesy of Leslie Samson, Samson Angoras, Brantford, Ontario)

Qiviug

Qiviuq (or qiviut) comes from the musk ox, species *Ovibos moschatus* ("musky sheep-cow"), living far above the tree line in the Arctic tundra (see Figure 2.41). The undercoat is very fine and lofty, much warmer than wool, and in a subtle, pleasing range of taupe colors. This fiber is just beginning to be used beyond craft products, as the basis of an Inuit industry. The largest population of musk oxen is in Canada's Northwest Territories (NWT) and Nunavut, primarily on the Arctic islands, and these herds are growing rapidly. Beginning in 1975, musk oxen from the NWT and Alaska were reintroduced to Russia, where the animal had been extinct for some 2,000 years. The herd, in the Taimyr Peninsula, is well established, if not large.

Other Specialty Hair Fibers

Yak hair is used in Tibet (China) where this animal is used to carry burdens, and has been used in exported sweaters. Reindeer hair is used for effect fibers as in tweed; it is similar to caribou. Caribou hair (not available commercially) has a cellular core that traps air and provides excellent insulation. Caribou skins are used by the Inuit (see Section Seven), but it has been suggested to blend the hair with wool for increased insulation. Cow hair and many other hairs have occasional uses. Shahtoosh is a specialty hair fiber that became better known in the West during the late 1990s, made into shawls woven in Kashmir. It was said to be the fine undercoat of an ibex (mountain goat) which inhabited the Himalayas of China, Tibet, and India. It is now reported to be from a highly endangered species of Tibetan antelope (chiru-Pantholops hodgsoii), and as was long the case

Figure 2.41 Musk ox, source of qiviuq fiber.
(a) Logo, courtesy of Folknits, formerly Down North:

(b) Canadian stamp issued 1991.

with the vicuña, the animals are killed to obtain the hair. Trade in this fiber is now illegal in the United States and many other countries.17 Buffalo hair has been used to make very soft knitwear that is reported to be machine washable and dryable without felting. **Opossum hair** from New Zealand is another entry in the rare and luxury specialty hairs; the Maori name is koha. Blends of this fiber with wool and others have been used in some high end fabrics made in Japan. Fur fibers (except angora) are used mostly to make the best, most lustrous felt for hats: beaver fur undercoat makes exceptionally fine felt.

Plumage—Feathers, Down

Plumage, the outer body covering of birds, has been used in a variety of ways for fabric, including as a skin, complete with feathers (a superlight and super warm parka made of such duckskin is on display in the Glenbow Museum, Calgary, Alberta).

More often, plucked feathers are used for stuffing, being very lofty and resilient. Feathers have a guill shaft and vanes (see Figure 2.42) and are used mainly for stuffing pillows and upholstery (in most cases today, they are replaced by rubber or polyurethane foam or by polyester fiber). Feathers are also used, as is fur, to make the long, snakelike boa scarf.

Down, the undercoat of waterfowl, is a marvellous structure with fine, barbed filaments growing from a guill point (see Figure 2.43). It is very light and fluffy, highly insulating with little weight, and softer because it lacks the quill shaft or vanes of feathers. The best (most lofty) is goose down, followed by eider duck down, with white being more expensive than gray. Down is being challenged today by hollow and microfine manufactured fibers.

Silk Filament

Cultivated or reeled silk is the only filament natural fiber, discovered and developed in China and often called the "queen" of fibers. The character given only by using a filament (very long fiber) is shown in fabrics typical of the silk family (see Link 2-3).

We use other silk fibers, including silk in staple form, but when we talk about "silky," we imply continuous filament and a fine, lustrous, white fiber. To get such a long fiber, nearly the entire length of the

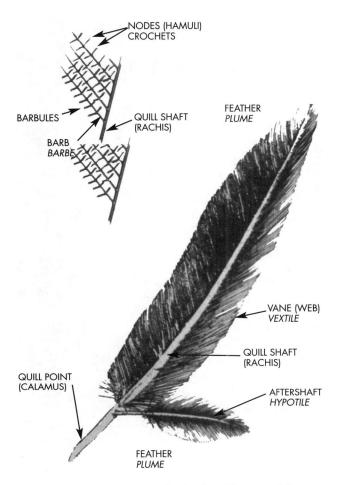

Figure 2.42 Structure of a feather. Reprinted from National Standard of Canada CAN/CGSB-139.1-M86, "Feathers and Down-Terminology and Characteristics." (Courtesy of Canadian General Standards Board. Structure of down is reprinted from the same source under Typical Features under Microscopic Fiber Examination.)

very fine filament making up the cocoon of the silkworm has to be reeled off unbroken, and when a sticky gum is removed, what we recognize as silky silk emerges. Only one combination of factors in all of nature and history has given this product.

Silk Production

Sericulture is the raising of silkworms for production of reeled silk; Figure 2.44 outlines the set of conditions that give us reeled silk, while Figure 2.45 shows the life cycle. These begin with the "silkworm"—the

Figure 2.43 Down. (Courtesy of the Textile Institute)

caterpillar form the egg of one species of moth, Bombyx mori (family Bombycidae), although there are many varieties. This moth is uncamouflaged (white) and unable to fly or look after itself after centuries of domestication. The larva or caterpillar that hatches from an egg must be fed the leaves of the white mulberry (Morus alba) and in a form that it can manage when it is tiny. Much research has been done to develop alternative foods, but especially in the final growth period, nothing else will do. Given the right diet, the caterpillar of this specific moth spins its cocoon of a filament that can be reeled off in an unbroken strand, giving us "silky" silk. The final condition is that the chrysalis or pupa inside is not allowed to emerge as a moth, which breaks the filaments; it is killed or stifled with steam or heat (hot air or sun).

Since a very few "wild" silk-producing types of silkworms are "cultivated," and a few others spin cocoons that can be reeled, the term "mulberry silk," rather than "cultivated" or "reeled silk," would probably be more accurate, but centuries of commerce and about 99 percent of silk production for textiles enforce the use of the terms "cultivated silk" and "reeled silk."

When the silkworm is ready to spin, it has stored a liquid protein, *fibroin*, in two glands running back into the body. These lead, in the head of the caterpillar, to a tube, opening at the *spinneret*. The silk filament is extruded (spun) from the spinneret as a twin stream (*brins*) of sticky liquid, to which has been added a coating of the protein gum *sericin* from another pair of glands. (See Figure 2.45[d], [e].) This liquid hardens to form the twin filament (*bave*), which has no internal structure, but in which the dividing line of the original two brins can sometimes be seen under the microscope. Fibroin contains no sulfur, which makes this protein somewhat different from the *keratin* of wool and hair fibers, detectable in a burn test.

This is raw silk—in the gum—one of the most misused terms in fashion fabrics. It is not the same as wild silk; gum makes raw silk dull and stiff and of an ecru color. It does not become silky until the gum is removed.

Before reeling (Figure 2.46), the gum is softened in hot water and the cocoon brushed to find the outside end of the filament, which is then reeled in combination with about eight others. These are next combined again, with a small amount of twist, to make a multifilament yarn; this process is called throwing—a term that has persisted into MF filament yarn, with production done by "throwster" firms. Raw silk filament yarns or fabrics made of them are termed **net silk** or **nett silk** as compared to spun silk (see Figures 2.46,2.47).

Degumming (boiling off) of silk is done by a wash that takes off the gum, and is necessary before silk will become silky. This leaves the filaments 25 percent or more lighter, showing them characteristically smooth, lustrous, soft, and drapable—in a word, silky (see Section Five). The time and method of degumming has been found to be important to the resulting fabric. A more lively and supple woven fabric results if degumming is done after weaving and without tension, in a batch method, to allow warp yarns to relax (develop crimp) and to take advantage of the thinning of the fabric as the gum is washed away. While the gum is left on, yarns need have little twist, since the gum holds them together and acts as some protection during processing. (See Figure 5.3.)

Moth (Bombux mori) lays 400-600 eggs. Eggs can be kept dormant in cold. Incubation takes 10-12 days.

Egg hatches into a tiny caterpillar ("silkworm")(see Figure 2.45[b]) which begins to eat after 1-2 hours. To produce silk, caterpillar must be fed leaves of white mulberry (Morus alba) especially in the final part of the 28-34 days as it matures. The caterpillar molts 4 times as it grows.

The caterpillar grows in length from 3 mm to 90 mm, through 5 instars—periods between moltings. It increases in weight 10,000 times, with a spurt of eating and growth after the last molt. Quarters must be airy, and kept clean (labor intensive!).

Caterpillar spins cocoon from its head (see Figure 2.45[d]); head moves in a "figure 8" pattern. Spins about 20 m/hr: (yd./hr.) for 2-5 days, a total of 400-1500 m (440-1640 yd.). Figure 2.45(e) shows mature silkworms at various stages of producing a cocoon. Occasionally one will wander into another's compartment. Two caterpillars spinning together, produce douppioni (dupion) (slubby) silk

Caterpillar changes to chrysalis (pupa). Cocoon is about the size of a peanut shell; weighs approx. 2 g (0.07 oz.).

If silk is to be reeled:

Chrysalis is killed (stifled with steam or dry heat). Cocoons are gathered, inspected, graded, and sorted. Cocoons are put into boiling water to soften gum, and silk filament is reeled (see Figure 2.46). It takes 45,000 cocoons to give 1-kg of raw silk.*

Silk filament is thrown (twisted, or combined with twist to form yarn—done by a throwster).

If moth is to breed:

Chrysalis is allowed to develop into moth (takes 1-2 weeks), which dissolves cocoon with alkaline saliva, and emerges leaving a hole in end of cocoon (see Figure 2.45[f]), to mate (see Figure 2.45[g]), after which female lays eggs (see Figure 2.45[a]) to complete the cycle.

*"Silk Facts," for exhibition "Bombyx mori, The Wonders of Silk: 4,000 Years of History," sponsored by UNESCO at the Montreal Botanical Garden and Insectarium, May-October, 1995.

Figure 2.44 The silk production cycle.

Reeling was long a skilled, hand process, but has been automated. A single bave is so fine (about 1 dtex or denier—there is no point in exact conversion in this sort of comparison), it is virtually never used alone as a monofilament. (See definitions of denier and dtex under "Yarn Classified by Linear Density" in Section Three.) MF microfibers were first defined as being fibers of less than 1 dtex or denier—rivaling the spinneret of the caterpillar. Since they are now being made much finer than that, the emphasis is on describing them as finer than any of the natural fibers.

Silk production has been intensively studied over thousands of years, and in Japan, especially, efforts were made to find a food that will allow hatching and feeding of caterpillars all through the year (with the natural cycle, the eggs are kept dormant by cold and hatch in the spring, just as the new leaves of the white mulberry are available). There is now even computer control of hatching! Needless to say, the breeding is carefully controlled to produce and select eggs (seed) of the most disease-resistant, best silk-producing moths: grainage is the term applied to this specialized procedure of seed production. A percentage of the

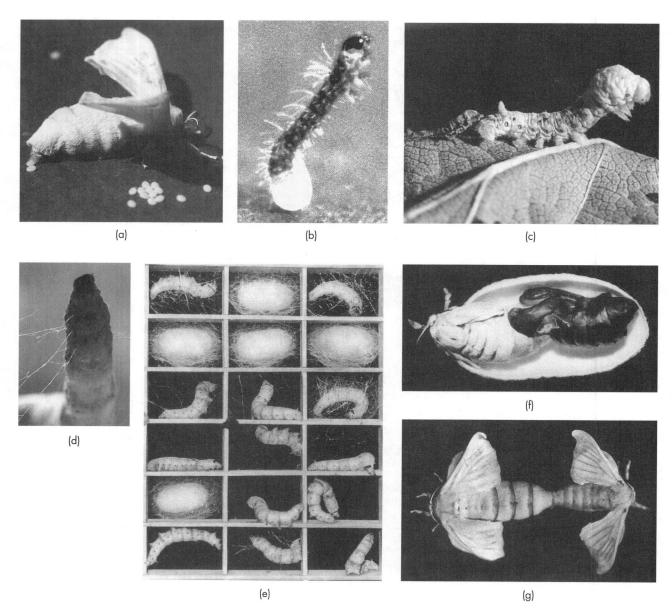

Figure 2.45 Life cycle of the "silkworm": (a) Moth Bombyx mori lays eggs. (b) Tiny caterpillar covered in black hair hatches from the egg. (c) Caterpillar eats mulberry leaves and grows, molting four times as it matures over about 4 weeks. (d) After the last molt, the caterpillar has a final spurt of eating and growing, then is ready to spin. The silk filament is extruded from the spinneret below the mouth. (e) Each caterpillar usually gets on with spinning in its separate compartment or mount. (f) Inside the finished cocoon the caterpillar becomes a hard chrysalis (pupa). When silk is to be reeled, the cocoon is treated with heat to halt the cycle, but when metamorphosis is allowed to proceed, the moth develops, dissolves the end of the cocoon, and emerges. (g) Female (left) and male (right) moths mate, after which the female will lay her eggs to complete the cycle. (Courtesy of Shigeki Furukawa and Masahisa Furuta, Cocoon's World, Yousei Printing Co., October 1994)

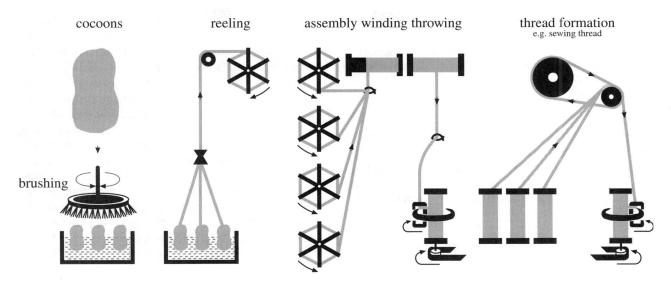

Figure 2.46 Reeling and throwing of filament (net, nett) silk. (Courtesy of the Textile Institute)

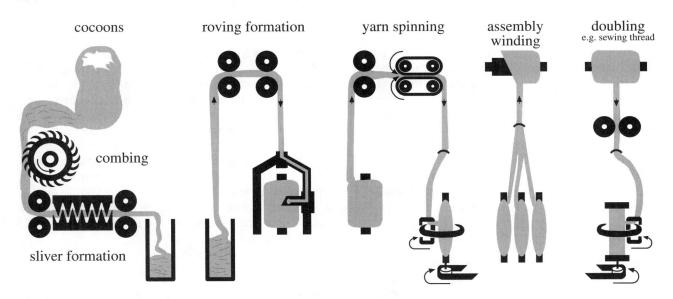

Figure 2.47 Production of spun silk. (Courtesy of the Textile Institute)

food can be other than mulberry leaves until the final stages of growth, but then, for best quality and yield, nothing but mulberry leaves will do.

It takes silk from over 100 cocoons to make a necktie, nearly 650 for a blouse. China, where silk originated, has increased its production of silk a great deal in recent years, after a long period when Japan was the leading producer. By 1995, China was producing 75 percent of the world's silk, and has held first place. Figures for world production of raw silk by country in metric tonnes for 2000 were: China 60,000; India 15,857; Brazil 1,389; Uzbekistan 1,100; Thailand 955; Japan 557; Others 1,250 (Total 81,108 tonnes).18 As labor costs rose in Japan and silk production fell, it imported raw silk to meet fabric manufacturing and printing needs. Although

Japan has produced so much less raw silk, improvements in the care of eggs and feeding of caterpillars more than doubled that country's efficiency (yield per box of eggs, field of mulberry bushes, or silk reeled per cocoon) for a while.

Silk Properties

Silk properties are unique, even though silk is a protein fiber like wool. The silk protein, fibroin, is simpler than wool keratin, without the coiling and cross-links, so silk is not as resilient as wool. It has low wet resiliency and wrinkles easily when wet—watch for this when caring for washable silk. Silk has a degree of elastic recovery or give.

It has a warm, dry hand and can be a good insulator, although we seldom use it as a fabric to keep us warm. Silk absorbs well, and is strong when dry, although it does lose strength when wet.

Silk can be weakened by long exposure to sunlight. More seriously—for most of us who do not have silk furnishings to worry about—perspiration can attack silk clothing. Proteins are not sensitive to acid but are to alkali; fresh perspiration is mildly acidic, but is acted on by bacteria on the skin, breaking down ammonium compounds to form alkali. However, it is only after time that this can concentrate and do damage to the fibers and to dyestuffs, so silks should be cleaned soon after wearing; home care is discussed in Section Six.

We value silk most for its beauty, the result of it being a smooth and fine filament: lustrous, soft, drapable. The supply is limited and price high because of its expensive (labor-intensive) production.

Silk Quality

Momme (mommie) is a Japanese unit of weight (see Section Nine for the exact weight equivalent) used for silk fabrics and sometimes cited in advertisements for silk blouses, etc. Fabric of a higher momme will be heavier, from use of heavier yarns and/or a closer weave.

Weighted silk (British: loaded) has had (cheap) chemicals added to make up for the body lost in degumming; it makes the silk stiff and lowers durability. While there was a good deal of this rather fraudulent practice when only silk could give filament fabric characteristics, it is not a problem today. However, one term linking it with lower quality still persists: pure dye silk; since weighting was done in the dye

bath, pure dye silk was defined by the U.S. Federal Trade Commission in 1932 to mean no more than 15 percent weighting for black, 10 percent for other colors. See also Section Five.

Silk has a crunchy, dry hand sometimes called *scroop*, but this term usually means the rustle typical of taffeta, produced by an acid treatment of silk.

Washed (sanded, chafed) silk and washable or washer silk are all modern treatments to give silk fabrics an informal, sometimes preworn look that demands less care than traditional silk fabrics require. Presumably, washable silks have colors that are fast to washing, but silk must never be washed under the same conditions as cotton. See Section Five for a discussion of sand-washed silk and Section Six for silk care.

Staple Silk (Spun)

We use and treasure silk in many ways other than as reeled filament.

Cultivated Silk Waste

Waste fibers occur at the start of reeling (floss or frison, the short fibers on the outside of the cocoon) or at the end, and from damaged cocoons, e.g., those from which moths have been allowed to emerge for breeding purposes. Silk waste is used as staple fiber to give spun silk. Production of spun silk is shown in Figure 2.47. The shortest waste silk is called noils and gives little bumps on the surface of the fabric called noile.

Double cocoons cannot be reeled and give the slubby *douppioni* (*dupion*) *silk* that may also be used for "silk linen."

Wild Silk

Wild silk comes from various types of moths, many of the family Saturniidae (called "giant silk moths"), genus Antheraea—varieties that give tussah, eri, and muga silk. Seed may be spread on trees such as oak, castor, or polyanthus, but most of the caterpillars forage for themselves, and the moths emerge, leaving cocoons with a hole in the end (see Figure 2.48) and broken filaments. The S. eri silk moth has been domesticated and cannot live on its own, but the silk has the character of wild silk: coarser than cultivated (mulberry) silk and gum that is darker and cannot be removed entirely. Silk from some of the

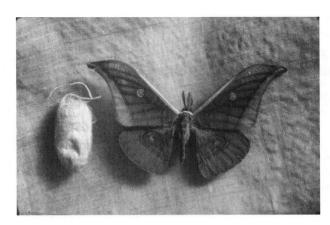

Figure 2.48 Muga moth (India), opened cocoon, fabric made from this wild silk. (Photo by Rick Wicker, Courtesy of the Denver Museum of Natural History)

wild varieties of India, such as tasar (from which tussah comes), cannot be reeled, whereas muga (mooga, moonga) silk can be reeled but the silk is coarse and golden brown (see Figure 2.48). Besides the Indian fabric names tussah and muggah, three connected with North China are shantung, honan, and pongee.

Thai Silk and Indian Silk

These silks traditionally have had slubs, especially in the weft. In most cases, these uneven yarns result from the moth being allowed to mature and leave the cocoon, rather than being killed with dry heat in the chrysalis stage (it is against Hindu teaching to kill any creature knowingly).

Spider Silk

For many years, the strong and complex silk spun by spiders (order Araneae, with over 7,000 species in North America) has been used for the cross-hairs in gunsights or microscopes. A spider spins a number of specialized types of filament from several spinnerets in the abdomen. These protein lines are only a tenth of the diameter of a human hair, yet have a unique combination of properties. They have tremendous strength (400,000 lbs./sq. in.), weight for weight five times that of steel. They are elastic, and can also absorb relatively huge forces, as when a web is unbroken after a bug has flown into it. Stopping a fly is recorded as the equivalent of stopping a jet plane with a net made of filaments one inch (25 mm) thick! 19 They also show what is called supercontraction; when wet, spider silk shrinks to almost half its length. Intense research to create this amazing and also renewable and biodegradable material yielded results that were first aimed at creating fibers for ballistic protection, aerospace uses, or medical applications. A fiber was made using milk from cloned goats with spider silk genes in their mammary cells. However, this development has been altered in direction—see BioSteel® proteins, Section Seven, "Biotechnology."

LINK 2-3 WITH FILES IN FABRIC GLOSSARY

These illustrate fabrics closely related historically with major natural fibers.

Look them up for a fuller understanding of how this contributes to the fabric character, and is an essential part of its name. You will also find photos of these named fabrics and other related textiles.

Fabric Glossary Fabric Name

Relationship to Fabric Reference Discussion

For a fuller list of fabric names associated with individual natural fibers, see the Fiber Families listing and discussion in Fabric Glossary. Look names up in Fabric Glossary Index.

Osnaburg, Unbleached Muslin

This fabric, discussed under Sheeting, shows bits of the cotton plant called "trash" remaining after the ginning process, which can be popular for a "natural" look.

Calico, Chintz, Muslin, Percale, Gauze, Jaconet, Mull, Nainsook These are all names associated with fine cotton fabrics from India or the route to Europe through Persia and the Middle East. Today, their weight and character may have changed.

Broadcloth (cotton)

Top quality used for finest dress shirts.

Fabric Glossary Fabric Name

Relationship to Fabric Reference Discussion

For a fuller list of fabric names associated with individual natural fibers, see the Fiber Families listing and discussion in Fabric Glossary. Look names up in Fabric Glossary Index.

Flannelette, Sateen, Velveteen, etc.

These names indicate a "lesser" (cheaper) fabric of cotton instead of the

original of wool or silk.

Linen may mean a fabric or a fiber, and different weights and textures;

investigate these possibilities.

These are names from linen history, although the fabrics today are most

often of cotton. See Fiber Families, Fabric Glossary.

The best damask for table "linens" will be all flax and of elaborate weave

and finish.

Crash, discussed under Linen, is a somewhat rougher material than the suiting weight we call just "linen," and has been made of hemp as well as

This fabric is heavily stiffened for interlinings, and is made of coarser cotton or bast fibers.

Canvas, Duck, Sailcloth, Tarpaulin These names are all connected with cloth for ships' sails, plus other uses the

material was put to. Made of linen or hemp, and later of cotton. Roughest, cheapest fabrics made of jute, better quality of hemp.

By name associated with wool through Welsh origin of name. Crisp fabric, combed (worsted) yarns, suited to day-in, day-out wear.

Special light weight wool suitings that were developed for hot weather

wear.

Typical of fabric made with coarser wools, tough, "sporty," may contain

"effect" fibers.

Fabric with no yarns, made by felting of wool or hair fibers, many uses

including hats.

Overcoats Fabrics, especially Melton Wool in these fabrics is purposely felted (fulled) on the surface, to make it

better suited to cold weather outer garments, and also to certain interiors

The wiry hair from the mohair goat, and from horse's tails have been (and are) both used for their stiffness. Horsehair, besides acting as a springy filling

in Victorian sofas, has been used for braids for summer hats, and for hems,

and both are used in interfacing "hard" tailored garments.

The first stiff crinoline was made of horsehair.

Tailor's (Hair) Canvas Best still uses wiry mohair or horsehair for interlining.

Wiry mohair is used to make some expensive bouclé loop yarns of great

"airiness."

Other properties of mohair make it tops for use in upholstery.

Find why the name of this Scottish town is linked with one of the most universally used design motifs, with a direct connection to cashmere fiber.

China Silk, Chiffon, Crepe de Chine, The "silkiness" of these fabrics was possible in natural fibers only with Organza, Satin and variations.

cultivated or reeled silk—unique among all natural fibers, even other kinds of

There are many fabrics made of uneven silk, and we treasure them for their

textural interest or soft, comfortable hand.

Wild silks from Northern China and from India have given famous names to

the rough or slubby materials made of them.

Linen

Batiste, Cambric, Lawn

Damask

Crash. Linen

Buckram

Burlap, Hopsack(ing)

Flannel

Worsted Suiting Tropical Worsted

Tweed

Felt

Millinery, Hem Braid

Crinoline

Loop Yarn

Plush

Paisley

Taffeta Douppioni (Dupion), Fuji, Noile,

Spun Silk, Tsumugi

Honan, Pongee, Muggah, Shantung, Tussah, Wild Silk

REVIEW QUESTIONS 2-3

- 1. What is the basic unit of the long-chain polymer. cellulose? What other familiar material is a polymer made up of the same type of unit repeating?
- 2. There are many seed fibers in nature: what allows some cotton varieties to be used as textile fibers? Which types cannot be used? Which types make the best textiles, and why?
- 3. When cotton has been harvested, what has to be done to get the fiber ready to be made into yarn and used for fabrics? What is this process called?
- 4. Summarize the reactions of cellulose to: water. heat, flame, acid, alkali, light. Classify it as excellent to poor in: absorbency, loft, resilience, strength, abrasion resistance. How does this "profile" of its properties account for some of the main uses we make of cotton, our major cellulose fiber?
- 5. What are the names of the three best varieties of cotton (one has a trademark name as well)? What are their four most outstanding properties that contribute to the highest-quality cotton fabrics?
- 6. Name two seed fibers other than cotton, and their uses.
- 7. What is the general name for fibers taken from the stems of plants? What is the best-known of these, and a fabric name connected to it? Which is the most-used of these, and a fabric name connected to it?
- 8. What is the characteristic of leaf fibers that restricts their use? What is the best-known one, and its uses?
- 9. What is the main advantage and disadvantage of the one mineral natural fiber, asbestos?
- 10. What is the unit of a protein called? What are two main differences in the makeup of the protein of wool fiber compared to cellulose?
- 11. What is the name of the protein of wool? Of silk? Of leather?
- 12. Summarize the reactions of protein to: water, heat, flame, acid, alkali. Classify it as excellent to poor in: absorbency, loft, resilience, strength, abrasion resistance. How does this "profile" of its properties account for some of the main uses we make of wool, our major protein fiber?

- 13. What is a fleece? Why do we use this term for sweatshirt "fleece," or "fleecy" clouds? What are the two layers in the hair covering of most animals called? What name is given to coarse wool that will not dye, and is used in mixtures to give texture as an "effect fiber"?
- 14. Name the breed of sheep best known for fine wool. Where is most of this produced? What fabrics or garments are made of it? Name one breed that gives medium-fine wool, and a suitable use. Name one breed that gives a coarse wool, and a suitable use. Where is much of this wool produced?
- 15. Name three registered trademarks for the finest quality wool. What is a trade term used to define the best wool worsted fabric?
- 16. What is virgin wool? What is the name of reclaimed wool? What is lamb's wool? What is botany wool?
- 17. Name two characteristics or properties compared to wool which we make use of with each of the following specialty hair fibers (and often pay more for): mohair, cashmere, camel hair, vicuña, angora, horsehair.
- 18. What is the main reason that silk is so expensive? Give three other factors in its production that also add to the cost.
- 19. Define: sericin, brin, bave, reeling, throwing, momme. What does "pure dye silk" signify on a label?
- 20. Although silk is a fine fiber, it is very strong; describe two conditions that permanently weaken silk, and what you should do to avoid this happening.
- 21. List three sources of uneven silk.
- 22. What are four fabric names all originating with wild silk? What is the term widely used instead of wild silk for a slubby material, of an ecru color when undyed? What does this term really mean?
- 23. What are two special properties that make spider silk of great interest in textile research today?
- 24. Why does down insulate so well?

2-4 MANUFACTURED FIBERS

The silkworm was the direct inspiration for manufactured (MF) fibers, since the process could be seen and is simple: a sticky liquid is ejected in a thin stream, which turns into a solid as a filament. Furthermore, silk has been long prized as one of the most desirable textile fibers. The first MF fibers were made using a naturally formed polymer, cellulose, as the raw material. This was imitating the silkworm which eats leaves (cellulose); but the silkworm produces a protein, very different from cellulose (just as a cow eats grass but produces milk). Eventually, in the development of MF fibers, the polymer raw material was synthesized as well, to give synthetic fibers.

Most methods begin with a solid raw material that is converted to a sticky liquid, forced through holes in a spinneret in streams (*extrusion* or chemical spinning), and turned into a solid filament. It is a matter of awe to hear what heights engineering has reached in this area of chemical spinning. First is the construction of spinnerets with tiny, sometimes specially shaped holes with microdrilling helped by laser.²⁰ Next is extruding of these filaments at speeds such as 400 km/h (250 mph), while keeping the precise physical properties of each fiber constant.²¹

The flowchart of MF fibers (Figure 2.4) shows three main divisions: ready-made natural polymers, minor-use specialized fibers made from inorganic materials, and synthetic fibers.

Spinning Manufactured Fibers

Spinning Methods

Several spinning methods are used:

Wet spinning. The fiber-forming liquid is extruded into a bath of liquid, in which the filament is solidified; an example is viscose rayon. (See Figures 2.49, 2.54.)

Dry spinning. A solid raw material is dissolved in a solvent that evaporates, leaving the solid filament; an example is acetate. (See Figure 2.50.)

Solvent spinning. The fiber-forming material is dissolved in a solvent, then extruded and coagulated in a liquid bath with no chemical combination intermediate; an example is lyocell.

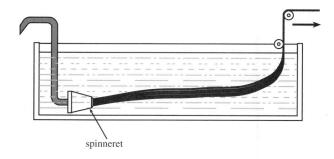

Figure 2.49 Wet spinning of manufactured fiber.

Melt spinning. A solid raw material is melted and spun, and forms the solid filament as it cools; an example is nylon. (See Figure 2.51.)

Gel spinning. The fiber-forming material, as a very thick (viscous) liquid, is extruded, the filament is set as a gel, and the solvent washed off after; an example is the very high molecular weight high-tenacity fiber Spectra.

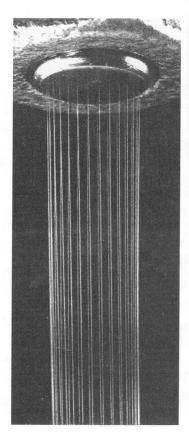

Figure 2.50 Closeup of spinneret; dry spinning of acetate filament. (Courtesy of the Textile Institute)

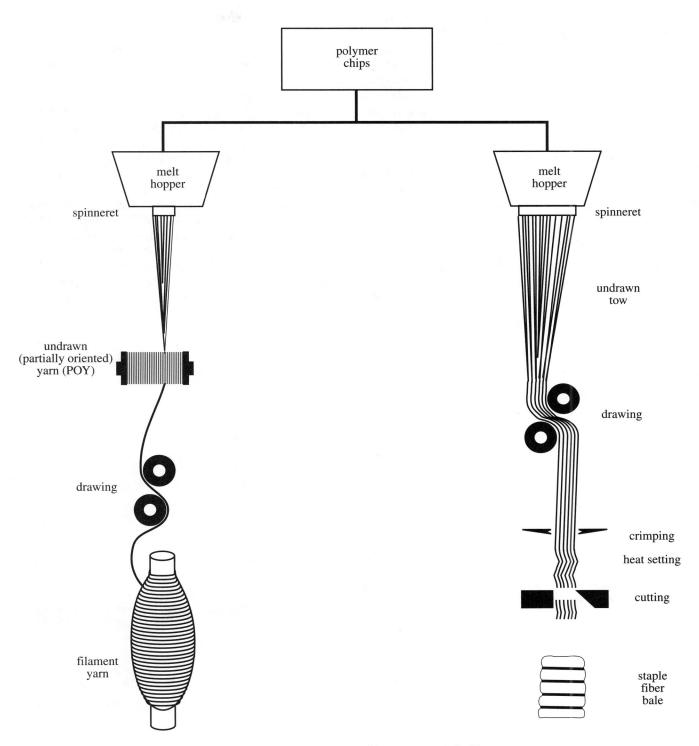

Figure 2.51 Melt spinning—filament or staple fiber.

Electrospinning. This method is used for production of most nanofibers. The polymer liquid (melted or in solution) is "charged with a high electrical voltage and extruded through a spinneret of 0.1–1 nm in diameter, the extruded polymer jet being drawn towards an earthed collector. By manipulation of the electrospinning conditions, microfilaments can be produced with different diameters." Uses of such extremely fine fibers in filters to keep out harmful particles and a number of medical applications are multiplying. 23

Spinneret Types

Spinneret types differ for filament or staple fiber. When filament yarn is intended, the number, size, and in some cases the shape of the spinneret holes

are engineered so that the product of that spinneret can be wound up as the yarn—hence the term *chemical spinning*. When it is planned that filaments should be broken or cut into staple fiber for eventual mechanical spinning into spun yarn, much larger spinnerets with many more holes are used, and the product of several of these is gathered together to give *tow*—a thick rope of MF filaments intended for conversion into staple. (See Figure 2.52.) (Note that the same term, *tow*, is used for short flax waste, for who knows what reason.)

Spinnerets for microfibers (finer than silk) can give filaments with diameters of 1 μ m; using special methods, such as bicomponent fibers, the end result can be much finer. Such are often referred to as "submicron," using the old term *micron*; the SI metric unit *micrometer* (μ m—one millionth of a meter) uses the same symbol for the *micro* prefix.

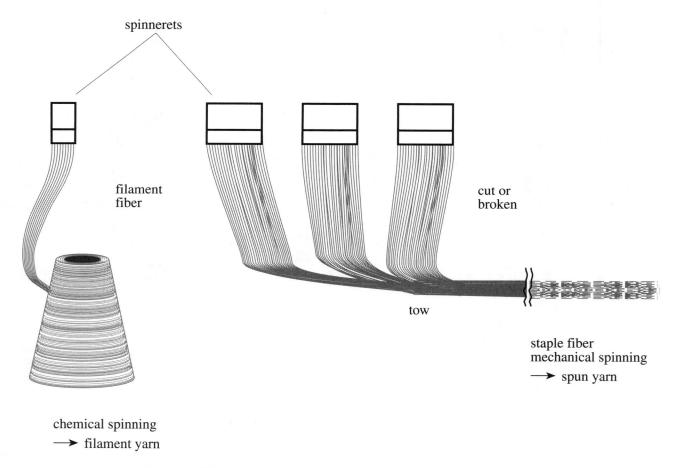

Figure 2.52 Manufactured fiber may be spun as filament or staple.

When the fibers are not intended for continuous filament yarn for weaving or knitting, but perhaps to form a nonwoven layer, spinneret holes of extreme fineness are achieved: 1 nm = one billionth of a meter (see the definition of Nanoscience and Nanotechnology under "Other Basic Terms" in Section One). These are also discussed under "Microfibers and Nanofibers" in this section. For more on nanotechnology, see "'Added Value' and Special Purpose Finishes," Section Five, especially the comparative size chart in Figure 5.13. Looking at this, consider that a human hair has a diameter of about 80 µm, which makes it 80,000 times thicker than the "nanowhiskers" of 0.001 um diameter shown in the chart.

It has been noted that some materials are included in nanotechnology that have a dimension of up to 100 nm. To clarify the definition of what constitutes nanotechnology, some authors in this field specify that the processes can show control over molecular-scale structures, and can be combined to make larger structures.²⁴

Drawing Manufactured Fiber Filaments

When MF fibers are spun, the long chains of polymer often lie at all angles to one another—what is called a random or disoriented arrangement. Such disarray produces a fiber with less tensile strength than if the molecular chains are aligned nearly parallel to each other in an oriented arrangement and packed closer together in a more crystalline structure. Drawing or pulling out of the fiber after spinning can accomplish this and is an integral part of production of our strongest fibers, such as nylon and polyester. After the filament is drawn it is thinner, and tests demonstrate the changes this brings: tenacity testing reveals the increased strength, while x-ray diffraction testing indicates a more crystalline structure. The aligning of molecular chains is shown in Figures 2.53 and 2.60.

Cellulosic and Minor Natural Polymer Manufactured Fibers

Of those MF fibers using natural polymers for raw material, some are minor, such as fibers from proteins, seaweed, or chitin; most of our discussion of this type will be of the cellulosic MF (CMF) fibers, which use cellulose as the raw material. Of these, those that reconstitute cellulose in the MF fiber by regeneration or precipitation are much more important commercially than the cellulose acetate compounds. It can be noted that until 1953 in the United States all CMF fibers were classified as rayon. After that (much later in Canada), rayon was reserved for fibers regenerated by the viscose or cuprammonium process, while cellulose acetate compounds were given a separate generic grouping.

General advantages of MF fibers and of CMF fibers have been noted earlier in this section. In the 1990s, a new type of reconstituted cellulose fiber, lyocell, was introduced commercially. It is produced by reconstituting cellulose from a solvent, using chemicals and processing methods that give superior CMF fibers and have little impact on the environment. This has a profound effect on the position of the more traditional fibers that regenerate cellulose

(a) Undrawn polymer; no orientation or crystallinity (amorphous).

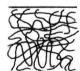

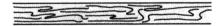

(b) 3:1 draw ratio; alignment of some chains and crystallinity introduced.

(c) 6:1 draw ratio; high degree of chain orientation and crystallinity.

from an intermediate form, as with viscose, or a complex, as with cuprammonium. However, we should still examine the older methods, especially the long-time commercially successful viscose process.

Reconstituted Cellulose Fibers

Rayon

Rayon, the oldest MF textile fiber, has accounted for the greatest part of world CMF fiber production, and almost all of this has been viscose, with cuprammonium minor in production. (It should be noted that Europe and the ISO withdrew support for the generic name *rayon* in 1971, while in Canada, lyocell, as well as viscose or cuprammonium, can come under the generic of rayon.)

Viscose Rayon Production. Viscose is made by the odd, complicated viscose process; this is a rather inelegant way of converting cellulose (solid) to a liquid form, then wet spinning it, to regenerate it as an MF fiber filament (solid), but it has worked well since its development in England in 1892–1905. Further, it is multistage and allows many modifications to produce special versions, the most important being HWM (High Wet Modulus) rayon (modal). The wrapping film cellophane is viscose rayon in another form.

The standard viscose process results in a fiber with a skin/core structure, depending on the speed of regeneration of the fiber in the spinning bath. Because of the wrinkled outside of the fiber, the lengthwise appearance under the microscope shows many striations, while the cross section shows an almost serrated edge. Some modifications have made use of the skin/core structure to make self-crimping viscose. The viscose process is shown in Figure 2.54.

Trademark names for standard viscose rayon are not often seen; the better-known trademark names have been those given to HWM forms of viscose.

Cuprammonium Rayon (Cupro) Production.

Cuprammonium rayon (generic name is *cupro* in a number of countries) is made by a process that is much simpler than that for viscose. Cuprammonium, a deep blue solution of copper in ammonia, converts the cellulose to a liquid form believed to be a complex formed with cellulose by the cuprammonium solution. Cellulose from purified wood pulp is combined with the

 $\begin{array}{l} logs \to wood \ pulp \to purified \ pulp \to cellulose \ (in \ sheets \ like \ thick \ blotting \ paper) \end{array}$

[steeped in sodium hydroxide (NaOH), very strong alkali, also called caustic soda or lye.]

- \rightarrow alkali cellulose (alkcell) [shredded or ground] \rightarrow crumbs [aged, + carbon disulfide (xanthation process)]
- ightarrow sodium cellulose xanthate (intermediate)
- [+ weak NaOH] \rightarrow thick, syrupy, (viscous) orange liquid [ripened, filtered, gas bubbles removed] [wet spun (see Figure 2.49) into dilute sulfuric acid bath, with some other chemicals]
- ightarrow solid filament of regenerated cellulose [stretched around Godet wheels] ightarrow filament yarn or tow [washed]

Figure 2.54 The viscose process.

cuprammonium solution, and when the resulting sticky liquid is spun and washed with water, cellulose is regenerated as filaments. Because spinning takes place downward through a funnel, the fibers are stretched somewhat, making them finer and slightly stronger than those from the standard viscose process. Cuprammonium rayon is most often used in high-quality lining fabrics because it is made in a finer filament than most viscose. Cuprammonium does not regenerate slowly as viscose does, and so does not show a wrinkled surface; it has a round cross section.

This form of CMF is still marketed under the trademark name Bemberg® (now by Kasei Fibers), used since the fiber was developed by the Bemberg Company (Germany) in 1890.

Viscose and Cuprammonium Rayon Properties. Properties will be similar for any standard viscose or cuprammonium rayon. Since it is composed of cellulose, like cotton, it is absorbent—in fact, it absorbs more than cotton, so it is comfortable to wear, with good static resistance and cool hand. Rayon has good heat resistance, but like cotton it wrinkles, has poor wet press retention, and allows mildew growth. Because it swells as it absorbs moisture, rayon in fabrics tends to shrink even more than cotton.

The main area of difference from cotton is in strength, especially wet strength. Cotton has good strength when dry and gains significantly when wet, but these rayon fibers have only fair strength when dry and lose about half of that when wet. In converting the cellulose to fiber, the molecular chains end up shorter

and less oriented than those in cotton—making a weaker fiber. This low wet strength makes these fibers less able to stand up to machine washing and drying in consumer use, and unsuited to the wet finishing in fabric manufacture that can give resistance to wrinkling and shrinking (Durable Press)—to deliver the ease of care consumers want: fabric articles that are machine washable and dryable and require little or no ironing.

Most viscose and cuprammonium is used as staple fiber (spun rayon), but filament rayon is found in linings, apparel velvet, trims, and furnishing fabrics such as damask drapery material.

High Wet Modulus (HWM) Rayon (Modal). The viscose process can be modified to leave the cellulose chains longer, with more orientation, giving a High Wet Modulus or HWM rayon (the generic name is modal in a number of countries) that comes closer to cotton in strength. Its strength when dry is fairly good, better than standard rayon, and it loses less strength when wet.

The higher wet modulus means that the fiber is less prone to stretch when damp or wet; heavy drapes of standard rayon, for instance, lengthen in high humidity and shorten in drier air—what is called an "elevator effect." Otherwise, HWM rayons behave like any rayon. Lenzing Modal uses the (non-United States) generic name modal. There is also an unofficial term, polynosic, for one type of HWM rayon manufactured in some countries.

Lvocell

Lyocell is a solvent-spun cellulosic fiber—an innovation of the 1990s in this oldest group of manufactured fibers. Research went on at Courtaulds Fibres Plc., U.K. from the late 1970s, with the pilot plant stage reached in 1988, and first commercial production (Mobile, Alabama), in 1992. This was staple fiber, with the trademark of Tencel® (produced first by Courtaulds, now by Lenzing Fibers (see Figure 2.56). A lyocell fiber is also produced by Zimmer AG. Tencel is used alone and blended with cotton, flax, polyester, and wool, plus some blends with spandex.

Lyocell as a generic name was established promptly in Europe, where the generic rayon has not been used since the 1970s, and is now listed under rayon as a generic in the United States. In Canada it can be used as a generic or classified as another rayon.

Lyocell Production. Lyocell is made by dissolving purified cellulose from wood pulp in an amine oxide, N-methylmorpholine-oxide (NMMO), an organic solvent that is much less harmful or irritating than others used in fiber production. After the clear, viscous (thick, sticky) liquid is filtered, it is extruded (spun) in a bath of dilute NMMO, where the fiber coagulates as reconstituted cellulose. It is then washed and dried. The process is shown in Figure 2.55. Like cuprammonium, lyocell has a smooth surface and a round cross section. Since this is a "closed-loop" system, and virtually all the solvent can be recovered and used again, the process is largely pollution-free and is estimated to take only one-sixth of the time needed for the viscose process.

Lyocell Properties. Lyocell has dry strength comparable to cotton and some polyester, very high wet modulus, and it retains 85 percent of its dry strength when wet, so it will stand up well to home laundering. It can also withstand wet mill finishing to give Durable Press, for instance, so wrinkling and poor wet press retention can be counteracted. Of course, being made up of cellulose, it has the advantages of good moisture absorption, good static resistance, cool hand, and good heat resistance. It is used in apparel, especially sports and leisure wear, and for household textiles such as bedding.

Lyocell fibers can have a tendency to fibrillation—to splitting off if abraded when wet, forming surface fibrils (see Figure 2.56). These give a very soft "peach skin" hand, which can also be promoted in finishing by physical abrasion, by enzyme treatment, or by chemical (alkali) treatment. In making some industrial fabrics, a "fast fibrillating" type is

 $logs \rightarrow wood pulp \rightarrow purified pulp \rightarrow cellulose$ mixed with organic solvent amine oxide (N-methylmorpholine-N-oxide—NMMO)

- → heated, cellulose dissolves→ clear, viscous liquid
- \rightarrow filtered \rightarrow extruded (spun) in bath of diluted amine
- → coagulates to solid filament of cellulose
- \rightarrow washed \rightarrow dried
- diluted solvent from washing → purified
- \rightarrow recovered by evaporation of water \rightarrow totally recycled: "closed-loop" system

Figure 2.55 Solvent spinning of lyocell.

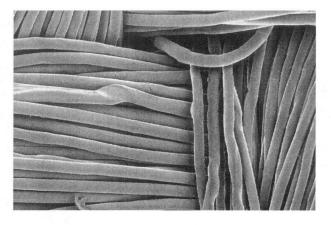

Figure 2.56 Fabric of Tencel® lyocell, before and after fibrillation. (Courtesy of Acordis; Tencel® now by Lenzing Fibers)

useful to generate microfibrils, as for filters. However, the tendency to fibrillation can also result in a difference in light reflection from the surface that may be interpreted as graying. As well, without fibrillation, different hands can be achieved that are desirable for certain products.

Minor Reconstituted Cellulose Fibers

Seaweed is used to add special properties to a cellulosic MF fiber, SeaCell[®]. A cellulose-based fiber is first made by the lyocell method, which then serves as a substrate for the seaweed. The fiber produced by incorporating this marine plant is reported to add trace elements that protect the skin and have anti-inflammatory properties. Because it is also soft and absorbent, it is a desirable fiber, although still in minor use. Another version, SeaCell[®]Active, is

included in "Additions to Manufactured Fibers Before Spinning," under "Bioactive Agent," this section.

Bamboo-regenerated cellulose MF fiber is produced, as well as taking the natural fiber from the stem of the bamboo, and a finer, softer fiber is possible this way. It is this type that is blended in a Drirelease fabric (by Optimer) discussed under "Blending of Fibers," this section.

A **Wood Material Science Research Project**, launched in Northern European countries in 2006, is expected to lead to new cellulose derivatives from wood (given the name NewCell).

Cellulose Acetate Compounds

Cellulose Acetate and Triacetate

Cellulose will combine with acetic acid to produce new compounds with very different properties from the original cellulose, and therefore different from cellulosic natural and reconstituted cellulose MF fibers. Attempts to make fibers of cellulose acetate compounds were made from the late 1890s, at a time when there was intense experimenting to put cellulose into a liquid form to extrude into textile fibers.

Cellulose acetate compounds of two types are made into fibers. **Triacetate** is the one discovered first but not commercially made until, as Arnel, it was marketed in 1954 by American Celanese. Production of triacetate was phased out in North America in 1987 because the solvent used was considered environmentally unacceptable. The generic called simply **acetate**, introduced about 1905, is a secondary cellulose acetate compound, sometimes called a "diacetate."

Cellulose Acetate and Triacetate Production. The relationship of these fibers comes from the structure of the cellulose chain unit, which is a residue of the sugar glucose, shown in Figure 2.8 in the discussion of "Cellulosic Natural Fibers." The reaction to produce a cellulose acetate compound is shown in a different style in Figure 2.57. On each unit, there are three active hydroxyl groups (OH) where chemical reactions can take place. If cellulose (purified from wood pulp) is steeped in very strong (glacial) acetic acid, eventually an acetyl group (CH₃COO) will attach itself to each of the hydroxyl groups, with water (H₂O) lost. Since

Figure 2.57 Formation of cellulose triacetate.

there are three OH groups, the result is cellulose triacetate.

Cellulose acetate production follows the same procedure, but acetic anhydride is added when the reaction to form cellulose triacetate is complete, and then the solution is aged. The compound is reduced slightly until there are approximately two acetyls per unit, giving a secondary cellulose acetate with the generic name acetate.

The compound is solidified and broken up into white flakes, which are dissolved in acetone for dry spinning; the solvent evaporates, leaving the solid filaments, just as liquid nail polish quickly becomes solid. The first cellulose acetate was used in large amounts, not to make fibers, but as "dope" to paint the fabric of early airplanes. Although the solvent in nail polish is not acetone, it is related closely enough that it will affect acetate or triacetate fabrics.

Triacetate is disintegrated by acetone, but does not form a smooth solution for spinning, as acetate does. In fact, it was the search for a suitable solvent that delayed introduction of triacetate half a century (no one wished to use the known one, chloroform). The one used eventually, a mixture of alcohol and methylene chloride, was also a difficult chemical to work with.

Cellulose Acetate and Triacetate Properties. These two types of fibers show both similarities and differences, since they are closely related, yet individual—like family members.

Cellulose acetate and triacetate are thermoplastic—they soften and melt on application of heat. Both are weak fibers with low abrasion resistance and

tenacity, and both lose much of this low strength when wet. In burning, both fibers have an odor of vinegar, which relates to their composition: vinegar is weak acetic acid. On the other side of the scale is the important economic advantage of cost: CMF fibers are more economical to produce than synthetics.

Triacetate softens at a higher temperature than acetate and can be given a heat set in garment manufacture, using carefully controlled presses. It also withstands a fairly high iron heat, although care must be taken with any thermoplastic.

Acetate is produced almost entirely as filament, and in this form has good luster; a soft, smooth hand; and pleasing drapability. In other words, it can give very silklike fabrics. This allows very pleasing, silky, yet inexpensive fabrics, often used in linings. Acetate is fairly heat sensitive; this means pressing heat must be low to avoid "sticking" (melting). Acetate cannot be given a permanent heat set and with its low strength, especially wet, is anything but an easy care or high performance fiber. Within its limitations, however, it gives satisfactory fabrics, mostly classified as dry-cleanable; only more informal fabric styles such as crushed satin are presented as washable and "no iron." It is used in women's and men's apparel, linings, and home furnishings.

Minor Natural Polymer **Manufactured Fibers**

Azlon (Protein)

A number of fibers have been made from proteins, in attempts to make a wool-like MF fiber, from before World War I until just after World War II. However, many of these used proteins for raw material from sources that are complete or first-class proteins in a nutritional sense—having all the amino acid building blocks humans and animals need to make protein in their bodies. It is not surprising that these fibers came to be of minor use. Also, synthetic fibers, particularly acrylic, have given wool-like properties for sweaters, blankets, and such with better performance than protein-based MF fibers. Many other protein sources continue to be researched for textile fibers, but the outlook for any but specialized use is not promising.²⁵

The generic name azlon was given to MF protein fibers, and they can have a soft, warm hand; have good absorbency; and take dye well, as wool does. Such fibers are weak, and weaker wet, and some, like those from corn protein (zein), were golden or tan in color. Others used were made using milk protein (casein), or peanut protein. Current research is investigating making fibers from the protein in the residues of various crops, including peanut and rapeseed.

The azlon fibers made now have been mainly from the protein of milk (casein) or soybeans, the latter gathering a good deal of favorable publicity, although it is still in minor use. Soy fiber, coming from a plant protein, fits today's search for products from renewable resources, environmentally friendly. The soybean grows easily, and is the world's greatest provider of protein (tofu being one food form) and oil. The process is described as using agents that will not cause pollution to remove the protein from the soybean cake after the oil has been extracted, using agents that are not harmful. The United States grows more soybeans than any other country, with much of it exported.²⁶

The fiber has been dubbed "soy silk," and even "vegetable cashmere," which indicates the softness most appealing to those who have worn clothing made of it. It has been used for underwear, socks, scarves, and sheets, to name a few items, not only for its softness and smoothness, but because it is absorbent. However, these are far from mass market products.

Alginate Fiber

Alginate is fiber made from alginic acid, derived from seaweed, and converted into calcium alginate to form a filament. This fiber is used because it will dissolve in an alkaline solution, such as of washing soda (sodium carbonate) and can be used for sewing or looping

$$\begin{bmatrix} CH_2OH & & & \\ C & & O & \\ H & H & & C \\ OH & H & H \\ C & & C \\ H & & NHCOCH_3 \end{bmatrix}$$

Figure 2.58 Structure of chitin and its derivative, chitosan.

articles together temporarily or as a ground material that is to be removed eventually. It has also found use in medicine, because alginate will help stop bleeding, is antimicrobial, and does not irritate.

Chitin Fiber

Chitin is a polymer based on a sugar-like unit that resembles cellulose (see Figure 2.58 compared with Figure 2.57). It is the main part of the hard outer covering of insects, arachnids, and crustaceans, as well as forming reinforcement in the cell walls of fungi, molds, and yeast. As such it is the most abundant organic compound after cellulose. It can be made into a fiber; in medicine it is absorbable as sutures and has been found to be antimicrobial and to speed healing greatly when used as wound dressings. Its derivative *chitosan* may also be used to remove offensive color from dyebath effluent, in combating water pollution (see Section Seven).

Synthetic Manufactured Fibers

The general advantages of MF fibers in general and of synthetic fibers in particular were noted earlier in this section.

Manufactured fibers were inspired by study of the production of much-prized silk filaments by a caterpillar, turning a thick, sticky liquid into solid filaments. However, it was a giant step to go from using a complex natural polymer, cellulose, as the raw material, to synthesizing such a fiber-forming material out of simple chemicals to create the very long molecular chains necessary to make a useful textile fiber.

This was the area of research chosen in the 1930s by a team of organic chemists at E. I. DuPont de Nemours and Company, Inc., headed by Dr. Wallace Hume Carothers. They knew that all the natural fiber-forming materials (cellulose, protein, rubber) were such long-chain or "giant" molecules, also called "high polymers." The research team was looking for small units that would have a reactive group at either end so that they might be made to join together into very long chains, rather like making up a necklace of pop beads.

The work of this team is widely regarded as one of the most significant (and probably the last) examples of "pure research"—the luxury to explore any area of knowledge, without necessarily coming up with any practical or valuable results. In this case, the team "hit the jackpot" in producing not only the first synthetic textile fiber, nylon, but also one which is still, so many years later, in the forefront of desirable and useful fibers. Nylon is also employed in many forms other than textile fibers, from bristles for paint-, hair-, and toothbrushes to buttons to cog wheels to liquid coatings.

On the way to developing the type of polymer that was eventually called nylon or polyamide, the team tried hundreds of units that did not work out, and along the way, touched on a number of families that would eventually be explored more fully (and successfully). Among the compounds tried by the DuPont team was one that could be stretched like "pull toffee" to some four times its length, at which point further stretching would break it. It would not return to its original length so was not a truly elastic fiber. This was the type that led to nylon.

Synthetics have long been made using fossil fuels (oil, gas, coal) plus air, water, and other chemicals as the raw materials. From these, chemicals are obtained to make the simple materials that will become the units of the fiber polymer. These units must have reactive groups at both ends; in polymerization, these groups join to form very long chain molecules with fiber-forming properties. Since the beginning of the 21st century, synthetics are also being formed with units made from renewable materials, such as corn starch (see PLA under "Bio-Based" Synthetic Fibers—From Annually Renewable Raw Materials).

Nylon (Polyamide)—The First Synthetic Fiber

Nylon was first marketed in 1938 as bristles and fishline, and in the early 1940s as nylon hosiery or "nylons."

Nylon contains carbon, hydrogen, oxygen, and nitrogen. There are now several types, but the generic name is defined by the amide linkage between units (see Figure 2.59); an alternative generic in many countries is polyamide, the name most commonly used in Europe. This is the same linkage as occurs in the much more complex molecular chain of a protein (see Figure 2.22). The original type has a unit made from the reaction between the comonomers hexamethylene diamine and adipic acid; there are six carbons in each, giving this the name nylon 6,6. "Deep dye nylon," called nylon 6, has six carbons in the caprolactam unit or monomer.

Polyamides containing 85 percent or more aromatic units were given a separate generic, aramid, discussed under "Flame- and Heat-Resistant Organic Fibers."

Nylon Production

Nylon production starts with the basic chemicals for any one type of nylon (derived mainly from petrochemicals), combined to form the unit compound; then polymerization takes place under heat and pressure. The polymer, a thick, sticky liquid, is solidified and broken into white flakes or chips. The chips are melted and spun (shown in Figure 2.51 under "Spinning Manufactured Fibers"). Melt-spun fibers hold the shape of the spinneret hole, so that modifications in cross section can be made (see "Solid Fibers with

$$-\left[\begin{array}{c} O \\ -C - N - \end{array}\right] -$$

Figure 2.59 Amide linkage in nylon (polyamide).

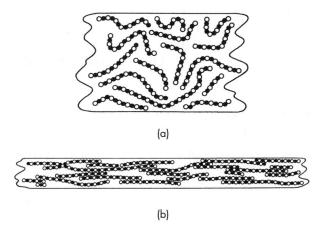

Figure 2.60 Polymer molecules in fibers: (a) undrawn and (b) drawn and oriented. (Courtesy of the Textile Institute)

Nonround Cross Section"). The resulting fiber is drawn to orient the molecular chains (see also Figure 2.60). Partially oriented yarn or POY is often produced if filament texturing is to follow, when the drawing will be completed.

Nylon Properties

Nylon's properties are outstanding; although no longer the most-used synthetic, nylon is still the strongest major fiber in its standard form. It was first used as filament in place of silk to give strong, light materials such as parachutes and women's sheer hosiery.

Although nylon is not a true elastomer, it has low modulus, so it "gives" when stretched. This contributes to its outstanding abrasion resistance and tenacity; nylon can withstand abrasion even when under strain, as in hosiery, and even small amounts of nylon blended with wool, for instance, extend the life of carpets or socks. However, this also means that in a blend with a more rigid fiber such as cotton, nylon elongates and leaves the cotton to take wear. Nylon is not ideal for sewing thread, either, because stitching can stretch and then contract, leaving a puckered seam.

The great strength of nylon can also be a disadvantage; it results in stubborn pilling. Balls of short fibers rolled up during wear cannot be brushed off, as they can with wool, but must be cut off with a sharp blade such as a razor. Electric pill removers are sold for the purpose; a pumice-stone has also been marketed to rub off pills. Stubborn pilling can be a problem with any very strong fiber used in staple form.

Nylon softens at a temperature high enough that yarn or fabric made 100 percent of it can be given a permanent heat set as defined in this *Reference*.

Nylon absorbs less moisture than natural fibers, which means less comfort in clothing, but its absorbency is not as low as acrylic, polyester, or olefin (in decreasing order).

Lower absorbency also signals collection of static electricity in dry air. When nylon clothing is worn next to polyester, as often occurs with nylon underclothes and polyester outerwear, there can be a particular problem; see the triboelectric series in Figure 2.7. Because of its fairly low absorbency, however, nylon is quick drying.

Nylon in standard form is weakened by sunlight; much nylon produced today has antioxidants or other stabilizers incorporated in the fiber to make it more resistant to the ultraviolet (UV) rays of sunlight.

Nylon is used for its strength, abrasion resistance, and heat settability in home furnishings, lingerie, loungewear, eveningwear, sportswear, activewear, footwear, and luggage. In some uses, thickness of yarn may be listed, usually as denier (in the order of 1,000 denier for luggage). Cordura® (by Invista) was a trademark for very tough nylon (now used for a variety of very durable materials). Figure 2.61 portrays the general acceptance of nylon as the strongest standard fiber ("super-strength" fibers are discussed later in this section).

Polyester—The Most-Used Synthetic Fiber

Polyester was the second synthetic fiber type to be developed (1941) and is now by far the most widely used, due to a balance of properties that gives it great versatility plus a less expensive manufacturing process compared to nylon.

There are several types of polyester, since the generic is defined as the ester of a dihydric (two hydroxyl groups) alcohol and an aromatic dicarboxylic acid. The original type is called PET for polyethylene terephthalate, the result of linking and then polymerizing ethylene glycol (antifreeze) and terephthalic acid. Ethylene glycol has two carbon atoms; PET is sometimes referred to a "2GT" polymer.

PET polyester is discussed here first, with a summary of some other types following. The acid component gives part of many trademark names for PET polyester, beginning with the first, Terylene (by

Figure 2.61 The superior strength of nylon is well known! (Reprinted by permission: Tribune Media Services)

ICI). Polyester is made up only of carbon, hydrogen, and oxygen (no nitrogen, as there is in nylon); the carbons in the acid are in rings, making this, in organic chemistry terms, an aromatic acid.

Polvester Production

Production of polyester follows steps similar to those outlined for nylon; it is also melt-spun and drawn after the fiber is made, and filament intended for texturing may be made as POY (see Figure 2.51).

Polyester Properties

Properties of polyester can appear very similar to those of nylon, so it is important to clarify how they differ. One thing is certain: If an MF fiber does not have specific, significant advantages over others, it will not be, or continue to be, produced.

Polyester has strength and abrasion resistance next to nylon and also takes a permanent heat set all "first-class" fiber properties, from the point of view of performance. The further characteristics that finally put polyester ahead of nylon in amount used are good resilience (the nearest to wool of any MF fiber) and high modulus; these mean that it is springy

and can recover well from strain, yet resists stretching better than nylon. Polyester also conducts moisture away from the skin better than nylon, dries faster, and is more supple in cold conditions.

This combination of properties has led to many uses: polyester can be used instead of or with wool (e.g., in suiting fabrics) and it is ideal to blend with cotton, rayon, lyocell, or flax, because it has wrinkle resistance and yet is fairly rigid, so no special form has to be made of it for blending with cellulose fibers, as was the case with nylon. Its better stability gives it an advantage over nylon as textured filament yarn in fabrics for more tailored articles. This lack of "give" under strain has also made polyester preferred over nylon for most sewing thread. It is "fiberfill" stuffing for pillows, insulation, batting, etc. Further, it has good sunlight resistance (excellent behind glass when the UV component is removed), so it is used for sheer curtains. Finally, filament polyester has been successfully altered to look and feel very much like silk. Current developments, especially in microfibers, are turning this "workhorse" fiber into more appealing "thoroughbred" types.

Figure 2.62 Corterra® PTT polyester is suited to various carpet types from plush cut pile to a tight loop to a soft berber. (Courtesy of Corterra Polymers)

Polyester does have particular drawbacks, too, one being that it holds oily stains tenaciously. It absorbs very little moisture, so it is less comfortable to wear in its standard form. It is also a static collector. (Of course, less absorbency means quick drying.) Like nylon, polyester fabrics show stubborn pilling because of the great strength of the fiber.

Two well-known trademark names of the *many* for PET polyester fibers are Dacron[®] (by Invista), and Fortrel[®] (by Wellman).

Aromatic Polyester (PTT)

Corterra® (by Corterra) is an aromatic polyester, polytrimethylene terephthalate, patented by Whinfield and Dr. J. Dickson at the same time the first polyethylene terephthalate (PET) was developed. For technical and cost reasons, PTT was not worked on until the 1990s, with introduction by Shell Chemical of Corterra in 1995. In long-term walker tests on carpet, it performed as well as nylon and better than PET polyester (see Figure 2.62). It is inherently resistant to water-borne stains, although not to oily stains, and generates low static charges. (See Figure 6.3 under "Home Treatment of Spots and Stains," Section Six.)

Other Types of Polyester

As explained peviously, the original type of polyester, and the most usual still made, is PET, polyethylene terephthalate. PTT (polytrimethylene terephthalate) has been discussed above. Some others, including copolymers, are:

PEN (polyethylene naphthalate). With modulus (resistance to stretching under strain) several times that of PET, and five times that of nylon, it is suitable for tire cords, cordage, and sails.

PCT (poly 1,4-cyclohexane dimethanol terephthalate). Has a lower specific gravity than PET and so has greater loft and cover. It has a higher melting point (more heat resistance), gives better soil release, and is soft.

Elasterell-p has been defined by the FTC as a subgroup of polyester (see Appendix for the full wording). To paraphrase the formal definition, elasterell-p must be composed of two or more chemically distinct polymers, contain ester groups as the dominant functional unit, and be stretchy. So it is a bicomponent fiber (see more later this Section) as well as a polyester. The first elasterell-p was made from Sorona® (a 3GT polymer, by Dupont) and PET polyester (a 2GT polymer), extruded together (see explanation of 3GT and 2GT following). Sorona of itself offers comfort stretch and recovery because of its "kinked" molecular chain structure (see Figure 2.63), while the difference between its properties and those of PET provide additional stretch to this type of bicomponent fiber.

DuPont™ Sorona® is outstanding in a number of ways, not least of which is the way it can be made—with carbon obtained from natural sugars, rather than petrochemicals (see Figure 2.64 for a graphic outline of this kind of revolutionary process, also referred to

Figure 2.63 3GT (Sorona®) molecule compared to 2GT molecule. (Courtesy of DuPont)

under "Bio-Based Synthetic Fibers"). Sorona is made up of units in which the key ingredient is 1,3 propanediol (PDO), polymerized with terephthalic acid (TPA), or dimethyl terephthalate (DMT). The resulting polymer has the built-in comfort stretch with recovery already mentioned. Because the PDO has three carbon atoms, it is sometimes called a 3GT polymer, whereas PET polyester, as explained earlier, is sometimes referred to as 2GT.

Fibers made with Sorona have the softness of a microfiber at greater than one dtex or denier (see "Microfibers and Nanofibers" this section). It has the resiliency, and resistance to staining, chlorine, and UV we expect of a polyester, but it is much more easily dyeable, and can give excellent washfastness (colors don't wash out). Its properties make it desirable for both apparel and furnishings, especially carpet.

Acrylic Fibers

Acrylic fibers are made up of 85 percent of the unit acrylonitrile (vinyl cyanide; see Figure 2.65); they contain carbon, hydrogen, and nitrogen. Since 15 percent of the fiber can be a copolymer (containing other chemicals), acrylics produced by different companies can have a variety of characteristics, or one company can market differently dyeing acrylics, for example.

From corn to polymers and fibers

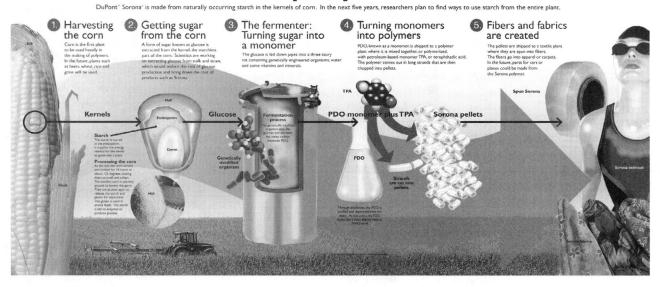

Figure 2.64 From corn to polymers and fibers. (Courtesy of The News Journal, Wilmington, DE, and DuPont)

Figure 2.65 Acrylonitrile unit.

Acrylic Production

Production may be by wet or solvent spinning (see "Spinning Manufactured Fibers"). One solvent for acrylonitrile is dimethylformamide.

Acrylic Properties

The properties of acrylic fiber include the most woollike hand of any MF fiber: warm, dry, and soft. Acrylics are also lofty (of low density) with good resilience—a combination to make into wool-like fabrics that are warm with little weight. All acrylic in consumer use is staple fiber, and much is used in place of, or with, wool, since acrylic is much less expensive than wool, does not felt in machine washing, has fairly good strength, and does not lose strength when wet. Acrylic has taken over much of the market of wool in blankets and moderate- to lower-price clothing, especially for infants and children. Acrylic has been successfully used in upholstery, especially as velvet, giving a pleasant hand, crush and stain resistance, cleanability, and resistance to light. It also resists chemicals and even weather.

Acrylic has quite low absorbency, giving stain resistance and cleanability, as noted, but exhibiting static collection and lowering comfort in clothing.

Acrylic is more sensitive to heat than nylon or polyester—it is well to remember this when tumble drying articles of acrylic (see Section Six).

Acrylic cannot be permanently heat set, although it will take a durable heat set. It is "meta-stable" in very hot, wet conditions, and will shrink if steamed. If stretched or put under tension, it will relax when heated; by combining fibers that have been relaxed with those that are still under tension, yarns (Hi Bulk) can be produced in which the shrinking fibers "elbow out" the relaxed or stable fibers to create a bulkier yarn. Using this same latent shrinkage in acrylic (and modacrylic) fibers, sliver-knit pile fabrics can be created with a very furlike guardhair/underfur look and feel. The sliver is made by blending heavier fibers that have been stabilized with finer fibers that will shrink

when steamed; after knitting, the fabric is steamed, and when the fine fibers shrink, they lie under the coarser ones (see "Direct Spinning," Section Three, and "Knit Pile," with Figure 4.65, Section Four).

A pure white acrylic fiber was achieved in 2002, with use of an ultraviolet ray treatment by Daqing Petrochemical in China. This opened up use of acrylic in many products while offering, as well, a possible route to color application.

Fibers Related to Acrylic

Vinyon, saran, and modacrylic are all related to acrylic in varying degrees; all feel soft, warm, and dry like wool, and all are more heat sensitive than acrylic.

Vinyon and Saran (Chlorofibre)

Vinyon and saran are both given the generic chlorofibre in many countries including Canada, but not in the United States; vinyon contains at least 85 percent vinyl chloride, saran at least 80 percent vinylidene chloride units. Both have good chemical resistance, warm hand, and insulate well. The chlorine component makes them flame resistant (see "Performance Characteristics" in Section One for the definition of flame resistant), but all melt and are sensitive to tumble dryer heat.

Modacrylic

Modacrylic is a "modification of acrylic" in that it is a copolymer with units of both acrylonitrile and either vinyl chloride or vinylidene chloride.

Modacrylic fibers have properties from both the acrylic and chlorine-containing units: warm hand, good chemical resistance, good heat insulation, but they are used mainly for their flame resistance—they are self-extinguishing when a source of flame is gone. This is important in many home furnishings fabrics (drapes, carpets), for blankets on airlines, and essential where fabrics trap air, such as with wigs, and deep-pile coats, or rugs, since this air can contribute to burning if flammable fibers are present. The main trademarks left in modacrylics are Kanecaron or Kanekaron, and Protex (by Kaneka).

Vinal (vinylal, also given as PVA, polyvinylalcohol)

Vinal is made up of vinyl alcohol with various acetal units. As first made, this produces a fiber soluble in water, useful as a ground for lace or in blends to give sheer fabric when it is dissolved away, or as a connecting thread in knitting (see also the discussion of alginate, the other soluble fiber, under "Minor Natural Polymer Manufactured Fibers"). Further treatment develops a strong fiber with good elongation that melts but is self-extinguishing, with good chemical and rot resistance. It has been made for some time in Japan.

Nytril

Nytril is another minor and related generic, made up mainly of vinylidene dinitrile. This fiber was made in the United States as Darvan, used for furlike fabrics, but was discontinued.

Olefin Fibers: Polypropylene, Polyethylene, Subgroup Lastol

Olefin has been the least familiar of the major generics, but has many outstanding and interesting properties and has rapidly come of age in widening its uses from furnishings to consumer apparel.

Olefins are paraffin-like (waxy), with rather simple units, which makes them the most economical synthetics to make. The most usual member of this family in textile consumer goods is polypropylene. Another family member, polyethylene, is more often put to nontextile use in squeezable toys and kitchenware (Tupperware); it is sometimes used in textiles, for example as tent floors, as well as nonwovens, e.g., Tyvek* (by DuPont) (see "Nonwoven, Spunbonded").

Polypropylene is produced not only by melt spinning but by the economical split-film method of fibrillating (see "Continuous Filament Yarn" in Section Three). It has the lowest density of any fiber (specific gravity less than 1.0, lighter than water—like wax) and so is very lofty, giving good cover for low price. It has good tensile strength, abrasion resistance, wrinkle recovery, and chemical resistance. Its modulus is between that of nylon and polyester, and in spite of almost no moisture absorbency, it has good static resistance. All of the foregoing have ensured its use in carpets and home furnishing fabrics. However, again in spite of almost no moisture absorbency, olefin wicks, and so moved into use in garments, first as staple (spun yarn) in underwear, but later as filament in a wide variety of activewear. Innova® (by American Fibers and Yarns) has performed well in specialized sportswear such as for warm weather diving, paddlesports wetsuits, surfing, bike tights, and aerobicwear. Low absorbency gives olefin stain resistance in furnishing fabrics and quick drying in garments. With almost no absorbency, unmo olefin is difficult to dye; solution dyeing is the most effective way to color the fiber; solution-dyed colors cannot fade in light or during washing, and are not affected by chlorine.

Because polypropylene is less complex to make than other synthetics, carpet makers can manufacture their own bulked continuous filament (BCF) polypropylene yarn in the heavier filaments used (most at 2,600 denier, some at 1,300–1,500 denier).

Unmodified olefin is very heat sensitive, having the lowest melting point of any major fiber; do not use tumble dryers for garments, watch out for any hot embers on upholstery or carpet, and do not drape any over hot radiators. In standard form, olefin is weakened by sunlight, but can be stabilized to give excellent resistance to UV rays. In coarser fibers, olefin has an unpleasant, waxy hand.

In microfiber form, olefin gives enormous surface area for air-trapping insulation in a thin layer of fibers (e.g., ThinsulateTM by 3M); see "Microfibers and Nanofibers."

A polypropylene-based fiber, Marquesa* (also by American Fibers and Yarns), is promoted as "earth friendly," made from material reclaimed as a by-product of petroleum refining. The relatively simple synthesizing process, the fact that the fiber resists stains without any added finish, and finally, that it can be reextruded up to ten times without taking it back to monomers and re-synthesizing, all make it more environmentally friendly.

Olefins are used to make a wallcovering, EarthtexTM (by Designtex), which is PVC-free, and can be recycled. A more complete description of its construction is given in Section Seven, under "Recycling." The yarn used is soft and supple, so the development is aimed also at fabrics for upholstering of furniture. In both uses, olefin fibers offer durability and excellent cleanability.

Olefin Subgroup Lastol

Lastol was established by the FTC as a subgroup of olefin, and is represented first by the olefin-based elastic fiber, XLA™ (by Dow Fiber Solutions). This is a melt-spun fiber, with chemical, heat, and UV light resistance, good durability, and all this with a "soft" stretch, giving comfort while helping clothing keep its shape. It is promoted to be used in everyday apparel, and washed freely.

Elastomers

Elastomers are different from any fibers discussed so far; they can be stretched to several times their length and they will recover immediately. For many years the only elastomer was rubber, both natural latex (the sap of the rubber tree) and synthetic rubber.

The major synthetic elastomer, spandex (elastane), should be compared only to rubber in properties. It does not conform to the general behavior of synthetic fibers, since its strength is relatively low. Lastrile is an elastomer now classified by the United States as a type of rubber, composed of a diene and acrylonitrile; another type of elastomer, anidex, has been discontinued for some time.

Elastomers are needed to provide *power stretch* or *active stretch* in garments that compress, control, or support the body during wear. Smaller amounts can provide stretch for comfort, fit, or fashion.

We are clothed in a "stretch fabric"—our skin! (See Figure 2.66.) The amount the skin stretches when the body moves is shown in Table 2.4.

Rubber

Rubber occurs as a natural diene compound, latex, the sap of a tree, but is also synthesized (e.g., neoprene). It is a good elastomer but is always used as a

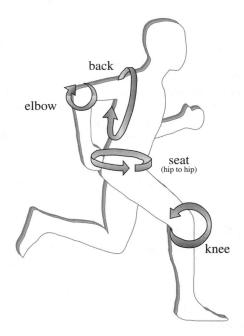

Figure 2.66 Skin stretches as the body moves. (Adapted courtesy of the DuPont Company)

Table 2.4 Skin Stretch

	Percent Skin Stretch	
Body Movement	Horizontal	Vertical
Back—in tieing shoe	47	_
Elbow—full bend	15–20	50-51
Seat—hip to hip, when sit down	15–20	27
Knee—deep bend	28–29	49–52

Source: "A Practical Guide To Stretch," DuPont International, SA

core, wrapped or covered. It does not take dye so it "grins through" if the covered yarn is stretched so the core shows. A trademark name is Lastex.

Rubber has low strength; it is deteriorated by oil and dry heat, both encountered in wear and care, especially with garments worn next to the body that are washed and tumble dried often, such as power stretch articles or underwear with waistband elastic.

Spandex (Elastane)

Spandex is segmented polyurethane—some blocks or segments of the molecular chains (polyurethane) are "hard" while other segments (polyether or polyester) are "soft" or elastic. As Figure 2.67 shows, when the fiber is relaxed, the soft chains are tangled together; they straighten out under tension, but always pull back to the shortened tangle. Spandex

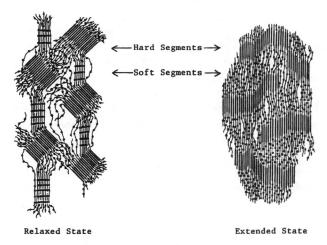

Figure 2.67 The action of the elastomer spandex (segmented polyurethane) in Dorlastan[®]. (Courtesy of Bayer Corporation)

LYCRA® Trademark

Figure 2.68 Lycra® is a registered trademark of INVISTA for premium stretch fibers and fabrics. (Courtesy of INVISTA)

can stretch up to seven times its original length and recover instantly when tension is released.

Spandex is the most complex and expensive of all synthetic fibers to make, originally developed by DuPont; their trademark name Lycra® (now owned by Invista) is one of the most-recognized consumer brands (see Figure 2.68). However, this name may now be approved in connection with products that offer comfort, fit, or freedom of movement, whether or not they contain spandex (see comments under "What Is a Trademark Name?" earlier in this section).

The early use of spandex seldom went beyond applications in which rubber had been used, such as elastic waistbands and what is termed "intimate apparel." Even in these basic applications, technology has been developed to give comfort along with good control in waistbands or body-shaping apparel.

Spandex has now been used in an ever-widening array of articles, for wovens as well as knits, in amounts from about 3 percent to upwards of 50 percent in combination with other fibers. Amounts would be in the order of: 2–10 percent in outerwear; 2-25 percent in underwear (and a similar range in swimwear); 2-40 percent in pantyhose; 10-45 percent in foundation garments; and 35-50 percent in medical hosiery.

Beyond these, there has been a considerable increase in the use of spandex in all kinds of activewear. (The market for spandex was reported to triple between 1995 and 2000.)27 This parallels consumer preference trends to clothing especially designed for vigorous sports (athletic compression garments) as well as for "second skin" clothing fashions. There are demographic changes as well, with older consumers representing more of the market and wanting comfort stretch in, for instance, jeans. A strong turn to cotton knits brought introduction of blends with spandex, since recovery in cotton knits, especially at cuffs, is better with a small amount of spandex in the yarns. There has also been a positive response by consumers to wearing traditional tailored clothing made of fabric that provides more ease of movement and holds its shape better; this has been seen with clothing of wool and of linen.

None of this would promote this relatively costly synthetic, however, if it did not have great advantages over rubber. It is much stronger and can be used uncovered; this means that power stretch can be obtained with a much finer yarn than with rubber, allowing much lighter "contour fashions": foundation garments, swimwear, and all kinds of actionwear, to say nothing of medical support stockings. It is also used in a number of other yarn "configurations" as a core wrapped with staple or filament of other fibers. Corespun/core-plied yarns have staple fibers spun around a core of stretched spandex. The resulting yarn has the hand and texture of the covering fiber, with stretch. This may also be achieved by feeding stretched spandex through an air jet along with a multifilament nonelastic yarn, so that the textured filament partially covers the spandex core. Spandex can also be wrapped with one or two strands of a nonelastic filament to give a smooth stretch varn.

Spandex also has good resistance to dry heat and oil and can be dyed as rubber cannot, so it does not "grin through" in a stretched-out fabric, as a rubber core would. The fine, uncovered yarns have had a tendency to break and protrude through swimwear after wear, and one of the few basic drawbacks of spandex has been yellowing in chlorine bleach. Use of more colored articles and changes in care procedures make yellowing less troublesome and changes have been made in the fiber as well. Special types are offered for swimwear, with chlorine resistance and more durability.

Use of a small amount of spandex with regular filament nylon in pantyhose results in a smooth feel with good fit, an improvement over the use of textured stretch nylon yarn, which is duller and more easily snagged. Here, again, DuPont offers a special form for knitters of hosiery, in blends with any fiber to ensure a consistent body-hugging fit.

The muscle vibration encountered by many sports participants can be reduced by wearing compression garments. However, it took intensive research to develop fabrics and garments that would do this and still allow unrestricted movement. Results of a five-year study done at Penn State Center for Sports Medicine were released in 1998 by DuPont. Garments incorporating the then-newly developed Lycra® Power and made to specification were reported to give a 10-20 percent average improvement in force and power production in subjects who were "fatiguing" after standard repetitive jumping tests. Since then, sports clothing, especially for competition, is seen which is based on highly sophisticated design and fabrics, incorporating spandex fibers, usually with polyester or nylon. These special designs and tests (including in wind tunnels) for "second skin" clothing are relevant where differences in timing involving hundredths of a second are decisive. Use is made of fabrics of varying degrees of power stretch and different colors (muscle temperature), with lighter, more breathable materials where power is less needed. So, all that sleek athletic wear can offer definite physiological advantages—making you feel right as well as look right.

Elastoester

A generic name was given to a Japanese development of a polyurethane-ester fiber that can be meltspun, which is preferable to dissolving with most organic solvents. The elastoester has a low modulus, and can be processed more readily with polyester than spandex, which is usually used more with nylon than with polyester.

Elasterell-p is a generic name given to a polyester with "comfort stretch" (see under "Other Types of Polyester"). **Olefin subgroup lastol** is an olefin-based "soft" or "comfort stretch" elastic fiber (see under "Olefin Fibers").

Flame- and Heat-Resistant Organic Fibers and Other High Performance Fibers

(See also "Inorganic Manufactured Fibers," and "High-Tenacity Fibers" under "Physical or Chemical Properties Modified," and "Flame Retardant" under "Additions to MF Fibers Before Spinning.")

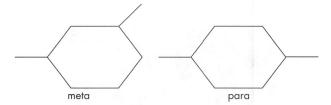

Figure 2.69 Relationship for aramids: meta-, para-.

It is important to distinguish between flame resistance or retardancy and heat or temperature resistance. To clarify this distinction, see "Burning Behavior" under "Fiber Identification."

Aramid

Aramid is a separate generic assigned to aromatic polyamides because of their special properties, and is divided into the subgenerics *meta-aramids* and *para-aramids* according to the position of joining of the aromatic rings relative to one another (see Figure 2.69).

Meta-aramids are both flame resistant and heat resistant. This is not from any chemical element, such as a halogen (e.g., chlorine) or phosphorus, but from the fiber structure: When exposed to heat, it tends to char, not melt, and is self-extinguishing, giving off little smoke. It has been used for filters, aircraft furnishing fabrics, lampshades, and protective clothing for fire-fighters or racecar drivers. Filament yarn rather than spun has been tried for strength with light weight. Complex tests with instrumented mannequins can be carried out to determine the effectiveness of these fibers in protective clothing (Figure 2.70).

Trademark names include the first and best known, Nomex® (by DuPont), plus Kermel® (by Rhodia), a polyamide-imide that can be classified here.

Para-aramids are fibers of very high orientation, which results in *very* high strength at low density (five times stronger than steel for the same weight). These fibers also have good flexibility, good resistance to stretching (high modulus), and tremendous resistance to heat or flame.

Kevlar® (by DuPont) is the best-known trademark name. It is used in safety and protective clothing such as gloves to offer cut protection (see Figure 2.71), plus body armor and firefighters' coats. It is used also for cables, coverings (e.g., protection of optical fibers), and reinforcing. This fiber type is strong but lighter than glass fiber and so is good in tires. It has been used to provide very special reinforcement for sport sock heels and toes, and in patches at shoulders

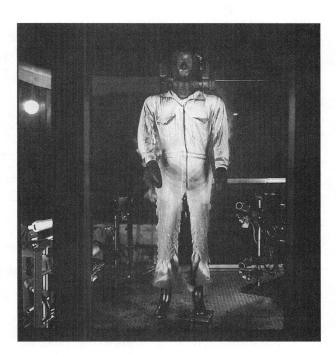

Figure 2.70 DuPont Thermo-ManSM thermal Instrumented Mannequin System evaluates the relative predicted body burn a wearer would receive in a simulated flash fire, to measure the efficiency of clothing made of heat-resistant fibers. (Courtesy of E. I. DuPont de Nemours and Company)

Figure 2.71 100 percent DuPont Kevlar® paraaramid is used in hand and arm protection to offer outstanding cut and heat resistance. (Courtesy of E. I. DuPont de Nemours and Company)

or elbows of skiwear. Its use in sophisticated sports equipment prompted a writer for the newsletter of the Ontario Science Centre to comment some years ago that "Until recently, sports equipment was made from steel and natural materials including wood, bamboo, leather and gut. . . . Sports equipment catalogues now read like works of science fiction, complete with futuristic designs and exotic materials."28

DuPont is researching new forms of Kevlar fibers, among them one for body armor inspired by the unique ballistic properties of spider silk, noted in this section.

Aramid fibers are increasingly used in contract furniture coverings, e.g., for hospitals and hotels, to meet strict fire safety standards.

Novoloid

Novoloid is a fiber unique in having no orientation (no crystallinity); in the most intense heat or flame, it turns to carbon, keeping its form without melting, burning, or giving off smoke. Novoloid is a novolac, a cross-linked phenolformaldehyde polymer. This fiber is not strong and is golden in color, so is of limited, very specialized use.

PBI (Polybenzimidazole)

PBI is a fiber type that does not burn or melt and stays intact even if charred. It is strong and absorbs well, although it is difficult to dye. PBI is used in protective clothing and in furnishings.

Other Minor Organic Synthetic Fibers

Fluoropolymer (fluorofibre)

PTFE. This has been well known by the trademark name Teflon® (by DuPont) but is not often seen as a fiber in consumer goods. Teflon as a fiber is composed of polytetrafluoroethylene (PTFE) (when used as a finish, the name is no longer limited to PTFE). The properties that make it useful as a coating on cooking pans are useful in specialized fabrics made of the same substance in fiber form. It has no absorbency at all; has a very slippery surface; does not conduct electricity; and is inert to chemicals, light, and insects. As we might guess from its use on cookware, it is very heat resistant—it will eventually melt but cannot burn. PTFE has been used as covers for hot head presses. Since human tissues do not react to PTFE, it has been used to make such body replacement parts as artificial blood vessels and heart valves (shown in Figure 1.3[b]).

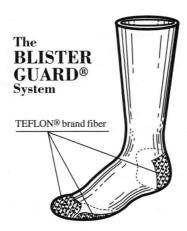

Figure 2.72 Teflon® fluoropolymer filament at heel, toe, and pad of Blister Guard® socks. (Courtesy of PTFE® llc)

With Teflon filament yarn knitted in at the toe, heel, and pad of Blister Guard™ socks (by PTFE®), this specialized fiber found another application in "low friction clothing" (see Figure 2.72). Reduction of friction between the foot and shoe in hiking or active sports reduces the chance of developing blisters; field tests with football and field hockey teams and with soldiers on maneuvers, where previous experience of blisters was high, confirmed the effectiveness of the socks.

Sulfar

Sulfar is polyphenylene sulfide (PPS), an aromatic polysulfide. This fiber is gold in color and strong with good elasticity. It is resistant to most chemicals. It can melt but is very flame resistant. Low absorbency limits its use in apparel.

Melamine

Melamine fiber is heat resistant, does not melt, and has been used in fire-fighting gear, mattresses, furniture stuffing, and for thermal insulation in filters.

Carbon

Carbon fibers conduct electricity and are incorporated into other filaments or fabrics to confer permanent antistatic properties, or as heating elements. A carbon fiber, when preburnt to remove all combustible elements, can be made into a fire-resistant material suitable for racing drivers' outfits, or if coated with

aluminum, for fire-fighters. These fibers have also been used to make fire-resistant mattresses.

"Bio-Based" Synthetic Fibers—From Annually Renewable Raw Materials

As noted early in this section (see "General Advantages of Synthetic Fibers [and some Drawbacks]"), synthetic fibers from their inception to the beginning of the 21st century have required petrochemicals as part of their raw materials. Although fibers and plastics use accounts for a very small proportion of fossil fuels used overall, this is still a finite (nonrenewable) source. Now there are synthetic fibers made using annually renewable materials such as corn, soy, and other cereal wastes, instead of the nonrenewable fossil fuels: these have been termed bio-based. To make them, sugar such as dextrose is obtained from a starch such as corn by fermentation, then distilled, then polymerized. These can have a high melting point, are easily dyeable, and are being used for apparel and other purposes, such as geotextiles, as they are biodegradable.

PLA (Polylactate) was the first generic name assigned to a synthetic polymer made from a renewable resource, in this case, corn. The polymer is produced as Natureworks[®] PLA under the name Ingeo™ (pronounced *in-jee-o*, by Natureworks LLC). Waste parts of corn as well as other plants are being researched to yield similar synthetics, which will come from annually renewable resources, and are compostable when no longer of use as a fabric.

The process is in some ways similar to that used to synthesize part of the first elasterell-p fiber, a bicomponent fiber made with Sorona® (by DuPont) and PET polyester extruded together; see earlier under "Other Types of Polyester," especially Figure 2.64.

In the case of these "bio-based" synthetics, then, carbon fixed by plants' photosynthesis comes not from fossil fuels, but from a current crop. With PLA, sugar is first extracted from the starch of corn, then by fermentation and distillation, lactic acid is obtained, which can be synthesized into a polymer. Other companies make the melt-spun fibers; one, Fiber Innovation Technology (FIT) has listed some of the properties of PLA, and www.fibersource.com gives others. These sources cite such properties as good strength, excellent wrinkle resistance, low moisture absorption but high wicking, low flammability and smoke generation, and high resistance to UV

degradation. With lower specific gravity than many other fibers, it offers very good bulk and loft, useful for stuffing pillows and in bedding such as quilts.

Inorganic Manufactured Fibers

(The inorganic natural fiber, asbestos, was discussed under "Natural Fibers.")

Glass

Glass as a fiber gives fabrics that are flame-proof, as well as being very strong; nonabsorbing; and inert to light, weather, age, and most chemicals (think of a windowpane). Silica sand and limestone, plus other ingredients such as soda ash (sodium carbonate), are melted at about 1370°C (2500°F) to make the special glass that is formed into marbles about 15 mm (5/8 in.) in diameter. In the usual spinning method, each perfect marble is melted in a small furnace and extruded through tiny holes in a platinum bushing to form filament or staple fiber.

REVIEW QUESTIONS 2-4

- 1. How does manufacture of fibers imitate the silkworm?
- 2. How is the diameter of MF fibers controlled in manufacture?
- 3. What is the process that strengthens an MF filament after it has been extruded or "spun"?
- 4. Which is the main process for deriving textile fibers from cellulose? How does it differ from the process developed in the 1990s?
- 5. List four generic names of fibers that are all CMF-they use cellulose as the main raw material. What is the usual source of that cellulose?
- 6. In what two ways is HWM (modal) rayon different from standard viscose?
- 7. What is the main trademark name for lyocell fiber? In what way is lyocell superior to viscose rayon? What uses does this allow for fabrics made of it that are limited with viscose rayon?
- 8. What two types of finish can be achieved using specific versions of lyocell fibers, and how are these identified to the consumer or buyer?
- 9. How is acetate different from viscose rayon or lyocell? Where is it usually used, and why?

Glass fiber is used for window screening, tires, thermal and electrical insulation, reinforcing in plastic to form composites for trays and many other products, filters, and of course, the core for fiber optics in communications systems.

Metallic Fibers

Metallic fibers, notably stainless steel, have been made as a high-strength fiber for tire cords and used in blends to conduct static electricity, especially in

Most metallic, however, is more a yarn than a fiber, and is discussed under "Novelty (Fancy or Complex-Ply) Yarns" in Section Three.

Miscellaneous

Other inorganic MF fibers are made, such as boron and ceramic, but these are still experimental and/or for extremely specialized uses.

- 10. Why can the CMF fibers not be termed synthetic? What was the first synthetic fiber, what company made it, what was the first textile made of it, and when did this appear on the market?
- 11. What is the linkage between units of a nylon fiber? What other generic name for this group is derived from this? What natural fibers have the same linkage between units?
- 12. What is the spinning method for both nylon and polyester? What advantage does this give as to shape of cross section?
- 13. Nylon was the dominant synthetic fiber for many years; today polyester is by far the most-used. What are its two main advantages compared to nylon? List four other properties of polyester that are advantages compared to nylon.
- 14. Give five outstanding uses of polyester rather than nylon that have developed because of the combination of properties listed above.
- 15. What are three main drawbacks of polyester?
- 16. What are three special characteristics that acrylic fibers contribute?
- 17. Why do we use modacrylic fibers? Name five products where this is particularly important.

- 18. What are five major advantages of olefin fibers? Where do we make use of each?
- 19. Define "power stretch"; what type of fiber is necessary to achieve it? List five ways "comfort stretch" can be obtained (consult Fabric Glossary as well).
- 20. What are three major advantages of spandex elastomer compared to rubber, and where is use made of these?
- 21. What high-performance garments make the most use of spandex power stretch?
- 22. What properties make aramid fibers distinct from nylon? Name two special uses and a trademark name for a meta-aramid fiber, and the same for a para-aramid.
- 23. "Bio-based" synthetics offer what main advantage compared to any others so far developed?
- 24. What are two inorganic MF fibers, and one advantage and use of each?

2-5 MODIFICATIONS OF MANUFACTURED FIBERS AND BLENDING

Manufactured Fiber Modifications

One of the great advantages of an MF fiber is the possibility of producing it in many shapes and forms. One major area of modification gives us special versions of the major synthetics that are more pleasing and/or more comfortable—in other words, closer to natural fibers in aesthetics, but maintaining excellent performance. Japan has given us a name for such new synthetic fibers—shingosen.

Specialized Physical Modifications

Solid Fibers with Nonround Cross Section

These are produced to alter the characteristics of fibers that have a standard form with a round cross section; this applies to the two main synthetics, nylon and polyester. Nonround or irregular cross section can give a shape with lobes, like a clover leaf (trilobal, pentalobal, octalobal, or often just lobal). (See Figure 2.73.)

The main thrust of this development has been in filament fibers, to give a different light deflection off the fiber. Silk has a nonround cross section, roughly triangular in shape, and its beautiful luster sets a standard. When light falls on a rodlike, round cross section fiber and is deflected in broad beams, it gives off a hard shine; with fine filaments of a nonround fiber, light is broken up to give that silklike subdued luster. In coarse filaments, a nonround cross section results in a glitter or sparkle; this has been used to make "sparkling nylon" pantyhose or glittering organza for holiday season wear.

Lobal filaments also have a drier, less slippery hand, again more silklike, plus somewhat improved

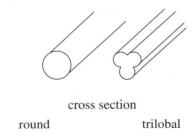

Figure 2.73 Round vs. lobal cross section.

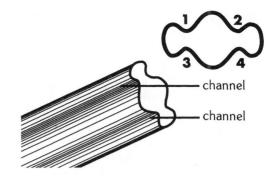

Figure 2.74 A cross section with four channels running the length of the fiber promotes moisture wicking. (Diagram courtesy of the DuPont Company, when it represented one of their fibers)

moisture absorbency and/or wicking action, giving more comfort, less static collection, and better soil release.

DuPont™ Tactesse® (by Invista) nylon 6,6 fine filament has a unique nonround cross section which, for carpet, gives a tightly-packed yarn of relatively fine filaments. As used in DuPont™ Stainmaster® (by Invista), this is said to decrease matting and crushing in wear, and gives cut pile a cleaner-looking surface.

CoolMax® (by DuPont) began as a polyester with a definitely irregular cross section; it had four channels or grooves that increased surface area (by 20 percent), moisture absorption, and wicking ability. This gave a polyester found comfortable for active-wear (see Figure 2.74). Fibers with such an irregular cross section, with 4 or 6 channels, pack together less in a yarn than those with round cross section and so give better airflow through fabrics. The trademark, now owned by Invista, is applied to various (approved) moisture management fabrics.

Morpho-structured Fiber

This is an interesting modification from Kuraray of Japan (see Figure 2.75). The fiber combines different kinds of flat profile and multispiral formations, taken from the shape of the wing scales of the Morpho butterfly; the result in fabric is to give changeable color, like the iridescence of a butterfly's wings. See also the discussion of "chameleon" porous fibers, under "Air Spaces Incorporated into Manufactured Fibers."

Morpho Butterfly

Morpho-Structured Fabrics

Color-producing scales of Morpho Butterfly

Figure 2.75 The morpho-structured fiber is flat with a multispiral form to imitate the wing scales of the Morpho butterfly of South America for the same visual effect. (Courtesy of Kuraray Company Ltd.)

Flat Filament or Tapelike Fiber

When coarse, this form produces a glittery look; a traditional fabric has been called "crystal acetate." Rayon with a wide, flat cross section can give a linenlike look and hand to a fabric. Very wide, flat rayon fiber is used for strawlike hats in millinery. Flat rayon filaments are also used extensively to replace the wiry hair fibers, mohair and horsehair, in much tailor's "hair" canvas interfacing; these are cheaper, but cannot be molded with steam in tailoring as the hair fibers can.

Air Spaces Incorporated into Manufactured Fibers

There are a variety of ways to introduce air spaces into a fiber for a range of characteristics.

Soil Resistance

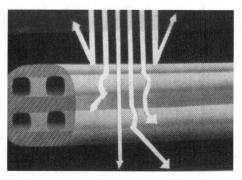

Figure 2.76 Voided fiber hides soil. (Original diagram courtesy of the DuPont Company)

Voided Fibers. Voided fibers, with hollow channels or air spaces inside, have been used for carpets and other furnishings because they have soil-hiding ability (see Figure 2.76). They may also be made antistatic and/or soil resistant.

Hollow Fibers for Insulation. These are widely used for their air-trapping ability and lightness, as fiberfill for pillows, comforters, mattress pads, and quilted outerwear. The fiber may have a hollow center, rather like macaroni, or may have four or more channels running through it (see Figure 2.77). The extra channels add insulation for cold weather clothing. They also give better loft and resistance to crushing, and so are suitable especially for pillows and comforters. Trademark names multiplied, coming many times from the fiber maker, but there are also store private labels, many with II, III, etc., following to indicate degrees of firmness or other changes.

Some hollow fibers are used for clothing insulation. Hollow-core polyester fibers, used for close-fitting clothing such as long underwear or turtlenecks. trap air and with their large surface area also allow for faster evaporation of perspiration in outdoor activewear.

Hollow Viscose. Hollow viscose gives loft; bulk; and a firmer, less limp hand. It also absorbs even more than regular viscose and contributes to insulation.

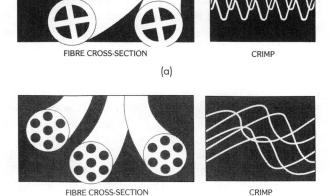

Figure 2.77 (a) Four-hole crimped fibers give resiliency that promotes warmth and loft as do (b) seven-hole crimped fibers.

(b)

Hollow Fibers for Dialysis. Hollow fibers are used in artificial kidneys; blood is pumped through a fabric made of some 7,000 special hollow cuprammonium fibers of the right pore size to let waste products go through but retain blood. Hollow nylon fibers and a reverse osmosis process allow purification of seawater; the salty water is pumped through the hollow fibers, and drinking water comes through the walls of the fibers, while concentrated salty fluid emerges out of the end. This trick is also turned around, to allow concentration (getting rid of water) of liquids like some juices that do not take kindly to heating to drive off the water.

Crater Fibers. These have a pitted surface, which increases absorbency. One very specialized fiber is both cratered and hollow: a Tetoron® polyester (by Teijin), that provides even more absorbency; see Figure 2.78.

Porous Fibers. Porous fibers can be a significant development, with channels running through them side to side, as well as end to end, to give a microporous structure. Such channeled fibers go beyond the

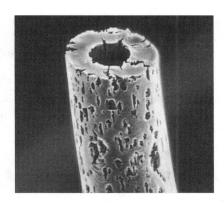

Figure 2.78 A hollow fiber of Tetoron® polyester with a cratered surface for greater absorption. (Courtesy of Teijin Limited)

cratered surface of a solid fiber already discussed, although most are aimed at the same purpose—increased absorbency. Acrylics of this type have been made, with a special porous structure: an outer sheath and a spongey core, rather like wool. This allows it to absorb a great deal of moisture without feeling wet—the hygroscopic property valued in wool. However, production was discontinued.

Porous fibers also feature in some of the "chameleon" or polychromatic fabrics that can change color with variations in light or temperature. This is done by means of dyes held in the channels of the fiber that react to changes in light or temperature.

Microfibers and Nanofibers

A microfiber is taken to be one finer than silk, approximately 1 dtex or 0.9 denier (these are terms that measure linear density of yarns, but are used as measures of fineness in fibers; they are defined under "Yarn Classified by Linear Density" in Section Three). Since the figures for denier and dtex are so similar, only dtex will be quoted in the rest of this discussion. Conventional fiber spinning through finer spinneret holes, plus drawing, can produce filaments down to about 0.3 dtex; ultra-microfibers down to 0.1 dtex (3 µm or µ diameter) and lower are made by other means, discussed under "Bicomponent Fibers." Nanofibers are a thousand times smaller than microfibers, and have been defined under "Basic Terms" in Section One. They are returned to after the discussion of microfibers.

Filament Microfibers. Filament microfibers will be discussed first, for the early concentration was mainly on making fabrics more silklike in attempts to equal the finest natural fiber and the only natural filament. Filament microfibers can give finer, softer, lighter fabrics, even when yarns of equal size are used. Yarns made of microfibers have a higher number of filaments compared to yarns made with standard fibers. This gives a more silklike hand, drape, and even color brilliance. When made of polyester, as many are, they deliver high performance and ease of care as well.

Microfilament yarns are as strong as standard yarns, but individual filaments are more easily broken by emerizing (see Section Five), giving the popular peach-skin surface.

However, other dimensions of microfilaments are being discovered. One is that, aside from aesthetics, the packed microfilaments in yarns of a woven fabric give materials that deliver the high performance combination of being permeable to moisture vapor (perspiration) to let the body "breathe" while blocking rain and wind—and this without adding a film (see "Compound Fabrics" in Section Four) or putting on a coating (see "Coatings" in Section Five). Figure 2.79 shows water beading on the outside of such a fabric, made of Trevira® Finesse® (by Trevira) microfilaments.

Microfilaments have shown up in fabrics for all kinds of apparel end uses and in price ranges from

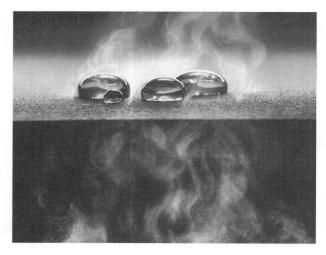

Figure 2.79 Trevira® Finesse® gives breathable yet highly water resistant fabric, plus protection from wind, through the high number of densely packed microfilaments. (Courtesy of Trevira)

those of exclusive designer lines to mass produced. It would be well to have some firm standard for the term, as it has been given to many fibers that are quite fine but not microfine. Terms such as "ultrafine" or "ultramicrofiber" have already been used, with no standard definition.

Staple Microfibers. Like filament microfibers, staple microfibers have been explored in a trend to augment or substitute for the most desirable features of wool, cotton, and even flax; Figure 2.80 compares fineness of an MF microfiber, Trevira® Micronesse® (by Trevira), to these three important natural staple fibers as well as to silk.

Developments in staple microfibers have produced these in polyester, to extend the supply of the very finest wool for suitings. This is a very different use of blending from just "diluting" wool with a cheaper fiber. There are, or have been, staple microfibers produced also in acrylic, HWM rayon, modal rayon, and viscose rayon.

A caution: as the fibers become finer, the tendency in fabrics to pill increases.

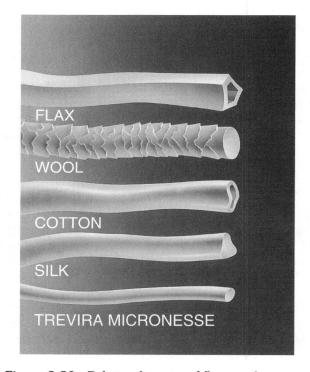

Figure 2.80 Relative diameter of flax, wool, cotton, and silk compared to $Trevira^{\circ}$ microfiber. (Courtesy of Trevira)

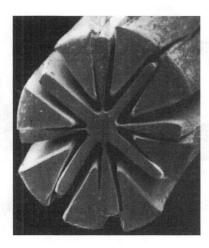

Figure 2.81 Formation of ultra-microfiber Belima X[®]. A single petal-shaped bicomponent filament is split into 9 to 13 parts, which may be as fine as 0.15 dtex. (Courtesy of Kanebo Ltd.)

Suedelike fabrics, to come very close to the velvety hand of real suede, must have ultra-microfibers on the surface, on the order of those on the surface of a mushroom. One such advanced technology fiber is Belima X[®] (by Kanebo). The individual filaments split from a petal-shaped bicomponent are as fine as 0.15 dtex (see Figure 2.81; see also "Bicomponent Fibers"). These very "real" suedelike fabrics often incorporate polyurethane foam to give the sponginess as well as the softness of suede skin. The construction of most of these is nonwoven, discussed in Section Four. One of these, under the trademark name of Ultrasuede® (by Toray Ultrasuede [Americal] is well-known in apparel and furnishing fabrics, while Alcantara® is used for luxurv car upholsterv.

Insulation in a thin layer is possible using microfibers because they provide a tremendous amount of surface area in a small amount of fiber. When that microfiber is olefin (polypropylene), there is the added advantage of the least dense fiber we have, giving a very thin, light layer of highly insulating material.

Thinsulate™ (by 3M) is a widely known name, the original thermal insulation version being made of microfibric (0.2 dtex) olefin, in some lines with standard size polyester (see Figure 2.82). It is said to give insulation equivalent to down in a layer about half the thickness. Furthermore, olefin will not rot or get wet. Caution with heat is necessary, especially steam heat in dry cleaning.

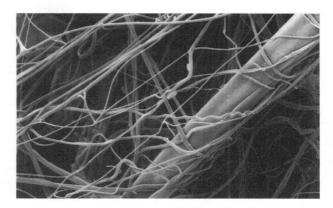

Figure 2.82 ThinsulateTM thermal insulation made up of microfibric olefin and standard polyester fibers. (Courtesy of 3M)

Thermolite® (by Invista) is a very fine microfiber intended to give excellent insulation with a thin layer of soft fiber, which is resistant to migration.

Nanofibers. The definition of nanotechnology was given in "Basic Terms," Section One, and there will be considerable discussion of its applications (using the creation and manipulation of nanoparticles of a size in the order of molecules and atoms) under finishing in Section Five; there a chart showing the size of nanofibers relative to a red blood cell or a grain of sand can be seen in Figure 5.13.

Use of fibers of diameter perhaps 20-200 nm, and usually electrospun, is not as well established as finishes. However, teams of experts, not only in chemistry and physics, but also in electronics, medicine, military concerns, and others, have combined to explore these unusual creations. Early uses have been in filters, to trap and hold out toxic chemicals or microbes; and specialty fabrics as for surgery or clean room products.

A tubular form of carbon nanofiber has been produced which has tremendous tensile strength, and conducts heat or electricity extremely well. Nanotubes are suited for extra-strong cables, wires, or other components in electronic devices, and any use for conducting heat or electricity. Some futuristic applications are recorded in Section Seven, under "Smart" Fabrics.

Forming nanofibers by electrospinning onto various substrates or collecting surfaces has produced composite materials with great surface area or in several layers, which can have different properties.

Physical or Chemical Properties Modified

Some modifications have already been discussed, such as HWM rayon.

High-Tenacity (High-Strength) Fibers

High-tenacity fibers have been made in many generics, including rayon, nylon, polyester, acrylic, and vinal. However, by far the strongest standard fibers (not nanofiber forms), are those made of high-density polyethylene (HDPE). This strongest, lightest fiber is a form of ultra—high molecular weight polyethylene (extra-long molecular chains) with "super strength." They are claimed to be up to 15 times stronger than quality steel. They float on water, and are very resistant to moisture, UV light, and chemicals. Such fibers are used for protective clothing (shrapnel-proof vests); to protect from shearing forces, such as in gloves for meat cutting; for tough body connectors such as tendons; and for sails, nets, and cordage in the fishing and shipping industries.

To give another idea of relative tenacity, if viscose is about 3 grams per denier (gpd), nylon about 6 gpd, and a para-aramid about 20 gpd, an HDPE would be about 40 gpd. These special forms are obviously not your average consumer product fibers! Two outstanding trademark names are Spectra[®] (by Honeywell), and Dyneema[®] (by DSM Dyneema).

Low-Pilling Fibers or Fibers to Be Sueded

These are achieved by providing a fiber that can be broken so that pills can be brushed off in the manner of wool, or allowing easier finishing in giving a suede-like or softened surface.

Pil-Trol[®] is a low-pill acrylic (by Solutia); Figure 2.83 shows the logo used for articles made of this, when tested and approved by Solutia.

Trevira GmbH makes the Trevira® 350 family of low-pill polyester fibers. The fibers behave like any others in spinning and weaving but have a complex molecular structure that will split up to some degree after final heat treatment so that pills developing in wear break off, even on very soft or stretch (textured yarn) fabrics. Figure 2.84 contrasts a pill formed on fabric of regular polyester with the pill-free surface of a similar fabric made with Trevira® 350 polyester.

More Dyeable Fibers

More dyeable fibers are made in a number of generics, but particularly in polyester. Acid-dyeable rayon is made so that it can take up the same type of dye

Sweaters with the Pil-Trol® trademark are made with S-63®, a low pill acrylic fibre, and have been tested and have met Solutia's rigid standards. Pil-Trol fibre was developed to specifically answer your need for a high performance low pill sweater.

Pil-Trol and S-63 are registered trademarks of Solutia, formerly Monsanto.

Figure 2.83 Hangtag for Pil-Trol® apparel made with low-pill acrylic fiber. (Courtesy of Solutia, Inc.)

as wool in blends. An important breakthrough has been dyeable polypropylene, as with Chromalon[®] (by Equistar).

Antistatic Fibers

Antistatic fibers often contain a very small amount of a material such as carbon that will conduct electricity; this is termed an *epitropic* fiber—one with an altered surface property. X-Static nylon (by Noble) is coated with silver.

Additions to Manufactured Fibers before Spinning

Dulling or Delustering Agent

This is a white pigment, usually titanium dioxide, added to the liquid before the fiber is spun or extruded; an MF fiber with no dulling agent is often shiny and is termed *bright* fiber. The bright form is sometimes considered to have a hard shine that looks artificial and "cheap" compared to the soft luster of silk or the light-absorbing *matt* (*matte*) look achieved by delustering. Heavily delustered fibers give a chalky appearance to the fabric. Because a dull fiber absorbs more light, delustering increases the tendering action of sunlight.

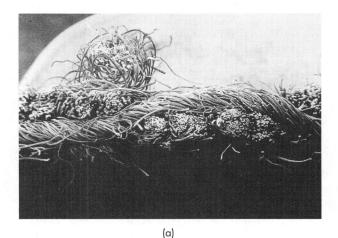

(b)

Figure 2.84 Electron microscope picture of a pill formed on a standard polyester fabric during wear compared with the clean surface on fabric of Trevira® 350 low-pill polyester. (Courtesy of Trevira GmbH)

Bright fiber is also desirable in other applications, such as when making a staple acrylic to look and feel like mohair, which has a definite luster, or when using filament nylon in lingerie fabric, where a gleam is desired.

Ultraviolet Resistant, Light Stabilized

Light-resistant nylon is achieved by incorporating antioxidants or UV absorbers into the fibers to prevent tendering by the UV rays of sunlight. One is Solarmax® (by Invista). Such fibers are useful for flags, life jackets, or tents.

Colored Pigment

Colored pigment added before spinning yields an MF fiber called solution-dyed (producer-, polymer-, spun- or dope-dyed). Such color is completely fast to any treatment or condition of use that will not damage the fiber itself; details and discussion are in Section Five.

Flame Retardant

A flame-retardant agent incorporated into fibers helps to prevent propagation of flame; such fibers are in many cases identified with FR after the fiber trademark name, such as Avora FR polyester (by Invista). Trevira® CS polyester (by Trevira) has a flame retardant polymerized into the fiber as a co-monomer.

Bioactive Agent

Incorporation of a bacteriostatic agent will inhibit the growth of bacteria, while a biocidal antimicrobial agent will kill bacteria or fungi (mold, mildew). Such agents may also be applied in a finish (this is discussed in Section Five). Whether the property is in the fiber or the finish, it acts to prevent the breakdown of perspiration by bacteria on the skin; it is only after this breakdown that perspiration develops an unpleasant odor.

There is a complication to the development of more hygienic fabric: We usually wear several layers of clothing, and if any textile is not bacteriostatic, perspiration odor can develop there, just as it will on unwashed skin, and be transferred to other fabrics.

With consumer interest and concern coinciding with progress in biotechnology, there has been an explosion of developments in this whole area, and dust mites are a target as well as bacteria and fungi (mold and mildew). There has been great activity in research to add permanent agents that will do away with the minute arachnids we call dust mites, which contribute to house dust and cause allergic reactions when growing in bedding and furnishings.

A sample only of the trademark names in many fiber groups are: a series from Acordis, with Amicor® Pure having all of antibacterial, antifungal, and anti-dust mite action, used, e.g., for bedding; SeaCell® Active, which has seaweed added to Lyocell by Zimmer, with added silver, giving antimicrobial properties; SteriPur® AM polyester (by DAK Americas), which incorporates AlphaSan® (by Milliken), also containing silver, which is a potent and benign antibacterial agent; X-Static nylon (by Noble), a wellknown silver-coated fiber.

Cut-Resistant Particles

Ceramic particles may be added before spinning to confer cut resistance to material made of the fibers. One application would be seat upholstery in trains or subways.

Bicomponent Fibers

Bicomponent fibers as originally defined covered only fibers made of two variants of the same generic type of polymer, but the term now is also used to describe what used to be called *biconstituent* or *bigeneric fibers:* fibers made up of two different generics.

Bicomponent Fibers (a)

In a fiber made up of two variants of the same generic of polymer, one variant shrinks more than the other, resulting in a self-crimping fiber. This development was the result of study of the crimp of wool, which was found to derive from its bicomponent structure, with two types of cortical cells lying next to each other in a spiral line the length of the fiber (illustrated under "Wool Structure," Figure 2.28). When this structure is built into an MF fiber, the result is a crimp or curl forming as the fiber dries. With staple bicomponent fiber, this was used at first to give a more wool-like effect—better bulk and resilience and has been applied in acrylic craft yarns. Articles made of such fibers after washing should be tumble dried or dried without tension (not hung) to let fibers develop crimp, so that the fabric recovers its original shape and size.

Bicomponent Fibers (b)

These are biconstituent or bigeneric fibers made up of two different polymers extruded in the same fiber. This may be in various arrangements:

Conjugate, side-by-side, or lateral. From a spinneret with a double orifice.

Sheath/core. From one spinneret inside another; the sheath (outer layer) can now be just $1~\mu m$ thick.

Matrix/fibril or islands-in-the-sea. Drops of one polymer in another, giving fibrils in a matrix—what is called islands-in-the-sea.

Petal-shaped or segmented-pie fiber of one polymer set in another. Multisplitting of such a petal-shaped fiber gives ultra-microfibers such as Belima X* (see Figure 2.82 under "Microfibers and Nanofibers").

Different polymers in layers. Splitting of such multilayer fibers can give flat ultra-microfibers down to 0.1 dtex.

When the generics can be separated later, as in the case of Belima X^{\circledast} , the bicomponent is called a graft polymer. When a matrix/fibril bicomponent is a graft polymer, if the matrix is dissolved away by a solvent that does not affect the fibrils, ultramicrofibers well below 0.1 dtex can also be produced. Conversely, if the fibrils are dissolved away, a channeled fiber results.

When the sheath of a bicomponent fiber has a melting point lower than the core, it allows bonding of nonwovens while retaining fiber strength. With a single polymer, this has been termed a *heterofil*. In nylon, it has been used to fuse together a nonwoven fabric. In polyester, Wellbond® (by Wellman) is thus used in thermal bonding of nonwovens. It has a polyester core with a co-polyester outer sheath, which melts at a lower temperature. It is also used in pillows and quilts to give the filling better stability.

Blending of Fibers

Fibers can be teamed together in fabrics in two ways:

- 1. **Combinations** (called *union* or *mixture cloths* in the United Kingdom) have yarns made up of differing fibers, as in the crash drapery fabric called *union linen* that has warp made of cotton with weft of flax (linen). Even one ply of a yarn might have a different fiber content from another. (I have examined a fine sari fabric to find that it was all silk, except for one very fine ply of the warp, which was rayon!) In a knit, one yarn feed might differ in fiber content from another, as in the case of the Blister Guard* socks with Teflon* in heel and toe (see Figure 2.72).
- 2. **Blends** (also called *intimate blends*) are the result of mixing fibers together, before or as a yarn is spun. This is usually done only with staple fibers, although intimate blends of filaments can be produced. Such a filament blend comes only from an MF fiber producer, as it can be accomplished only at the time the fibers are extruded; for this reason they may be called feeder blends. It is impossible to have a blend of reeled silk (filament) with an MF filament; any silk blend must use silk as staple fiber.

Reasons for Blending Fibers

Economy

Blends are sometimes used because a more economical fabric can be produced by "diluting" a highly desirable but expensive fiber with a cheaper one, to retain some of the good properties of the more costly type. Specialty hairs such as camel, cashmere, or angora, blended with wool, are examples. With wool prices high, we see blends with polyester in suitings, or with acrylic in softer materials. To qualify for the Woolmark® Blend, such a blend must have at least 50 percent new wool and meet the strict quality standards of the Woolmark Company; see wool quality terms under "Wool," plus "Quality, Fashion, and Comfort" below. WoolBlend® is the Woolmark Company trademark for 30-49 percent wool blends.

Blending wool with cotton or rayon is usually mainly a matter of economy, since these fibers are much less expensive than wool and of different behavior as well; there can also be improved performance from wool blends (see "Improved Performance in Wear and Care" following).

Quality, Fashion, and Comfort

Blends using silk or flax with MF fibers are encouraged when fashion turns to "natural" appearances and textures. However, when such blends incorporate the minimum of prestige fibers allowed to be stated on a fiber content label, consumers are being offered something close to a gimmick, playing on the appeal of silk, linen, cashmere, etc., with little of the character of that fiber contributed.

Blends that combine the best and rarest natural fibers with the best and most pleasing of MF fibers microfibers—are a much more legitimate approach (see the discussion of staple microfibers under "Microfibers and Nanofibers"). For example, a very lightweight blend of wool can be made with a microfiber nulon or polyester to give a high-quality fabric that still carries the ease of care associated with more practical but usually less pleasing and comfortable fabrics. Further, these lighter-weight wool blend fabrics can be made with some stretch for better wrinkle resistance.

There has been a much-increased introduction of some stretch in many fabrics we use, in clothing and in furnishings. First, it was just spandex with other fibers, considered quite "new" when it appeared in more tailored clothing with wool. Staid linen then had spandex added for crease resistance. Today, as well as having small percentages of spandex in a blend, there is a choice for a fabric or a blend using "soft stretch" fibers discussed earlier: elasterell-p (with Sorona® by DuPont), and lastol (XLA® by Dow Fiber Solutions). More participation in active sports and various leisure activities, with a larger percentage of the population appreciating some "give" in favorite jeans, for example, have fueled this develop-

We have also seen a strong trend to using more comfortable (absorbent) fibers in clothing. This led some years ago to using a higher percentage of cotton in blends with polyester. Instead of always using 65 percent polyester with 35 percent cotton, we saw blends of over 50 percent cotton—what has been called "cotton rich." Now a battery of minor natural fibers and MF fibers made from natural polymer raw materials has been used in what were at first high fashion blends (hemp being one of the first), now followed, as recorded earlier, by bamboo, seaweed, soy, and many others.

One company is using such blends to tailor yarns for fabrics that can be used by garment makers to offer clothing that will give outstanding comfort, and even meet the most demanding conditions. Optimer Performance Fibers is developing innovative technologies for custom products that are virtually endless, but the first offerings go under the brand of Dri-release® with an accompanying odor neutralizer FreshGuard® (see Figure 2.85 [a]). To bear these names, products must pass rigorous testing and be approved. The fiber blends were developed to absorb well, and also aid in evaporation of water from wet fabric. This is an aim of a number of developments described in Fabric Reference, but the approach here is different. (The need for all is to prevent a wet, heavy, "sticky" feeling when conditions are hot, and protect the wearer against chills and hypothermia in cold, wet conditions [see "Basic Principles of Physiological Comfort in Clothing," Section Seven]). Drirelease varns work through blending a synthetic, hydrophobic fiber with a relatively small amount of a hydrophilic fiber, to give fast drying but comfortable performance fabrics (see Figure 2.85 [b]).

Various hydrophilic fibers have been used in the Dri-release yarns, e.g., cotton, flax, rayon, Tencel®, wool, bamboo, and SeaCell®. Fabrics being made from these yarns are in many constructions and range from very light to fleece weight and beyond. See "Care of Special Items," Section Six, to avoid

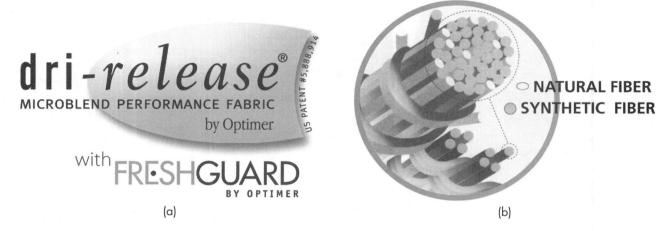

Figure 2.85 (a) Dri-release® and FreshGuard® are registered trademarks of Optimer Performance Fibers. (b) Dri-release® yarns work through blending a synthetic fiber with a small amount of a hydrophilic fiber. (Courtesy of Optimer Performance Fibers)

counteracting the absorbency of these products by using softeners in laundering.

FreshGuard is not a finish, but becomes active on special treatment of the licensed yarns developed by the company, creating a bacteriostatic effect within the fabric that cannot be removed. This makes these fabrics ideal for creation of casual wear, "regular" active sports wear, or garments for extreme activity, such as mountaineering; the fiber blend absorbs and releases moisture (perspiration), while the Fresh-Guard prevents odor development.

Figure 2.86 shows the owner of the Lorünser Sport Hotel in Austria, Gebhard Jochum, on this occasion trekking in the Himalayas. The shirt is one of the "Latitude 15" line, made by Americas International Consultants Inc. The face of the fabric is knit with a blend of baby alpaca and silk, with the underlayer a Dri-release blend of hydrophobic and hydrophilic fibers. (Latitude 15 is the latitude at which alpaca live in Peru, where the shirts are made, and the president of the firm is an alpaca farmer.) This shirt is designed to provide a base layer comfortable from below zero. through room temperatures, to scorching heat. One does not have to trek in the high mountains or across desert country to appreciate it, but the wearer here attests that, "The level of comfort it provides in an extreme outdoor environment is amazing."

There is now also a flame resistant Dri-release[®] FR, developed originally for the U.S. military. The blend has all the advantages outlined for Dri-release, but removed from flame is self-extinguishing, quickly

Figure 2.86 "Latitude 15" shirt keeps Gebhard Jochum comfortable while trekking in the Himalayas. (Courtesy of Gebhard Jochum, Sporthotel Lorünser)

turns to ash, and does not melt or drip—very important for a fabric worn next to or near the skin.

Another branded blend is aimed to be used in all kinds of apparel; this is Merino Coolmax®, a collaboration between Australian Wool Innovation (AWI) and Invista, which owns the Coolmax registered

trademark. This blend also works without any chemical treatment, relying on soft, fine, absorbent Merino wool and the moisture management properties that come with the name Coolmax. It has aimed to be appealing from high performance sportswear, or leisure wear, up to haute couture. Although this is listed here among blends, the name may appear on articles (especially if knitted) where one ply of a yarn is made up of each component, or the Merino wool and Coolmax may be in separate varn ends plated (plaited) in knitting (see "Knitting Terms," Section Four).

Dyeing Effects

Multicolor effects in dyeing are achieved by blending fibers that take up dyes differently. Most of the major MF fiber generics can be produced in a number of differently dyeing modifications. This means that a fabric could be 100 percent of one fiber generic and still allow this "magic" of what is called cross dyeing or fiber mix dyeing, or differential dyeing; see Section Five. Cross dueing is used most often for carpets. to allow piece dyeing; this delays decisions on color which, if carpet were made up in fiber- or yarn-dyed colors, could leave warehouses stocked with giant rolls of less popular shades.

Safety and Hygiene (Flame Resistance, Anti-Microbial Action)

Besides the general discussion of using modacrylic fibers for flame resistance (see "Modacrylic"), a selection of blends for flame resistance includes: furnishing fabrics of 80 percent modacrylic, 20 percent polyester; and garments of 80 percent lyocell, 20 percent FR polyester. Odor prevention from bacterial or fungi growth has been noted using at least 30 percent of a bioactive fiber with other fibers in sportswear or underwear.

Improved Performance in Wear and Care

This is one of the notable reasons for blending fibers—part of what may be called fabric engineering. We can make up for a disadvantage or weakness in one fiber by picking the right partner. Blending of 10 percent nylon with wool in socks or 20 percent in carpets greatly increases the wear life of the wool. Tilley Endurables travel-wear offers socks of 49 percent olefin, 46 percent nylon, and 5 percent spandex, with an "all-holes-barred" three-year guarantee. However, among ultimate for-strength blends in apparel, one must rank Kevlar® (para-)aramid/cotton for motorcycle outerwear at the top.

For years, cotton has been mixed with wool to give a material that will not felt, mat, or shrink in machine washing and drying, yet will carry some of the warm, comfortable feel and loft of wool.

There is an odd but long-made blend used for long underwear (by Damart of the United Kingdom), knit of 85 percent vinyon blended with 15 percent acrylic. Its trademark name is Thermolactyl—just keep it away from heat, as it is very heat sensitive.

Thinsulate™ (by 3M) is often a blend of microfibric olefin and standard polyester (see Figure 2.82) to give high insulating value (much fiber surface area) in a very thin, light layer of material. A variation, Thinsulate™ Lite Loft™ insulation, gives maximum warmth in sleeping bags with the least weight. The air-laid nonwoven material is a blend of fine (not micro) fibers, with thermal bonding of the fibers to maintain the structure; see Figure 2.87. See "Care of Special Items," Section 6. Thinsulate™ Flex Insulation, developed for use with stretch fabrics, combines special elastomeric olefin fibers with regular size staple fibers to allow 40 percent stretch in all directions.

Many tests and trials have produced the best blends we have now. This is where the term engineered blend is deserved. The manufacturer of such a blend uses a mixture of more than one fiber. not as a sales gimmick but to produce a fabric superior in performance and/or more comfortable and more pleasing.

Figure 2.87 ThinsulateTM Lite LoftTM insulation blends fine fibers in a nonwoven fabric with thermal bonding to maintain the structure for insulation. (Courtesy of 3M)

LINK 2-4, 2-5 WITH FILES IN FABRIC GLOSSARY

These illustrate fabrics closely related with certain manufactured fibers. Look them up for a fuller understanding of how this contributes to the fabric character and is an essential part of its name. You will also find photos of these named fabrics as well as other related textiles.

Fabric Glossary Fabric Name	Relationship to Fabric Reference Discussion			
Look names up in the Fabric Glossary Index.				
Spun Rayon	Often used with rayon (or with silk) to distinguish a "cottony" fabric from a "silky" material.			
Ciré	This thin, shiny fabric with a good deal of water resistance is now usually made in nylon for strength.			
Braid	Braid used to stiffen hems or to make light, wide-brimmed hats is today usually made from a coarse monofilament synthetic or a tape-like rayon.			
Voile, Filament	The most common, of polyester, is used to make what we call "sheers," for window covering.			
Fur-Like	These "fake furs" usually contain modacrylic fibers to lower flammability, but also make use of reaction to heat of acrylics (patent shrinkage) to simulate the "guardhair/underfur" layers of a real fur (see <i>Acrylic Properties</i>).			
Split-Film Yarn	Olefin most easily forms filaments by this inexpensive process, and these find specialized uses—though not in high fashion fabrics!			
"Power" Stretch vs Stretch for Comfort, Fit, Ease of Movement	There is a sharp difference between these two kinds of stretch or "give" in fabrics, one of which calls for a specific type of fiber, while the other has many ways to achieve it.			
Canvas, Tailor's	To give the stiffening in this interlining, some special forms of MF fibers are substituted for the more expensive, wiry specialty hair fibers.			
Color Variable	Some MF modified fibers can give a variable color effect.			
Sueded	To feel like real suede, a fabric surface must be made of very fine fibers—what we call "microfibers" today.			

REVIEW QUESTIONS 2-5

- 1. For a fiber that usually has a round cross section, what is another name for a nonround form? List three results of such a change. What is the best-known trademark name for a nonround fiber (nylon)? What is the difference in appearance when such a fiber is coarse compared to fine?
- 2. What types of modifications of MF fibers are used to act as stuffing for comforters, pillows, furniture cushions? What types are used to give insulation against heat loss?
- 3. Define *microfiber* as it is used in textiles today, and give a "benchmark" to illustrate this degree of fineness. What would the term *ultramicrofiber* mean? What term is used for the next degree of fineness in diameter?
- 4. What is the result in hand and drape of having a very fine fiber? How is the surface of a fabric

- affected if it is woven of microfiber yarns? What are three main practical advantages of this?
- 5. What two elements of real suede have to be present in an MF material for it to be very suede-like?
- 6. How is a fiber changed to reduce tendency to pill?
- List six additions that can be made to MF fibers while still in liquid form, and an advantage of each.
- 8. Which is better for drapes, a delustered fiber fabric, or one made with bright fibers, and why?
- 9. Define a *bicomponent* fiber, and list three ways to accomplish this.
- 10. Give three advantages gained with each of the following blends, in terms of specific end uses where each would work well (assume 50 percent of each fiber): lyocell/polyester; wool/flax; rayon/olefin; nylon/acrylic; otton/modacrylic.

2-6 FIBER IDENTIFICATION

The first and most basic information about a fabric is fiber content. Although the way a fabric or garment is made and finished will affect its suitability for different purposes, nothing will counteract the mistake of using a fiber in riding pants, for instance, that cannot withstand abrasion.

Although most fabrics are labeled as to fiber content, there are many occasions when you might wish to determine or confirm this: You may have fabric that was a remnant, a gift, or acquired long ago, with content uncertain. In business, you may simply be unsure of the fiber content you are quoted; however, you cannot depend on your own determination in any legal sense.

For anyone studying the basics of textiles, few demonstrations are more convincing of the real differences between fibers or fabrics that may look and feel similar than a burning test or microscopic examination; these can also show that a relationship does exist between fibers that may look and feel very different!

Fiber identification is a useful skill and can develop into a kind of detective process. With very little equipment, you can at least determine a fiber's general type. Conclusive tests probably have to be made in a laboratory, sometimes with expensive equipment, certainly needing skilled staff.

Fiber Identification Methods

The following is general information on the methods of fiber identification; we will then examine several of them more closely:

1. Burning test. A burning test is often the simplest to carry out, as long as precautions are taken with open flame and there is a receptacle for burning or melting material. The test is useful if only a single type of fiber is present in a yarn; if any varn contains a blend of fibers, the test will reveal only the presence of fibers with very characteristic odors, such as protein and cellulose, or of fibers that melt—but that is good general information. If someone has told you that a fabric is "all silk" and you do not smell burning protein, you know there is no silk at all; however, if you do smell the characteristic odor of burning silk, you do not know whether it is 100 percent silk.

Discussion in detail of this procedure follows, with results of typical burning tests on various fibers.

- 2. Microscopic examination. A lengthwise (longitudinal) view of fibers is easy to get and very helpful. A cross section of fibers may sometimes be needed for positive identification, but is much more demanding to prepare. You do not need an expensive microscope; a child's or hobby type will do well, as fibers reveal most of their significant appearance at a magnification of 100 times (100x) or even less, and mounts made in water give a good, undistorted view, although they do dry up quickly. Detailed discussion of this procedure follows.
- 3. **Staining test.** A stain test provides a useful cross-check in identifying fibers, as long as they are not already too dark a color, either naturally or from having been dyed. The identification (ID) stain will have a mixture of dvestuffs in it that gives different colors on different fiber types—a variation of cross-dyeing. When microscopic examination is made of a sample that has already been stained, both appearance and color contribute information. For example, a number of major fiber groups are round in cross section and so appear structureless in lengthwise view—like a rod. Use of an ID stain, especially if a piece of multifiber cloth is included, often helps greatly to distinguish among these groups. Testing laboratories regularly use such multifiber cloth, woven with 5 cm or 10 cm repeats of a variety of fibers in strips. The makeup of a 13-fiber cloth and a result with one ID stain mixture are shown in Figure 2.88; for sources of multifiber cloth, see Section Eight.
- 4. Solubility or chemical test. This kind of test is needed when an unknown is very dark in color, when two or more fibers are present in a blend (which makes a burning test inconclusive), when fibers have very little visible structure, and in general, as a conclusive cross-check to burning or stain tests or microscopic examination.

One of the few specific chemicals readily available is nail polish remover, which, although it is not acetone, will affect only acetate or triacetate at room temperature. Most other chemicals needed in fiber identification are hazardous and used only in laboratories. However, a chart on page 99 shows some key fiber solubilities.

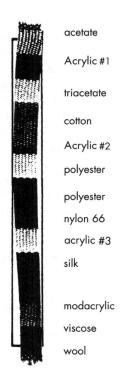

Figure 2.88 A 13-fiber multifiber cloth stained with an identification stain, made up to give different colors on different fiber types.

- 5. **Fiber density, infrared spectrophotometry, gas chromatography.** These are all positive identifying tests, but are very specialized. Near-infrared (NIR) spectrophotometry has provided a quick identification of fibers in textiles intended for recycling.²⁹ DNA "fiber profiling" has been developed by the British Textile Technology Group to distinguish among animal fibers, such as cashmere and yak.³⁰
- 6. **Fiber melting point.** This is a specialized method with significant drawbacks for identification. Many synthetic fibers give a range of melting point figures, or may decompose before their melting point is reached. The copper block method commonly used indicates a softening point which may not be close enough to the melting point.

Textile Flammability

This topic touches far more than just fiber identification, so before proceeding with specific information on burning tests, we should consider fire safety as it relates to textiles. Fabrics are all around us—in clothing and household furnishings; in whatever transport we use; in schools, offices, theaters. Concern that dangerously flammable textile products should not be allowed on the market has led to increasing legislation in this area in a number of countries. In the United States, the original Flammable Fabrics Act (1953) was amended in 1967 to outlaw highly flammable fabrics for interiors as well as apparel. Since 1973, under the Consumer Products Safety Act, an independent agency, the Consumer Product Safety Commission, creates and enforces the rules for textiles (as well as other products). Standards in effect can be found in parts of Title 16 of the Code of Federal Regulations, Subchapter D—Flammable Fabrics Act Regulation in: part 1610, clothing textiles general; 1611, vinyl plastic film in apparel; 1615, children's sleepwear, sizes 0 through 6X; 1616, children's sleepwear sizes 7 through 14; 1630, 1631, carpets and rugs, small and large; 1632, mattresses, mattress pads. In Canada similar regulations exist under the Hazardous Products Act (1969), through Consumer Product Safety, under Health Canada's Product Safety Programme. The standards in both countries establish a base level of safety for consumer apparel, with special standards for items such as children's sleepwear, and also for carpets and mattresses.

Flammability of furnishings fabrics is also of great concern. The Upholstered Furniture Action Council has drawn up voluntary standards for upholstered furniture. There are many fire regulations governing acceptable levels for components of public buildings, such as hospitals and schools. Students in interior design should realize that professionals are expected to know and meet standards of safety set for contract work for their project and area, not only in the fabrics they choose, but to meet local fire codes in wallcoverings as well—if designers are certified, the responsibility is with them. A contractor can give the information on what class of fire rating is needed, and the designer should get a certificate from any fabric supplier stating that the fabric meets these ratings. If a fire were to occur and the proper materials had not been used, the designer could be held responsible.

So far as choosing apparel and fabric for domestic use, we should be aware of fire hazards in general, and this is an important focus of the general discussion of flammability that follows.

Burning Behavior

Flame retardancy is measured by the amount of oxygen needed to support combustion (Limiting Oxygen Index or LOI³¹); fibers with an LOI greater than 25 are said to be flame resistant or retardant, that is, there must be at least 25 percent oxygen present for them to burn. Glass, for instance, will not burn even in an atmosphere of 100 percent oxygen. Glass is also very resistant to heat, but other fibers may be flame resistant vet heat sensitive, such as the modacrylics.

Fiber Type and Fire Safety

Just as fiber behavior is basic to wear, ease of care, or comfort of our textile articles, so it is to their relative flammability. However, at this point we should note that what follows is a description of the relative flammability of fibers without modifications. Many MF fibers are available also in a flame resistant or retardant form, with the trademark name often followed by the letters FR (see "Additions to Manufactured Fibers before Spinning" earlier in this Section). Flame retardant finishes can be given to natural and MF fibers, and will be covered in Section Five.

The following lists, then, describe behavior in flame and removed from it, by fibers not given any flame retardant modification or finish:

Most Flammable

 Cellulosic fibers (such as cotton, flax, viscose, lyocell). Once alight, these burn readily and so can "propagate" flame to other fabrics; can leave glowing embers.

Intermediate

- Acetate, triacetate. These melt as they burn; burn more readily than the groups listed next.
- Nylon, polyester, olefin (polypropylene), acrylic, spandex. These do not catch fire (ignite) readily; once ignited, burn and most melt; tend to drip (especially nylon); the drops tend to carry the flame away, so the fabric self-extinguishes in some situations.

Less Flammable

 Protein (wool, silk). These do not ignite easily; burn slowly; tend to self-extinguish, except in very dry air or with very open fabric.

Flame Resistant (LOI greater than 25)

Will not continue to burn when the source of ignition is removed (self-extinguishing).

- Modacrylic, saran, vinyon. These melt; modacrylic does not drip.
- Aramid. These do not melt but char; tend to selfextinguish; give little smoke.
- Certain modifications. Some MF fibers are given flame resistance by agents put in before the fiber is spun.

Flameproof (Nonflammable)

- Novoloid, polybenzimidazole (PBI). These will not burn; do not melt; char, but stay intact.
- Inorganic fibers (asbestos, glass, metal, etc.). These will not burn; can melt, but at temperatures so high they do not figure in textile fire safety!

Fabric Construction and Fire Safety

The way the fabric is constructed is another very important factor in fire safety:

- Lighter-weight fabrics, especially light, sheer, or open fabrics, burn faster than heavier fabrics (of equivalent fiber types).
- Fabrics with a raised surface burn faster than smooth fabrics.
- Open, porous fabrics or those with a more sparse pile burn faster than those with yarns packed closely together.

Garment Design and Construction and Fire Safety

The style and construction of a garment affects flammability:

- Loose-fitting garments, with flaring skirts or sleeves, with gathers, ruffles, trim like lace, anything with a lot of air incorporated with it, will ignite more readily and burn faster than closely fitting, virtually untrimmed articles. This means that flowing, at-home garments should be worn with care around the kitchen stove or barbecue.
- Thread may be more flammable than garment fabric, so an article can burn preferentially at the seams.

In almost a summary of the preceding "lineup" of hazards from fiber type, fabric construction, and garment design, product safety authorities in the United States and Canada in August 1994 were alarmed about full skirts imported from India made up of rayon chiffon over gauze, some of which had been found to be dangerously flammable.

Other Fire Hazards

Other fire hazards involving textiles include the following:

- Bedding and upholstery made of fabric covering over foam present a fire hazard; the resistance to burning or even melting of the covering fabric is evidently crucial in preventing fire from reaching the foam, which burns readily because of the air trapped in its structure.
- One of the hottest fire sources is an unextinguished cigarette or cigar; a combination of one of these with a mattress or a wastebasket of paper is often deadly.
- Other areas of concern (and legislation) are tents, dining shelters, and the like.
- Clothes dryer fire hazards from lint and foam are noted in Section Six.

Fiber Identification Burning Test

You will be working with an open flame—from a Bunsen burner, a candle, or even a match—so **take care**, especially to keep long hair well clear of the flame. Samples for burning tests should be quite small, although if you use the recommended loose fibers or bundles of yarn, you will probably keep the sample small in any case. Fiber material burns very quickly when it is not held in a fabric, so twist fibers together and bundle yarn pieces, so they will not burn too quickly. Always hold the sample (or a flame source such as a match) in tweezers or tongs and work over something like a sheet of foil or metal tray, in case you drop burning material. Make sure the surface under the foil or tray is protected from heat.

The sampling procedure itself is very important if you wish to get the maximum information from your test. You should take yarns from warp separately from weft in a woven fabric, and if any contain more than one ply, test the plies separately. Twist short lengths of the yarns into a bundle; bring the sample slowly up to the flame source from the side (not

pushed into the top of the flame); note what happens as the sample approaches the flame—does it "shrink away" as a thermoplastic fiber will?

Put the sample in the flame and note whether and how it burns. Remove it and see whether it goes out on its own (self-extinguishing), whether it smolders, or whether it goes on burning. Samples that burn and melt will often drip; take care with this molten material—it is very hot. If a sample burns "fiercely," you may have to blow it out so it will not all be burned up.

As the flame goes out, note the type of smoke and its odor.

Finally, let the residue cool (use caution again with this) and examine its character: soft ash, crushable or hard bead, smooth or irregular.

Note that the dyes and finishes used on a fabric can affect its behavior in burning and the color of the residue.

Results for major fibers are presented in Table 2.5; the order is not connected with relative flammability as given in the opening of this segment; instead, it is one you might follow if you are doing a systematic series of burning tests, to prevent your sense of smell from getting fatigued early by the really acrid or pungent odors of the fibers listed farthest down the table.

Microscopic Fiber Examination

Microscopic examination can be a good first step in fiber identification, and the microscope need not be an expensive one. However, every microscope is a carefully engineered optical instrument and should be handled with knowledge and care. The main parts are shown in Figure 2.89; the two lenses that do the magnifying are the eye-piece (ocular) and the objective. Many microscopes have a revolving turret nosepiece, allowing you to interchange objectives. An eyepiece of 15 times magnification (15x) used with an objective of 10× will give you a magnification of 15×10 or $150 \times$. As mentioned in the introduction to this segment, that is more than enough for examination of fibers; in fact, for an inexperienced person, too high a magnification (in the order of 600) can make locating the sample difficult, or give a very confusing picture.

Handle any microscope with care. A soft lens paper should be used to keep the lens system as clean as possible. Water from the slide or chemical

Table 2.5 Burning Behavior of Major Types of Fibers

Fiber Type	Behavior Up to Flame	Behavior in Flame	Behavior Removed from Flame	Odor of Smoke	Type of Residue
asbestos, glass	No effect	Glows	No change	None	NA
cellulosic, such as cotton, linen, viscose, lyocell	No effect	Burns fiercely	Burns, can glow, smolders	Like burning wood, paper, leaves	Soft, gray ash
acetate, triacetate	Curls	Burns, melts	Burns, melts	Like vinegar	Bead—can crush
nylon	Shrinks away	Melts, drips	Tends to go out	Like celery seed(?)	Hard bead
polyester	Shrinks away	Burns, melts,	Tends to go out	Aromatic(?)	Hard bead
olefin (polypropylene)	Shrinks away	Burns, melts, black smoke	Burns, melts	Like wax	Hard bead
acrylic	Shrinks away	Burns	Burns	Fishy	Bead—can break
modacrylic	Shrinks away	Burns	GOES OUT	Like animal waste!	Bead—can break
silk	No effect	Burns slowly	Tends to go out	Like burning feathers	Ash—can crush
wool	No effect	Burns slowly	Tends to go out	Like burning hair, meat	Ash—can crush

NA, Not applicable.

reagents must never be allowed to come in contact with the lens. Care should also be taken that water does not seep between the slide and the stage.

You will need some microscope slides, cover slips, two long needles, and a dropper bottle of a liquid medium such as glycerine or just water. Glycerine

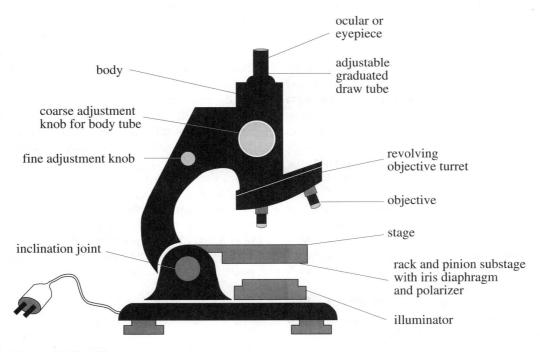

Figure 2.89 Main parts of a microscope.

does have advantages over water for mounting all fibers except acetate: water evaporates quicker, swells many fibers, and does not allow as good definition. On the other hand, water is readily available, and there is little distortion as light passes through the glass, water, and fiber. For student use in introductory courses, or for amateur interest, water does very well. For the long needles, use dissecting needles, hat pins, or darning needles with cork on the eye ends.

The procedure outlined here will give you a lengthwise (longitudinal) view of fibers; to see the cross section, you must take a slice across the fibers, which requires some special equipment plus manual skill and practice.

Fiber "knowns" are an invaluable help in microscopic examination of fibers for identification. You can consult printed guides such as you find in this *Reference* and others, but if you can look at an actual sample of what you know to be that fiber, it is much more revealing and conclusive. A collection of known samples can be made, of which only a fiber or two is needed, to be mounted alongside an "unknown," to give you a great deal more assurance in making your identification.

Alternatively, you could assemble a set of permanent slides to give you a known to compare with an unknown. A permanent slide can be prepared by mounting in a medium such as *collodion*, which hardens on drying. (Collodion is available from a laboratory supply house.) If using such a medium, take care to move the fibers in it as little as possible, or many bubbles will form; these are most distracting and misleading when you are examining what is on the slide. A set of such slides can be prepared more cheaply than buying a commercially available set, can cover many more interesting examples (e.g., wool fibers bitten by larvae, see Figure 6.10), and, in my experience, can be prepared to a higher standard (fewer bubbles)!

See the sampling procedure described for the burning test. Ravel yarn off the cloth and untwist; if there is more than one ply, examine each separately, and look at warp separately from weft. In a fabric with yarns of different colors, you should really look at each color separately.

When the yarn is nearly untwisted, do not pull it apart—hold it over a drop of water or glycerine on a microscope slide and clip off a length of about 10 mm (1/2 in.), letting it drop onto the slide. Using two

needles, tease the fibers to separate them; ideally, you should not have fibers crossing each other at various levels. It is a common mistake to have far too many fibers on a slide.

Drop a cover slip on top, and examine for air bubbles; if present, press gently on the cover slip with the tip of a needle, not your finger. If bubbles are still present, hold a needle against one edge of the cover slip, and raise the slip with the other needle from the opposite edge, using the first needle like a hinge; introduce a little liquid, and lower the slip slowly. You may wish to use this technique in any case, rather than "dropping" the cover slip on. Blot excess liquid away; absorbent papers are available from laboratory supply houses, with the rather W. C. Fieldsish name of bibulous paper.

Place the slide on the microscope stage so that the fibers on the slide are in the center of the hole. Use an objective and eyepiece to give a magnification of $100-150\times$ if possible, but even $60\times$ will do. The microscope can be tilted by the inclination joint. Clips on the stage hold the slide in place, and there is usually an iris diaphragm below the stage to allow more or less light through. If a mirror is used, the concave side concentrates light more than the flat or plane side. An illuminator lamp, useful to throw a good light below the stage, may be clipped in place where a mirror would be, if a light source is not fitted to the microscope.

Focusing is done first with the coarse adjustment knob, then the fine. First, guiding yourself by looking from the *side* of the microscope, lower the objective until it nearly touches the slide. Then, with your eye to the eyepiece, turn *up* slowly, until the material comes into focus. (If you do not follow this procedure, you run the risk of grinding a lens into the slide.)

When the fibers have been brought into view, focus carefully using the fine adjustment knob. Sometimes details can be seen more clearly if the light coming into the microscope is reduced by use of the iris diaphragm. In other cases, such as with lobal MF fibers, you get a better impression of the shape of the fiber if you focus up and down through it. Try to keep both eyes open when using a microscope; this will result in less eye fatigue.

Typical Features

Following are descriptions of fibers seen through the microscope at magnification of 60-150x.

Cross-sectional shape is described and shown as well as longitudinal features. With reeled silk and (particularly) MF fibers, it is important to know the shape of the cross section in order to understand the lengthwise view you see. You will not be able to see the cross section, however, unless a slice has been taken of the fiber; as noted before, this requires special equipment and a good deal of practice. What you will ordinarily be looking at is the lengthwise (longitudinal) view.

- **Natural fibers** have very definite characteristics in each type; e.g., hair fibers will have features in common, as will bast fibers; it is very difficult (if not impossible) to tell a cashmere fiber from very fine wool,³² or flax from hemp or ramie, but the type is unmistakable.
- Cotton (mature or lint fiber) looks like a twisted ribbon, with a central canal, the lumen, clearly visible at this magnification. Views seen in many textbooks and Figure 5.4(a), given by a scanning electron microscope, show the surface but not the lumen. Immature cotton is twisted, but has no inner substance.

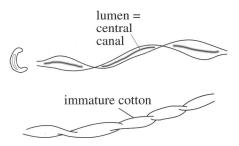

 Mercerized cotton shows few twists, because it has been swollen in caustic soda; the smoother surface after mercerizing gives luster (see also Figure 5.4[a]). Immature cotton will not react in mercerizing, as there is no secondary wall to swell; it remains looking like (insubstantial) twisted ribbon.

 Flax and other bast fibers show nodes swellings along the length, like the "elbows" in bamboo—plus cross cracks.

• Wool shows overlapping scales, like shingles on a roof or fish scales; the edges protrude slightly toward the tip of the fiber. Coarse wools may show a medulla—a dark space in the center (see also Figure 2.27).

 The finer the hair fiber, the smaller the scales, so cashmere undercoat has very small scales that seldom overlap on one side of the fiber.

 Mohair has large, platelike scales that project hardly at all from the fiber; these account for the dirt-shedding character and luster of mohair.

 Angora has an appearance typical of fur fibers: air spaces in the center of the fibers look like "box cars," scales project hardly at all.

• Down shows a truly wonderful construction: a quill point with fine branching arms, carrying tiny barbs. Since this is all made of a light material (protein), it gives air trapping with little weight. Note: Since down was intended to resist wetting, it is almost impossible to mount in water without a lot of air bubbles. Find a bit without too much intrusion from bubbles, and enjoy!

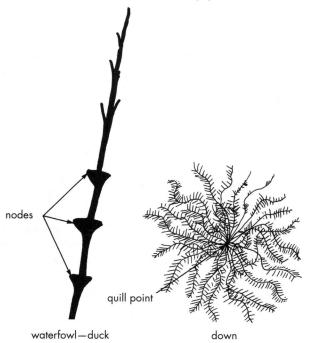

• Cultivated (reeled) silk is the only natural fiber that is structureless, since it was formed by a liquid solidifying. Sometimes a faint lengthwise line can be seen to mark the joining as the fiber was spun of the original two brins into one filament. Silk is always very fine and is irregular in diameter; the cross section is roughly triangular. Wild silk has a rather striated appearance and is much coarser than cultivated silk.

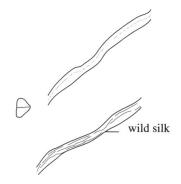

• Any MF fiber may appear clear, or with specks through the fiber, no matter which group it falls into according to the fiber shape and type. Clear fibers are called bright and will look shiny; the specks are granules of a white pigment dispersed in the fiber before it was spun, to give a dull, delustered, or matte appearance. Some fibers have very little delustrant, while others are heavily delustered; since light cannot pass through the (white) pigment granules, they look like dark specks.

Major features identifying various groups of MF fibers follow:

Structureless MF fibers have a rodlike shape, with a round cross section. Among the many structureless fibers are cuprammonium rayon lyocell, standard nylon and polyester, olefin, glass, and saran.

 One line or "crease" is the result of a dogbone or bean-shaped cross section. Fibers of this type could be spandex, some modacrylics, and some acrylics.

- A few lines are given by lobal cross sections of two differently appearing types:
 - 1. Two to four lines lengthwise, the result of lobes a little like clover leaves, are found with acetate and triacetate
 - 2. A few wider, shallower grooves with more solid lobes, the swelling of which can be seen by focusing up and down through a fiber, can be seen in a lobal fiber either fine or the coarse filaments used for most of the "sparkling" fabrics. (A few such sparkling fabrics may still be made of flat, tapelike filaments, such as "crystal" acetate.)

 Many lines are seen only in viscose rayon, the result of a wrinkled, almost corrugated surface that gives a **serrated cross section**. This is a result of the fiber precipitating gradually in the acid bath.

It is also interesting to look at a sample containing microfibers, to get an idea of just how fine these are. The tiny fibers in Thinsulate™ are on the order of the size of the fronds and barbs of down, and microfilaments can also be compared to silk.

Solubility or Chemical Tests

When other tests are inconclusive, solubility tests must be made using chemicals that are both hazardous to

REVIEW QUESTIONS 2-6

- 1. What is the most available and easiest method to obtain information on fiber content from a fabric sample? Name two more methods possible to carry out with minimum laboratory facilities.
- 2. What is LOI? What use is made of this measure?

handle and not easily available. This portion, then, may largely be of limited interest, but is included for reference.

Sampling is done with very small clumps of fibers, short lengths of yarn, or (least desirable) small pieces of fabric. Comments on sampling for burning tests apply, in regards to trying to test each type of fiber present.

You should have at least 100 units of solution for every unit of sample. Leave the sample in the liquid for five minutes, stirring periodically. You may need a special light or background to see the effect on the sample.

The following are solvents specific for the fiber(s) mentioned, but often after other possibilities have been eliminated by burning, microscopic examination, or stain testing:

Solvent	Temperature (°C/°F)	Specific for
acetone	room	acetate (dissolves), triacetate (disintegrates), modacrylic, vinyon (softens)
cresol (meta-)	95/200 (hot)	polyester (if nylon and acetate have been eliminated)
dimethyl- formamide	95/200 (hot)	acrylic, modacrylic (if acetate has been eliminated and if saran, spandex or vinyon is unlikely)
hydrochloric acid (20% by weight, sp.gr 1.096 at 25°C/75°F)	room ·	nylon
sodium hypochlorite (5% av. Cl)	room	wool, silk

- Discuss the difference between heat resistance and flame resistance in relation to specific fibers.
- 3. Name three elements of an article of clothing or furnishings that affect flammability.

- 4. What information can a burning test (properly carried out) give as to fiber content of a yarn or fabric? (Take into account clues from the reaction of the fibers to heat; whether the material burns, and if so, the way it burns; whether the flame tends to go out; the smell of the smoke when the flame is extinguished; and the type of (cooled) residue.) What two main pieces of information are usually not clear from a burning test?
- 5. What accounts for the similarity in burning of cotton, flax, rayon, and lyocell? Name five other fibers that would give similar results.

- 6. What accounts for the difference in burning behavior of silk compared to wool?
- 7. What can a microscopic examination reveal that a burning test cannot?
- 8. What do lengthwise lines indicate in the longitudinal view of a fiber (fiber flat on the slide)? What does it mean if no lines at all are seen? What do dark specks throughout the fiber mean?
- 9. What common chemical substance can indicate presence of one common fiber?

INVESTIGATIONS TO DO WITH TEXTILE FIBERS

- 1. (a). What five fibers are present in most of your own clothing? Make up a table showing the article, the fiber content, and the properties of that fiber that make it suitable for that use.
 - (b). Do the same for your household fabrics (bedding, towels, drapes, upholstery, carpets, table linens).
- 2. Try the comparison test for absorption of a linen handkerchief (or tea towel) compared to one of cotton (see "Flax Quality," this Section).
 - 3. Demonstrate thermoplasticity by applying a dry hot iron (with a cotton pressing cloth to protect the iron in case a fabric melts) to folded or pleated fabric of: cotton, viscose rayon, acetate, nylon, polyester. Try to apply the iron with consistent pressure, and for the same time (e.g., a count of ten). Save a strip of the original, and wash the rest to see in which fabric the fold or pleat lines are most durable.
 - 4. You have a "silky" fabric (filament yarns, no fiber ends protruding). Make one simple test to tell you whether it is made of silk or an MF fiber. What will this test by itself *not* tell you?
 - 5. Demonstrate how acetate differs from viscose rayon.
- 6. Imitate dry spinning (with good ventilation and no open flame nearby). Clue: aim for an acetate filament.
- Examine several clear wrapping films and determine if any are made of *cellophane* or if all are synthetic (e.g., saran wrap).
- 8. (a). You are the interior designer for an office suite, which will include selection of drapes,

- upholstery, and carpet. What flammability regulations must be met? Whose responsibility is it to ensure that fabrics meet these?
- (b). You are the buyer for children's sleepwear. What flammability and other regulations must be met? Whose responsibility is it to ensure that fabrics meet these?
- 9. Gather five 100 percent cotton fabrics, of as widely varying weight, construction, and finish as you can find. Do the same for five 100 percent of wool, and five 100 percent of polyester. Give a fabric name (as from Fabric Glossary) to each sample. This investigation should illustrate why the answer to "what is this fabric called?" should NOT be simply "a cotton," "a wool," or "a polyester." If you can, continue to add to and identify entirely distinct fabrics in each of these three categories to see how many you can find.
- 10. Collect at least ten different advertisements, hangtags, or labels, for apparel, accessories, or household furnishing fabrics. Make out a page or large file card for each of the ten items. Record: (i) the merchandise to which that promotion refers, and all data the sources give, including any information from sales staff; and (ii) information on fabric behavior which the fiber content provides from your study of fibers so far in Fabric Reference, citing the page(s) where you find this information. KEEP THESE RECORDS and add to them later under headings (iii) yarn; (iv) fabric construction; (v) finish; contribution of dyeing, printing, or other treatment; and (vi) care, as these are covered in your course of study.

- 11. Collect samples, preferably 100 percent of various fiber contents, and follow through burning test comparisons as outlined. This will help you answer 2–6 Review Questions 4 through 6.
- If you have access to a microscope and simple supplies, follow directions for untwisting yarns, and mount fibers in water on slides, with a cover

slip over each, to give you a *longitudinal view*. Compare the principal natural fibers with each other, and with viscose rayon, acetate, nylon, polyester, and acrylic. Compare, if possible, mercerized with untreated cotton. Try to find the "Typical Features" shown in this section. This will help you answer 2–6 Review Questions 7 and 8.

NOTES SECTION TWO

- TFPIA (Textile Rules); for definitions of fiber generic groups, see the Appendix of this book, or ftc. gov/os/statutes/textile/rr/-text1. htm, section 303.
- 2. Federal Trade Commission (FTC), Bureau of Consumer Protection, 600 Pennsylvania Avenue NW, Washington, DC 20580; www.ftc. gov/os/statutes/textile/rr-text1. htm.
- 3. "Guide to the Textile Labelling and Advertising Regulations," Fair Business Practices Branch, Competition Bureau, 50 Victoria Street, Hull, QC Canada K1A 0C9.
- 4. G. R. Lomax, "The Polymerization Reaction, Part 2: Natural Textile Polymers," *Textiles*, 16/3, 1987: 77.
- 5. Figures for 2005 from the United States Department of Agriculture, Foreign Agricultural Service, as cited by the National Cotton Council of America, www.cotton.org./econ/cropinfo/cropdata/rankings.cfm.
- Lewis Miles and Peter Greenwood, "Cotton," Textiles, 1992/3: 6, 7.
- 7. W. Bally, "Cotton," *Ciba Review*, 95 (December 1952): 3400–3403.
- 8. Robert R. Franck, editor, *Bast and Other Plant Fibres* (Cambridge: Woodhead Publishing, 2005).
- 9. Just-style, http://www.just-style.com, (Aroq Ltd.) 22 January 2002.
- "Cloth That Grows on Trees," 2006/2007 exhibition, Textile Museum of Canada, see on www.textilemuseum. ca; color brochure available for some years.
- Commodity Research Bureau, Commodity Yearbook 2004; www2.barchart.com/comfund/ wool.asp.

- "Worldwide Raw Wool Production," Fiber Organon, Fiber Economics Bureau, Inc., Volume 72, No. 12, December 2001: 234.
- 13. Errol J. Wood, editor, *Tangling with Wool*, Wool Research Organisation of New Zealand (WRONZ), 2000: 3.6–3.8. (See also References and Resources.)
- A Guide to Wool, The Woolmark Company, 1997.
- 15. John Hare, *The Lost Camels of Tartary* (New York: Little, Brown, 1998).
- 16. Lil Peck, Angora rabbit breeder, www.angorarabbit.com.
- 17. Earth Island Institute, "Tibetan Plateau Project," www.earthisland.org/tpp/tppframes.htm.
- 18. S. Vishwanath, "Silk and its future," *International Textile Bulletin*, 2/2002: 21.
- 19. Michael L. Ryder, "Can Spider Silk Be Used in Textiles?" *Textiles Magazine*, Issue 2, 1999: 20–22.
- 20. Phil Owen, "Swiss Power—Spinneret firm's unique asset," *Textile Month*, April 2001: 27.
- Dr. Albin F. Turbak, Professor, School of Textiles, Georgia Tech. and U. of Georgia, talk given to the Institute of Textile Science, Toronto, Ontario, April 12, 1989.
- 22. Ian Holme, "Nanotechnologies for Textiles, Clothing, and Footwear," *Textiles Magazine*, 2005, No. 1: 8.
- 23. Jason Lyons and Jim Kaufmann, "Electrospinning: Past, Present & Future," *Textile World*, August 2004: 46–48.
- 24. Richard G. Mansfield, "Fueling Nonwovens Growth," *Textile World*, November 2003: 52–55.

- 25. John W. S. Hearle, "Protein Fibres: 21st Century Vision," *Textiles*, 2007, No. 2, 14–18.
- 26. Swicofil AG Textile Services, "Soybean protein fiber," www.swicofil.com/products/209soybean.html.
- 27. "The Fiber Year 2000," Textile Month, July 2001: 23.
- 28. "Dressed for Success," *Newscience*, Ontario Science Centre, 13/3, Summer 1988: 1.

- 29. Textile Month, August 1999: 34.
- 30. Textiles Magazine, 1998, Issue 3: 14-17.
- 31. IS Co., Ltd., "LOI (limiting oxygen index) value data: a scale for measuring flame-resistance," http://textileinfo.com/en/jcfa/kaneka/page4.htm.
- 32. Dr. Phil Greaves, Francis E. Bainsford, "Camelid Fibres Compared and Contrasted," *Textiles*, 2005, No. 3/4: 46–48.

SECTION THREE

Yarns — From Fiber to Fabric

3-1 YARN TYPES, CLASSIFICATIONS, NOTATION

Yarn Types and Constructions

Yarn is a continuous strand of textile fibers, filaments, or other material in a form suitable for knitting, weaving, or otherwise intertwining to form a textile fabric (ASTM definition). In other applications, it is called *thread*, e.g., for sewing or embroidery.

Filament yarn (also called continuous filament yarn) is formed by gathering a number of filaments together to give *multifilament* yarn, formed with or without twist; with MF fibers, a single continuous filament may form *monofilament* yarn. Most MF filament (and all reeled silk) yarn is multifilament. The main uses of monofilament yarn are in very sheer women's hosiery, as "color blending" sewing thread, and for wiry millinery and hem braids used in place of horsehair or mohair. Where two or more continuous multifilament yarns are intermixed without adding twist, the result is called a *commingled* yarn. This type would usually be used as a reinforcing yarn in a specialized industrial fabric.

Yarn may also be formed of one or more strips made by the lengthwise division of a sheet of material such as a polymer film, paper, metal foil, or other fabric, used with or without twist in a textile construction.

Spun yarn results from the mechanical spinning of staple fibers, twisted together and drawn out to form yarn (see "Conventional Processing" under "Spun Yarn"). Fabric names such as *spun rayon* or *spun silk* (see *Fabric Glossary*) indicate the characteristics given by spun yarn, in contrast to the "silky" character given by filament yarns.

Spun Yarns Compared to Filament Yarns

Look, Hand

Spun yarns, because of the protruding ends of fibers, have a duller, more fuzzy surface, more noticeable with carded than with combed yarns. Filament yarns (unless textured) are smoother, more lustrous, more slippery, and will ravel or pull out of a fabric more easily, but will not shed lint or form pills as spun yarns do. Fabrics made of spun yarns have more loft,

bulk, and cover but soil more easily than do those made of filament.

Comfort

The protruding fiber ends of spun yarns hold the yarn away from the skin. This creates still air space, which is a good insulator to prevent body heat from being lost in cold weather; it also makes spun yarn fabrics more comfortable on a hot, humid day. The comfort in hot weather of fabrics made of filament yarn, which lie close to the skin, depends on the absorbency of the fiber used and/or its wicking ability. Static buildup is closely associated with absorbency or wicking. Spun yarns, being more absorbent than filament of the same fiber, are more resistant to static buildup.

Textured filaments give yarns somewhat greater absorbency, warmth, bulk, and "spunlike" loft than standard (untextured) filaments; see "Textured Manufactured Filament Yarns."

Durability, Strength, Cost

These can be compared only for yarns of the same fiber type; in this framework, filament yarns are more durable than spun, as they do not have fiber ends to wear away on the surface.

Moreover, in MF fibers, the filament form is purposely made somewhat stronger, as well as more even (uniform in diameter). Filament should be *stronger* because the strength of a filament yarn depends on the strength of each individual filament in that yarn; strength of a spun yarn depends more on the amount of twist and the length of the staple. Filament should be *more even* to prevent different shades in dyeing that can give streaks called *barré* or *barriness*, caused by any changes in fiber diameter. These show up much more in a fabric made of filament yarn, e.g., nylon hosiery or (especially) a warp knit such as tricot for lingerie. See "Dyes and Colorfastness" in Section Six regarding nylon and practical results in colorfastness because of the dye type used to prevent barré.

All of this means that filament fiber costs more; offsetting this, the many steps needed to spin staple into yarn on conventional systems are also costly, especially those for very fine, even spun yarn. With consumer demand high for this quality, spun yarn may, on the whole, be more costly. Newer, faster spinning systems, like open-end or direct, make some spun yarns cheaper.

Yarn Classification

The bulk of our discussion will be of simple yarns, those in which all parts are the same (as opposed to **novelty** or complex-ply yarns discussed later).

Yarn Classified by Ply

Figure 3.1 illustrates the types of yarn as classified by ply, as follows:

Single. Made by any method; can be untwisted in one operation to separate into fibers.

Plied or folded. Two or more singles twisted together for strength. For identification of plied varns see "Yarn Notation."

Cord, cable, or hawser. Two or more plied varns twisted together for even more strength, e.g., cotton 6-cord sewing thread (see "Thread") or as a bulky cord for decorative ties or trim. This class of yarn is also important as rope and cordage (see "Rope").

Yarn Classified by Twist Direction

Figure 3.2 illustrates the types of yarn as classified by twist direction, as follows:

S twist. Put in by a clockwise rotation; the spiral of the twist follows the direction of the slope of the letter S. In determining twist direction, it is often easier to note the direction in which the twist loosens: S twist loosens in a counterclockwise direction (to the left).

Z twist. Put in by a counterclockwise rotation; the spiral follows the direction of the slope of the

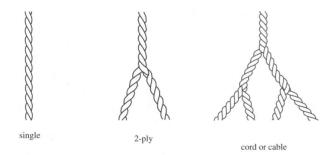

Figure 3.1 Yarn: single, plied, cord or cable.

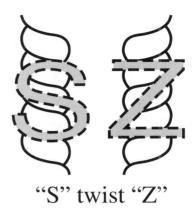

Direction of twist in "S" twist and "Z" Figure 3.2 twist yarn.

letter Z. This twist loosens in a clockwise direction (to the right).

Twist of plying is almost always the opposite of the twist of the singles, to prevent the resulting yarn from twisting and turning on itself (developing torque), which can make it unmanageable. A notable exception is the twist-on-twist used in the best voile; see "Yarn Classified by Amount of Twist."

Yarn Classified by Amount of Twist

Figure 3.3 illustrates the types of varn as classified by amount of twist, as follows:

Zero twist. Possible only in raw reeled silk (filament) yarns, where the silk gum can hold the filaments together. (See "Silk Production" in Section Two for the significance of the stage and method of degumming silk to produce a "lively" fabric.)

Very low twist. 1–2 turns per cm or 3–5 per inch, possible with any filament yarn because the strength of the yarn does not depend on twist and fiber cohesiveness, as it does in spun yarns; all that is needed is enough twist to keep the filaments together during processing into fabric. The lowest twist in spun yarn, about 2–5 turns per cm or 5-15 per inch, is used in the weft (crosswise) varns of a napped fabric, where the low or soft twist helps the tearing out of fibers. which are laid on the surface as nap. These are

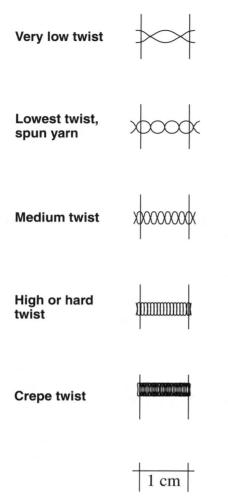

Figure 3.3 Degree of yarn twist from very low to very high (crepe).

taken from weft yarns in wovens or from laid-in yarns in weft knits. Low-twist yarns are also used for the pile of candlewick fabric.

Medium twist. 8–10 turns per cm or 20–25 per inch, used for most spun yarns, e.g., sheeting. Strength increases with twist, up to a very high amount, but will eventually lower strength. **High or hard twist.** 12–17 turns per cm or 30–40 per inch, used to give the firmness of voile. *Twist-on-twist* yarns are used for the highest-quality voile; these are hard-twist yarns formed by twisting the plies in the same direction as the singles to give a lasting firmness to the fabric. The yarns are difficult (and so more costly) to process.

Crepe twist. 17–30 turns per cm or 40–75 per inch, the highest twist of all. When made of fibers that absorb moisture, the fibers swell in the wet-finishing creping treatment and form tiny bumps on the surface to give the pebbliness of *crepe*. For plied crepe yarns, singles are first twist-set to make them less lively and "kinky," then plied with twist at 1–2 turns per cm.

The amount of yarn twist has a considerable effect on luster: Low-twist yarns of smooth filament have a high luster, while high-twist yarns such as crepe give a duller, matte effect and a lively, drapable fabric.

Yarn Classified by Linear Density (Count or Number)

Linear density, notated as count or number, refers to what the consumer would perceive as the thickness or weight (mass) of a yarn or thread. The size of a yarn and its notation (the way it is specified) are of particular importance to those working in the textiles industry or to designers of woven and especially of knitted fabrics. As well, certain quality terms used in merchandising are related to yarn number (see "Indirect Yarn Number" below).

Traditionally there have been two methods of recording yarn count: indirect and direct yarn number.

Indirect Yarn Number

This is calculated according to the length of yarn spun from a given mass; the larger the number, the finer the yarn. This system has been used for spun yarns of staple fibers, with a slightly different base for each of the major natural fibers.

A #1 yarn would be the following lengths weighing one pound (or spun from one pound of fiber): cotton (English system), 840 yards; linen (wet or dry spun), 300 yards, count called a *lea*; wool (worsted system), 560 yards; wool (woolen system), 256 yards. For woolen yarns there is also the *run* system, in which for a 1 run yarn a 1,600-yard hank weighs one pound. Woolen yarns are usually singles and range from 0.5 run (coarse) through those in tweed jackets (yarns of 2 to 3 run) to hosiery made of finest yarns, of 8 run.

Cotton sewing thread numbers are based on the English cotton yarn count, with #10 being a very heavy thread, #50 medium, #80 quite fine. A custom-made cotton shirt may be promoted as using "2-ply

160" yarn—stronger because it is 2-ply and fine, the equivalent of a single 80s (the s is added in textile circles but usually dropped in advertisements to the consumer).

Many of the indirect yarn counts have converted to tex (see "Direct Yarn Number"), but in the United Kingdom, the woolen and worsted counts persist. As noted in Section Two, wool fiber quality numbers are related to the count of worsted yarn, with 40s coarse, 60s finer (botany), and 80s or higher very fine (Superfine). Superior suitings are often described with these numbers, such as "Super 100s."

Direct Yarn Number

This is calculated according to the mass of a given length; the larger the number, the heavier the yarn.

Denier has been the best-known direct system in traditional counts. It is based on the weight of a Roman coin, developed to describe silk (filament) yarns and used also for MF filament yarns. Denier is the number of 0.05 g units in 450 m of filament (or g/9,000 m). The range of varn size in consumer articles is from 7 denier in some very sheer hosiery to over 1,000 denier in luggage and footwear.

The SI metric system (see Section Nine description) calculates the number of all yarns using a direct metric unit: tex. Tex is the mass in grams of 1,000 meters of the yarn (g/1,000 m). Tex will usually be used for spun yarns, with kilotex (ktex) (kg/1,000 m or g/m) for coarser units such as sliver or tow, and decitex (dtex) (g/10,000 m) for finer yarns, especially filament. It is easy to see that the decitex count of a filament yarn (g/10,000 m) will be close to denier (g/9,000 m), but the traditional spun yarn counts are very different from tex.

Yarn Notation

Notation is identification of yarn construction and count and differs according to the fiber the yarn is made from, as follows:

Cotton yarn. The notation 60s/2 means a 2-ply yarn made up of singles that are each of traditional cotton count 60s (9.8 tex); the resultant yarn is equivalent to a traditional cotton 30s (19.7 tex).

Worsted yarn. This notation is in the reverse order: a 2/60s also denotes two 60s singles plied, with the resultant yarn equivalent to a 30s. In marketing, this yarn number would probably be called 2/60 Nw, meaning two 60s singles plied, giving a "normal worsted" number (Nw). Yarns noted on the metric (tex) system would be identified as Nm or "normal metric."

Spun silk. A 2-ply yarn notated as 60s/2 means that the resultant yarn is a 60s count, made up of two plies of 120s count (4.9 tex).

If the count of a plied yarn is listed with "R" before it, this shows the resultant count and is giving the ply-to-single notation. After the "R" may be listed the direction and amount of plying twist, then a slash and the number of the singles in the plied yarn, followed if necessary by the direction and amount of twist. If the count (linear density) of the single is given, it is separated by a semicolon.

Yarns of fine filaments. These are notated as total yarn count in dtex or denier and the number of filaments in that yarn, in the formats shown below. To convert denier to dtex, multiply by 1.111; to convert dtex to denier, multiply by 0.9, as shown in the following comparison:

Total Yarn Count (dtex)	Number of Filaments	Total Yarn Count (denier)	Number of Filaments	
111	166/32 111/50 78/136		150/32 100/50 70/136	

3-2 SPUN YARNS

Conventional Processing

Hand methods of spinning, developed mainly for wool and flax, were the models for the machine spinning developed at the time of the Industrial Revolution; the machines, however, were applied first to spinning cotton. These machines developed from the first eight-spindle "spinning jenny" in 1764 to pervasive power machine spinning by the early 19th century.

Today, electronic controls have been applied not only to spinning but to virtually all of the processes of textile manufacture; it is interesting to note that in the making of Harris tweed, which is still handwoven in the Outer Hebrides off northwestern Scotland, the rest of the operations are done by the most modern, automatic machinery. The wool fiber scouring, dyeing, and blending are all computer controlled, as well as the yarn carding and spinning and the fulling to finish the fabric.

Main Conventional Processes

Today the main conventional systems for processing staple fiber into spun yarn are those developed for cotton and wool; what follows are those designed mainly for cotton.

Carding. All staple fibers are carded when being processed into yarn on conventional machines; Figure 3.4 shows the stages. After opening of bales, loose fiber is blended and formed into a picker lap, which goes into the carding machine; these can also be air-fed. Here, fine bent wires on revolving cylinders pull the fibers apart, remove waste, and begin to arrange the fibers enough that they can be spun into yarn; in cotton spinning, about 10 percent of the weight of fiber fed in is lost during carding. Fibers emerge from carding in a fine web, which is gathered together into a loose rope called a sliver, which is often coiled in cans. After carding (plus, for top-quality yarns, the additional processes of combing—see "Carded versus Combed Yarn"), fibers are taken through a number of stages to become yarn.

Drawing (drafting) and doubling. This is the process of running slivers between sets of rollers, each moving faster than the ones before, which draw out or draft a number of slivers to the thickness of one; this process is repeated until the fibers are well mixed.

Slubbing to Roving. Slubbing draws the sliver out to a strand about the size of a pencil, called *roving*, which is given a very slight amount of twist. This is the last stage before actual spinning into yarn.

Spinning. During spinning, the roving is drawn out to yarn size and given considerable twist to become yarn.

Types of Conventional Spinning Frames

Today, **mule spinning** is still done, with an *intermittent* action, adapted from the hand methods of the drop spindle or the large, single-belt wheel, where the drawing out and twisting was done as a first step, with the yarn wound up in a separate action. In mule spinning, a moving carriage on a frame draws out the rope of fibers, then the spindles insert twist; winding up is done as the carriage moves back.

The other types of spinning frames accomplish the twisting/drawing out and the winding up of the yarn as a continuous, rather than intermittent, process. Some spinning is still done on the earliest type of continuous spinning frame, the **flyer**, adapted from the hand spinning flyer wheel (see Figure 3.5). This familiar spinning wheel, which was sketched by Leonardo da Vinci around 1516, allowed the spinner to sit down to this constant chore and was adapted to flax spinning as the Saxony wheel by Johann Jurgen in 1533. Some spinning of wool by **cap spinning**, another continuous type of spinning frame, is also still done today.

Most conventional spinning now (e.g., of cotton) is done on the **ring spinning** frame. In ring spinning (shown in Figure 3.4), twist is inserted as the fibers from the roving are carried by the *traveler* around the edge of the *ring*, inside of which is the faster-rotating *spindle*. The roving is drawn out to yarn size and is simultaneously wound up on this faster-moving spindle. Ring spun yarn (also called ringspun or ring-spun) is still the predominant type of spun yarn, especially for cotton, as it can give strong, fine, and smooth

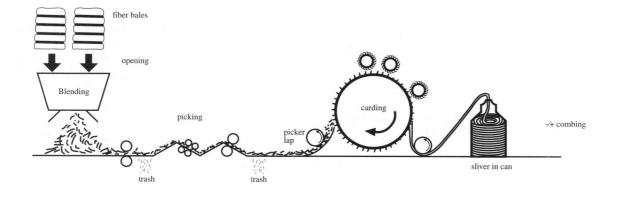

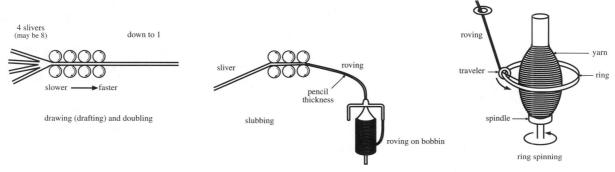

conventional spinning - staple fiber

Figure 3.4 Conventional spinning of staple fibers into spun yarn. Since about 2005, high quality 100% cotton

Figure 3.5 Hand spinning on a flyer wheel.

goods are often described in advertisements as "ring spun." It has taken on something of the cachet of "combed," and is used with articles from cotton duck overalls through thick bath towels to 300 thread count percale sheets. See advantages also under "Some Twists on Conventional Processing."

Carded versus Combed Yarn

Carded Yarn

Carded yarn has a fuzzy appearance and is loftier than yarn that is combed as well (see Figure 3.6). If spun on the cotton system, such yarn is called simply carded; on the wool system, it is called woolen. Fabrics made from yarn that is carded only have a more hairy surface and will pill more, and the weave or knit may be indistinct; this type of yarn in low twist is used for the weft in napped fabrics. Typical effects can be seen in most spun yarn fabrics.

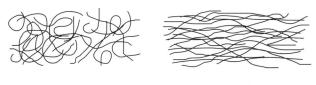

carded yarn

combed yarn

Figure 3.6 In carded yarn, fiber ends protrude; the surface of combed yarns is much smoother.

Combed Yarn

Only the "elite" of spun yarns are combed as well as carded. Combing removes any shorter fibers and arranges the remaining longest fibers more or less parallel to each other (see Figures 3.7[a] and [b]).

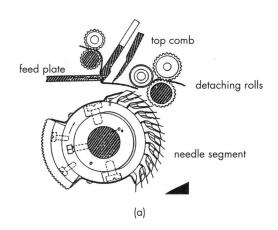

Figure 3.7 (a) The combing process removes shorter fibers and lays remaining fibers nearly parallel to each other. (b) Closeup of rectilinear combing machine. (Courtesy of Dominion Textile Inc.)

After combing, fibers are gathered into a loose rope called *top* in wool system spinning; in combing, about 15 percent further weight is lost.

When these fibers are spun into a tightly twisted yarn, it has a smooth surface. Spun on the cotton system, such yarn is called *combed*; spun on the wool system, it is called *worsted*. These special yarns are usually so identified in advertisements, whereas carded-only yarns are "no name." For typical combed yarn fabrics, see the *Fabric Glossary* Index under "combed yarns" and "worsted."

The main differences between fabrics made of combed yarns and those carded only are easier to see and feel with fabrics made of wool or blends. Worsteds (compared to woolens) will be relatively smooth, even, strong, and fine, and will have higher twist; most will have a firm hand (though worsted knitting yarns of fine wool will be soft). Woven fabrics made of worsted yarn will have a firm, smooth, often crisp feel, hold their shape better, take a sharp crease, show weave or knit distinctly (clear finish), and tend to develop less pilling.

Combed yarns cost more because (in most cases):

- More raw material is used, especially with wool, with more waste (at least one-third waste). Part of this expense in wool is due to the greater amount of waste in relation to fiber (see Figure 3.8). While a Merino fleece has slightly less suint (perspiration salts) and water, it has much more grease (lanolin) and dirt than the coarser fleece from an Australian Crossbred sheep.
- The raw material is the best and hence the most expensive: a long-staple cotton variety for the finest, smoothest combed cotton yarn, or the finest, softest wool, such as Merino for worsted. "Golden Bale" yarns spun by Lumb's in England of very fine Merino wool net only about eight pieces (150 suit lengths) in any year; the "Lansmere 210" worsted suiting yarn count of 150 offered by the large tailoring fabric manufacturer, Cheil Industries of Taegu, South Korea, is only enough for about 100 suit lengths in a year.
- It takes many passes through combing equipment to take out any shorter fibers and lay those that remain almost parallel to each other.

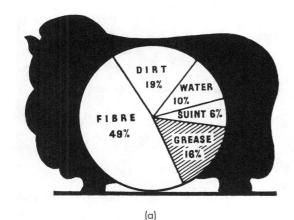

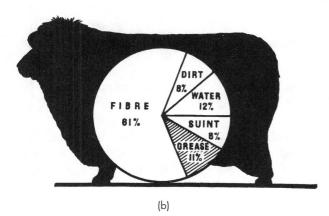

Figure 3.8 Amount of fiber compared to waste in (a) Merino fleece and (b) Australian Crossbred. (Courtesy of the Woolmark Company)

Some Twists on **Conventional Processing**

Compact Spinning

An extra process has been developed that pushes fibers together between the final drafting in conventional ring spinning and insertion of twist (see Figure 3.4). This added "compacting" results in a smoother yarn (fewer fibers protruding—less hairy), which can be stronger or softer, depending on the amount of twist put in. The results can be seen in comparison of a fabric woven of ring-spun yarns with one woven of Com4® compact yarns (by Rieter) (see Figure 3.9); there is more luster, and a clearer surface (prints would show more clearly). ComforSpun cotton yarns are so smooth they may

be able to be knitted with the fine needles on tricot warp knit machines, giving a spun tricot. Another area of use is with short-staple fiber where compact spinning can give better yarn.

However, to keep perspective, it should be realized that the above and the unconventional spinning processes that follow (vortex, rotor spinning, etc.) still leave standard ring spinning accounting for some ten times more yarn than even rotor spinning, principally because of the strength, fineness, and aesthetics of the yarn it produces.²

Sirospun and Solospun

The Woolmark Company has developed the Sirospun technology to give 2-ply yarns by spinning two strands and twisting them together in one operation instead of having a separate plying (folding) process; this greatly cuts the cost of producing the yarn. Going even further, Solospun is the Woolmark Company's technology that so improves abrasion resistance that lightweight yarns of wool can be woven as singles instead of having to use 2-ply.

OptimTM Technology for Wool

As a result of a research development by Woolmark/CSIRO,* an advanced technology for handling wool sliver resulted in the Optim™ process. introduced commercially in late 2001 as giving a "new generation" natural fiber. This procedure twists wool fibers in the sliver to lock them so that in extension the pull is on the fibers themselves. which are made finer. (This is comparable to the process described in the following "Unconventional Processing" under "Break Spinning," which converts MF filament tow into staple. Similarly, strains are left in the wool fibers which can be removed [relaxed or set], or left to develop bulk in later processing.) The Optim process can produce two variations. OptimTM Fine, with the wool fibers permanently set, is described as having the superior hand, drape, and luster of silk. The other variation is Optim™ Max, where the fibers are left with an average extension of 20-30 percent, which can go back to the original length during wet treatment to give a bulky yarn.

*Commonwealth Scientific and Industrial Organisation, Australia's national science agency.

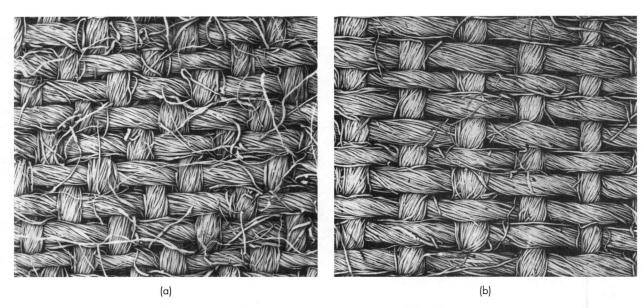

Figure 3.9 (a) Fabric woven of ring-spun yarns. (b) Fabric woven of $Com4^{\circ}$ or ComforSpun compact-spun yarns shows a smoother, less hairy surface. (Courtesy of Rieter Machine Works Ltd.)

Unconventional Processing

Open-End, Rotor, or Break Spinning

This type of spinning takes fibers from a sliver and in one machine, within a very small space, produces yarn (see Figure 3.10). This is in marked contrast to the succession of processes in conventional carding and spinning. The fibers from the sliver are laid into a groove inside a rotor by centrifugal force—like clothes flung against the drum of a washer in spinning extraction. The fibers are peeled off to join the end of already formed yarn. This method does away with many steps of conventional spinning and so is very economical; it is used mostly to spin coarser cotton yarns, e.g., for denim. To produce finer yarns, the rotor must turn faster, and this takes a lot of energy. MF fibers can clog the rotors. However, open-end spinning is now used widely throughout the world.

Air-Jet Spinning

This is the other major unconventional process to challenge ring spinning. Drafted sliver is led into first one, then a second nozzle, in which jets release air at high pressure, with the direction of airflow in the second nozzle being the opposite of that in the first. By this means, during passage through the nozzles,

some fibers get wound around the main group, producing a yarn. This process is very fast, producing yarn at higher speeds than open-end and many times faster than ring spinning.

Vortex Spinning

Murata Machinery introduced *vortex spinning*, in which, after drafting, fibers from the sliver are dragged by an air current to wrap around a hollow (stationary) spindle, imparting twist. This is promoted as spinning at high speeds, and giving smooth yarn.

A number of other nontraditional methods have been developed to spin fibers, already in staple form, into yarn, but none has yet made a significant impact in the marketplace: electrostatic, friction (DREF II, a variation on open-end spinning), "disc," twist, self-twist, false-twist (staple), and adhesive spinning.

Direct Spinning

Direct spinning is an economical method that takes MF fiber tow, breaks it into staple fiber, and then converts it into sliver or yarn on one machine (see Figure 2.52). Staple from this process will have tensions or strains in the fibers until it is relaxed, e.g., by steaming. When such fibers with "latent shrinkage" are blended with others that have been shrunk

(a)

(b)

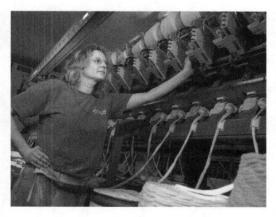

(c)

Figure 3.10 (a) Open-end spinning—sliver below to yarn above in a very small space. (b) Closeup of the rotor where fibers from the sliver are twisted into yarn. (Courtesy of Dominion Textile Inc.) (c) Open-end spinning frame, Guildan Activewear. (Courtesy of Canadian Textile Journal)

or stabilized, a "Hi Bulk" yarn can be created; the fibers that shrink "elbow out" the others to give a more open, bulky yarn. Bi-Loft (by Solutia). Cresloft (by Sterling), and Recoil Courtelle (by Acordis) are high bulk acrylic yarns.

Furlike fabrics with guardhair/underfur effects can also be achieved, as mentioned under "Acrylic Fibers" in Section Two. Finer, high-shrink fibers are blended with coarser, stabilized fibers; after steaming, the finer fibers shrink to form the "undercoat" in a fake fur, while the coarser fibers remain on the outside, like the guardhairs of real fur (see "Knit Pile," Section Four).

3-3 FILAMENT YARNS

Cultivated or reeled silk is the only natural filament, with a maximum length of $1.5\,\mathrm{km}$ (nearly a mile) but one cocoon usually yields only $500\text{--}1,000\,\mathrm{m}$ or yards of usable fiber. MF fibers can be produced in virtually endless continuous filaments when extruded from the holes of a spinneret, and most are made this way.

Filaments can also be created very economically by splitting film (usually polypropylene) into fine strips to make flat fibers (called split-film, fibrillated, stretched-tape, or slit-split filaments) (see Figure 3.11). This method is used to make twine and yarn for sacking, carpet primary backing, and for the backing for some sliver-knit pile fabrics. Fibrilon (by Synthetic Industries Europe) is a solution-dyed, fibrillated polypropylene yarn.

Standard MF filament yarns are even in diameter and relatively smooth. Yarns are formed of such filaments by gathering them together as they are extruded from the spinneret (see "Spinning Methods" under "Spinning Manufactured Fibers" in Section Two).

Textured MF filament yarns have had the filaments disarranged so that the yarn is no longer smooth and compact; these bulked continuous filament (BCF) yarns are often processed by throwsters using partially oriented yarn (POY), mentioned under "Nylon" and "Polyester" under "Synthetic Manufactured Fibers" in Section Two. In this case, the process is really draw-texturing, since the drawing of the fiber is completed along with the bulk texturing.

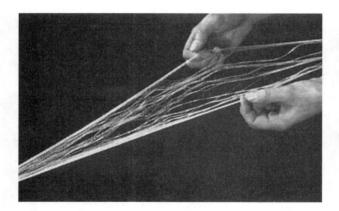

Figure 3.11 Formation of split-film filaments by fibrillating polypropylene film. (Courtesy of the Textile Institute)

Textured Manufactured Filament Yarns

Textured versus standard filament yarn has more bulk and so has better insulating properties and creates better cover. It has less shine and snags more easily. There is better absorbency than with a standard filament yarn of the same fiber.

Specific texturing effects can be stretch, crimp, loop, or a texture more like spun yarns, but all of these are more economical and easier to produce than spun yarn from staple fiber.

Textured yarn of microfibers has even more bulk, since there are so many more filaments in a yarn of equal count; Figure 3.12 shows the increased bulk given by using microfiber polyester (formerly made by Acordis) compared to a standard-size textured filament.

Stretch Texturing

Stretch-textured filament yarns have a springiness that has been heat set into the filaments by a number of methods. Such stretch yarns are produced and used

Figure 3.12 Textured yarn of microfiber polyester has much greater volume and softness than one of the same count made of standard textured filament fiber: (a) 100 dtex f 36, (b) 100 dtex f 144. (Courtesy of Acordis)

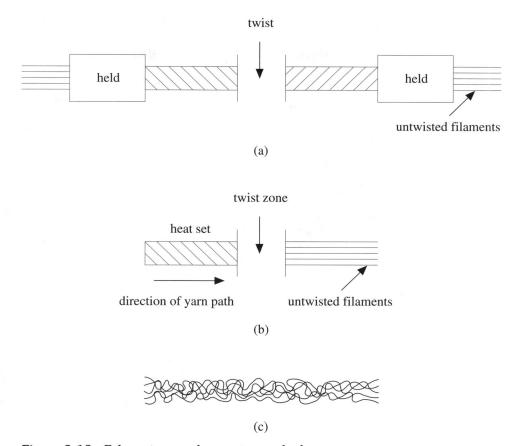

Figure 3.13 False-twist stretch texturing method.

mainly in nylon or polyester and all kinds of body-fitting clothing, giving comfort stretch, fashion fit, or fewer sizes (for "power" stretch, some elastomer is needed; see "Spandex (Elastane)," Section Two.)

False-Twist

False-twist yarn is so-called because, if a filament yarn is held at two points and twist is inserted between these points, the twist in the left portion is equal and opposite to that in the right portion. If the twisting point is removed, the two twists cancel each other out and the filaments return to their untwisted state (see Figure 3.13[a]). However, in producing a stretch yarn by the false-twist method, thermoplastic filaments are not static; since they are moving through the machine, they are heat-set while they have a coil from twisting (Figure 3.13[b]), but the twist is removed as they come off the spindle to be wound, so they retain their crimped form (see Figure 3.13[c]). This type of stretch yarn is the least expensive to make and can be single or ply, unlike Helanca.®

Coil, Step-by-Step, Twist-Heat Set-Untwist

This is the oldest method, being the one by which Helanca[®] (by Heberlein) stretch yarn is made. Twisting puts the yarn into a coil-spring shape, which is set by heat. The yarn now has stretch, but also tends to twist or torque; to counteract this tendency, each of these stretch yarns is plied with another yarn twisted in the opposite direction. This method still gives strong stretch for a textured filament (see Figure 3.14) but cannot produce a monofilament (single ply) stretch yarn for sheer hosiery.

Knit-Deknit

This type is made by knitting up a tube of fabric, heat setting it, then unraveling and winding up the yarn, kinked in the shape of the knit stitch, on cones (see Figure 3.14).

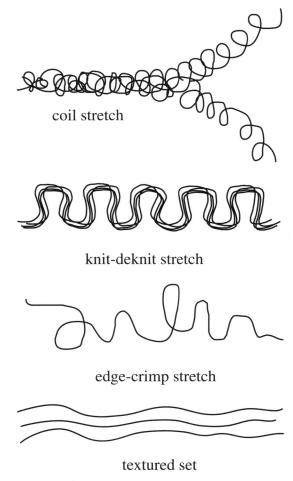

Figure 3.14 Various filament stretch texturing methods (other than false-twist—see Figure 3.13).

Edge-Crimp

This gives a curl to yarn by drawing heated filaments over a knife edge and flattening them on one side, resulting in a randomly curly stretch yarn (the effect we get pulling giftwrap ribbon over a sharp edge) (see Figure 3.14). This method is used to make Agilon (by Milliken), and was important before the development of false-twist, since it gave a single-ply stretch yarn, needed where monofilament was to be used for sheer hosiery.

Textured Set

Textured set yarns are what we generally mean by textured. Yarn is first false-twist processed then

steamed to remove the stretch and leave just a crimp (see Figure 3.14). A crepe yarn effect can also be given by these textured set yarns, although it usually has little of the drapability and liveliness of a true high-twist crepe yarn. Crimplene polyester (by ICI) was a well-known trademark name in the doubleknit explosion of the 1970s. The general term *crimpknit* still refers to doubleknits made of textured set polyester yarns.

Crimp Texturing

Crimp yarns have some degree of stretch, plus some bulk. Filaments are given a wavy crimp by being fed into a heat setting *stuffer box* faster than they are led out so that they pile up in a wavy mass. Crimp is also put in by heated gear or tunnel methods.

Air Texturing or Interlacing, Air-Jet Texturing, Loop Texturing

Air- or loop-textured or air-jet yarns are produced by feeding filaments over or past an air-jet faster than they are taken up by rollers. The blasts of air force some of the filaments into loops. Visible loops give a bouclé effect, texture, and bulk, but no stretch. This method can be used to give these characteristics to fibers such as rayon and glass (as well as to fibers such as nylon), since there is no heat setting involved. A well-known trademark name is Aerocor® glass (by Owens-Corning).

Spun-like Effect

Tiny loops, virtually invisible, give a spun-like effect to filament yarn; the process may also include random breaking of outer filaments. These yarns are now being made with microfibers to achieve a hand more like fine cotton or wool yarns. Supplex[®] and Tactel[®] (by Invista) have a cotton-like feel, and are made of very fine fibers, probably in some cases microfibers. However, currently the names represent the properties of the yarn, not a particular type of textured MF filament yarn. Supplex and Tactel may or may not be air-textured.

3-4 NOVELTY (FANCY **OR COMPLEX-PLY) YARNS**

Novelty (also called fancy or complex-plu) varns have a built-in irregularity: the plies differ in construction and/or are twisted together at different tensions or speeds. These yarns are more expensive than simple ones, usually contribute textural interest to fabrics, and some increase insulation by trapping air.

The many types of novelty yarns are divided here into their main groups. Not all conform to the "classic" novelty varn diagram and sample shown in Figure 3.15; these have three distinct components. but many will have one or two effect plies with a core or tie yarn, and some will be singles. In a classic novelty yarn, one ply forms a core or base. Another ply around it makes the effect, be it loop, nub, slub, or wrapping. Figure 3.15 shows a closed-loop type (bouclé). The effect ply is held to the core by a (usually fine) tie varn or binder.

Main Types of Novelty Yarns

Loop Yarns

Loop, curl, bouclé, bouclette, and gimp yarns all have closed loops along the yarn, seen in Figure 3.15: gimp varns give the small loops in ratiné fabric. Spike and snarl varns have open loops. Loop varns add textural interest to fabrics, although they would not be suited to take hard wear. Some, especially if made with wiry mohair, give insulation by trapping air—type shown in Figure 3.15.

Nub Yarns

Nub, knop, knot, spot, nep, knickerbocker, and bourette yarns all have an effect ply twisted many times in the same place, or small tufts of fiber twisted into the core to give small lumps or thickenings in the varn (see Figure 3.16). Tweed is a fabric in which nubs, often of different colors, are characteristic.

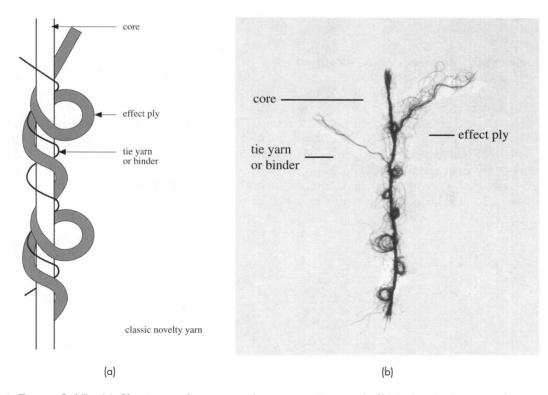

Figure 3.15 (a) Classic novelty yarn, with core, tie yarn, and effect ply—in this case, forming a closed loop. (b) Sample of closed-loop novelty yarn, showing these classic three elements: core, tie yarn, and effect ply.

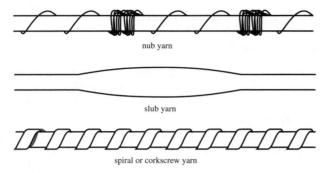

Figure 3.16 Nub, slub, and spiral or corkscrew (wrapped) novelty yarns.

Slub Yarns

Slub yarns are thick-thin, of irregular thickness, often with soft, untwisted places at intervals (see Figure 3.16). **Flake, flock,** and **seed yarns** are similar, with longish tufts of roving held by a tie yarn. Slubs are typical of linen fabric and of materials made of wild silk, such as shantung, pongee, honan, and tussah, and of douppioni (dupion) silk.

Wrapped Yarns

Spiral, corkscrew, covered, and **wrapped yarns** have a core with wrapping around it (see Figure 3.16). In a decorative yarn, filament is usually wrapped around cotton. For some purposes, as in display, the core may be a wire, so the yarn will hold the shape into which it is bent. Rubber yarns are always covered, usually with cotton yarns, and since the rubber core does not take dye, it can *grin through* when the yarn is stretched; spandex can be used unwrapped, but when it is the core in a

wrapped yarn, it takes dye and does not grin (show) through.

Some novelty yarns do not conform at all to the classic construction discussed. Two of these follow.

Metallic Yarns

These are most often made of strips of foil, usually aluminum "sandwiched" between layers of film to prevent oxidation; coloring can be introduced in the film or the adhesive used for lamination. Yarns will differ in price, strength, and heat sensitivity according to whether the film is acetate or (better quality) polyester. Other metals used historically are either very expensive (gold) or tarnish badly (silver, copper). The fabric name connected with metallic yarn is lamé.

Metallic yarn trademark names are Lamé (the same as the general fabric name referred to above), Lurex[®] (by BASF), and Metlon. A letter *M* after the trademark name may indicate that the film covering is Mylar[®] (by DuPont) polyester film.

A few metallic yarns are made with metallic particles incorporated in the filaments; this can give a fine, smooth yarn, more suitable for knitting.

Chenille Yarn

Chenille yarn is the "caterpillar" yarn, produced traditionally by a leno weaving process; see Figure 4.42 under "Types of Weaves" in Section Four.

There are also **mock chenille yarns**, made to give a fuzzy surface much more cheaply by various methods. A fairly soft, fluffy surface can be achieved by twisting together two spiral yarns in which the effect ply is soft and wound loosely around a finer core.

LINK 3-1, 3-2, 3-3, 3-4 WITH FILES IN FABRIC GLOSSARY

These illustrate how yarn type and classification affect fabrics; and in what ways spun and filament yarns and novelty yarn types are significant for certain fabrics made with them. Look these up for a fuller understanding of how this contributes to the fabric character and behavior, or is an essential part of its name. You will also find photos of these named fabrics, as well as other related textiles.

Fabric Glossary Fabric Name	Relationship to Fabric Reference Discussion
Look names up in the Fabric Glossary Index.	
Bouclé under Loop Yarn	A major type of novelty yarn, makes both aesthetic and practical
Tweed	contributions to fabrics. Tweed almost always has nubs of color in its yarns; Donegal is an outstanding example.
Linen or Linen-like, Shantung, Satin/Shantung or Antique Satin	These woven fabrics are all characterized by having slubs in at least one set of yarns (with linen, in both).
Gimp (Guimpe) "Braid"	This narrow trim has decorative wrapped yarns on its surface. (It is not braided, hence listed as "braid.")
Lamé	Any fabric called lamé will have a metallic gleam, which may or may not come from an actual metallic yarn.
Chenille (from Chenille Yarn)	This yarn is actually prepared from a woven material, and so is quite expensive to make. There are cheaper imitations, since chenille makes a wide variety of attractive woven or knit materials.
Silk, Cultivated; Satin	These represent characteristics that fine, smooth, continuous filament yarns contribute to fabrics.
Braid	Monofilament yarn made with synthetic materials is used in this specialized stiff braid that has also been made of horsehair and mohair.
Spun Satin	Short (staple) fibers can be seen protruding from the yarn surface. Twist (certainly in warp yarns) is lowest, with certain results.
Tufted Chenille or Candlewick Sheeting	Twist of the tufting yarn is low; use is made of this in finishing. Represent the great bulk of fabrics: medium twist spun yarn.
Voile (cotton)	High or "hard" twist, very fine yarns, best quality "twist-on-twist"; see photos.
Chiffon, Crepe, Georgette	Highest "crepe" twist, related to properties of crepe fabric.
Spun Silk or Rayon	Description "spun silk" indicates fabric made with short waste silk (staple) fibers, not reeled filament.
Flannelette, Fleece, Knit, Single Face	These fabrics have low twist spun yarns running across the back of the material, from which fibers are torn in napping.
Broadcloth (Cotton), Lisle, Tropical Worsted, Worsted Suiting	High quality of these fabrics will be made with combed yarns, to give a smooth surface.
China Silk, under Silk, Cultivated Satin (made of MF fiber)	These are examples of fabrics made with standard filament fibers, one natural, one manufactured.
Split-Film	This yarn is made by splitting a thin film into (flat) filaments.
Stretch, Comfort or Fit	MF filaments can be textured to give various degrees of stretch.

3-5 THREAD AND CORDAGE

Thread, which holds fabric sections together in seams to create a garment or other textile article, is really a specialized yarn. It has to be strong, so it may be multiply or cord to give strength with pliability.

Thread strength will depend on how even the varn is (few knots, slubs, or nubs) and its fiber content. Strength needed to sew will vary with the type of machine and speed; strength needed in use will vary with reaction to heat in sewing and pressing, perspiration, and chemicals met in cleaning. In general, it is better if thread tensile strength is less than that of the garment fabric, so that under strain, the seam will break before the fabric tears. As well as strength, colorfastness and shrinkage resistance of thread must be suitable for recommended fabric care methods. Flex resistance of thread is also very important to the life of a seam, with nylon and polyester having good flex abrasion resistance. Specialized garments need seams of like performance to the main fabric, e.g., water repellent or flame resistant.

Types of Thread

Cotton thread is the only natural-fiber thread in wide use; the other main types are synthetic, both spun and filament.

Cotton Thread

Cotton thread has the advantage of resisting high temperatures, either the heat generated in high-speed sewing or the heat of pressing garments. The best cotton thread is not only of cord construction but mercerized for added strength and luster. A #10 cotton thread is very heavy, #50 is medium, and #80 is fine (see "Indirect Yarn Number"). It is not suitable for fabrics of high-strength synthetics, such as nylon and polyester, as the seam will be of significantly lower strength and abrasion resistance than the fabric and might shrink. Cotton thread is also more expensive than, for instance, spun polyester thread.

Cotton thread comes as *soft* (slightly fuzzy, with no finishes, and so less expensive) or in various finishes, of which *mercerized* has been mentioned. *Glacé* is polished (with a smooth wax, starch, or resin

finish), and strong; it is used in making shoes and canvas goods. (The equivalent synthetic thread, filament or spun, is *bonded* to give a smooth, protective coating for heavy-duty sewing uses.)

Synthetic thread (nylon, polyester) is made in both **spun** and **filament.**

Spun Polyester

Spun polyester is now a standard for general sewing, giving good sewability, seam strength, stitch locking, and abrasion resistance. It adapts well to a wide variety of sewing machines, is least costly, and is not likely to cause seam puckering (as nylon is).

Filament Threads

Monofilament

Monofilament, also called *colorblending thread*, is usually made of nylon. This is a single filament, rather like a fine fishing line. Since it is translucent, virtually no changing of thread is needed to match a complete range of fabric colors with just clear and dark monofilament thread. It is strong but stiff, unravels readily (from a chain-stitched hem, for instance), and may shrink in washing.

Multifilament

Regular multifilament gives a smooth yarn, stronger and with less bulk than spun, but with a tendency to slip. It is used in guilting and in lingerie sewing.

Bulked or Textured Filament

This has stretch and is used as serger thread, for hems, and in activewear. It is inexpensive and so is preferred for serging, which uses large amounts of thread.

Specialized Threads

Corespun is costly thread, but solves the problem of polyester fusing from excessive needle heating in high-power machine sewing by wrapping a polyester filament core with a (spun) cotton cover.

Elastic thread is usually a spiral-wrapped novelty yarn with a core of rubber or spandex.

Embroidery and buttonholes require specialized threads in home sewing, as in manufacturing.

Silk thread is rarely used by the home sewer but is still made, both filament and spun, for some high-grade custom work. It is strong, has a degree of give, takes good colors, and behaves well in sewing wool and silk fabrics.

Solar reactive thread shows no color under indoor light, but brilliant color in sunlight.

It is important to use a **specialized thread** with fabrics of microfibers; the thread must be very fine, have some elasticity, be well balanced, and shrinkproof to avoid difficulties in sewing.

REVIEW QUESTIONS SECTION THREE

- 1. Explain one difference between spun and filament varn in each of: look or feel (hand), comfort, durability.
- 2. If only one set of yarns in a woven fabric is plied, which will it be and why? Discuss the reasons in relation to either material for slacks or for drapery.
- 3. Name a fabric where the lowest twist (filament) yarns are used. Do the same for spun yarns of low twist, medium twist, and high twist. Note in each case the effect or use made of that degree of twist in that fabric.
- 4. Describe three effects that increasing amount of twist in yarn has on fabric made of it. What fabric name epitomizes most of the effects of using highest twist yarns?
- 5. What is the most-used spinning method for staple fibers? Name three other methods used to a significant extent, although much less than the first. What are the advantages of the first?
- 6. What are the two main results of combing in conventional processing of spun varn?
- 7. Name three features other than combing of yarns that contribute to the highest quality (and price) of the best sheeting or dress shirt fabric. Do the same with worsted suiting.
- 8. Explain how spinning can achieve a coarser 'guardhair"/finer "underfur" effect in a fake fur fabric. Is this really an effect from yarn?

Cordage

Braided structures make up cordage, which includes ropes, cables, and hawsers. Rope, the thinnest of these, is multi-ply for strength, and has been an important type of "yarn" for ten thousand years—just think of fishing nets, rigging for sailing ships, or the means of hauling loads. In the last sixty years, fiber cordage has been developed for many specialized industrial applications, making use of high performance materials in place of steel cables for building construction, towing, bridges, mooring oil rigs, and other uses.3

- 9. What are five advantages which can be added with texturing of manufactured filaments? What is a main disadvantage?
- 10. Which method of texturing filament yarn gives the most stretch? Can this type of yarn give "power stretch," as used in swimwear, bicycle shorts, etc.?
- 11. What type of texturing does not use heat setting? For what manufactured fiber types does this provide a means of filament texturing?
- 12. What are the components of a "classic" novelty yarn? How do these usually compare in size?
- 13. What is the difference between a gimp yarn and a spike yarn? Between a slub yarn and a flake yarn?
- 14. What yarns are always wrapped, although they are not used for "novelty" effect?
- 15. What is used today for the metal in fancy yarns? How are different colors achieved?
- 16. Why are chenille yarns expensive to make the traditional way? How can they be imitated by a less costly method? What would be advantages of chenille made by the original method?
- 17. What is the most-used type of sewing thread for apparel? For interiors, e.g., in drapery? In each case, why is this used?
- 18. What is color-blending thread? What advantage does it have in commercial stitching? What disadvantage does it have for consumers?
- 19. Name two products in common consumer use which represent the rope (cable) construction.

INVESTIGATIONS TO DO WITH YARNS

- Collect five samples of yarns (raveled from fabric, knitting or craft yarn, thread, cord, twine, etc.) Record for each whether it is single, plied (how many?), or cable. Record whether each (part) is S or Z twist, and try to find (or estimate) the degree of twist.
- 2. Collect samples of fabrics made with yarns with degree of twist from low to high. Note the effect on appearance and hand (feel).
- 3. Consult the Index of Fabric Glossary for names of fabrics made with combed yarn; in most other fabrics of spun yarn, it will be carded only. Collect three to five examples of cotton (family) fabrics made with yarns that are carded only, and others that are combed. How can you tell when combed yarns have been used? Do the same with wool (family) fabrics, where combed are described as worsted.
- 4. Find cotton thread identified by number (various, if possible), and a description of men's (high quality, possibly custom-made) cotton dress shirts where yarn type or number is recorded. What do these numbers signify?
- 5. Find an example of a fabric made using each of these types of novelty yarn: loop, nub, slub, wrapped, metallic, chenille. Note if it represents a particular name within that type (e.g., gimp or snarl within loop).
- 6. As a class, or working in teams, collect samples of as many as possible of the following sewing threads, and compare them as to smoothness, luster, and strength: cotton, spun polyester, monofilament (color blending), multifilament, bulked (serger), corespun, elastic, embroidery, silk.

NOTES SECTION THREE

- Jenny (pronounced "jinny") is a corruption of engine, in spite of the persistent tale that James Hargreaves named the machine for his daughter Jenny.
- 2. Phil Owen, "Why ring is still king," *Textile Month*, February 2000: 10, 12.
- 3. John W. S. Hearle, "Ropes and Cordage 1—The First Ten-Thousand Years," *Textiles Magazine*, Issue 4, 1998: 8–13; "Ropes and Cordage 2—Fifty Years of Change," *Textiles Magazine*, Issue 1, 1999: 9–15.

SECTION FOUR

Fabric Constructions

4-1 FABRICS—TWO SIDES

Fabric was described in Section One as including products woven, knitted, braided, twisted, felted, and non-woven, sheets of film or foam, even leather and fur—all used today as textiles. This section will therefore discuss all these types of construction.

Fabric Right Side versus Wrong Side, Face versus Back

Many fabrics are functionally reversible; they have no built-in difference between face and back, though one side may be given a slight luster in finishing. These are often unprinted fabrics in plain weave and may have yarn-dyed checks or stripes; reversible compound weave fabrics are discussed in the Fabric Glossary.

Many fabrics do have a definite **face** (usually used as the **right** or upper side) as compared to the **back**; these concepts are discussed further in the Fabric Glossary under Notes on Mounting Swatches. There are some general rules for distinguishing the face of a fabric from the back; with fabrics, however, there may be an exception to any rule! Beyond these general guides, the face of many fabrics will be apparent when the particular characteristics of that fabric are known, as with the puffed surface of matelassé or the soft napped side of wool broadcloth.

General Guides to Fabric Right Side and Face

The right side will (usually):

- be more closely constructed (to take wear).
- be more lustrous (except antique satin).

- show design (especially a print) as brighter or more distinct.
- have more marked texture: twill line, ribs, cords, slubs, nubs, pattern with raised outline, puffed or blistered-looking surface, pile, nap (except fleece, single face).
- have fewer imperfections; knots will be put to the back at the selvage.
- be folded to the inside as shipped from the manufacturer.
- have smaller tenter holes, rising in the shape of a volcano, usually on the face.

Particular Guides to Fabric Right Side and Face

Twill Line

Twill line with even twill weaves of the wool or silk family will be up to the right or *right hand*; you must know the warp direction to apply this guide. Twill line with cotton family twills may be left or right. Warp face twills (such as gabardine) have virtually no twill line showing on the back.

Stitch Side

In plain stitch (jersey) knit fabrics, the shank of the stitch is the technical face, though not always used as the right side (see *Fabric Glossary* under Notes regarding Mounting Swatches). Similarly, the side of tricot knits that looks like jersey or plain (filling) knit is the technical face, though again not always used as the right side.

4-2 WEAVING—GENERAL

Weaving is the process of interlacing two or more sets of yarns at right angles to each other; these yarns lie parallel and perpendicular to the fabric edges. (This distinguishes a weave from a braid, in which the yarns are at right angles to each other but diagonal to the fabric edges.) This is done on a loom or (current industry term) weaving machine.

Weaving has been used more widely than any other method of fabric construction and gives a tremendous range of fabric character; if you go through the Fabric Glossary and pick out just the simplest, plain weave fabrics, you will be amazed at the variety, to say nothing of all the more complex weaves.

The yarns that lie parallel to the fabric edges laid down first in the loom—are the warp yarns, also called ends. Yarns inserted in the crosswise direction are called weft or filling, also picks or (archaic, literary) woof. (See Figure 4.2[a]).

The direction of the warp is called the lengthwise grain; the direction of the west, the crosswise grain (see Figure 4.1). Most articles hang and wear better if cut so that the lengthwise grain is vertical; for this reason, it is also called true grain. Sometimes use is made of the "give" in the yarns when fabric is cut on the diagonal or bias. (See Figure 4.1.)

Speed in Weaving: Notation

Speed in weaving has been notated in picks per minute (ppm), i.e., insertions of weft per minute, also called WIR (weft insertion rated). The basic top

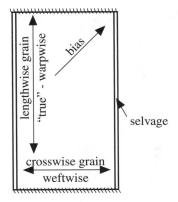

Figure 4.1 Grain (lengthwise, crosswise) and bias in woven fabric.

speed of a shuttle loom is 200 ppm. With the varying widths of looms, a more uniform comparison of speed in weaving is meters per minute (m/min); basic top speed of a shuttle loom is 400 m/min. (There are no conversion figures given—weft insertion is quoted only in m/min and loom widths only in cm. When comparing widths with shuttleless looms, therefore, keep in mind that a loom 150 cm wide weaves the traditionally "wide" [60"] fabric; the widths capable on some models of the new looms are several times this.)

Types of Looms (Weaving Machines)

Shuttle Looms

Shuttle looms (also called **fly shuttle**) are the standard, historical type; see the simplified diagram in Figure 4.2(a). With this type of loom, the west yarn, wound on a bobbin, held in a metal-tipped shuttle, is hit across the loom by the action of a picker stick, through the shed or space created when a group of warp varns (attached to one or more harnesses) is raised; thus the weft interlaces to form the weave. (The shed can also be clearly seen in Figures 4.3(c), 4.6. and 4.38—not all shuttle looms in these pictures.) The weft yarn (pick) is then beaten up (pressed into place) by the action of the reed, batten, beater or sley (slay); a different selection of harnesses is raised (shedding); and the shuttle travels back, carrying the weft yarn. The process is: shedding, picking, beating or battening, taking up (of finished fabric), along with the letting-off of more warp yarns. When yarn in the bobbin gives out, shuttle changing is automatic on modern power looms. The edge of the fabric just woven is termed the fell. The term sley (reed) is also used to mean the number of warp ends per inch; "high sley" then means many warp yarns per inch.

A box loom is a special shuttle loom that presents a shuttle of the correct color of yarn as required for a pattern with multicolor weft (vertical stripes are laid down in warping). A shuttle for each color needed in the weft is held at the side of the loom and is selected automatically as needed.

Dobby and jacquard are special loom attachments developed first on shuttle looms, but now used on other types; see Harness Control and Jacquard Control for details.

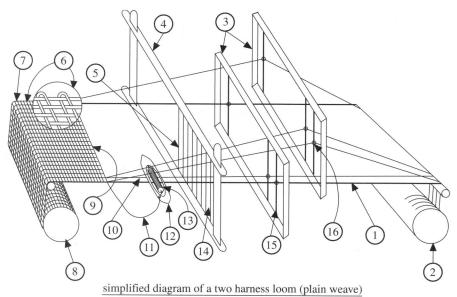

note: repeats of all parts not shown

- 1. warp yarn or end
- 2. warp beam
- 3. harness
- 4. batten, beater or slay
- 5. reed
- 6. selvage, selvedge
- 7. woven cloth
- 8. cloth beam
- 9. fell (edge of cloth as woven)
- 10. shed (space for shuttle) 11. weft, filling yarn or pick
- 12. shuttle
- 13. bobbin, pirn or quill
- 14. dent or split (space in reed)*
 15. heddle, heald
- 16. heddle eye

(a)

(c)

Figure 4.2 (a) Simplified diagram of important parts of a two-harness shuttle loom. (b) Modern automatic shuttleless looms in a weave room. (Courtesy of Masters of Linen/USA) (c) Flexible rapier weaving machine with eightcolor capacity. As with all shuttleless looms, yarn is fed from one side only. (Courtesy of Picanol N.V.)

^{*} If some warp yarns are left out, some dents will be empty, and a latticed or ladderlike openwork strip will result, called skip-dent or à jour (Fr. = "to the day{light}").

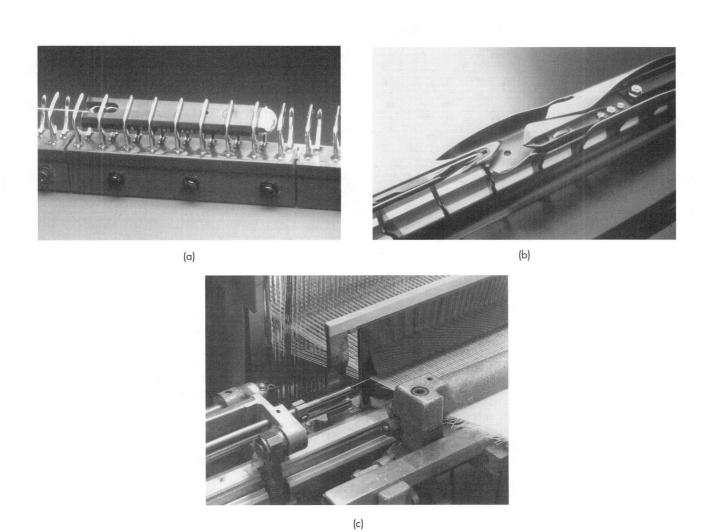

Figure 4.3 (a) Gripper carrying the weft yarn. (b) Two arms of rapier exchange weft yarn in the shed. (Courtesy of Sulzer Canada Inc.) (c) Weft yarn leaves the nozzle on an air-jet loom. (Courtesy of American Textile Manufacturers Institute, Inc.)

Shuttleless Looms

Shuttleless looms have increased the speed of weaving, are much quieter, and most take up less space on a weave-room floor. In all shuttleless looms, weft yarn is carried across from one side only (either premeasured and cut, or cut after insertion); this allows much larger yarn supplies than bobbins in a shuttle, and the shed can be shallower, putting less strain on warp yarns. See Figure 4.2(b) and (c), and Figure 4.4(a), as well as specialized shuttleless looms under "Jacquard Control of Complex Weaves" (Figure 4.27) and "Warp Pile Weaves," slack tension warp method (Figure 4.39).

The following are the major types and speeds of shuttleless looms. 1,2

Projectile, in which a small gripper takes the cut yarn across the loom; these may work from one side or both (see Figure 4.3[a]), and can weave fabrics of different widths at the same time. Speed is 370 ppm and up, and with wide looms (over 540 cm), weft insertion can be up to 1,400 m/min.

Rapier, rigid, or flexible looms represent the largest number of shuttleless looms and have been heralded as the "conventional loom of the future."3 They have two carriers mounted on flexible tapes with a guiding mechanism. The yarn is taken midway by one carrier to be picked up there by the other (see Figure 4.3[b]). Speed with a flexible rapier loom (see Figure 4.2[c]) is 700 ppm and up, with wide loom (400+ cm) weft insertion of up to 1,500 m/min.

Air-jet (pneumatic), where a puff of compressed air carries the yarn across (see Figure 4.3[c]). The width of such looms has been limited, but developments have been rapid and these looms are now set to excel water-jet. They are suited to spun yarns, absorbent fibers, and can run at speeds up to 1,800 ppm, with widths of 180 cm, giving around 3,000 m/min. They are used in all types of weaving including terry and jacquard.

Water-jet, in which a jet of water under pressure carries the weft across. This is obviously not suited to yarns of absorbent fibers, but reaches very high speeds when used with hydrophobic synthetics; speeds of 1,500 ppm or wide loom (up to 200 cm) weft insertion of 2,500+ m/min are attained.

Multiphase, in which several picks are inserted in separate sheds at the same time, is a departure worked on most of the last half of the 20th century. Much work was done on the *waveshed* principle of opening a number of sheds in the weft direction. A series of weft carriers or shuttles moves along these sheds in succession in the same plane. When the weft carriers travel in a circular path, the machine may be called a "circular loom" (see "Textile Terms & Definitions" under *References*). For increasing the speed of weaving, these machines did not succeed past the testing stages.

The multi-linear or sequential-shed action, brought to practical reality by Sulzer Textil in 1995, gives astounding results. In this multiphase air-jet loom, four wefts are inserted at the same time (see Figure 4.4[a]), allowing insertion of 3,800 ppm on looms up to 190 cm wide, giving weft insertion rates between 4,000 and 6,000 m/min! Needless to say, the yarn must be of high quality to avoid breaks at these speeds.

The warp is led over the continuously rotating weaving rotor (Figure 4.4[b]). Combs on the rotor form the sheds as well as guide channels for the weft. Four sheds are formed in the warp direction, one behind the other and in parallel, right across the

loom, and into these four weft yarns are inserted simultaneously. When the shed is formed all the way across, low-pressure compressed air carries the weft through the channel, and further weft yarns start to enter the combs that follow. As soon as the weft is right across, it is clamped and cut on the feed side.

The end of the weft yarn is led to the next free insertion position by the weft yarn controller "S" (see Figure 4.4[c]).

There are also **needle looms** weaving narrow fabrics, and **triaxial looms** weaving with two sets of warp and one of weft, which form 60° triangles and a very stable fabric. Both are minor in use.

Selvage

The finished warpwise edges of a piece of woven fabric are called *selvages* or variations of this spelling, e.g., *selvedges* (literally, "self-edges"). In a shuttle loom, selvages are formed as the shuttle carries the weft yarn back and forth; in a shuttleless loom, various types of edges may be formed (see Figure 4.5):

Tucked-in—cut weft is tucked into the weave at the edges.

Fused by heat, when there are thermoplastic fibers in the fabric.

Leno weave at the selvage.

Warp versus Weft in a Weave

Before weaving can begin, there is a lengthy process of preparation of warp yarns and the "warping up" of the loom—the winding on of the hundreds or thousands of warp yarns, each held in precisely its correct place and under tension, with microprocessors greatly aiding in this operation. But then these yarns are selected and threaded through heddle eyes on a harness loom. (Figure 4.6[a] shows two of four harnesses raised to create the shed.) This threading is done by hand, and is termed reaching in or drawing in (see Figure 4.6[b]), after which yarns are passed through the dents in the reed. This means that, although electronic controls are used extensively in weaving (see Figures 4.7 and 4.30), as well as computer-assisted design (CAD) systems, there cannot be the "quick response" getting out a patterned woven fabric to meet a sudden or fleeting

demand of fashion that there can be with some types of knits or prints.

Warp varns are sized or stiffened with some sort of adhesive and a lubricant to prepare them for the weaving process. The adhesive has traditionally been a starch or gum, but today many other compounds are used, preferably those that can be removed before finishing with a simple wash. A sheet of warp yarns is led through the sizing bath, then dried. At this stage, the yarns are stuck together, and before they are wound on the warp beam, they are separated by splitting with what are called *slasher rods*; this is probably the origin of the odd name given the process: slashing.

Warp yarns are held under considerable tension in weaving (to prevent ripples and puckers). To withstand this strain, warps are selected to be stronger; if only one set of yarns is ply, or the weave is the basket variation of plain (more than one finer yarn taken as one), that will be the warp, for strength.

Balance in a weave means that the two sets of varns (warp and weft) are much the same in type, size, and number. However, even in a fairly well-balanced

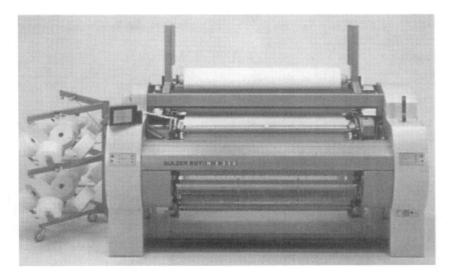

(a)

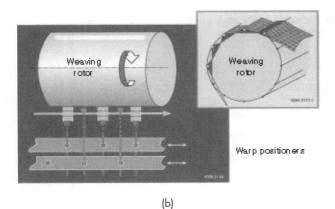

Weaving rotor

(c)

Figure 4.4 (a) Multiphase air-jet loom can insert nearly 3,000 ppm. (b) Warp positioners determine which yarns will be raised. (c) Weft yarn controller S, with its two disks, is located concentrically to the weaving rotor. It moves the yarns using compressed air to line them up with the insertion channels. (Courtesy of Sulzer Rüti AG—merged with Nuovo Pignone—now Sulzer Textil)

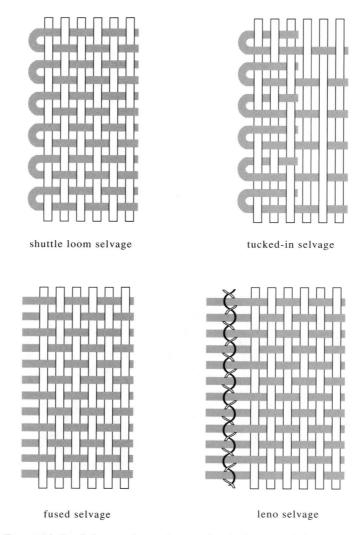

Figure 4.5 Selvages formed on a shuttle loom and three types formed on shuttleless looms.

plain weave or *square* construction, warp yarns are usually somewhat finer, higher twist, and set in more closely than weft, all for strength.

Because warp yarns are held taut, while weft yarns are not, the weft has more weave crimp: It looks wavier and there is a slight stretch or "give" in the weft direction.

If one set of yarns is simple and one is novelty (fancy), the simple yarns will usually be the warp (but not invariably!).

Many finishing procedures give a *one-way lie* to yarns or fibers, and this will be in the warp direction.

The only absolutely sure guide to warp is the selvage, being parallel to the warp. However, many

fabrics have a guide to warp direction in their "profile" of characteristics, such as the puckers of seer-sucker, the crossed warp yarns (leno) of marquisette, or the warp float of a filament-yarn satin weave. If the face of a twill weave fabric is known, the direction of the twill line in wool and silk family fabrics is right hand; this will indicate the warp.

Thread or Cloth Count

A thread or pick counter (also called a loop glass or linen tester) is a small magnifier with an opening of a square centimeter or square inch, marked in

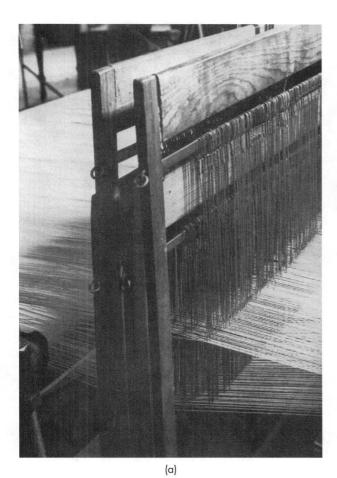

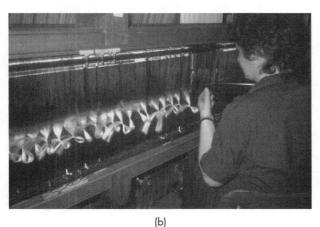

Figure 4.6 (a) Close-up of two of four harnesses on a simple loom, as they form the shed through which the weft can be inserted. (Courtesy of the Woolmark Company) (b) "Reaching in" to thread silk through heddle eyes.

Figure 4.7 Controls on a modern automatic loom. (Courtesy of Sulzer Canada Inc.)

millimeters or fractions of an inch. With it, the fabric construction can be examined, but it is also used to count warp and weft varns, to indicate thread or cloth count or closeness of weave (Figure 1.4).

The figure is recorded as the number of warp by (x) the number of weft, and the thread count is the sum, or the number of yarns altogether in the square.

At point of sale (POS) of consumer goods, thread count used to be most often stated on a label for a **sheeting** in a fairly well-balanced plain weave. Since this notation is not familiar to consumers in metric units, the following examples are given in the inch system:

#	warp	× #	weft.	=	thread	count	
	92 x	88	(/in.)	=	180		

percale sheeting cotton broadcloth $122 \times 58 \, (/in.) = 180$

This example shows that thread count, of itself, does not give information on whether a weave is balanced; cotton broadcloth has at least twice as many warp yarns as weft yarns, giving the fine crosswise rib and firm hand of this dress shirt fabric (see additional note on it below), whereas sheeting, if also a plain weave, is quite well balanced; as stated earlier, there will usually be a few more warp yarns than weft yarns.

For plain weave sheeting, then, thread count is a very useful comparison figure in relation to fineness of varn and closeness of weave; the typical range has been as shown in the table that follows.

Thread Count	Quality	Fabric Name
115	Quite open and "sleazy"	Called muslin
128	Medium weight	
140	"Family" or institutional weight, close weave, sturdy	
180–350	Fine, smooth yarns, close weave, lighter weight	Called percale
400+	Luxury sheets & very closely woven covers for downfilled duvets	

It should be understood that the fabric in some very high thread count bedding items is sateen, not percale, i.e., woven in a *satin weave* with more yarns packed in. Another misleading label figure is a very high number like 600. This does not mean a thread count of 600; rather, it usually expresses a thread count of 300 using 2-ply yarns. The Federal Trade Commission clarified this in 2005 by saying that a manufacturer or retailer should identify a product made with plied yarns as "300 thread count made using two-ply yarns," rather than "600 thread count." These and other aspects of sheeting are discussed more fully in *Fabric Glossary*.

Even though thread count in cotton broadcloth and other plain weave shirtings does not give as direct a reading of closeness of weave as that for sheeting, identification of the best quality in a dress shirt will often include thread count as part of the indication of quality (close weave and fine yarns); custom-made men's shirts could be described as made of long-staple cotton fibers (Pima or Egyptian), 100s 2-ply yarns, with thread count from 150 (good quality shirt) to 230 (superb).

Point Diagrams, Notation of Weaves

The way yarns interlace in a weave is often represented by a *point diagram* on graph paper, with each square representing the position of a yarn in the weave; three point diagrams are shown in Figure 4.8.

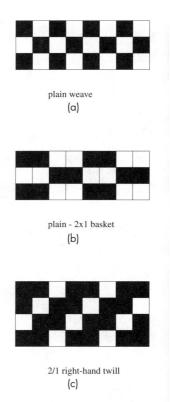

Figure 4.8 Point diagrams of (a) plain weave, (b) plain 2×1 basket weave, and (c) 2/1 right-hand twill weave.

If a warp yarn has been raised when the weft yarn is passed through the shed, that yarn will lie on the surface of the fabric; its square is filled in (darkened, or marked with an X) on the graph paper. When the weft yarn is on the surface, the square is not filled in.

A weave is described as "X up, Y down" (written X/Y), indicating how many warp yarns were raised at each passage of the weft and how many not, in groups across the loom—equivalent to how many harnesses were raised or not. The sum of this figure, then, is the number of harnesses, each one threaded differently, needed for that weave; this is also called the shaft.

A plain weave, the most commonly used, requires only two harnesses. They are raised alternately at each passage of the weft, so a plain weave is always a 1/1 weave. In two of the point diagrams shown under "Twill Weave" (Figures 4.12 and 4.13), the 3/1 twill weave (read "three up, one down") and the 2/2 (read "two up, two down,") both require four

harnesses. The 4/1 satin weave (in Figure 4.19 under "Satin Weave") takes five harnesses and is described as a 5-shaft satin.

Another convention of a point diagram is that it needs to be filled in only until there is a repeat of pattern so it will show the number of rows, each one different, needed to complete the pattern and one row of repeat; this is equal to the shaft plus one. For example, diagrams for two versions of plain weave are shown in Figure 4.8, both requiring only two harnesses to weave, so the "checkerboard" diagrams are only three rows deep. The 2/1 twill takes three harnesses to weave, and the diagram is four rows deep.

To understand why a twill direction is called right or left hand, begin (or "read") a point diagram from the lowest line, as if you were weaving a fabric; in a simple twill at each succeeding weft insertion, the interlacing moves over one. If this is to the right, the line will run "up to the right" and will be a right-hand twill; if to the left, the line will run "up to the left" and will be a left-hand twill.

4-3 BASIC WEAVES

Plain Weave

Plain weave, also called *taffeta* or *tabby weave*, is the simplest and most commonly used, representing over 70 percent of all woven fabrics worldwide. The weft passes over and under alternating warp yarns across the cloth; in the next pick, the weft yarns go under and over alternating warp, then these two rows are repeated. This gives the maximum number of interlacings (crossings of warp and weft) you can have in a weave.

Plain weave requires only two harnesses, one with every even-numbered warp threaded through the heddle eyes, the other with every odd-numbered warp (see Figure 4.2[a] and point diagrams (a) and (b) in Figure 4.8). Although the interlacing in a plain weave is simple, the resulting fabric need by no means be plain! There are more distinctive "name" fabrics in plain weave than in any other construction.

Balanced Plain Weaves

Balance was discussed under "Warp versus Weft in a Weave," and "Thread or Cloth Count;" there are many examples of balanced plain weaves.

Unbalanced Plain Weaves

These occur when the number, size, or type of one set of yarns is different from the other.

Plain weave **rib** fabrics may show allover or occasional ribs. In those with allover ribs, the ribs run crosswise; this is a result of weaving with more (and usually finer) warp than weft. If such a ribbed fabric is closely woven (and most are), it will have firmness and good body. Besides the interesting texture of the rib, the closely packed warp yarns give good cover and often a pleasing sheen, while the fact that the weft is not packed so closely together makes for better hand and drape in the fabric, compared to a similar weight woven in a balanced plain weave.

The finest rib occurs when warp and weft are similar in type and almost the same size; the rib is formed when there are at least twice as many warp as weft, as in broadcloth (cotton); see discussion under "Thread or Cloth Count." There is a similar fine rib in the silk family with taffeta.

Coarser, more visible, or prominent crosswise ribs develop when there are more warp yarns than weft and the weft are definitely thicker (see Figure 4.9), as with poplin in the cotton family. (Note that in the United Kingdom, the name poplin is used for fabrics as fine as cotton broadcloth [men's dress shirt fabric], as well as the sturdier type for which the name poplin is usually reserved in North America.)

There is a large group of these crosswise rib fabrics in which the warp at least is **filament** yarn, completely covering over the weft, to give a "silky" face, e.g., faille, poult de soie (or just "poult"), bengaline, grosgrain, gros de Londres, gros de Paris, etc., and givrene. (Moiré is usually based on one of these fabrics, or on the finer rib taffeta.) Any of these rib fabrics can show wear of the fine warp, or develop yarn or seam slippage (discussed under "Tender, Loving [Home] Care" in Section Six; see also the discussions of seam slippage under "Nontechnical Fabric Tests" in Section Eight).

Two other fabrics with prominent crosswise ribs do not always have filament warp, but may be made of various fibers, including silk or MF filament, wool, cotton, flax, MF staple, and therefore of filament or spun warp and weft. Repp has allover, heavy ribs while ottoman has occasional heavy ribs (which may be bundles of yarns).

Only a very few plain weave fabrics have a lengthwise rib, and then only **occasional**. The best known is dimity, which always has an occasional lengthwise rib but may have the rib running both ways (crossbar dimity). A fabric with occasional ribs both ways, framing yarn-dyed checks, is called tissue gingham.

(Note: Lengthwise cords are more complex weaves, discussed under Dobby.)

Basket weave is a variation of plain weave that is often unbalanced, having two or more yarns carried

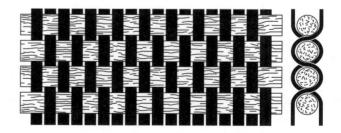

Figure 4.9 A prominent crosswise rib forms in a plain weave when weft yarns are much heavier than warp yarns.

as one in the weft and/or warp direction. This gives more porosity (comfort) and wrinkle resistance to a plain weave fabric.

The weave is described according to the number of yarns carried together in the warp by the number in the weft, and is written " $X \times Y$." A 2 \times 1 basket weave (two by one) such as oxford cloth shirting has double fine warp yarns while the weft is single, of softer twist, and as thick as the two warp together; this might be termed a "half-basket" weave. Other well-known basket weave fabrics are hopsacking and monk's cloth. Some canvas and chintz (cretonne) may be basket weave, although these fabrics are often a balanced weave.

Other Plain Weave Variations

Plain weave variations can be obtained by using yarns of different fibers, tensions (seersucker), degrees of twist (crepe de chine), or color (gingham, madras); or by using novelty yarns (linen; loop yarn, bouclé, shantung). Shagbark fabric has occasional loops of warp varn for surface texture—see Figure 4.10.

Many other variations may be achieved by means of finishing: applied design such as a print (calico), embroidery (eyelet), a glaze (chintz), nap (flannelette, and flannel [can also be twill]), or a finish such as plissé, which gives a three-dimensional effect.

Figure 4.10 Shagbark has occasional loops of warp yarns, giving surface texture to a plain-weave fabric.

Twill Weave

In a **twill weave**, a weft yarn may pass or *float* over two or more warp yarns, and interlacing progresses by one yarn to the right or left in succeeding rows, giving a diagonal line called a wale; this is a progression of one—also called interval, step, shift, offset—and is used with most twill weaves except broken twills, which are often found in fancy suitings (see Figure 4.11).

The simplest twill requires three harnesses on a loom (e.g., 2/1—see the point diagram in Figure 4.8). This is described as an **uneven twill.** as more of one set of yarns is on the face; a 2/1 is a warpface twill (gabardine is usually made in this weave). Since warp yarns are stronger than weft, a warp-face twill will give better wear than an even twill (if fiber and varn are equivalent). A 1/2 would be a weftface twill.

A 3/1 left-hand twill (see Figure 4.12) has an even higher proportion of warp on the face than a 2/1, and so is even tougher; it occurs in the workwear fabric drill and in some denim.

An **even twill** has weft yarns passing over and under the same number of warp yarns each time, e.g., a 2/2 twill (see Figure 4.13); the diagonal wale is as noticeable on the back as on the face. This is the weave of many wool family fabrics, serge suiting, authentic glen checks, tartan, and mackinac. When a plaid is woven in an even twill, such as a glen check or authentic tartan, lines match lengthwise and crosswise, producing a neat effect in garment construction; see Figure 4.14. The silk family twill (surah, foulard) is an even twill.

Figure 4.11 Broken twill fancy suiting.

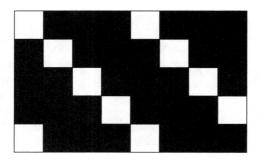

Figure 4.12 A 3/1 left-hand twill (uneven, warpface).

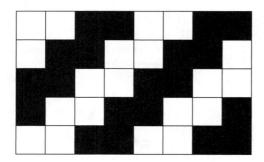

Figure 4.13 A 2/2 right-hand twill (even).

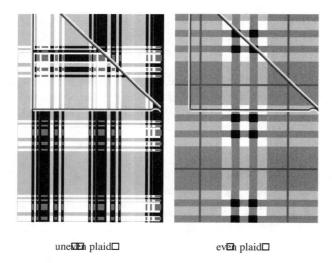

Figure 4.14 Matching is easier with an even plaid than with an uneven.

Broken or irregular twills have an irregular interlacing along each row (see Figure 4.15) and may also change direction to give such reversing patterns as herringbone (see Figure 4.16).

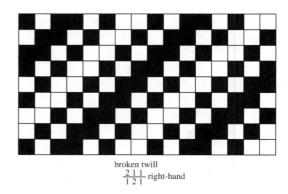

Figure 4.15 Broken or irregular twill weave.

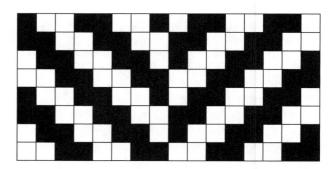

Figure 4.16 Herringbone—a reversing twill weave.

Twill Direction

This was discussed under "Point Diagrams, Notation of Weaves;" right-hand (RH) twill has the twill line up to the right (from lower left to upper right), left-hand (LH) up to the left. Twills originally made of wool or silk are RH; today, of course, these may be of rayon, polyester, or any MF fiber, but the twill direction on the face is still RH. If made in twill weave, wool fabrics for overcoats will be RH. Cotton family twills are traditionally LH, but this does vary. You will find much denim, for instance, with an RH twill line, although most North American denim is woven with an LH twill.

Angle of Twill

This is classified as regular (45°), steep (63°), or (rare) reclining (23°); see Figure 4.17. If yarn type and twill interlacing are the same in two fabrics, when there are more warp yarns, the twill becomes steeper. Since warp is stronger than weft, a steeper

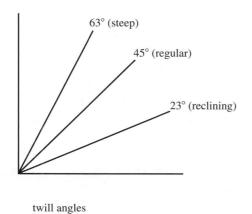

Figure 4.17 Twill angles—steep, regular, or reclining—can reveal probable fabric durability.

Figure 4.18 Two gabardines; the steep RH twill fabric on the left (a) has more warp yarns and will wear better than the regular-angle twill sample on the right (b).

twill will be more durable. Figure 4.18 shows two gabardines, of which the one showing the steeper twill is of better quality and stronger. This is one case in which a very practical application can be made of a rather academic guide, without dissecting the fabric. A buyer finding two twill fabrics with a difference in angle of the twill line could choose the one with the steeper twill as the more durable, as long as the materials are quite similar in fiber content and weight.

Satin Weave

Satin weave is a highly unbalanced twill intended to produce a surface without apparent pattern, with interlacings as far apart as possible, and no two ever adjacent. One set of yarns passes in long floats (four or more) over the other set, then interlaces with a single yarn; the number of harnesses used (the shaft) is always the number of the float plus one.

Only certain intervals or progressions will make a satin weave: these are numbers that add to the shaft number (reciprocals) but not including 1 (which would give a twill) nor any with a common divisor or that divide into the shaft number. Satin floats range from 4 to 12 or more, and so satin weaves are 5 shaft or more; the progression for a 5-shaft satin could be 2 or 3. Traditional peau de soie was 8 shaft (7/1, float of 7) but is now usually 5 shaft (4/1).

The original satin weave fabric, developed in China using cultivated silk (filament), had warp floats; any filament yarn satin weave, of silk or MF fiber, still has warp floats (smoother lengthwise) and so is a warp-face satin weave (see Figure 4.19). This weave shows the maximum luster from smooth filament yarns, represented until about 1900 by silk. When cotton (spun yarn) is woven in a satin weave, it is usually a 1/4 weft-face version. This fabric will use fairly low-twist weft yarns floating across the fabric, and is called sateen (see Figure 4.20). When cotton is woven in a warp-face satin weave, yarn twist is usually higher to give a stronger fabric, which is called cotton satin, farmer's satin, or warp sateen. In a satin weave, most of one set of yarns is on the face of the fabric; if the other set of yarns is guite different in character, there will be a different look and feel to the other side as in satin, brushed back; satin/crepe; satin/shantung; another fabric is antique satin.

Figure 4.19 A 4/1 satin weave (warp-face).

Figure 4.20 A 1/4 satin weave (weft-face).

Comparisons Among Plain, Twill, and Satin Weaves

In the following summary, each statement should be prefaced by "other things being equal," such as yarn size and type. Plain weave fabric, with the greatest number of crossings of warp and weft yarns, can give greatest strength or abrasion resistance, e.g., in a fabric like tarpaulin. Plain weave tends to wrinkle, and shows soil more easily, although it is also more easily cleaned.

The twill and especially the satin weave can allow more yarns to be packed into a given area. The satin weave, with the fewest interlacings, allows yarns to be packed in most tightly to make a heavy fabric with good drapability, wrinkle resistance, and resistance to wind and rain. However, satin is not often used for raincoats because of the possibility of the long floats snagging and roughing up in hard (abrasive) wear. This also affects its use in home furnishings. Satin is often used for linings and drapes because of its smoothness and drapability (see Figure 4.21[b]). On the other hand, satin that is not closely woven will feel cheap and sleazy (see Figure 4.21[a]). Satins will ravel most readily, and are more expensive to make than twill or (least expensive) plain weave fabrics.

The twill weave has a good balance between strength and wrinkle resistance (pliability), plus soil resistance, all important for clothing that has to be worn day in and day out, such as suitings and workwear, and for furniture covers that must take heavy wear. A steep twill angle, as with cavalry twill, indicates more yarns packed in than a shallower angle, and this makes a fabric well suited to outer-wear for cold or rainy weather; the name of the typical trenchcoat fabric, gabardine, derives from "protection from the elements" (see Figure 4.18).

See Table 4.1 for an overview comparison of the basic weaves: plain, twill, and satin.

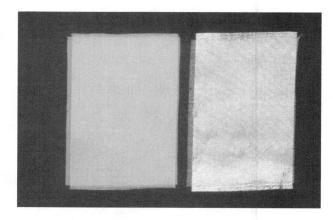

(a)

Figure 4.21 (a) Close, heavy satin vs. sleazy, lightweight satin. (b) Satin is much used in linings for jackets and coats.

Table 4.1 Weave Effects: Comparison of Plain vs. Twill vs. Satin*

Feature	Plain Weave	Twill Weave	Satin Weave
Right or wrong side (face or back)	None (unless printed)	Yes; twill direction changes from face to back	Yes; floats are on the face
Weave as base for finishing processes	Good background for applied designs, including prints	Seldom printed, except light, silky twills, since weave itself gives texture	Design usually achieved by changing float direction; sateen often printed
Strength, abrasion resistance, thread count, durability possible	Highest strength, abrasion resistance; maximum number of interlacings of warp and weft, but cannot pack the most yarns in	Next highest; fewer interacings allows higher thread count, yet float and interlacing well balanced = durable fabrics for constant wear	Lowest; minimum interlacings, so can have high thread count; if so constructed, get strength, body, wind and water resistance
Raveling, snagging	Ravels and snags least readily	Slightly more than plain	Most easily raveled, snags most from long floats
Wrinkle resistance, drapability	Least wrinkle resistant	Fewer interlacings give more wrinkle resistance, pliability	Most wrinkle resistance, drapability, pliability
Soiling, ease of cleaning	Most easily soiled and cleaned (most porous); soil shows on plain surface	Resists soiling, but harder to get dirt out; may become shiny with wear; soil shows less on uneven surfaces	Does not soil readily, but soil shows up against luster of threads
Comfort	Most porous; good for hot weather, especially basket version of plain	Closer-packed yarns better for cool weather	Can pack yarns very closely to give wind or water resistance
Basic appearance and variations	Often balanced; much same size and type of yarn for warp and weft, can be unbalanced (basket, rib). Interesting effects created by changing kind, color of yarns	Diagonal twill lines, varying in prominance, direction, or steepness; steeper twill = more warp yarns, therefore is stronger	Luster from long floats on face; satin = warp floats + filament yarn; sateen = weft floats + spun (cotton) yarn. Luster of satin looks best in soft (evening) light
Weight range made	Sheer to very heavy	Sheer fabrics seldom made	Light or medium as a rule; can be made with great body
Relative cost to manufacture	Least expensive (2 harnesses used)	More expensive (3 or more harnesses used)	Most expensive (5 or more harnesses used)

^{*}Comparisons such as those in this table assume fabrics of roughly equal yarn type, fiber content, and weight (linear density).

LINK 4-2, 4-3 WITH FILES IN FABRIC GLOSSARY

These illustrate how these fabric constructions affect and are significant for the many fabrics made of them. Look these up for a fuller understanding of how this contributes to the fabric character and behavior, or is an essential part of its name. You will also find photos of these named fabrics, as well as other related textiles.

Fabric Glossary Fabric Name Look names up in Fabric Glossary Index.	Relationship to Fabric Reference Discussion	
Selvage	Types of selvage made on shuttle and various shuttleless looms.	
Sheeting, Muslin, Percale, Holland, Osnaburg	These represent <i>balance</i> in a plain weave, making	
Batiste, Canvas, Sailcloth, Awning, Duck, Tarpaulin Challis, Organdy, Organza, Voile, Sharkskin, Tropical Worsted, Suiting	thread count a useful comparison figure. Other (usually) balanced plain weave fabrics. Balanced plain weave.	
Broadcloth (Cotton), Poplin Taffeta, Faille, Poult de Soie, Bengaline, Grosgrain, Gros de Londres (de Paris, etc.), Givrene, Moiré, Repp	Plain weave, unbalanced: many more warp than weft, and may be finer, creates a crosswise rib.	
Ottoman, Dimity	Plain weave, occasional ribs.	
Basket Weave, Hopsack(ing), Monk's Cloth, Oxford Cloth	Plain weave, basket, two or more yarns taken as one.	
Seersucker	Plain weave, lengthwise puckered stripes woven in.	
Plissé	Plain weave, surface puckers, chemically produced.	
Chiffon, Georgette, Crepe de Chine	Plain weave, very high (crepe) twist yarns one or both sets, give fine (bumpy) surface.	
Gingham, Madras, Plaid	Variously colored yarns give pattern, plain weave.	
Linen, Loop Yarn (Bouclé), Shantung, Shagbark	Novelty yarns, plain weave.	
Calico, Cretonne, some Toile de Jouy, Chintz	Distinctive prints on plain weave.	
Eyelet	Embroidered, with cut-out holes, usually on plain weave.	
Flannelette, some Flannel	Soft surface (nap): fibers taken out of fabric (worsted flannel will usually be twill weave).	
Tweed (some)	Fiber-dyed yarns show heather effect, may have nubs. Many tweeds are twill weave.	
Gabardine, Denim, Drill	Warp-face twill weave for sustained wear.	
Serge, Twill Checks (incl. Glen), Tartan, Mackinac, some Tweed, Surah (Foulard, French Twill), some Flannel, some Overcoats	Even twill weave.	
Herringbone, Coutil	Reversing twill weave.	
Cavalry Twill, Whipcord	Steep twill weave for hard wear.	
Barathea	Twill weave with basket weave element.	
Satin, Sateen	Satin weave, floats warp-face or weft-face.	
Brushed-Back Satin, Satin/Crepe, Satin/Shantung (Antique Satin)	Satin weave, warp float is filament yarn, weft quite different yarn type; some are reversible.	

REVIEW QUESTIONS 4-1, 4-2, 4-3

- 1. List five general guides to the right side of a fabric, with an example for each.
- 2. How do you determine whether a textile has been woven on a shuttle or shuttleless loom?
- 3. What are three advantages of shuttleless looms over those using a shuttle?
- 4. What types of fabric cannot be woven on a waterjet loom?
- 5. What do all shuttleless looms have in common as to the path of the weft yarn?
- 6. What does a harness on a loom do, and how is this accomplished? What is the minimum number of harnesses to produce a weave?
- 7. What are the usual differences between the warp and the weft in woven fabric? What is the only sure way of knowing which are the warp?
- 8. What is thread count? Where can it give the most useful information? Where and how is it sometimes used to give misleading information?

- (See also Investigation 4, under "Investigations to Do with Fabric Constructions" at the end of Section Four.)
- 9. What are two main reasons why so many different fabrics are made in a plain weave? What are two main advantages of a twill weave compared to plain? What is the main advantage of the satin weave? Its main disadvantage?
- 10. How do you recognize each of the following: gabardine, serge, cavalry twill, whipcord?
- 11. Why would a gabardine woven with a steep (63°) angle be more durable than one showing a 45° angle (fiber and yarn types being comparable)?
- 12. What makes an authentic tartan? What advantage does it have in (a) promotion, and (b) working with the fabric in a garment?
- 13. Why can the face and back of a satin weave fabric be quite different? Name three distinctive fabrics that show this.

4-4 COMPLEX WEAVES

Harness Control of Complex Weaves (Dobby)

Raising of harnesses for plain, twill, and satin weaves can be activated and the order controlled by means of cams, but a different direct control is needed for more complex interlacing. The dobby (or dobbie) attachment on a loom can control the action of multiple harnesses (maximum 32, usually fewer) (see Figure 4.22[a]). A pattern chain (or draft chain) traditionally selected which harnesses were raised. This older chain worked with a continuous loop of strips with holes in them, into which projections on a cylinder fit, to raise a particular harness. Today, of course, computer control is usual, but with older looms a perforated paper strip or electronic tape may be used. Figure 4.22(b) shows a perforated strip controlling the action of a number of harnesses.

The dobby attachment allows a pattern with a repeat not greater than 32 rows of weft, and produces relatively small designs, usually geometric in shape (hard-edged, not curving) (see Figure 4.23[a] and [b]). Typical fabrics with this kind of dobby design include armure, birdseye, honeycomb, huckaback, madras shirting, waffle cloth.

Dobby control of a fairly complex repeat of tiny floats in a weave is one way to produce the pebbly surface of crepe, also called granite or momie weave. It can also prevent yarn slippage in latticed effects that look like leno (at less expense, called *mock leno*, or a mesh-like cloth; see Figure 4.24); with yarns closer, it gives a basket-like weave (called natté; see Figure 4.25).

The dobby loom is used to control most compound weaves, those using more than two sets of yarns and up to five in true double cloth (two sets each of warp and weft to weave the two sides, with a third set of warps weaving the two together). This type of loom, therefore, can be used to produce reversible fabric. A true double cloth weave may be used for that purpose, or to give cut warp pile material (see "Warp Pile Weaves"). All of these possibilities of weaving with a dobby attachment are discussed and the results illustrated in four Files in Fabric Glossary; for fabric names, see Link 4-4 with Files in Fabric Glossary.

Of course, some compound fabrics with a more intricate design woven in have to be jacquard

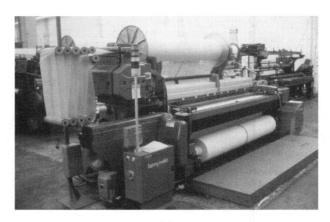

(a)

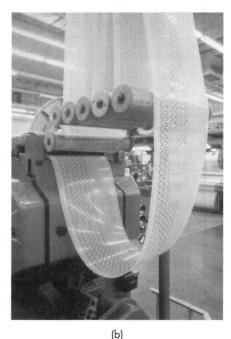

Figure 4.22 (a) Dobby attachment on a loom allows weaves more complex than plain, twill, or satin. (b) A perforated paper strip controls multiple harnesses with this dobby attachment. (Courtesy of Dominion Textile Inc.)

controlled, rather than dobby. Stuffer yarns may be incorporated in some of these corded fabrics; these do not interlace, but lie under the cords to raise them and add firmness. Diagrams of such weaves typically show a cut edge, to render the depth of structure, as with a warp piqué (see Figure 4.26).

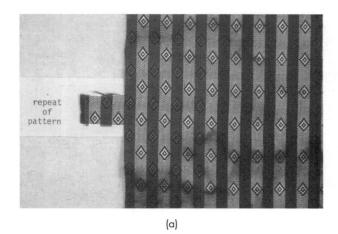

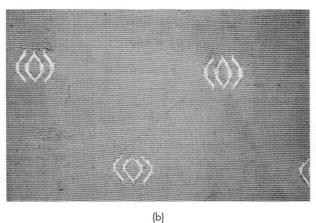

Figure 4.23 Typical dobby weave pattern repeat: small, geometric motif (a) in a lining fabric, (b) in sturdy pocket fabric.

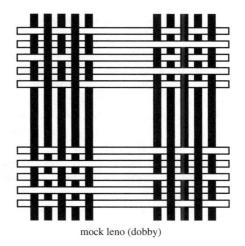

Figure 4.24 Dobby control can produce openwork effects where yarns do not slip or shift, and at less expense than with leno weave, hence the term mock leno.

Figure 4.25 A basket weave effect (natté) can be given with dobby weave, but is much more complicated than basket plain weave.

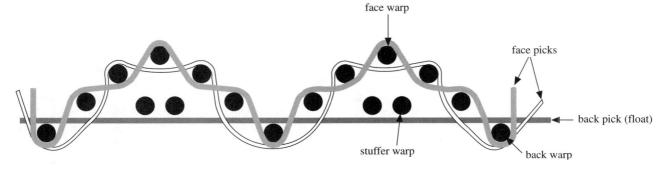

Figure 4.26 Structure of a warp piqué, viewed from a weftwise cut edge. The stuffer warp yarns do not interlace but pad the cord and add firmness.

Jacquard Control of Complex Weaves

A jacquard attachment on a loom makes it possible to produce any design, however intricate, since each warp yarn can be controlled separately for each pick (insertion of weft). This was the result of improvements and changes made by Joseph-Marie Jacquard (1752–1834) in Lyons, France. His development, between 1801 and 1810, gave automatic control of raising of the warp yarns, and the punched card method used was a forerunner of our early computers.

A very much simplified drawing of a common earlier version of the apparatus is shown in Figure 4.27, with views of the loom setup in Figures 4.28, 4.29, and 4.30. The heddle (or *leish*, if it is a cord with an eye) governing each warp yarn is weighted with a *lingo*. The heddle is connected to another cord (see Figure 4.28[b]) that passes up through a *comber board* and is joined to the *neck cord*. This connects with a hook that can be moved if it is in the right position to be caught by a *lifting knife* on the *griffe bar* as the bar goes up and down.

Each hook (and therefore the cord controlling a warp yarn) is linked at the top of the loom to a crosswise-placed, spring-loaded wire. Manipulation of warps is governed by cards that allow for a hole to be punched (or not) for each warp, with a row for each pick in the repeat of pattern. The cards—there can be thousands of them for a large design—are laced together and pass over the top of the loom during weaving (see Figure 4.29). They pass over a perforated cylinder, with a needle board in front, against which the spring-loaded wires push. If a wire encounters a hole in a card, it goes through and by this action puts the hook in a position to connect with the lifting knife on the griffe bar, and the warp yarn is raised; if there is no hole, the warp is not raised. As noted, Figure 4.27 is a very much simplified presentation of the action, and many jacquard looms are considerably more complex, with double griffes, double cylinders, or even more than one jacquard attachment for very wide designs.

Continuous paper strips have been used to replace the bulkier cards, but on looms made today, electronic controls are applied to key aspects of jacquard weaving. Computer-assisted design (CAD) also greatly shortens the design and pattern-cutting preparation time, and electronic controls are applied to the actual weaving of these most complicated

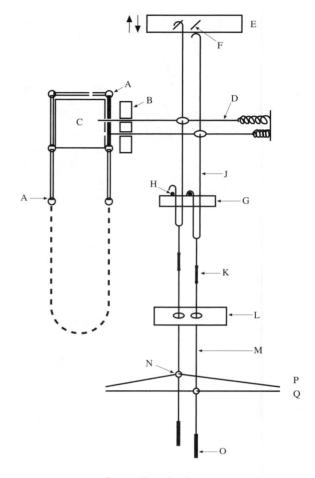

jacquard mechanism

A card J hook
B needle board K neck
C cylinder L com
D spring-loaded wire or needle
E griffe bar N eyel
F griffe blade or knife O ling
G grate P warr

H spindle

J hook (may face either way)
K neck cord
L comber board
M heddle or harness thread (leish)
N eyelet or mail (equivant of heddle eye)
O lingo (weight)
P warp (raised)
Q warp (not raised)

Figure 4.27 Selection of warp yarns by the conventional jacquard mechanism, very much simplified to show one warp yarn raised, one not.

interlacings. Designs can be transmitted directly to these fully electronic jacquard looms.

Developments in this area came very quickly. One from Bonas Machine Co.⁷ allowed a machine with the hook as the only moving part of the selector mechanism to have up to 5,000 hooks, with electronic process monitoring, and with any machine in a network connected to a central control computer. Others have followed. Figure 4.30 shows an air-jet

(a)

(b)

Figure 4.28 (a) Typical intricate, curving design in fabric being woven on a jacquard loom. (b) The heddles connect to cords that pass upward to the jacquard attachment that controls the raising of warp varns.

jacquard DORNIER machine, nominal width 430 cm. with harnessless end-bu-end control.

There is a natural affinity for jacquard looms and electronic control. The jacquard mechanism was the first application of the principle of binary selection, by which telephone and computer controls work: each "decision" in a process is either path 1 or 2 (in the case of computer "bits," either 0 or 1, off or on). As an example of the astounding fineness achieved from the early days of this mechanism, the sample weaving "l'hommage," sent by Jacquard to Napoleon as a demonstration piece, had a thread count of 1,000 per square inch and required 24,000 cards, each punched with 1,050 holes.8

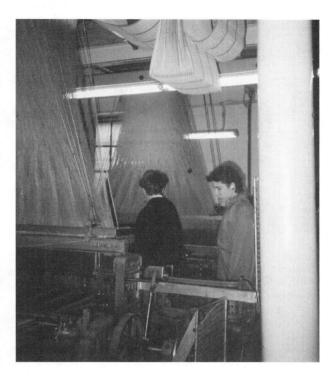

Figure 4.29 Curtain of cards laced together, typical of jacquard attachments using punched cards to control raising of warp yarns.

Since there does not have to be a harness for each change of warp yarns raised as the weft is interlaced, a jacquard design can be intricate, curving, and/or large (see Figure 4.28). When a yarn does not appear on the face, it may float on the back, as in many brocades (see Figure 4.31[a] and [b]).

A general term for smaller or less distinctive jacquard woven-in motifs is figured, often in connection with a name appropriate to the background weave if the figure is small and scattered. An example is shown in Figure 4.31(c), where the small but intricate designs are on a plain ground weave, with low twist filament warp and very high (crepe twist) weft; the name of this fabric would be "figured crepe de Chine."

Leno Weave

Leno weave is also called lock, doup, or gauze weave. (Note: the fabric called gauze is plain weave. This is the much cheaper, open weave used in cheesecloth and gauze bandages, in which the yarns can and do slip easily.) Leno weave requires a special doup

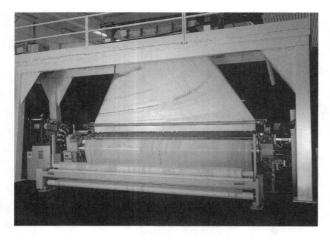

Figure 4.30 Lindauer DORNIER air-jet weaving machine Type LWV8/J, electronic jacquard, nominal width 430 cm. (Courtesy of Lindauer DORNIER GmbH)

attachment on the loom that allows one of a pair of warp yarns to change position from side to side between each pick, or interlacing of weft. By the time the fabric is wet finished, the warp yarns appear to have crossed in pairs, one yarn of each pair always in front of the other as it interlaces with weft (see Figure 4.32).

Weft yarns can be kept well separated yet held firmly so they do not slip, useful in sheer curtain fabric (see Figure 4.33), such as marquisette, or in mosquito netting; grenadine is an allover leno weave apparel fabric. A *latticed* effect may be introduced into summer dress or shirt fabrics with strips of leno weave (see Figure 4.33), or a single warp may be moved from side to side to give a wavy pattern. Leno thermal cloth holds air for insulation, in blankets, for example. Leno weave is also used to hold selvage in fabric woven on some shuttleless looms (see Figure 4.5), and is the core of chenille yarn (see Figure 4.42).

Surface Figure Weaves

Patterns in weaves can be produced by figures woven into the base cloth using extra yarns. The three methods of accomplishing this are used to produce dotted Swiss (see Figure 4.34) as well as other surface figures.

Swivel

Extra weft yarns may be carried on small shuttles or swivels set along the width of the loom. The yarn from

(b)

Figure 4.31 (a) Face of a brocade, woven with jacquard attachment; (b) the back of the fabric shows floats where a color is carried when it is not being interlaced. (c) Jacquard woven pattern on a plain ground weave, warp yarns low twist, weft yarns high (crepe) twist; might be called "figured crepe de Chine."

each swivel is woven with a group of warp yarns, and the yarn is clipped between the spots. This method (the original dotted Swiss from Switzerland) gives only two cut ends per spot, making this the most durable type of dotted Swiss but the rarest and most expensive.

Clip-Spot

Clip-spot (clip-dot, spot-dot) patterns are usually formed by shooting extra weft yarns across the width of the goods, interlacing only where the pattern is to be formed, i.e., floating between designs. After the cloth is woven, the floats are sheared or clipped; the design has two cut yarn ends for each row of weft

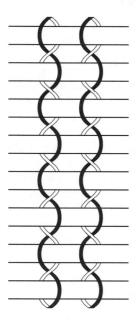

Figure 4.32 Leno weave is accomplished by crossing pairs of warp yarns from side to side so that weft yarns may be held apart without slipping.

(see Figure 4.35[a]). Clip-spot woven dotted Swiss (called American type) is good quality, though the dots are not held as firmly as by swivel weaving. Most clip-spot fabrics are plain weave ground; Madras muslin has clipped weft varns, with figures held in leno weave. In some clip-spot fabrics the spots are formed by extra warp yarns. With clipped ends in the vertical position, the resulting tiny fringe is called evelash as with lappet.

Figure 4.33 Semisheer leno curtaining, and latticed leno stripes in a dress fabric.

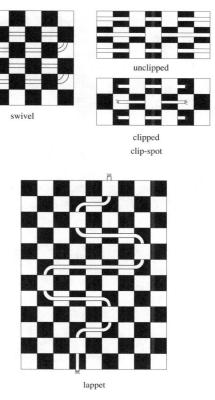

Figure 4.34 Surface figure weaves.

Lappet

Lappet patterns are formed by extra varns in the warp direction carried by needles set in a bar in front of the reed. These yarns can be moved to interlace with the weft yarns. The long floats that are formed between figures are usually left unclipped; if clipped, the result is called eyelash effect (see Figure 4.35[b]).

Pile Weaves

Pile weaves create a three-dimensional effect by weaving an extra set of warp or weft yarns into the basic structure of a fabric. These may be left uncut as loops or cut to give a plush effect.

Various methods are used to incorporate the extra yarns into the weave, but the ground is usually a plain or twill weave. Twill back (Genoa back) is likely to be more durable because the weave can be closer, so that the pile tufts can be held more securely. Plain weave back is also called tabby back.

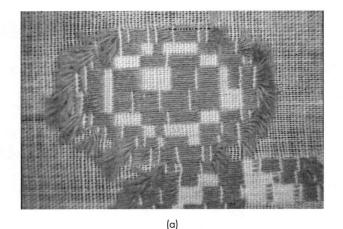

(b)

Figure 4.35 (a) Clip-spot and (b) eyelash effect surface figure weaves.

The density of pile yarns is an important determinant of quality in any pile fabric. It is possible to pack in more pile tufts when weaving with extra warp than by the weft pile method. Woven pile is made of cotton with both warp pile (velour, cotton velvet) and weft pile (corduroy, velveteen). When an especially durable cotton pile fabric is desired, the warp pile weave is used; some cotton upholstery fabrics that look like corduroy are woven with warp pile for this reason. If you have a fabric sample, you can make a quick check by pulling a weft yarn; with warp pile

weave, the weft will carry the warp pile tufts, like a caterpillar (see Figure 4.36[a]). In a weft pile fabric, the tufts hang on a warp yarn.

A woven pile fabric may have a V-loop construction or "V" interlacing, in which the pile loop is held by only one yarn of the opposite set, or it may have a "W" interlacing (sometimes advertised as "interlaced three ways"), much more durable, with each pile tuft firmly held in three places by yarns of the opposite set (see Figure 4.36[b]).

Quality and durability in a woven pile fabric will depend on the fiber used, yarn quality, height of pile, ground weave (twill or plain), how the pile tufts are held, and density of pile (see notes on carpet quality at the end of "Pile Weaves" for the term *grinning* when pile is sparse).

Warp Pile Weaves

These represent the original of pile weaves, by which velvet was made of silk. Three machine methods are used today for fabrics other than carpet, which can be woven by the third method described here plus a fourth unique to carpet:

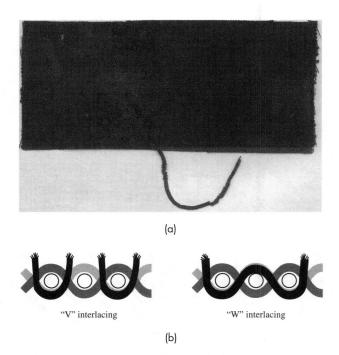

Figure 4.36 (a) Velour (cotton) warp pile tufts hang on a weft yarn. (b) "V" interlacing; "W" interlacing.

- 1. Double cloth method, face-to-face (Figure 4.37. Five sets of yarns are used, two sets of warp interlacing with the wefts, inserted by a yarn carrier with sheds opened one above the other, so that two fabrics are woven face to face, bound by a third set of warp yarns, which will form the pile [see Figure 4.38[a]). This double cloth is immediately cut apart (on the loom) to give two lengths of cut pile fabric (see Figure 4.38[b]). Most velvet and velour today is made by this method. A velvet with both cut and uncut pile must be woven by the over-wire method (see Method 3).
- 2. Slack tension warp method. This is used for most terry cloth. In a terry loom, a second warp beam supplies the varn that will produce the pile loops, and this loom is engineered so that the tension on those yarns can be let off (see Figure 4.39). Suitable spacing of the west varn from the cloth fell must be allowed, with the number of weft yarns inserted per pile loop called the shot. In Figure 4.40, three picks have been inserted (a three-shot construction), and then tension is released on the pile warp varns. When these warps are beaten up, this group of picks (weft) slide along the taut ground warp, and the slack pile warp yarn is pushed into loops, which can be formed on one side of the fabric or both sides. Loops can be made higher or lower according to the distance selected between the group of picks and the fell, or there can be different pile heights from one side to the other. Cut loops (terry/velour) are produced by shearing, as discussed in Section Five.
- 3. **Over-wire method.** An extra set of warp yarns is held up in loops by a round wire or a metal strip inserted across the loom every few picks. instead of weft. Frisé with its uncut loops, is

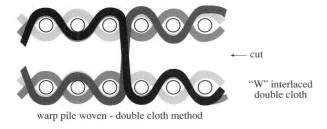

Figure 4.37 Double cloth cut to form warp pile.

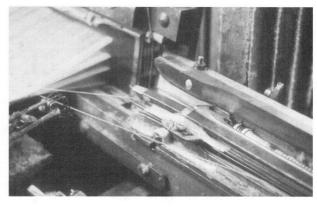

(a)

(b)

Figure 4.38 Double cloth weaving of velvet or velour with five sets of varns, in this case, on a shuttle loom. The two sheds, one above the other, are visible in (a) on the left, and there is a second shuttle working below the one that can be seen. In (b) the double cloth (jacquard pattern) is seen at the left, just before it is cut apart on the loom; two pieces of cut-pile fabric are wound up as the product of this weaving methoddouble cloth cut apart into two cut-pile fabrics.

made by the over-wire method, as is a small amount of velvet and terry. This is the method used for a fabric with both cut and uncut pile, such as ciselé velvet.

To produce a cut pile, as in plush, the "wire" has a sharp knife at the end, which cuts the loops as it is withdrawn. Some moquette has the loops cut.

Machine woven carpet has long been made by the over-wire warp pile method. Over

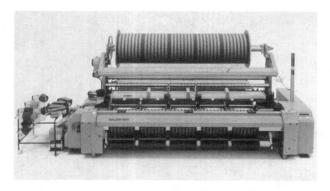

Figure 4.39 Terry loom with two warp beams. (Courtesy of Sulzer Canada Inc.)

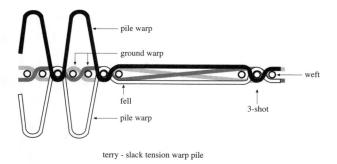

Figure 4.40 Weaving terry by the slack tension warp method.

the last half of the 20th century, only a very small percentage of carpet was woven (however, note developments with Axminster looms under Method 4). The famous methods using the overwire method that are outlined briefly here are of concern only to those in the interior design business at the top of the market.

One over-wire woven type still well known is **Wilton**, a cut-pile jacquard-controlled warp pile weave with not just two but three sets of warps working. **Brussels** is an uncut carpet made the same way, often called Wilton as well. One group of *chain* warp (often cotton) interlaces with the weft to form the ground fabric, and a special group of warp does not interlace at all but is carried in the structure as *stuffer yarns* to give added body. (Because of these, one does not roll a carpet of this weave lengthwise!) The pile warp (usually wool) is carried on frames, one for each color required, a maximum of six frames. At each passage of weft, the

appropriate colors are presented to be held up by wires in loops on the surface; with Wilton, the wires (metal strips) carry a knife end, and as they are removed, the pile loop is cut. Yarns in colors not forming pile at any point are carried in the body of the carpet—what has been called the *hidden value* of a Wilton (or Brussels) carpet. As a result, this carpet has a deep structure and is expensive to produce.

Velvet (cut loops) and **tapestry** (uncut loops) carpet is also warp pile woven, but without the complexity of structure of the Wilton.

4. **Precut warp pile.** One giant machine—the Axminster loom—follows original hand methods closely, in that it tucks into the weave a pile tuft, either precut, or cut as inserted. Here colored yarns, in order as they appear in a design, have been traditionally wound on spools or handled by grippers, a separate arrangement for each row of the design. When the appropriate yarns are presented to the loom, the pile tufts are cut, and they are woven into the ground. With this ingenious loom, a large number of colors for any size design has always been woven much more economically than by over-wire methods. A fast Axminster Loom was developed that rivals tufting in speed and has no backing of material that may be difficult to recycle. Across a width of over 450 cm, the heavy weft can be inserted at 200 ppm (contrasted with 50 ppm achieved traditionally), and the pile insertion mechanisms. made strong and light, move short distances.

However, weaving by any method is a very small part of carpet making today—under 5 percent. Even rarer than machine-woven carpets, of course, are the warp pile *handwoven* carpets, such as **Oriental.** In these, warp pile tufts are tied in as the ground is woven; Figure 4.41 shows the traditional knots used: the Ghiordes or Turkish knot, and the asymmetrical Sehna or Persian knot, which can be packed in more closely to give the densest pile.

Carpet Quality

Quality in a carpet depends on the factors outlined for any pile fabric: density of the pile, height, fiber used, yarn quality and twist (hard twist contributes to resiliency), pile cut or uncut, ground weave (plain or twist), and how the pile loops are held. A vivid trade term—grinning or grin-through—is used probably

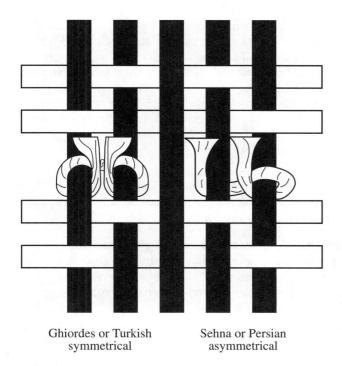

Figure 4.41 Two main types of knots used in handwoven Oriental carpets with hand-tied knots.

most often with poor-quality carpet, when sparse pile allows the ground to show when it should not! (The term is also applied to poorly covered woven ribs, double cloth not closely woven, or as noted in Section Three under "Wrapped Yarns," a rubber core showing when an elastic is stretched.) In carpet, the number of warps per 10 cm in width is called the pitch of the carpet, the number of rows per 10 cm in length is called the wires; traditionally, pitch has been warps or reeds per 27 in. and wires the number of rows per inch.

Other Pile Terms, Fabrics

Berber is a term originally applied to carpet of natural color, made of bulky wool yarns, with low, level loops and a pebbly or nubby texture. The name is that of a number of indigenous peoples living in North Africa, mainly in Morocco and Algeria, who have made such hand-woven wool carpets. Now the name is applied to many fabrics with a somewhat homespun, "woolly" look, and bumpy texture, such as two face knit fleece.

Velcro[®], the "touch and close" fastener, is the trademark name of what is technically a two-part

warp pile woven fabric of a most unusual sort, used in two layers that stick together. One layer is covered with loops (that feel like velvet), the other with tiny barbs (like crochet hooks) (thus the name, "vel-cro"), all made of stiff nylon monofilament in standard Velcro. The inspiration came from natural burrs, with their barbed prickles that stick tenaciously to any hairy surface.

The touch-and-close type of fastener represented by Velcro has found myriad applications in clothing, household, and other consumer, medical, and industrial articles, and special high-performance versions have been made.

Weft Pile Weaves

In a weft pile, extra weft yarns float over the warp

Floats in lengthwise rows after cutting produce the vertical pile wales of corduroy, a cotton family fabric. Types of corduroy, names, and wale sizes are defined and shown in the Fabric Glossary; this covers featherwale to widewale, with number per inch.

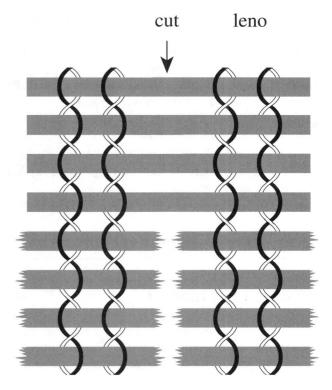

Figure 4.42 Making chenille yarn.

Velveteen is produced by cutting floats that are scattered over the base fabric, so there are no visible wales. The name denotes that this is a "lesser" fabric than velvet (warp pile originally of silk), being made of cotton and by the less-expensive weft pile method, with less dense pile possible.

Chenille yarn can make another type of weft pile woven fabric, although not a common one. A special yarn called *chenille fur* is first prepared on a loom, using leno weave, with fine warp yarns and

heavier, softer-twist weft that will become the cut pile. The resulting fabric is cut into strips of fringed "yarn" (see Figure 4.42 on page 151), which are then used in weaving as pile weft. This material is most often used for upholstery, but a few very high quality carpets are still made with chenille yarn pile. (It is also used in knitting and for decoration as with embroidery.) (Note: "Candlewick" chenille is produced by tufting; see "Tufting" this section.)

LINK 4-4 WITH FILES IN FABRIC GLOSSARY

These illustrate how these fabric constructions affect and are significant for the fabrics made of them (dobby and jacquard control; leno; surface figure weaves; pile weaves, including carpet). Look these up for a fuller understanding of how this contributes to the fabric character and behavior, or is an essential part of its name. You will also find photos of these named fabrics, as well as other related textiles.

Fabric Glossary Fabric Name Look names up in Fabric Glossary Index.	Relationship to Fabric Reference Discussion
Crepe by (Dobby) Weave	Compare durability of "pebbliness" of woven crepe with other methods.
Dobby Design, Armure, Birdseye, Honeycomb, Huckaback, Madras Shirting, Waffle Cloth	Note limitations in size and shape of these designs.
Dobby Openwork: Natté, Mock Leno, Latticed or Mesh Look, Aida or Java Canvas	Compare with other openwork woven patterns.
Dobby Compound, Single Face: Bedford Cord, Piqué	What is required to weave these?
Reversible Double Cloth, Double Face	· ,
Jacquard Woven (Figured), Brocade, Damask, Matelassé, Cloqué, Tapestry	Classic "jacquard" designs.
Leno (Latticed), Marquisette, Grenadine	Advantage of this method, applications.
Surface Figure Weaves: Swivel, Clip-Spot, Lappet, Dotted Swiss (Woven)	Compare in cost, durability, effect.
Velvet (many names), Velour Woven Pile, Plush, Terry Cloth	Major warp pile fabrics; methods, quality.
Corduroy, Fustian, Velveteen, Chenille Woven Pile	Main weft pile fabrics; methods, quality.

REVIEW QUESTIONS 4-4

- 1. What limits the size and shape of patterns that can be woven on a loom with a dobby attachment? How does the jacquard attachment overcome this?
- Name five complex fabrics woven with dobby control. Name three well-known fabrics always machine-made with jacquard control.

- 3. Explain the difference between plain weave gauze (as in cheesecloth) and a similar open fabric of leno weave.
- 4. Why is it incorrect to describe pairs of warp yarns in a leno weave being twisted or wrapped around each other with each passage of the weft? If only one of the pair of warp yarn is moved, (half leno), what is the decorative effect in the fabric?
- 5. Name three fabrics made in leno weave.
- 6. Why is a swivel-woven dotted Swiss more durable than a clip-spot? What method(s) of extra-yarn figures give an "eyelash" effect?

- 7. What are the two main types of pile weaves? Name three pile fabrics given by each method.
- 8. What type of surface is not possible with the double cloth method of pile weaving?
- 9. Name five main factors in quality of a pile weave (including woven carpet).
- 10. What are the two main methods of weaving carpet? Distinguish between them as to cost, speed, color selection available, durability of product.

4-5 KNITTING

Knitting is formed by a series of loops, intermeshing in rows, each hanging from the last. Each loop is called a *stitch*; a vertical row of stitches is a *wale* and a horizontal row of stitches is a *course*.

Knitting as a fabric construction method, according to surviving artifacts, is not as ancient as weaving. While knit fabric remnants exist from around the fourth century B.C., woven fabrics from ancient Egypt were sophisticated by the fourth millennium B.C.

Hand knitting became common only by the fifteenth century A.D.; by 1589 the Rev. William Lee in England had developed a machine that could knit a coarse flat fabric in plain stitch.

Modern machine knitting is of two types, **weft** and **warp**, terms relating to the direction from which varn is fed to the needles:

Weft knit. Yarn is fed to the needles from the side, and loops are formed across a course.

Warp knit. Yarn is fed to the needles from the end, a separate yarn feed for each needle, so loops are formed in the direction of the wales.

These two types are shown in Figure 4.43, along with a single loop and its parts. It is evident here also that knitting has an altogether different "geometry" from weaving. Because of the arrangement of yarns in loops, and the interdependence of adjacent loops (especially in weft knits), there are some significant differences between knitted and woven fabrics.

Knitted versus Woven

In Character

For a given quantity of yarn used, knits will:

- be lighter and more porous.
- be more easily distorted, leading to shrinking, or stretching and sagging. However, this also allows some degree of "give" in the structure (see next).
- have comfort stretch. Woven fabrics have "give" only on the diagonal or bias, not much on the grain lines unless made with stretch yarns.

The degree of comfort stretch varies with the type of yarn used, of course, but aside from that, it varies with the knit stitch, which in turn is governed

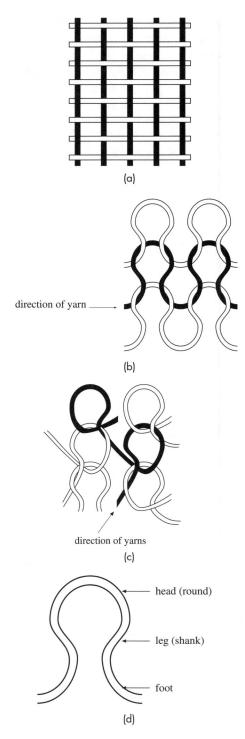

Figure 4.43 Arrangement of yarns is contrasted: (a) weave (plain) (b) weft knit (plain stitch technical face), and a (c) warp knit (tricot); (d) parts of a knit loop.

by the kind of machine that produces it or the type of needle used on that machine (see "Knitting Action, Types of Needles").

So the character of knitted fabric depends on the type of machine used, much more than in weaving. Production of a fine, close-knit fabric is a good example, being dependent not only on using a fine yarn, but on having a machine with fine needles set close together. Fine yarn knit on a machine with coarser needles set farther apart just gives a lighter, more open fabric. Changing machines can be a very expensive step.

In Use

The effects of the differing geometry of knits compared to wovens are seen in comfort, wear, and care.

Comfort

Knits are more comfortable in cold, still air, since the porous structure insulates better; it holds more air (especially a rib knit) to prevent loss of body heat. However, in cold, windy weather, a closely woven fabric can give much more wind resistance.

In wet conditions, a knit will simply "strain the rain" without a water-resistant layer, usually woven, behind it or on top. (See Table 4.1 for a comparison of plain, twill, and satin weaves.)

In hot, humid weather, a crisp woven fabric, especially made of spun yarns and in a basket plain weave, will allow the best air circulation over the skin to help take perspiration away.

Wear

Knits, in general, are not as durable to hard wear as woven fabrics. Knits do have inherent wrinkle resistance, but can sag or bag in wear, especially single plain-stitch knits.

Care

Knits are more easily cleaned than wovens.

Resistance to relaxation shrinkage is best with wovens, or warp knits. Of the knits, warp knits and doubleknits generally show the best stability to care. such as machine washing and tumble drying.

Steaming a knit lightly will counteract bagging after wear. Let the fabric cool and dry in its pressed position.

Single knits should be stored folded or rolled, rather than hung; a shaped hanger is all right for most doubleknits or warp knits.

A heavy brooch should be pinned through fabric or tape put inside a knit garment to prevent sagging or damage.

Other aspects of care of knits are discussed in Section Six

Handling in Garment Construction

Knits must be handled with special care and differently, in many cases, from wovens in garment construction.

Pattern

The pattern must be suitable to the amount of stretch in the knit fabric used. Doubleknits and tricot have more of the stability of woven goods; single knits, especially plain stitch, or knits with stretch yarns require specially adapted patterns with less ease allowed; see the knit stretch gauge in the Fabric Case History record in Section Eight.

Layout

Put as little tension as possible on knit fabric; allow it to lie and "relax" before cutting.

Weft knits form "runs" one way. A silky interlock ("double jersey") may run easily; if so, lay it so the run direction is up. In construction, garment pieces can then be secured at the hem.

Watch for different stretch in wales versus courses direction; where there is a difference, lay all one way.

Marking and Cutting

Mark darts, etc., with tracing paper, chalk, or tailor's tacks, not with holes or nicks. Cut with sharp scissors, flat-blade preferable to pinking.

Lining and interlining should have "give" comparable to the knit.

Stitching

Polyester thread is often used for some "give." Seams must have some elasticity; use zigzag or other stitch to give some stretch. Wales-wise seams can be finished by double stitching and trimming close. A ballpoint needle in good condition is preferable, especially for knits from "silky" yarn, as it tends to part filaments rather than break them (see Figure 9.2). A straight needle must be fine and sharp (new). Pins should also be ballpoint, or fine and sharp.

Tape seams that take strain, as at shoulders. For a sharp crease, either stitch the crease or have it commercially pressed (heat set) if the knit is made of thermoplastic fiber.

Fasteners

The best continuous fastener for light knits is the coil type with tricot tape. With other fasteners, put some support behind the knit, or take care that the fastener is not so heavy that it will pull, as heavy buttons might on a light knit fabric.

Knitting Terms, Knitting Action, Types of Needles

Two main types of needles are used in knitting machines, and these have a considerable effect on the character of the fabric produced; they are **latch** and **beard** or **spring beard** (see Figure 4.44).

Knitting action—the formation of the stitches—is different with these two types of needles (see Figure 4.45). In any machine knitting, the needle hook must be *open* to receive yarn that will form a new loop, but it must *close* to allow the needle carrying the yarn to pass through the previous loop to form a chain. With a latch needle, the hinged latch

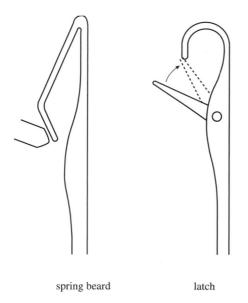

Figure 4.44 Two main types of knitting machine needles.

closes as it touches the previous loop; a presser closes the flexible "beard" of the hook of the spring beard needle.

Latch needles can accept a wide range of yarn types, from finest to heavy and irregular; spring beard needles can knit only fine, regular yarns. **Hybrid** or **compound** needles are made to give some characteristics of each of the main types.

Terms relating to closeness of needles on knitting machines are somewhat confusing:

cut. A machine term, meaning the number of needles per inch around a circular weft machine; it is often applied to a fabric (fine cut, 18 cut), but is a general guide to stitch only, not a stitch count

gauge. Varies in technical definition with different machines: It is needles per inch for circular weft knits and tricot; needles per $1\frac{1}{2}$; inch for flat (full-fashioning) weft machines; needles per 2 inches for raschel machines.

The metric measure suggested for knits is stitches per 100 mm of fabric.

Some Other Knitting Terms

plating (plaiting). Feeding two yarns to each needle, one covering the other; this can result in a different texture or color on either side.

gating (gaiting). The relation of one bed of knitting needles with another in a weft knitting machine. In *interlock gating*, the needles are exactly opposite each other, producing the structure shown in Figure 4.54. With *rib gating*, two sets of needles work at right angles, as in the machine shown in Figure 4.53. *Purl gating* occurs with flat or V-bed machines (Figure 4.50) with needles either two-ended or two sets but in the same plane.

weft insertion or laying-in, also called inlay or inlaid (do not confuse with *intarsia*). A yarn is fed in (laid in) that does not loop, but is held in the loops.

flechage. Short row knitting, holding stitches of one area while knitting another, to fashion the knit material or even knit in effects such as pockets—see 3. Purl Stitch under types of single knit machines.

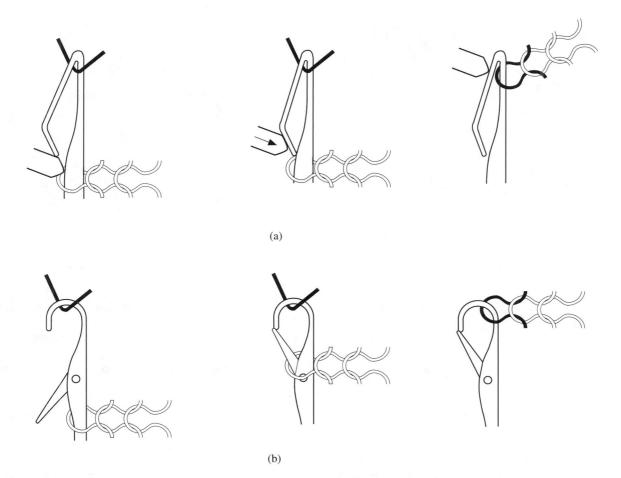

Figure 4.45 Formation of stitch with (a) spring beard vs. (b) latch needle.

Types of Knits

Weft (Filling) Knitting

Single Weft Knits

These can be made with one yarn forming loops; theoretically, a single yarn could form all the loops in a complete fabric. In practice, a number of yarn feeds or ends are usually used simultaneously in machine knitting.

Single knits may be **flat** or **circular**:

• Flat knitting machines are able to shape or fashion the sides of the knit fabric, creating fullfashioned articles. These are better fitting, and the pieces can be neatly joined by looping together, with no seam. This is also a good method of knitting garments of very expensive yarns (such as camel hair), as there is no cutting waste.

- Fashioning marks will be seen along an edge if stitches have been increased or decreased, e.g., for sleeve shaping in a sweater (see Figure 4.46). However, machines capable of flechage can shape articles without such fashioning marks (see earlier definition of flechage).
- As an intermediate method, "blanks" may be knitted roughly to the size of garment pieces and then cut and sewn for the various sizes in a range.
- Circular knitting is faster than flat and turns out fabric in tubes, which are often slit open and then treated like any piece goods to make "cut and sew" articles. (See also "Seamless Garment Knitting" in this weft knitting section.)

Figure 4.46 Fashioning marks on a sweater sleeve.

There are three **types of single weft knit machines**, with different stitch capabilities:

1. **Plain stitch** is formed with loops drawn always to the back of the fabric, giving the face an appearance of vertical rows (the *shank* or leg of the stitch), while the back shows the *round* or head of the stitch (see Figures 4.43[b] and 4.47).

This machine is the fastest weft knitting type; since circular machines knit faster than flat, the circular plain stitch machine (also known as the "jersey" machine) is the fastest, often termed the "workhorse" of the (weft) knitting industry.

Plain stitch knits fit the body well, but are the most easily distorted of all knits, and can "run" (stitches drop, forming a "ladder"), sag, and shrink most readily. The edges curl because of the difference in tension between the face and back.

Fabrics made in plain stitch are jersey, balbriggan, and lisle. Just as plain weave fabrics need not be plain, so plain stitch knits can have intricate, knittedin jacquard patterns.

The plain stitch machine is also used and modified to give fabrics with weft insertion or inlay (see "Knitting Action"), e.g., knit fleece, fur-like sliver-knit

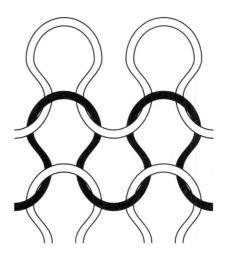

Figure 4.47 Plain stitch technical back.

pile, knit velour, knit plush, and knit terry. Some knit fabrics referred to as "fleece" are more complex; see two-sided weft knit fabrics under "Other Knitted Fabrics and Terms."

2. **Rib stitch** requires that all the loops of some wales be drawn off to the face and those of other wales to the back. To do this, the machine has two sets of needles, usually set at right angles to each other (rib gating).

Rib knits are described according to the number of stitches drawn to one side by the number to the other, e.g., 2×2 , which is read as "two by two." The simplest rib is a 1×1 , shown in Figure 4.48.

A rib knit has excellent crosswise stretch and recovery, and so is used for snugness in bands at neck, sleeves, and waist. It also makes a very warm fabric because of the air trapped in its "hill and valley" surface.

Special rib knits are described in *Fabric Glossary:* Rib Knit, covering accordion, cable, poor boy, and shaker. To knit cable, a group of plain stitches is made to change places with an equal group for some courses, giving a braided, cordlike effect.

3. **Purl stitch** draws loops to the back of the fabric on one course and to the face on the next course (see Figure 4.49). To knit this stitch, some machines use a double-headed latch needle; these machines may be called *links and links* (from the German word for *left*, from the direction of travel of the carriage). Many modern machines accomplish this stitch using a V-bed carriage, with two needle beds set at an angle to one another; this type is

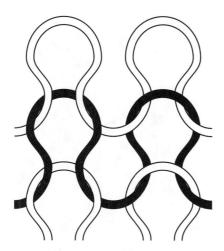

Figure 4.48 A 1×1 rib knit.

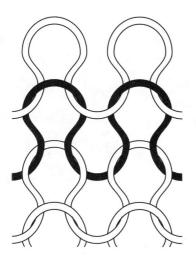

Figure 4.49 Purl stitch.

shown in Figure 4.50. Such a machine can also produce a sweater front, for instance, not only fashioned, but with collar, pocket, and buttonhole knitted in (flechage). This can effect significant savings in labor costs of assembling a garment (once the capital investment in the machine has been made!).

Computer-assisted design and manufacturing (CAD/CAM) is shown in Figure 4.51 with a computer design system that can operate this V-bed knitting machine. Intricate designs can be "drawn" on the computer screen and translated directly into

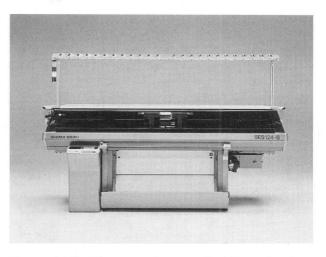

Figure 4.50 Electronically controlled flat weft V-bed knitting machine can knit the purl stitch (and plain and rib as well). (Courtesy of Shima Seiki U.S.A. Inc.)

control that produces jacquard-knitted patterns in whatever size or color combination is desired.

Machines that knit the purl stitch are the slowest of the three weft knit types, but can also knit plain and rib stitches; this means they are the most versatile. A combination of plain, rib, and purl knitting in one article could come from this type of machine only (see Figure 4.52).

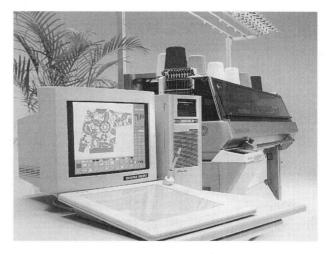

Figure 4.51 Designs created by "drawing" on the computer screen can be knitted directly into fabric on this V-bed machine with this electronic control system. (Courtesy of Shima Seiki U.S.A. Inc.)

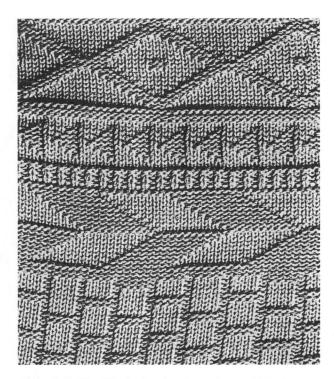

Figure 4.52 Machines that knit the purl stitch are the only ones that can knit all three weft stitches: plain and rib as well as purl, as seen in this knit fabric.

Fabric in purl stitch has good stretch, especially lengthwise, and does not curl.

Doubleknits

Doubleknits are weft knits produced on circular rib machines (using latch needles) by using two yarn feeds, knitting now on one set of needles, now on the other to form a tube of two fabrics knitted together (see Figure 4.53). Doubleknits, therefore, cannot be fashioned.

Interlock is the simplest form, a fine double 1×1 rib, with the needle gating such that stitches on one side are set right behind those on the other side; Figure 4.54 shows this arrangement of stitches, seen as if the fabric were viewed from an end with the loops spread open. *Both* sides of the fabric *look like* the face of plain stitch single knit and jersey is the best-known fabric in that stitch, so interlock is often called "double jersey," especially when it is knit of filament yarn rather than cotton.

What we commonly call a **doubleknit** may be of various stitches. One with a kind of honeycomb stitch

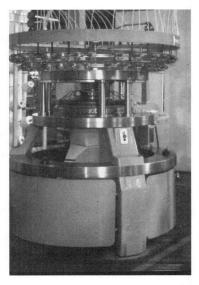

(a)

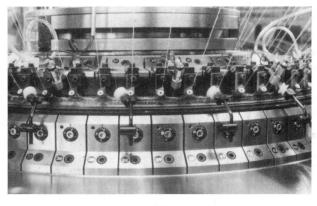

(b)

Figure 4.53 (a) Circular rib knitting machine that can produce doubleknits, since in this machine, two sets of needles work at right angles. (b) Close-up of the knitting elements of this circular rib machine. (Courtesy of Speizman Industries, Inc. for Jumberca, S.A.)

is called double piqué, and another is ponte di Roma. Bourrelet is a doubleknit having a corded effect on the surface. Doubleknits of textured set filament polyester varn have been known as *crimpknits*.

The two sides of a doubleknit can look and feel similar, although if there is a jacquard pattern knitted in, it will be clear on the face and will often have what is called a *birdseye* look on the back. Alternatively, the face may be puffed or otherwise separated from the back, since there are really two fabrics knitted together.

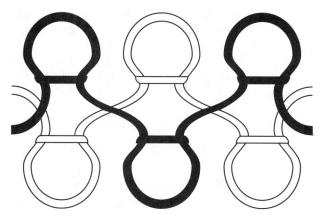

Figure 4.54 Interlock structure shown as if the loops were spread open as the fabric is viewed from an end.

Weft Knit Stitch Variations

Some basic variations on weft knit stitches are:

Float or miss stitch occurs when one or more needles do not form a stitch, and the yarn floats across the back of the fabric (see Figure 4.55).

Tuck stitch occurs when a needle holds the old loop and then gets a new yarn, so both stay in the needle hook. This stitch shows as an inverted V on the back of the fabric (see Figure 4.56).

Half cardigan stitch has only one set of needles knitting and tucking on the face or back on

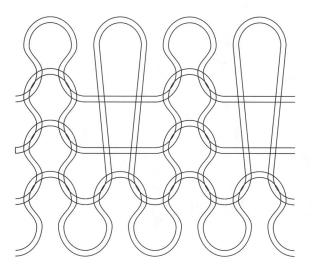

Figure 4.55 Float or miss stitch, fabric back.

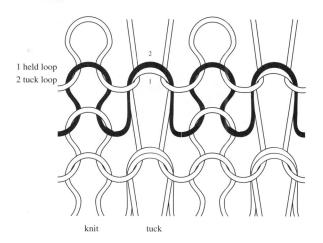

Figure 4.56 Half cardigan stitch (alternate knit and tuck), fabric back.

alternate courses. The construction on the face is the reverse of the back (see Figure 4.56).

Full cardigan stitch is produced in rib knits by alternately knitting and tucking on the two sets of needles, then tucking and knitting on the next course, producing a thicker, bulky fabric. The fabric has the same look on both sides (see Figure 4.57).

Rack stitch is a variation of the half cardigan that gives a herringbone pattern on the face.

Some of these stitch variations give floats that can snag.

Seamless Garment Knitting

In a simple form, seamless garment knitting has been around since circular weft knitting began, and is the basis of most hosiery. However, the machines that can produce seamless garments, the yarns used, and the range of products have multiplied and become much more sophisticated in recent decades. All kinds of fashionable intimate apparel, swimwear, activewear, sportswear, and ready-to-wear have been successfully produced, not only on circular machines, but on the complex flat-bed machines such as those described under Purl Stitch, with two major machine makers, Shima Seiki (Figures 4.50, 4.51), and Stoll. By 2001, Stoll found that the technology that made "Knit and Wear" possible was drawing about 25 percent of its sales.9 Seamless garments increased from 1 percent of knit production in 1997 to 7 percent in

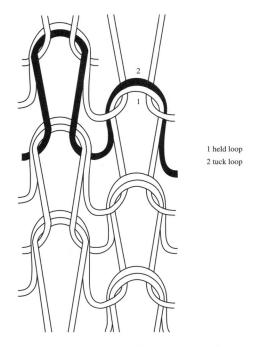

Figure 4.57 Full cardigan stitch, face or back.

2003, and is still growing.¹⁰ When knitted using microfibers, the garments not only give close fit and comfort stretch, they feel luxurious, as well as not showing lines if worn under close-fitting outer apparel. However, an elastomer is needed if they are to shape the body.

Warp Knitting

This form of knitting is very different from standard hand knitting; the earliest warp knitting machine was Crane's tricot machine (England), built about 1775. In warp knitting, a yarn is fed to each needle from the lengthwise direction. A bar guiding the yarns to the needles can move from side to side, or to the front or back of the needle, so that the loops can be interlocked in a zigzag pattern. Very wide (over 400 cm, nearly 170 in.), flat fabric can be produced by warp knitting, at speeds in the order of 1,000 courses per minute, giving almost 3 m²/min (3.6 sq. yds./min). The two main machine (fabric) types are **tricot** and **raschel**.

Tricot

Tricot is a machine with one needle bar (spring beard type) and one to four guide bars (most are two-bar or three-bar) (see Figure 4.58). The spring

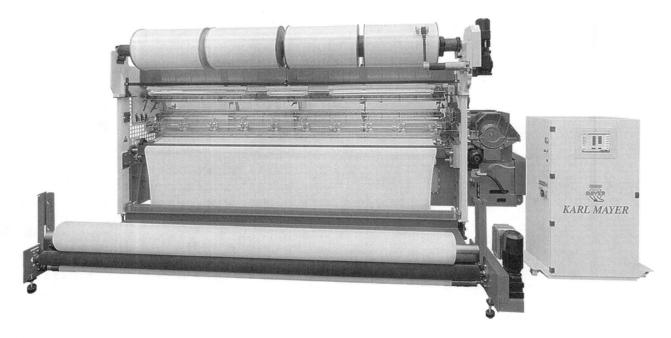

Figure 4.58 High performance tricot machine, type HKS 3 M. (Courtesy of Karl Mayer Textilmaschinenfabrik GmbH)

beard needle, accepting mainly filament yarns, has limited the depth of texture that can be achieved in tricot fabrics; some fine spun tricot, produced on machines with hybrid needles, was introduced many vears ago, but does not seem to have taken hold in the marketplace.

Figure 4.59 shows a tricot fabric. It can be seen from this photo why a simple tricot is often called "jersey"; the face looks like west plain stitch face. although the back has a different and distinctive look-like chevrons on their sides (>>>>>)because of the zigzag path of the varns. This

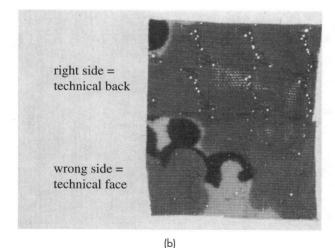

Figure 4.59 (a) Tricot technical face (top) looks like plain stitch (jersey), while technical back has crosswise lines of chevrons on their sides and is often more smooth and lustrous. (b) This side (technical back) is often the right side of a tricot, smoother for printing and showing a contrast yarn more cleanly.

technical back of tricot is often used as the "right side," as it is smoother, e.g., for printing, and the yarns are more available for brushing or sanding. Moreover, if there are variously colored varns in the tricot, they meet in a lengthwise stripe much more cleanly on the technical back (see Figure 4.59 and Fabric Glossary: Tricot).

Tricot does not ravel, can curl somewhat, and has almost no stretch or "give" lengthwise but a little crosswise. (Note: It may be confusing for French-speaking people to find the word tricot meaning, in the English language, the product of this specific warp knitting machine, when in French, un tricot means simply "a knit," and tricoter "to knit.")

Raschel

Raschel is the other main warp knitting machine. Fabric from these machines may be of any weight or thickness from lace to carpet; the one feature they share is a pillar-and-inlay effect: wales like hand crochet chains forming the "pillar" (see Figure 4.60), with other yarns laid in to form patterns or the main body of the fabric, usually making up the right side.

Raschel machines have one or two needle bars (usually latch, but may be spring beard), set horizontally on wide or narrow machines with 1 to nearly 100 guide bars (one jacquard raschel lace machine from Karl Mayer has 95 bars); see closeup of guide bars. Figure 4.61(b). The multiguide bar types are used mostly for laces; most of our moderate-priced laces are knit on this type of machine, especially for curtains

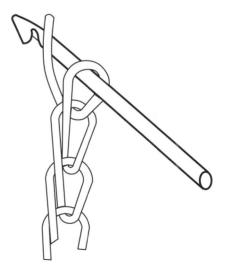

Figure 4.60 Hand crochet stitch is very like the formation of warp knit loops.

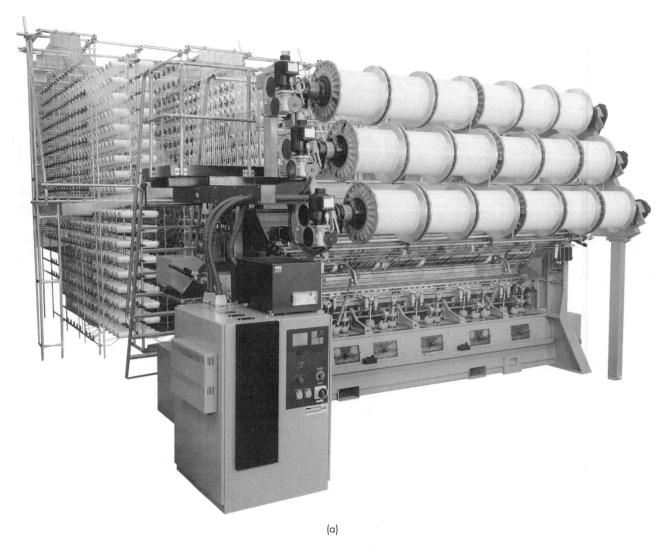

Figure 4.61 (a) Curtain jacquard raschel knitting machine, RJPC 4 F-NE.

(see Figure 4.61a). They do not have the depth of texture that the twisted Leavers laces or the embroidered Schiffli laces have. Powernet, knit on the raschel machine, incorporates elastomeric yarn to give one-or two-way power stretch for contour fashion.

Variations on raschel-type machines include **crochet, ketten raschel,** and **Cidega** machines. The latter, similar to raschel, can knit various fabrics side by side, and so is used for many narrow trims called "braids," such as gimp, and ball fringe.

Minor Warp Knits

Simplex is a machine with two horizontal needle bars and two guide bars, producing a double tricot

type of warp knit in a fine gauge, with two threads to each loop. The needles in one bar are directly behind those in the other, in much the same way that needles in the weft knit interlock are aligned; like interlock, simplex *looks like* plain-stitch jersey on *both sides*. The fabric is very firm and stable, used for its greater firmness in loungewear, uniforms, and gloves.

Milanese is a machine with one needle bar, one guide bar, and two sets of threads; one forms the face of the fabric, the other the back. Yarns are carried diagonally all the way across the fabric. Milanese is knit flat (spring beard needles) or circular (latch needles).

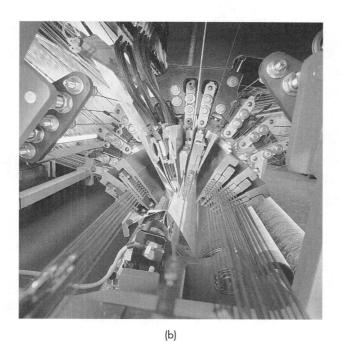

Figure 4.61 (b) Closeup of guide bars on a Textronic[®] Lace, Type 66-Multibar-Jacquard raschel machine, for the production of high-quality elastic and rigid fabrics. ([a] and [b] Courtesy of Karl Mayer Textilmaschinenfabrik GmbH)

Other Knitted Fabrics and Terms

Jacquard knitting control uses punched cards, wheels/drums, electronic tape, or direct computer control to produce intricate knitted-in patterns, usually multicolored (see Figure 4.51). A varn not looping on the face floats across or is caught into the back.

Fair Isle is one well-loved design from hand knitting reproduced by machine with jacquard control. The design is named from the southernmost of the group of Shetland and Orkney Islands, northeast of Scotland. Patterns are horizontal bands of colored geometric and floral designs on a contrasting ground. Figure 4.62 contrasts the face of the knit, showing the clear intricate pattern, with the back, where other colored yarns are carried when they are not part of the pattern.

Intarsia (from Italian meaning "inlaid") is usually knit on a flat V-bed machine. The yarn knits only where the design (usually a geometric motif) is formed, so the back of the knit design is the same solid color as the face, giving a sharper, cleaner definition to the pattern. Argyle is one classic pattern that looks best when intarsia knit. This knitting method, especially when isolated motifs are shown

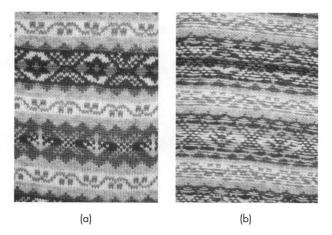

Figure 4.62 Face and back of a Fair Isle knitted pattern, typical of jacquard control in machine-knit goods. Where a yarn does not loop on the face, it is carried in the back. (Courtesy of Seneca College Fashion Resource Centre)

on a garment, requires careful planning and precise control, and so is usually expensive. A garment with an intarsia motif usually exhibits other features of high-quality knitwear: fashioning, with looping of seams, so the inside of the garment is finished almost as well as the outside, as in Figure 4.63.

Pointelle is a pattern of holes in a knit (see Figure 4.64).

Knit pile fabrics can be produced with extra yarns knitted into either weft or warp knits, left with uncut loops for knit terry or sheared if a plush surface is desired, as with knit velour or knit plush.

Another method, most often used to give deep pile, fur-like fabrics, catches tufts of sliver in the loop of a plain knit stitch (see Figure 4.65). To create a very fur-like guardhair/underfur look and hand, the latent shrinkage in some acrylic fibers can be used (see Acrylic, Section Two, and Direct Spinning, Section Three). In this area of designing, a thorough knowledge of machine technology is required; Figure 4.65(b) shows the right and wrong side (technical back and face) of such sliver-knit pile imitating one of the endangered spotted cat furs. It would be hard from the wrong side to guess the look or the impact of the right side.

Two Face Fleece Knit

Two-sided weft knit fabrics are well known; a simple "sweatshirt" fleece, for instance, would qualify as two-sided, since it has a very different look and hand on the face and back. However, some knit fleeces

Figure 4.63 (a) Sweater with Argyle intarsia pattern; (b) the back of the pattern (inside the sweater) is the same solid color as on the outside. This quality garment shows a clean finish on the inside, as well as the clear intarsia pattern. (Courtesy of Parkhurst Knits, Dorothea Knitting Mills Ltd.)

have been developed which can be truly described as "two face," with not only greater depth than "sweat-shirt" fleece, but where each side can give performance for a specific purpose. By far the best-known of these is the original Polarfleece® (by Malden

Figure 4.64 Pointelle is a pattern of holes in a knit.

Mills), which carries a polar bear logo, shown in Figure 4.66.

There are many similar fleeces, even having trademark names suggestive of polar regions, but a lot will be produced without the company's Polartec® Technologies, which by now also offers a whole range of "advanced materials" for specific needs. These include giving comfort worn next to the skin; all kinds of outdoor clothing needs, from hot weather to very cold heights of mountain climbing; protection from fire, water, cold, sun—it is a long list and growing; for more detail, visit www.polartec.com.

Polartec® Technologies are also on the front line with other textiles innovators. BodyClimate® is a different kind of mattress ticking developed by Polartec, and made by Tietex International. It has been designed especially for foam mattresses, either latex or visco "memory foam."

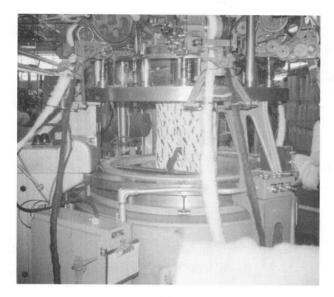

(a)

Figure 4.65 (a) Sliver-knit machine produces circular plain stitch knit with fiber from sliver caught into the round of the stitch at the back (inside the knit tube). (b) Deep-pile, sliver-knit, fur-like fabric. The right side is the technical back, while the wrong side (top) is the technical face of the plain stitch.

Figure 4.66 Logo for the very well-known Malden® Polarfleece®, the original of this type of fabric. (Courtesy of Malden Mills Industries, Inc.)

Knitting with Weft or Warp Insertion

Some knitting machines can lay in yarns crosswise (weft insertion) or lengthwise (warp insertion); a woven appearance plus better stability and resistance to distortion are the advantages. Weft insertion is also applied in Malimo machines, held by warp knit looping—see "Stitchbonded."

REVIEW QUESTIONS 4-5

- 1. What is the basic difference in arrangement of yarns in a knit compared to a weave?
- Record three differences between these constructions for each of: character or behavior, suitable uses, care.
- 3. Clarify basic knit terms, such as wale and course, latch and spring beard needle, cut and gauge, plating, gating, inlay, flechage.
- 4. List six types of weft knit machines. Which is the fastest? slowest? What are the advantages of the slowest (most expensive) method?
- 5. What type of machine is needed to knit a doubleknit? How do you know an interlock from other doubleknits?

- 6. Where are seamless knit garments used?
- Contrast the two main types of warp knit fabrics as to: type of yarns used, range of weights produced, main uses.
- 8. Clarify the knitting terms/patterns: jacquard, Fair Isle, intarsia, Argyle, pointelle.
- 9. Name five advantages of a "two face" weft knit fleece fabric for a child's Fall jacket. What drawback do some less expertly finished fabrics show?
- 10. Distinguish among three fabrics called "jersey" because they have the look of the face of jersey on one or both sides: jersey, jersey tricot, double jersey. Name one other fabric that looks like the face of jersey on one or both sides.

4-6 OTHER CONSTRUCTION METHODS USING YARNS

Twisting (Knotting)

Twisting, looping, or tying yarn upon itself is involved when making net and lace by hand. Since yarns must be moved three-dimensionally, machines to make net or lace by twisting are the most complicated and massive in textile manufacturing, notably the Leavers machine, which makes "Nottingham" lace.

A machine with a bobbin Barmen mechanism intertwines threads to give narrow widths of fairly heavy trimming lace, such as Cluny or Torchon.

Net

Net is probably the most ancient textile structure, having been used for hunting (snares) and fishing from prehistory. Net is an openwork mesh fabric formed of yarns twisted to form four-sided or six-sided holes. Some well-known names are illusion, point d'esprit, and tulle. Net fabrics can also be warp knitted: tricot or raschel. (Note that most net today is knitted, usually by a raschel or tricot machine.)

Construction of **bobbinet**, a six-sided (hexagonal) hole net, was developed by John Heathcoat in the area of Nottingham, England, in 1808 (see Figure 4.67). Yarns on brass bobbins can be twisted around warp threads in the machine to form the hexagonal hole of bobbinet. This invention paved the way for development of the more complex Leavers lace machine; in the interim, "lace" was produced by hand embroidering on the more economical machine-made net.

Lace

Lace is an openwork fabric with a pattern or design in it.

Machine-Made Lace Types

Knit Lace. Virtually all the lace used today is machine-made, and most is produced on raschel or similar warp knitting machines. This method gives little depth of design, but is much less expensive than the other methods.

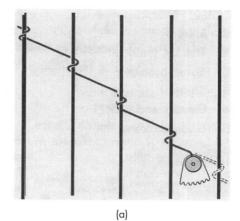

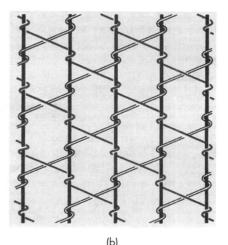

Figure 4.67 Bobbinet construction: Yarn on a brass bobbin is twisted around each warp yarn in turn (a). There is a bobbin for every second warp end (dark yarns, b), and another set is added, which moves across the other diagonal (white yarns, b). Bobbinet has a hexagonal hole (c). (Courtesy of the Textile Institute)

Schiffli Lace. With this type a lace is achieved by embroidering a pattern on fabric and then dissolving the ground. This method is expensive, but reproduces well some of the needlepoint lace types with great depth of design and no mesh background that go under the rather general name today of Guipure (see "Some Other Handmade Lace Types").

Twisted—Leavers (Levers), Nottingham Lace. This is produced by twisting yarns, as described in the opening discussion of twisting. The **Leavers machine** is the most complex used in the textile industry, very large in size, with over 30,000 parts, many finely engineered. There are warp or beam yarns set up in the machine, and the complex intertwisting is done by yarns carried on paper-thin bobbins that can move in and out among the warp yarns in any direction, controlled by a jacquard mechanism (see Figure 4.68).

This machine most nearly duplicates the movement of hands in making lace and can reproduce closely the "look" of many of the grand handmade laces. A brief review of these follows, to help us understand (a little!) when we might call a machinemade lace by one of the handmade lace names, which carry such an aura of elegance and refinement into our modern world.

Handmade Lace Types

According to *Ciba Review*, ¹¹ the main divisions of handmade laces evolved from very simple treatments of:

- **Seams**, embellished by drawn-thread work, as in hem-stitching or *fagoting* (shown in Figure 4.72[c]). This gradually led, through cutwork on a larger scale (*reticella*), to **needlepoint lace**.
- Warp yarns, which must be cut when woven material is taken off a loom; twisting and tying of these yarns (as in macramé) led to bobbin

Needlepoint. Needlepoint was the first real lace, derived from embroidery done on parchment, which was later cut away to leave the lace free (punti in aria: "stitches in air"). This art/craft began in Italy in the late 15th century, centered in the Venetian Republic; by the late 16th century, lace-making of various kinds was widespread in Europe.

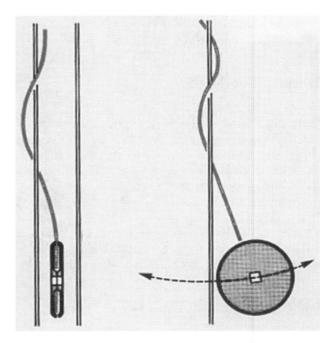

Figure 4.68 In the Leavers lace machine, thin brass bobbins twist thread around warp yarns. (Courtesy of the Textile Institute)

The parts of lace often have special names (many are French). The pattern (toilé) is connected with and set off by the ground (fond), which may be a mesh ground (réseau: net, or fond simple, a sixsided mesh), or just tie bars (brides). There may be loops from the edges or surface of the design (picots or bead edge). All this is worked with needle and thread, in stitches derived from embroidery. Often these laces have (naturally) a buttonholestitch look. Figure 4.69 shows a "generic" needle lace closeup, with the outline thread at the edges held with buttonhole stitches, a more open pattern made with detached buttonhole stitch, and denser pattern achieved by adding extra thread each row, stitched over. See Fabric Glossary, Needlepoint Laces, for "generic" point de gaze, and point de rose, showing crown with picots. Photos and analysis courtesy of Elizabeth M. Kurella; see References and Resources.

Some famous needlepoint laces are: Alençon, rosepoint, Venetian point, gros point, point de neige, point plat, coralline, point de gaze.

The best machine-made versions of a lace such as Alençon come from the Leavers machine, which

Figure 4.69 Closeup of a "generic" needle lace. (Courtesy of Elizabeth M. Kurella)

can make the mesh ground and the designs with their heavy outlining thread (cordonnet). When such a cordonnet is applied by hand, often not just a yarn but a special decorative trim like sequin strips, the lace is called re-embroidered and is usually very expensive: Figure 4.70 shows re-embroidered lace of both these types.

Guipure lace typically has no mesh ground; the thick patterns are built up with buttonhole stitches joined by tie bars; it is well reproduced by machines that embroider (Schiffli). The name Guipure comes from guipe, a cord base around which silk is wrapped to create a spiral yarn, as used in gimp (guimpe) "braid."

Bobbin or Pillow Lace. This type is formed by threads fed from many bobbins; the work of intertwining the threads is done over a pattern on a bolster or pillow, the threads held by pins. The bobbins are often weighted where the ends hang down.

This type of lace has a "clothy" or woven look in the more solid pattern areas: the Leavers machine can produce this look well. Some famous bobbin laces are: Binche, Valenciennes (Val), Mechlin or Malines, Bruges, Chantilly, Cluny, duchesse, and torchon (beggar's). Honiton was a later English type.

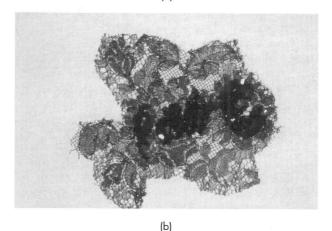

Figure 4.70 Re-embroidered lace is usually very expensive, with hand-guided application of (a) heavy cordonnet, or other embellishment such as (b) seguins.

When pattern and net are all made of the same (fine) thread, it is called fil continu (French, "continuous thread"); made by hand, this method gives relatively narrow lace, an example being Valenciennes or Val.

Some Other Handmade Lace Types. Appliqué lace has a pattern of lawn or cambric appliquéed to a net ground, then the net cut away from behind the appliqué. An example is Irish Carrickmacross.

Filet or darned lace, with a square mesh, is made by working thread in and out of a square mesh net.

Tenerife, Paraguay, South American, Spider, nanduti, and Tucuman are all associated with similar patterns of *ruedas* (Spanish, "wheel") or *sol* (Spanish "sun"), and often look like a spider web. These were developed from drawnwork, made in Spain, South America, Mexico, and (still) the Canary Islands (Tenerife), where rosettes of cotton thread are made within a frame.

Battenburg lace is one of the "renaissance" laces popular as a craft at the end of the 19th century, following a renewed interest in ancient Italian designs. The design is outlined with ready-made tape held together by loose brides (see Figure 4.71). A Honiton tape lace was made in Devon, England.

Tatting gives delicate laces made of fine, hightwist yarn, using a small, flat, shuttle-like carrier, helped by use of a hook like a crochet hook.

Crochet lace, made with a crochet hook in looped chains of stitches (see Figure 4.60), is well reproduced on the raschel knitting machine.

Lace-like fabrics can also be produced by weaving, weft knitting, and tricot warp knitting.

Lace Forms and Terminology

As well as the terms already discussed, the "vocabulary" of lace also includes names for special forms—the sizes and edge finishes in which lace can be selected for particular purposes. ¹² Many of these apply to any trim, including braids and embroidered fabrics.

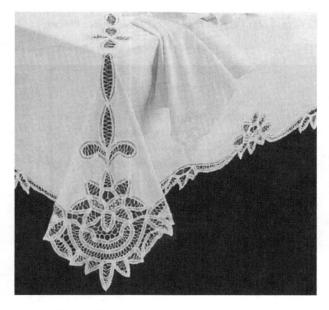

Figure 4.71 Battenburg (tape) lace.

allover. Pattern all over the surface of the fabric, cut and used like any piece goods; 100 cm (36 in.) or other normal fabric width.

galloon. Both edges scalloped or indented irregularly; up to 50 cm (18 in.) wide.

flouncing. One edge only scalloped, used for ruffles, flounces; 50–100 cm (18–36 in.) wide.

edging. One edge only scalloped, used for edging; usually quite narrow, maximum 50 cm (18 in.) wide. Some examples of this form are seen in the Fabric Glossary: Lace, Twisted.

insertion. Narrow, both edges relatively straight, used between two pieces of fabric or as edge trim (Figure 4.72[a]); picots (loops) on edges.

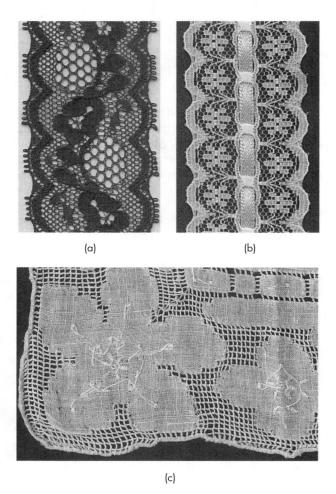

Figure 4.72 See text for definitions: (a) insertion with picots, (b) beading with ribbon, and (c) drawnthread work.

beading (often insertion form). Has slots in it, through which ribbon can be threaded (Figure 4.72[b]): in cheaper versions of beading, ribbon may be simply stitched behind the slots, or the effect of ribbon through slots may be incorporated during manufacture of knitted beading.

medallion. Single design or motif used for appliqué, usually Guipure type or other joined by brides, not mesh (see Fabric Glossary: Lace, Embroidered).

fagoting. Drawn-thread latticed effect or "ladder" work; threads drawn out of woven fabric, the remaining threads bound with buttonhole stitch (Figure 4.72[c] illustrates drawn-thread work).

Tufting

Tufting creates a pile fabric by inserting yarns, carried by needles, into a base fabric (called the primary backing in a carpet), and usually woven (see Figure 4.73). This is like the method used for hand-hooked

rugs, but with many needles working, each supplied with yarn. The loops can be of varying height, cut or left uncut, and the process can be electronically controlled. These pile fabrics are used for carpets, rugs and mats, upholstery, and bedspreads (candlewick). Figure 4.74(a) shows a full-width tufting machine for "broadloom" carpet, with primary backing woven of split-film polypropylene. Figure 4.74(b) and (c) give a closer look in a sample-sized tufting machine, with yarns brought to the multiple needles through narrow tubes from the back of the machine.

Floorcovering (carpet) is probably the heaviest fabric in consumer use. Over 95 percent of this today is tufted, the primary backing made traditionally of jute but increasingly of polypropylene woven of fibrillated or split-film yarn (see Figure 4.75). The tufted fabric for carpets (also for mats and upholstery) is coated on the back to hold the pile tufts (see Figure 4.76[a]).

Much carpet also has an additional secondary backing or a foam backing for self-underlay that conceals the tufted structure. Figure 4.76(b) shows two backings made of polypropylene; on the left, an

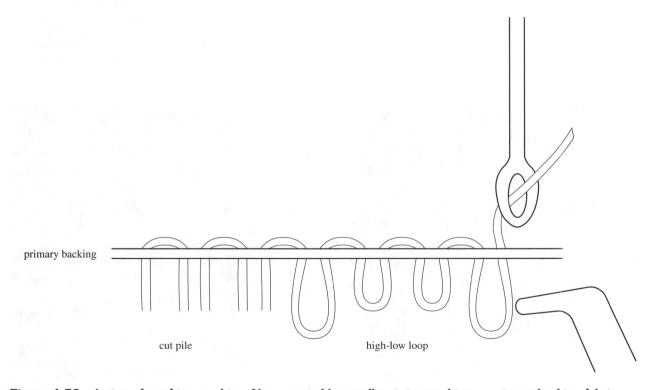

Figure 4.73 Action of a tufting machine. Yarn, carried by needles, is inserted into a primary backing fabric; loops may be of varying height and may be cut or left uncut.

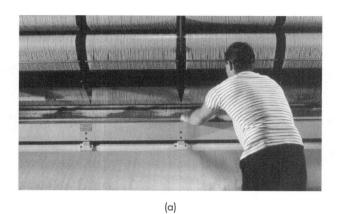

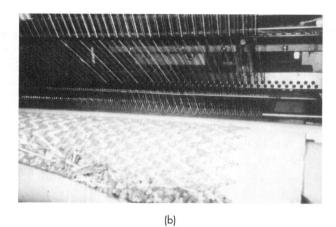

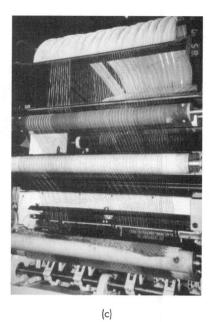

Figure 4.74 (a) Full-size tufting machine for broadloom carpet. Primary backing fabric here is woven of split-film polypropylene. (Courtesy of Dominion Textile Inc.) (b), (c) Sample-sized tufting machine at the Woolmark Research and Development Centre, Ilkley, W. Yorkshire, U.K.

Figure 4.75 Face and back of carpet tufted into a primary backing woven of split-film polypropylene yarn.

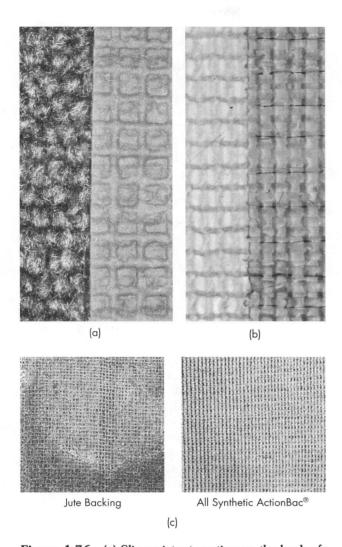

Figure 4.76 (a) Slip-resistant coating on the back of a tufted carpet. (b) On the left, Polybac®/AS antistatic primary backing for tufted carpet, woven of split-film polypropylene; on the right, Actionbac® secondary backing for tufted carpet, leno-woven of polypropylene. (c) A traditional woven jute (burlap or crash) backing for tufted carpet is subject to rot, mildew, odor, staining, and stretching or shrinkage. Actionbac® fabric for tufted carpet secondary backing is free from these hazards. (Courtesy of American Fibers and Yarns Company, now Propex)

antistatic primary backing, Polybac*/AS, woven of split-film yarn, on the right, a leno-woven secondary backing, Actionbac* (both by Propex). Such a secondary backing gives superior performance compared to traditional jute-woven fabric and at reasonable cost (see Figure 4.76[c]).

Candlewick or chenille is one of the few tufted fabrics that has no coating on the back; a "blooming" or untwisting of the plied, thicker, soft-twist cotton pile yarns, along with shrinkage of the base fabric in wet finishing, holds the tufts in place. It is used principally for bedspreads, but also for mats, bathrobes, and some sportswear.

Braiding

Braided fabrics are formed when yarns are plaited or interlaced diagonally. Braiding produces narrow, flexible, flat or circular fabrics; variety and consumer uses are shown and discussed in the *Fabric Glossary*. Industrially, braiding is significant in providing **cordage**, including **ropes**, **hawsers**, and **cables**. These are braided structures of many types, put together in a variety of ways, that can sustain great pulling forces. The structure of a cable (cord, hawser) is shown in Section Three, under "Yarn Classified by Ply." Uses are discussed under 3–5, "Thread and Cordage."

Braid is also a general term for narrow trims, such as ball fringe or gimp "braid," made not by braiding but usually by warp knitting. *Passementerie* is an even more general term that includes beads, cord, and narrow lace trims.

Stitchbonded

Stitchbonded, stitch-knit, knit-sew, and **loop-bonded** are all names applied to a method that can produce fabric very quickly on machines using a warp knit type of looping to hold together components such as yarns, fiber batt, or foam layers.

- Mali fabrics have been a family of stitchbonded materials made on machines developed by Malimo Maschinenbau GmbH in the late 1940s in what was then East Germany. It is now part of Karl Mayer Textilmaschinenfabrik (Karl Mayer America in the USA and Canada).
- Malimo is made up entirely of yarns in a flat, often open fabric used in draperies, or semisheer curtaining (see Figure 4.77[a] and [b]).
- Maliwatt has a base of fiber batt held together with the lengthwise rows of yarn loops, giving a corded effect.

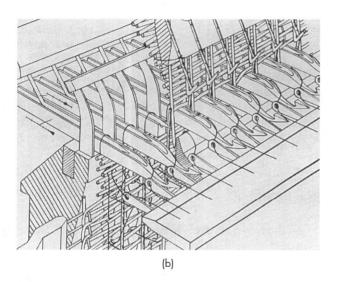

Figure 4.77 (a) Malimo, the original stitchbonded fabric. (b) Stitchbonded process to give Malimo fabric (all yarns). Fine yarns, carried by guide bars to horizontal needles, loop together a layer of horizontal yarns with vertical (warp) yarns. (Courtesy of Malimo Maschinenbau GmbH, now Karl Mayer Malimo Textilmaschinenfabrik GmbH)

The process to give Malimo is shown in Figure 4.77(b): horizontal needles carry yarn for the knit looping or stitchbonding, brought through guides; this looping yarn is usually fine, as shown here, so that it is often hard to see in the completed fabric. Vertical (warp) yarns and yarns like weft, but laid at slight angles to the horizontal, are thus held together to emerge as Malimo fabric.

Stitchbondoc fabric does not have the inherent elasticity of a true knit, unless elastomeric yarns are incorporated.

Malimo, because of the speed of construction, was originally expected to be a much cheaper way of making fabric than weaving, but it is a three-yarn system, and the quality of the stitching yarn must be high, both factors making raw material costs not less than weaving. Then direct costs are higher, because it takes many times more people to attend these machines than looms. High quality stitchbond machines, however, are now made by Karl Mayer in Germany, capable of weft insertion of some 1,600 ppm. The world's largest producer of stitchbonded fabrics is Tietex International Ltd., of Spartanburg, SC, and the variety of end uses has grown, especially in home furnishings, such as bedspreads, drapery, upholstery, and mattress ticking.

A number of machines of the Malimo type do not use yarns at all, but take a web of fibers and, in effect, form some into stitches to hold the web together; these are described under the heading, "Fabrics without Yarns."

Embroidered, Base Dissolved

Embroidery has been covered in earlier editions under Section 5-6, "Other Applied Design." However, it has now become a method of making very useful and "high tech" materials to be used in surgical implants. Technical implants, shown in Figure 1.3 (b), have had to be made by knitting, weaving, or braiding, with disadvantages to each. Embroidery, by forming stitches on a base cloth, allows these to be placed in any position, and modern embroidery machines use sophisticated computer control software. Fiber arrays can thus be designed for virtually customized surgical implants, converted from a rough sketch to an embroidery design and then to a manufactured product in a few hours. 13 Ellis Developments Limited have explored this, and it is being used for surgical implants; Figure 4.78 shows a bioimplantable device for reconstructive shoulder surgery (would grace an art gallery!). There are many other possibilities (see www.ellisdev.co.uk).

Figure 4.78 Snowflake-like structure given by embroidering, with the base fabric then dissolved away. The product here was stitched with surgical thread to be bioimplantable by surgery. (Courtesy of Ellis Developments Limited)

4-7 FABRICS WITHOUT YARNS; FABRICS WITHOUT FIBERS

Fabrics without Yarns

Felt

Felt traditionally is a fabric formed by the felting of wool or hair fibers. When a mass of fibers containing about 50 percent wool is agitated with heat, moisture, and pressure, the surface scales allow the wool fibers to move only in the direction of their root ends; eventually the mass of fibers shrinks together, interlocks, and mats into a fabric—felt.

There should be about 50 percent of wool to form felt if nonfelting fibers such as cotton or rayon are used with it in a blend; an all-wool felt will be much the strongest, and the best grades may use the short *noils* removed in combing during worsted yarn spinning of high-grade wools, or lustrous undercoat fur fibers such as beaver.

A web or batt of fibers is prepared, steamed, and pounded until a sheet of fabric is formed. Felt is made in many thicknesses, used for gaskets, boot insoles, and padding. "Numdah" rugs are felted, and to make felt hats, nearly shapeless hoods (body hoods) are formed. These are then steamed and blocked on forms, to make a variety of hat shapes or bodies, from which the headgear is finally made. (See Fabric Glossary under Felt.) Fur felt uses the underfur of certain animals, with beaver giving superb quality and rabbit lower grades; fur fibers give luster, resilience, and water repellency.

Nonwoven

Nonwoven is the term applied to fabrics made directly from fibers, but not by the felting of wool or hair fibers. The technology and uses of these fabric constructions have grown globally and with extreme rapidity in this 21st century. The products of the various methods of making fibers directly into sheets of fabric are being created for more and more specialized and varied uses: medical, construction, geotextile, transportation (especially automotive), agriculture, packaging, and filtration, as well as apparel and furnishings. They can be single-use or extremely durable. Manufacturers of both traditional fabric constructions and machinery have entered this field, to make possible ever more innovative and specialized textiles.

There are many methods of achieving these fabrics, including mechanical, thermal, and chemical

bonding. Methods can also be successfully combined to give useful fabrics, giving rise to a *composite* technology delivering properties of two or more types in one fabric. This makes for a segment which is not easy to present in a logical, succinct treatment. The beginnings were probably in the first method to be discussed—using a bonded fiber web.

Bonded Fiber Web

Fiber webs may be laid at random, crosswise, or lengthwise (a web-forming machine is shown under another nonwoven category in Figure 4.81). Webs may be bonded using adhesives or heat; many of these are used in apparel manufacturing and they come in a wide variety of weights and thicknesses. Some carry dots of material of lower heat-softening point to make them fusible; Figure 4.79(a) shows interfacings used to build and hold shape in tailored shirts, and Figure 4.79(b)

(a)

Figure 4.79 (a) Nonwovens used for interfacings in

shirts. (Courtesy of Dominion Textile Inc.) (b) Nonwoven interfacing hidden in tailored clothing.

reveals some that will be hidden by lining in tailored iackets and coats.

Needled

Needled (needle-punched, needle-woven, "needle felt") fabric involves inserting fine barbed needles into a fiber batt or web and tangling some of the fibers as the needles go in and out (see Figure 4.80).

Needled nonwovens will hold a good deal of liguid, and for this reason have been used extensively for medical uses and wipes. The felt-like "indoor-outdoor" carpeting is usually needled. A type of miniature needling apparatus is used to hold layers of nonwoven fabric together to make shoulder pads.

Very realistic suedelike fabrics can be produced by needling, in a high-tech process that leaves ultramicrofibers on the nonwoven fabric surface, giving the soft hand of real suede (which is created by the naturally formed fibrils of the flesh side of a skin). A web of bicomponent matrix/fibril (islands-in-the-sea) fibers is needled to give an entangled nonwoven fabric. This is

(a)

Figure 4.80 (a) Sample-sized needling machine; (b) section through needled fabric. (Courtesy of Ciba Review)

impregnated with polyurethane, then the matrix is dissolved with a solvent that does not affect the fibrils. leaving these ultra-microfibers (which can be well below 0.1 dtex) in place, giving the very soft surface. This can be sanded for the ultimate suedelike surface.

The best-known suedelike in the United States has been Ultrasuede® (by Toray Ultrasuede [America]). created as Ecsaine® (in Japan by Toray), and named Alcantara in Europe. There are and have been many trademark names for various similar suedelike and also leatherlike materials, many still current, but they are too numerous and changeable to list.

Stitchbonded No Yarns

Various stitchbonded processes were described earlier that use yarns in a warp knit looping to hold other components together into a fabric. A number of machines of the Malimo type do not use varns at all. A web of fibers is stitchbonded by forming the fibers into stitches to hold the web together as described under needled, except the needles are quite different, and the possibilities for fabric character are much wider (see Figure 4.81). A web formed into half stitches that show on one side only is called Malivlies, while the Kunit type forms plush fabric (see Figures 4.82, 4.83).

Malimo machines can also take Kunit fleece and feed it to a Multiknit machine, which will knit a fleece on the other side to give a double-sided fabric. This may be taken to move these materials into a third construction category—see Compound Fabrics—as a composite. and offers the possibility of constructing and/or finishing one side of the fabric differently from the other.

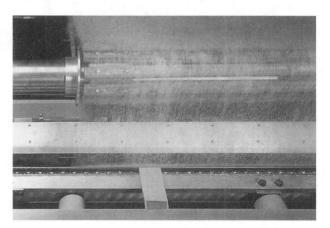

Figure 4.81 Web-forming machine delivers fibrous fleece to a Kunit machine to be stitch-knit into a plush fabric containing no yarns. (Courtesy of Malimo Maschinenbau, now Karl Mayer Malimo Textilmaschinenfabrik GmbH)

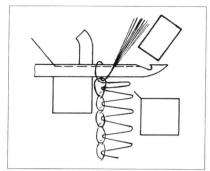

Working position in the KUNIT process

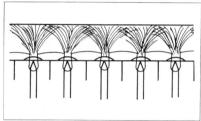

Cross section of KUNIT textile fabric

Figure 4.82 Diagrams of the Kunit process for stitch-bonding a fiber web into plush fabric. (Courtesy of Malimo Maschinenbau, now part of Karl Mayer Malimo Textilmaschinenfabrik GmbH)

Figure 4.83 Kunit plush fabric, stitchbonded with no yarns. (Courtesy of Malimo Maschinenbau, now Karl Mayer Malimo Textilmaschinenfabrik GmbH)

Spunbonded (Flash Spun)

Spunbonding involves holding filaments together just after they are extruded from a spinneret. Reemay, Inc. is a major manufacturer of spunbonded polyester and polypropylene materials, mainly for industrial uses, such as geotextiles, or housewrap (Typar®). A very well-known nonwoven, Tyvek® (by DuPont™), is made from very fine, high-density polyethylene, spunbonded by **flash spinning**. This involves extruding the polymer in a solvent which evaporates rapidly at the spinneret, fibrillating the filaments, which are collected into a web, and held together by various means. Tyvek is an outstanding industrial packaging material: strong but lightweight, resists abrasion and punctures, as well as water, but is vapor-permeable. Its other properties make it ideal for medical packaging as well as general use, such as courier shipping envelopes.

Nonwovens have also been spunbonded by *melding*: the action of heat on bicomponent filaments. The "skin" of the filaments has a lower softening point than the core, so when heat is applied, they fuse to form a fabric. This is one method used to produce Cambrelle® (by Camtex Fabrics Ltd.), in various forms for shoe linings. These are designed to resist abrasion, and with built-in moisture transport and microscopic air pockets, help keep feet cool and comfortable. Linings can also be made to keep down static collection and danger of a spark, or to be bacteriostatic.

Meltblown

Melted polymer is extruded into an air jet, producing relatively fine fibers. These are collected as a sheet of nonwoven fabric, useful as filters and food packaging.

Spunlaced (Hydroentangled)

Spunlaced fabrics can be formed by tangling filaments after extrusion, using jets of water to form a soft, unbonded structure that can have a repeating pattern. Evolon® (by Freudenberg Nonwovens) is made by splitting bicomponent filaments after extrusion as they are drawn, laying them down in a continuous process, and holding them together by water jet bonding (spunlacing). These fabrics can be custom-designed for many different applications, just one having been anti-allergenic bed linens. Another technology from Freudenberg also produces Novolon™, a family of three-dimensional nonwovens which can take many forms and have many properties. The materials are deep molded by

a continuous process. Applications include bedding, medical, filters, and outdoor gear.

Steam Heat + Jet Blasts

Nonwovens have been produced using steam heat and high speed jet blasts to hold together fabrics made of Sophista® fibers (by Kuraray Kuraflex). Because of their makeup, these EVAL fibers (ethylenevinylalcohol) hold together from the heat, contain a hydrophilic group, and are strong, making for an interesting entry in nonwovens.

Combinations of Nonwoven Methods

Increasingly nonwovens are being produced by combining technologies. The Aquajet spunlace systems (by Fleissner) combine hydroentangling with airlaid technology (see Figure 4.84). This can produce fabric of cotton or rayon, e.g., useful in medical and many other applications. Carpet backing can be made that is held by these techniques and not rubber. Segmented microfiber filaments can be split and then spunlaced on these machines.

Spunjet (by Rieter Textile Systems) forms fabric by spunbonding, then water jets are used to give the fabric a softer hand. DuPont Nonwovens Advanced Composite Technology combines spunbonded and meltblown technology, and uses bicomponent fibers to give a wide variety of products. There is, in fact, something of a flood of manufacturers, variations on method and technology, and trademark names in nonwoven products—too many to record all here.

Fabrics without Fibers

Film

Film is a structureless polymer sheet (no fibers, no yarns), commonly used for shower curtains, inexpensive rainwear, and wrappings. Thickness is identified

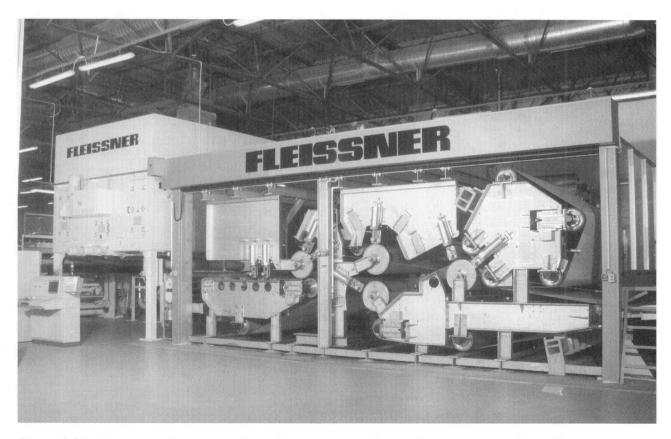

Figure 4.84 Aquajet spunlace system for making nonwoven fabrics, of cotton or other fibers. (Courtesy of Fleissner GmbH)

by gauge number. Common materials are vinyon (what we call *vinyl*), saran, polyethylene, and polypropylene; viscose rayon film is used in packaging (*cellophane*). Film is usually impermeable to water drops or vapor.

Supported film involves a polymer coating on a fabric backing, such as vinyl- or urethane-coated leather-likes; see Section Five.

Microporous film (U.K.—microporous polymer laminate) has come to the forefront of development of clothing for inclement weather, with the first and best known an essential part of Gore-Tex* fabrics. Gore Fabric Technologies now has two components in

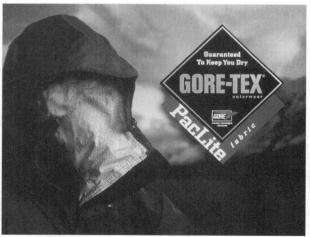

Figure 4.85 Raised dots on special film used in Gore-Tex PacLite™ fabrics protect against abrasion, allowing a lighter assembly without liner. (Courtesy of W. L. Gore & Associates, Inc.)

this membrance: an expanded polytetrafluoroethylene (ePTFE) film ("expanded" indicating its microporous state), plus an oleophobic substance, polyalkylene oxide polyurethane-urea, which prevents contamination of the film by oily materials, such as cosmetics, food, or insect repellent. Since Gore fabrics are laminated constructions, they are described further in $Compound\ Fabrics$, this section. A version of the film (PacliteTM) has raised dots all over the membrane, which protect against abrasion when it is used, so a substantial fabric liner is not needed (see Figure 4.85).

Reflective film is used as a safety marker on clothing and accessories in ScotchliteTM (by 3M). Tiny reflective beads are incorporated into film, the product designed to be highly reflective and durable, so as to increase visibility by day or night, or in dense smoke (for firefighters).

Film carrying a bar code and able to withstand the chemicals and high temperatures of textile processing has been used to help automatic production of fabric.

Foam

Foam in sheets is used as interlining, padding, or cushioning, usually laminated to another material (see Figure 4.86); it is not a strong structure. Its uses are discussed in the *Fabric Glossary*, but a significant one in home furnishings is foam-backed drapery or lining, for its insulating and/or room-darkening effect.

There is a flammability hazard with foam-padded clothing if left in a hot pile after tumble drying (see Section Six).

Figure 4.86 Tricot bonded to foam by heat, used for lining and cushioning in footwear.

4-8 LEATHER, FUR

Animal skin is often used as what we could term a "natural fabric," although it is not made by any of the processes that technically qualify it as a textile.

First, the skin must be stabilized chemically to prevent rot, a process called tanning for leather, dressing for fur. An undressed fur skin is called a pelt. Used with the hair left on we call it fur; with hair removed, we may use the outer side, called grain or top grain leather, or the flesh side, called suede; the middle layer is called the corium (see Figure 4.87, Figure 4.88).

Leather

Leather is composed of a very complex protein, collagen, classified as a triple alpha helix (see Figure 4.89, which shows only the axes of the polypeptide chains; the spaces between are packed with groups present on each amino acid residue). This is more complex even than the alpha-helix form of wool protein, keratin (see Figure 2.22). It shares many reactions with protein fibers; for instance, it can be molded with steam.

Figure 4.87 Cross section through leather (scanning electron microscope). The grain (skin side) layer is at the top, the middle is the corium, and the inside (flesh side) is suede. (Courtesy of SATRA Footwear **Technology Centre**)

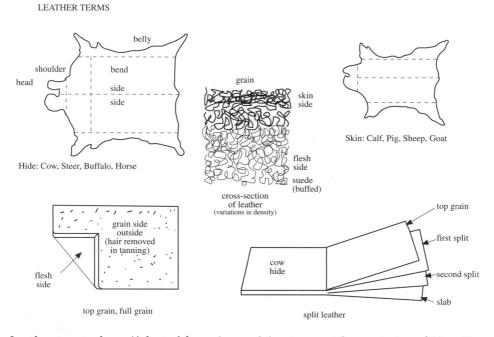

Figure 4.88 Leather terminology. (Adapted from Apparel Anatomy, with permission of Mary Humphries)

Figure 4.89 Collagen protein of leather—polypeptide chains form a triple α -helix. (Courtesy of the Textile Institute)

Leather from a smaller animal is called a *skin*; from a larger animal, a *hide*; so we have *pigskin* but *cowhide*. Half a hide is called a *side*. A thick hide can be *split* into thinner sheets, but an *inside split* will have no top grain and so will be less able to withstand wear; these terms are illustrated in Figure 4.88. "Chamois," as used for coat interlining, is an inside split suede sewn into *plates*; the same is done with fur (see Figure 4.90). (See also *plates* in the Glossary of Fur Terms under "Fur.") Leather is still sold by the square foot, an odd practice in a mostly metric world, and there is no sign that this is about to change. A sheepskin is about 5–8 sq. ft.; a lambskin about 4 sq. ft.; and a cowhide side, 20–30 sq. ft.

Sources of Leather

If it has a skin in the animal world, it has probably been made into leather by humans! Common sources of leather include:

Domestic animals. Sheep (and lamb), goat (and kid, although all goatskin may be called kid), pig, cow (and calf), horse (and pony), deer (and doe)—ranched in New Zealand, buffalo.

Cordovan is a soft goatskin leather. Nappa (Napa) is soft, full-grain leather from sheep, lamb, or kid, specially tanned.

Other animals. Kangaroo, rhinoceros, elephant, hippopotamus, etc.

Nonmammals. Snake, alligator—endangered (crocodile), lizard, frog, eel, fish (salmon), birds (see "Plumage—Feathers, Down," Section Two).

Tanning

Tanning of leather preserves the skin, which has earlier been *cured* in salt (brine). The skin, then, is first soaked in a rotating drum to remove the salt, then *fleshing* cleans the inside of the skin of any flesh. Liming or unhairing uses alkaline chemicals (e.g., calcium hydroxide or lime) or enzymes to remove hair and roots. Bating is a final cleaning before the actual tanning.

Vegetable tanning uses chemicals from bark (notably oak, spruce, hemlock), sumac, or wattle; it takes several weeks to stabilize the skin, but the process is still used. Much modern leather, however, is **chrome tanned**, taking only 4–6 hours. First the skin is *pickled* to bring it to the right acidity so that the tanning agents will be soluble. Then chemicals, mainly chromium salts, accomplish the tanning. There is also a combination **vegetable/chrome tanning** process. Chrome-tanned leather has good resistance to moisture, perspiration, and heat.

"Wash leather" of sheep- or lambskin (chamois, or shammy) is treated with halibut oil to preserve it in a particularly soft state.

Hides are next wrung to squeeze out excess moisture, and then go through splitting and shaving to adjust and give uniform thickness. Some will have a retan with different compounds, and coloring can be done with dyestuffs (aniline finish) or pigments.

Fat liquoring is an oiling process (often using fish oils) that governs how soft or firm the leather will be. Setting out stretches and smooths the leather before it is dried. Drying affects the look of the leather; the hides may be hung, vacuum dried, or pasted on large plates. After drying, the leather is conditioned to introduce some moisture. Staking is done on a machine that stretches and flexes the leather in all directions; seeing a motion picture of this machine at work, one is reminded that leather can be chewed to soften it, an action reproduced by the staking machine!

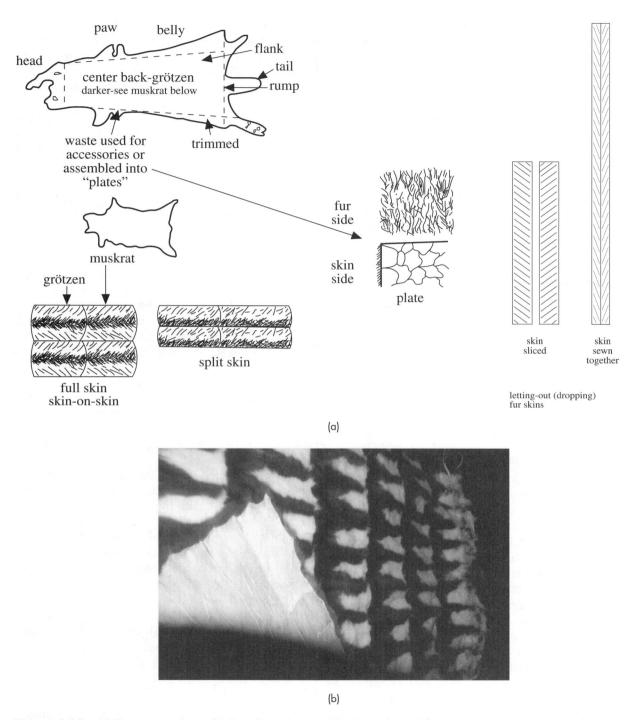

Figure 4.90 (a) Fur terminology. (b) Fur plate, face and back. (Adapted from Apparel Anatomy, with permission of Mary Humphries)

Buffing is a kind of sanding that smooths the grain surface of leather, readying it for further finishing treatments; if it is not buffed, it is called full grain. Finishing contributes some stain and wear resistance to the leather surface, and usually color as well. It is simplest for the best skins with the fewest imperfections; these may be colored, but receive little surface "cover-up," and are left feeling soft and "buttery." Less perfect skins or hides may receive pigment or other coating, glazing, metallic laminating, as well as embossing, tooling (pushing out from the back), antiquing, etc., all of which can cover or change the surface and even give the look of other leather grains, such as snakeskin. Plating is the application of great pressure to smooth the surface.

Leather Properties

Leather is strong, resistant to punctures, and has "give" and flexibility. It is windproof, and if it is dry, it insulates well; however, it absorbs moisture, and if damp will not keep a person warm (see Section Seven). Leather is permeable to moisture vapor and so allows perspiration to pass through, and its absorbency means more comfort in shoes when feet perspire. If coated (as for patent leather) or made truly water-proof, this permeability is usually lost. Leather can be shaped (molded) and will hold a form. Care and storage of leather are discussed in Section Six.

Fur

Fur as a fashion fabric has been criticized for some time by animal rights activists. It is covered in this *Reference* because furs from animals that are either in what is termed "abundant supply" or raised for the purpose (ranched) are certainly still being used as a fabric. It is a very special, usually relatively expensive fashion material on which information is sparse. In the United States, the Fur Products Labeling Act (1952, last amended 1998) requires that the animal be identified by a true name in English, and that dyeing or other alteration be specified along with country of origin.

Fur Quality/Price

Fur is not an investment in the sense that it would be expected to appreciate in value; it is an investment in beauty, glamor, and comfort.

Quality of any one type of fur is affected by weather (the best are taken in the coldest climates or weather), the condition of the animal, and its genetic background. Good-quality fur will be lustrous; feel soft and silky; and have soft, pliable leather. The guardhairs will be uniform in length and silky, and the underfur should be dense; check this by blowing the fur lightly on the edge of the garment fronts—it should spring back quickly and fully. Skins from a female are smaller, with finer, silkier hair and lighter skin than those from a male.

Durability, however, depends on the type of fur (see Table 4.2) as well as its quality, and on the care it receives (see Section Six). Water animals, such as mink, need a coat that protects them all over, and so the skin and hair covering is much the same on the belly as on the back; not so with a longer-legged land animal such as the fox, where the hair on the underside is more sparse and the skin much thinner.

Longhaired furs in general do not wear well, since the guardhairs tend to break and/or shed; one longhaired fur that does wear well, however, is raccoon

Change of color is another aspect of wear. A dyed color can, of course, change more readily than a natural shade (bred in the animal), but all furs develop some yellowing with age; this will be less noticeable if the original color has a bluish overtone rather than a reddish.

Price is affected by quality, supply and demand, style, and the amount of labor a garment requires. Furriers tend to use skins that are reasonable in price, and these, as a rule, will be the most plentiful.

The best buy in a fur would be a good quality of a type with good durability, which was not the most popular or in demand that season!

Furs are sorted and graded by human hand and eye for color, size, and quality, although there are electronic sorting machines for color (see *matching* under Glossary of Fur Terms). Enough skins to make a garment are put into and sold by *bundles*.

Construction of Fur Garments

A muslin *toile* is first made so that any adjustments of fit or cut can be made on it at this stage; one does not experiment with fur. The shape is then translated into heavy paper pattern pieces. Furs are matched and placed on the pattern in order, then given to the cutter.

Table 4.2 Fur Durability in Wear

Name of Fur	Durability of Hair	Durability of Skin	Name of Fur	Durability of Hair	Durability of Skin
Rodent Family:		***************************************	Mongolian lamb	F	F
Beaver	E	Е	Persian lamb—natural	E	E
Chinchilla	F	F	Persian lamb—dyed	G/E	F/VG
Hamster	F	G	Pony	F	E
Marmot	FG	VG	Spanish lamb	VG	E
Muskrat—natural	VG	F	Swakara** (Karakul lamb)	G	G
Muskrat—dyed	VG	F	Zebra	G	E
Nutria	E	G	Weasel Family:		_
Rabbit—longhaired	F (sheds)	G	Badger	VG	VG
Rabbit—sheared	G	G	China mink	F	G
Squirrel, Canadian	F	F	Ermine—winter	FG	F
Squirrel, Russian	G	G	Fisher	Е	E
Seal Family:			Fitch (polecat)—natural	VG	VG
Hair—natural	G	Е	Fitch—dyed	G	G
Hair—dyed	Е	Е	Kolinsky (Russian mink)—	F	G
Hair—Norwegian	G	Е	dyed		
Hair—white coat	FG	G	Kolinsky—sheared	F	VG
Fur—Alaska	Е	G	Marten—baum	FG	G
Fur—Cape, South-West	G	G	Marten—stone	G	G
Africa			Marten, Canadian	G	G
Fur—Russia	Е	G	Mink	Е	VG
Fur—Uruguay	G	FG	Otter, Canadian	Е	Е
Bassarisk (Ringtail cat)	VG	VG	Otter, South American		
Raccoon—natural	Е	E	river	E	VG
Raccoon—sheared	VG	Е	Sable	Е	VG
Raccoon, Asian	F	G	Skunk Plantigrade (Flat-	Е	Е
Hoofed Family:			Footed) Family:		
American broadtail			Feline Family:†		
sheep	FG	G	Genet	FP	G
Borega (jumbo	VG	VG	Lynx	G	Е
broadtail sheep)—			Lynx cat (wildcat)	FG	VG
South America			Lynx cat (Peludo)	G	G
Broadtail, Russian*—	F	F	Canine Family:		
natural			Fox, Asian red	FP	G
Broadtail, Russian*—	FP	FP	Fox, Australian red	F	F
dyed			Fox—blue	FG	VG
Broadtail, South-West	FP	FP	Fox—cross	FG	VG
Africa		500 994	Fox—kit	F	G
Calf	G	Е	Fox—red	FG	VG
Kalgan lamb	F	F	Fox—silver	E	E
Kidskin	FP (sheds)	FG	Fox—white	FG	VG
	(0.1000)				(continued

Table 4.2 Fur Durability in Wear (continued)

Name of Fur	Durability of Hair	Durability of Skin	Name of Fur	P 4	Durability of Hair	Durability of Skin
Wolf	G/E	E	Miscellaneous:			
Marsupial Family:			Mole		F	FP
Kangaroo	F	G	Monkey		F	G
Opossum—United States	F	G				
Opossum—Australia, New Zealand	G	G				

E=excellent VG=very good G=good FG=fairly good F=fair FP=fairly poor P=poor

Cutting will be by one of four methods; from least to most expensive, they are: skin-on-skin (full skin), split skin, semi-let-out, or fully let-out (see Figure 4.90[a] and Glossary of Fur Terms). With any of these, skins must be cut so that each part matches the color and pattern of the fur next to it.

The cut skins are carefully marked and handed in groups to the sewer, who stitches them together on a special machine, taking care not to catch any of the fur hairs into the special overlock seam (for more detail, see *letting-out* under Glossary of Fur Terms).

A fur coat cannot be pressed, as cloth coats can, to make seams straight and the coat hang properly. Instead, as it comes from the sewer, it is dampened and stretched to fit a chalked pattern on a large wooden board. It is then nailed on the board with the leather side out and left to dry. In let-out garments, every seam for the length of the garment is nailed firmly in place to assure a good hang, using thousands of nails.

After the fur is dry and removed from the board, it may be glazed; edges are closed and taped, lining sewn in, and buttons and other trim put on.

A slight scalloped effect at the hem of a fur coat is a good sign; it indicates that the skins were not stretched taut.

Glossary of Fur Terms

bleaching. Lightening of the natural color of a fur by a chemical process; most furs are bleached before being dyed to fashion colors.

boa. A rounded, plain fur neckpiece.

carving. Cutting away or sculpturing fur in parts to make a pattern.

cutting. Done by highly skilled fur craftspeople, using only a knife like a razor blade in a handle. For most intricate cutting, see *letting-out*.

damaging out. Cutting out poorer sections and replacing with better; shows on the inside as tiny, jagged joins.

down. See underfur.

dressing. The treatment of skins to preserve them, comparable to tanning of leather, except that in dressing, the hair is not removed.

feathering. Tipping fur with a dye to make the fur lustrous; a chemical spray gives sheen; water followed by pressing makes the fur smooth.

grötzen or groetzen. The line of darker color down the center of the back of furs. (See Figure 4.90[a]).

guardhairs. Outer hairs that protect the animal from weather; flat furs such as Persian lamb have no guardhairs. Guardhairs are shaved down in shearing.

hair-up. The process of reversing a skin so the rump end of the fur is at the top of the coat. The hair falls away from the body to look fuller.

hide-out. A special technique to make an unlined fur coat reversible.

knitting. Most fur "yarn" for knitting is made of narrow strips of fur sewn together; in a very few cases, yarn may be spun of fur.

^{*}Russian broadtail fur comes from still-born lambs of the fat-tailed Bokhara ("broadtail") sheep.

^{**}Swakara is a TM of the South West African government Karakul sheep breeders.

[†]Others of this family are considered endangered (listed in the Red Book of the International Union for the Conservation of Nature: leopard, ocelot, etc.).

leathering. Strips of leather, suede, or ribbon inserted into longhaired furs, such as fox, to make the coat lighter and less bulky.

letting-out, letting-down, dropping. The most skilled method of joining skins. Most skins are too short to be used for the full length of even short garments. The easiest way to join skins is full skin or skin-on-skin, which does not give much length. Letting-out is a much costlier method, which involves lengthening the skin into a single, longer, narrower strip. Fully let-out means that each skin, possibly combined with one or two others, runs the length of the garment; semi-let-out merely increases the length of each skin somewhat.

To let-out or drop skins, each is split along the grötzen, matched with one or two others, then each half skin is cut on the diagonal into strips 3 mm (1/8)in.) to less than 1 cm (no more than 3/8 in.) wide; as noted under cutting, this takes great skill. Another expert worker sews the strips together, with the edge of one placed a short distance below the previous, to extend the length. This is done on a special seaming machine, holding the two edges of the leather side together and keeping the hairs on the other side out of the way; this makes a flat seam like the overseam used on leather gloves. The result is that the area of the fur has been used, but the shape has been changed (see Figure 4.90[a]).

matching. Done by a skilled person to match furs that are to lie next to each other, considering length and texture of the hair and fur, color, markings, and the size of the skins. An electronic color shade sorting machine was developed by the Hudson's Bay fur auction house in London, England (no longer any connection with the Canadian firm).

nailing. Nailing dampened garment sections, leather side out, to a board to dry to shape.

oxidization. Natural aging—fading or yellowing—caused by light and air.

peltry, pelt. A raw, undressed skin.

plates. Small waste pieces of fur (paws, tails, neck [gills], flank [sides], etc.), stitched together into a "patchwork" which is then used in the same way cloth would be; the term is also used with leather scraps (Figure 4.90[a] and [b]).

plucking. Removing quardhairs to improve the texture of the fur or when the fur is to be sheared (see shearing).

pointing. Coloring the tips of the guardhairs. scarf. Fur used in its original shape, with head, paws, and tail attached.

shearing. Cutting the fur (plucked unplucked) to an even, velvety texture; this should be done only where the underfur is strong enough. Shearing does not affect warmth, but makes the fur lighter.

skin-on-skin (full skin, brick, chinchilla, or square cut). A method of joining pelts one below the other, giving a pattern of horizontal marks in the garment (Figure 4.90[a]). Seams between the pelts may be straight (weakest), wavy, or zigzag (strongest).

split skin. A method of joining skins in which each skin is split down the center and the halves turned on end, to run side by side, giving narrower dark stripes. For short garments, this method is much less costly than letting-out. (Figure 4.90[a]).

stenciling. Printing on fur, e.g., to get zebra stripes or leopard spots.

stole. A short fur cape extending in long panels down the front.

sweep. The circumference of the skirt at the hem.

toile. A garment made up in muslin to check the cut and fit before translating into fur.

underfur, "down." The soft, fine, downy underhair of furs that also carry guardhairs. Usually more dense and lighter in color than guardhair.

whole skins. A few peltries that are large enough to be used from neckline to hem, e.g., some lambskins.

4-9 COMPOUND FABRICS

Compound fabrics (also called multicomponent, multilayer, multiplex, layered/joined) are made of different layers, held together by various means and used as one. The components may be joined *all over* by **bonding**, **fusing**, or **laminating**, using adhesive, by heat, or by polyurethane foam made sticky with flame heat (see Figure 4.86).

Stitching holds layers together *intermittently*, as in **quilting** with thread. Trademark systems such as Pinsonic* use chemicals or heat (from ultrasonic vibrations—*ultrasonic sewing*) to "spot fuse" fabrics together in a stitch effect; other systems use chemicals. Vellux* (by WestPoint Home) is an interesting compound fabric, where foam is used on both sides of a lightweight nylon fabric (scrim) core, with flocked fiber on the surfaces. This results in a soft and sturdy blanket-like material (see *Fabric Glossary* under Flocked, and flocking in general in Section Five).

Stitchbonded can give a nonwoven compound fabric, called multiknit.

Vapor-Permeable/Water-Resistant (VPWR) Fabrics

Compound fabric configuration is very much in the news with accelerating developments in clothing that is not just high performance (durable) plus water- and windproof, but also comfortable because it is "breathable," i.e., water vapor (perspiration) permeable (VPWR).

Besides creating a very closely packed surface (see Figures 1.8 and 2.84), two main approaches have been taken, both involving microporous materials:

- 1. A coating (see Section Five).
- 2. A film laminated to other fabric(s). This is the method used for the original of this type, Gore-Tex® fabric, and its construction has been a model for many others, as well as the beginning of a number of other fabrics from Gore Fabric Technologies.

The basis for Gore-Tex fabric is the very thin microporous membrane described under "Film," this section. This is expanded polytetrafluoroethylene (ePTFE), having about 1.4 billion pores per cm²

(about 9 billion per sq. in.) (see Figure 4.91). The pores are too small for a water drop to penetrate (about 20,000 times smaller), but allow water vapor (perspiration) to pass through (some 700 times larger), ensuring comfort for the person wearing a fabric "system" incorporating this film. In the "second generation" Gore-Tex film, the membrane is combined by Gore with a compound that resists oily substances (body oils, cosmetics, and insect repellents) that might contaminate the film and make it less resistant to water as explained under "Film;" this compound renders the membrane windproof.

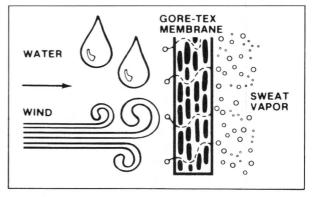

(a)

Figure 4.91 (a) Action of Gore-Tex $^{\circ}$ membrane; (b) tiny pores shown at $5000\times$ magnification. (Courtesy of W. L. Gore & Associates, Inc.)

In biology, a film such as ePTFE is called a semipermeable membrane, and indeed, the thin film feels eerily like a natural membrane, e.g., the inside of an eggshell. However, most people never see or feel this crucial part, as it is laminated to an outer fabric, often a taffeta or poplin, and, in the three-layer laminate, to a liner such as tricot (see Figure 4.92[a]).

GORE TEX ® membrane outer fabric liner fabric wind rain body moisture

Figure 4.92 (a) Three-layer laminate of Gore-Tex® fabric, with appropriate logo. (b) Action of Gore-Tex® fabric, which allows body moisture vapor to pass outward through the fabrics and membrane, but blocks water drops or wind. (Courtesy of W. L. Gore & Associates, Inc.)

The membrane used in Paclite™ fabrics, as explained under Microporous Film, allows fabric laminates that are 15 percent lighter than an equivalent 3-ply article (see Figure 4.85). See the special note on care of Gore-Tex fabrics under "Care of Special Items" in Section Six.

So this film provides the magic total—vapor permeable/water resistant (VPWR) plus windproofneeded for body comfort outdoors in inclement weather; Figure 4.92(b) shows the action of such a fabric. In addition, the company will guarantee durability, plus quality of the finished article when made with this fabric by licensed manufacturers (see Section Six. "Private Sector Labeling").

Gore developed material specifically for footwear, one of the hardest parts of the body to protect and keep comfortable in bad weather. A Gore-Tex bootie ensures that footwear is waterproof (see Figure 7.4).

Fabric System with Impact-Hardening Layer

The Dow Corning® Active Protection System is described as a three-dimensional spacer fabric, which can be built many different ways, with a very special silicone coating. This is a soft, flexible, and moldable dilatant silicone, which means that under pressure or force as upon impact, the fabric hardens. This absorbs and distributes energy away from the impact area. When the force is removed, the material at once returns to its flexible state (see Figure 4.93). Unlike many "body armor" materials, e.g., motorcycle apparel, which are hard-shell or only semiflexible components of the gear, the fabric in this system moves with the body and "breathes," unless it encounters impact force, and then the reduction of impact force is said to be more immediate and longer-lasting than rigid systems provide.

Many types of textiles can be built in this way, and all can be cut and integrated into a garment wherever wished, in one or several thicknesses. Some applications are: bicycling, motor sports, running, contact sports, and construction or other industrial work.

Normal conditions: Flexible

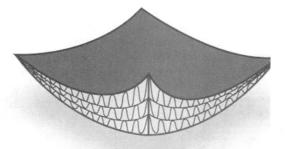

During impact: Hardens instantly

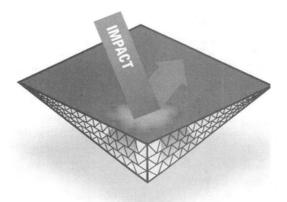

After impact: Immediately returns to a flexible state

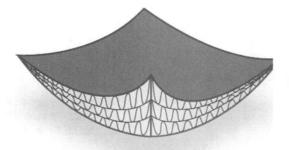

 $\textbf{Figure 4.93} \quad \text{Dow Corning}^{\$} \text{ Active Protection System (APS) fabric in clothing can change from flexible to rigid on impact, returning to its flexible state when the force is removed. (Courtesy of Dow Corning)$

LINK 4-5 TO 4-9 WITH FILES IN FABRIC GLOSSARY

These illustrate how the fabric constructions of knitting, and other methods with and without yarns and fibers affect fabrics, and in what ways these constructions are significant for certain fabrics made with them. Look these up for a fuller understanding of how this contributes to the fabric character and behavior, and is an essential part of its name. Look also for photos of these named fabrics, as well as other related textiles.

Fabric Glossary Fabric Name Look names up in the Fabric Glossary Index.	Relationship to Fabric Reference Discussion			
Stretch, Comfort or Fit	All knit fabrics fit this category to some degree; compare type of knit with end use for which its stretch is suitable.			
Jersey, Balbriggan, Lisle	Give close fit: underwear, hosiery, gloves.			
Fleece Knit, Single Face	Classic sweatshirt fabric, napped inside.			
Rib, Accordion, Cable, Poor Boy, Shaker	Crosswise stretch, insulate (warm).			
Interlock, Doubleknits General	Cannot be fashioned. Interlock same look both sides, other doubleknits may be same or quite different, face and back.			
Tricot, Simplex, Souffle	Warp knit, usually filament. Limited stretch, relatively stable.			
Raschel, Knit Lace, Gimp "Braid"	Warp knit, any type of yarn, Gimp "braid" uses wrapped yarns.			
Jacquard Knit	Electronic control of each needle for complex and/or multicolor patterns.			
Fur-Like Sliver Knit Pile	Pile from sliver (fibers), not yarn, can imitate guardhair/underfur.			
Velour Knit Pile, Knit Terry	Loop knit pile, cut or uncut.			
Fleece Knit, Two Face	Much variety in finishes on basic loop pile knit.			
Net, Bobbinet, Illusion, Tulle, Point d'esprit, Malines, Cape Net	Nets formed by twisting yarns; four-sided or six-sided (hexagonal) holes.			
Lace, Handmade, Needlepoint, Alençon, Rosepoint, Guipure	Laces with ground and pattern made using needle and thread, chiefly with buttonhole stitch. May have net ground or not.			
Bobbin, Chantilly, Cluny, Duchesse, Valenciennes (Val)	Laces formed by twisting yarns; no net ground.			
Lace, Embroidered (Schiffli), Guipure	Machine lace formed by embroidering on material which is later dissolved away; major machine Schiffli. No net ground. Often called guipure.			
Lace, Twisted (Nottingham)	Machine lace formed by twisting yarns; can have net ground and outlining thread.			
Lace, Knit, Crochet; Raschel	Most machine lace raschel knit; not much depth to pattern.			
Tufted, Chenille (Candlewick)	Pile fabric made by adding yarn to base fabric. Most is carpet. Chenille (candlewick) has no backing coating.			
Split-Film Yarn	Inexpensive way of making filament; specialized uses, often carpet backing.			
Braid, Rick-Rack, Soutache, Mohair/Horsehair Braid used for Millinery/Hems	Always narrow fabric, finished edges; specialized uses.			
Stitch bonded (Mali)	Fast, inexpensive way to make fabric; special uses.			
Felt	Formed by felting of wool or hair fibers; special uses. (continued)			

LINK 4-5 TO 4-9 WITH FILES IN FABRIC GLOSSARY (continued)

Fabric Glossary Fabric Name	Relationship to Fabric Reference Discussion			
Nonwoven, Bonded Web (J-Cloth), Needled (Ultrasuede), Spunbonded, Meltblown, Spunlaced, Stitchbonded (No Yarns)	Wide variety of materials for specialized uses.			
Film, Foam, Coated	Specialized uses for fabrics formed from liquid polymer, with no yarns or fibers. Coated fabrics may be looked on as supported film.			
Compound (Bonded/Laminated, Stitched/ Quilted): Leatherette/Leather-Like, Oilcloth, Slicker, Waterproof, Gore-Tex®/+ other High Tech "Systems"	Developed to meet demand for more and more "high performance" fabrics for sportswear and interiors, as well a technical and industrial use.			

REVIEW QUESTIONS 4-6, 4-7, 4-8, 4-9

- 1. How is the yarn arrangement in net or twisted lace different from that in weaving or knitting?
- 2. What are the three main machine methods of making lace today? How do they compare in cost, types, and depth of pattern possible?
- 3. How are tufted pile fabrics different from woven or knitted?
- 4. What is the principal use of tufted material?
- 5. Why is it often difficult to "dissect" a sample of tufted carpet or upholstery?
- Clarify the unique features of tufted chenille or candlewick, and its uses.
- 7. How does braiding differ from weaving? Why is it well suited to the uses made of it?
- 8. How is stitchbonded different from other constructions using yarn discussed so far? What is its chief advantage?
- 9. How is felt made? How does the character of the resulting fabric make it suitable to the uses made of it?
- 10. In nonwoven fabrics, distinguish among: bonded web, needled, spunbonded, and spunlaced (note the other names for some of these processes). Where is each used?
- 11. Outline the process of tanning, which stabilizes animal skins to use as leather. What is the difference between leather and fur? What is the name

- of a fur skin before stabilizing, and the name of the process for fur?
- 12. What are the advantages and disadvantages of leather when used as a fabric, for apparel or in home furnishings?
- 13. What is a "plate" in leather or fur? What is the name of the interlining usually made of plates of inside split leather skins?
- 14. What are four signs of high quality in a fur? Does this mean the fur will be more durable in use? Give examples.
- 15. Why is a "fully let-out" fur coat so expensive? What are the other (less expensive) ways to handle skins?
- 16. What are three uses for (impermeable) film? For sheets of foam?
- 17. What are two major ways of creating compound fabrics?
- 18. A major development for sportswear or high performance clothing has been introduction of a layer that is vapor permeable but water resistant (or proof). How has this been accomplished? List some major trademark names.

INVESTIGATIONS TO DO WITH FABRIC CONSTRUCTIONS

- 1. Examine samples of five woven fabrics with no selvage included. Estimate which set of yarns are the warp, and give your reasons.
- 2. Examine full-width pieces of fabric (or take notes in a fabric store) to find examples of cotton or synthetic apparel material (not wool or decorator material) woven with a shuttle loom, and if possible all three main types of shuttleless looms. Compare the widths; what do you find, and why? If you find a hand-woven fabric such as Thai silk, note width of that as well, with reason.
- 3. Find examples of similar woven fabrics with regular compared to steep twill line (e.g., two gabardines). If possible examine them to see which has warp yarns closer together (more warp). Is the warp yarn single or 2-ply? If plied, is it in the regular or steep twill?
- 4. Working alone or as a team, find promotions for high quality sheets that specify the thread count. Is the fabric named as percale or sateen? If not, assess which you think it is, and why. Do you think the thread count has been manipulated to seem higher than it actually is, and if so, in what way?
- 5. Draw a point diagram for a 7/1 satin weave. How do you "read" this figure and how many harnesses are needed for this weave?
- 6. Set up a table to sort and record weave variations covered in Chapters 4-3 and 4-4, with

- names of fabrics that take their character from this, origin of the name, plus any adjectives to describe the fabric (sportif, elegant, tough, and so on). Do the same with fabrics of twill, satin, and complex weaves. This can provide an excellent quick checkback reference in work with fabrics.
- 7. Find references to seamless knit garments in advertisements, catalog descriptions, etc., for as wide a range of garments as possible.
- 8. Collect pictures, diagrams, and descriptions of as many handmade "name" laces as you can, with notes on their distinctive features. Do the same with the various forms of lace.
- 9. Start a Fabric Case History Sheet (see Section Eight) for each material you work with. Include samples of lining, trim, etc.
- 10. Select a fabric name hitherto unknown to you; research its background, name origin, construction. Then use your findings either to design a garment or interior featuring it, or to write a promotion, to reflect its character.
- 11. Collect and identify samples of as many different leathers and furs as you can, or make it a class project.
- 12. Find five examples of compound fabrics in articles for sale, and identify the method(s) by which they are combined. What is accomplished in each case by the use of several materials taken as one?

NOTES SECTION FOUR

- 1. McAllister Isaacs III et al. "ATME-1 2001: Better Than Expected," includes Weaving Machines Chart, Textile World, June 2001: 62-73.
- 2. Dr. Kim Gandhi, "WIRs through the Roof." Textile Month, December 2000: 6-13.
- 3. Dr. Kim Gandhi, "WIRs through the Roof." Textile Month, December 2000: 6-13.
- 4. Alois Steiner and Dr. Ing Werner Weissenberger, "Multiphase Weaving—Historic Review and

- Outlook," OTEMAS, Osaka, Japan, October 1997.
- 5. "Federal Trade Commission Clarifies Thread Count Rule," Textile World, October 2005: 19.
- 6. Adrian Wilson, "Italian Textile Machinery: Cautiously Confident and Ultimately Flexible," Textile Month, October 1998: 18.
- 7. "Weaving Technology, Portuguese Pioneer Sets Europe-Wide Standard," Textile Month, October 1998: 44.

- 8. Charles Tomlinson, ed., *Cyclopedia of Useful Arts and Manufactures*, Geo. Virtue, London and New York, 1853.
- 9. John Mowbray (editor, *Knitting International*), "Design Content," *Textile Month*, April 2001: 38–40, 56.
- 10. Just-style, www.just-style.com, (Aroq Ltd.) July 8, 2003.
- 11. Marie Schuette, "Techniques and Origins of Lace," *Ciba Review*, 73 (April, 1949): 2675–2684.
- Most of these lace forms are listed in *Textile Fabrics and Their Selection*, 8th Edition, Isabel
 Wingate and June F. Mohler, printed here courtesy of Prentice Hall Inc., Englewood Cliffs, N.J., 1984.
- 13. "Embroidery Technology for Surgical Implants," The Textile Journal, November–December 2006: 39.

Finishing of Fabrics

5-1 ROLE OF FABRIC FINISHING

Greige or gray goods refers to fabric as it comes off the loom (loomstate), knitting machine, or whatever machine made it, before it is bleached, dyed, or otherwise finished. It is usually rather unattractive, may be soiled, is often a creamy or dull shade of off-white (unless fibers or yarns have been dyed), and has developed little of its potential beauty or character of surface. You would not usually be able to buy fabric "in the greige" (old-fashioned term "factory cotton"), but compare unbleached sheeting with finished to see what a great difference bleaching (see Figure 5.1), dyeing, or printing can make. Finishes such as glazing or embossing, which also produce a marked effect on the fabric surface, bring about even more startling changes. Unbleached muslin (the fabric osnaburg) is close to being an example of greige goods, although it is certainly scoured (washed).

Differences can be even greater in wool family fabrics, e.g., a blanket or coating cloth, in which fulling and napping in finishing totally change the character of the cloth (see "Wool: Fulling").

Finishing is done in special plants called converters, which are usually separate from the textile mill that manufactured the cloth; only large manufacturers are vertically integrated to perform almost all functions (short of producing MF fibers), including finishing.

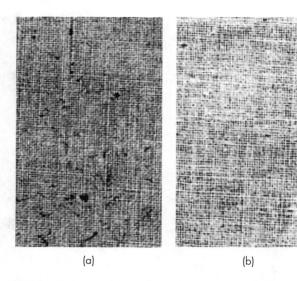

Figure 5.1 (a) Greige fabric; (b) scoured and bleached, most trash and motes removed.

Finishing the Natural Fibers

Certain finishing procedures have been developed over the centuries, as human skill—art and craft—created superlative fabrics of each of the "big four" natural fibers: wool, silk, cotton, and flax.

Wool

Wool, a protein fiber, is not sensitive to acids but is to alkalies and chlorine bleach; this affects the choice of chemicals in finishing.

Scouring

Scouring (washing), done with low-alkali agents, removes up to 50 percent of the original weight of the fleece: soil, *suint* (perspiration), wool grease (more properly called "wool wax"), and some vegetable matter caught in the fleece. In order to prevent the wool grease from going rancid and to get rid of a lot of dirt, wool is generally scoured in its loose state, pushed by rakes through successive bowls of a scouring machine and passed through wringers between each bowl and the next.

Refined wool grease is *lanolin*, reclaimed for pharmaceutical and cosmetics use, as it goes into human skin with less feeling of greasiness than ordinary animal fats.

Bleaching

Bleaching must be with mild oxidizing agents or reducing bleaches, the types used in household "bleach for the unbleachables." (See "Bleaches" under "Laundering" in Section Six.)

Carbonizing

This is a process unique to wool, whereby any residual plant matter caught in the fleece is removed; this includes twigs or leaves, but especially burrs. The wool is treated with dilute sulfuric acid, then heated, which concentrates the acid, charring the plant material (turning the cellulose to carbon) so that it can be shaken out.

Fulling

Fulling is the controlled felting of surface wool fibers, producing a dense, compact surface and a thicker fabric. Nearly every fabric of wool receives some fulling in finishing. Fulling is accomplished by squeezing or pounding the fabric in a soap solution, and is closely related to **milling.** Fulling is usually done most vigorously on wool fabric of spun (carded only)

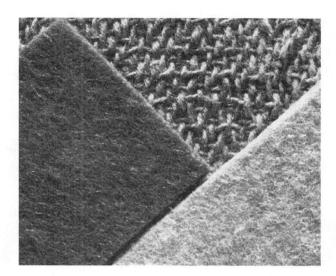

Figure 5.2 Melton fabric in the greige or loom state (top), after fulling (lower right), and finished (left). (Courtesy of the Woolmark Company)

yarns, especially thick (winter) coat fabrics. Melton has almost completely felted surfaces on both sides. Figure 5.2 shows the dramatic change fulling can make, often in combination with napping (see "Other General and Basic Finishes"). A combination of fulling and napping can even produce a curly or wavy surface, as on chinchilla cloth. A thick, knit wool fabric, very heavily fulled, produces the comfortable coat fabric Boiled Wool.

Decating and Crabbing

Decating is a special steaming process to smooth wool fabrics; crabbing is a treatment in boiling water to remove strains that might result in shrinkage or creases later (see also the discussion of London shrinking under "Other Special Finishes-Dimensional Stability").

Mothproofing

Mothproofing of wool makes the protein of hair fibers indigestible, or kills the larvae. Most agents have been insecticides, and today such a finish is not usually identified by a trademark name, as it once was, since the cost of application has gone down. A principal use is for wool carpet. Such a compound has to be safe for all concerned and resistant to removal by the conditions of care. For more details on attack on wool by insect larvae, see Section Six, "Storage of Textile Articles."

Silk

Silk undergoes specialized processes, the most significant being degumming of raw silk (see Figure 5.3): the stage at which to perform this essential process to give the best-quality product was already discussed in Section Two under "Silk Production." Selective degumming can be used to create patterns on a dved ground, as in Japanese Gunma silks. Wild silk has gum that cannot be entirely removed.

(a)

Figure 5.3 (a) Raw silk fabric before degumming; (b) degumming reveals the white, drapable silk fabric. The other silk finishing terms mentioned in Section Two are weighting, pure dye silk, and scroop. Weighting of silk has been done to increase the body of these expensive fabrics; it is not common any longer. Metallic salts are used, often tin salts. Weighted silk is not as strong as fabric without weighting; weighted fabrics are more stiff, can crack more easily, are more readily attacked by perspiration and light, and show water-spotting, which unweighted silk will not. See "Other General and Basic Finishes" for a discussion of mill washing of silk.

Cotton

Cotton, a cellulose fiber, is not sensitive to alkali or chlorine bleach but is to acid, especially mineral acids.

Scouring

Scouring of cotton is done near the boil, in a kier, with high-alkalinity built detergents ("heavy-duty" detergents; see Section Six).

Bleaching

Bleaching of cotton is safe with strong oxidizing agents; the types most familiar to consumers are sodium hypochlorite (liquid "chlorine" bleach) and calcium hypochlorite (solid type). Scouring and bleaching of cotton also remove the last of the plant impurities called *trash* or *motes* (see Figure 5.1). Sometimes this "natural" look is retained on purpose, when fabrics such as osnaburg become fashionable.

Mercerizing

Mercerizing of cotton is a permanent alteration accomplished by treatment with the strong alkali sodium hydroxide (NaOH, also called caustic soda or lye). The material is usually held under tension, or it will shrink up; **slack mercerization** (without

tension) gives a degree of "stretch" to woven cotton. The cotton fibers swell, losing their twisted ribbon shape, to revert to a nearly cylindrical form (see drawings of typical features of fibers seen through the microscope, Section Two, plus Figure 5.4[a]). They are smoother and more lustrous, and also get stronger and more absorbent. Goods that are mercerized are usually high quality, i.e., made of long-staple cotton fibers in combed yarns. Such mercerized fabrics are usually "top of the market." Lisle (shown in Figure 5.4[b]), and other such classic mercerized fabrics, are discussed in detail in Fabric Glossary and are listed in Link 5–1. Mercerizing is also used for good-quality cotton sewing thread (see "Thread" in Section Three).

Flax (Linen)

Flax, although a cellulose fiber like cotton, is given specialized finishing procedures.

Bleaching

For the best-quality linen, bleaching is done by somewhat milder methods than for cotton, including *dew* or *grass bleaching*, in which the fabric is spread on grass fields to allow the moisture of dew and the natural oxidation of light to bleach it. Chlorine bleach must be used with more care on flax because this bast fiber is composed of many cells (rather than a single cell like cotton); if the waxes and pectins holding these cells together are attacked, as by strong bleach, the fiber can be weakened.

Beetling

Beetling is applied to table linens such as damask or to cottons to give a linen-like finish. The fabric is hammered by wooden blocks (fallers) for up to 60 hours, flattening yarns permanently and closing the weave to give a soft hand and luster.

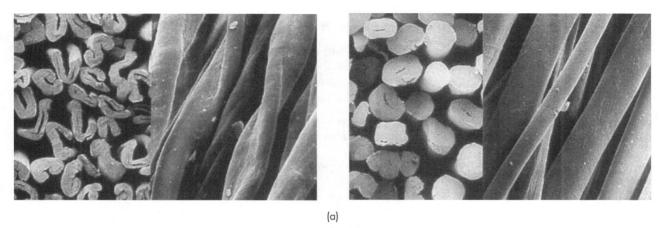

 $\textbf{Figure 5.4} \quad \textbf{(a) Cotton fibers (left) are made smoother (right) by mercerizing. (Courtesy of Morrison Textile Machinery Company) \textbf{(b) Lisle, knit of mercerized cotton.}$

LINK 5-1 WITH FILES IN FABRIC GLOSSARY

These illustrate the role of fabric finishing and aspects of many special processes applied to the major natural fibers. Look them up for a fuller understanding of how this contributes to the fabric character, and is an essential part of its name. Look also for photos of these named fabrics, as well as other related textiles.

Fabric Glossary Fabric Name	Relationship to Fabric Reference Discussion
Look names up in the Fabric Glossary Index.	
Calico, Chintz, Toile de Jouy	Dramatic changes in finishing from greige goods; addition of color by printing.
Osnaburg or Unbleached Muslin	Fabric close to greige goods, still contains "motes" or "trash"—waste bits of the cotton plant that are removed in finishing most cotton fabric.
Coated, Embossed	Surface totally changed from greige goods.
Overcoat fabrics	Fulling involved in finishing virtually any wool fabric; yarns closed up to make the fabric thicker and warmer, as in coat materials.
Melton	Fulled the most; virtually windproof surface looks and feels like felt.
Boiled Wool coating	Example of vigorous fulling of a bulky knit. However, almost any fabric made of wool will have been fulled to some extent.
Chinchilla	Surface with a wavy curl, from repeated fulling and napping processes.
China Silk	This fabric, if made of silk, would not be "silky" without degumming; Silk, Cultivated discusses this dramatic change from dull and stiff to soft, white, lustrous material, lighter, more drapable.
Wild Silk, Shantung, Tussah	These have a tan color, slubs, and are not as soft as cultivated silk. Other famous names are also described: honan, pongee, muggah, yamamayu.
Batiste (Cambric, Lawn, etc.), Broadcloth (Cotton), Chino, Lisle	Top quality of all of these cotton fabrics will have been mercerized for luster and other advantages.
016.0.6.70	Knit of (fine) mercerized yarn to give it smoothness and luster.
Stretch for Comfort, Fit	Slack mercerization (without tension) gives slight stretch to cotton goods.
Damask	High quality damask made of linen has been beetled—the reason it will get softer and more lustrous with wear.

5-2 OTHER GENERAL AND BASIC FINISHES

Heat Setting of Thermoplastic MF Fibers

The basis of ease of care of two major synthetic fibers, polyester and nylon (besides good strength when wet), is rooted in the fact that they become thermoplastic, and can be shaped by heat, at a temperature high enough that heat in normal wear and care will not be higher; this is taken, in this text, to be considered a permanent heat set, as was outlined in Section 2-2. They are not affected by hot water in laundering (although the dyes may be), and a normal home dryer will not damage them on high (cotton) heat. If they are taken out warm, and hung or smoothed, they will not need pressing; pleats will stay sharp, and so on. This does not include using a hot iron; care must be taken with any thermoplastic in that regard.

"Three Dimensional" or "3-D" Surfaces

1. **Napping (Raising).** Fiber ends are teased out of loosely spun yarns and brushed so they stand up on the surface of the fabric. Fine bent wires are used to nap most fabrics. Figure 5.5 shows how a nap covers the weave structure; the change of shape of the square check pattern to a rectangle reflects the lengthwise pull on the fabric during heavy napping. As examples, flannel, flannelette, "sweatshirt" fleece (fleece knit, single face), plus most overcoat or blanket fabrics will have been napped using wires. With a woven fabric, napping is usually done on a weft-face material; with a single face knit fleece, it is done on a weft inlay yarn.

Materials of fine specialty hair fibers, such as cashmere, and a few fabrics of very fine wool. notably wool broadcloth, are napped with natural teasel burrs, a process called gigging. In Yorkshire and the Scottish borders, these are also called

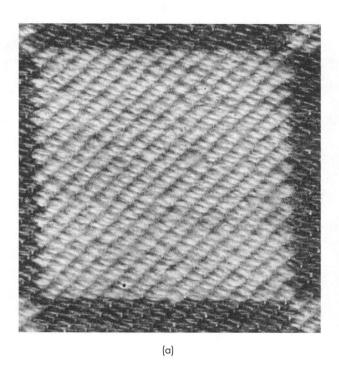

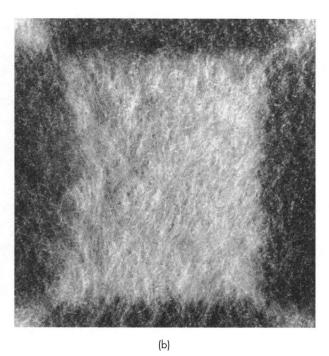

Figure 5.5 Effect of napping on a 1/3 weft-face twill check. (a) Before napping; (b) note extension in length of the check after napping. (Courtesy of the Woolmark Company.)

"mousers," suggestive of cats' claws. Because these burr barbs will break before the delicate fibers do and the burrs have to be replaced frequently, imitation "burrs" of nylon have been tried for this purpose.

When fiber ends are worked out of some cotton fabric, such as denim, it is termed **brushed**, rather than napped.

- 2. **Emerizing (Sanding).** Emerizing with emeryor sandpaper-surfaced rollers produces a brushed or "sueded" finish. Emerizing has long been used for fabric such as tricot, to break the filaments and leave a soft surface. When microfibers have been used to make the fabric, a hand more like real suede is given, since the inside of a skin is made up of fibrils that are very tiny. The most realistic suede-like materials are not achieved in finishing, but are made with a special fabric construction (see Section Four, "Needled").
- 3. **Shearing (Cropping, Cutting).** Shearing is applied to much napped and pile fabric, by passing it over a cylinder with blades like a giant hand-pushed lawnmower; in fact, this machine was the inspiration for that lawnmower (see Figure 5.6). The fabric may then be brushed to remove cut bits of fiber, or brushed and steamed to lay a nap or pile in one

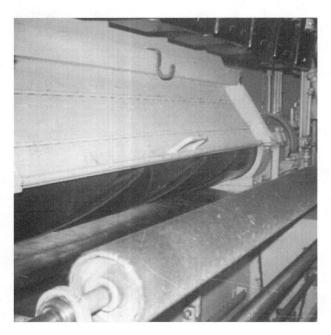

Figure 5.6 Shearing machine uses a cylinder with a blade like a giant hand lawnmower.

direction; **brushing** here is done with bristles set in a cylinder, not wires or an emery surface. Napping, emerizing, or brushing all leave the surface fibers lying one way (see Figure 5.5), so care must be taken when using (as with pile fabrics) to have fabric laid out all in the same direction, or light will reflect off various pieces differently.

Singeing or Gassing

This is the process of passing a fabric quickly over a gas flame to burn off any protruding fibers. It is done to give a smooth surface, as in lisle and the highest quality cotton broadcloth. Singeing can also help prevent pilling, for instance, in polyester suitings, by fusing any protruding fiber ends.

Calendering

Calendering is mill ironing or pressing, done by passing fabric between huge, heavy, heated rollers. In **friction calendering,** that heat and pressure polish the cloth. Wax may be added, as it was originally to give ciré; today ciré is usually made for sportswear out of nylon taffeta. The heat and great pressure on a thermoplastic material like this make the face shiny, and also permanently flatten the yarns, closing up the holes between them (*interstices*), to produce a high degree of water repellency. The *Schreiner calender*, engraved with many very fine lines, gives a satin-like luster; this is often applied to tricot used for lingerie, referred to as satinized or given a name like *satinesque*.

Creping

Creping gives the pebbly surface associated with crepe fabrics as traditionally produced by using very high twist yarns containing a fiber that will swell in water. When the fabric is immersed in the creping bath, it shrinks as the fibers swell; held tightly in the high-twist yarn, fibers form little bumps on the fabric surface (as with chiffon) or, in a more complex weave, the bark-like wrinkle of crepon, also called bark crepe. A crepe effect can also be obtained by using textured set filament yarns that will shrink up in wet finishing to give a crepey surface. (Many crepes owe their pebbly surface to an irregular weave; see under "Harness Control of Complex Weaves [Dobby]" in Section Four.)

Crinkle Sheeting

This is achieved by shrinking high-twist yarns to give a bark crepe effect.

Stiff or Crisp Finish

Stiff or crisp finishes may be durable or not. Nondurable types are given by sizings or fillers such as starch or natural gums; a durable crisp finish can be given by resins. A permanent crisp finish is given to organdy by the action of acid on cotton cellulose; a similar process on other fabrics or paper is called parchmentizing: the acid turns some of the cellulose to a jelly, which hardens, leaving the fabric thinner and permanently crisp. This process takes great skill in order not to damage the cotton; such organdy will be expensive.

Softeners

Softeners very similar to those sold for home use are often applied to goods in manufacture to give a pleasing hand and more fullness. They will also take up moisture from the air to help dissipate static, but have only a temporary effect, and most can cause yellowing. However, more durable, high-quality softeners have been developed.

Mill Washing

Mill washing or prewashing of cotton fabrics has grown greatly in popularity; it gives a "relaxed," worn look, popular for some time with denim in jeans and other garments. Stone washing is applied mainly to blue denim, and consists of wet tumbling with pumice—small lava rocks found in areas with recent active volcanos, which are much less dense (lighter) than regular stones (see Figure 5.7).

Other denim finishes give a worn appearance variously called, depending on the effect, frosted, distressed, or abused, and indeed, this tough fabric has been attacked with buckshot or even sandblasting so that the most fashionable and highest-priced jeans can look to be in the worst condition! Some effects called "sandblasted" spray the material with sand, but others use less abrasive solid material or powdered color remover. Other finishes have achieved the well-used look by methods with little relation to the name given them: Acid-washed employs an oxidizing chemical

Figure 5.7 Denim stone-washed with pumice.

to take out color, either chlorine (wet process) or permanganate (dry), while mud-washed usually gets its effect from prewashing and overdyeing.

The processes have been refined in recent years to give the effect with much less actual damage to the fabric (or to the environment—see Section Seven). For instance, **enzyme-washing** uses cellulases enzymes that weaken surface (cellulose) fibers instead of or along with stone washing. This process removes any surface fuzz on cotton fabrics to prevent or reduce pilling in use; biopolishing or bioscouring have become general terms for the process.

With linen, a term used for mill-washed flax yarns is delavé. A "laundered" finish gives woven linen a smoother surface with less slubbiness.1

For a while, this worn look was in demand even for silk, and what was called sand-washed silk appeared in more casual wear. This seems to have faded from popularity, but for a few years may have done some harm to silk's image as the luxury "Queen of Fibers."

Other Regular Finishing Processes

The tenter or stenter frame holds fabric as it goes through various processes, such as coating and drying (see Figure 5.8). Whether pins or clips are used

Figure 5.8 Montex 5000 stenter. (Courtesy of A. Monforts Textilmaschinen GmbH & Co.)

along the edges of the material, tenter holes are left along the selvage of woven goods or the waleswise edge of flat knit fabrics or circular knits slit open to handle flat in finishing. These holes are usually smaller on the face of the fabric; if visible, they look like small volcanoes.

Weft straighteners can be sophisticated machines used with tenters to prevent *off-grain* wovens, in which the weft is not lying at a 90-degree angle to the warp; these are termed *bowed* if the weft is curved, or *skewed* if the fabric, held up along a weft, does not fall straight.

Fabrics with slight flaws can be reclaimed by careful hand **mending** in a textiles mill, and most fabrics have any loose ends clipped off in **burling**, usually done along with mending. **Final inspection** or **perching** is carried out as fabric is passed over a raised, lighted frame, and today this process usually provides computer-controlled tracking of faults for quality control.

There are even automatic **on-loom inspection** systems, one using a camera tracking over the fabric on the take-up roller. A Uster® Fabriscan record for denim with a yarn defect is shown in Figure 5.9. The fault is automatically located, marked, and classified.

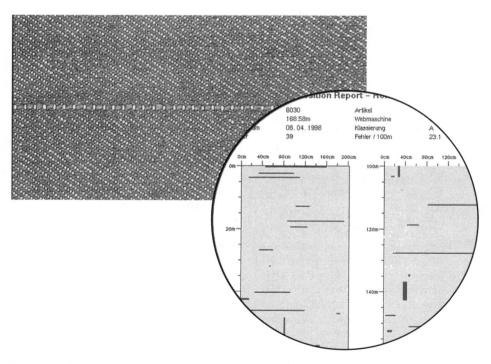

Figure 5.9 The weft yarn defect seen here in denim would be recorded on the Uster® Fabriscan position report, an automatically-produced "map" showing all defects found along the whole roll of fabric. (Courtesy of Zellweger Uster, Uster/Switzerland)

LINK 5-2 WITH FILES IN FABRIC GLOSSARY

These illustrate the role of fabric finishing and aspects of many of these general and basic finishes. Look them up for a fuller understanding of how these contribute to the fabric character, and are an essential part of its name. You will also find photos of these named fabrics, as well as other related textiles.

Fabric Glossary Fabric Name Look names up in the Fabric Glossary Index.	Relationship to Fabric Reference Discussion
Overcoat: Melton; Duvetyn; Fleeces Woven and Knit; Mackinac; Flannel; Flannelette	Napping (raising) brings fibers out of a fabric to give a soft, fuzzy surface. Most done by wires set in cylinders.
Wool Broadcloth	Fine fibers, napping done gently with natural or MF burrs.
Sueded	Soft finish, very short nap, and matte surface given by rubbing with emery-surfaced rollers; microfibers often used.
Velour Knit	Loops on knit fabric are sheared (cut) to give a velvety surface.
Corduroy, Velveteen, Velour Woven	Most pile fabrics are sheared and then brushed, to give an even surface, which lies one way.
Smooth surfaced cloth, especially Ciré, also "Satinized"	Calendered—mill term for applying heat and pressure.
Crepe, Crinkle Sheeting, Chiffon, Georgette	For many crepe fabrics the pebbly surface is given in wet finishing; other methods under Crepe, All Types.
Book Muslin, Buckram, Mousseline de Soie, Organdy, Organza, Taffeta, Tarlatan	Certain fabrics are known for their stiffness or crispness; this may be nondurable, durable, or permanent.
Denim, given a Stone-Washed or otherwise "Distressed" finish	Special mill washing can give a fabric a worn look, most popular with denim garments.
Tenter (Stenter) Holes along Selvage (Selvege)	Most fabrics carried through finishing on tenter frame; holes left along selvage shown in photo in <i>Fabric Glossary</i> under Selvage.

5-3 "ADDED VALUE" AND SPECIAL PURPOSE FINISHES

This part of the Fourth Edition of Fabric Reference focuses on many of the developments that represent a leap forward in technology, largely because of the rapid sophistication of nanotechnology. Therefore, a major rearrangement has been imposed on many entries to accommodate this.

Finishes that can be classified as "added value" or **special purpose** are chemical and additive, but not always detectable by look or hand, especially if achieved by nanotechnology. Many do carry trademark names, but only a few of these have been recorded in this edition, for reasons given in earlier sections.

So some of the following will be standard finishes, some applied through nanoscience, and only a few trademarks are listed.

Coatings

Standard coatings have become increasingly complex, and the line between coating and compound (multilayer) fabric grows increasingly hard to draw, so refer also to "Compound Fabrics," Section Four.

Besides many applications we are familiar with in clothing (leather-likes, rainwear) and household furnishings (upholstery, wall coverings), coatings are very important in such articles as automobile air bags, tents, awnings, and protective clothing. They are most frequently applied to fabrics of polyester, cotton, or nylon.

Coatings of "vinyl" (polyvinyl chloride or PVC), rubber (latex), resin (one incorporates dimethylformamide or DMF), polyurethane (PU), nylon, polyester, foam, or metallic particles (usually aluminum) in a resin may be applied. Of these more common coatings, PU has the considerable advantage for rainwear of being dry-cleanable, which vinyl and rubber are not. A combination of PVC and PU has also been used.

Leather-like fabrics very often incorporate a coating, often an "expanded" foam layer with a somewhat spongy feel to imitate the hand and construction of actual skins (see Figure 5.10). This is often being embossed to simulate the "top grain" look of a specific leather.

Pile fabrics (tufted, sliver-knit, fur-like pile and upholstery materials such as frisé) usually have a

Figure 5.10 Cross section through a leatherlike fabric. A coating of foam provides the outer layer (like leather grain); a nonwoven fabric acts like the leather corium layer (scanning electron microscope). (Courtesy of SATRA Footwear Technology Centre)

coating on the back to bind the pile to the fabric; latex (rubber) is often applied. **Drapes** may have a foam backing to make them opaque for room darkening, and for added insulation. Latex coatings on drapes or tufted mats and carpets can either dry and crumble or turn to sticky goo with heat and age.

Impermeable. When a coating is impermeable, it is virtually a film supported by a fabric, and is definitely waterproof. Such impermeable coatings have been very useful in applications such as upholstery, or shower curtains, but in most cases are less so in clothing, especially activewear for cold weather because of the wearer's discomfort when water vapor (from perspiration) cannot pass off. In these cases, people can become wet from *inside*, even though a downpour of rain cannot get through to them.

There has been a good deal of work done, however, to bind hydrophilic molecules within such impermeable, nonporous coatings or film. The hydrophilic material takes up the water vapor from perspiration, and a "push, pull" mechanism operates to get rid of the vapor. This is brought about because of a difference in pressure and temperature between the body side and the outside. An interesting advantage is that when perspiration is removed in this way from underwear, odor does not develop—an antiperspirant, deodorant effect.

Vapor Permeable, Water Repellent (VPWR). Microporous ("breathable") coatings are usually part of a fabric "system" of a number of layers (which takes many into the area of compound fabrics, as noted earlier).

In most clothing applications, microporous coatings are intended to give protection against inclement weather, particularly wet conditions, while keeping the wearer comfortable, i.e., to be permeable to vapor, but repel water; this is usually given as VPWR. The importance to comfort of moisture vapor (perspiration) being allowed to escape was discussed in Section Four under "Compound Fabrics." Microporous foam coatings can do this because they are permeable to the vapor form of "insensible perspiration," and are emphasized further in much more detail under "Basic Principles of Physiological Comfort in Clothing," in Section Seven. Such coatings are discussed briefly here, although as noted, it is often hard to distinguish a microporous or permeable coating from a laminate with a microporous film (Section Four).

Microporous polyurethane (PU) is a major type of VPWR coating, and may be used on the inside of rainwear (see Figure 5.11). Some systems include a very thin coating on the outside to shed water.

Photoluminescent. Reflective Reflective, coatings have been used to create "Space Age"

Figure 5.11 Microporous polyurethane coating on the inside of rainwear allows perspiration vapor to escape but stops water. (Courtesy of Consoltex Inc.)

high-performance textiles, to conserve body heat in very light fabrics.

Metallized lining fabrics are no longer much used in clothing, but a wider use for a metallized coating is on the back of drapes for insulation and/or room darkening.

Photoluminescent coatings are applied to clothing as well as structures to glow in the dark or in smoke, a boon for fire and other rescue service personnel. Another approach to making highly visible safety material is Scotchlite[™] reflective fabric (by 3M).

Encapsulation Technology

Micro-encapsulation

Micro-encapsulation is a technique of putting a thin polymer coating around very small bits of a substance, which can then be coated on a material, or incorporated into its structure. We are used to "scratch and sniff" fragrances on a card, and this is a type of encapsulation, but significant applications in textiles have been multiplying, with fabrics produced using micro- and nanotechnology that can administer Vitamin C, soothe arthritis pain, prevent odor developing from perspiration, or deliver other special performance functions with apparently never-ending variations. Some of these are discussed here.²

Temperature Regulation or Thermal **Comfort Management**

These were originally called Phase Change Materials (PCMs), using microcapsules (also called microspheres) of material that would become liquid around skin temperature. Added as a coating to fabric or incorporated into the structure, these can protect the body against cold by providing a heat-flow barrier to prevent heat loss. Some of the substances used are purified waxes (paraffinic hydrocarbons), either synthetic or obtained from petroleum.

With the selection of different microthermal materials, various temperature ranges can be targeted, e.g., protection for firefighters. However, the original research was applied to protection from cold. A leader in this field, Outlast®, is shown as a coating in Figure 5.12(a) with the process given diagramatically in Figure 5.12(b). When these PCMs are incorporated into a garment worn outdoors in cold weather (or in a commercial cold room), excess heat

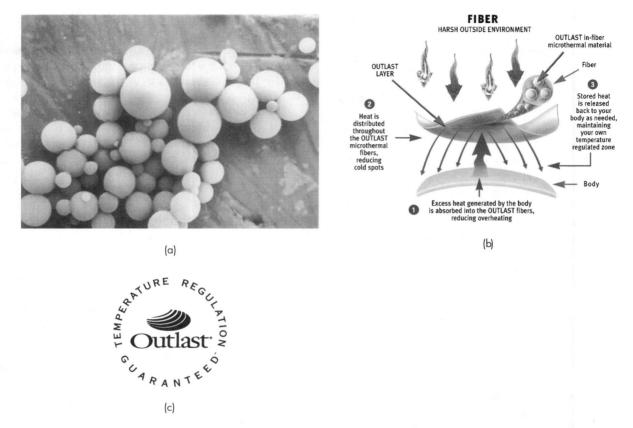

Figure 5.12 (a) Outlast® temperature regulation fabric is coated with microthermal material, which acts as a heat flow barrier. (b) Temperature regulation in a cold outside environment. (c) Outlast® logo. (Courtesy of Outlast Technologies, Inc.)

spots. Stored heat is released back to the body as as well as apparel, gloves, hats, and blankets. needed, and will not be lost to the outside until the PCMs are all in a liquid state, and then more slowly Body Interactive Encapsulations heat (see Figure 5.12[b]).

gloves, to give nonlofted insulation that did not ingredients to textiles. As the article made with the insulation, the insulating value is not lost. Wetness that the treatment is lasting, even through many

nonwoven, also uses PCM materials to add "climate products.

generated by the body is absorbed into the microther- control," to regulate body temperature in heat as well mal layer and distributed throughout, reducing cold as cold. These branded products are used in footwear,

than through a fabric without the PCMs. Once liquid, Other micro-encapsulated materials have effects on the PCMs will again solidify in the cold, giving off the body of the person wearing that fabric next to the skin. One of these is Sensory Perception™ (by Outlast was developed under research for NASA International Flavors & Fragrances [IFF]), which and the U.S. Air Force, with the original use in space binds microcapsules of fragrance or beneficial active depend on air entrapment. Such articles are not only fabric, be it clothing, carpet, or drapes, is used, the less bulky, but if they do get wet, unlike air-trapping active ingredient is gradually released. IFF indicates from perspiration is less of a problem, since overheat- washes. IFF has worked with the Woolmark Coming is deferred. In shoes, PCMs provide foot cooling. pany in applying this technology to wool and other Comfortemp® (by Freudenberg), an "intelligent" fibers, and with Invista to create Lycra® Body Care

Other Approaches to Encapsulation

Consumer textile applications have "taken off" in this field, with a major one being $EPIC^{TM}$ (Encapsulated Protection Inside Clothing) (by Nextec®), which delivers fabrics that are breathable but highly resistant to water and wind. This is accomplished by encapsulating the fibers within, and making sure that there is what is called a "barrier polymer" in the spaces between fiber bundles. Because this is not a coating on one side of the fabric only, protection against wind and water is described as "exceptional," and the hand and drape of the fabric are not affected.

Water Repellent, Stain Repellent, Soil Release, Moisture Management

These general categories of finishes are no longer necessarily neatly divided off, although some will still include finishes for one purpose, applied with standard processes. A well-known name is Visa* (by Milliken), which provides table linens with soil release, i.e., oily stains and others wash out more easily. There are also water repellent (showerproof) finishes using perhaps resins, but silicone-containing compounds are more effective. In the 1990s, wax finishes on cotton and linen fashion fabrics were popular, and such "old-fashioned" treatments come and go in fashion. Such finishes will hold off a light fall of rain (in advertising terms, they are showerproof, but are far from waterproof). They will also resist waterbased or -borne stains to some degree.

Stain-resistant finishes must go a step further than the water repellent and repel oily as well as water-borne stains; in the past this was done by fluorocarbon finishes, but formulations have been changed to include other compounds for major trademark names such as Scotchgard® (by 3M), DuPont™ Teflon® (by Invista), and StainSmart® (by Milliken), so that these finishes offer not only stain resistance, but soil release, and some versions add anti-static or hydrophilic properties to the fabric.

StainSmart® Comfort Zone adds moisture wicking by the back of the fabric, while the face offers resistance to liquids, and the whole fabric provides a soil release property.

In carpets, DuPont[™] Stainmaster® (by Invista) is made of Tactesse® 6,6 nylon fine filament fiber. The company, through this brand, promises lasting

protection from stains, superior soil resistance, and lifetime static protection.

Nanotechnology entered finishing with use of tiny particles to confer stain resistance and many other attributes. The tremendous difference with using particles of molecular size is that they can be designed for specific purposes, put on the fabric with great precision, and permanently attached to the fibers, so they will not be removed by wear and care. Even more welcome, there is no change in the fabric in appearance or hand; the finish does not change the aesthetics of the material.

To get an idea of what is meant by "tiny particles," compare the size of "whisker" fibers of 1 nanometer (nm) in size with other invisible (to the naked eye) or visible materials in Figure 5.13. It is easier to realize what a revolutionary technology this is when one thinks in terms of entities so much smaller than a grain of sand, a red blood cell, or a virus. Another comparison given in an earlier Section was that a human hair is some 80,000 times thicker than one of these "nanowhiskers."

Nano-Tex[™] (logo seen in Figure 5.13) was the first company to provide such a stain-resistant treatment, and the dramatic result of its Nano-Tex[™] Resists Spills finish is demonstrated vividly in Figure 1.4, Section One. Not only is this finish stain and soil repellent, but it has soil release action as well. It was first applied to apparel, but has been adopted by firms providing fabrics for interiors, for both residential and contract work, KnollTextiles being one outstanding example. There is a "family" of finishes: Nano-Tex[™] Resists Static is self-explanatory, as is Nano-Tex[™] Repels and Releases Stains; Nano-Tex[™] Coolest Comfort adds moisture wicking for clothing, but also bedding, bath, and other home furnishings fabrics.

P2i is another company using nanotechnology to add desirable properties to textiles in finishing. It uses plasma-enhanced chemical vapor conditions to apply layers just molecules thick over the surface of products, with a wide range of results possible. P2i's "enhancement" process has been applied to textiles to repel liquids, including oil and water. It is noteworthy that an entire garment, or objects like zippers can also be treated, as well as surfaces such as ceramic, glass, paper, or metal.

Nanoscale finishes are highly useful in consumer textiles, then, plus special security protective and high performance clothing markets; they also have a

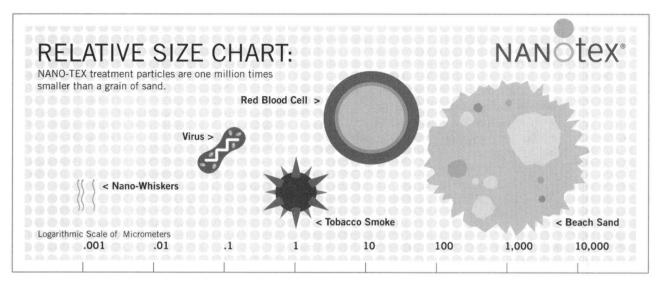

Figure 5.13 Relative size of nanoscale fibers (Nano-Whiskers) compared to other entities up to a grain of sand. (Courtesy of Nano-Tex, Inc.)

place in automotive, aerospace, electronics, military, and biosciences fields.

Moisture management enhances the comfort of clothing fabrics. Most consumers enjoy wearing or using fabrics of cotton, but there is no doubt that, when damp (water or perspiration), cotton does tend to cling to the body, and is by no means quick-drying. Cotton Incorporated developed a moisture management system for fabrics made of this "King" of fibers, to encourage wicking of perspiration away from the skin, so the wearer feels drier; it is branded Wicking Windows™. At the same time, the absorbency of cotton was somewhat reduced, and the treated fabric dries in a shorter time.

Various significant moisture management systems have already been outlined under "Quality, Fashion, and Comfort" in "Blending of Fibers," Section Two; plus "Compound Fabrics," Section Four. These discussions should be reviewed for a more complete coverage under this heading.

Bioactive Agents

This is a rapidly developing area for finishes that counteract bacteria, and/or mold, mildew, and fungi, plus dust mites, and insects. For some time, chemicals have been incorporated into fibers to make them antimicrobial in an attempt to prevent unpleasant odors from developing in textiles (discussed in Section Two under "Additions to Manufactured Fibers before Spinning").

Such bioactive agents have also long been applied as finishes for this purpose, but the scope is constantly widening. Consumers have become very interested in textiles such as towels with a hygienic property. A review of the many places microbes can thrive and their harmful effects, backed up this consumer interest and concern.³ The negative effects of dust mites in cases of allergy or asthma has been more fully realized, with much attention paid to bedding and carpets.⁴ It has also been pointed out that people are using water at a lower temperature, and lower volumes of it in machine washing, or are hand washing more delicate fabrics.

A good many of the prominent branded agents use silver, often as nanoparticles. Silver has a powerful antimicrobial action, yet is neither toxic nor allergenic. The efficacy of silver has been known for ages. but it has taken modern methods to bring the cost of a lasting finish to the level of consumer goods, and the best brands will have been tested to make sure the finish lasts through many washings. Ultra-Fresh Silpure® (by Thomson Research Associates—see Figure 5.14) is applied using technology developed over 50 years for applying antimicrobial finishes to give lasting resistance to odor and fiber degradation. (It is one of the Ultra-Fresh® family of lasting antimicrobial finishes). In the case of Silpure, addition of nanotechnology made it possible for the firm to break the cost barriers that have restricted the use of silver-based antimicrobials in the past; they can now be used for a wide range of

(a)

(b)

Figure 5.14 (a) Ultra-Fresh® and (b) Silpure® are registered trademarks of Thomson Research Associates Inc. (Courtesy of Thomson Research Associates Inc.)

consumer products. Some others of this type of finish are: Alphasan (by Milliken); Genesis® Silver (by Difco); SilverClear[™] (by CTT Group + Transtex Technologies); and SmartSilver (by NanoHorizons).

A well-known name, Sanitized® antimicrobial, is now part of a family, with Actigard® dust mite protection, and Actifresh® odor protection (all by Sanitized).

Stain Repellent, Bioactive and UV Protective

It was impossible to find another heading under which to "file" a fabric line developed by Weave Corporation: Weatherwize®. This is upholstery for indoor/outdoor use, and requires a battery of protective agents, especially when it begins with high qualfine polyester yarn-dyed, jacquard-woven materials in fashionable designs. The company has made sure that there is UV and antimicrobial resistance, and high water repellency. The fabrics are offered as "elegant and comfortable enough to use for indoor upholstery" (see Figure 5.15).

Besides finishes for consumer products, medical research has been aimed at developing materials for implants that are resistant to infection.

Another direction has been incorporation of agents that repel insects such as mosquitos (studying repellency, reduction in landings, or in blood feeding); some have been found also to hold off sand flies

Figure 5.15 Outdoor furniture with Weatherwize® fabric covering. (Courtesy of Weave Corporation)

and bedbugs, as well as dust mites. One insectrepelling agent, BUZZ OFF™ (by BUZZ OFF™ Insect Shield), was the first ever registered by the U.S. Environmental Protection Agency as being effective. (There is increasing concern about diseases carried by insects. BUZZ OFF clothing repels mosquitos, including those that can carry West Nile Virus, and ticks, including those that can carry Lyme disease). Even if one is not in that kind of danger, having clothing repel insects is much easier than applying repellents and renewing them frequently. BUZZ OFF lasts through washings, but should not be dry cleaned (see the note under "Care of Special Items." Section Six).

Other Special Finishes

Flame Retardant

Flame-retardant finishes can be applied to fabrics of cellulose or other highly flammable fibers, but generally these give poor aesthetic qualities, e.g., a harsh hand. Approaches to conferring flame resistance, other than by finishes (such as fabric construction and garment design), were discussed in Section Two under "Burning Behavior."

Wrinkle Resistant or Crease Recovery

Such a finish is needed with cellulose fiber fabrics. A durable finish will last for the life of the article under normal wear and care, but will soften or lose some of its effectiveness over that time. **Crush resistance** is a special finish applied usually to rayon velvet.

Durable Press

Durable Press (often called "perma-press" or some such term falsely suggesting permanence) gives the completed article a set shape and size and a pressed or finished look. Cotton family fabrics are often a blend with polyester; in such a blend, a **resin** finish holds the cotton, while the **heat** to cure the resin holds the polyester. With such a blend and finish, a durable rather than permanent set results. Formaldehyde has been used to give a Durable Press finish on cotton, by forming cross links between cellulose molecules; however, a weakening of the fabric results.

To set a Durable Press on 100 percent cotton fabrics, a liquid ammonia process has been used. There has also been nonformaldehyde finishing of all-cotton fabrics, applied to such a major trademark name as Levi's jeans.

Manufacturers and retailers had to clarify promotions that used the term "wrinkle-free," (as in Haggar "Ultimate" or Dockers® wrinkle-free pants) rather than Durable Press. This term was quite misleading to many consumers; it means "wrinkle-free—(warm) from the dryer," not that wrinkles will never occur during wear. Advertisements now state this clearly.

For care procedures to get the best performance (including the least wrinkling) from Durable Press, see Section Six.

Dimensional Stability, Including Shrinkage Control

When a fabric will not shrink or stretch during use and care, it is dimensionally stable. **Heat setting** of nylon, polyester, or triacetate fabrics can accomplish this.

Shrinkage control may involve counteracting relaxation shrinkage in fabrics of almost any other fiber, as well as felting shrinkage, specific to wool and hair fibers.

Felting shrinkage of wool must be counteracted by an **antifelting** treatment to prevent this special kind of matting and thickening, which results in shrinking (see Figure 5.16). The best (trademark) finishes make wool fabrics machine washable and, if the article allows, machine dryable, with no matting or

shrinking. This is achieved by chemical alteration of the fiber surface, or by coating it with a very thin layer of polymer to make the scale surface smoother, as shown in Figure 5.17(a). Treatments by the latter method and backed by the Woolmark Company are identified by the logos for Machine Washable Wool, or Total Easy Care Wool, Figure 5.17(b), and Figure 5.17(c) (see Section Six, "Wool and Hair Fibers," under "Tender, Loving (Home) Care (TLC)" for laundering such machine washable wool). Effortless Wool is the trademark name from Burlington Performancewear (BPW) for wool wovens that can be machine washed and tumble dried.

Relaxation shrinkage is possible in a fabric of any fiber content, if there are tensions in the material that can **relax** when strains are released in wet treatment or washing and (especially) tumble drying (see Figure 5.16 [middle photo]).

Shrinkage-controlled cotton or rayon fabric may have a **resin** finish, which will give at best a durable shrinkage control.

For a more permanent treatment, woven goods such as cotton sheeting are given a **compressive preshrinking**; Sanforize (by Cluett, Peabody) was for

Figure 5.16 Shrinkage control may have to counteract relaxation shrinkage or, in wool fabrics, felting shrinkage. (Courtesy of the Woolmark Company)

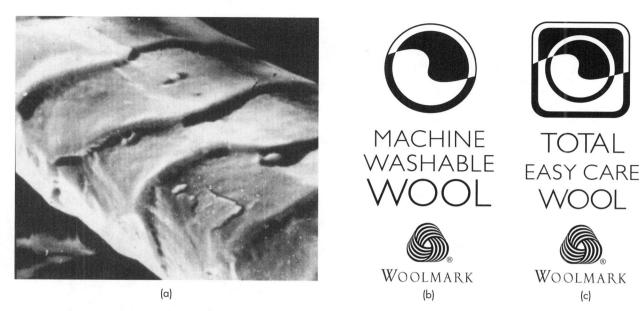

Figure 5.17 (a) Wool fiber with scales coated to prevent felting. Logos for (b) Machine Washable Wool with Woolmark® and (c) Total Easy Care Wool (machine washable and dryable) with WOOLMARK®, treatments that offer easy-care wool. (Courtesy of the Woolmark Company)

a long time a very well-known trademark name for such a treatment. Before such a process, each fabric is tested to determine possible shrinkage and then forced to shrink that much. (Figures 5.18[a] and [b] show the effect of the process.) This is accomplished by passing the wet fabric, sticking tightly to a compressible felt or rubber blanket, first over a convex curve where the blanket is extended, then through a concave curve, so that the material is compressed and dried in this form by a steam-heated Palmer cylinder (see Figure 5.18[c] and [d]). The guarantee is that there will be no more than 1 percent residual shrinkage (if the article is pressed). It is generally much harder to stabilize weft knits than wovens, since their stitches, from single varn feeds, are much more distortable than woven structures (see "Knitted versus Woven," Section Four). For additional comments on shrinkage and fit, see Section Eight.

London shrinking is a special process used for fine worsteds: Tensions are released by allowing fabric to lie between cold, wet blankets, then after slow drying, fabric is subjected to great pressure in flat presses.

Carpet Shading Prevention

Shading is an optical effect that results when carpet pile leans in different directions. This is, of course, more noticeable with a plain shade, cut-pile carpet, but with pressure from crushing during manufacturing or shipping, or from foot traffic when it is first laid, can become permanent. Technologists at WRONZ Developments in New Zealand have came up with a Trutrac treatment to set the natural pile lay so that it will not be disturbed in use (see Figure 5.19).5

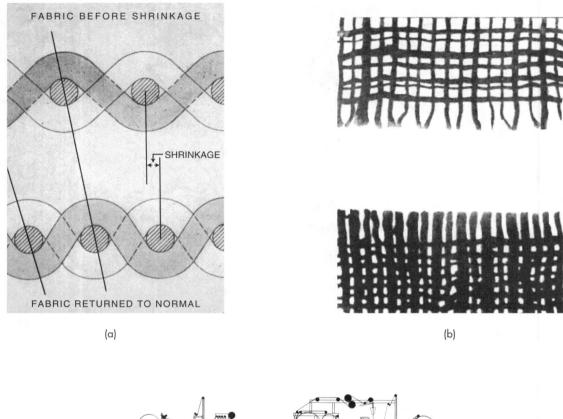

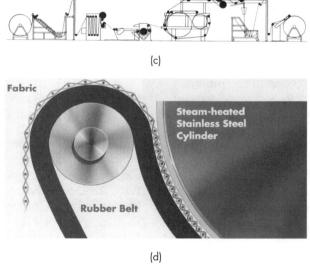

Figure 5.18 (a) Diagram of cross section of woven fabric before and after controlled compressive shrinkage. (b) Woven fabric before and after a controlled compressive shrinkage process. (Courtesy of the Sanforized Company division of Cluett, Peabody & Co., Inc.) (c) Controlled compressive shrinking process: overview, with (d) enlarged diagram of area in which controlled shrinkage takes place. (Courtesy of Morrison Textile Machinery Company)

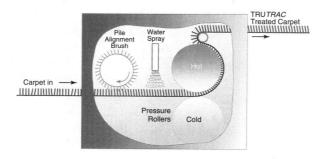

Figure 5.19 Trutrac prevents carpet shading by setting the pile permanently to its natural orientation. (Courtesy of WRONZ—Wool Research Organisation of New Zealand [Inc.])

LINK 5-3 WITH FILES IN FABRIC GLOSSARY

These illustrate the role of fabric finishing, including aspects of these "added value" and special purpose finishes. Look them up for a fuller understanding of how this contributes to the fabric character and is an essential part of its name. You will also find photos of these named fabrics, as well as other related textiles.

Fabric Glossary Fabric Name	Relationship to Fabric Reference Discussion	
Look names up in the Fabric Glossary Index.		
Coated, Color Variable, Embossed Water Repellent, Waterproof	Coatings are shown that give leather-like fabrics, and waterproof. Decorative effects can also be seen from coatings with changeable color or embossed. Although these finishes cannot be seen, they will usually carry a label indicating their presence, often with a trademark name; look for these. You can test to see the difference between water repellent and waterproof.	

REVIEW QUESTIONS 5-1, 5-2, 5-3

- 1. Name a finishing procedure unique to each of the following: wool, silk, and cotton, and for which you can list three results that improve fabric made of that fiber.
- 2. What main characteristic of the fiber is involved in that procedure?
- 3. Name two finishing processes carried out mainly for linen fabrics, and their result. What main characteristic of linen (flax), compared to cotton, is involved with both procedures?
- 4. Name two major ways fibers are made to stand out from a fabric and laid to give a soft, fuzzy surface. In what important practical way does this affect using such a fabric?

- 5. Distinguish the above procedures from construction of pile fabric. How is the result the same? (The two are often confused.)
- 6. What final finishing processes are often applied to fabrics where fibers or yarns are meant to stand up on the surface?
- 7. What procedure is used to help give a smooth surface to cotton yarns in lisle or fine broadcloth shirting?
- 8. What is the mill term for ironing or pressing? Name two effects other than smoothness achieved this way.

- What two factors make the pebbled surface of traditional crepe develop in wet finishing? Name five fabrics of this type.
- 10. Describe two other ways of producing a crepe through wet finishing.
- 11. List agents or processes that produce nondurable, durable, and permanent stiffness to cotton organdy. Is there a difference in cost, and if so, why? What is another name for the process that gives permanent crispness?
- 12. Name four agents that are used to give cotton denim a worn look in mill washing. Name two that are least harmful. What other advantage does this process give to denim?
- 13. Fabric is carried continuously through finishing on a frame that leaves an impression on the fabric. If you are working with piece goods, what practical use can you make of this?
- 14. Name three effects that can be achieved by applying a coating to a fabric.
- 15. Distinguish between water repellent and waterproof; between soil resistance and soil release. Give an example of a use where each would be suitable.
- 16. Name two finishes that can give a "VPWR" fabric. For what applications is this combination of properties needed?

- 17. Explain the process by which microPCMs, applied to a fabric, can keep a person warm after going outdoors in cold weather? Name a year-round occupation where such clothing would be appreciated.
- 18. How many times smaller is material measured with nano as a prefix, compared to micro? Cite three advantages of applying materials of this size to textiles.
- 19. Is application in a finish the best way to confer flame retardancy on a fabric? If not, what method(s) would be better?
- 20. What is the main aim of antimicrobial finishes on textiles used in clothing and how is this successful? What is the main aim of antimicrobial finishes on textiles used in household fabrics and furnishings?
- 21. Distinguish between a Wrinkle Resistant finish and Durable Press (DP). How is DP achieved on cellulose? What is the drawback of a formaldehydebased treatment? What kind of home care should be satisfactory for a garment labeled Durable Press, and either carrying a known DP trademark name or from a dependable manufacturer?
- 22. Which is more difficult to preshrink, a woven fabric or a weft knit, and why?
- 23. In what kind of carpet is "shading" in use most noticeable?

5-4 APPLICATION OF COLOR

What Is Color?

For all of our poetic, romantic, or sentimental references, color is actually a sensation in the eye from absorption (or reflection) of light by an object. That is the scientific and technical answer to "What is color?" but much more is needed for an adequate treatment of its importance in textiles used for apparel and especially interiors. This can be found in a book that covers everything from myths to marketing, and offers another basic fact of color: "Color is constantly changing because light is constantly changing."6

Electromagnetic wavelengths are measured in Ångstrom units (1 Å = 10^{-10} m), or in SI metric, in nanometers, or millionths of a millimeter (1 nm = 10^{-9} m); by comparison, the diameter of fibers is measured in millionths of a meter with microns (symbol u), or, in SI metric, in micrometers, (1 $\mu m = 10^{-6}$ m). The wavelengths of light to which the human eye can respond are in a very narrow band of the total range of electromagnetic radiation, the rest being absorbed but not seen.

The range is as follows:

- gamma-rays (shortest, highest energy), in the order of 10⁻¹³ m)
- x-rays, from below 10^{-11} m, midpoint 10^{-10} m (1 Å), to 10⁻⁹ m (1 nm)
- ultraviolet rays, from 1 nm, midpoint 10 nm, to over 100 nm, tanning rays 280-400 nm
- visible light rays, from about 400 nm to 700 nm
- infrared heat rays, from 1000 nm to 10⁻³ m (0.001 m)
- radio waves, from "short wave" to longest— 0.001 m to 100 m

A beam of white light breaks into the visible spectrum of colors in order as violet, blue, green, yellow, orange, and red, representing increasing wavelengths as noted. This is the separation that takes place when we see a rainbow or when we see light passed through a prism. What color an object will appear to us is determined by which wavelengths of light falling on it are absorbed; we see the color of the wavelengths that are reflected. If all wavelengths are absorbed, the object appears black. If the object absorbs wavelengths outside the visible range, or if all light is reflected, it will appear white.

As we all know, different people see colors differently. Some cannot distinguish red from greenwhat we call "color blindness"—and anyone can see color differently depending on what is placed next to it, or in what kind of light it is viewed. When a color looks different when viewed in daylight compared to artificial (incandescent or tungsten-filament bulb) light, the phenomenon is called metamerism, which can also affect perception of a color in an older person compared to a younger, due to changes in the eye. It is important when matching trim to a main fabric, for example, to view it in both daylight and artificial light. Another significant aspect of the subjectiveness of color vision is the way a color can look different when placed next to another.

Hue is the word used to signify one color distinct from another (red, blue-green, brown, etc.). Value is the degree of lightness (tint) or darkness (shade) the color shows. Intensity or chroma represents how strong or saturated the color is, how intense or vivid: with low intensity, colors are dull rather than bright.

Application of Color to Textiles

As in most of the aspects of textile processing discussed to this point, electronic controls govern the action and timing of application of color in the most modern methods. This can be especially noteworthy in areas that have involved a good deal of art and craft. One of these is dye formulation and shade matching, where use of a computer color-control system, which includes a spectrophotometer, can dramatically improve the speed and accuracy of both formulation and color matching (see Figure 5.20). Gaston County (U.S.) has a total automated dueing system called Millennium (see Figure 5.26[a], [b]), and other systems also automatically monitor and control all stages of dyeing or printing from a central computer and spectrophotometer, governing chemical and dye stocks, color matching, and more.

Preparing color pastes for top-quality screen printing might be thought to be a handcraft operation, but even here, mechanisms evolved to replace hand-mixed pots of print paste with a computercontrolled machine that delivers the mixture automatically (see Figure 5.21). However, in both of these cases, the human eye usually remains the final judge of color, pattern, or total result.

Figure 5.20 Color-control system includes Datacolor International's Chromasensor® CS-5® spectrophotometer. (Courtesy of Hafner Fabrics)

Figure 5.21 (a) Print paste hand-mixed—Ratti printworks, Italy, 1986. (b) Computer-controlled print paste mixing—Ratti printworks, Italy, 1988.

Printing is taken to be the application of a pattern to the *surface* of a fabric, whereas **dyeing** involves *penetration* of the material.

Many fabric designs are produced in several combinations of color, or *colorways*.

Dyeing

Dyeing is usually carried out in a water bath (dye liquor), though there are other methods, such as solvent and molten metal dyeing.

- A dye, therefore, is defined first of all as being able to be dissolved in water, as opposed to a pigment, which cannot be dissolved. One type of dye—disperse—is only slightly soluble in water, but it is still classified as a dye.
- A dye (in most cases) appears to the eye as a color, although reference to colorless dyes will be made.
- Many dyes are substantive to the material being dyed—that is, they are taken up by it without a mordant, or material that binds the dye to the fiber (from French mordre meaning to bite, that is, to hold the dye). Other dyes are changed or actually created within the fiber, usually to give better wetfastness, but there are methods to get them in there, and so they qualify as dyes.

Two exceptions to any definition of a dye are included in this discussion, pigment "dyeing" and solution "dyeing."

Different fiber generics accept only specific types or classes of dyestuffs, as discussed under *Dyes and Colorfastness*, Section Six.

Types (Classes) of Dyes

As noted, **substantive** dyes are taken up or adsorbed by a fiber, but need specific treatment if they are not to have only fair-to-poor wetfastness; that is, if in water (e.g., in washing) they are not to come out of the fiber as readily as they went in. The various classes of dyes accomplish this in varying degrees and various ways.

Acid Dyes. These are salts of color acids, substantive to wool, silk, and nylon, and can be applied to special forms of acrylic and polyester. They give bright shades, usually have good fastness to light, but are seldom of good wetfastness.

Chrome or Mordant Dyes. Historically, oxides of a number of metals (aluminum, chromium, copper, iron, tin) have been used as mordants and give different shades with the same acid dve. Today, chromium salts are nearly the only mordant used to hold acid dyes to wool or nylon, and so the type is called a **chrome dve.** The addition of metal dulls the shade but greatly improves wetfastness. The mordant may be applied before, during, or after dueing with acid dues.

Acid Metallized, Premetallized, or Metal-Complex Dues. These are very much like chrome dye, but the metal is incorporated as the dye is manufactured. These dues are applied either in a strongly acid bath (acid metallized) or a nearly neutral one (premetallized), in an operation considerably simpler than chrome dyeing. They offer muted shades of excellent fastness.

Basic, Cationic Dyes. These are salts of color bases, and so are cationic (see Section 8). They are substantive to silk; the first synthetic dye ("Perkin's mauve," 1856) was a basic dye used for silk. These older silk dyes have poor wet- and lightfastness. It was found that these dyes are also substantive to acrylic, and with the need for better fastness for this synthetic fiber, superior dyes of the basic group were developed and given the name cationic. They may be used on special forms of nylon and polyester as well as acrylic.

Disperse Dyes. Disperse dyes are very finely ground colors, almost insoluble in water, that are dispersed in a detergent solution to be taken up into the fiber. They due the less-absorbent fibers that do not swell or allow the soluble types of dyes to enter. They are used most on polyester, acetate, triacetate, and for lighter shades on filament nylon (see the discussion of nylon in "Dyes and Colorfastness" in Section Six); they are also used on acrylic and even olefin.

Direct Dyes. Direct dyes are substantive on all cellulose fibers, but need special fixing treatments to prevent them from coming right off again; i.e., to give them better wetfastness.

Direct Developed Dyes. These have better wetfastness, because after the direct dye is applied, it is diazotized and developed, creating a larger and less soluble dye in the fiber; this is, of course, a longer method. These dyes are not fast to chlorine bleach.

Reactive (also called Fiber-Reactive) Dyes. Reactive dues are different from any other due type. because they form a chemical union with the fiber. They are used mainly on cellulose fibers, the dyeing can proceed at room temperature (these are the "cold-dyeing" types), and there is a full range of bright colors. However, for deep shades, these dues are expensive because it takes a good deal of due to give a full shade. Reactive dyes are also used to a lesser extent on wool, silk, and nylon but are still principally applied to cellulose, and that means mostly cotton, where they show excellent wet- and lightfastness, but are not as fast to chlorine bleach as vat or naphthol dyes.

Naphthol (Azoic) Dyes. These dyes are formed in the fiber from two components added one after the other. A coupling takes place producing the final dye and color inside the fiber (also in the dyebath if excess chemical is there). The process is run very cold, hence they are also called ice dves. Naphthol dves have excellent fastness even to commercial laundering (very hot water, built detergents, chlorine bleach). Oddly enough, some are not at all fast to dry cleaning.

Vat Dyes. Vat dyes are a group of dyes that are insoluble in water, but they can be reduced, in alkaline conditions, to a form that has little color, or an entirely different one, but is soluble (the leuco form). When it has been taken up by the fiber, the dye is oxidized and left in the fiber as an insoluble color. Application of these dyes is long and fairly difficult, but they are substantive to cellulose fibers, give superb wetfastness even with chlorine bleach, and the lightfastness of most is good. This is one dye type name we are familiar with, from the stamp "vat dyed" on good linen tea towels (dish towels) or interiors material. Also, indigo, used to dye the warp yarns in denim for "blue jeans," is a vat dye. There is not a complete color range in vat dyes; for instance, they lack a true bright red. Vat dyes are sometimes applied to wool, although, since the bath must be alkaline, conditions must be carefully controlled.

Sulfur Dyes. Sulfur dyes are also insoluble in water, but will dissolve in a solution of sodium sulfide, with or without sodium carbonate. Sodium sulfide reduces the dye to a compound that is substantive to cellulose, and which oxidizes back to the original state. Sulfur dyes are inexpensive and wetfast but have not traditionally been fast to chlorine, and they have only a narrow range of dull shades. Improved sulfur dyes have been developed.

Pigment "Dyes." "Pigment dyeing" is application of color, both pigments and dyes, not really by any dyeing process but by binding the color to the surface of the fabric, much as a print paste is applied, using resins as a rule. This can produce a rather stiff fabric, and while colors may have reasonable wetfastness, they may crock (rub off); if the binder is sensitive to solvent, the color could come off in dry cleaning.

Dyeing Stages, Methods, and Effects

In processing fibers to fabric, the earlier the stage at which color is introduced, the better chance there is that it will not be removed in processing, use, or care—that it will be *colorfast*. See "Dyes and Colorfastness" in Section Six for a discussion of the relationship between the types or classes of dye used on various fibers and colorfastness.

Many design effects are related to a certain stage of dyeing (heathers, checks, etc.). If such an effect is imitated later, by printing, for instance, the pattern will likely be less well defined and of inferior fastness, but it will be considerably cheaper, as a printed compared to a yarn-dyed woven glen check will be (see Figure 5.22). In a plain weave, a woven check is also *reversible*, an advantage in garment construction, as with a convertible shirt collar (discussed under "Yarn Dyeing").

Cost alone, per dyelot or batch, would probably make an early dye application seem less expensive, as it usually involves a large lot; however, there is a general "expense" in applying color at an early stage—

Figure 5.22 Transfer-printed glen check (left) vs. yarn-dyed woven glen check (right). The more expensive woven check is clearer and more durable.

you have then made a *color decision*. You are committed to warehouse a distinct coloration, and even more nerve-wracking, as well as potentially expensive, you have "second guessed" a fashion direction! More on this in the discussion of cross-dyeing, but these cost and risk effects underlie the summaries of stages and methods of dyeing that follow, which are listed in order, from the earliest stage of coloration to the latest.

Solution Dyeing. Fibers solution-dyed (also called producer-, polymer-, spun-, or dope-dved) as suggested in the earlier definition of a dye, do not really qualify as dved, since in this process, pigment or dve is added to the liquid before an MF fiber is extruded. The color is locked into the fiber, and therefore is completely fast to any condition, from sunlight to water at the boil, that will not actually damage the fiber itself. This method has traditionally resulted in a huge batch of each (fairly standard) color, and so is not usually suitable for fashion items, which normally call for a season's specific shade of color. It can be used in patterns, such as stripes, checks, or plaids, where a limited number of colors can produce a wide range of pleasing, "classic" combinations; one example is taffeta in a red and green with white, black, and/or gold plaid, which is perennially popular for holiday ribbons and piece goods—very likely solution dyed. Such fabrics are also often used for neckties, ribbons, and less-than-highfashion umbrellas for the person who wants basic rain protection that will "go with everything," last for many years, and can be left between showers to withstand horrendous exposure "tests" in the back of the car of a person like me. Solution-dyed fiber is called for anywhere exceptional fastness is required, such as dark sliver for a spotted-cat look in a fake fur, which might then be overdyed (at the boil) to give a range of ground shades. Figure 4.65 shows knitting of such a fabric.

In recent years, specialized companies are producing small batches of solution-dyed fiber to meet the fashion need for specific, unusual, or changing colors.

Fiber Dyeing. Fiber dyeing (stock dyeing) is done at the earliest stage at which a natural fiber can be colored. Loose fiber is dyed either in the bale (a relatively new method) or held in a basket in a dye machine (see Figure 5.23[a]). Using stock-dyed fibers, various colors can be blended to give heather or mixture effects, adding a misty, indistinct tone to the overall shade, although individual fibers may show

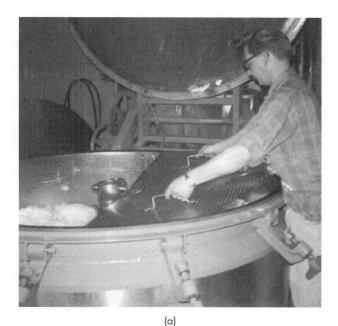

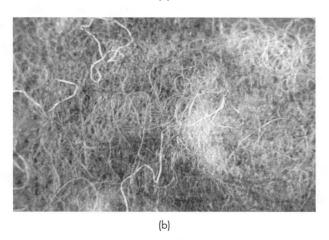

Figure 5.23 (a) Fiber or stock dyeing machine. (b) Fiber-dyed mix for tweed.

quite strongly colored (see Figure 5.23[b]). Colored nubs can be introduced into a yarn using stock-dyed fiber. Fibers may also be dyed before spinning in top form, when the loose rope formed after combing is wound on perforated cores. Marl is a mottled look, usually tone-on-tone rather than multicolor, given by blending top-dyed roving in a single yarn, or in at least one ply of a 2-ply varn; other names used for this effect are salt-and-pepper or ragg, the latter originating with ragg wool, reclaimed and reworked,

but now used for a pleasant "mixey" look no matter what the fiber content. Marl or heather effects and colored nubs are all characteristic of tweeds.

Yarn Dyeing. Yarn dyeing requires making sure the yarn does not get tangled as it is dyed; while some soft or bulky yarn is skein- or hank-dyed, most is package-dyed, where it is held more firmly and so is much easier to handle. For package dyeing, yarn is wound on packages, each with a hollow center that allows liquid to flow through it. The packages are stacked on perforated, hollow posts, and liquid is pumped through these and the packages. Package machines are enclosed and can be pressurized, so the dye liquor can reach temperatures above the atmospheric boiling point (100°C or 212°F) for faster dyeing; this is especially helpful in dyeing standard types of polyester in normal batch times, without having to use chemical "carriers." (See Figure 5.24.)

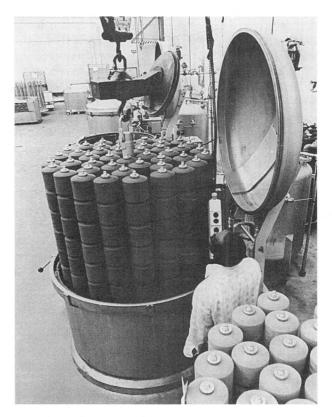

Figure 5.24 Package dyeing machine is used for most yarn dyeing. (Courtesy of American Textile Manufacturers Institute, Inc.)

With woven fabrics, for example, shirtings, the term yarn-dyed is connected with quality: a check woven in with dyed yarns will look sharper, with a clean, well-defined pattern, compared to one printed (see Figure 5.22) and will probably be more colorfast. It is also reversible, as most prints are not, except in the case of the few duplex prints and those on sheer fabrics. This is an advantage in garment construction, as with a convertible shirt collar to be worn closed or open.

Many fabrics have their character derived from dyed yarns; see Link 5–4 (with 5–5 and 5–6) to Files in *Fabric Glossary*.

When knitted fabric is made with dyed yarn, the color or design is said to be *ingrain*, and almost all *jacquard* and *intarsia* knits are ingrain. These two patterned knits can look very similar on the face; they can be distinguished from one another by looking at the back. In a jacquard knit, any color not looping on the face is carried in the back on that course, and can be clearly seen, in both single knits (see Figure 4.62) and double knits. With intarsia, each colored yarn loops only in the area of the motif, so the back shows the same color as the face in that area (see Figure 4.63).

Variable color effects are given when fabric is woven with warp a different color from weft, so that the color changes as the fabric is moved; this effect is variously called chameleon, *changeant*, iridescent, luminescent, pearlescent, and shot (as in taffeta). A number of distinct effects are achieved by having a pattern in the yarn before the fabric is made; these and others are discussed in Link 5–4 with Files in Fabric Glossary.

Space-dyed is the effect of yarn-dyed with more than one color or shade along its length at random intervals (see Figure 5.25). This can be done by injecting packages of yarn with color, or yarn may be knit up into a tube, printed, unraveled or "deknit" to be used as space-dyed.

Yarns hand dyed by the **tie-dye** method in patterns before weaving give *ikat* designs, which have an indistinct or blurred outline called a *chiné* effect. Designs can be warp or weft ikat, from only warp or only weft yarns tie-dyed, or the astounding *double ikat*, such as patola, in which both warp and weft have been tie-dyed and the design emerges as the cloth is woven. Other color effects in yarns come through printing: warp yarns printed give a chiné effect and *mélange* is a different printed effect. These are discussed under "Printing Methods and Effects."

Figure 5.25 Fabric knit of space-dyed yarn.

Piece Dyeing. Piece dyeing is done after the fabric is made. The most common method traditionally has been with the **winch** dyeing machine or **beck**, in which goods are sewn into a loop (what is called rope form), to be dyed as a continuous piece, drawn out of the dye bath over a winch reel or roller, and returned to the bath to continue the cycle. Lengths of fabric are also wound on a beam, in a compact machine that is much easier to pressurize than the due beck and so is useful for polyester fabrics. In the jet dyeing machine, goods are forced through a narrow jet but then lie loose as they pass through the machine cycle; this type is especially suited to dyeing knit goods as there is little strain put on the fabric. Both knitted and woven textiles, delicate, stretch, or commodity goods can be dyed in rope form in another horizontal pressure dyeing machine, the Millennium (by Gaston County), which has automatic controls, and low ratio of liquid to goods (see Figure 5.26[a] and [b]). In both **pad** and **jig** methods, piece goods are passed from one roller to another through a trough containing much smaller amounts of liquid than is used in the machines discussed so far (see Figure 5.27). The fabric is held at full width, so there is less chance of wrinkling and creasing during dyeing. Padding is also used to apply finishes, as the thick liquids, dye or finish, are pressed into the fabric.

Union-dyed is a term used for achieving a single (solid) color on piece-dyed fabric of differently dyeing fibers. Dyes of different types suitable for each fiber present, and of the same shade, are included in the dyebath. (Home dye tints are made up with such mixtures; see the discussion under "Dyes and Colorfastness" in Section Six.)

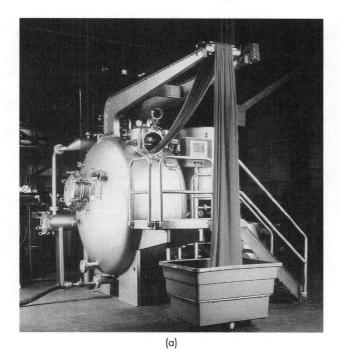

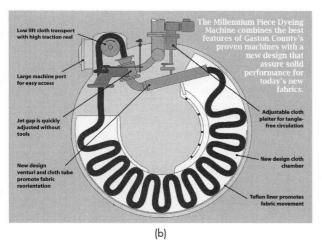

Figure 5.26 (a) Millennium piece dyeing machine rope form. (b) Diagram shows features of the machine action. (Courtesy of Gaston County Dyeing Machine Company)

Cross-dyed describes the effect of getting a multicolor, tone-on-tone, or heather effect on piecedyed fabric of differently dyeing fibers (also called fiber-mix or differential dyeing). A dye bath made up with dues of different types for the differently dueing fibers, and those in different colors will give a multicolor dyeing. The fibers may be of different families

Figure 5.27 In a pad-dyeing machine, piece goods are passed from one roller to another through a trough.

that take different dye types or may be modifications of the same generic that accept either different due types or the same type but to a different depth of shade, as with nylon 6, 6 and "deep dye" nylon 6, giving tone-on-tone effects. Dueing one fiber and leaving the other undyed for heather effect is a good deal less expensive than blending stock-dyed fibers. Cross-dyeing is used mostly for carpets, where it is an advantage to have these huge pieces of fabric on hand undyed but with the possibility built (tufted) in of almost infinite colorations. A customer can select from a sample and *then* the fabric can be piece-dyed. Figure 5.28 shows a cross-dyed sock knit of nylon (dyed) and polyester (undyed).

Figure 5.28 Sock cross-dyed, knit of nylon (dyed) and polyester (undyed).

Product Dyeing. Knit garments such as socks and sweaters are dyed in bags in **paddle machines**, with paddles over or at the side of the machines to move the bags about in the dye bath by bumping them. A type of revolving drum machine, similar to those used to process and dye leather hides and skins, is also used for product dyeing, while other front-loading drum machines have been developed for the latest wave of product dyeing.

In recent years, dyeing of finished consumer products, especially towels and casual wear garments of woven fabric, has been used to give the "edge" of lower inventory and quick response to orders in times of tight money and intense competition. Dyeing at this last possible stage works only with a fabric that dyes fairly simply and, of course, where compatible thread, trim, etc., have been used; an example would be an all-cotton garment, either woven or knitted, and stitched with cotton thread, although garment dyeing is not limited to these. The hangtag shown in

Figure 5.29 warns that in such articles color evenness and garment fit often vary from one dyelot to another.

GARMENT DYED WASH SEPARATELY BEFORE WEARING

DUE TO THE SPECIAL NATURE GARMENT DYEING SLIGHT VARIATIONS IN COLOUR AND FIT CAN BE FOUND WITH EACH GARMENT THESE ARE INHERENT CHARACTERISTICS ASSOCIATED WITH THE PROCESS. MAKING UNIQUE **EACH** ITEM AND RESULTING IN TRULY Α VIBRANT COLOURED COMFORT-ABLE GARMENT.

Figure 5.29 Tag from a product-dyed article explaining that color and fit may vary from lot to lot, in a way not tolerated with dyeing at other stages.

5-5 PRINTING

Printing is the application of a design, whether colored or not, using dyes or pigments, usually in a thick paste, bound to the surface of a fabric or other substance (paper, leather).

This brings up the distinction between applied and structural design: Applied design is a pattern put on after the fabric has been made, such as a print or embroidery. This is distinct from structural design, a pattern built into the fabric during construction, such as a dobby birdseye, a jacquard damask, a knit cable, or a doubleknit houndstooth effect; with all these structural designs, the fabric comes off the machine that made it with the pattern already showing.

The combination of colors in a print design is termed the colorway. Any design is commonly produced in several colorways.

Printing Methods and Effects

Sliver or Top Printing

Sliver printing or top printing, then spinning, gives mélange yarn, which looks very like heather or marl except that individual fibers may not be entirely colored; mélange printing is also called vigoreaux (vigoureux).

Warp Printing

Warp printing involves printing the warp yarns when they are wound on the warp beam, then weaving the cloth with weft all one (usually dark) color. The result is that the print pattern is slightly disturbed and has a blurred, indistinct outline, as if the colors had "run" or "bled"; this effect is called chiné.

Roller Printing

Roller printing is still a very fast method of printing and can be relatively inexpensive, once the rollers are made (see Figure 5.30). For a long time, this ensured roller printing's place as an important method, but it has become a minor type. Preparing the rollers is expensive and takes a long time; fabrics are commonly made today that are too wide for roller printing (see following); improvements in rotary screen printing and the development of the revolutionary digital ink jet methods have worked against it.

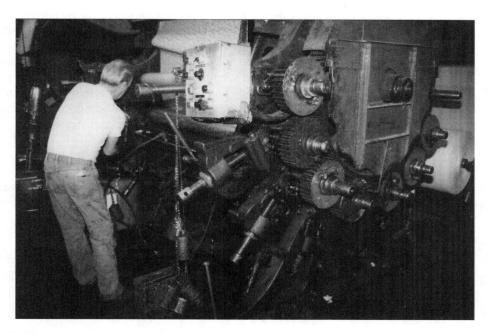

Figure 5.30 Roller printing is fast, but the expense involved in preparing the rollers has relegated it to a much-less-used method. (Courtesy of Cranston Print Works Company)

Rollers, one for each color in the design, are etched or engraved with the part of the pattern to be in that color. Each roller turns in a trough of color paste, which is scraped off with a doctor blade, except where it remains in the engraved grooves. This color pattern is applied to the fabric (which is moving over a central drum) as each roller is pressed against it. The general name for this type of printing from a recessed pattern is intaglio or gravure printing.

The length of the pattern (pattern repeat) is limited by the circumference of the (heavy) metal rollers—a maximum of about 45 cm (18 in.)—and the width by the weight of the rollers—usually not much wider than 1 m (40 in.), or they bend and distort the design. Preparation (engraving and chroming for surface protection) of the copper rollers is very expensive. For these reasons, roller printing is most suitable for relatively small designs or pattern repeats, on lessexpensive fabrics and/or those of standard, "classic" design, such as calico and some chintzes. It is not used for large, topical, and/or exclusive designs. Figure 5.31 shows the contrast between a typical rollerprinted repeat of pattern (looking from bottom to top of the fabric, not from side to side) and a screenprinted toile de Jouy drapery fabric (of which we do not see the entire pattern in this segment).

Screen Printing

Screen printing may be done by two methods:

1. Flat (silk) screen printing, (also called flatbed printing, provides a means of printing large patterns with designs that are exclusive or topical, since

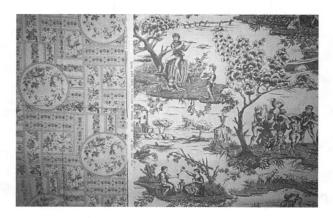

Figure 5.31 Size of roller-print pattern repeat (left) compared to that of a screen print (right).

the cost of preparation of the screens is much less than for rollers or rotary screens. It also gives excellent definition, as needed, e.g., for a complex printed paisley design. The design is put on "screens" of a fine, plain weave fabric, such as filament voile, which today is made of nylon rather than silk. One screen is prepared for each color, with areas other than that color's design covered with a substance that will resist the dye paste. When the paste is forced over the screen with a flexible (rubber) blade called a squeegee, the color passes through the screen only in the area of the design for that color. Flat screen printing can be either manual, with each register of the screen made, and the screen moved on, by hand (also called table printing—see Figure 5.32[a]), or automated (also called flatbed printing—see Figure 5.32[b]). Figure 5.31 shows a good example of a typical large-scale screen print; see comments on repeat of pattern under "Roller Printing" earlier.

2. **Rotary screen printing** is done with thin metal foil "screens" in a cylindrical form with the print paste in the center pulled through by electrostatic force. These screens are tricky and expensive to prepare, but once up and running, can print even very wide fabric, such as sheeting, very quickly (see Figure 5.33).

This has grown to be by far the dominant printing method, although the order that follows of the various types does not take into account the impact of digital ink jet printing. Aside from that most modern method, roller screen printing accounts for about half of all printing, automatic screen printing about a quarter, and much smaller percentages for hand screen, transfer, and roller printing.

Jet Printing

This is a category that covers methods that allow color to be applied from jets positioned above the surface of fabric moving beneath them. A few are discussed here:

Polychromatic printing (or dyeing) is the result when a number of dye jets are set to squirt color over a fabric in a changing, random pattern. The result can be a multicolor pattern or a tie-dye effect using one color.

Digital (ink jet) printing allows complex designs to be programmed and then printed onto

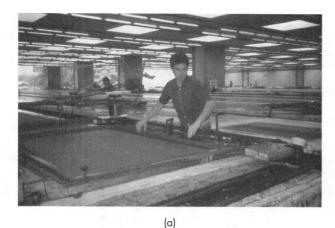

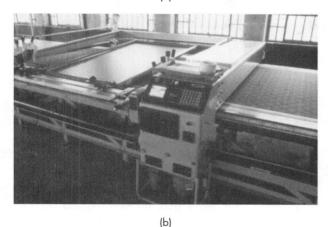

Figure 5.32 (a) Manual screen printing. (b) Automated screen printing. (Courtesy of Masters of Linen/USA)

Figure 5.33 Rotary screen printing can print multicolor designs on wide (such as sheeting) fabrics very quickly. (Courtesy of American Textile Manufacturers Institute, Inc.)

fabric or other materials, such as wallcoverings. with direct control from a computer. Various approaches have been taken, but the method did not prove of commercial importance for textiles until developments between 1999 and 2001 allowed it to work successfully for production runs, rather than just samples; print on wide fabrics; and print with good colorfastness. It has not yet achieved the speed of rotary screen printing.

For short-run printing, a number of continuous ink jet machines (CIJ) send a stream of droplets from the nozzle and use a process such as electrostatic deflection to form the image of the print.

Other ink-jet machines are called drop-ondemand (DOD). With one type, the thermal or bubble-jet DOD, print heads eject a drop of dve heated until it forms a bubble of vapor. When the bubble cools and contracts, the head refills.

Another type of DOD machine accomplishes eiection of a drop of ink when an electric field causes deformation of a piezo crystal in the print head chamber. (Piezo electric substances, usually crystalline, are able to convert mechanical signals into electric and vice versa; they are the basis of many electronic marvels of our age, such as the guartz clock.) These are used mostly to print samples, or for short production runs, although others of this general type originally used to print only such things as billboards on paper, have been adapted to print fabric up to 16 feet (nearly 5 m) wide, and at speeds up to 100 m²/h. They have used only solvent-based dye systems, and these are considered less desirable for textiles than water-based.

DuPont™ Artistri™ Technology for Digital Textile Printing is the result of a three-part effort involving development of the printing machine (built by VUTEk), the color control and management, and special inks including water-based pigment inks. These inks provide excellent colorfastness on a wide variety of fabrics. It has a 360 dpi resolution with 70 pL drops' and can print fabric up to 3.2 m wide. This system aims for the wide fabric home furnishings market (bed coverings, draperies, upholstery, and table linens), or it can print two narrower rolls side by side (see Figure 5.34). It permits designs to be translated to printed fabric in days as compared to weeks with screen printing. Color and design changes are made at the computer, rather than having to clean screens and change inks. The length of repeat of

Figure 5.34 Freshly printed fabric is rolled immediately on the $DuPont^{TM}$ Ink Jet 3210 printer. (Courtesy of $DuPont^{TM}$ Ink Jet)

design is not limited by the length or diameter of a screen. Many other companies are working on developments in this rapidly evolving field, including in garment printing.^{7,8}

Transfer Printing

This method gives prints that are very well defined, with a "3-D" look (see Figure 5.22). It is ideal for knits, since the fabric is not under tension, so the design will never be distorted, as it is sometimes when a knit relaxes after being pulled or stretched in other printing methods. Special paper is prepared with the design, which may be in a number of colors. This paper is brought into contact with the material being printed (fabric or other), and the pattern is transferred.

The original type of transfer printing has been called **thermal** or **heat transfer printing (HTP)**, as it involves applying heat, which causes the dyestuffs on the paper to *sublime*, or turn from solid to vapor, and so transfer to the fabric. This has also been called **sublistatic** or **vapor-phase transfer**, and one of the original companies was named Sublistatic. The machines involved in transfer printing are not expensive, relative to other textile equipment. Printing can also be done on completed garments as

well as on piece goods. Designs can be exclusive, and there are many to choose from. Printing of coordinated patterns on materials other than cloth is also possible. An advanced sublimation process, Photofabric (by CPL Group), gives full color printing with near-photographic quality.

There are also wet and melt transfer printing processes, though the original HTP is still most used, employing wide rolls of paper transferred by heat to piece goods, especially knits. The paper retains a (pleasing) subdued pattern after printing, and this good-quality paper may be used to print from more than once, or is recycled, for example by florists to wrap bouquets.

Photographic, Laser Printing

Photographs transferred to fabric were mentioned in the above discussion of transfer printing, but photographic printing is also done by more straightforward methods, using sensitized fabric and light through a negative. The laser process mentioned earlier in connection with creating worn effects on fabric such as denim (Icon systems) can also create graphics and photographic images at any stage, on fabric, cut pieces, or finished garments.⁹

*The size of drops in digital printing introduces the *picoliter* (symbol pL or pl), a measure not heretofore common in textiles. "Nanotechnology" was touched on in 5-3, under "Added Value Finishes," and also under "What Is Color?" Where *micro* is the metric prefix for a millionth of a unit, and *nano* is the prefix for a thousand millionth, *pico* is a thousand times smaller still: 10^{-12} (see Section Nine for the whole metric measure picture).

Engineered Prints

Engineered prints are those designed to fall in a certain predetermined position on the garment or article to be made of that fabric. These are usually prepared by screen or transfer printing.

Blotch Print

A blotch print is one in which the background, as well as a design motif, has been printed on (not dyed). Unless the fabric is very lightweight, the printed color will not penetrate well enough to show as strongly on the back as the face, and this naturally gives a less solid-looking ground than the much more costly processes of piece dyeing the background, with either resist or discharge methods to provide for the motif areas (see Resist, Discharge Printing). What might be thought of as a blotch print with splotches of color is termed a tachiste print, from the French meaning spot or blot.

Resist Printing

This involves coating certain areas of a pattern with a substance to resist the color; the fabric is then piecedved, with the result that the background and pattern areas are equally distinct on the face or back of the fabric. See Link 5-4 with Fabric Glossary concerning ancient hand resist methods of batik and tie-due.

Discharge Printing

This is an expensive method, not much used today, that also involves piece dyeing the fabric. It gives an excellent result when a deep background color with an overprint is desired, as in a traditional challis print. The background color is then removed chemically (discharged) from the areas that will receive the overprint. This discharge process can damage the fabric if not carefully done and neutralized. Fabric Glossary:

"Pattern in Yarns or on Dyed Ground" shows how to recognize a discharge print; the ground due is not taken out on the back of the fabric as "cleanly" as on the face, so some of the ground color can be seen on the back, within the "discharged" and overprinted areas.

Duplex Printing

Duplex printing is achieved by printing both sides of the fabric, either in the same pattern or with different designs on each side; Figure 5.35 shows a right-hand drill fabric printed on the face, over the steep twill line, with a scattered motif, while a denim look has been printed on the back, where the fabric is quite flat, with little of the weave twill line visible.

Block Printing and Stencil Printing

These are methods rooted in handcrafts that are seldom sold commercially but may occasionally be used. A color paste is applied from the projecting pattern created on a block, or forced through pattern spaces cut in a card or thin metal stencil.

Figure 5.35 Duplex print on white drill; back is printed to resemble denim.

5-6 OTHER APPLIED DESIGN

Printing Other than Color

Some applied design methods involve printing, but not application of color.

Burned-Out

Burned-out, etched, or découpé is an effect achieved on a compound woven fabric, with surface yarns made of one fiber type and a ground weave made of another. Some surface yarns are removed, usually by printing on a chemical that will dissolve them without affecting the (usually sheer) background weave. This effect, then, is neither "burning" nor even "cutting" as the name découpé suggests.

Plissé or "Crinkle Crepe"

Plissé is a puckered effect that may resemble seersucker or an allover crepe or may have a small pattern showing as a crinkle. Some areas of a cotton fabric are brought in contact with caustic soda (sodium hydroxide, NaOH), the chemical used for mercerizing; in those areas, the fabric shrinks, and the other parts of the fabric form puckers. This may be accomplished by printing caustic soda onto the cotton or by printing on a resist agent and then immersing the fabric in caustic.

Flocked

Flocking involves applying and holding short bits of fiber (*flock*) to a fabric (or wallcovering) by means of adhesive printed on in a pattern. The fibers may be shaken onto the adhesive, or held in an orderly arrangement in an electrostatic field.

Much cheap dotted Swiss has flocked dots, which are likely to come off easily (there are tales of dots coming off as a garment was being sewn), and they make the fabric less flexible than the much more expensive woven-in dots (see "Surface Figure Weaves" in Section Four). Similarly, less-expensive point d'esprit (dotted veiling) also has flocked rather than worked-in or embroidered dots.

If adhesive and then flock are applied all over the fabric, a suede-like or pseudo-velvet can be produced. In this form, the stiffness, lack of pliability, and durability are even less appealing than a flocked dot.

Flocked fashion fabrics, then, whether an applied design or an allover effect, are usually associated with cheap, nondurable, and less desirable effects; see Section Six, "TLC or Beware: High-Fashion Specialties." However, flocking can be very durable if fibers are oriented by electrostatic flocking and a lasting adhesive is chosen, as with Vellux® (by WestPoint Home), described under "Compound Fabrics," Section Four.

Mechanically Applied Design

Embossed

Embossing is the result of passing fabric between rollers, at least one of which is engraved with a design. Most leather-like fabrics have a grain effect embossed on them (as well as some inside split leather!), and coated upholstery fabrics may also be embossed, for instance, with a jacquard weave pattern, such as a brocatelle. Pile fabrics are sometimes embossed, so that part of the pile is pressed flat in a pattern.

Sculptured or Carved Design

This involves considerably more processing: A pile fabric is first embossed, then the pile left upstanding is sheared off, and that which was flattened is brushed up, leaving the sculptured or carved design. Note that these terms are used also for *structural* designs built into pile fabric such as carpet or velvet, which have been tufted or (over-wire method) woven with pile of different heights.

Moiré

Moiré is a random "woodgrain" or "watermark" design. This pattern is produced when plain weave, crosswise-ribbed fabric, such as taffeta or faille, is calendered in a double layer; the ribs in one layer do not lie exactly over those in the other layer, and so flatten these at random, creating the moiré pattern also called "watered silk." If the fabric is made of thermoplastic fiber and the calender rolls are heated, a durable moiré results. Acetate gives a good-looking, inexpensive moiré, although polyester is now in much the same price range, is more durable, and is easier to care for. Moiré can also be embossed from a roller engraved with the pattern, or the effect can be printed on or woven in.

Two layers of sheer, plain-weave fabric, such as organdy, lying one over the other but with varns not exactly aligned, will also show the typical woodgrain effect in a visual pattern called birefringence.

Embroidery

Embroidery is applied to piece goods by huge machines with hundreds of needles controlled by punched cards; the Schiffli machine, developed in Switzerland, can embroider elaborate patterns in this way on woven fabric (see Figure 5.36) or net. Eyelet is embroidered fabric with holes cut within the embroidery pattern. Individual motifs are embroidered on garment sections or small pieces of fabric by machines with multiple separate "heads."

What is called Schiffli lace is the result of embroidering all over a fabric in a continuous design; the background fabric must be made of a fiber that can be dissolved away by a chemical that will not affect the stitching thread (see "Schiffli Lace." Section Four). There is also a new heading in Section Four to allow for very different applications of embroidering, then dissolving the base away (see "Embroidered. Base Dissolved," and Figure 4.78). In this case, the structure that remains is being used for a surgical implant. Complex designs can be created and embroidered much faster by computer-controlled embroidering machines than any other method. It is interesting that fabric for such a serious and highly technical purpose can be so beautiful. In other cases, the base is not removed; see Figure 1.3 (a) for a medical use for embroidering with wire.

Figure 5.36 Embroidered fabric.

Other Stitching

Stitching can give surface results other than embroidery. Stitching with elastic thread results in various raised, puckered, and puffed designs. Stitching with padding, often involving two or more layers of fabric. can give the decorative result of trapunto (backing of the design padded) and **Italian guilting** (padding cord under the stitched-down design lines only), plus regular quilting, which also introduces a surface design. Various kinds of gathering, some involving decorative stitching, also serve as applied design: smocking, ruching, shirring, even top-stitching. Appliqué involves stitching pieces of one fabric (or more) in a motif on another piece of material.

Pleating

Pleating, or pressing fabric into sharp folds or creases, is sometimes done in such a way that it may be considered an applied design. Form pleating uses paper forms to hold the fabric as it is pressed (previously called gauffering [see Figure 5.37]). Some pleating is accomplished by crushing the fabric, or embossing, and in all cases, use of a resin can give a durable result: use of heat on a thermoplastic material can give a durable or permanent design. Crushing is usually taken to mean a kind of unorganized pleating: "broomstick" pleats result from such crushing when fabric, wound around a core, is compressed. Fluting is rounded folds, and may result from the fabric structure, as in sheer tricot knit fluted edging, or may be applied.

Figure 5.37 Pleating with paper.

Miscellaneous Effects

Fabric or lace may be **embellished** with such addons as sequins, decorative cord, and the like, on lace

called re-embroidered—see Figure 4.70. Other applied design is **painted on,** or like studs, **hammered on.**

LINK 5-4, 5-5, 5-6 WITH FILES IN FABRIC GLOSSARY

These illustrate the role of fabric finishing, including aspects of the dramatic changes brought about by dyeing, and printing or other applied designs. Look them up for a fuller understanding of how this contributes to the fabric character and is an essential part of its name. You will also find photos of these named fabrics, as well as other related textiles.

Fabric Glossary Fabric Name Look names up in the Fabric Glossary Index.	Relationship to Fabric Reference Discussion
Sliver-knit fur-like (fake or faux fur)	If dark color used with light, as in a faux leopard look, the dark fibers will be solution dyed for highest colorfastness.
Tweed, Covert Cloth	Tweed is usually made of yarn spun from mixtures of dyed and
	undyed fibers, and so may show any of a number of classic color effects: heather, marl, mélange, nub, salt-and-pepper, ragg. Covert cloth usually has a marl or mottled coloring.
Chambray, Check (including Glen Check,	Dyed yarns create special effects which give many woven fabrics
Houndstooth, and others), Herringbone, Madras, Mackinac, Plaid, Tapestry, Tartan, Ticking	their individual names, discussed under "Pattern in Yarn."
Doubleknit, Jacquard Knit, Jersey	Each of these may show a pattern knitted in, which can be a stripe or a complex jacquard design.
Chameleon, Changeant, Iridescent, Luminescent, Pearlescent, "Shot"	These are all special effects that can come from use of dyed yarns in weaving, discussed under "Color Variable."
Chiné, Ikat, Jaspé, Kasuri, Matmee, Mudmee, Patola, Space Dye, Strié, Yarn Tie-Dye,	This "bleeding edge" look is more often used in interiors fabrics than in apparel. They are discussed under "Pattern in Yarns."
Warp Print	
Calico, Chintz, Toile de Jouy	Each of these represents a scale, character, speed, and cost of
	print related to the method of printing it. The most usual are screen ("Print, Large Scale") or roller, plus some newer methods.
Paisley	Paisley is a pattern that is often simplified and stylized, but when full and complex, it is often accomplished with screen printing ("Print, Large Scale").
Bandana, Batik, Plangi, Shibori, Fabric Tie-Dye	These are discussed under "Pattern on Dyed Ground," and include famous resist effects given by hand craft methods. The resist process is considered printing, but dyeing of the fabric is involved as well. Many prints today do not go through the traditional steps to get these effects; they are produced with a "batik look" or a "tie-dye look."
Challis	The character of this fabric has traditionally been related to the expensive discharge printing method; only the best are so printed today.
Burned-out (Burn-out, Burnt-out), Coupe de Velours, Dévoré or Façonné Velvet, Satin or Voile Découpé	These effects are discussed under "Pattern Applied—Chemical." They require some of the fibers to be dissolved away, and the materials are usually expensive and often showy or glamorous.

Crinkle Crepe, Plissé, Seersucker Look

Dotted Swiss, Point d'Esprit (Dotted Net)

Embossed

Moiré

Broderie Anglaise, Eyelet, Embroidered or Schiffli Lace, Madeira Work These fabrics are discussed under "Pattern Applied—Chemical," and they all show puckers formed by chemical action.

A flocked dot is one of the least expensive ways to produce a dotted Swiss, or point d'esprit net.

Most leather-like fabrics are embossed, and many other effects can be given. The general discussion is under "Pattern Applied—Pressure."

Moiré is an elegant "watermarked" fabric, used much in interiors as well as apparel and accessories.

Eyelet is a "name fabric" involving embroidery; *broderie* anglaise or Madeira work is one variation. Embroidered lace (Schiffli) gives a special effect and is quite expensive.

REVIEW QUESTIONS 5-4, 5-5, 5-6

- Distinguish among hue, value, and intensity of a color.
- 2. What is the difference between dyeing and printing?
- 3. What is the earliest stage at which a fiber can be colored? What main division of fibers cannot be colored this way?
- 4. Specify an economic cost and an advantage to solution dyeing. Name three end-use items that might likely be made of solution-dyed fibers.
- 5. Name three color effects given by use of stockdyed fibers.
- 6. Discuss the cost of a woven yarn-dyed check compared to a printed check. What are three main advantages of a yarn-dyed stripe in shirting, for example?
- 7. What is the meaning of *ingrain*, and of *intarsia?* How would you distinguish an intarsia pattern from a jacquard knitted one?
- 8. How can a variable color effect be produced in weaving? What is the name of one fabric associated with this phenomenon, and what is the special effect called?
- 9. Name three color effects that can be achieved by fiber-mix or differential dyeing. What advantage does this method have?
- 10. Discuss product dyeing pros and cons.
- 11. List three ways that a chiné effect can be produced. What are other names for fabrics with these effects?
- 12. By what method will a calico probably have been printed, and why?

- 13. By what method will a toile de Jouy probably have been printed, and why?
- 14. What method(s) might be used for chintz, and why? (Although some solid-colored fabrics are called chintz, it is taken here to be printed.)
- 15. How can you tell a true resist or discharge print from all other methods (on a medium weight fabric)? How do you know whether such a fabric has been discharge printed?
- 16. What do a façonné velvet and a burnt-out voile have in common? (Try to find and examine a sample of each.)
- 17. How would you tell a plissé seersucker look fabric from a true seersucker? The plissé will be cheaper; what are two disadvantages of the plissé?
- 18. Name a fabric in which a flocked pattern is found on less expensive versions, and is usually not durable in use. Name a fabric with a durable flocked finish. What are two components of the process that contribute to durability?
- Distinguish between embossing and sculpturing, with fabric examples.
- 20. What is needed for a moiré pattern given in finishing to be durable?
- 21. When could you refer to an eyelet as like Madeira work or broderie anglaise?
- 22. How do trapunto and Italian quilting differ from ordinary quilting? How are they different from one another?
- 23. Distinguish among pleating, crushing, and fluting.

INVESTIGATIONS TO DO WITH FINISHING OF FABRICS

1. Demonstrate fulling by progressive felting of a piece of wool fabric. Start with an undyed piece of either knitted or woven wool fabric (preferably all wool), about 25 cm (10") square, with the edges of the woven material serged. Run this through a succession of machine washings (be careful that there is no chlorine bleach), noting the effect of each on the fabric surface. After five washings, also put the sample through a tumble drying (low heat). This usually produces much more felting than washing alone.

If seven samples of the same fabric are available, six could be put through the first washing, with one removed after each wash for a record, the sixth showing the effect of the tumble drying as well, with the seventh serving as an original.

- 2. If possible, collect examples of cotton articles with and without mercerizing such as broadcloth dress shirts, chino pants, lisle knit tops, and cotton sewing or embroidery thread. What are the characteristics of mercerized goods? They are usually in the higher price ranges; what other characteristics of best quality do they show? (Advertisements or catalog descriptions for these articles will offer some of the same answers to this second question.) If you can, examine fibers from cotton articles without and with mercerizing (see "Microscopic Fiber Identification," Section Two).
- 3. Examine and compare the "hairiness" of weft yarns from flannelette, brushed denim, and if available, a "sueded" microfiber woven, as well as the crosswise inlaid yarn from the back of a single-face knit fleece (sweatshirt fabric). These show a range of effects from napping or emerizing. How would these "3-D" surfaces stand up to wear compared to that of pile fabrics such as velour, woven or knit?
- 4. Compare a crepe by weave alone (yarns not high twist) with a crepe such as georgette, woven with very high twist yarns but in plain weave. If you can find one, also compare a crepe fabric with both crepe weave and high twist yarns. What are the differences in character?

- 5. Research the marketplace and record as many different "washes," or surface-affecting finishes on denim as you can find, taking note of terms used in advertisements and on labels.
- 6. Assemble samples of fabric showing tenter holes along the selvage; can you place them face or right side up?
- Collect labels or advertisements for activewear materials with special coatings offered as waterproof yet comfortable to wear ("breathable").
- 8. Examine advertisements, promotions, displays, catalogs, etc., to find clothing, household textiles, or furnishings that carry a finish that makes them stain repellent, antimicrobial, or other of the special-purpose finishes (at least five examples). Record the brand names, and note any specific care instructions. Note any of these finishes that are achieved with nanotechnology, and any that use silver to give an antimicrobial or biocidal effect.
- 9. Note the exact wording of advertisements for "wrinkle free" pants. Does it mean exactly that?
- 10. Find two shirts in a striped or checked pattern, one printed on, the other woven in (yarn-dyed). Compare price, sharpness of pattern, appearance where the collar is opened and turned back. What type of printing would give a pattern most closely resembling yarn-dyed?
- 11. Find fabrics printed with three sizes of pattern repeat: a small one (calico), an intermediate one (chintz), and a large one (a "toile" [toile de Jouy] pattern, or other large repeat). You can find these in stores or catalogs showing sheets and comforters, or (for toile) in an interiors fabric store, for bedding, drapery, or wallcoverings. What kind of printing process could each be done by? Are differences in cost reflected in the cost of the fabrics?
- 12. Find at least five examples of applied design other than color printing (actual article, a picture, or description in an advertisement or catalog).

NOTES SECTION FIVE

- 1. "Ireland: New Finishes Transform the Face of Irish Linen," http://www.just-style.com, 16 May 2001.
- 2. Ian Holme, "Microencapsulation: The Changing Face of Finishing," Textiles, 2004/4: 7–10.
- 3. Barrie Clemo, "Consumer demand fuels growth in antimicrobial treatment," Textile Technology International, 2001: 72.
- 4. Phil Owen, "International Report," Textile World, December 1999: 86.
- 5. Lado Benisek, "Carpet's New Image," Textile Horizons, November/December 2000: 11.

- 6. Dr. Kenneth R. Fehrman & Cherie Fehrman. Color: The Secret Influence, Upper Saddle River, NJ, Prentice Hall, 2000: 4.
- 7. K. G. Melling, "Digital Printing Makes an Impression," Textile World, March 2001: 40-48.
- 8. Ian Holme, "Digital Ink Jet Printing of Textiles," Textiles Magazine, 2004, no. 1: 11-16.
- 9. "USA: Textile Laser Embellishment and Pre-Fading Process," http://www.just-style.com/ news, 14 June 2001.

6-1 HOME CARE

Where Are the "Knows" of Yesteryear?

Old-fashioned know-how—what used to be called household science—has gone down the drain for many consumers, as far as caring for today's fabrics is concerned. Even older people may be no wiser when it comes to washing or pressing or taking a stain out of one of the bewildering array of materials used in our modern clothing and household textiles. The resurgence of interest in fabrics such as silk that can require special care just adds another source of problems.

Many people developed a strong feeling over the last quarter of the 20th century that we should turn back to a more conserving attitude toward the resources around us. Concern over the environment in general has increased, underlined by government action in many areas, such as pollution prevention. Such a trend need not be at odds with the mainstream of the fashion industry; it does lead us to focus more on **quality for purpose**, and to acquire and apply **knowledge in selection and care**.

An identical consumer focus comes with times of economic hardship, and this, too, in the 1990s, heightened consumers' search for quality in textiles and clothing and for information on proper care. To teachers and communicators in general this offers a welcome challenge to provide new-fashioned know-how—consumer science for the 21st century!

Because, in addition to caring for contemporary textiles, consumers sometimes want to preserve heirloom items for posterity, rudimentary conservation skills are needed as well, and so more information is given on this (see also "Teaching Aids and Resources" at the back of this book).

Fiber Properties and Care

The way a fabric without special treatment behaves in care is based on the reaction of the fibers to heat, water, mechanical action, and chemicals. This discussion covers the first three as they are encountered in home care, and deals mainly with the major fibers we use.

Heat in Fabric Care

Heat is one of the main factors that must be considered in care of fabrics, in relation to fiber content. Cellulose fibers (such as cotton or rayon) are resistant to heat, and so can stand hot wash water, a hot clothes dryer setting, and even ironing at high settings. Nylon and polyester, being thermoplastic, would melt under a hot iron, but will withstand hot water or a hot (cotton setting) home dryer; for this reason, they are not classified as heat sensitive in this Fabric Reference. However, commercial gas dryers could reach temperatures unsafe for nylon. Ironing or pressing any thermoplastic fiber must be done with care (that includes all major MF fibers except those of reconstituted cellulose, such as rayon).

Acrylic fabrics should be protected from hot drying, or they may become lifeless and feel somehow thinner, although they may not have been otherwise damaged.

Heat-sensitive fibers (defined in Section Two) should not be exposed to heat, as in tumble drying, without great care; in the case of olefin (polypropylene), avoid use of a heated dryer at all; articles made of olefin will dry quickly anyway.

There are other heat hazards for textiles made of heat-sensitive fibers:

- If a fur-like fabric coat is damp, perhaps with snow, do not throw it over a hot **radiator** to hasten drying—this would only hasten the end of its life as a fashion garment.
- There is also the story of a woman checking the progress of a pie baking (very hot **oven**), while she was wearing a wig (modacrylic); the dry, hot air frizzled the locks immediately.

Heat has a harshening and drying effect on wool, silk, leather, and fur; see notes including detailed instructions and cautions for a number of such specific fiber types and fabrics under "Tender, Loving (Home) Care."

Overdrying fabrics such as cotton sheeting, which are not actually harmed by the heat, can still leave the material feeling harsh against the skin, and develops more pilling than if articles are taken out when they are *just* dry; this is not always easy to

achieve in practice, but if someone complains of skin irritation from cotton bedding or garments, it may be worth the trouble.

Water and Mechanical Action in Fabric Care

Fiber strength, especially when wet, is significant in home care. Fibers that are weaker when wet need support and TLC (tender, loving care) when they are washed.

Foremost is wool, often made into a bulky article that can absorb a lot of water; the wet garment is heavy. Wool in any article needs careful handling in washing, even if it has an antifelt treatment, because, like our own hair, it is weak when wet. Silk also loses strength when wet, but it is much stronger than wool to begin with, and fabrics made of it are often light.

Standard rayon and acetate both lose a great deal of their strength when wet and have only fair or poor strength to start with, so care is needed. HWM rayon has better dry strength than standard rayon and loses less strength when wet.

Only two fibers, cotton and flax, are significantly stronger when wet—ready for lots of mechanical action in laundering. Lyocell fibers, which are stronger than cotton when dry and do not lose a great deal when wet, can stand laundering procedures well. Synthetics start with good to excellent strength (except for spandex, present in small amounts as a rule) and change strength very little when wet. These types are the best candidates for machine washing care at home. With a Durable Press finish, the strong cellulosic fibers can also offer total easy care.

Home Care—Washables

General Method for Machine Washing in the Home

A recommended method for machine washing (from the Canadian Home Economics Metric Committee discussions) describes judging an acceptable load by volume, not by weight. Materials must have room for efficient agitation, and it is the relative *bulkiness*, not weight, that is important. The resulting load description and procedure were as follows:

Top loading washing machine. Pour the required amount of detergent into the wash tub/basket before or as the machine begins to fill. Load the washer with dry, unfolded articles of various sizes, starting with large, bulky items. On top of these drop small items, one at a time. Then place medium-size articles on top; do not pack down any of the load items. The layering of the load will help prevent clothes from slipping over the top of the wash tub/basket during the spin. For a maximum load, fill to a level about 5 cm from the top of the tub/basket, or to the top of the agitator vanes.

Front-loading washing machine. For a maximum load, add dry, unfolded articles loosely to the top of the door opening.

Easiest home care, for most people, probably means machine washing and drying, with little or no pressing. So, a procedure to accomplish just that:

Steps for avoiding having to press after laundering (mainly applying to Durable Press items)

- Do not overload the washer. If possible, separate bulky or heavy articles (towels, jeans, fleece) into a load separate from lighter articles, which do not need as much drying time. (Saves energy and is easier on the lighter-weight pieces.)
- 2. Avoid "shock cooling" between washing and rinsing, which may produce stubborn wrinkles (going from hot wash to cold rinse). Many detergents can be used in cold water for washing, resulting in savings in energy, and less effect on colors or some kinds of coating, specifically reflective coatings.¹
- 3. Add fabric softener to the last rinse (or use in dryer) to lubricate fibers and yarns.
- Use a tumble dryer (we are not dealing here with heat-sensitive fibers); select a lower temperature for thermoplastic fibers, especially acrylic.
- 5. Take articles out of the dryer as soon as it stops; if articles are allowed to cool lying in the dryer, the weight of other items in the load will set wrinkles in heat-softened pieces, even knits.
- 6. Shake out, smooth, fold, lay flat, or hang newly dried articles, "finger pressing" edges to shape,

closing fasteners, etc., to arrange for the best possible finished look.

In this outline, one of the most significant steps is the tumble drying. Most of our "easy care" fabrics contain thermoplastic fibers and/or resin finishes, and we can use the softening action of heat to help **remove** wrinkles (if misused, however, heat can **set in** or create wrinkles). Promotion of a garment as "Wrinkle Free" really means as taken out of a (warm) dryer (discussed in more detail under "Durable Press" in Section Five). Tumble drying is also the best method to allow the self-crimping action of bicomponent fibers.

Tumble drying, then, is virtually essential to easiest care, even though there can be problems with static electricity developing unless an effective fabric softener is included in the wash or dry cycle. A great many people still do not own a dryer, but may have access to one in an apartment building or can use one in a laundromat. What do you do if you do not have access to a dryer at all, or, almost as troublesome, no convenient access? This is the case with the large number who use laundromats or are apartment dwellers; they must either lurk in a laundry room for hours, dash there by the clock, or expect wrinkles in a cooled-down dryer load.

Tumble dryers pose fire danger from two sources. One is **lint**, which is highly flammable as a rule, virtually exploding into flame at a spark. It should be cleaned out of the lint trap after *each* drying load; occasionally vacuum out any traps, pipes, or openings you can get at, as well. The other fire hazard is **foam**, used as padding in bras, shoulder pads, and such, or as backing on some small mats. Do not allow these to get bone dry, nor to lie warm and damp in a load, in or out of the dryer; enough heat to cause a fire can be generated "spontaneously" in warm foam.

Drip drying is the next best method to tumble drying. You must not wring articles, and it is well to bypass the machine spin-dry, although you could try a gentle salad-spinner extraction (yes, literally) for small items. Now you proceed with drip drying, hanging clothing dripping wet on rustproof hangers, arranging items following step #6. Most people abhor this "drippy" route, and be prepared: with every move away from steps #1–6, you move further from literal wash and wear (without pressing).

Tender, Loving (Home) Care (TLC)

Tender, loving care (TLC) is given few textile articles by modern consumers, for it entails hand washing, air drying, careful dampening, and painstaking pressing—who needs it? It is reserved, by most of us, for items such as cherished table linens or special (expensive) lingerie or blouses. We do not expect "easy care" for these (unless we take them to an expert cleaner—easy care of another kind, but hardly home care).

Discussed in this section are major cautions for home care of silk, linen, cotton, lace, pile fabrics, wool, down, suede, leather, and fur, followed by general care required by some trims and high-fashion creations, plus notes on care of modern special items, such as Gore-Tex® fabrics and stain-blocked carpets. Care of glass fiber fabrics is discussed under "Inorganic Manufactured Fibers," Section Two.

Silk

Silk garments should be cleansed soon after they are worn, to avoid the tendering action of perspiration discussed in Section Two.

Silk articles respond well to hand laundering, if (a) the color is fast; test by pressing an unexposed piece of the material between layers of dampened white tissue or fabric, leave to dry, and examine for any staining; and (b) there is little fear of shrinkage; heavier (suiting) fabrics of silk may shrink out of fit, unless they have been preshrunk. In any case, dry cleaning may be preferable for these heavier fabrics, as they may pill less and they may keep their shape better if not softened by washing.

In hand-laundering silk, use wool method #2 under "Wool and Hair Fibers" to give heat and chemical conditions suitable for a protein fiber. There is less worry about agitation while hand-washing silk, for there can be no danger of felting as there is with wool.

Washable silk (washer silk) is expected to be machine washable, but it is imperative that you treat it as silk, not cotton; in particular, do not use built detergents (heavy-duty), or yellowing may result and more color loss than with the milder conditions as outlined for wool. Color on washable silk is often not fast, so get it dry quickly, either by tumble drying or rolling in a towel and pressing at once.

(Dry cleaning may be no solution for this silk, as dyes may be more fugitive in dry-cleaning solvent.) Fabric softener is recommended for "sandwashed" silk, to prevent stiffening. In my experience one of the main weaknesses in less-expensive silk garments aimed at the middle market is inadequate seam finishing, quite aside from any special care needed for the fiber or fabric; with such smooth yarns, an enclosed seam such as flat felled is necessary to prevent yarn slippage along any seam that takes stress in wear.

Cultivated silk fabric (smooth, silky) should be pressed when slightly damp, on the wrong side, using a dry (not steam) iron set at warm; or use a damp press cloth. Silk may water stain if too damp during pressing. **Wild silk** is better pressed when nearly dry.

If the silk article is printed with more than one color, those colors are probably not fast. If you wash it, prevent colors from bleeding: First, remove excess moisture by rolling it in a towel immediately after washing, and then press dry at once. Do not leave it lying damp, or colors may "migrate" and bleed.

For storage of silk, see "Storage of Textile Articles."

Linen

Linen (fabric made from flax fiber) takes vigorous washing well; avoid chlorine bleach, because linen can be attacked by it sooner than cotton. It is safer to use a mild bleach like perborate. Wash dark-colored linens separately, and do not overload the machine, or you may get lighter streaks in the fabric. Linen demands TLC mostly in ironing (you could never call it just pressing!). Linen articles to be ironed must be thoroughly, evenly damp, yet cannot be left long at room temperature without danger of mildew growth; put dampened articles in the freezer to hold them safely for ironing. Linen calls for a hot (top setting), dry iron, and must be ironed until completely dry, or wrinkles form as soon as it is moved. This is TLC, and it can be worth it for a favorite linen garment or a splendid damask tablecloth, once in a (long) while. To avoid shine, as with dark linens, iron on the wrong side; for luster, iron on the right side.

For storage of linen, see "Storage of Textile Articles," but always avoid sharp folds; flax can crack where folded continually.

Cotton

Cotton fabrics, in general, do not call for TLC, unless they are high-fashion items; in fact, "careless care" of **top-quality**, functional articles of cotton is perfectly expressed in the care instructions for Tilley Endurables*: "Give 'em hell!"

However, to keep colors bright, or dyes from bleeding, use a lower washing temperature; if you wash with cold water, you will not get as efficient cleaning, although it may not be critical if the article is not badly soiled.

Pretreatment of soils will greatly help in removal, especially oily soil at collars and cuffs and any oily spots (see "Home Treatment of Spots and Stains"). Counter mildew smell with a germicide or a fragrant fabric softener dryer sheet.

Ironing of firm cotton fabrics with **no Durable Press finish** is the same as for linen. **Durable Press finished** cotton and blends of cotton and polyester can be ironed without dampening, dry, with a steam iron.

Lace

Lace can be pinned or sewn into a bag or pillowcase before washing if it is valuable or the openwork vulnerable; use a washing method safe for the fiber content and lace construction.

Press lace with a cloth covering to protect it from the point of the iron; for lace with a raised design, see method for pressing of pile.

Pile Fabrics

Pile fabrics need special care in pressing to prevent the raised (three-dimensional) surface from becoming flattened; this procedure applies not only to pile fabrics such as velvet, velveteen, and corduroy, but to lace with a raised pattern or heavily embroidered fabric. Press face down into a thick terry or velour towel; for **velvet**, use a special needleboard, or lay the fabric face down over a horizontal raised screen (for small areas, over a clean, firm, flat hairbrush); press with a steam iron. To remove wrinkles, a velvet garment may be hung in a steamy bathroom. Brush pile with self-fabric or a soft brush.

Launder washable pile fabrics inside out, to avoid trapping lint in the pile. Remove from the dryer while still slightly damp, to prevent crushing.

Carpet is a pile fabric and requires care different from most pile garment fabrics. Crushing and matting

in use may be construed by consumers as wear, but as long as the carpet pile is not worn away, it is considered to have performed satisfactorily, according to a typical carpet guarantee that states something like: "will retain at least 90 percent of its pile for 5 years ... when properly maintained."

Proper maintenance includes vacuuming often, using a machine with a beater bar, and keeping the carpet clean. Dry powder cleaners and/or application of carpet "shampoo" suds are two other stages of regular carpet care. See also "Care of Special Items" for care of stain-resistant nylon carpet. Vacuuming at least twice weekly is recommended not only to look after the carpet, but to remove dust and microorganisms, especially where there is little fresh air ventilation. Spills on carpet should be taken up at once; Figure 6.3 under "Home Treatment of Spots and Stains" shows such a procedure.

A good carpet underlay will prevent some crushing, entrance mats can collect dirt before it gets tracked onto a carpet, and more even wear can be encouraged by rearranging furniture from time to time, if possible, so heavy traffic is redistributed.

Upholstery Fabrics

Much of the advice given above for carpet care applies also to upholstery. Frequent, thorough vacuuming using a special upholstery brush is essential. Stains should be taken up at once, as recommended for carpet. Upholstered items may also carry a care label, indicating by a letter what care is appropriate. A W means that water-based cleaning agents may be used; an S indicates that solvent-based agents only are safe; WS means that either may be used; an X warns that no liquid cleaner should be used—vacuum only. See also "Other Tests with Ratings for Interiors Fabrics," Section Eight.

Wool and Hair Fibers

Wool and hair fibers must be treated as protein fibers, not like cotton, using washing conditions that would be safe for our own skin and hair. Avoid alkali and high temperatures to prevent harshening and yellowing: no heavy-duty (alkaline) detergents, NEVER chlorine bleach, water lukewarm rather than hot. Keeping these cautions in mind, wool articles are laundered either by machine washing (with or without machine drying) or by hand:

- 1. Machine washable wool will carry a label or hangtag announcing some (trademarked) antifelt treatment (see Section Five). Use warm water, a good suds of mild (unbuilt) detergent (Ultra Ivory Snow will do), reduce time or agitation, and add fabric softener; if the article is labeled as Machine washable and dryable, use a lower dryer temperature. This latter designation is suitable usually for knitwear given an effective antifelt treatment; such is the case with the trademark Total Easy Care Wool (includes the Woolmark®) (logo Figure 5.17[c]) from the Woolmark Company. Items so labeled are guaranteed not to show felting or relaxation shrinkage, color bleeding, or pilling with machine washing and drying. Articles such as wool trousers, which may be machine washable without felting but should be hung to dry (largely because of components in the garment construction other than the wool fabric), represent a separate category. For this, the Woolmark Company developed the trademark Machine Washable Wool (includes the Woolmark®) (logo Figure 5.17[b]). Pressing is part of the procedure for this type of garment (see pressing of wool below).
- 2. Hand washable wool (not labeled as machine washable) articles are possibly not safely washable at all, if color could bleed or "migrate" and leave the article ruined on this account—especially important if two or more colors are present. Because wool and hair articles not given an antifelt treatment are expected to be dry-cleaned, their dyes have not been selected to be washfast, as they are for machine washable wool. Test the colorfastness before proceeding (press an inconspicuous part of the garment between two layers of dampened white tissue or fabric, leave to dry, and examine for any staining). See "Dyes and Colorfastness" for general comments on colorfastness of dyes on wool.

If the color is fast enough for washing, and keeping in mind that wool and hair fibers are weaker when wet, your main concern is prevention of felting. The finer the fiber, the more care is needed, so a very fine wool needs more care than a coarse one, and **cashmere**, for instance, needs extreme care to avoid felting.

Felting is encouraged by any unnecessary agitation, so wool articles should be hand-washed in lots of lukewarm water; have a good suds of mild (unbuilt) detergent (liquid hand dishwashing detergent or shampoo can be used); avoid moving the article about—keep it below the surface, and do not lift it in and out; do not rub—gently work the material to loosen soil or spots, and alternate this gentle hand working with soaking; let the suds run away without lifting the article; give rinses until the water is clear; add fabric softener to the last rinse, using as little water as possible; gently squeeze water from the article; roll in towels to extract excess moisture.

Dry flat on a towel, sweater dryer, or screen. If you wish to block to dry, you must draw an outline of the article before washing, and use rustproof pins to hold it to this outline during drying. Press wool using steam, and never directly on the fabric; use a press cloth; do not press heavily with the iron.

A **blanket** or other large article can be dealt with in a bathtub but is more easily soaked in the tub of a top-loading washing machine (lukewarm suds), given brief rinses and a spin extract, and dried over two parallel clotheslines.

Storage of wool and hair fibers is discussed under "Storage of Textile Articles."

Down

Down is the under-plumage of water birds and makes a light, soft, air-trapping filling for cold-weather clothing or bedding. Feathers, less desirable with their stiff quills, are often mixed with the scarce and expensive down.

When buying a down-filled item, look for one closely quilted, preferably in more than one direction, to prevent the down from shifting and "clumping," as it tends to do when the down can move up and down long channels. During use, check for, and repair at once, any breaks in the quilting stitching; check especially before cleaning. Fluff down filling from time to time, by hand or by tumbling in a dryer set on low or "air" setting, with something like a couple of clean tennis balls or a clean running shoe to promote the fluffing action.

Do not allow items to get too soiled before cleaning. On the other hand, down duvets in constant use during cold weather usually need washing only about twice a year. Take any duvet larger than twin-size to a laundromat with an oversize machine and an extractor. If the general construction and fabric of the downfilled article allow washing, follow this procedure:

Close fasteners. Pretreat stains or more-soiled areas with detergent. Use soft water, if possible, and select conditions as outlined for wool method #1 or 2; the action of a front-loading

washer is easier on a quilted article than the agitation of a top-loading machine. If using a toploading washer, let it fill partly, push in the down article, and continue filling. Check during washing and press air out of the fabric from time to time. You can also handle a large item, such as a comforter or sleeping bag, as recommended for a wool blanket. Avoid lifting a wet down-filled article, as it will be very heavy. Rinse well, or residual detergent can cause clumping during drying. After extracting water, dry in a dryer using low heat, with white tennis balls or a clean running shoe and towels to assist fluffing and drying. **Feathers,** which have a hollow quill shaft, will take considerably longer to dry than down. This lengthy procedure, for down or feathers, may go better in the larger machines in a laundromat, provided you can select a low heat.

For storage of down, see "Storage of Textile Articles."

A down-filled duvet that has gone flat or lumpy may be renovated by a duvet maker—the down washed and blown back into a new cover. These duvet cover fabrics are very tightly woven (part of the expense of a down duvet), with thread counts of from 230 to over 300.

Pillows with Synthetic Fiber Filling

A recommended procedure is to machine wash warm, using mild detergent, gentle cycle. Do not bleach. To maintain machine balance, wash two or three pillows at the same time.

At the end of the complete cycle, reset to normal spin dry cycle to ensure best water extraction.

Tumble dry, low heat. As with down, it is helpful to include white tennis balls or running shoes to help fluffing and drying.

Suede and Leather

Suede and leather are composed of protein, like wool. While they can give excellent wear, they are specialized items, and do not invite careless handling.

Suede has a soft, velvety surface, made up of tiny fibrils. Light-colored suedes will soil easily, and the buyer must accept the need for more frequent cleaning; since this should be done by an expert cleaner, upkeep of suede can be quite expensive.

"Lamb suede" is a type of lightweight suede with no surface treatment to protect it from stains. Permanent staining can result if a protein-containing stain is allowed to dry and bond to this unfinished suede; wet out such a stain (e.g., egg or milk), seal the article in plastic, and see that it gets to a specialist suede cleaner before that stain dries out.

If a new suede article sheds fine particles, brush gently with a dry sponge or damp towel; this will remove loose fibrils, and they will usually not go on shedding long. Brush suede garments frequently, but never with a wire brush; use a bristle brush or dry foam sponge. Avoid cleaning fluids; use an eraser for nonoily spots, and try to prevent stains, for instance, by wearing a scarf to avoid skin oil and makeup staining at the neckline.

We do not depend on leather to give us waterproof footwear, but often cannot avoid exposing it to snow, rain, or slush. If suede or leather gets wet, dry away from heat or direct sunlight, hanging a garment so that it does not touch other clothing and stuffing shoes or boots with paper. Press, using heavy brown paper as a "press cloth," at low heat, use no steam, and press lightly on the outside.

Thorough spraying of suede or leather when new, using a stain repeller such as Scotchgard® or those especially intended for the purpose, such as Tana All Protector®, can prevent much soiling, though they will likely be less effective on suede (or not recommended). One of the scourges of freezing weather for leather and suede can be road salt stains. Dried salt should brush off protected articles, and then leather can be given a final wipe with a damp cloth.

Again, suede will probably retain some staining, even with spray protection. White vinegar is recommended to remove salt stains on leather.

Leather should be polished frequently; for some firm leather boots, saddle soap will resist soil and keep them soft, but use with care on fine fashion leathers. Leather can be wiped off with a mild soap on a soft, damp cloth.

For storage of suede and leather, see "Storage of Textile Articles."

Fur

Fur requires care both for the **skin side**—the same general care in drying as leather, for instance—and for the **hair side**—protection in storage very much

like wool. However, since fur garments can be so valuable, commercial "cold storage" over the summer is usually needed; control of humidity is as important as a cool temperature, and is often not available or effective at home. However, if a home is equipped with a good air-conditioning and dehumidifying unit, a fur could be safer in home storage than in a poorly maintained commercial storage unit.

In winter, during use, air may be too dry; try to have sufficient humidity in the air. Do not expose a fur to direct heat, such as a radiator or heat vent, nor to direct sunlight for an extended time; heat and light can dry the leather and harshen the hair.

Guidelines for care in use include the following:

- Provide a broad-shouldered, curved, padded hanger for a fur coat or jacket; never hang on a hook.
- Make sure there is good air circulation where the fur article is hung (not crushed into a full closet).
- Shake fur frequently.
- When fur becomes wet or damp, shake off water and hang the article to dry, away from heat, with good ventilation.
- Wear a scarf at the neckline.
- Never put perfume on furs.
- Never pin jewelry on furs.
- When wearing a long fur coat, undo the lower buttons and flip the skirt up when you sit; in a car, undo all the buttons, or take the coat off.
- Do not spray moth repellent on a fur.
- Try not to get road salt on a fur garment, as it can affect the hair and lining.
- If hair becomes matted, for instance, from the friction of a seatbelt, comb the fur lightly with a plastic comb in the direction the hair flows, and not at all deeply with longhaired furs. If this does not give instant results, take the fur to a qualified furrier cleaner.
- Have fur cleaned and glazed as needed—not necessarily every year, but according to the amount of wear you give it. Fur picks up a good deal of dirt, and fur cleaning is a specialized process. The garments are tumbled in a drum of sawdust dampened with solvent. The sawdust (and dirt) are shaken and blown out, and the

garment finished, with any minor repairs needed.

For storage of fur, see "Storage of Textile Articles."

Care of Special Items

Gore Tex® fabric was first used in garments intended to be washed, and many items will still be constructed of materials that can be laundered. If you buy an article with care instructions to dry clean, it may also carry special instructions that you should take to the dry cleaner (for instance, to clean in distilled solvent or follow cleaning with several rinses). The microporous film can become clogged with soil, and if this happens, while it will still repel water, it does not allow perspiration vapor through and so will no longer keep the wearer comfortable. Clean solvent will flush out the soil, restoring the film to its full performance. The film used in Gore-Tex fabrics now has a component to resist such contamination (see "Film" in Section Four). Dry cleaning "charge" systems (containing detergent—a wetting agent) can counteract water repellency of an outer fabric, and so a spray treatment may be needed after cleaning for this outer layer, even though no water will get past the film layer beneath it.

Stain-resistant nylon carpet is such a sophisticated product that cautions are given for cleaning, most directed to commercial cleaners but some affecting consumers' home care. Cleaning solutions must not be too alkaline, so do not use ammonia (unless in a procedure followed by a vinegar solution) or heavy-duty (built) detergents on stains. Do not use hot water on such a carpet. Finally, do not put a bacteriocide, antistatic agent, or softener into any cleaning solution; these are probably cationic and negate the stain-blocking ability built into the carpet.

A number of prominent fiber manufacturers give very specific directions regarding both cleaning and what "topical" treatments (surface stain resistants) may be applied, if their guarantee is to hold.

Garments insulated with Thinsulate™ (by 3M) may be damaged in dry cleaning with perchloroethylene; shrinkage can occur after processing more than about four minutes, and even cold tumble drying can damage. Follow the manufacturer's directions; the article may be hand or machine washable or dry cleanable.

Articles insulated with Thinsulate™ Lite Loft™ (by 3M), such as sleeping bags, carry directions such as these:

- Can be machine-washed cold, gentle cycle, with a mild detergent. Tumble dry low, remove promptly. Do not wring or stretch. DO NOT DRY-CLEAN.
- Store away from heat and never compressed (rolled, or stuffed into a small sack); hang loosely in a large storage sack.
- To revitalize, tumble dry low.

Dri-release® fabrics (by Optimer) depend for their effectiveness on rapid absorption of perspiration to be evaporated on the outside; this prevents sweat building up between skin and fabric, giving that uncomfortable, "sticky" feeling. Most dryer sheets should not be used, and some liquid softeners are hydrophobic and will interfere with the effectiveness of the fiber blend. If you have used a softener, test after drying by dropping a small drop of water from about 2 cm (an inch) above the material; it should be completely absorbed in no more than 3 seconds. If it takes longer, the fabric can be made hydrophilic again by giving a wash with a detergent such as Tide.

Nano-Tex™ fabrics should be washed as normal, but use of softeners is not recommended; if one is used, a dryer sheet affects the fabric's performance less than liquid softener added to the wash cycle. Tumble drying with heat is required to sustain their stain resistance, and steam ironing will enhance performance. These articles should not be dry cleaned. (See Frequently Asked Questions on website: www.nano-tex.com/faqs.)

Articles with BUZZ OFF Insect Shield® can be freely washed and dried, with the promise that it will be effective through 25 launderings, which is equated with the life of many garments. Compare this performance to the application of insect repellents to the skin (see Section Four regarding the exceptional effectiveness of this system).

TLC or Beware: High Fashion Specialties

Certain areas of high fashion fabrics need really expert care, or they may become "wardrobe gremlins"—a source of trouble and grief to the consumer-owner, the

retailer, and probably the dry cleaner. Some of these, and their particular weaknesses, follow.

Lightweight, sheer fabrics such as chiffon, very crisp materials such as taffeta, and especially crisp sheers such as organza are easy to damage, particularly if the fabric is relatively inexpensive for that type. Some stiffeners shift in water; if you lose that crispness, a less-than-expert dry cleaning process will leave fine "cracks" or hair lines. Fragile materials such as lace are usually of limited service-ability by their very construction.

Embossed designs and raised and puffed effects are often characteristics of fabrics that need TLC, such as matelassé, cloqué, moiré, and sculptured surfaces, to prevent distortion of those effects.

Beads, sequins, and such fancy trims may bleed or dissolve in dry cleaning solvent or be heat sensitive. There are also mirror-look plastic trims with solvent-soluble backing. Since such trim is usually applied to garments for special occasions, and these are normally dry-cleaned, the manufacturer should make sure such trim will withstand solvent, and the retailer or consumer had better get some assurance that it will, and pass on any information, such as on a hangtag, to the cleaner.

Surface designs in general are likely to show wear quickly. Sequin and bead trims have been mentioned, but there are also metallic brocades, all kinds of shag, pile, nap, or other three-dimensional surfaces, floating yarns that can snag as in satins, and heavily printed fabrics. Pigment-printed fabrics can lose or change color, and this often produces streaks, due to rubbing off (crocking); other prints do this too: gilt, paint, etc. (See Section Eight regarding testing for crocking of color.) A few surface designs are simply glued on; if the adhesive is dissolved by dry cleaning solvent, there goes the design! In most cases, these would fare no better in washing.

Unbalanced fabrics can wear easily, those, for instance, with fine yarns in one direction of a weave and much heavier yarns in the other. The fine yarns usually cover the other set and so form the surface, take most of the wear, and can split from strain. Such fabrics can also show yarn or seam slippage: rough or bulky yarns will slip along finer, smooth ones, leaving openings and distortions in the weave at points of strain, including seam stitching. (See Section Eight regarding testing for yarn or seam slippage.) These fabrics include the large family of

dressy, silky-surface, plain weave ribbed materials: bengaline, faille, moiré, and others. Fabrics with stiff silk yarns running one way only (usually warp) can become tender from perspiration, and will then split in wear or cleaning.

Suede and leather may cause problems in commercial cleaning unless the consumer is able and willing to take them to a specialist and pay for the service. Restoration of the surface appearance and color of suede, for instance, requires a real expert and a good deal of time, hence the labor cost and high price. Dark leather combined with light fabric can give problems of color loss from the leather.

Crushed velvet-like fabric with a flocked pile surface, as explained in the discussion of flocking under "Printing Other than Color" in Section Five, has given poor wear in fashion fabrics, although manufacturing technology can produce flocked surfaces that give very good wear. When the flock fibers are held by an adhesive that is loosened by the dry cleaning solvent, the material will give trouble, even when cleaned by an expert.

Knits of fine-filament, textured yarns, especially if made of microfibers, are easily distorted or snagged; their behavior in use depends first on proper handling in manufacture of the yarn and fabric, and next of the garment, e.g., in laying out. They will always call for TLC in use and care.

Potential Troublemakers in Fabrics and Garments

Some articles taken to a dry cleaner may cause trouble if you pick an inexpert cleaner, but there is a limited category of unserviceable merchandise that cannot be satisfactorily cleaned, no matter what the method or skill applied. To avoid stocking these, the retailer must refuse merchandise if the manufacturer cannot provide reasonable care instructions (difficult for any of these), while the consumer should look for a written assurance that the article can be cleaned by some method. Otherwise, there is risk of returns, complaints, or lost customers for either dry cleaner or retailer. This can happen not only with "low-end" or cheap merchandise but also with high fashion specialties, and the dry cleaner is usually the first suspected of causing trouble when it occurs, because most consumers have a distorted idea of what goes on in a dry cleaning plant.

In the category of unserviceable articles are those with a cloth component that shrinks in wet cleaning, sewn to vinyl-coated trim that will not stand dry cleaning: you ruin it any way you try.

Bonded fabrics, one laminated to another, have caused many complaints in the past, though better techniques have lessened the problems a great deal. Trouble arises if one adhesive is attacked by solvent, while another type will not stand washing. A different method of bonding uses a thin sheet of foam, which, when heated, acts as the adhesive; foam laminates may deteriorate, separate, or turn quite yellow and show through a light-weight face fabric over time.

Buttons or trim, especially some polystyrene, can bleed color, swell, dissolve, melt under heat, crack, or break, creating havoc in a dry cleaning load. Such buttons, for instance, may be either very cheap or costly. You can detect some bad actors by running your finger around the edge of a button; if you feel a slight projection, it is the type to give problems. Elaborate buttons, such as those with rhinestones set in, should always be removed before cleaning, as should any trim of questionable performance (wooden, china, etc.).

Dark interfacings such as black buckram, hidden in a garment, may bleed from a spill or during spotting in dry cleaning.

Laundering

Water—The Basic Cleansing Agent

"Getting it clean" in washing fabrics is first of all a matter of using water. Water itself can remove much soil, especially things such as perspiration salts or sugar, which dissolve in it. Water, however, needs help to make things wet! Because of surface tension, we must add substances to water to act as wetting agents; we must also counteract problems from minerals or other substances in the water, assist in loosening oily soil, and help keep soil suspended until it is rinsed away.

Water "Hardness"

Water hardness is one of the most significant factors in choice, amount used, and effectiveness of fabric washing compounds. Water dissolves mineral salts from rocks and earth. The type that precipitates out of boiling water onto pots and teakettles will not

cause trouble in washing (unless you are still using a wash boiler!). The so-called *permanent hardness* minerals are usually salts of calcium and magnesium; these can cause trouble in laundering (and bathing and dishwashing). They combine with soap, replacing its sodium (or potassium) with calcium or magnesium, and create an insoluble (soap) compound that we see as a gray curd or scum. This is what forms a bathtub "ring," or in laundering, settles on fabrics to reveal itself as a "tattletale gray" color, a harsh feel, or even an unpleasant odor if it goes rancid.

Water will in general have highest hardness levels where there is limestone rock, which is easily dissolved.

In the United States, this is in the north-central area down to the west part of Texas, plus the Florida peninsula. (There are many exceptions, of course, in such a broad area.) In Canada, the hardest water regions are the midwest (except where the Laurentian Shield curves down from the north into the Prairie Provinces), and around the limestone escarpment (Niagara to Manitoulin Island) and Kingston areas of southern Ontario.

The softest water (most free of minerals) will be rain or melted snow, plus ground water that cannot dissolve anything out of the hardest rock, or where there is not much mineral substance available. On the map these areas are the upper New England states; the East Coast generally in both the United States and Canada; the area draining into the central part of the Gulf of Mexico coast; the West Coast states of Oregon and Washington plus the Canadian West Coast; parts of Alaska and the Yukon; and areas in Canada over the granite of the Laurentian Shield; that is, the Northwest Territories, Nunavut, northern parts of the Prairie Provinces, Northern Ontario, and most of Quebec.

Degree of water hardness has traditionally been given in grains per gallon (gpg), a figure that is converted to parts per million (ppm) by multiplying it by 17.1; water with 1 grain of hardness has 17.1 parts of mineral to every 1,000,000 parts of water (17.1 ppm).

Soft water, then, has up to 3.5 gpg of hardness, or up to 60 ppm; medium-hard water has up to 7 gpg, or 120 ppm; and very hard water has 10.5 gpg, or 180 ppm and up.

Detergent directions for amounts to use will probably be based on medium-hard water.

Iron

Iron in water is another mineral that can cause problems with fabrics, either by staining as rust or by accentuating the action of chlorine bleach, resulting in holes in cotton fabrics; do not use chlorine bleach where rust is present.

Water Softeners

Water-softening (ion exchange) units remove hardness minerals from water by passing water through zeolite, a complex resin that takes out calcium and magnesium, replacing them with sodium. When the zeolite is saturated with calcium and magnesium, it is recharged by passing through it a solution of common salt (sodium chloride), which reverses the combination and puts back sodium ready for another cycle.

Water Pollution

Since the 1970s changes have been enforced or introduced in the agents we use in home laundering, with the aim of maintaining the quality of our water sources—avoiding water pollution. There are different kinds of water pollution.

The most obvious type is **harmful bacteria**, counteracted by primary treatment when sewage is processed.

Next in priority is the presence of any **toxic or unpleasant chemicals.**

A nonharmful but unsightly type of pollution was caused when laundry detergents were not biodegradable, that is, when they could not be broken down by bacteria and so persisted, causing unsightly foam buildup. All major manufacturers changed to biodegradable detergents around 1970.

Acid pollution is a result of "acid rain" from air pollution. Acid forms when moisture combines with some chemicals in the air, mostly sulfur dioxide emissions, plus some others such as nitrogen oxides. The long-range effects of acid rain are of great concern to many environmentalists and to citizens with property on lakes where the water has become too acidic to allow many forms of life to survive; such lakes may be unnaturally clear—lifeless.

The most direct link between water pollution and home care of fabrics involves another kind of pollution that is not directly harmful to humans, but does lower water quality—again of concern to cottagers. This chain of events promotes the natural process called **eutrophication**, whereby a body of water changes from one rich in aquatic life to a kind of mud puddle. When water quality is highest—for fishing,

swimming, boating, or just looking at—it is not only uncontaminated by germs or chemicals and relatively clear (though not so clear as a too-acidic lake), but has a good supply of oxygen, which supports sport fish such as trout. As eutrophication proceeds, there is less and less oxygen in the water, and life is gradually snuffed out.

This is the process: Algae (one-celled plants) and other aquatic plant growths, when nourished by certain substances in the water, thrive, eventually die, and rot in the water. Besides being unsightly and smelly, the rotting algae take precious oxygen from the water, affecting first the "highest" forms of fish, such as trout, then on down through other fish, turtles, and various aquatic creatures, until the body of water is "dead"—able to support only the most primitive forms of life (such as mudworms) that need almost no oxygen.

In the ordinary course of nature, the progression of eutrophication takes long ages to accomplish; we are seeing it happen in a frighteningly short time as human activity results in a lot of nutrient material entering the water. Algae, thus encouraged, increase dramatically to form large, often greenish "blooms" that seem to hang in the water.

Phosphate salts in water act as nutrients for algae growth; some of these are among the most effective aids to detergent action ("builders"), but have been virtually eliminated from laundry detergents because of this effect on algae growth; they were limited to 25 percent in 1970 and 5 percent in 1974. By 1978, this phosphate "ban" was credited with lowering phosphate in some municipal water effluents by about 50 percent. In the 1990s, major companies reduced phosphate content of heavy-duty machinewashing detergents to zero. Of course, phosphates are an essential part of plant fertilizers and so still enter our waters as runoff from farmland, as well as from other sources.

Detergents and Detergency

A detergent helps water cleanse—mainly by helping it make things wet. Water is made up of countless molecules strongly attached to one another by forces that act in all directions. However, on the surface, where there are no forces acting from outside, the molecules are drawn in to reduce the surface area to a minimum: a sphere. The tension in the surface prevents further shrinking. This surface tension prevents

water from coming into close contact with the fabric surfaces, or the dirt to be removed; it keeps water from "wetting out" the fabric.

Detergents (soap or synthetic detergents) have a "head and tail" structure; the head is hydrophilic—attracted to water—while the tail is hydrophobic or oleophilic—attracted to oil or grease (Figure 6.1). Detergents reduce the surface tension of water (they are *surfactants*) and so act as wetting agents—breaking the bonds between water molecules at the droplet surface by means of the hydrophobic tails pushing out away from the water. Detergents also help remove soil by loosening it from the fabric (see Figures 6.1 and 6.2) and then helping to hold it suspended or emulsified until it can be rinsed away—the oleophilic tails in the surface of the greasy soil, the hydrophilic heads in the water. Heat and agitation further the process of soil removal.

Soap

Soap is one of the best detergents possible, in both soil removal and suspension, if it is used in *warm*, reasonably soft water. However, it does cause problems with hard water, as was described earlier in the discussion of water "hardness" under Water. Soap is the salt of an alkali and a fatty acid from a natural fat (oils as well as animal fats)—a triglyceride. When the alkali is sodium hydroxide, we get a "hard" soap, which needs hot water to dissolve it. When the alkali is potassium, we get "soft" soap, which will dissolve

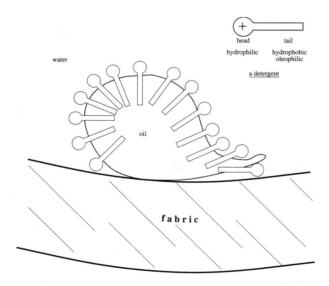

Figure 6.1 Detergents act as wetting agents or surfactants to loosen soil from fabric.

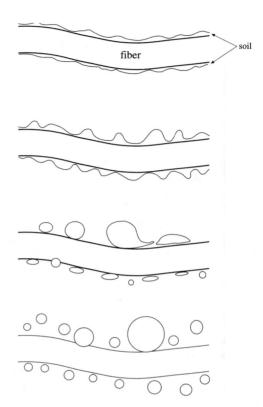

Figure 6.2 Roll-up and removal of soil in laundering.

in warm water. Toilet soaps and products such as the original Ivory Snow (a soap) are made to act in lukewarm water and to have no free (excess) alkali left from the process; even the mildest soaps, however, are slightly alkaline in solution, whereas synthetic detergents are neutral.

Synthetic Detergents

Synthetic detergents or "syndets" have a chemical makeup of the normal hydrophilic head and hydrophobic or oleophilic tail, but they differ from soap in that they cannot react with the calcium and magnesium salts in hard water to form a curd; this means that they will act in cold water, hard water, or even seawater.

Hand dishwashing liquid (which is mild or unbuilt syndet) is "pure" syndet in the same way a toilet soap is "pure" soap—nothing has been added to it. Compounds called *builders* are added to make "heavyduty" or *built* detergents, suitable for machine-washing heavily soiled fabrics that are usually cottons (**note** that some built detergents are available in liquid form).

None of these built detergents is appropriate for protein fibers because of their alkalinity. By contrast, unbuilt syndet is safe for all fibers, but is a very efficient oil remover and so may take skin oil from the hands of someone doing dishes. For this reason, it may seem "harsh," even though it is chemically neutral. These liquid hand dishwashing detergents provide a safe and inexpensive detergent for hand-washing protein fibers such as wool and silk, or other delicate materials. Shampoo or products such as Woolite or Zero may also be used. Ultra Ivory Snow detergent has been formulated to be safe for machine-washable wool or silk.

Heavy-duty syndets, such as Tide or Cheer, are designed for machine washing of clothing and household textiles, especially cottons. Do not confuse a **liquid** heavy-duty syndet such as Wisk with dishwashing **liquid** (unbuilt detergent).

By the late 1990s, built detergents were marketed more in formulations from which much "filler"—material such as Glauber's salt (sodium sulfate) with no active washing properties—was removed, so that the consumer got used to using less than a third of the amount formerly measured out.

Other Laundry Agents

Water Softeners

Water-softening agents have traditionally been added along with soap, to wash in hard water. Washing soda (sodium carbonate), sodium silicate, borax (sodium tetraborate), and ammonia are agents well known for this use. If soap alone is used in hard water to wash fabrics, the soap will be used up until it "softens" the water, i.e., reacts with all the calcium and magnesium; only then will soap form suds and perform its detergent functions. More hard water curd can be formed in the rinse water too, as its minerals react with soap carried over in the fabrics. Today, it is usually easier and more effective, when using hard water with soap, to add a water conditioner or softener such as Calgon to both wash and rinse waters. It sequesters or hangs on to the hardness minerals, so that soap will not react with them. Such a product helps whenever soap and hard water are used, e.g., in the bath.

Builders

Builders are alkaline salts added to help detergents disperse soil and hold it in suspension until it is rinsed away; they are added to give heavy-duty washing

products. Syndets are very efficient at loosening dirt and do not cause the troubles with hard water that soap does; for these reasons, there is no soap used for home machine-washing products, although some of today's well-known names were once soap-based heavy-duty products, such as Rinso. Syndets, however, are not as good as soap at the "holding in suspension" function of washing, and so need builders even more than soap did. Since phosphate salts have been drastically reduced in amount used, old-fashioned agents such as nitrogen salts, or borax, are used as builders. Borax (sodium tetraborate, also known as "boric acid" or "perborate," represents a number of related compounds, the most used being borax decahydrate: Na₂B₄10H₂0. In washing, borax can hold dirt, and produce hydrogen peroxide, a mild bleach.

Bleaches

Bleaches may be added to detergent compounds or used separately.

Oxygen bleaches are the mildest type and include sodium perborate, monosodium persulfate, and the liquid hydrogen peroxide; one, Bleach For Unbleachables[®], is a powdered oxygen bleach. These are the only type safe for protein fibers like wool and silk (or human hair), or for many colored materials. In the United Kingdom, Ace liquid hydrogen peroxide bleach (by Proctor and Gamble) was approved by the Woolmark Company. Oxygen bleaches are introduced more as lower wash-water temperatures are used, since these are less effective in removing soil.

Chlorine bleach, so-called, is used for stronger whitening action, stain removal, or disinfecting action on cellulose fibers: the liquid, sodium hypochlorite (Javex, Clorox), or the solid, calcium hypochlorite. These should always be used with care: it always added to the water before the clothes are added—never poured undiluted over a load already in the washer; never used on dyed goods without first checking the colorfastness (see "Dyes and Colorfastness"); NEVER, ever, used on wool or silk; can harm rubber; will yellow spandex.

The safer (non-chlorine) bleaches are represented in the care symbol system in Figure 6.7 by the triangle with two lines in it.

Reducing bleaches are compounds used for removing or "stripping" dyes, or for treating certain stains. The **color remover** sold with home dyeing products such as Rit or Tintex is of this type, as is sodium hydrosulfite. If a stain or discoloration does

not come out with an oxygen bleach, then a reducing bleach might be tried; use a rustproof pan, and follow the procedure for whitening nylon under "Dyes and Colorfastness."

Optical bleaches—whiteners or fluorescers—are fluorescent dyes that convert light that would be invisible (at the ultraviolet end of the spectrum) to visible light; they therefore *do* make fabric "whiter than white" or "brighter than bright." The type included in detergents "takes up" on cellulosic fibers, so the whiteness of cottons is renewed with each washing, as long as chlorine bleach is not also used; this bleach destroys the fluorescent. See the discussion of brighteners under "Dyes and Colorfastness" for notes on optical bleaches on fibers other than cotton.

Disinfectants

When someone has an infection, or when laundering articles such as diapers, it is often desirable to make sure bacteria will be killed during laundering. Very hot water and the process of washing will do quite a good job, but wash boilers are not part of 21st-century home laundries, and today we may lower the temperature of wash water from normal hot (about 60°C [140°F]) to cool to save energy. Chlorine bleach would disinfect, but is often undesirable for its effect on color, protein fibers, rubber, spandex, etc. Quaternary ammonium compounds, which do not harm fabrics and have no odor, are very suitable, or phenolic disinfectants may be used.

Enzymes

Enzymes in presoak or prespray compounds are of the *proteinase* (protein "digesting") type, effective in lukewarm water, to break down stains such as egg, meat juice, blood, milk, and milk products. They are knocked out in hot water, can irritate skin, and should not be used for soaking wool and silk (protein fibers).

Home machine washing compounds, then, contain a variety of agents to assist in cleaning fabrics, aimed mostly at cotton (cellulose fiber). All that advertising of "X is better than Y" is not entirely "suds in your eye"—there are other special additives, such as metal protectors to prevent corrosion in the washing machine, suds suppressors to prevent excessive foaming, fragrance, fillers to keep a powder running freely, and so on. Consumers should keep in mind that all wash loads do not need a "total" complex built detergent; if the wash is made up of colored or

dark fabrics, a detergent with a bleach incorporated is not necessary.

Fabric Softeners

Fabric softeners (not to be confused with water softeners, discussed earlier) deposit a waxy or fatty lubricant on fabrics to give a number of advantages. Most are cationic (positively charged, usually quaternary ammonium compounds) that cling to the surface of (usually negatively charged) fabrics, making them softer, fluffier, and easier to iron (or need less ironing). Because the softener absorbs moisture, static is conducted away. Some leave a fragrance in the fabric. There can be yellowing of some fabrics, and some loss of absorbency has been reported, although tests do not agree on this latter point.

Some softeners are designed to be used in the tumble dryer; this is a boon to those who have no means of conveniently adding liquid softener to the last rinse in washing. Dryer manufacturers have warned against any that give a noticeable buildup on the inside of the dryer drum. Another problem that seems related to the use of fabric softeners in the dryer is the occasional development of darker spots or splotches, usually on a plain polyester fabric in a solid, light color (no "camouflage"). These spots can usually be removed by treating with an oil- or greaselifting agent and rewashing; avoid drving with the same type of softener sheet. If the marks are small, round, darker spots, and you used too much softener in the wash rinse, they may have been driven into the fabric at the tub holes during the water extraction spin. Light spots, by the same token, are usually from lint, produced on the fabric in the same way. One dryer softener sheet maker has developed a product intended to add stain resistance to fabrics being dried with it: the claim is that over a number of dryings, the articles gradually acquire stain resistance. There is a recommendation to give any oily spots that may develop much the same treatment as outlined above for any marks attributable to softener.

Home Dryer "Freshening" of Non-Washable Articles

There are now products designed to "freshen" normally commercially-cleanable-only garments in a home dryer, between commercial cleanings. One of these is Dryel (by Proctor and Gamble). It comes as a kit, with a spot remover for pretreating stains;

testing by the International Fabricare Institute indicates that this is meant for water-soluble stains, and might spread solvent-soluble soil (grease or oil). Articles can then be put in a knit bag along with one of the four pads supplied with the kit. The solvent that moistens the pad is activated during tumbling for 30 minutes in a medium to hot dryer, creating an atmosphere that takes out wrinkles and helps remove (some) water-soluble stains, while odors such as smoke or perspiration can escape through vents in the bag. The article will be slightly damp. and should be hung up as soon as the dryer stops. Dryel is not meant for leather, suede, or fur, and is not suitable for heavily soiled or grease-stained garments. A commercial dryer will be too hot, and could damage the bag.

Home Treatment of Spots and Stains

Before discussing spots and stains, it may be notable that we are and will be using an ever-increasing number of fabrics with stain resistance and/or stain release capabilities, as discussed in Section Five. However, we still have to deal with a good many

spills and other accidents that leave unwanted marks.

In this book, home treatment of these spots and stains, usually called (optimistically) *stain removal*, is presented in a very condensed format, beginning with a set of dos and don'ts:

DO decide first whether you can safely and effectively apply home treatment; it will be safe for most washable articles.

DON'T use complicated or strong home "recipes." Commercial cleaners are often faced with a worse stain when someone has first tried Great-Aunt Agatha's sure-fire mixture.

DO attend to spots and spills *at once*, though not necessarily at home! Stains treated early will not become set, they are still at the surface of the material, and you usually know what caused them. Figure 6.3 shows such treatment with a carpet, in this case inherently stain-resistant because it is made of Corterra® PTT polyester. A stain left for a time can concentrate, until an otherwise harmless substance such as lemon juice can attack a fiber or color; time also allows oils to oxidize and darken.

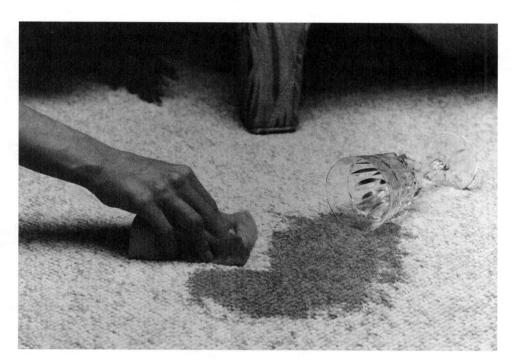

Figure 6.3 Prompt treatment works well for spills on this inherently stain-resistant carpet of Corterra® PTT polyester. (Courtesy of PTT Polymers)

Follow steps in the order given.

Stain Type	Key #	Stain Type	Key #	Stain Type	Key #
adhesive tape	1, 6, 9	hair tint	DC	water based	2, 9
asphalt (see tar)		ice cream	2, 6, 9	(must be still	
beer	3, 9	ink:		wet)	
berries	3, 9 + 7a	ballpoint	6, 5a, 9	pencil	soft eraser
blood	2, 8, 9	marker,	6, DC	perspiration	5a, 8, 9
butter (see grease)		permanent;		rubber cement	2, 5a, 6, 9
carbon paper	5a, 9	India		rubber heel marks	5a, 6, 9
chocolate	1, 6, 8, 9 + 7a	washable	7a, 9	rust	7c, 9
coffee	3, 9 + 7a	iodine	6c, 7b	salad dressing,	3, 8, 9 + 7a
cold wave	DC	ketchup	3, 7a, 9	cooked	
(permanent)		lard (see grease)		salad dressing, oil	3, 5a, 6, 9
cosmetics:		lipstick (see cosmetics)		salt, road	2, 9
foundation	6, 9, DC	margarine (see grease)		scorch	7a, 9
lipstick	6, 9, DC	mascara (see cosmetics)		shoe polish	5a, 6, 9
mascara	6, 9	mayonnaise	3, 7a, 8, 9	shortening (see grea	ise)
other	5a, 9, DC	meat juice	2, 8, 9	soft drink	3, 9 + 7a
crayon (see wax)		medicines	7a	softener, fabric	5a, 9
cream	2, 6, 9	mildew	7a, 9	soy sauce	3, 7a, 9
deodorant	5a, 9	milk	2, 6, 8, 9	sugar solution	2, 9
egg	2, 8, 9	mucus	8, 9 + 7a	tar	5a, 6, 9
excrement (feces)	4b, 4a, 8, 9 + 7a	mud	5b, 9	tea	3, 9 + 7a
fruit juice	3, 7a, 9	mustard	3, 5a, 7b, 9	tobacco	3, 9 + 7a
glue (except	DC	nail polish	6d	tomato sauce	3, 7a, 9
rubber cement)		oil:		urine	4a, 3, 8, 9
grass	6c, 9	cooking	5a, 6, 9	varnish	6d
gravy	6, 8, 9	motor	5a, 6, 9	vegetable juice	3, 7a, 9
grease: auto	5a, 6, 9	skin; hair	5a, 6, 9	vomit	4b, 4a, 8, 9 + 7a
food	5a, 6, 9	paint:		wax	1, 6c, 9
gum, chewing	1, 6, 9	oil based	6d, 9	wine (especially red)	11, 3, 9 + 7a

Figure 6.4 Stain Treatment Procedures Chart. (Refer to key on facing page.)

Permanent stains can be caused by alkali, age, or heat. Following are the three worst "scenarios":

1. **Tannin** becomes set with alkali, if left too long, or if exposed to heat. Tannins are the coloring matter in most plants and in most foods (except

beets) and drinks, from wine to ginger ale, and including tea and coffee.

2. **Oil oxidizes** if left too long or heated. It turns darker (think of the color of old salad oil); from being almost invisible, it becomes a noticeable stain, impossible to remove. Oil can be from food/cooking oil or

Key to Procedures Figure 6.4

DC = Take to an expert dry cleaner.

- #1 Chill by application of ice, or put in a freezer.
- #2 Cold water; soak if possible; if not, sponge.
- #3 Cool water + 5 mL/250 mL (1 tsp./cup) each of liquid hand dishwashing detergent and white vinegar; this is on the acid side.
- #4a Cool water + 5 ml/250 mL (1 tsp./cup) each of liquid hand dishwashing detergent and ammonia; this is slightly alkaline.
- #4b Dry baking soda; this is also alkaline.
- #5a Work liquid detergent (undiluted) into the stain to penetrate and lift oil.
- #5b Make a paste of liquid detergent and powdered (mild) bleach suitable for all fabrics.
- #6 Solvent; may be any of #6a, 6b, 6c, or 6d.
- #6a Gasoline type: lighter fluid, wood floor cleaner (Varsol); this type is flammable—use with special **CARE.***
- #6b Nonflammable type: perchloroethylene—use with special **CARE.***
- #6c Rubbing alcohol or other colorless alcohol; flammable—use with special **CARE**.*
- #6d Special or specific solvent, such as nail polish remover, paint thinner, (for paint, varnish, etc.), or manufacturer's recommendation; flammable—use with special **CARE.***
- #7 Bleach or other special chemical; use with care; if in doubt, take the article to an expert dry cleaner (DC in chart).

- #7a Chlorine or oxygen bleach as safe for fabric or color; oxygen bleach in as hot water as is safe. (*Note:* Do not mix chlorine bleach with, for instance, ammonia or vinegar. See #7.)
- #7b Reducing bleach or color remover; see #7.
- #7c For rust only (see #7):

Oxalic acid crystals; use **with care**, wear rubber gloves.

Lemon juice, white vinegar, or citric acid crystals, with salt: cool water + 5 mL/250 mL (1 tsp./cup) of each.

Commercial rust remover.

On carpet: after application, rinse well, dab up excess moisture, then (if rust is gone) hold a steam iron over the area for a few minutes.

- #8 Enzyme presoak or enzyme detergent, 5 ml/250 mL water (1 tsp./cup), or make a paste with water.
- #9 Wash as appropriate; Water as hot as is safe.
- #10 White absorbent substance such as talcum, cornstarch, chalk (on suede: ground, uncooked oatmeal).
- #11 Shake salt on a wine spill, then shake salt off with absorbed stain, or vacuum.

*CARE: Do not breathe solvent more than necessary, use with good ventilation; watch sparks or flame with flammable types; never use with electrical appliances; watch any heat source near solvents, as vapors will form that may be toxic.

it can be skin oil (sebum), which gives "ring around the collar." Oily stains are very troublesome on polyester/cotton Durable Press fabrics, since both polyester and the resins in most Durable Press cotton finishes hold oily soil. When oil is not removed, not only is a stain left, but bacterial action on residual oil can develop clinging, unpleasant odors. Treatment is described in the Stain Treatment Procedures Chart (Figure 6.4).

3. **Sugar caramelizes** with application of heat; it turns brown—the change we see when we toast a marshmallow or make caramel or butterscotch.

Again, a spot that was invisible (dissolved white sugar) becomes noticeable and permanent. There may be sugar in drinks that do not have much color, such as tonic water; this is one main reason for the warning against pressing over a spill before the spot is removed. It is also why we should mark and identify a spill for a dry cleaner so it will get a prespotting treatment; otherwise, the article will go through solvent cleaning, which does not remove sugar well, and a spot like this can caramelize from the heat in subsequent drying and pressing.

"First aid" for treatment of stains on washable fabrics:

DO remove excess material—blot up excess liquid (do not rub into the fabric) OR absorb with powder (cornstarch, talcum) and let the paste dry; gently scrape off solids with a spatula, spoon or dull knife (except those that call for chilling, which is #1 in the Stain Treatment Procedures Chart); try not to rub into the fabric.

DON'T use alkaline agents as a first aid treatment, without consulting the Stain Treatment Procedures Chart; alkaline agents include heavyduty machine-washing agents, ammonia, borax, washing soda, and even soap.

DO treat protein-containing spots and stains at once, avoiding heat, and if possible soaking in or applying a product containing an enzyme, usually a protein-digesting type (proteinase).

DON'T use such protein-digesting products in treating wool or silk (protein fibers). Stains containing protein include those from any animal material (blood, secretions, meat, egg, dairy products in any form, and products made using dairy products or egg, such as mayonnaise), so the range is wide. Enzymes are inactivated by hot water.

DON'T press over a stained area, especially if it is nearly invisible when dry, as is a stain containing dissolved sugar.

Dry-cleanable articles or any you are unsure of treating at home:

DO take to a reputable cleaner.

DO pin on a note stating the nature and location of the stain (especially important if it is nearly invisible), plus information on anything you have already tried on it.

Figure 6.4 gives a Stain Treatment Procedures Chart and is followed by the key to the procedures. These procedures avoid hot water or alkali until the final wash, except for #4a and #4b, which are rarely applied. Try to test first on an unexposed area. Following is the method for stain treatment: With spot laid face down into white absorbent cloth or paper (tissues or towels), drop the solvent agent through the fabric (a dropper bottle works well). Do not rub: use a dabbing or patting action, working from the outside of the stain to the center; you are pulling the stain out and into the absorbent material by capillary action. As the stain is taken up, move to a clean area of the absorbent material, being careful not to transfer any staining back from the absorbent material.

6-2 COMMERCIAL CLEANING

Fabric care is important—that is not just a selling line for commercial cleaners. Soil can harm fibers and fabrics, either physically (tiny specks of grit cut and abrade fibers), or chemically (action of stains, or even moisture and sunlight reacting with certain dyestuffs). An advertisement (for Eureka vacuum cleaners) savs that a clean-looking carpet can hold 1.5 times its own weight in hidden dirt—about 90 pounds for a 9 ft. × 12 ft. carpet (40 kg for 275×365 cm). A carpet can hold more dirt than most other fabric articles we use, it is true, but all fabrics can hide a certain amountsomething to think about. If the consumer cannot or will not undertake cleaning at home, then a commercial cleaner should be found. Commercial cleaning. until the mid-1990s, was taken to mean dry cleaning or commercial laundering; the latter does not come into the scope of Fabric Reference, except to define it as being applied mainly to cotton fabrics, using very hot water, and built detergents (plus chlorine bleach). To these has been added commercial wet cleaning and others, but dry cleaning will be discussed first

"Dry" Cleaning?

There has been a credibility gap between consumers or even retailers and dry cleaners. The public does not understand what dry cleaners can and cannot do, or how various fabrics can and cannot be cleaned or handled. Possibly most bewildering of all, the name does not make sense to the literal minded: "They call it dry cleaning when you can see your clothes sloshing around in some kind of liquid!"

What Happens in a Dry Cleaning Plant?

Basically this: Clothes are cleaned in a liquid solvent other than water (hence the "dry"); in comparison with home laundering, such solvents remove oily and greasy soil better, take out some soils or stains that are a challenge to budge in water, minimize shrinkage from fiber swelling, and minimize disturbance of colors and finishes, as well as keeping the garment's original shape and tailoring details which will be disturbed more in water, requiring restoration in finishing beyond the skills of the consumer using home equipment. However, some commercial wet cleaners

have successfully developed machines, special detergents, and protective and finishing agents so they can manage using water rather than solvent for most articles except furs and some items of rayon (see "Commercial Wet Cleaning").

Most plants use solvents in what is called a charge system; in this a small amount (1 to 2 percent) of detergent is added to the solvent to carry some moisture needed to dissolve out some kinds of soil, such as perspiration. Some cleaners will use this only for a batch that is very heavily soiled, such as seldom-cleaned trench coats. For most systems, tumble drying in a stream of warm air evaporates off the solvent, and cleaning is followed by steam pressing or steam-air finishing.

Dry Cleaning Solvents

The entire discussion of dry cleaning solvents was rewritten for this edition. The significance of some elements had totally changed, and many new solvents have been and are being developed to clean fabrics. In late 2005 it was estimated by the International Fabricare Institute (IFI)² that of some 30.000 dry cleaning plants in the U.S., 80% used the chlorinated solvent "perc," a major type used since the 1930s. There is a good deal of space taken here recording characteristics of other categories that began to be used around 2000, but it wouldn't be a "Fabric Reference" without this. This is because these newcomers and other methods such as wet cleaning are gradually but steadily replacing perc in many plants; in 2000, probably 85% of dry cleaners used perc, and some 90% around 1990-1995. Some of these relative newcomers will flourish in the years to come and awareness of commercial cleaning is important to anyone working with textiles. To understand why such a big change is occurring, perc, under the general heading of "Synthetic Solvents," must be the first discussed.

Synthetic Solvents

Chlorinated. The chlorinated solvent perchloroethylene, usually shortened to perc as noted above (or another that has been used in Europe, trichloroethylene), is nonflammable and therefore suitable for use in the many neighborhood, on-the-spot cleaners, as it meets fire regulations. It is also a highly efficient solvent of oil or grease, rated as having great "solvent power." However, that can have drawbacks; rubber (e.g., a rubber-backed sleeping

bag) or vinyl can be ruined by one cleaning in perc. It is gradually losing ground as the principle solvent because its fumes are toxic if a lot is inhaled, and even small amounts accumulate in the body. These solvents are now classed among other Volatile Organic Compounds (VOCs) and considered to be pollutants of air and water. The U.S. Environmental Protection Agency (EPA), with the industries involved, have explored alternative cleaning agents, but there has also been a notable sophistication in the design and engineering of machinery used to clean with perc, to reduce negative effects on employees and the environment.

Fluorinated. Fluorinated solvent has had minor use in dry cleaning, but since it was classified as a chlorofluorocarbon (CFC), contributing to depletion of the ozone layer, its production has been banned in various countries.

Hydrocarbon Solvents

Hydrocarbon solvent is a derivative of petroleum, and this type is next in frequency of use in the U.S, although well behind perc. Historically, dry cleaning is said to have started in early- to mid-19th century when an observant Frenchman, Jean Baptiste Jolly, overturned a kerosene-fueled lamp on a tablecloth, and noted after it had evaporated, that grease had been removed in the area of the spill. This and other solvents closely related to gasoline were used for cleaning, but were extremely flammable. A distillation fraction called Stoddard solvent was developed which had a lower flash point (lowest temperature at which evaporated liquid with oxygen present will ignite and continue to burn). This solvent became extensively used in dry cleaning (it is called white spirit in the United Kingdom; but in Europe is referred to as just hydrocarbon). Plants using this have to be located where fire regulations can be met, and that is not in malls or neighborhood shops. However, receiving stores can be in malls and such, with clothes sent to the main plant, to be picked up at the store or delivered to the customer. Stoddard solvent has been preferred for some articles, as it does not damage vinyl, rubber, or leather, but its grease-dissolving power is not as good as that of perc. At one time (1950s) Stoddard solvent was used by about half the plants in North America; it continues to decline in use, as the statistics quoted for the percentage use of perc indicate, and the listing of newer solvents and description of wet cleaning which follow will also suggest.

Newer hydrocarbon solvents are updated enough from the older types to show good promise. Two are: **DF 2000** (by ExxonMobil Chemical), somewhat less flammable than Stoddard solvent, and **EcoSolv** (by Chevron Phillips Chemical), a hydrogenated isoparaffin, flash point 61°C (142°F), biodegradable, and (unlike Stoddard) virtually odorless. Hydrocarbon solvent cleaning leaves a softer hand in fabrics. EcoSolv has also been used in a different type of machine, IPURA (by Columbia Ilsa), which does not saturate the materials with solvent, so no extraction is needed to remove excess at the end of the process. This combination of solvent and machine also does a good job of cleaning difficult items such as those with sequins, painted-on designs, wedding gowns, and suedes.³

Other Dry Cleaning Solvents

At the time of this revision, the following types of solvents are used by a *very* small percentage of cleaners; they are recorded roughly in order of numbers of cleaners adopting them. However, this business is obviously in a state of flux, and the degree of success of any will be affected by political (governmental regulations, public opinion) and economic forces, and of course, impact of wet cleaning and/or other solvents yet to be tried.

Silicone-Based Solvent

This category is not a Volatile Organic Compound (VOC) as the hydrocarbons are, and therefore safer to work with and for avoiding air pollution affecting global warming. **Green Earth** cleaning uses a silicone-based solvent D5 (decamethylcyclopentasiloxane) (by GE and P&G). It is used also in personal care products such as deodorants, and so can be taken to be as described: nontoxic, and nonirritating to the skin.

CO2-Based Solvent

This category also is not classified as a VOC. **Washpoint** (by CoolClean Technologies in the U.S., Linde in Europe, with Uniqema, a subsidiary of ICI, the British specialty chemical maker) is a product that combines liquid CO₂ with a special detergent. Liquid CO₂ is recorded as having good cleaning properties: it penetrates fibers easily, is nontoxic, nonflammable, and odorless. It produces no hazardous waste or emissions.

Glycol Ether Solvents

Impress (by Lyondell Chemical) and **Rynex** (by Rynex Holdings) are propylene glycol (PG) ether systems that are VOCs, but with a much higher flash

point than most hydrocarbon solvents: 88° C (190° F). They are less effective grease cleaners than perc, but are not considered to be hazardous chemicals or air pollutants.

n-Propyl Bromide-Based (NPB) Solvents

Drysolve and **INPRO** (by Dry Cleaning Technologies) are described as safe for the environment and to work with, requiring only very short cycles to complete cleaning. They were rated by IFI tests as being more effective than perc, yet can be used to clean leather, suede, and fur, or to apply finishes such as water repellent or fireproof. They have the approval of the Environmental Protection Agency (EPA) as having little or no flammability, and not being carcinogens.

Commercial Wet Cleaning

Commercial fabric cleaning or fabricare went through a dramatic refocusing at the end of the 1990s, with stringent governmental controls of solvents used in dry cleaning, and much more acceptance of commercial wet cleaning. Water, in specially designed machines, was first successfully used in the mid-1990s to clean some leather and vinyl-and-leather garments; Suede Life developed a process called "Clean & Green," so-named for being more environmentally "friendly" than dry cleaning. However, not just any machine could be used for wet cleaning leather, since a load of leather garments is very heavy compared to fabric, and there were other problems.

By the end of the 1990s, machines and process additives had been developed so that some plants were able to wet clean from 60 to 96 percent of all garments left for commercial cleaning. not just leather. Wet cleaning has become a legitimate adjunct to or alternative to dry cleaning. The most advanced equipment such as that developed by the German machine maker Miehle can give super-gentle action, as slow as 2 seconds of agitation followed by a 28-second pause, for articles such as mohair or angora garments. Sizing or softener can be added during cleaning. A low speed extractor removes all but about 35 percent of moisture. Drying may be completed with garments hanging in a warm air drying cabinet. Special finishing techniques have been developed for wetcleaned garments.

Ultrasonic Cleaning

Ultrasonic (high frequency sound) waves were worked with in the 1980s to clean garments by shaking soil loose in a very short time; because soil was so thoroughly removed, with a fluffing out of the fibers, it was said that little pressing was needed in comparison with traditional processes, "dry" or wet. Little impact seems to have been made in the commercial cleaning market since then, however. It must have been hindered by the advent of wet cleaning and many new solvents, plus machinery modifications.

How to Rate Cleaning

The range of prices, especially in dry cleaning, roughly parallels the quality of expertise or service, from self-service (coin-operated machines—not many of these around), through economy "clean and steam" processes, to much-higher-priced service by expert "professional" operators. In between the last two, of course, may be the plant that advertises what is apparently complete service but which cuts corners with inexperienced staff or poor equipment maintenance/quality control.

To budget cleaning for best value, you must know:

- How to recognize a trained cleaner for treasured articles.
- What you can satisfactorily clean in economy processing.

Quality Checklist

The best cleaning will give you:

- Articles tagged; any buttons or trim removed that might be damaged; materials sorted, so that fabrics of similar weight and color are put together; fragile articles bagged. (Note: if you are dealing with any but the best [most expensive] service, you should take care to check and clean out pockets, and to brush out cuffs.)
- Articles put through clean solvent or solutions; articles resized if fabric had stiffening in it; solvent removed—no trace of "cleaning odor" left; colors bright and (within reason) stains removed. If a stain is not removed, a note should inform you of this defect.

- Garments well pressed; pleats and creases sharp (and in the right place!); no old wrinkles or creases left around seams, buttons, crotch, or underarms; no fabric shine; lint brushed out from cuffs and pockets.
- Minor repairs taken care of, e.g., standard buttons replaced, tears mended.
- Special services, by many plants, include mothproofing, showerproofing, suede and leather cleaning. Rug, drape, or fur cleaning may also be handled, as well as shirt laundering.
- Note that this quality checklist will be the same for any commercial cleaner, including those using wet cleaning. Also, if any article you are having commercially cleaned is part of an outfit, e.g., a dress and jacket, or a suit, both parts should be cleaned each time to keep each piece the same color.

When You Need the Best Cleaning

In the quality checklist are tucked the two most important reasons to take some articles to the best cleaner you can find: (1) removal of tough spots and (2) expert finishing.

Tough Stain Removal

Removal of spots and stains in many cases requires different solvents or chemicals from either dry cleaning solvent or water. It takes a special kind of wizard to make an educated guess at what treatment will do the job for a particular stain (often unidentified) on a fabric of a certain fiber content (known only if the label is still with the article), with dyes or finish that may not react kindly to the manipulation needed to deal with the stain; and often involving interlining, buttons, trim, or other decorations that might bleed or melt during this tricky operation. This hair-raising procedure is known, perhaps unfortunately, as spotting.

It is very important to the treatment of some stains that they be *prespotted*, that is, done *before* the article goes through cleaning, after which it is dried. Heat can develop stains of tannin, oil, or sugar so that they darken and may be impossible to remove. Tag a garment or other article to show where a spill has dried, especially when it leaves little mark, identify the substance, and record any treatment you tried yourself.

Finishing

Finishing is the second significant service given by a commercial cleaner. You can put bulky sweaters, sleeping bags, blankets, children's play coats, or snowsuits through solvent cleaning in even a self-service, coin-operated machine, for none requires careful steaming and pressing.

Articles that *do* require careful finishing will look "like rags" until they receive it. Such items generally fall in the class of tailored clothing, such as suits.

Dry cleaners' presses are many and specialized. Two of them are **form finishers**, which bring the garment to shape with steam, and special **puff presses**. Another variety is **tensioning** equipment, used for dry cleaning, but emerging into the spotlight as very important with wet cleaning. With tensioning, cleaned garments are put on a tensioning unit where most of the finishing is done. A final touch-up is accomplished with an iron on what is called an up-air board, almost the reverse of traditional finishing. Figure 6.5 shows a Fimas shirt tensioning unit, and there are others, e.g., for trouser legs.

Even these methods will not restore "as new" the finish given a custom-tailored suit, involving hand pounding and pressing. Still other cleaners give a soft, partly handpressed finish. However, the cleaner with a high quality standard will do a good job on finely or elaborately constructed apparel.

The "bottom line" is that both expert spotting and careful finishing can cost a good deal; the consumer must decide when this is well worth it.

How to Select a Dependable Cleaner

Choice of a dependable cleaner can be important to a retailer (of ready-to-wear or piece goods) as well as to consumers. To the uninitiated, most dry cleaning plants look equally impressive if the equipment is located right there (on the spot), or equally mysterious if you deal with a branch store of a company with a central plant or with a small store that acts as an intermediary only, sending cleaning to a large whole-sale plant that serves many separate companies or stores.

Among all these are some cleaners you can depend on to give you quality cleaning and even good advice when you need it. To locate one of these, you should look first for identification of the cleaner's membership in one of the trade associations that inform their members of the best way to handle new

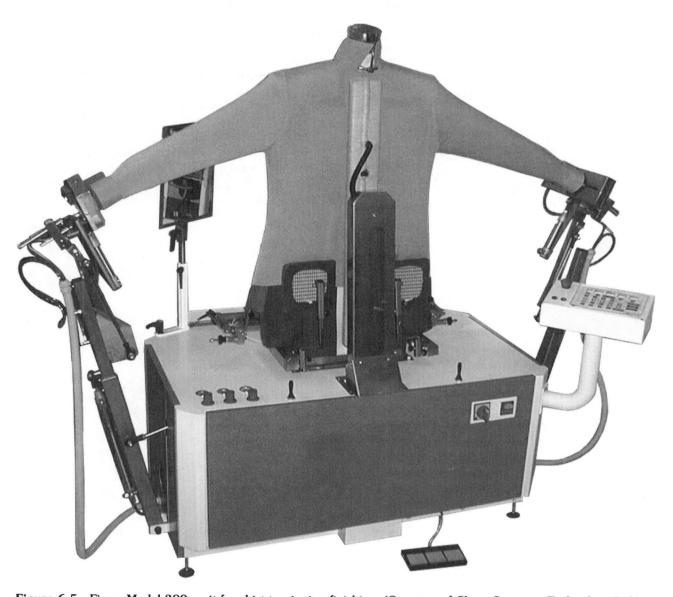

Figure 6.5 Fimas Model 389, unit for shirt tensioning finishing. (Courtesy of Clean Concepts Technology Ltd.)

or difficult fabrics. Many cleaners in the United States and Canada belong to a long-established organization, the International Fabricare Institute (IFI), 14700 Sweitzer Lane, Laurel MD 20707. A national group was re-formed in Canada in 1994 under the name Canadian Fabricare Association, 11045 124th Street, Edmonton, AB TSM 0J5 Canada.

Having identified a cleaner as a member of a trade association, make a personal survey: Pick a special garment, perhaps a good-quality suit, an all-weather coat, or an evening gown. Take it to several cleaners near you. Ask some basic questions:

- Do you run your own plant?
- Where is the cleaning done?
- What is your cleaning charge for this specific garment?

Of course, you will find some cleaners more expert than others, even within the membership of a

trade association, and the final "proof" is the quality of the actual cleaning job. The price charged, as with many consumer items, is a rough guide—up to a point. With a rock-bottom price, some of the points of quality cleaning will almost certainly be scanted on or missed.

Beyond a certain point, you pay for super, "custom" cleaning, which, you will remember, includes finishing. This may be well worth it for a suede suit, an elaborate cocktail dress, a fine knit outfit, a good fur- or suede-like fabric coat; it may also be worth it for a retailer to have a top-notch cleaner deal with a

customer's article if there is a question or problem to do with cleaning high fashion merchandise from your department or store.

For many simply constructed garments or straightforward materials with no difficult stains, you do not really need the most expensive cleaning service.

When cleaning costs are budgeted over the range from most expert cleaner (expensive) to lowest price or even to coin-op loads, a consumer can receive better value and feel less resentful about the cost of cleaning care.

6-3 DYES AND COLORFASTNESS

Colorfastness is a term used for the degree to which a dye holds "fast" to the fiber or fabric. A high or good fastness means that the dye does not fade in light, bleed or run in washing, crock or rub off in wear. Colorfastness is also measured to perspiration, seawater, pool water (containing chlorine), dry cleaning, weathering, various types of washing, fume fading, as well as finishing processes such as milling, decating, and others. A fugitive dye or tint is one that is easily removed; sometimes one is applied to identify a particular construction, e.g., for easy identification while it is being processed in a mill (British: sighting colour).

What Can We Deduce about Colorfastness?

Textiles texts written for fashion or consumer studies programs invariably discuss dyestuffs according to type or class, e.g., vat, direct, acid, etc., outlined in Section Five. While it is necessary to have some familiarity with these names, it is almost *never* significant to the consumer or retailer to be told how or to what fiber each type is applied. This is because none, with the exception of vat dyes, is ever identified as such when articles are sold, and *that* is when we wish to know something of what colorfastness to expect.

This anomaly in all available texts gradually dawned on me as I began teaching textiles to fashion students at Seneca College in 1968. Most of my working life before that was spent running a testing and development laboratory that served textile mills. Our greatest single effort was the development of formulas (recipes) for dyeing almost every fiber and combination. Putting that "inside information" to work, I have arrived at some generalizations we can make concerning the colorfastness to be expected of various fabrics: We do not know whether an article has been dyed with chrome, disperse, reactive, or whatever dye; we do know:

- of what fibers it is made
- the character of its color (bright, dull, deep, pale)
- the price range of the fabric or article (cheap, expensive).

Here is what you can deduce from this, working from the *fiber*.

Acetate

Acetate gives no trouble in dry cleaning, and most fabrics of acetate are dry-cleaned. It has only fair to poor fastness to washing; the hotter the water, the worse the fastness. Fume fading is a problem met with dyed shades on acetate: certain blue shades (or blue-containing, such as green or purple plus gray or beige) show a change to pink when exposed to the fumes formed when many fuels are burned (nitrous oxide fumes).

Dyes used are disperse, and while there are fume-fading-resistant members of this dye type, they are more expensive and are not generally used on acetate, since consumers' expectation of performance has been generally lower for acetate.

Acrylic

Acrylic shows good general fastness to care, including washing and light, no matter what the brightness or depth of shade. The cationic dyes used give bright, fast shades on acrylics, and other fast dye types are used as well.

Cellulose Fibers

Cellulose fibers (cotton, flax [linen], ramie, lyocell, viscose, cuprammonium, rayon, hemp) will all take the same types of dyes. In general, fastness is closely linked to price and quality.

Inexpensive products made of cellulose fibers, if made in a wide range of colors, will likely have only fair to poor fastness to wet conditions or to light, and very low fastness to chlorine bleach; they were probably dyed with direct dyes, which are not fast. I do not know of any effective home treatment to "fix" such dyes to make them fast, in spite of many "old wives' tales." Some inexpensive articles in limited and rather dull shades may show good fastness to washing and light, but will not stand up to chlorine bleach; these would have been dyed with sulfur dyes.

Deep shades (navy, burgundy) on moderatepriced articles could be fast to warm water washing, but not to hot water nor to chlorine bleaching; this will be the case if they have been dyed with direct developed dyes, which are more color fast and costly than the simpler direct dyeing process. More expensive articles of these fibers should have significantly better fastness. There are, for instance, direct dyes of very high fastness, but these cost more than those used on cheap items.

Highest fastness, though, comes only with dyes and/or dyeing methods that are very expensive; with these you get excellent fastness to even hot water washing, including heavy-duty detergent, and to chlorine bleach and light. These will be dyed using vat, naphthol, or reactive dyes.

Consumers may be suspicious of tags on some (usually cotton) articles, declaring the need to "wash separately," or "wash before use"; however, either is probably a reassuring direction, because deep shades on good-quality items such as cotton terry towels can exhibit a washing off of surface dye, as a result of complicated methods of application. If washed with like colors a few times, the excess dye will be removed, and the dye in the fibers will show its good fastness from then on (see Figure 6.6).

These top-notch dyes are vat and naphthol, with long and complex methods of application, plus reactive, which are expensive to buy, call for a lot of dye, and are tricky to apply. Reactive dyes are not quite as fast to chlorine bleach as vat or naphthol. Where highest fastness to chlorine bleach is needed (such as vat dyes can give), naphthol dyes may also be needed, for instance, to give a deep, "true" red, which does not exist in the vat dye range. Note the anomaly that some dyes of top washfastness bleed in dry cleaning solvent—naphthol bright red is one!

Although indigo, traditionally used to dye the blue warp yarns of denim, is a vat dye, as most of us

know, excess color does come off new items; a practical consumer's tip is to wash faded denim with a new blue denim article—that is, unless one *wants* the faded look.

Nylon

Nylon articles divide into two groups, pastel shades or deep colors, from which there are different expectations of colorfastness.

Pastel or light shades on nylon articles made of filament fiber, such as stockings and lingerie, will have only fair washfastness in anything but lukewarm water, no matter how expensive the garment. Disperse dyes must be used for pale shades on filament nylon to ensure level dyeing (no streaks or *barré*). Other, faster types can be used for deeper colors.

Deep shades may be quite washfast if they have been "fixed" on the fiber; you can expect this with good-quality articles and may get it even in cheap ones.

Whereas it is difficult to build up deep shades on nylon, the fiber takes up small amounts of dye very quickly. This leads to what is called "scavenging" of dis-coloring matter from wash water; pale or white nylon articles should be washed separately to keep a distinctive shade or bright white. Further, all parts of a set of nylon nightwear, e.g., gown and peignoir, should be washed together (the same number of times) to keep the shade the same in each.

If nylon becomes stained or dull-looking, it is probably from this taking up of color from other articles. Use the color remover sold with home dyes such

100% COTTON/COTON/ALGODÓN
MADE IN U.S.A.
FABRIQUÉ AUX ÉTATS-UNIS
HECHO EN E.U.A.
©SPRINGS INDUSTRIES, INC.
FORT MILL, SC 29716
TWIN/JUMEAU/INDIVIDUAL
FOR 39 IN Y 76 IN MATTRES

FORT MILL, SC 29716

TWIN/JUMEAU/INDIVIDUAL
FOR 39 IN X 76 IN MATTRESS
POUR 99 CM X 193 CM MATELAS
PARA 99 CM X 193 CM COLCHÓN

WASH BEFORE USE. WASH WARM, DARK COLORS SEPARATELY. NO BLEACH. TUMBLE DRY, LOW. REMOVE PROMPTLY. LAVABLE AVANT USAGE. LAVABLE TIEDE, LES COULEURS FONCÉES SÉPARÉMENT, NE PAS BLANCHIR. SÉCHAGE PAR CULBUTAGE, BASSE TEMPÉRATURE. RETIRER IMMÉDIATEMENT. LAVAR ANTES DE USAR. LAVAR A TEMPERATURA MEDIA, COLORES OSCUROS SEPARADAMENTE. NO USAR BLANQUEADORES. SECADO A TEMPÉRATURA BAJA. REMOVER RÀPIDAMENTE.

(a)

(b)

Figure 6.6 (a) U.S. care label with phrases in English, including warning to wash dark colors separately. (b) U.S. content/care label, in English, French, and Spanish.

as Rit or Tintex to strip color (use a rustproof pan and wear rubber gloves); then apply a brightener (see "Brighteners").

Polyester

Polyester dyed articles will not bleed, and do not pick up dye stains easily (but tend to hold oily stains).

Polyester is very difficult to get dyes into, unless it is a special, more dyeable form. Dyeing of standard polyester is accomplished in a reasonable time either by (a) using *carriers*—chemicals to swell the fibers—dangerous and unpleasant to work with, and largely phased out in the 1990s, or (b) dyeing in pressurized machines above the temperature of atmospheric boil reached by open machines (100°C or 212°F); at a temperature of 120°C (248°F), for instance, dye penetration is greatly speeded up. With polyester, then, once in the fiber, dyes will not come out easily.

Do not confuse dyed fabrics with printed; pigment prints on polyester may show rubbing off (crocking) of color.

Silk

Silk articles are generally expensive, but unfortunately there is no established connection between price and good wet- or lightfastness of dyes used on silk. Colors on silk give no trouble in dry cleaning. Now that more medium-price silk garments are marketed, usually as being washable, we may see a better level of fastness to washing, perspiration, water spotting, and light. Fast dyes for silk are available, but some old-fashioned basic dyes that have poor wet- or light-fastness are still used.

Triacetate

Triacetate (fiber little used now) usually shows good fastness to washing as well as to dry cleaning. Disperse dyes are used on triacetate, as on acetate, but since the consumer *expects* to wash triacetate articles, dyes of better fastness (to fume fading, e.g.) are chosen from this group, or the more expensive disperse developed dyes are used.

Wool and Specialty Hair Fibers

Dyes on wool and specialty hair fibers (cashmere, mohair, angora, camel, et al.) show good fastness in dry cleaning, so tailored apparel and many other

high-quality articles of these fibers are usually thought of as "dry clean only." Pale and/or very bright shades on wool are likely to have poor fastness to light; beware a shade such as aqua, for instance, in wool carpet or an upholstered furniture suite that will be exposed to direct sunlight!

If a wool item carries a "machine washable" label, you can assume that the dyes will be washfast under conditions suitable to wool washing. If there is no such label, you cannot assume that the dyes will be washfast, so even if you know how to hand-wash wool without felting, you must take care to test the color, as indicated under "Tender, Loving (Home) Care" for wool. Good wetfastness on wool can be achieved by moderate-priced dyes in dull shades: metallized or chrome (mordant) dyes. In bright shades, expensive dyes must be used: specially selected acid dyes, reactive, or even vat dyes. An added difficulty with pale, bright shades on wool is that the naturally creamy fiber must first be (carefully) bleached.

Home Dyes

Home "dyes" such as Rit or Tintex are mixtures of dye types (probably direct, acid, and disperse) able to cover cellulose fibers, wool, silk, nylon, and acetate, to roughly the shade shown on the package (*union dyeing*). These products will not dye acrylic, standard polyester, or olefin.

"Dyeing" at home presents a choice: get the color on fairly levelly by using a washing machine and the hottest water from the tap (not hot enough for fastness, even if these home dyes would give it), or dye in a pan on the stove, where you get the heat necessary for good dye penetration, but will probably find uneven shading from "hot spots," where the material settles to the bottom of the pan. A baffle (like a trivet) placed in the bottom of the pan can help reduce this hot spotting.

Brighteners: What to Expect of "Whiter Than White"

The glaring white on many textiles today is achieved by an *optical bleach* (see "Other Laundry Agents" regarding bleaches). Here is the fastness you can expect on various fibers: Cellulose fibers. Satisfactory and renewed with detergent washing.

Acrylic, polyester. Do not take up brightener in detergents, but those put on in manufacture of the fibers have good fastness to washing and light.

Nylon. Will not take up the brightener in detergents, but special products are sold as nylon brighteners.

Wool. Fluorescents available have poor light-fastness. If a wool article has one of these brighteners on it, the dye will break down after a relatively short exposure to sunlight, giving yellowing. This dye residue has to be removed before whiteness can be restored. Better to cultivate a taste for naturally creamy or less than glaring white wool!

6-4 CARE LABELING

Many countries have developed systems for labeling textile products to denote care, in some cases mandatory, in many others voluntary, but with a specific system available. In most, symbols are used to represent various aspects of cleaning and maintenance of fabrics, as a means of offering information without the use of language. But the question then is, do consumers readily understand the label directions? The debate goes on.

U.S. Care Labeling Rule

The Care Labeling Rule, drawn up by the United States Federal Trade Commission, was first passed in 1972, revised in 1984, especially as to the Glossary of Standard Terms, with alternative Care Symbols in place by 1999. The rule requires that textile clothing carry a permanent label giving one method of care safe for that article. There is no requirement to give all safe methods nor to warn about procedures that may not be safe (unless the product cannot be cleaned by any procedure). The Care Labeling Rule thus requires instructions either for home washing or commercial cleaning but may be modified to provide both, so that consumers would know if they could choose between these cleaning methods. Certainly commercial cleaners would prefer that both be shown if the article can be cleaned either way. Care information is also required for certain piece goods. If a product can be cleaned by all of the most severe methods, it does not have to carry a regular permanent care label, but should be marked "wash or dry clean, any normal method."

A glossary of short phrases to convey care instructions with an agreed-on meaning was developed. Labels are required to be in English (see Figure 6.6[a]), although the addition of other languages is allowed. This has become more significant under the North American Free Trade Agreement, which includes countries using French and Spanish as well as English (see Figure 6.6[b]). The revised rule and the glossary did address some of the misunderstandings that arose with earlier phrases, such as "no iron," which could certainly be taken to mean "needs no ironing" but which was intended to convey "do not iron." There is no national standard, inspection, or testing for how the label care instruction terms are

used. The system developed by the American Society for Testing and Materials (ASTM) D5489–01a, Standard Guide for Care Symbols for Care Instructions on Textile Products, may be used instead of words or combined with words (see Figure 6.7). The manufacturer or importer is responsible for labeling with an appropriate wording or symbol choice. No other symbol system may be used in the United States.

A discussion of just what these **symbols** mean should help clarify many aspects of systems used in many other countries as well (shown under Figure 6.8). The five basic symbols represent **wash**, **bleach**, **dry**, **iron**, and **dry clean**, and any that are used on a label must appear *in that order*. In all cases, a warning appears as the **symbol with a X over it**, to indicate DO NOT do that.

The **washtub symbol** (for washing) may seem archaic, since most of its references are to machine washing, but it is used because it is very difficult to devise a symbol that looks like a washing machine (some are front-loading) but is distinguishable from a tumble dryer. **Wash cycles** for machine are indicated by no line under the tub (normal), one line (permanent press), or two lines (delicate or gentle); a hand in the tub means hand wash. **Water temperature** is given by dots inside: from 1 (cool), through 2 (lukewarm), 3 (hand hot), 4 (hot).

Bleach is indicated by a **triangle**, indicating any bleach when needed, unless there are two lines through it, warning to use only nonchlorine bleach.

A square represents drying. The symbol for drying the most fragile materials represents drying flat, plus symbols for drip dry, linedry/hang to dry. Tumble drying agitation is given by no line under the square (normal), one line (permanent press), or two lines (delicate or gentle cycle). Tumble dry temperature is indicated in the circle in the square, which represents the dryer door, by no dot (any heat), dark circle (no heat/air dry), one dot (low), two dots (medium), and three dots (high).

Additional instructions may be included using either specific symbols developed for this ASTM guide, or words: do not wring, and dry in the shade.

Ironing is indicated by a hand-iron-shaped symbol. Dry or steam **ironing heat** is shown as one dot (low), two dots (medium), and three dots (high) in the same way as on an electric heating pad switch. Addition below the iron of a jet and an X indicates *do not use steam* (no steam).

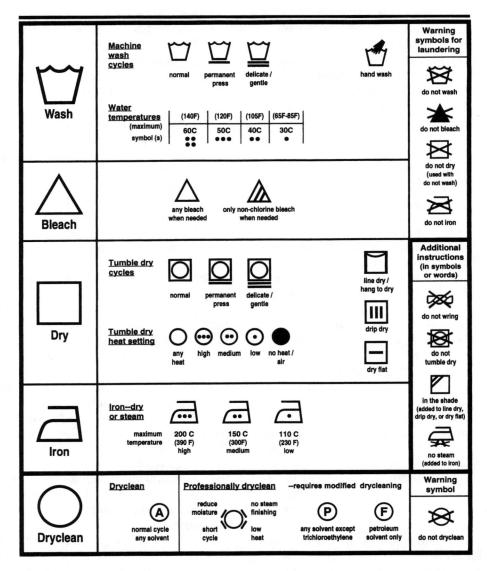

Figure 6.7 This figure has been reproduced by Prentice Hall under license from ASTM International. This figure is reprinted from ASTM Standard D5489–01a, Standard Guide for Care Symbols for Care Instructions on Textile Products, © ASTM International, 100 Barr Harbor Drive, West Conshohocken, PA 19428, USA (phone: 610–832–9585, fax: 610–832–9555, e-mail: service@astm.org, website: www.astm.org). Copies of the official standard should be obtained directly from ASTM.

A simplified and lively page is available to summarize the foregoing symbols: "Fabric Care Language Made Easy! If you know these symbols (wash, bleach, dry, iron), and these codes (more dots—more

heat; more bars—more gentle; X—do not) then you know the language!" This comes from the Soap and Detergent Association, developed in cooperation with the Federal Trade Commission (obviously for home

Care Labelling Symbols

(Wash tub)	95	95	60	60	40	40	40	30	30	30	LA LA	×	
~~	normal	mild process	normal	mild process	normal process	mild process	very mild process	normal process	mild process	very mild process	hand wash	do not wash	
_	The numbers in the washing tub specify the maximum temperature in °C which must not be exceeded. The bar underneath the wash tub characterizes a mild process with reduced mechanical action especially for easy car articles. The double bar indicates a very mild process especially for woollen articles.												
(Triangle)		\triangle											
\triangle	any oxidizing bleaching agent allowed					only oxygen/non-chlorine bleach allowed					do not bleach		
IRONING (Hand iron)						Ξ						図	
Iron at maximum temper of 200° C				re Iron					n at maximum sole plate emperature of 110° C		do not iron		
	The number of <i>dots</i> indicates the severity as regards to temperature of the hand iron.												
PROF. TEXTIL CARE	prof. dry cleaning normal process p			<u></u>		(Ē)			<u>(F)</u>		×		
(Circle)			prof. dry cleaning mild process		prof. dry cleaning normal process			prof. dry cleaning mild process		do not dry clean			
	The <i>letters</i> within the circle specify the <i>solvents</i> that can be used. The <i>bar</i> under the circle indicates a mild professional dry cleaning process, the <i>double bar</i> a very mild process. These may concern mechanical action and / or drying temperature and / or water addition in the solvent.												
	W				<u>w</u>			<u> </u>			1		
	professional wet cleaning normal process			pr	professional wet cleaning mild process			professional wet cleaning very mild process			Do no	ot wet	
	The <i>letters</i> within the circle specify the <i>wet cleaning process</i> . The <i>bar</i> under the circle indicates a mild professional dry cleaning process, the <i>double bar</i> a very mild process. These may concern mechanical action and / or drying temperature and / or water addition in the solvent.												
TUMBLE DRYING	\odot						\odot			8		₹	
(Circle in a square)	tumble drying possible normal temperature					tumble drying possible lower temperature						not le dry	
	The num		s indicates		ty as regar	ds to temp		•		cess.			

© by GINETEX Secretatriat at: SARTEX Beethovenstrasse 20, Postfach 2900, 8022 Zürich Tel. +41 1 289 79 49, Fax +41 1 289 79 80 www.sartex.ch / E-Mail sartex@sartex.ch

 $\textbf{Figure 6.8} \quad \text{International Symbols for textile care. These are trademarks registered with WIPO (World Intellectual Property Organisation) and are the property of GINETEX. (Courtesy of GINETEX) \\$

laundering, not dry cleaning); see www.cleaning101 .com/laundry/fabricsymbols.cfm. It would be good for staff training or light-hearted consumer use.

A **circle** represents dry cleaning, normal cycle, with **letters** inside as to which **solvent** is safe: A for any solvent; P for any solvent except trichloroethylene; F for petroleum solvent only. (It may be confusing to have this letter used in North American care symbols with a different meaning from that formerly used in Europe.) Additional instructions as to dry cleaning are given by lines in any one of four positions around the circle. As of March 2001, garments should not be labeled "Dry Clean Only" if they can be washed without harm.

Canadian Standard Care Labeling

Canada has long had a National Standard for Care Labelling of Textiles, similar in many respects to the systems used by other countries, but originally with extra meaning given through addition of the three traffic light colors (stop, go, caution). Since the previous edition of Fabric Reference the system has been redesigned to harmonize with the North American Free Trade Agreement (NAFTA) as well as the symbols in the ISO international standard, although none of the systems is considered final.

There is no chart here for the revised Canadian General Standards Board (CGSB) standard (CAN/CGSB-86.1-2003), but a very good *Guide to Apparel and Textile Care Symbols* can be obtained at: www.consumer.ic.gc.ca/textile—click on the PDF printable version.

- The symbols are familiar, but are now in black and white. The temperature of a treatment appears either in degrees Celsius or is defined by a series of dots, with less mechanical agitation indicated by one or two lines under the symbol.
- There is a hand wash symbol, a "do not wash," and where the tub has nothing in it, the meaning is to wash in a domestic or commercial machine at any temperature at normal setting. The water temperature indicated by the number of dots in the washtub symbol is the same as in Figure 6.7 up to 4 dots (hot), but goes on, higher than any usual consumer water temperature, with extremely hot

 $(5 \text{ dots} = 70^{\circ}\text{C or } 160^{\circ}\text{F})$, and to commercial laundering (6 dots = near the boil at 95°C or 195°F). As with the other systems, one line under the tub indicates a permanent press setting, two lines a delicate/gentle setting.

- The bleaching, drying, and pressing symbols all carry the same meaning as those in Figure 6.7.
- The earlier Canadian symbols in a square, representing drying, were adapted in the ASTM and ISO systems, but with the ISO system, the circle in the center touches the sides, to ensure no confusion with a front-loading washing machine.
- The Guide available on the website enlarges on the application of the safe temperatures given by the number of dots in the iron symbol, to list for which fibers each would be recommended—a very worthwhile addition.
- There are two differences between the ASTM standard and the Canadian to do with commercial or professional cleaning (the circle symbol). In the U.S. standard, a circle with an A inside means normal cycle dry cleaning, any solvent; Canada does not have this symbol. On the other hand, as with the ISO (GINETEX) system (Figure 6.8), Canada has a circle with a W in it to indicate professional wet cleaning (discussed under Commercial Wet Cleaning, earlier in this section). The ASTM felt that at the time D5489–01a was set, no firm standard had been worked out as to what professional wet cleaning meant.

One important aspect of the system often not understood is the number of symbols that must be used. There must be enough to enable the article to be restored to acceptable, usable condition. If bleaching, for instance, would damage an article, the label must give this warning. On the other hand, a warning should not be given just to be "on the safe side"—what is called "low labeling" or "underlabeling." This is a tendency to give care instructions for the mildest treatment (safest for the manufacturer to promise fastness), but not necessarily easiest for the consumer and still safe for the article; it can lead to those "hand wash" labels on children's play clothes!

Optional care information may be given in words (English and French) near or on the symbol label, e.g., "wash separately/laver seul."

Care Labeling—International Symbols

Care labels giving instructions by means of symbols have been found for years on textile articles from many countries, based on or following fully the standard set by the International Organization for Standardization or ISO (pronounced ice-o, not as three letters, since it derives from the Greek word meaning uniform, as in isobar for lines of equal pressure.) The ISO is based in Switzerland. The standard for care labels uses a system of pictograms formulated (and owned as registered trademarks) by GINETEX—the International Association for Textile Care Labelling, which licenses use of it to members. These symbols are adopted by ISO#3758: Care Labelling Code Using Symbols, published in 1991. revised 2005 (see Figure 6.8), with the sequence of symbols changed since then to place drying third in order (rather than fifth), according to consumer habits. Figure 6.8 also shows the trademark logo of GINETEX.

Many similar features have been discussed in the description of U.S. and revised Canadian systems already given, and so are abbreviated here in some parts, but with remaining differences pointed out. Until committees working on this standard as well as those in North America can come up with a single global system, there will be changes from time to time, as with the order of symbols mentioned above. These standards are worked on with the help of national organizations from many countries and have active input from all concerned with fabric care: manufacturers, retailers, various parties concerned with textile care, and consumers. It is noteworthy that thanks to the work done by GINETEX and its members, more than 95% of textiles in Europe feature care symbols.

- Symbols are printed in black only; a symbol with a St. Andrew's cross (X) through it means: "Do not use this procedure."
- As with the other systems, an open washtub represents washing by hand or machine; when there is a hand in the washtub, it means do not machine wash. Unlike the systems already shown, temperature of water for machine washing is indicated, not by dots, but by a figure inside the washtub symbol which is the temperature in

- degrees Celsius. Lines under the tub signal degree of agitation recommended: no line for normal process, one line for mild process, two lines for very mild process.
- A triangle with nothing in it indicates use of any oxidizing bleach is safe; two lines across mean use only oxygen/nonchlorine bleach.
- A circle within a square represents machine drying, and in the GINETEX system, the circle touches all sides of the square, to distinguish it from a front-loading washing machine. Dots indicate drying temperature: two for normal setting, one for lower temperature setting.
- A hand-iron-shaped symbol represents ironing or pressing. Heats low, medium, and high are given with one, two, or three dots.
- A circle represents professional cleaning. With the letter *P* or *F* in the circle, dry cleaning and the solvents that can be used are specified; a line beneath the circle means using a mild process, no line means a normal process. The GINETEX system also includes a circle with *W* in it, indicating professional wet cleaning (not the same as washing—see discussion under "Commercial Wet Cleaning" in 6–2, Commercial Cleaning). Here a bar under the circle indicates a mild professional wet cleaning, and two bars specify a very mild process is needed.

Care Labeling in the United Kingdom— HLCC System

The HLCC—Home Laundering Consultative Council—is a British trade association that helped develop, through the British Standards Institute, a system to indicate washing methods, using numbered symbols along with words. The numbers had appeared inside the washtub, but work to develop an ISO standard led to a compromise, whereby the numbers are used only in additional information, which includes directions in English, very like the phrases used in the U.S. care system. The HLCC website carries some information specific to U.K. consumers, but there are sections on "benefits of dry cleaning," and "caring for furnishing fabrics" which are helpful: www.carelabelling.co.uk.

Private Sector Labeling with Implications for Care

Trade Associations

A number of labeling schemes have been established by trade associations or interest groups in the private sector, as distinct from government-backed or -imposed systems. Among the most recognized and trusted are the Woolmark® and Woolmark® Blend, backed by the Woolmark Company. Symbols associated with the use of cotton do not have such a clear basis of quality, but are known by many, especially that of Cotton Incorporated.

Individual Companies

Private companies give many specific promises relating to textile performance, with development, quality control, and promotion done on their own. In fact, a great many trademark names can be taken to represent just this, since they are often not applied for

retailing until the quality standards of the owner of the trademark have been met. Where there is no trademark name, the items are often made of "commodity goods"—textiles which may be manufactured to minimum quality standards (see Section Two, "What Is a Trademark Name?"). Fibers and special yarns from all the major producers implicitly carry this type of assurance.

A company with a long record of delivering satisfactory performance along with their trademarks has been Cluett, Peabody, with Sanforized®, Sanfor-Set®, and other well-known finishes.

A leader in advanced performance textiles, W. L. Gore, has a total guarantee: "If you are not satisfied with the performance of your Gore-Tex® outer-wear, send it back to us, and we will either replace it, repair it, or refund your purchase price." Backing such a warranty means establishing a quality control program for all manufacturers using the Gore-Tex® fabric component—a sweeping commitment (for more on Gore materials, see "Compound Fabrics" in Section Four).

6-5 STORAGE OF TEXTILE ARTICLES

In most storage conditions, natural fibers and leather are acted on by many forces of dissolution: microorganisms, insects, chemicals, oxidation (light and weather). Few fabrics, therefore, are of great antiquity, much less in good condition. Some have been preserved by unusual chemical conditions (such as tar deposits) or by virtue of the dyestuff used on them. Aside from these, the best examples of preservation of ancient textiles have come from Egyptian tombs or certain caves. Conditions in these were ideal:

Dry, cool, clean, dark, dustfree (sealed).

Home storage, especially of winter articles in a climate of cold winter/hot summer, almost never provides this optimum combination. The article can be cleaned, it is true, and can be stored sealed, away from light. However, in most homes in summer, the only **dry** place would be an attic (who has one anymore?) and this would be hot, while in any **cool** place the air is usually fairly damp, especially in a basement. An unheated garage or cottage offers textiles a wildly varying "climate."

Commercial "cold storage" offers controlled humidity as well as a low temperature (dry and cool) that makes it essential for valuable articles. However, there is a home procedure that will give at least essential protection for any textile article, though commercial storage is recommended for expensive items such as furs, or for heirlooms or antiques (more on these under "Storing Vintage Textiles").

Basic Home Storage Procedure

The following steps make up a basic home storage procedure:

Location. Choose as **dry** and **cool** a location as possible.

Clean. Never store any article that is soiled, has been worn, or has perfume on it; wash or have it commercially cleaned (unless it is an heirloom or vintage textile that should have special conservation procedures). Stains can concentrate with time and attack fiber or color. Insect larvae will

eat any fiber with a protein stain on it. Do not use softener or starch when washing before storage.

Roll Some Fabrics. Roll linens or other items such as quilts rather than folding them for storage. It is good to pad folds in any article if it is not rolled.

Opaque container. Keep light out, or store in a dark place. Plastic film should not be used, as it is not moisture vapor permeable.

Protective fumes. Inside, at the top of the container, hang a perforated holder with moth crystals (paradichlorobenzene), which are much better than mothballs (naphthalene). The fumes from these crustals are heavier than air, so they drift down through the stored material. It is safer not to sprinkle the crustals directly among the articles, as some materials (e.g., vinyl) and dves may be damaged. Fumes also prevent mildew. Do not trust cedar to keep hair fibers or fur safe from moths; aromatic cedar has a reassuring odor when fresh, but is not an insect repellent: red cedar has never been claimed as a moth killer. Cedar chests generally gave an airtight container-all to the good, but not "mothproof."

Seal. Seal the storage container to hold the fumes in and keep out dust and dirt. If even after airing, the odor of moth crystals or mothballs persists when articles are removed from home storage, try a commercial cleaner who deals with fire insurance claims (smoke damage) or has an ozone generator (try drapery cleaners). There are not many, and the service may be costly.

Major Hazards to Textiles

Major hazards to textiles are listed here, with illustrations of the insect hazards (Figures $6.9,\,6.10,\,6.11$); the numbers serve as the key to the Principal Storage Hazards Chart in Figure 6.12, in relation to specific fibers.

 Mildew or other fungus growth thrives in damp, especially warm and damp, conditions. It can stain fibers, leave a musty odor, and will eventually rot materials. Cellulose is especially liable to fungal attack, but leather is also often ruined by mildew. Cotton towels left damp in

(a)

(b)

Figure 6.9 (a) Larvae of the webbing clothes moth and (b) carpet beetle do great damage eating protein fibers such as wool and fur. (Courtesy of Merrow Publishing Co. Ltd.)

Figure 6.10 A wool fiber showing mandible marks of the larva of a black carpet beetle. (Courtesy of Merrow Publishing Co. Ltd.)

warm conditions quickly develop a sour or musty odor. To avoid mildew, dampened linen can be held in a refrigerator or (if for longer than a few hours) freezer before ironing.

Bacterial rot is much less of a hazard in temperate climates than in tropical or subtropical

Figure 6.11 Silverfish eat what moth and carpet beetle larvae do not: starch and cellulose.

(Use the numbered list in the text as the key)

Fiber	Key #
silk wool, hair fibers leather, suede fur down rubber nylon other synthetics cellulose fibers flax (linen) acetate	6, 4, 5 2, 5, 4 1, 5, 4 (to color) 2, 1, 5, 4 5, 1 5, oxygen, oil 4 none if clean 1, 8, 3, 4, 5 also 7* none (to fiber) if clean; fumes (to
	colors)**

^{*}Store unstarched; pad folds, roll, or hang over a rod to prevent cracking.

 $\begin{array}{ll} \textbf{Figure 6.12} & \textbf{Principal Storage Hazards (in order of importance)}. \end{array}$

areas. Again, microorganisms grow best at body temperatures.

Clothes moth and carpet beetle larvae eat protein, even tiny bits such as nail parings or whisker clippings. Larvae of the webbing clothes moth and various types of carpet beetle

^{**}Fumes from burning fuels (furnace, gas stove) will cause fume fading; i.e., a change in many blue or blue-containing colors to a pinkish tone. Keep acetate away from such fumes (e.g., from heat vents) in storage or when hung in closets.

do millions of dollars of damage to valuable fibers and fabrics of wool and hair fibers plus furs. If a sample of yarn at a hole can be examined before cleaning, such "chomped" fibers provide definite identification of the reason for the hole! (See Figures 6.10 and 6.11.) Good "first aid" for an item found infested with moths, carpet beetles, or their wool-eating larvae is freezing—seal in a zipper plastic bag and put in a freezer for simple and effective eradication.⁴

- 3. **Silverfish and firebrats** are primitive insects that feed on cellulose or starch. They live a surprisingly long time (several years) and like undisturbed, dark places. Silverfish prefer those that are damp, such as basements, firebrats those that are warm, such as furnace rooms or a bakery (yum! starch and heat!). These insects eat cotton, linen, rayon, and other cellulose fibers, as well as paper; with wallpaper, they can enjoy both the paper and the starch paste. However, they are not nearly as great a commercial hazard as the protein-eating larvae. (See Figure 6.12.)
- 4. Light can oxidize some materials till they fall to powder. Two of the strongest fibers, silk and nylon, are tendered by prolonged exposure to light, although light-resistant nylon can be produced. Light will also yellow fibers and fade dyestuffs.
- 5. **Heat** will harshen and stiffen materials by drying them out, especially protein fibers and leather. Heat can also develop and concentrate stains.
- Perspiration, if allowed to age, first changes from slightly acid to slightly alkaline, and will then concentrate so that it can attack some materials, notably silk.
- 7. **Sharp folds** can cause a stiff fiber such as flax (linen) to crack. Repeated sharp folds in the same place can lead to splitting in tablecloths and napkins; it is better to roll them. Roll most carpets.
- 8. Acid attacks cellulose fibers, especially over time. Ordinary paper, cardboard, and unsealed wood are all acidic. For lengthy storage of special cellulose fiber articles, pad folds or line boxes, drawers, etc., with washed sheeting or acid-free paper, or use acid-free cardboard or olefin plastic boxes (obtain acid-free products from a museum or art supply company).

Storing Vintage Textiles

The handling of vintage or antique textiles in a museum is, of course, much more elaborate than the steps a consumer might take to preserve an heirloom fabric article at home. For a number of worthwhile references with a bearing on home storage and care, see "Storage and Conservation of Textiles and Vintage Articles" under "Teaching Aids and Resources." However, there are basics that are in keeping with professional conservation. If you have much-prized textiles and want to keep them for future generations you should follow carefully the home procedure already outlined for storage, particularly the steps to avoid the major hazards to fabrics. If the article is truly rare and valuable perhaps you should consider whether home storage can provide suitable conditions at all, since, as discussed earlier. great changes in the "environment," normal for homes, are harmful.

If you are dealing with a vintage item at home, first make sure there is nothing on it that can rust, such as pins, paper clips, metal backings on covered buttons, and such. The next step with many such items is vacuuming—this should be done with the fabric supported and shielded by nylon or glass fiber screening. Use a hand tool such as an upholstery brush and reduce the vacuum suction as when vacuuming drapery. However, it is hazardous to vacuum articles with much surface embellishment, such as beading, or embroidery.

Even after checking colorfastness, think well before embarking on washing an old fabric article; commercial wet cleaning may be far safer because the physical conditions and agents used are much closer to what professional conservators would use. However, if you do go ahead, support the article on nylon screening (with fragile pieces, stitch between two layers of the screening), and arrange a soakwash in a large sink or a bathtub. Conditions should be the same as outlined in this section for hand washing of wool, and soft water should be used if at all possible. Keep the fabric supported during rinsing and drying. Depending on bulk, shape, and fragility, store the item rolled, flat, or on a (padded) hanger; if hung, cover with well-washed sheeting, not plastic.

REVIEW QUESTIONS SECTION SIX

- What basic effect of water on some fibers calls for care in laundering? List those fibers, and summarize laundering directions for them and the other main generic groups.
- 2. Review the five main steps in home machine laundering to ensure as little need for pressing as possible. What is the most important part of this procedure?
- 3. Your wash hamper includes: white nylon underwear; light colored printed sheets and pillow-cases; mauve polyester nightgown; dark green acrylic sweater; celery green cotton T-shirt; dark green cotton golf shirt; deep brown bath towel; blue jeans. Which articles can you safely mix in a wash load, and at what settings of washer and dryer? Explain your choices.
- 4. Besides the possibility of felting in washing, what other reason is there for having wool or cashmere sweaters commercially cleaned?
- 5. Is the water in your area hard or soft? What effect does this have on home washing procedures?
- 6. Explain why soap forms a curd in hard water, whereas a synthetic detergent (syndet) does not.

- 7. Explain the process of *eutrophication*, including why phosphate salts were taken out of detergents. What are other sources of phosphates entering ground water?
- 8. What are three ways stains can become set in fabrics?
- 9. Name two common staining agents that are colorless at first, but darken and may be impossible to remove. What should you do to prevent this?
- 10. What advantages does commercial cleaning (dry or wet) offer compared to home laundering? What articles should be so cleaned? When does washing give a better result?
- 11. What is a *charged* dry cleaning system? What does this accomplish that solvent alone does not?
- 12. What type of solvent is most likely to be used by your neighborhood cleaner? (See also Investigation # 5.)
- 13. What can cause larvae of clothes moths or carpet beetles to chew holes in a fabric that is not made of wool or hair fiber? What general rule of storage does this emphasize?

INVESTIGATIONS TO DO WITH CARE OF FABRICS

- What are the expectations of colorfastness to washing, light, and crocking of: (a) an inexpensive dark-colored cotton canvas, to be used for slipcovers; (b) a tie-dyed silk hanging; and (c) navy blue polyester slacks?
- Examine care instructions in relation to fiber content and fabric type for five apparel articles, and five textiles used in furnishings. Comment on the suitability of each. Where symbols have been used, express what each means, according to a Guide in this section.
- 3. If available, try a Dryel kit and report your results (a team of four could share one kit, and up to four garments can be cleaned each time).

- 4. Visit three dry cleaners and ask each their prices and any extra services offered for: a polyester/cotton raincoat; a suede jacket; a beaded dress. Note if any is a member of an association such as IFI.
- 5. Perhaps as a team, find what types of commercial cleaners are in your neighborhood. What solvent is used? What other services, such as water repellency or mending, do they offer? Is there any wet cleaning?
- Find at least three trademarked items of sportswear or activewear that are new to you. Note what care is recommended and what implicit guarantee of performance is given. Do the same for broadloom carpeting.

- 7. Gather information on a Fabric Case History sheet (see Section Eight) for a fabric someone you know is making into a garment or using for home decorating. Make up a care label for it, using the ASTM symbol system.
- 8. (a) You have inherited a linen sampler, embroidered about mid-19th century. How should this be cared for? (b) Pick a bridal gown from a magazine or newspaper description, and outline what should be done to store it after the wedding.

NOTES SECTION SIX

- 1. "Low Temperature Laundering," *Textiles Magazine*, Vol. 30, No. 4: 5.
- 2. Michael McCoy, "Dry Cleaning Dreams," *Textiles Magazine*, Vol. 30, No. 4: 5.
- 3. Ron Eckroth, "The Lowdown on Ipura," Fabricare Canada, 2006 September/October: 11, p. 244.
- 4. "Moths, Shoes and Home Freezers," Footnotes: The Quarterly Newsletter of the Bata Shoe Museum, 2/2, Fall 1996: 7.

Fabrics and Ecology

7-1 CLOTHING AS ENVIRONMENT

For many urbanites in developed countries, by the third quarter of the 20th century clothing had come to have little functional relationship to our surroundings; one might even have to put on a sweater in airconditioned buildings in hot weather, and have little need for protection in cold weather, going from centrally heated homes, offices, and schools via heated transport to closed-in shopping malls or other complexes. Design and construction of seasonal clothing became much less a part of fashion aimed at the ordinary urbanite's wardrobe.

Various changes and developments in lifestyle in the last quarter of the century had a considerable impact on textiles and the uses made of them. We will focus on clothing to introduce this topic. There was a spike of interest in conservation of natural resources in the late 1970s, with the "energy crisis": clothing had to be changed to keep warm while using less fuel. at least by those who experience a really cold winter. Since then there has been the market impact of the large population segment born just after World War II. called "Baby Boomers," growing older. They have shown a determination to stay fit, and enjoy an active life. This has certainly affected design of apparel. fashionable but comfortable, with innovation and special developments, especially in sportswear. In the background, there has been a general growing concern in this 21st century about ecology, the environment and our relationship to it, in consumption, but also in production of goods. More on all this later in this section. Let us first look at the idea of clothing as our most immediate environment.

Comfort in Clothing

This Reference opened with the question: "What do we want in clothing?" The answer was, "We want clothing to make us look and feel good." More consumers are responding to textile products that have been produced with the environment in mind, and safety in use; discussion on this appears later in this section. We have also discovered anew that looking good will not necessarily result in our feeling good, and technologists have helped designers make this connection.

Two kinds of comfort, psychological and physiological, must be recognized. *Psychological* comfort drives the *eco-friendly* and *safety-guarding* developments that make us "feel good"; it has also been the core motivator of fashion—clothing with consumer acceptance and/or the individual appeal that makes you "feel good" because you "look good." Clothing that delivers *physiological* comfort, on the other hand, has either to follow traditional, tried and true forms, or consciously take into account how the body functions in the particular end use for which the garment is intended. To do that, innovative research is crucial.

Basic research into functional design until nearly the 1980s was carried on largely by groups developing workwear or military clothing, clothing that was anything but good looking! By now, though, fashion design has addressed itself with avidity to making special-purpose apparel appealing, using many technological developments that seem to spring up everywhere, including those that derive from research for the U.S. space program. The research still goes on, but more often now it is done from the beginning with consumer apparel and other textile products in view.

As with the "chicken or egg" question—which brings on which? It does seem that changes in consumer lifestyles have been key to the growing interest in making functional clothing fashionable. The basics of insulation in cold weather, for instance, have been well documented for decades, particularly by researchers for defense specialists for far northern countries who often studied the clothing of our Arctic peoples—the Inuit. In the 1950s, insulated garments were produced for the military at considerable expense, but there was no chance of getting these garments for even interested consumers until there was (a) more consumer demand and (b) acceptance of their look in fashion, or (c) new ways to achieve the result with a more acceptable fashion look, such as occurred when less-bulky guilted clothing was possible with Thinsulate™ instead of down.

Laboratories other than defense or space research institutes, but usually government backed, still develop clothing (often protective) for specific occupations, such as fishing, mining, or firefighting. Such basic research continues, monitoring the effectiveness of specialized materials in clothing. This may be done on real people, or by means of a "skin model," which can be computer directed.

Some of the complexities of measuring and recording clothing comfort with real people are involved in the testing shown in Figure 7.1. The bikelike machine is called an ergometer, and the wear comfort of an absorbent acrylic fiber in clothing is being tested in a climate-controlled room (temperature, relative humidity, and air speed are all controlled). A test subject "works" and rests for alternate periods. The person can record subjective feelings of heat and cold, of dampness of the test garment, scratchiness on the skin, etc.; the climatic, machine, and physiological data are automatically registered. The latter include pulse, skin temperature, humidity between skin and textile, skin conductivity as an indicator of perspiration, heat flow density to help indicate excess perspiration on the skin, and body radiation.

Tests using a "skin model" may be done with a complex instrumented mannequin like the one called "Copperman Charlie," used at the Hohenstein Institute in Germany (see Figure 7.2). In this case, clothing of Gore-Tex® fabrics is being tested in much the same way as outlined for a live test subject. The "climate" in the room for "Copperman Charlie" dressed in a Gore-Tex® fabric outfit will probably be more severe: cold, windy, and rainy, no doubt.

Figure 7.1 Ergometer testing of wear comfort of absorbent acrylic fiber in top worn by test subject. (Courtesy of Bayer AG)

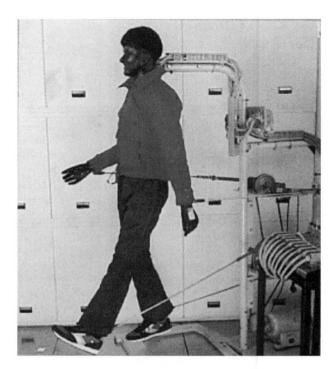

Figure 7.2 "Copperman Charlie"—instrumented mannequin—testing wear comfort of Gore-Tex® fabrics in clothing, Hohenstein Institute, Germany. (Courtesy of W. L. Gore & Associates, Inc.)

Basic Principles of Physiological Comfort in Clothing

Permeability to Water Vapor

This is now commonly recognized as a vital element of comfort in clothing that is worn for any extended period. Perspiration is essential to our temperature-regulating system; clothing must allow this moisture to be dissipated. (More on perspiration and its importance under "Warm Weather Tactics.") We throw off about a liter (quart) a day of *insensible* perspiration as vapor, diffused through the skin from the blood vessels; we never notice it until heat loss must be increased and we get drops gathering on our skin from the activity of the sweat glands. When we are really active this can be as much as 10 liters! If we are outdoors in the cold and fabric is not permeable, that perspiration vapor will condense on the *inside*.

In some specialized conditions, there is a need to prevent any penetration of clothing by water: very

heavy rain, waves hitting a small fishing vessel, water under high pressure from a fire hose. Fabric for articles worn in these conditions has traditionally been made waterproof but impermeable, e.g., oilskin or rubber-coated fabric. This kind of fabric is not allpurpose, however; it cannot be worn for long, or the wearer will be soaking wet, not from water coming from outside, but from perspiration inside! Many exciting developments have occurred in the category of fabric that can act as a layer permeable to vapor (perspiration) but not to liquid.

For outdoor activewear, it is especially important to have water vapor permeability in areas of greatest concentration of sweat glands: head, hands, and feet (see Figure 7.3). A design for footwear that is waterproof, insulating, and water vapor permeable is shown in Figure 7.4. A drawstring or lacing at the top of a boot keeps snow out, especially important for children's boots.

Head and Hands

These are two critical parts of the body in considering heat loss. It is relatively easy to prevent heat loss from the trunk, harder for the limbs, hardest for face and hands, yet much heat can be lost from the uncovered face and hands, by radiation, convection, and evaporation.2 If you are one of those who goes without a hat in cold weather, consider this: Heat loss from your unprotected head can be half or more of your body's heat production at a temperature of -15° C (5°F); in

Feet Sweat

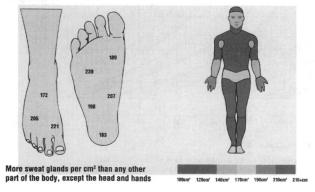

Figure 7.3 Concentration of sweat glands. (Courtesy of W. L. Gore & Associates, Inc.)

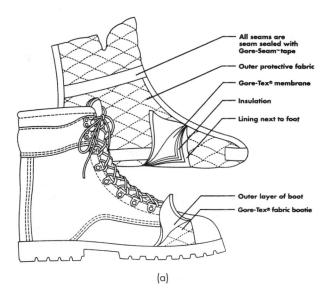

Figure 7.4 (a) Design of footwear that is waterproof, insulating, and water vapor permeable, (b) with appropriate Gore-Tex® footwear logo. (Courtesy of W. L. Gore & Associates, Inc.)

less chilly conditions, with even a light wind blowing, if your head is not covered and dry, you can still lose a quarter of your body's heat production (see Figure 7.9). Headbands protect only the ears and so are not an adequate substitute for hats.

Water Conducts Heat

Water conducts heat some 24 times faster than air: when fabrics get wet or damp, water replaces air, and the material can chill us quickly. We must guard against this. One important step that can be overlooked is the need to waterproof seams.

Insulation

Insulation prevents body heat loss when the surrounding air is cooler than body temperature. It is hard not to think in terms of "keeping the cold out," but there is no such thing as "coolth"—only absence of warmth! One of the most effective insulators known is still air; it is what we use in thermal windows (double- or triple-pane, with air between) or fluffy wall insulation. In windless conditions, clothing that traps air, such as a thick sweater, will prevent loss of body heat; if wind blows, a barrier must be present or heat will dissipate rapidly. (See the Windchill Chart in Figure 7.5.) We even call one such garment a windbreaker. Windstopper® (by Gore) fabrics were developed to provide insulation and wind protection in one light, vapor-permeable layer (see Figure 7.6). A truly "Space Age" approach to insulation is the heat-flow barrier (see "Microthermal" under "Added Value Finishes" in Section Five).

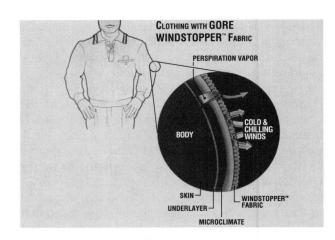

Figure 7.6 Action of Windstopper® fabric to protect the body's "microclimate." (Courtesy of W. L. Gore & Associates, Inc.)

WIND CHILL COOLING RATES * (Watts Per Square Meter)

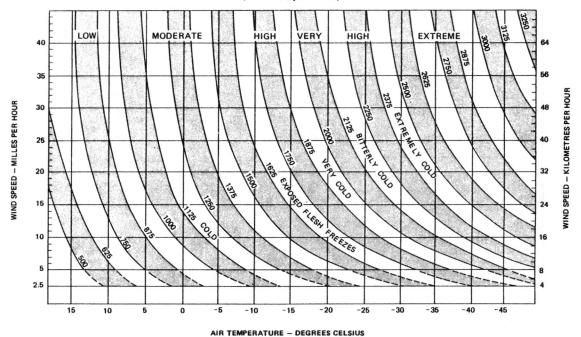

To determine the wind chill factor follow the temperature across and the wind speed up until the two lines intersect. The value of the wind chill factor can be interpolated using the labeled wind chill

Chart courtesy of Atmospheric Environment Service, Environment Canada.

For example, at -10° C with a wind speed of 20 miles per hour the point of intersection lies between 1500 and 1625, or approximately 1570.

It is not recommended that wind chill factors be calculated for wind speeds below 5 miles an hour, since it is difficult to determine wind chill factors at these wind speeds and because other factors such as relative humidity become important.

Figure 7.5 Windchill Chart.

factor curves

Heated Air Rises

Air warmed by the body rises and will escape from waist, neck, and head areas if the person is standing. A person lying down will allow even more heat to escape. In much high performance outdoor wear. mesh panels or zippers allow the wearer to release excess body heat; for example, those placed at underarms of snowboarding outfits are now called "pit zips."

Circulation of Blood

Blood circulation must not be impeded; what keeps us warm is our blood, and whether we wish to conserve heat or disperse it, clothing must not be too tight. Constricting clothing also squeezes out insulating air.

Density

Density is significant; a fiber of low specific gravity will be lofty, allowing warm fabric with little weight.

Basic Principles Applied: Traditional Inuit Clothing

Clothing Developed by Arctic Peoples

This is clothing that has kept people warm, living fulltime and for much of the year in very cold conditions. over some 20,000 years, and which still rivals our modern technology! These are the Inuit (pronounced in-you-eet, the name agreed upon at the 1977 Circumpolar Conference in Barrow, Alaska, to replace the word "Eskimo"), with 1997 world population approximately as follows: Siberia, 1,600: Alaska. 50,600 (10,300 urban); Yukon, NWT, Nunavut (Canada), 32,400; Kalallit Nunaat (Greenland), 51,650.3

The photos in Figure 7.7 are of some items of genuine Inuit garb, which would also include mitts, stockings, and mukluks (boots), as well as parka, and pants. (The terms given to the parts of clothing will in many cases be those commonly used by the rest of the population of the United States and Canada the appropriate ethnic terms will be found with an accurate description, tremendously detailed and well illustrated, in the text cited in endnote 3. Examples are shown in the outfit in Figure 7.7(a), plus another special-purpose garment pictured in Figure 7.7(b), with its detailed cut and waterproof seaming.

The parka for a man in many cases also has an extension at the back, like a shirttail, to give a sitting pad. A woman's parka (amauti) differs at the back hood to accommodate a baby; there is an apronlike front flap, and her boots or mukluks (kamiks) are much higher, with the pants shorter. The parka for winter wear is traditionally a double one of caribou skin, a layer fur side out and a layer fur side in. The skins are scraped to become quite permeable to water vapor yet still wind resistant. This is helped by the unusual nature of caribou hair: It flattens down in the wind, and each hair has a cellular, air-trapping core, providing more insulation. No underwear is worn traditionally—the person is naked under the pants and parka.

The genuine Inuit cut of the hood has no seam at the neck; the hood curves up to form an elflike peak in the back, then comes down in a perpendicular line in one piece with the back. The face opening is just large enough to allow the hood to be pushed back from the head in calm weather. The ruff of the parka shown in Figure 7.7(a) is rare wolverine fur because, better than any other fur, it sheds the frost formed by condensation of breath; this was found to be because wolverine guardhairs are thick, strong, smooth, long, and uneven. Soft fur of even hair length such as fox turns into solid ice if covered with vapor from the breath.

The traditional Inuit hood is cut so that it fits closely around the face, and although styles do vary across the Arctic, there is usually no front body opening. The rising heated air can be trapped at the waist and chin. The arrangement at neck and head is vital: it is called the air-capture principle. The sleeves on the Inuit parka are long enough to cover the hands and close enough to prevent cold winds from entering if the person is moving.

The pants of the Inuit ensemble have no front opening, but there is a drawstring or toggle/loop closing at the waist and perhaps at the legs; these and the stockings are double layered for winter, like the parka. Mitts and mukluks complete the clothing, which weighs only 4.6 kg (10 lb.).

Besides making careful choice and use of specific skins and parts of skins, Inuit women tailor and fit these garments, using darts, gussets, and easing, and sewing waterproof seams with caribou sinew (ivalu). with exquisite technique (see Figure 7.7[b]). All this produces what the author of Sinews of Survival called in an earlier article "the most appropriate,

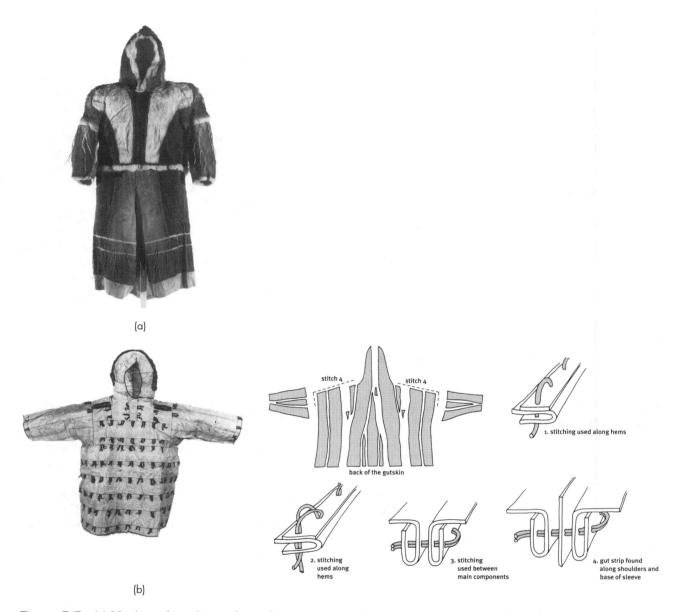

Figure 7.7 (a) Man's caribou-skin parka and pants, sewn with sinew, Copper Inuit, early 20th century.

(b) Gutskin (waterproof overgarment), walrus intestine, auklet beaks, and feathers, sewn with sinew. Collected at Sivuqaq, Alaska, by Henry Collins in 1930. Drawings show pattern, seams, and stitches for similar garments.

(Illustrations reprinted with permission of the Publisher from Sinews of Survival: The Living Legacy of Inuit Clothing by Betty Kobayashi Issenman [Vancouver: University of British Columbia Press 1997] each reserved by the Publisher.)

sleep an hour at a time hunched forward, sitting up, but if you lie flat in cold surroundings, retained air will escape so fast the chill will waken you in minutes.

efficient, sophisticated, and elegant clothing" to meet the extreme weather conditions in which the Inuit live a good part of the year, clothing that takes "great skill to make, repair, use, and maintain."

A person caught without shelter in a blizzard could literally "sit it out," pulling arms inside the parka—the

On the other hand, a person wearing such an outfit while moving, or when it is not so cold, can

easily let warm air escape (periodic ventilation) by pulling the garment forward at the front of the throat. or pushing back the hood, and by loosening the closure at the waist.

When Europeans came into the Arctic, most made changes that greatly reduced the efficiency of this clothing: Hoods were made large enough to go over a fur cap, making gaps that let warm air escape; front openings were made in the parka, a fly opening was made in the pants, and so on.

When we depart from the basic principles of cold weather dressing now, there are no drastic results in most cases, since we do not have to survive a blizzard in our clothing, but it is well to understand the superefficient clothing system developed by the Inuit.

Fashion and Energy

When we ignore clothing as environment and if we wish to keep comfortable indoors, we put more emphasis on heating and cooling (air-conditioning), using energy to accomplish both. This energy is derived largely from nonrenewable fossil fuels, especially for heating systems. While some energy sources are renewable or huge in supply, such as hydroelectric, tidal, wind, nuclear, solar, wood-burning, wood alcohol, and hydrogen power, it seems unlikely that we will be able to ignore basic questions about our use of energy.

Technology has allowed us to ignore climate in cities, but it has also allowed us to develop remarkably functional special-purpose clothing (discussed in Sections Two, Four, and Five). These have served to counter the rigors of climate for any of us, and also provide space suits, armed forces clothing, all kinds of special work-wear, and active sportswear. Most of these advanced, highly engineered materials are made of synthetic fibers. In case you recall that they, too, have needed petrochemicals in their manufacture, the small amount involved was noted in Section One. Figures consistently quoted into the 1980s assigned only about 5 percent of oil used worldwide to making chemicals, plastics, and fibers, with the most being used for fuel. Figures for the United States indicated that synthetic fiber manufacture accounted for only 1 percent of the petroleum used and only half of that for actual feedstock or raw material, while the whole U.S. chemical industry used only 5 percent of the total. These percentages did not change markedly through the 1990s. Most hydrocarbon fuel in the United States is used to heat homes, offices, and factories; the percentage is undoubtedly higher in Canada, Renovations of large office buildings are expensive, but have yielded huge savings in power bills as well as offering environmental benefits in reducing carbon dioxide emissions. Energy-efficient lighting fixtures are installed, and changes made to heating, ventilation and air conditioning.4 Such "environmental retrofits" do give impressive results and have a major impact in a city, but changes can be made at home, too.

Cold Weather Tactics

To conserve body heat indoors in cold weather and so reduce a hefty fuel consumption, we can investigate the efficient use of clothing and furnishing fabrics to help insulate ourselves or a room. It is worthwhile to emphasize cold weather tactics, since the benefits of conservation in cooler climates can be great; steps to take to keep cooler and save energy in warmer climates or warm weather are discussed later in this section.

It helps if the home is well insulated and tightly built. If so, turning a thermostat down three Celsius degrees (five Fahrenheit degrees) overnight should reduce fuel consumption by about 5 percent; setting it back six Celsius degrees (ten Fahrenheit degrees) should cut fuel consumption by about 8 percent. If you also turn the home thermostat down during workday hours, a three Celsius (five Fahrenheit) degree reduction should net about an 11 percent fuel cut, and a six Celsius (ten Fahrenheit) degree downturn should give about a 15 percent lowering of fuel consumption. A tight, well-insulated house may not even cool this much while the thermostat is lowered. However, with an old, underinsulated, leaky house, the thermostat could be turned down more, as the inside temperature will drop much faster.

A note of caution: When dealing with babies or the elderly, we should be aware of the dangers of hypothermia, body temperature too low for safety. Elderly people can suffer hypothermia at a room temperature that would seem just uncomfortably cool to others: between 10°C (50°F) and 18°C (65°F). If you go in for this fuel-saving effort, you will certainly have to change what you wear at home to stay comfortable, and change what you wear when you come home from frequently over-heated offices, schools, or shopping malls.

Another aspect of energy savings comes with laundry care of fabrics (washing, drying, pressing); a revealing chart can probably be obtained from your electric or gas company recording energy use and approximate monthly cost for various home appliances. Some programs will test and rate appliances according to efficiency in energy use, with a labeling system to inform the consumer at point of sale. Water heaters are a major energy user: there are many ways to cut hot water usage (and bills), from repairing leaking hot water taps to installing water-savers on taps or shower heads. It is also of significant help to insulate the first 1-2 m (yd.) of hot water pipe from your water heater. A main step is to lower the temperature control setting; this is usually all to the good, except for having less of a disinfecting action in the washing machine. A water level control on a clothes washer can save water and energy, and front-loading machines use less water than top-loading. A clothes dryer that shuts off automatically as soon as the load is dry will save energy and your clothes.

Clothing for Cold Weather

The **air-trapping principle** can be applied to everyday, indoor clothing both in materials used and in clothing design or selection. Heat can be kept from escaping at the neck with a turtleneck or a convertible type of collar that can be worn open or closed; blouson tops and drawn-in pants are available in lounge- and sportswear; sleeves can be long or have a turn-back cuff. Warm slippers lined with cozy pile or foam are available. It is hard, though, to keep hands warm in a cool room—great-great-grandmother's fingerless gloves, anyone?

Several layers of light fabric can be more flexible, and so more comfortable, than one thick layer, and will trap air between layers, especially if made of resilient fibers. A light, long-sleeved sweater has been estimated to add about 1 C degree (0.6 F degree); a heavy sweater can add 2 C degrees (1.2 F degrees), and two light sweaters about 2.5–3 C degrees (1.4–1.7 F degrees).

Air spaces in fabrics provide insulation, and we incorporate them using constructions such as foam, cellular knits or weaves, napping, pile (double faced even better than single), double woven or doubleknit fabrics, or batts of loose fiber quilted or otherwise held to other layer(s).

To maintain air spaces created in napped, pile, or quilted fabrics, we use materials that are **resilient**

(springy). Fortunately, most of these are also of low density or specific gravity, so we can have a lot of airtrapping volume with little mass—these are lofty materials that give us warmth with little weight: protein (wool and other hairs, silk, down), acrylic, and polyester. Special forms of some fibers have air-trapping channels to improve the insulating ability of a given amount; see "Modifications of Manufactured Fibers," Section Two. See also the explanation of insulating value measures (tog and clo) under "Metric in Textiles Study," Section Nine.

The general guide in fabrics for warmth used to be that insulating value varies directly with the thickness of a fabric, unless a very thick material is also very open in construction. This guide has been true because fibers do not keep us warm—they simply trap the still air that can. This rule is no longer valid when some new factors are introduced, such as microfibers, which have tremendous surface area and so have increased air-trapping power: this is made even more effective when the microfibers are olefin (polypropylene), the lightest fiber we have, used in Thinsulate™ (by 3M). This gives so much fiber surface with so little mass that a relatively thin layer will provide insulation equivalent to a down laver nearly twice as thick. The 3M website (www.3M.com) offers excellent, accessible information on Thinsulate products, and the whole subject of keeping warm.

Stretchy fabric should not be put over insulating (air-trapping) layers, as it will compress them and reduce insulation. If it is a power-stretch fabric, it will also reduce blood circulation.

Wind has to be taken into account when selecting or designing apparel and accessories for use outdoors in cold weather; see the windchill chart in Figure 7.5. Unless air is still, we need an **outer wind-resistant layer**, since wind blowing against "thermal" materials will reduce or destroy the air-space insulation. Such a layer should still be permeable to water vapor, whether or not it is water resistant or waterproof. Less high tech but more traditional, closely woven fabrics have also been used as windbreakers: Gabardine (twill weave) and satin have been used, since in these weaves, yarns can be packed closely together. Microfibers have been used here to give an exceptionally wind- and water-resistant fabric with no special finish at all (see Figure 2.79).

Inner layers need to be **permeable** and either be **absorbent** or **wick** to let vapor through and to take up sweat from the skin.

Plain weave is regularly used for ski- and rainwear, because it is strong for its mass; plain weave taffeta in a tough fiber such as nylon or polyester can be calendered using heat and pressure to flatten and close up the yarns—giving ciré. Since such a thin fabric, even of tough nylon, can tear, it is often made in a "rip-stop" form, with occasional heavier varns in a crossbar effect. With some cotton fabrics, e.g., Shirley Cloth (developed by the Shirley Institute), the swelling action of the cotton fibers when the cloth is wet is counted on to close up the pores in the fabric.

Other approaches to keep the elements out, for fabrics of cotton or its blends, are to apply waterrepellent finishes to, for instance, poplin, or to apply a permeable coating such as microporous polyurethane. These and other fabric systems for inclement weather are discussed in Sections Four and Five.

A traditional "natural fabric" for winter outdoor wear is fur, although for maximum insulation, we should wear it with the permeable and wind-resistant skin side out and the air-trapping hair inside.

A wind-resistant outer fabric shell with a removable insulating liner such as pile is a good textile combination. A fashionable but accurately designed garment that goes a step further is Linda Lundström's Laparka® (see Figure 7.8); a water-repellent. machine-washable nylon shell may be worn by itself as a windbreaker or over the wool duffel coat, which may also be worn by itself.

Head protection is vital, as outlined under Basic Principles of Physiological Comfort. Yet so many people do nothing about headgear in even the coldest weather, due in many cases to peer pressure to be "cool"—and they will be (see Figure 7.9).

Fasteners for cold-weather clothing, if they will be close to the skin, should be plastic, not metal. If metal is used, there should be a covering placket, fastened outside with buttons or toggles. Zippers (especially for children's wear) should be large for outdoor use, when fingers may be clumsy with cold; on a long jacket, a two-way zipper should be used to allow the wearer to sit or bend without the jacket riding up. Velcro® is also a very good fastener for cold-weather outdoor wear.

Furnishings to Retain Warmth

Foam-lined drapes keep drafts out; carpet with foam, cellular, or fibrous underlay (unless one has in-floor heating), draft-inhibiting rugs, and other window and

Figure 7.8 Laparka® features two layers, worn separately or together: a wind- and water-repellent. machine-washable nylon shell and a wool duffel coat. (Courtesy of Linda Lundström Ltd.)

doorsill guards are all helpful. Wing-sided chairs keep one cozy—remember the basic principles—you will feel chilly faster if you stretch out on the couch. Articles that might be classified as either home furnishings or clothing are air-entrapping wraps and throws such as afghans. In cold parts of the country in the late 1970s, the "Snug Sack" was offered, a guilted comforter-cum-wrap. It was a great help, but the upper half was not well designed. Every few years some form of this gets reinvented; some years ago it was a "comfy bag."

Warm Weather Tactics

Regulation of Body Temperature

Keeping cool in hot weather is difficult, especially when it is humid with no breeze, because an essential cooling mechanism of the body is evaporation of perspiration, taking care of about a quarter of body heat. When body heat and perspiration cannot be lost, we feel both hot and sticky! We lose about a liter (quart) a day of perspiration as vapor, without even knowing it (called insensible perspiration); it is only when more heat must be lost that sweat glands give off

Figure 7.9 When it's "cool" to wear no hat. (For Better or For Worse ©. Universal Press Syndicate. Reprinted by Permission.)

drops of moisture on the skin, and we are aware of sweating. This regulation of body temperature takes place at our skin, from perspiration formed mainly by the two to five million eccrine glands deep in the skin, taken to the outside openings (pores) by coiled tubes. Of course, when one perspires a lot, salt should be replaced.

Clothing for Warm Weather

Besides the cooling comfort bathing gives, we can choose clothing that helps: absorbent and porous fabrics, in garments that are loose to let air circulate. especially where perspiration glands are concentrated—on the back, the front of the chest, forehead. palms of hands, soles of feet, underarms (see Figure 7.3). To keep these areas open for evaporation, we should draw hair back from the forehead and up off the neck; select garments with a low-cut neckline, no sleeves, and no belt; and make sure our hands and feet are bare—not all possible at the office! There can be a "bellows effect" to help cool the body if air can be pumped across the back when the arms are moved. An air vent near the small of the back area will allow air to be pulled in there during movement and the upward movement of warm air will push it out at the neck.

Fabrics, as well as being absorbent, light, and porous, should also be crisp and of spun yarn, so as not to cling. A good deal of research has been done to achieve coolness in other than traditional informal summer wear.

With summer wear, we often have to balance comfort against ease of care. Fibers such as cotton, flax, viscose, and lyocell, with good absorbency, can wrinkle badly. They either take a lot of thorough ironing, or, if a Durable Press finish with resin has been applied, they lose absorbency and can lose strength. Newer finishes leave cotton soft while giving it wrinkle resistance; see Section Five for more detail. An easy-care fiber like polyester absorbs little in its standard form, although some do wick; more absorbent forms have been developed, and these, plus blends with absorbent fibers, are proving effective (see Section Two, including "Blending of Fibers").

Furnishings to Keep Out the Heat

Remember grandmother's cool summer parlor (maybe that was *great*-grandmother's)? If the air is cooler in early evening, open windows and doors to let the house cool all it can overnight. Close windows and blinds and draw drapes early in the morning. Sun-control film can be of great help on east- or

west-facing windows that receive sun when it is lower in the sky and are hard to block with awnings: awnings are better for south windows. These films reflect heat, to help in cold weather, too.

SunScreen exterior shading fabrics (by Phifer) are woven of fiberglass in a unique ribbed weave designed to block a good deal of the sun's heat and glare. This fabric can be installed as a regular screen is, even using the same frames, and it also will keep out insects, but let air through. It has good outward visibility, but adds daytime privacy to windows.5

Sun Hazards

Sun hazards come from both the heat of the sun, and ultraviolet (UV) light rays (about 6 percent of sunlight), which do not feel warm, and cannot be seen. In general, in hot weather, we are warned to protect skin from the sun's UV rays with hats, light-weight clothing cover, sunscreen cosmetics, and even parasols. A sunscreen should be applied about 15 minutes before you go outside and renewed after swimming or sweating. We should especially protect the head from the sun's heat when we are outdoors in hot weather, but other protective clothing is needed; watch infants and the elderly especially carefully in fact children in general, because they have more skin area in relation to body weight, thinner skin, and three times the annual sun exposure of adults. Babies are especially at risk, since, regardless of how fair or dark their skin, they are not born with a developed skin protection system. Also, they cannot tell us if they are in trouble with the sun, nor can they get themselves into the shade. Avoid exposure to sun when the rays are strongest, as much as possible; this will be approximately two hours before and after "solar noon"—whatever time the sun is highest. Sun can penetrate light cloud cover, fog, and haze; it is reflected off sand, snow, and water. Use lots of sunscreen with an SPF (see below) of 15 or more, and reapply every 2 hours if you are working or playing outdoors.

The sun's ultraviolet rays are divided according to three ranges of wavelengths: UV-C are the shortest (100-280 nm), and do not reach us; UV-B (considered the most damaging) are medium in wavelength (280-315 nm) and cause delayed tanning, burning, and aging of the skin; UV-A are the longest (315–400 nm) and cause immediate tanning, as well as aging and wrinkling of the skin. Holes in the ozone

layer allow more UV radiation to reach Earth. It is estimated that every 1 percent drop in stratospheric ozone will increase the rate of skin cancer by as much as 2 to 3 percent.

It is well to remember that there are considerable hazards from UV rays whenever sunlight is reflected. because you get hit twice—with direct and reflected radiation (e.g., 80 percent additional off snow). There is also reflection off ice, water, sand, and even concrete. Furthermore, for all kinds of trekkers in mountainous country, UV exposure increases 8-10 percent for every 1,000 feet of elevation.

Glass filters out UVB, and many auto windshields have been treated to filter UVA partially. A transparent UVA-filtering film has also been developed for vehicle side and back windows, and for use on house windows as well. The Skin Cancer Foundation has a Seal of Approval to verify effective products (see www.skincancer.org). The SunScreen products from Phifer are also discussed just before "Sun Hazards," as a means of exterior shading fabrics.

Research goes on investigating whether and how textiles can protect skin against UV. A good deal of early research was done by M. Pailthorpe, a textile scientist from Australia, where there is the highest incidence of skin cancer in the world. Professor Pailthorpe equated fabric properties to penetration by light to develop an Ultraviolet Protection Factor (UPF) and relate this to a sun-protective factor (SPF) that can be assigned to clothing as well as sunscreen lotions. Many aspects of a textile affect its UPF: fiber type; yarn; fabric construction, including cover, thickness, elasticity, luster, and color; and finishing, including dyeing and printing procedures.

Of the many aspects of a textile that affect its UPF, we can start with the fiber. A number of UV resistant types in nylon, polyester, and others are now made, in many cases including ceramic UV absorbers, notably titanium dioxide, and several using a bicomponent structure.6

In contrast, cotton is quite permeable to UV rays; an ordinary cotton T-shirt has an SPF of only 15 dry and 5 when wet. Wool fabrics, on the other hand, were reported to offer high protection.⁷

Evolon (by Freudenberg) is a sun-protective nonwoven made of filament with a triangular (reflective) cross section in microfiber, which makes a dense fabric with excellent cover, and also contains titanium dioxide. A general description of Evolon is under "Nonwoven, Spunlaced," Section Four.

Finishes are also applied to give sun protection. Silicone rubbers can not only increase strength of high-performance fabrics and supply water repellency, but also will filter out UV-B rays (see Figure 1.2 showing textiles used in windsurfing treated with Wacker silicones).

Professor Pailthorpe (Australia) ranks **fabric cover** as by far the most important factor in sun protective clothing, and this is involved also when a fabric is stretched (less cover) or wet. With water in the interstices of a fabric, there is less scattering of light than when the material is dry (air in the spaces) and more UV is transmitted. (It is the same as the optical effect that can make a wet T-shirt see-through.) Dermatologists recommend a minimum SPF of 15 wet or dry for hot weather clothing; when clothing gets wet or damp, the SPF factor is reduced by more than half. This can happen from perspiration, which also washes away sunscreens applied to the skin.

A widening choice of sun protective clothing has come on the market. One line was produced using fabrics developed in Australia, without special finishes, and claims well over 30 SPF protection, whether the fabric is wet or dry. These are $C\text{-}Tex^{\text{TM}}$ garments carried by C-Shirt Canada of Victoria, BC (see Figure 7.10). Solumbra® (by Sun Precautions®)

Figure 7.10 This mother has protected her child and herself from UV rays with outfits of $C\text{-}Tex^{TM}$ fabric, developed in Australia. It gives a sun protection factor (SPF) of well over 30 wet or dry. (Courtesy of C-Shirt Canada)

offers a wide line of clothing and accessories based on a 30+ SPF fabric. Figure 7.11 shows a Sun Cape from Sunsense $^{\text{TM}}$, made of a special fabric, Solarweave $^{\text{\tiny{\$}}}$, to protect children's sensitive skin from both UVA and UVB rays.

Two others usually mentioned on some excellent websites are: Sun Protective Clothing, and Coolibar, the latter Australian, but selling by catalog in the U.S. and Canada. The websites are those of the Skin Cancer Foundation, which has a Seal of Approval for effective products: www.skincancer.org; Dermatology Associates of Kentucky: www.daklex.com; and www.sunsafecity.org.

Suitable clothing can, of course, be found in general catalogs and store merchandise, such as L.L.Bean, Travel Smith, Tilley Endurables, and others. If you are shopping, hold the fabric of a garment up to the light; the Skin Cancer Foundation comments that if you can see through it, UV radiation can penetrate it—and your skin. An ordinary white cotton T-shirt has a UPF of only about 7, and that is when it is not tightly stretched, and dry. A long-sleeved, dark, closely woven shirt could have a UPF of 1,000 up to denim at 1,700—complete sun block.

Figure 7.11 SunSense articles, made of Solarweave®, a special fabric which gives an SPF well over 30, are designed to protect the very young—especially vulnerable to skin damage from UV. (Courtesy of SunSense)

Above all (literally), wear a broad-brimmed hat (8–10 cm [3–4 in.]), or carry a parasol! About 80 percent of skin cancers occur on the head and neck, so we need to shade face, ears, scalp, and neck. It is difficult enough to get a positive response to advice to wear a hat in cold weather—what can be done about the universality of the baseball cap in hot weather. which is woefully inadequate to protect ears and either neck or face, depending on which way the peak is worn!

Besides all this, we should be wearing an effective UV screen product, one designed just for giving better protection and as part of a cosmetic foundation. Look for those that protect against both UVA and UVB. Consider your eyes, too, and wear good sunglasses. which give protection against UVA and UVB.

A valuable laundry product available online or in stores such as Walmart is Rit SunGuard. This colorless dye is safe for sensitive skin and gives clothing a UPF of 30, which lasts through 20 washes.

Do not let numbers carry you away; an SPF of 30 screens out only about 2 percent more of UVB rays than one of 15. The FDA has banned claims of SPF higher than 30+, so do be sure to have protection, preferably against UVB and UVA, of at least 15, and make sure all your vulnerable skin is covered.

A **UV Index** has been developed in a number of countries to convey the day-to-day hazard of sun exposure, for example in weather reports. In the United States, exposure levels at the solar noon hour are given from 1 to 11+, with risk taken as: 0-1, minimal; 3-4, low; 5-6, moderate; 7-9, high; and 11+, very high. An informative website from the Environmental Protection Agency is: www.epa.gov/ sunwise/uvindex.html; this includes color mapping of the index by date for the continental United States. as well as other significant information. A number of other countries have a UV Index, but there are variations in the basis among these. It is easy to see that the scale itself, the time of day the reading is taken. consideration of cloud cover, and skin type used as the base for measure of "minutes to burn," are among many possible variables.

Color of cloth makes a difference. Some dyes absorb UV rays as well as visible, and the deeper the shade is, the better the protection, with black and dark blue being the best. However, bugs are reported to be attracted to blue, and there is a psychological effect of light blue and green seeming "cooler" than red or orange. Selecting closely-woven or knitted fabric for sun protective clothing should be your main aim for protection from UV rays.

7-2 TEXTILES AND ENVIRONMENTAL CONCERNS

Eco Concerns-How Green?

Having explored and recorded the contribution of textiles to human comfort, we must take a much wider focus to trace our continuing concern with ecology, defined as "the totality or pattern of relations between organisms and their environment." Interest in all things labeled "Green" has been both brought on and followed by the appearance of a myriad of products and services of varying validity, sincerity, and effectiveness!

"Eco concerns" were pushed first by warnings of danger to all of us if there were not concerted action to protect the environment, then pulled by the developing consumer acceptance that these predictions were legitimate and must be heeded. Next, action has been strongly propelled by government legislation in many jurisdictions, eventually impacting on both consumer and business activities.

Many voices from the scientific community said the earth could not sustain the industrial and population growth we were imposing, and that we did not have much time to make changes. Air and water pollution, deforestation, desertification, gradual warming of the planet, destruction of the ozone layer that shields us from ultraviolet radiation, acid rain—many of these problems need action on a global scale.

There is a United Nations Framework Convention on Climate Change (UNFCCC), generally called the Kyoto Accord, from the city in which it was signed, which came into force February 16, 2005. This represents the pledge of some 141 countries, accounting for 55 percent of greenhouse gas emissions (excluding large, developing countries including China, India, and Brazil), to reduce these by stated amounts in a given period. However, the United States is not a signatory. The overall hope is to deliver a "healthier, fairer, and more resilient world"—sometime.9 The European Union did set aims for reduction in greenhouse gases: 20 percent by 2020, and individual aims have come from member countries, e.g., the U.K. for a 50 percent reduction by 2050. Many commercial sources and citizen groups also are suggesting ways to go "carbon neutral"—make savings in energy use to try to balance their own consumption; or to work for production of our consumer textile goods that considers the environment, the people who provide the components at all stages, and the disposal of used items.

Some outstanding textile developments coincide with this hope. One was Tencel®, the lyocell CMF introduced by Courtaulds (now by Acordis). As well as the fiber being both absorbent and strong, the process uses a solvent for cellulose that is of low toxicity and virtually all recovered, so the fiber, made from a natural, renewable material (cellulose from trees), is genuinely "environmentally friendly."

However, an even more significant accomplishment has been the success in *synthesizing* a fiber generic such as PLA, with outstanding properties, biodegradable, and from annually renewable resources, using a process that does not harm the environment. Another synthetic fiber, the first elasterell-p, has a component, Sorona, for which carbon is derived from annually grown crops, rather than petrochemicals. (See Section Two for detail on all of these.)

There has been interest in use of what are called organic fibers. The earliest was cotton fiber colored naturally, as it grows. Instead of bleaching out this natural color, in the 1990s it was celebrated, thanks to the cross-breeding experiments of Sally Fox, growing the results in Arizona and Texas. She branded it Foxfibre® (see Figure 7.12), and since these colors

Figure 7.12 Label indicating use of Foxfibre® naturally colored cotton.

grow best without applying chemicals, she calls it Colorganic. The most frequent shades are various browns and a kind of celery green, soft tones that originate in wild cottons, which are shorter and weaker than standard upland varieties. Naturally colored cotton varieties represent less than 0.3 percent of the total U.S. crop. However, the program continues and the colored cottons are being improved to meet modern spinning technologies. Consult www.vreseis.com for developments, or to get varn.

Naturally colored cotton has been used in a varietv of products: Figure 7.13 shows some of the coordinated line of home fashions called Eco-Ordinates™ offered by Park B. Smith. To make these, naturally colored cottons are used with some that are dyed, but with natural dyestuffs such as natural indigo, acacia bark, madder root, onion skins, and pomegranate rinds.

Many odd and unusual minor fibers, either natural or made from an organic base, have been mentioned as coming into more use: hemp, bamboo, seaweed, nettle fiber, and others. These are of interest

Figure 7.13 Home fashions made with Foxfibre® cotton in natural colors or cotton dyed with natural dyes. (Courtesy of Park B. Smith)

as eco-friendly (hemp requires little if any pesticide or fertilizers), and/or because they are absorbent, therefore comfortable. Sometimes they have other interesting properties, such as being antimicrobial, or helping wounds heal. A Natural Technology™ has been developed by Burlington Worldwide with TrapTek to use activated carbon particles, derived from coconut shells, permanently embedded in the textile, to give an evaporative cooling effect, as well as UV protection, and odor resistance. This is aimed at activewear, and performance clothing, but also anything from home furnishings, through pet beds, to automotive products.

A "green" process to apply indigo for blue jeans varn came from research done at Genencor International in Palo Alto, California. Genetically modified bacteria use sugar as their raw material and create the indigo pigment—still more expensive than sunthetic indigo using fossil fuels (coal, oil) for raw material.

Research by CSIRO in Australia developed a "clean, green" processing at all stages for Australia's fine wool, which meets the European Union's Ecolabel standards.

Textiles' Impact on Water and Air

Water Pollution

In North America, for most of the few hundred years of settlement from Europe, lakes and rivers have been used as convenient sewers (as has the ocean. but most of us do not get our drinking water from the salt seas). The Great Lakes, shared by the United States and Canada, hold one-fifth of the freshwater on Earth and four-fifths of all the freshwater in North America, so the early settlers could be forgiven for thinking nothing could pollute them. However, we have succeeded in doing that thoroughly, making fish and other water life unfit for consumption and water unfit for swimming. Reports to the International Joint Commission on the Great Lakes have revealed high levels of toxic chemicals in the "smaller" of these natural marvels we have taken for granted. Dr. David Suzuki, a passionate and informed proponent of guarding the environment, reminds us of the eternal cycling of natural materials of which we are a part. We are made up of over 70 percent water, which could have been at one time part of an ocean, a rainforest, or the Serengeti plains. 10 We cannot lay all the responsibility of water pollution on the textiles industry, but it does use a great deal of water.

The textiles industry focused early on cleaning up wastewater (effluent) from mills in general and converters in particular, which use so much in finishing—scouring, all that stone washing and other pre-washing, and traditional water bath dyeing. Various levels of treatment are necessary, very much like municipal water treatment: primarily, to clarify wastewater by removing suspended material and dissolved compounds, then secondarily, to get rid of microbial pollution. Finishing using nanotechnology can reduce the need for these traditional treatments dramatically.

In textiles operations, besides the possibility of toxic chemicals in the waste from wet processing, there is offensive residual color from duelots. One fascinating paper dealt with this particular problem at a 1992 AATCC Symposium on "Environmental Awareness: Targeting the Textile Industry." A research team at North Carolina State University successfully used chitin (see Section Two) and a derivative chitosan, both obtained from ground-up crab shells. Chitin is the most abundant organic compound next to cellulose, which it resembles greatly in structure, as a polymer based on a sugarlike unit (compare Figure 2.58 with Figure 2.57). These compounds, and especially chitosan, removed dyebath residual color completely and guickly, for all types of dyes except basic!11 A similar conference in the United Kingdom reviewed a number of ways to remove color from wastewater; ozone treatment was found to be very effective.

Dyes that leave little or no undesirable residue in the wastewater are termed low-impact dyes, but it is very difficult to relate this to certain dye types (classes), much less to natural versus synthetic dyes.¹²

For end users of textiles—consumers—major efforts to reduce water pollution focus on what goes out with the wash water, and large detergent companies have taken *all* phosphates out of heavy-duty detergent compounds. Phosphate is still a major agent in most machine dishwasher powder detergents, unless no-phosphate products are sought out.

Loss of Fresh Water

One environmental problem with a different twist is that of water, not polluted, but disappearing. In many parts of the world, a process called *desertification* is proceeding, a terrifying inroad on the small percentage of the earth's land that produces food. One example linked to textiles is the shrinking of the Aral Sea in Uzbekistan, which was the world's fourth largest lake, and which may disappear in another few decades. Water was diverted from two rivers that used to flow into the Aral, for irrigation of cotton farms in what was then part of the U.S.S.R., but suggestions to reduce cotton crops to help the Aral meet considerable resistance. The lake's changed state is blamed for climatic changes, such as windstorms, and some say it could affect the climate of the world.

Air Pollution

Some dyeing and finishing departments or plants must address air as well as water pollution; many still have coal-fired boilers, contributing to emission of sulfur dioxide into the atmosphere, and so to the formation of **acid rain**. Burning any fossil fuels also produces carbon dioxide, the main "greenhouse gas" responsible for holding the sun's heat in the atmosphere, leading to now-acknowledged climate warming.

Solvents other than water are used, not so much in production but in care of textiles. Chlorinated hydrocarbon solvents were discussed in Section Six, and of late years, choices for dry cleaners have been reduced while regulations for safer use of the solvents have multiplied. This is in line with the general drive to reduce or eliminate chlorofluorocarbons (CFCs), which can destroy the ozone layer in the stratosphere, which protects us from very harmful effects of ultraviolet radiation in the sun's rays. Substitutes have been and are being found that will not have this effect and can be used in refrigeration systems, for instance, or in dry cleaning. By taking chlorine out or by adding hydrogen into the compounds, less harmful products have been worked with.

Chlorine again figures as a villain with polyvinyl chloride (PVC or vinyl), more common as a coating or film in textiles than as fiber (vinyon). It is seen as the largest source of **dioxin**, an especially long-lasting and toxic compound created as the vinyl is being made or even when finally disposed of, as in a land-fill. A PVC-free wall covering is discussed next, under "Recycling." Concern with chlorine, connected to the formation of dioxin or just on its own, brings us back again to water; chlorine use is being reduced or eliminated, for instance, in the treatment of pulp and

paper, in efforts to improve water quality; this has been a thrust of the International Joint Commission.

Recycling

Many of the most positive developments coming from environmental concerns have been in recycling of everything from chemicals, through fiber waste, to creative reuse of finished textile products.

Wellman, Inc. has been a pioneer and leader in this type of effort over a long period. Fortrel® EcoSpun® is a high-quality polyester fiber made by Wellman from recycled plastic pop bottles; the path of the recycling is shown in Figure 7.14. Wellman has the capacity to keep almost 3 billion plastic PET soda bottles out of the world's landfills each year, saving over half a million barrels of oil and eliminating 400,000 tons of harmful air emissions. EcoSpun is used alone or blended with other fibers, mainly for vests, jackets, pants, blanket throws, and accessories, but also in carpets, home furnishings, and as fiberfill.

Malden Mills makes a branded Polartec* Recycled Series, made at least 50 percent of recycled polyester. Malden calculates that an average-size jacket will keep some 25 large 2 L (2 qt.) beverage bottles out of landfills.

Interior designers have been specifying more recycled polyester textiles for offices and other contract work, for carpets, wall coverings, upholstery, draperies,

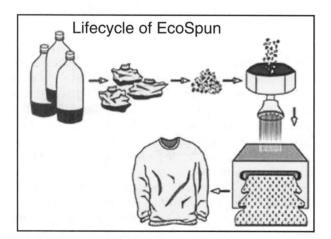

Figure 7.14 "Life cycle" of Fortrel® EcoSpun® polyester, recycled from PET polyester bottles and producer waste, as developed by Wellman, Inc. (Courtesy of Wellman, Inc.)

and other window treatments.¹³ However, olefin has also been promoted on the grounds that it is easier to recycle after its first use than polyester. Further, it is cited as the most environmentally "friendly" of the petrochemical-based synthetics in other ways.

Marquesa® polypropylene yarn (by American Fibers and Yarns) is made from material reclaimed from the petroleum refining process. It melts at a lower temperature than others, requiring less energy to manufacture, in a simpler process with a minimal amount of by-products and is recyclable. As an olefin, Marquesa wicks, and has the advantage of stain resistance without a special finish, good for mattresses and other strong properties noted in Section Two.

A wallcovering of olefin was developed to have environmental advantages. Earthtex™ (by Designtex) was the first PVC-free woven wallcovering. Earthtex has an olefin warp, while the weft is made with a solution-dved polypropulene (PP) core, coated with a blend of PP and polyethylene olefins (a PVC coating has been traditionally used); this gives a soft, supple yarn, suitable also for upholstery. Because the components in Earthtex are all of the same generic group, the trimmings and waste from making the wallcovering can be recycled. As well as being PVCfree, there are no heavy metals or plasticizers, so it is inert and nontoxic in a landfill, if it is disposed of. It is solution-dyed and so colorfast to cleaning. The company is also planning to make the standard backing of PLA, which is water-soluble and removable, unlike (cheaper) acrylic, so that eventually the entire wallcovering could be recycled. Earthtex was aimed first at health care buildings, with corporate use and many other applications also appropriate. 14

One company, 3M, has maintained a Pollution Prevention Pays (3P) program for over 30 years. From 1975 to 2005, the program's records show it prevented more than 2.5 billion pounds of pollutants and saved over \$1 billion, based on data from the first year of each 3P project. A key element is prevention of pollution at the source, rather than removing it after it has been created. The company has involved its employees, and reports saving money as well as improving the environment with its initiatives. It gives an enormously encouraging message.

A small firm in Ontario, Eco Fibre Canada, found and patented a way to recycle waste from the production of cotton consumer goods in North America. This waste is turned into yarn and clothing using no harmful processes (see Figure 7.15).

Figure 7.15 Products made from Eco Fibre™ recycled cotton waste. (Courtesy of Eco Fibre Canada Inc.)

Old-fashioned recycling has gone on in woolen goods for centuries. Used material, torn apart back to the fiber stage (garnetted), can be respun and rewoven or reknitted into sturdy fabric called **shoddy**, which did not originally carry the stigma we now associate with the name.

Carpet is another giant source of material for recycling, and can account for large volumes of material. When nylon 6 (caprolactam) has been repolymerized, it can be used as if it were virgin fiber. This cuts down not only on water and air pollution, but also on what goes into landfill.

An immense and ambitious national program came out of the Invista Carpet Reclamation Center, based in Calhoun, GA. It offered to recycle all types of carpet, of any fiber, and from all commercial dealers. The Center would provide containers for collection and trailers for transport, if needed, or deliveries could be made directly to the Center. By January, 2005, the Center had collected more than 100 million pounds of carpet, resulting in more than 370,000 cubic yards of conserved landfill space—a

huge accomplishment. Invista $^{\text{TM}}$ Interiors, manufacturer of Antron® nylon carpet fiber, is also active in maximizing the environmental advantages of using carpet made with this fiber; carpet specifiers can use online tools to assess this at www.antron.invista.com.

Automotive interior fabrics are another huge pool of material, but have proved to be very difficult to recycle in the most-used form: a compound material held together by lamination with polyurethane foam. Separation of this assembly seems impossible, so research is directed at developing 100 percent non-woven polyester fabrics that will do the job and would be recyclable.

Those in business who agree see a great need to educate and train people in waste minimization and hope for economic incentives that will encourage participation. One concept is that of "duty of care" on the part of the seller of goods, to be sure that they come from sources that are environmentally responsible. Otherwise, domestic manufacturers bear an unfair load of responsibility that may be avoided by foreign suppliers.

A battle has gone on between disposable and cloth diapers, since this is a large market, and arguments can be made on either side as to impact on the environment. As to convenience, cloth diapers have been redesigned, and there are diaper services to see to laundering. However, disposables have more than held their own in this marketing struggle.

Unusual Fabrics of the 21st Century

Biotechnology

Biotechnology is the application of the processes of living organisms to industrial and other uses. This area of research and development is expanding in all directions with dizzying speed—certainly faster than the body of opinion of those who debate ethics and philosophy can come to grips with, much less that of the ordinary citizen. So *Fabric Reference* can record only some of the work in this area to do with textiles.

Probably the earliest to make a real impact on the public was the first-time cloning of a mammal using a cell from an adult animal—a sheep, with progeny named Dolly. This research was carried out at the Roslin Institute, Edinburgh, with the aim of applications in curing genetic diseases such as cystic fibrosis. When Dolly the lamb was shorn for the first time in May 1997, the wool was eventually made

into a sweater, according to a winning design from a competition among schoolchildren (see Figure 7.16). A sample of the fleece and the story of this world's first is displayed in the Science Museum, London. What has happened since makes that initial breakthrough pale by comparison. The Canadian laboratory Nexia Biotechnologies, working over two years. produced a fiber that gave some of the ballistic properties hitherto unique to the wonderful fiber spun by spiders (see "Spider Silk," Section Two). A spider's protein lines can absorb a relatively enormous amount of energy of impact, and yet are fine and light. Nexia introduced crucial genes from spider's silk protein into the DNA of African pygmy goats work involving transgenic technology, and also the world's first cloned goats. Milk from these goats contains the protein, which can be retrieved. Nexia has concentrated on production of this recombinant dragline spider silk Bio Steel® protein, with specialized nano-scale fiber applications. 15,16 The ultimate possibilities of this first effort are not expected to be reached for some years, but the general method has already spawned many others, obtaining protein

Figure 7.16 The first fleece shorn from Dolly, the cloned sheep, went to make a prize-winning sweater designed by Holly Wharton, who wears it here. With her are actress Jenny Agutter, and Steve Melia and Barry Greenwood of the School of Textile Industries, University of Leeds, where the historic lamb's wool was processed. (Courtesy of School of Textile Industries, University of Leeds)

from other animals such as the cow and hamster. DuPont's research arm has also worked with spider silk and their aramid fiber, Kevlar®, to improve material for articles such as bullet-proof vests.

Even more "far out" is work done in Japan at the Kyoto Institute of Technology, implanting a jellyfish gene for fluorescence into female silk moths. After mating with normal male moths, about 3 percent of the resultant larvae spin glow-in-the-dark filaments. and the fluorescent gene has been passed down to other generations of larvae. This effort is not aimed at getting a fashion color in silk, but rather to create what could be a marker to trace the effect of various genetic experiments.17

Other "Forward" Developments

Light has been brought into and through textiles in a number of developments, from fashion showstoppers to serious medical applications. 18 Fiber optic cables in bedding can bring therapeutic blue light to jaundiced infants, and hospitals investigate the relaxing effect of light. In theater and fashion, a number of light-emitting or -changing properties give fascinating effects—see Holograms in Fabric Glossary. Wallcoverings have been developed that a lot of us might like to experience: nonwoven fabrics are inlaid with low voltage colored light strips, which can twinkle or be dimmed.19

"Smart Fabrics"

This is one name for textile developments that are often far from traditional; other terms are "clever clothes," or, to take in other uses, "intelligent textiles." What is essential with these is that they interact with their environment or electrical stimuli. The earliest areas of use (and source of the research capabilities to develop them) are usually for military, industrial, or health uses, and performance clothing.

Fabric Reference opened with an example of an interactive textile in Figure 1.1, showing control of electronic components such as an MP3 player, headphones, and a microphone, through switches in a watertight and impact-resistant keypad embedded in the sleeve of a jacket. Another in this category developed by Interactive Wear is called the "Know Where" GPS/Galileo jacket. It has a Global Positioning System terminal with the antenna built in to an epaulet on one shoulder for optimum reception of GPS signals. The

GPS over IP, or Internet Protocol, also allows the unit to know the person's position inside a building.

In home furnishings, we can have (eventually) electronic elements in pillows, curtains, or chair arms to control lights, or remote control for TV.

Many interactive textiles have a medical application, from rather frivolous (getting one's Vitamin C through the skin from a T-shirt, or from other garments infused with medicinal or soothing remedies such as herbs or seaweed), to an electronic bra which could be used to scan for possible breast cancer with less discomfort to the person than having a mammogram. Other significant applications are fabrics and clothing with built-in sensors that can monitor the body's vital signs, which could alert hospital staff to a patient's condition or keep track of one already discharged, provide warning for parents of babies at risk of sudden infant death syndrome, inform military medical teams as to soldiers who may need immediate assistance, or aid athletic trainers. One developed for women's sports and fitness use is a heart-sensing NuMetrex sports bra (from Textronics). Electronic elements in the fabric pick up the electrical pulse of the heart, and radio it to a monitoring watch or a fitness-machine monitoring device.

Besides these, sports articles such as footwear can record speeds and distances, and something like a bar code can be introduced into fabric to identify the wearer, or authenticate ownership. Other advanced materials can be included in garments to give camouflage protection by altering color as surroundings change, or in patches that would change color in the presence of harmful chemicals, or with changes in temperature. An "airbag jacket" for motorcyclists has been designed to inflate and protect the rider. An even more 21st-century development can be used to protect the body in dangerous circumstances by use of inserts of the Dow Corning® Active Protection System fabric, as described in "Fabric System with Impact-Hardening Layer," Section Four (see Figure 4.92). The amazing dilatant silicone in this "spacer fabric" can be built into any part of, e.g., a courier's jacket, or motorcyclist's gear, and is guite comfortable, but hardens under impact, and then becomes flexible again. Use of power stretch tights is being worked on to help blood circulation and prevent blood clots for crew or passengers on long flights.

A number of compound fabric systems (Section Four) and/or finishes (Section Five) have also been

mentioned that work to adjust body temperature in varying conditions, with increasing use of nanotechnology. Beyond these, work is progressing to use electronics to alter the behavior of fibers so that fabrics adjust to weather, for example, for water repellency or insulation.

One of the most futuristic aims of innovations in textiles is self-cleaning clothing. One effort from Hong Kong Polytechnic University worked with the fact that titanium dioxide, especially in nanoparticles coating a fabric, when exposed to sunlight, breaks down (oxidizes) carbon-based stains. Footwear manufacturers also dream of a nanocoated shoe material: add an antimicrobial agent while you are at it, and you have the possibility of a shoe or boot with a surface that is super-soil-repellent, will not be affected by perspiration, and could self-heal if scuffed.²⁰

All these developments seem able to bring about changes almost without limit. In reality, most of these innovations require experts from very different disciplines to work together, and this is not always easy or possible. There are also questions of safety, with electronics built into clothing and household furniture, and of how to conserve or dispose of such complex articles.

Another aspect is finding how to get apparel designed and made, then merchandised to the demographic segment given many names, from "Baby Boomers" to "Best Agers." They present a growing market with disposable income, who are "naturals" for the kind of smart textiles discussed in this edition. The difficulties were outlined by the first Director of a Smart Clothes and Wearable Technology research network, part of a multidisciplinary U.K. program examining many aspects of the dynamics of aging: "This growing market could benefit from the functionality of sports apparel for everyday 'lifestyle' clothing with its light-weight, wicking, insulating, protective, cut for movement, easy care, compact and comfort attributes." "21

It will be a challenging career to be part of achieving solutions to many of these problems. We have seen already a good deal of fashion pulled forward by highly technical research and its applications, rather than, as in the past, by designers. At the core of that concept of 21st-century fabrics are all the possibilities conveyed by the quote given in the Introduction to Fabric Reference: "Textiles can be anything." You couldn't have a wider field than that to work in!

REVIEW QUESTIONS SECTION SEVEN

- 1. Explain why the fabric for a cold weather outdoor garment must be water vapor permeable yet water resistant or waterproof (VPWR) for maximum efficiency. Name three other factors that must be considered for comfort.
- 2. Which articles of clothing present the most challenge to keep us warm in cold weather? What part does fashion play in this?
- 3. How does traditional Inuit clothing meet the criteria set in Questions 1 and 2, even in the extreme conditions of an Arctic winter?
- 4. List four ways in which interior furnishings can contribute to keeping a room (or person in it) warm in cold weather.
- 5. What can be done to keep a room cooler in hot weather (other than an air conditioner)?
- 6. What parts of sunlight are dangerous to humans, and in what wav?
- 7. List five aspects of fabrics that are important in producing sun-resistant clothing. Which is rated most important?
- 8. What level of Sun Protection Factor (SPF) should you look for? Is there a maximum?

- 9. What two outstanding manufactured fiber generic groups have been developed that are "eco-friendly," and why? Describe one such natural fiber, with reasons why.
- 10. Discuss the use of naturally colored fibers in terms of the environment, and impact on the marketplace.
- 11. What are three special pollution problems to which textiles production can contribute?
- 12. What are two outstanding examples of success in recycling that involve the textiles industry?
- 13. Name two main aspects of biotechnology that are involved in producing Biosteel®spider silk protein.
- 14. List ten examples of use of "smart" fabrics, either already on the market or being developed. Have you used any of these? If so, describe. If not, which would you most like to try, and why?
- 15. What kind of use of "smart" textile article would you introduce if you had with you a team with the technical knowledge to develop it?

INVESTIGATIONS TO DO WITH FABRICS AND ECOLOGY

- 1. Find an article of outdoor wear (or design one) that meets the criteria for cold weather clothing set out in Review Questions 1 and 2, and explain how it accomplishes that.
- 2. Examine several articles of high performance cold weather clothing. Where have similar principles to those of Inuit design been followed and where has modern technology allowed for effective insulation using different techniques?
- 3. As a fashion designer or merchandiser, propose at least one way you could encourage people to wear a hat for warmth in cold weather and for protection from UV rays in times of high sun hazard.
- 4. Try to find clothing with SPF ratings, compare these, and comment on their likely effectiveness in terms of the type of fabric used, the design of the garment, and its intended use.
- 5. Find or describe articles of clothing that are not especially promoted to be UV resistant, but which are; explain why.

- 6. Note whether an Ultraviolet or UV Index figure is given with weather reports (radio, television, or internet). What is the scale, and what do the various levels mean in terms of possible sun damage? Discuss how this varies with individuals over a range of skin colors.
- 7. Find an example of business or community concern for the environment. It might be a news story of countering pollution, recycling, planting trees, or an advertisement that explained an ecological advantage in a product.
- 8. Research/debate which of lyocell (e.g., Tencel®) or PLA (e.g., Ingeo™) presents the greater advantage compared to a fiber generic made using hydrocarbons for raw material (e.g., the most-used fiber, PET polyester) as to production and recycling. Take into account source, renewability, processing energy used, effect of production on the environment, properties of the fibers (advantages and disadvantages) for clothing and interiors/household

- textiles use (absorbency, strength, flammability), recycling, or biodegradability.
- 9. Can you find an example of biotechnology applied in textiles in a news story or information with a marketed product?
- 10. Find an example of an article of clothing or textile furnishing with development driven more by advanced technical function than design in the classic fashion sense.

NOTES SECTION SEVEN

- 1. The International Oeko-Tex Association, "Basic Thoughts on Ecology," *Textiles*, 2006 No. 3: 23.
- 2. D. M. Kerslake, "Physiological Aspects of Comfort," *Textiles For Comfort*, papers from the Third International Seminar, Shirley Institute, Manchester, U.K., 1971.
- 3. Betty Kobayashi Issenman, Sinews of Survival: The Living Legacy of Inuit Clothing, Vancouver Press, 1997.
- 4. Brian McAndrew, "TD Centre reno expected to reap green rewards," *Toronto Star*, May 5, 1999: B1.
- 5. "Protecting Your Home From The Sun," *The Textile Journal*, February 2007: 14.
- 6. Jürg Rupp, Andrea Böhvinger, Akira Yonenaga, and Prof. Dr. Hoachim Hilden, "Textiles for protection against harmful ultraviolet radiation," *ITB International Textile Bulletin*, 2001: 8–20.
- 7. Lado Benisek, "Protection against solar (UV) radiation," *Textile Horizons*, June 1999: 25.
- 8. M. Pailthorpe, "Sun-protective clothing," *Textile Horizons*, October/November 1996: 11–14.
- 9. "The New Climate Almanac 2007," *The Globe and Mail*, Globe Focus Section, February 17, 2007: F1–F7.
- 10. David Suzuki, "Paying Attention to the Warning Signals of Nature," *The Toronto Star*, March 24, 1990: A2.
- Brent Smith and Sam Hudson, "A Novel Decolorization Method for Textile Wastewater Using

- Crabshell Waste," AATCC Symposium, March 19-20, 1992, Charleston, S.C.
- 12. Brian Glover, "Are Natural Colorants Good for Your Health? Are Synthetic Ones Better?" *Textile Chemist and Colorist*, 27/4 April 1995: 17.
- Elaine Gross, "Commodity No More, Polyester Leads With Innovation," *Textile World*, November 2001: 33–40.
- 14. Janet Bealer Rodie, "Walls of Earthtex™," *Textile World*, October 2005: 66.
- 15. "Canada: Scientists Spin Their Own Spider Silk," http://www.just-style.com, 18 Jan 2002.
- 16. Nexia Biotechnologies Inc., "Technology, Bio-Steel®," www.nexiabiotech.com/en/01_tech/01-bst.php.
- 17. "Green light for genetic success," *Textile Horizons*, April 1999: 27.
- 18. "Tomorrow's World: Let There Be Light," Textile Horizons, October 1998: 17.
- 19. "Heimtextil Exhibitors Show Color Diversity in Collections," *Textile World*, March 2003: 13.
- 20. Ian Holme, "Nanotechnologies for Textiles, Clothing, and Footwear," *Textiles Magazine* 2005, No. 1: 10.
- 21. Jane McCann, Director, Smart Clothes and Wearable Techology, "Is there an expanding market for functional textiles?" *Textiles*, 2007, No. 1: 1.
- 22. Matilda McQuaid, editor, Extreme Textiles (New York: Princeton Architectural Press, 2006): 30.

SECTION EIGHT

Fabric Assessment

8-1 FABRIC ASSESSMENT— HOW IT'S DONE

An experienced technical specialist in textiles once said, "Fashion is not enough!" What he implied was that fabrics and clothing must perform adequately in use and care. Textile engineering is as important as design to the consumer, and with the burgeoning interest in and awareness of functional apparel, the results of technology have become a part of everyone's life.

Textiles are tested not only by the fabric manufacturer, but also by those closer to the consumer, such as garment makers, and retailers, or by customers (e.g., an architectural firm), in their own or a certified independent laboratory. The outlining of international product quality standards such as ISO 9000 has also increased the volume of testing.

While testing has become more common, some of the instruments now used are anything but. Like most other sophisticated products of our age, they can get results more quickly, and with greater precision. Others are designed to measure properties such as body heat loss (shown by infrared thermography), for which such test results are now highly significant, in this case in making and merchandising cold weather sportswear.

Various factors are involved in deciding whether an article will do a good job for a certain purpose. Factual information about the makeup of a fabric may be obtained from the manufacturer's label and/or from testing and analysis. Apparel designers or home sewers may wish to keep a record for a fabric of its makeup and the way it behaves in working with it and even later, in use; this is true also for materials used in interior design, especially contract work. A Fabric Case History sheet is included at the end of this section, and regularly keeping such records can provide an invaluable resource for a professional. Some amateur consumer tests are also suggested. Basic information that a testing facility might gather includes such things as fiber content, fabric construction and composition, strength, resistance to abrasion, wrinkle recovery, and colorfastness. For particular end uses, there may be special tests, such as water repellency for a raincoat, resistance to fading and tendering by sunlight for drapes, or (see Figure 8.1) slip resistance of shoe soles to floor surfaces. Furthermore, in many cases, particularly contract interior design, specifications must be

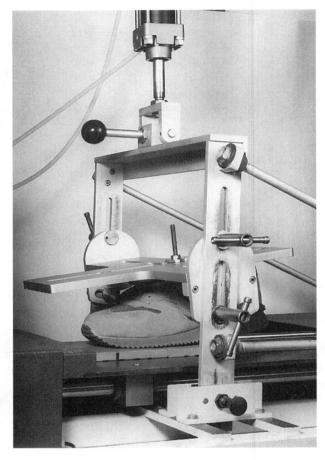

Figure 8.1 Slip resistance test of a shoe on standard quarry tile surface. (Courtesy SATRA Footwear Technology Centre)

met for fabric performance, usually related to standard tests.

Standard methods must be followed for any fabric assessment by testing to be fully meaningful. For textiles, this also involves keeping a laboratory at a standard temperature and humidity; for most materials this is kept close to 20°C (68°F) and 65% Relative Humidity. Certain items such as coated materials might be tested at slightly different settings, but standardized the conditions must be. After testing, you might want to convey to someone in another company that the dye in a jacket lining comes off on clothing worn under it. Without a standard test method, you would have to resort to phrases such as, "it bleeds a bit in perspiration" or "quite a lot of color rubbed off." With interior fabrics, you might want to indicate that one upholstery fabric could stand up to only

moderate wear while another would be satisfactory in a home with an active family; without standard ratings, you are left expressing this as, "X seems able to take a good deal more abrasive wear than Y." With a standard test, there will be a valid sampling technique; the person who runs the test must, of course, know exactly how to do it and record the results carefully; finally, that result will be given a rating according to a standard (see Figure 8.2 for a rating standard).

Textile testing in the United States follows many methods set down by the AATCC (American Association of Textile Chemists and Colorists) and ASTM International. In Canada, the CGSB (Canadian General Standards Board) methods are also used, and the United Kingdom has methods set by the British Standards Institute. A test result might be given as: Fastness to Perspiration: Grade 3, AATCC Test #15 + revision year. Such a result can be understandable to anyone, anywhere.

Unfortunately, no laboratory or accelerated test can duplicate actual wear. Therefore, wear trials or tests in use can provide the most revealing information about a fabric, but they take much longer to complete and are often difficult to assess. Individual differences introduce even more specialized wear that cannot be fully taken into account, for example, carrying a heavy handbag or working at a rough desk.

Any information gathered from testing must be evaluated, and on this basis we decide whether the article will do a good job in its intended area of use and care. Any experienced manufacturer, retail buyer, or consumer has built in a very complicated assessment

Figure 8.2 AATCC standard for rating seam puckering.

procedure over many years of observing how various factors affect performance in different situations. What the garment maker, the retailer, and of course, the consumer expects of the fabric is crucial in this process; someone buying materials for theatrical costumes, for instance, will look for characteristics very different from those appropriate for sportswear.

Selection of the right fabric for each use requires the application of both art *and* science; "fashion is not enough."

For fiber identification, see Section Two.

Standard Tests and Rating

Standard textile tests require a specially equipped laboratory and must be applied at a standard temperature and humidity if the results are to be strictly comparable to those from other test agencies. However, if you wish to make comparisons within a group of fabrics, you can run an approximation of these tests, since even such nonstandard attempts can yield helpful information, just as those strictly amateur ones outlined in this section can. They can also serve as a striking demonstration of fabric behavior for students or staff.

Some Standard Methods Sources

Standard textile testing methods may be obtained from the groups previously mentioned:

AATCC Technical Manual, updated annually, from the American Association of Textile Chemists and Colorists (see "Associations" under "References and Resources" at the back of this text for address).

ASTM methods, Section 7, Volume 07.01, Textiles (I): D 76-D 3218; Volume 07.02, Textiles (II): D 3333—latest, updated annually, from ASTM International (see "Associations" under "References and Resources" for address).

CGSB Standard Test Methods CAN2-4.2-M77 (see "Associations" under "References and Resources" for address).

Colorfastness Tests and Ratings

Samples given any colorfastness tests can be rated for staining of white cloth or for color change. Scales of standard rating evaluation greatly help consistency and are not expensive. They may be obtained from the AATCC; the Color Transference Chart (showing staining) is particularly useful (color change is officially rated using a separate Gray Scale that may not be very helpful to the uninitiated).

Following is the AATCC Grade Number rating for colorfastness tests (except to light), with the equivalent degree of staining or color change represented:

Grade #	Staining or Color Change (except to light*)
1	severe (poor fastness)
2	strong (fair to poor fastness)
3	moderate (fair fastness)
4	slight (good fastness)
5	negligible or none (excellent
	fastness)

^{*}Lightfastness is rated from Grade 1 (poor) to Grade 8 (excellent).

Multifiber cloth, used for fiber identification, is a useful part of colorfastness testing. It is woven with repeats of narrow strips of different fibers, used to register possible staining of those various fibers when a dye bleeds in a care procedure (see Figure 8.3). For example, color from a blouse fabric damp with perspiration might stain a nylon slip but not a rayon lining or a wool jacket; this would show in a single test with the basic "6-fiber cloth." Multifiber cloth can be obtained from Testfabrics, Inc., PO Box 26, West Pittston, PA 18643, (570) 603-0432, fax

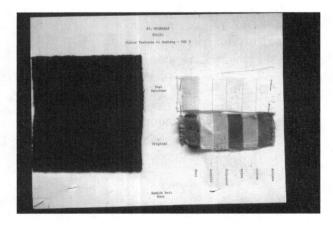

Figure 8.3 Multifiber cloth used in colorfastness test.

(570) 603-0433 (now by the meter); or Textile Innovators Corp., P.O. Box 8, 101 Forest Street, Windsor NC 27983, (252) 794-9703, fax (252) 794-9704.

Fume-fading of blue (or blue-containing) shades on acetate can be demonstrated by hanging the fabric over a solution that releases nitrous oxide fumes. To a 2 g/L solution of sodium nitrite add 2.5 g/L sulfuric acid; for 100 mL you can use 20 mL of 1 percent solution of sodium nitrite, make up to 100 mL, add 18 mL of a 1 percent solution of 75 percent sulfuric acid; use distilled water for solutions. (Note: use *caution* when handling strong sulfuric acid.)

Colorfastness to perspiration tests require making up two solutions, since perspiration when fresh is slightly acid and when acted on by skin bacteria becomes slightly alkaline. The "recipes" outlined for AATCC Test #15 are:

Acid Solution*

10 g sodium chloride1 g disodium orthophosphate anhydrous1 g lactic acid, USP 85%

Alkaline Solution*

Make up the same as the acid solution, except that instead of lactic acid, use 4 g ammonium carbonate USP.

*Measurement of **pH** is an important step in many aspects of textiles testing. The pH of a solution measures whether it is acid, alkaline, or neutral. The scale is from 0 to 14; very acid substances register at the lower end of the scale (e.g., battery acid 1, lemon juice 2, tomato juice 4); water is virtually neutral at about pH 7—neither acid nor alkaline; and very alkaline substances register at the high end (household ammonia 12, strong lye solution [NaOH or caustic soda] reaches pH 13). Machine-wash water would have a pH around 12, face soap about 8.

The measure is inversely related to the concentration of hydrogen ions and can be registered very accurately electronically. (An **ion** is an atom carrying an electrical charge; if positive, it is a **cation**, if negative, an **anion**. A substance may be defined as an acid if it releases positive hydrogen [H] ions in water; an **alkali [base]** releases negative hydroxyl [OH] ions in solution.) For less stringent tests there are **indicator papers**; the simplest is **litmus**, which simply indicates acid or alkaline, but others have a range, with a change to a specific color at a certain pH. One must be careful in storing such papers to protect them from fumes that could change or destroy their reaction; the older such papers are, the more chance there is that they have been affected. Indicator papers can be obtained from laboratory supply houses.

(If obtainable, add to either solution 0.25 g histidine monohydrochloride-to reproduce the effect of natural perspiration on some dyes.) Make up to 1 liter with distilled water.

Wet out samples of colored fabric about 10 cm × 5 cm (4 in. \times 2 in.), each having a similar piece of white (multifiber) cloth to back it (see Figure 8.4); roll in paper towels to extract moisture. If the standard apparatus (Perspirometer) is not available, roll test samples and insert to dry in narrow tubes or vials, with the end of the sample protruding about 2 cm (1 in.); when dry, rate Grade #1 to 5 (see the previous chart) for either staining of the white multifiber cloth or change of shade of the colored samples.

Figure 8.4 Standard colorfastness to perspiration test.

Absorbency or Wicking

This can be demonstrated using an approximation of the Weirick test (Sears Roebuck). Cut identical strips of various fabrics about 25 cm \times 2.5 cm (10 in. \times 1 in.); suspend over containers of water so that the strips will be under the surface about 2.5 cm (1 in.). Enter all strips at the same time, and note the rise of water on each strip after one minute (easier to see if coloring is added) and after five minutes, and record when the water reaches the top of the strip, if it does so in 30 minutes.

Thermophysiological Comfort

Standard tests for thermophysiological comfort of clothing are being applied. Three factors cited in Textiles² as measurable and significant are thermal insulation, permeability to vapor (perspiration), and wicking ability of fabric next to the skin. Clothing comfort is discussed in Section Seven.

Protection from Ultraviolet (UV) Rays

Development of tests to allow assignment of an ultraviolet protection factor (UPF) to textiles, and relating this to a sun protective factor (SPF) are discussed under "Sun Hazards" in Section Seven.

Other Tests with Ratings for Interiors Fabrics

The following types of tests are applied to many textiles, but are often a factor in selection of fabrics for interiors use, such as **upholstery**. A few examples are given here in that context, identified with a rating or result, which is linked to a recommended or satisfactory usage. Of course, many other standards are set in various jurisdictions.

Resistance to Abrasion

Wyzenbeek. ASTM D415, 7-92. Uses standard wire screen as abradant as in consumer use, but occasionally calls for #10 cotton duck. Contract textiles testing uses #10 cotton duck as abradant.

# Double Rubs With No Noticeable Change	Suitable Use
3,000	Light consumer use—adult household, only occasional use.
9,000	Medium—adult household, more than occasional but not constant use.
15,000	Heavy consumer use—family household, normal constant use; also general contract textiles.
30,000	Contract textiles for heavy duty.

Tensile Strength. Resistance of a textile to a pulling force, measured by the force at the moment the fabric breaks; for upholstery fabrics,

normally 222 N (Newtons—see Section Nine) (50 lbs.).

Tear Strength. Force to continue a tear, once begun; for upholstery fabrics, usually 27 N (6 lbs.).

Seam Slippage. Stress is exerted across a seam line; should resist 111 N (25 lbs.).

Pilling. There are a number of pilling test methods. One for upholstery is a Brush test, ASTM D3511, with minimum acceptable rating Grade 3.

Flammability Tests. For domestic upholstery, there is California Technical Bulletin 117, Section E. For upholstered furniture components, there is a UFAC Cigarette test. For seating furniture in public places, there is California Technical Bulletin 133. For wall coverings, there is ASTM 84 (Tunnel). For drapery, there is NFPA 701 Small Scale.

8-2 NONTECHNICAL **FABRIC TESTS**

You can make some very revealing tests on fabrics without laboratory equipment or training.

Not Requiring a Sample

Crease Resistance, Wrinkle Recovery

Simply crush the fabric in your hand, then release; if it creases sharply and there is no immediate sign of the creases coming out, the fabric will likely wrinkle badly in wear. You can also tie a knot in the material (or in a sleeve or pant leg), leave it for a given length of time. untie and observe. Creases tend to show up most on light, solid-colored materials; there is a camouflaging effect with dark color and surface designs such as prints.

Appearance, Drapability

Hold the fabric in different ways, gather it in your hand, and note how it falls; does the pattern look better going one way than another? Would you cut it on the bias? Drape lining along with garment fabric to see how they combine.

Closeness of Construction

The closeness of fabric construction can often be checked by holding it up to the light. The base fabric of terry towels, for instance, can be examined in this way; a sleazy, open ground weave will not give good wear no matter how dense a structure the pile loops seem to give.

Wind Resistance

Compare the resistance of fabrics of cold-weather sportswear as you blow through them. Hold the fabric taut and right up to your mouth. A closer construction will offer more resistance to your breath, as well as to the cold wind on a ski slope or at a bus stop.

Stretch and Recovery

Stretch wovens can be pulled out in the direction(s) of "give," and you can assess their tendency to snap back when that tension is released. Where stretch is vital in a knitted garment, a pattern will often include a

"gauge" against which you can check the extensibility and recovery of the fabric; see the Fabric Case History record for such a gauge, with the interpretation of the result. To test stretch this way, with the fabric held over the measure given in the gauge, grasp the material firmly at the two points, held in the direction you want to test stretch (lengthwise or crosswise); pull out firmly and measure the percentage increase in length.

Colorfastness to Crocking or Rubbing Off of Color

Rub the fabric with a white cloth or tissue held over a finger. Try this test two ways: (a) using a dry cloth or tissue and (b) using a cloth or tissue moistened slightly. You can also try rubbing with a clean eraser. Figure 8.5 shows a laboratory crocking test.

Figure 8.5 Colorfastness to crocking or rubbing off of color.

Seam Slippage

Give a good pull across seams to make sure there is no marked tendency for the yarns to slip and part along the seams. Seam slippage is a real problem with many moderate-price silk garments, where only a simple seam, such as overlock, rather than a stitched-down or enclosed one, such as French or flat-felled, has been used.

Seam Stretch

In garments made of stretch materials, pull a seam in the direction of the stretch, to make sure the seam has been sewn to give sufficiently with the fabric; otherwise there can be stitching breaks during wear.

Nap—Especially Wool Fabrics

Insert a straight pin through the nap only, and try to lift the fabric; the pin should not pull easily out of the nap. The fibers in the nap should be matted closely enough to support the weight of the fabric.

Quality of Felt

Pull on the felt, and scrape the surface with a hard object to see if the fibers hold together.

Requiring a Sample to Do the Test

Make such tests *before* making up your fabric. If you are assessing a ready-made article, take a small bit of fabric from a "nonvital" and inconspicuous part before using the item (seam allowance or self-facing), although not much information may result from a tiny piece.

Colorfastness to Cleaning

Test the colorfastness to the method of cleaning you expect to apply:

To washing. Using white thread, stitch the swatch of material to a large piece of white fabric similar in type. Try to duplicate actual washing conditions, without putting the test piece in a real wash load in case it does bleed. Use the

water temperature and type of detergent you would normally use, and after test washing or soaking and rinsing, roll and squeeze out most of the moisture and let the swatch dry on the white fabric. Check for bleeding or transfer of color to the white fabric, and note any change of shade in the washed sample compared to the original.

To dry cleaning. Follow the washing test procedure for making up the test swatch, and take it to a dry cleaner who uses perchloroethylene (perc); a dry cleaner will usually be glad to put a test swatch through a process suitable for that fabric. After dry cleaning, you will be looking mainly for shade change or color loss.

If you sometimes wish to wash the article and other times to dry clean it, be sure to test for color-fastness to *both* procedures.

Shrinkage

Mark a measured length and width on as large a piece of fabric as you can spare; a meter (yard) is best, because results will be very inaccurate with a small sample. Mark preferably with thread, and make at least three marks each way. Wet the sample thoroughly; you may need a very small amount of hand dishwashing liquid or shampoo to help wetting out. After wetting the sample, squeeze and roll out excess water, and tumble dry completely. Smooth out the sample and remeasure. If the fabric is badly wrinkled, first damp press using a steam iron, avoiding any pushing of the fabric as you press.

Shrinkage of 3 to 5 percent in all but easy-fitting garments would probably result in loss of fit, and would be quite noticeable in drapes. Unstable fabrics can shrink over 7 percent, which would shorten a pant leg of 80 cm (32 in.) over 5 cm (2 in.).

It is advisable to buy preshrunk material with a guarantee of no more than 1 to 2 percent residual shrinkage. If you plan to tumble dry cotton knit goods that do not have a "preshrunk" or "Durable Press" label, buy the article at least one size larger than usual. Garments with a good-quality Durable Press finish do not require such precautions—they are designed so that tumble drying can replace ironing; see Section Six for procedures to ensure the least need for pressing.

If you plan to use a garment without ironing, allow for some take-up in size by "wrinkle shrinkage,"

even for goods such as Sanforized® that will not shrink more than 1 percent if ironed.

Seam Raveling

Ravel a fabric to the straight of grain crosswise, and cut up along the selvage as well; pull yarns away to see how easily they ravel off in either direction. If a fabric you are going to use in a garment ravels easily, use some kind of stitched-down or enclosed seam. such as French or flat-felled. If you are testing a ready-made garment, check whether any seam edges are unfinished; if seams are well finished, you should not have to worry about raveling.

Seam Slippage

With piece goods, use an appropriate needle, thread, and stitch size to make short test seams both lengthwise and crosswise. Give a good pull across the seams. If the fabric tends to slip readily along a seam, again follow a stitched-down or enclosed seaming method to distribute strain.

Sagging, Bagging

Secure a sample of fabric over the neck or top of something such as a flask, bottle, or jar, using a heavy rubberband. Leave for a specified time, then remove

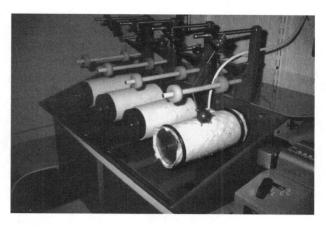

Figure 8.6 Snag test using "Mace."

the band and rate the degree of distortion, and time how long the fabric takes to recover.

Snag Resistance

Stroke the fabric sample with a Farri-Comb® (sold to remove pills), the rough (barbed) side of Velcro® tape, or a small grater; note the degree of snagging given by a specified number of strokes or count the number of strokes to produce snagging. Figure 8.6 shows a laboratory "Mace" test for snagging.

REVIEW QUESTIONS SECTION EIGHT

- For colorfastness testing, you are using a basic multifiber cloth with repeating strips of acetate, cotton, nylon, polyester, acrylic, and wool. Referring to "Dyes and Colorfastness" in Section Six, describe a combination of items of apparel and/or interiors fabrics that might
- reveal staining of some fibers and not others in one specific test (washing, dry cleaning, crocking, or perspiration).
- 2. Why are there two solutions for laboratory testing of colorfastness to perspiration?

INVESTIGATIONS TO DO WITH FABRIC ASSESSMENT

- Any of the nontechnical tests outlined in this section could be carried out on fabrics gathered by a class. Each student could outline a test procedure, for example, the tendency to sag and bag of specific knit fabrics compared to specific wovens, or the effect of a small percentage of spandex blended with another fiber compared to 100 percent of the other fiber.
- 2. Consult the suggestions under 8-2 this section and compare wrinkle resistance/recovery in a number of fabrics of about the same weight (note construction: what weave or knit), made of a range of fiber contents. With slacks (perhaps pairs from class members) it could be all wool, wool and polyester, polyester and viscose rayon, or another content with some spandex. Tie a knot in one leg and leave for a specified time, compare and rate, untie, leave again, and compare and rate recovery. Try to make the knot as nearly as possible the same tightness for each one. For dress shirts a sleeve can be used, and fiber contents could be polyester/cotton compared with 100% cotton. Note if any have a
- wrinkle resistant finish—does this seem effective? With long-sleeved blouses, compare polyester with rayon or silk.
- 3. Select one career area in which you would be dealing with textiles. Outline a case where you would use the services of a testing laboratory: the type of product, the fabric, what you wish to find out about the material, what tests are likely to be done, and what level of results the fabric should meet.
- 4. One sample of flat woven upholstery fabric is marked on the back "Wyzenbeek 5,000 double rubs," and another "Wyzenbeek 10,000 double rubs." For what purpose would each give satisfaction? Name two situations calling for higher abrasion resistance.
- 5. Make up a Fabric Case History record for at least one (preferably two to three) samples of fabric for apparel or interiors. The fabric may be one you have, or that someone you know is working with, or you can buy a short length from a fabric store.

NOTES SECTION EIGHT

- (The late) Fred Fortess, then (August 1968)
 Research Director, American Celanese, late
 Chairman, Department of Textiles, Philadelphia
 College of Technology and Science.
- 2. British Textile Technology Group (BTTG) activity, reported in *Textiles*, 1992/3: 5.
- 3. Typical tests applied by Bodycote Ortech Inc.

Fabric Case History	
\$	Fabric Name
Purchase Data:	
Source	Date
Width cm (yd)	Manufacturer
Price \$ /m (yd)	
regular retail	wholesale
sale	mfr. old stock
	Special fiber
Fiber Content	or yarn type?
Finish or care info. given POS?	
Sample: See back for sample mount. Intended use: See back for sketch, pattern picture, or Degree of stretch (stretch gauge on back):	
stable (< 10% stretch)	
moderate (20-30% stretch)	
high (35-80% stretch)	
power (30-50% stretch, 95% recovery)	
Was the pattern adjusted for stretch fabric? If so, spec	cify on back.
Layout: Specify any special matching, e.g., nap, pile,	one-way design
Cutting problems?	
Trim, findings	
Construction: Record any special techniques, seam fir	nishes, facings, hems, etc.
Pressing problems?	
Expected care method	
Behavior in use and care (notes to be made after garm	
Effectiveness re: design or pattern (line, drape, etc.)	
Looks retention (sagging, pilling, etc.?)	
Behavior in (circle applicable) home laundering / dry	
Color bleed, fade, rub off, change? Shrinkage, streto	ching? Lose body?

Sketch or other illustration of garment (indicate placement of warp with arrow)

Samples, identification trims, findings

Stretch Gauge (adapted from Butterick pattern gauge for knits)

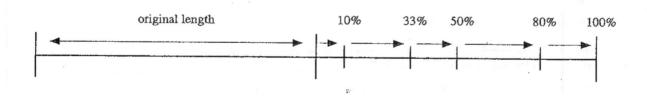

9-1 THE METRIC SYSTEM

In this 21st century virtually all countries in the world, including the United States, are committed to metric conversion, although a few still officially use inch-pound measures (English or Imperial system). Within a number of countries, however, there are still "islands" in the "metric sea," and the garment and furnishings industries, in both the United States and Canada, are definitely two of them. Official metric conversion went a long way in Canada, but withered after a change of government in September 1984. However, this *Reference* presents metric units used in textiles, clothing, and interior design work and study, as an essential basis for the global economics that affect everyone today.

There is a difference of enforcement to overcome between the European Union countries (EU) and most of North America. The EU began as early as 1979 to make illegal the use of any measurements other than metric (SI—see definition following), that is, no dual units to be used. In 2000, the deadline was put ahead to 2010. It applies to virtually all measures, not just labels, but any marked on items, plus advertisements, manuals, and so on. The U.S., on the other hand, allows dual measures to be shown, but forbids use of metric-only. Some sort of compromise would be best for both producers and consumers, perhaps giving the option of either metric-only or dual units labeling. This is a good example of just one pressure of doing business globally.¹

Origin of Metric Measurement

The earliest measures were derived from parts of the body (in fact, metric still carries over that base, since decimals probably relate to our 10 fingers and toes, when mathematically, we would be better off with a base 12). The metric system, on the other hand, started in France with a proposal in 1670, finalized in 1791, that the unit of length should be the *metre* (from the Greek *metron* meaning "measure"), which is one ten-millionth of a meridian of longitude between the North Pole and the equator. The decimal relationship was accepted, and a cubic centimetre of water became the unit of mass, called a **gram**.

In the same way, each metric unit has been firmly based scientifically and rationally developed.

When the length of the standard metre was finally determined, along the meridian that goes through Paris, the work had gone all through the French Revolution and its aftermath; when the standard metre was presented to Napoleon in 1810, he said, "Conquests pass, but such works remain." This standard metre was long a physical entity, but has now been redefined in terms of the speed of light (the last being 1983²)—insubstantial but much more accurate as a reference. So the science and technology of measurement (metrology) changed in the 20th century. Metrology, for any trading country, must have reference to internationally accepted standards, and these are expressed in metric terms. They are used often in electronics, and increasingly in fiber, yarn, fabric and finish measurement, as with micro in fibers, nano in finishes, and pico in digital printing.

SI Usage

There are choices to make even within metric systems, and **SI** (pronounced ess-eve) is one particular set of metric measures and units. The letters stand for Système International d'Unités, or International System of Units. The standard for the system is published by the International Organization for Standardization or ISO (pronounced ice-o, as explained under "Care Labeling-International Symbols," Section Six). SI has been stipulated as the accepted metric system and terminology for the United States, it was the one chosen for use in Canada in 1960, and it was followed in preparation of this Reference section. For this reason, too, spelling of metre and litre in this section follows international rather than the also acceptable American spelling. A unified American National Standard for use of SI was developed (1997) by the American Society for Testing and Materials and has replaced previous SI standards of ASTM and ANSI/IEEE. A Guide can be obtained from the U.S. Metric Association, Inc. (see "Teaching Aids" under "References and Resources" for details).

For temperature degrees (weather, cooking), SI uses the **Celsius** scale, the same scale as centigrade, with the same symbol, C; water freezes at 0° C and boils at 100° C, whichever name you give to the scale. However, in France, a *centigrade* is 1/100 of an angle (*grade*), so to avoid confusion internationally,

the temperature scale was given the name of its inventor, Anders Celsius.

Similarly, in yarn count, there is denier, which is metric based, but the SI unit is tex.

Because SI is an international measurement language, it has very carefully defined rules of usage, set down to avoid ambiguity or confusion. It is important for communicators to understand these rules. One basic principle is that with SI, we are using symbols. not abbreviations, and so neither a period nor plurals are needed (e.g., gram and grams are shortened to the symbol g, not gm. or gms.).

Further, prefixes can modify base or supplementary units to provide a range of dimensions:

Prefix	Symbol	Factor	Multiplier
giga	G	10^{9}	1,000,000,000
mega	M	10^{6}	1,000,000
kilo	k	10^{3}	1,000
deci	d	10^{-1}	0.1
centi	С	10^{-2}	0.01
milli	m	10^{-3}	0.001
micro	μ	10^{-6}	0.000,001
nano	n	10^{-9}	0.000,000,001
pico	p	10^{-12}	0.000,000,000,001

Some other major rules are outlined here:

- Where there is a prefix, accent the first sullable in pronouncing the measure; thus, one drives so many kilometres.
- A measure such as fabric weight (mass), in order to be understood in any language, is expressed as g/m², not g per sq. m.
- A space is left between the quantity and the sym-
- Symbols derived from a proper name are written as a capital, as C for (Anders) Celsius. Kilogram is therefore k, as K is the symbol for kelvin, the base unit of temperature, from the name of William Thomson, Lord Kelvin, British physicist and inventor.
- In some countries, a comma is used as a decimal, whereas most of North America marks a decimal with a period. For example, a fabric length would be marked as 2,90 m in Europe, but 2.90 m in Canada. Stemming from this is another difference: the metric countries that use a comma for a decimal use a space to mark off thousands in large numbers, whereas a comma is used in North America.

9-2 METRIC IN TEXTILES USE

Metric in Sewing

In Canada, conversion to metric of retailing of textiles to home sewers was officially observed with an "M" Day on July 1, 1978. Because of extensive preparation, the transition was for the most part painless, except where a small segment of retailers resisted it. (Because a metre is about 10 percent longer than a yard, the price per metre is more than the price per yard of the same fabric.) A major holdout on metric conversion came from carpet retailing, where the price difference for the "larger" metre is accentuated because you are dealing with square units.

Most of the problems were those of perception; a person will use the same amount of fabric and pay the same amount to make the same article, whether it is measured in metres or yards. Furthermore, there is much less complication in any calculation in metric. However, the process of total conversion got sidetracked in Canada, and has not happened in the United States. To this day, then, fabric (in Canada) is measured at retail by the metre, but may well be asked for and priced by the yard! In the garment industry in both countries, fabric may be bought by the metre, if the supplier is not in the United States, but everything from pattern-making on will probably be discussed in inches, feet, or yards.

Piece Goods (Rather Than "Yard Goods")

Length in metres and decimals, for example, 1.75 m (not 1 m 75 cm and certainly not 1% m); width in centimetres (fabric over 30 cm wide); narrow fabrics (trim, elastic less than 30 cm wide) in millimetres.

Following is a piece goods width comparison of metric to the English equivalent:

Metric	70	90	115	140	150	165 cm
English	27	36	45	54	60	66 in.

Sewing Machine Needle Sizes

Metric size is termed "Nm" (numérometrique or metric number). The diameter of the blade or shaft (the part just above the eye) is expressed in hundredths of a millimetre. Numbers 80 and 90 are the most commonly used needle sizes; see Table 9.1.

Table 9.1 Sewing Machine Needle Sizes

Ne	eedle Size	
Metric	Older (British)	Appropriate Fabrics
60–70	8–10	sheer, delicate fabrics: chiffon, voile, organdy, lace
80	12	light fabrics: crepe, taffeta, lining
90	14	medium fabrics: sheeting, velvet, light suiting, vinyl, sail cloth
100	16	heavier suitings, denims, coatings, drapes
110–120	18–19	extra heavy or tough fabrics: awnings, upholstery

Besides the right size of sewing machine needle, you should select the right type: a pointed tip (set point or cloth point) or a ballpoint needle will sew about 90 percent of fabrics; the ball point (rounded tip) avoids damage when sewing fine or light knit goods, especially synthetics (see Figures 9.1 and 9.2). Use a triangular point or denim needle for close, tough fabrics and a wedge point or leather needle for leather and leather-likes. Replace the needle often if sewing tough synthetics.

Stitch Length

This is measured in millimetres; a larger number equals a longer stitch. (The system on some machines

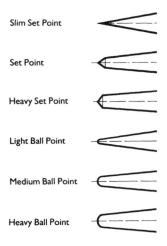

Figure 9.1 Tip shapes of needles. (Courtesy of Coats Patons)

Figure 9.2 Ballpoint needle for sewing jersey knit. (Courtesy of the Textile Institute)

of stitches per inch means that a larger number equals a shorter stitch.)

Seam Allowance

This is given in centimetres and decimals; a throat plate sticker can be made for some sewing machines that don't have the markings already on, when you are working in metric.

Following is a seam allowance comparison of metric to the English equivalent:

Metric 0.3 0.6 1.0 1.2 1.5 1.8 cm 1/4 3/8 1/25/8 3/4 in. English

Sewing Thread Length

This is given in metres per spool; if sold by mass, see yarn ball sizes.

Thread Size

Cotton thread marking is still based on the count of cotton varn (English number or Ne), where a larger number is a finer thread; the relationship is: #10 = 59 tex; #50 = 12 tex. Sewing thread made of synthetics may be marked in metric number (Nm) for spun yarn and denier for filament, but these figures are rounded off and do not correspond closely to standard units. Tex Count = 1,000/Nm.

The **ticket number system** (related to Ne, Nm, and denier) describes approximately the thread thickness. A synthetic thread ticket number multiplied by

0.6 is equivalent to a cotton number; e.g., a Ticket No. 60 synthetic thread would be equivalent to a Ticket No. 36 cotton thread (this compares size only. not strength).3

Measuring Tapes

These are marked in centimetres and millimetres: a tape at least 150 cm long is needed for body measurements.

Hem Markers, Gauges, Scissors, Blades

These are marked in centimetres.

Slide Fasteners (Zippers, Coil Fasteners)

Length is measured in centimetres, width in millimetres. Following is a slide fastener length comparison of metric to the English equivalent:

Metric 12 30 40 50 60 cm 18 5 English 7 9 12 16 20 24 in.

Buttons

Diameter is measured in millimetres (formerly by the line, which equaled 0.025 in. or 0.635 mm).

Craft Yarn (Knitting, Needlework, etc.)

The length of the ball or skein is measured in metres, the weight (mass) in grams. Following is a ball or skein weight comparison of metric to the English equivalent:

Metric 25 50 100 250 500 g English 1 16 oz.

Patterns for knitting or crocheting often give the metric conversion for the number of balls of yarn needed, stitch density, needle size, and so on. Old patterns will doubtless be treasured, however, so keep old needle sizers and such references, even when or if you are working more in metric.

Stitch density is given in rows per centimetre and stitches per centimetre.

Knitting Needle, Crochet Hook Sizes

These are marked in international or "continental" metric sizes, given in detail in Tables 9.2 and 9.3 from Patons & Baldwins.

Metric in Home Furnishings

Metric measurement and calculation of drapery fabric, for example, is so simple in a coordinated decimal system, and more so with areas, as with carpet, where the inch-pound system has figures such as 1,296 sq. in./sq. yd.! Tufted broadloom carpet width is given in centimetres until machines are built to tuft even 3- or 4-metre widths; lengths are given in metres.

Bedding (sheets, pillowcases, blankets, bed-spreads) as well as table linens, towels, and blinds are "sized" according to use in many cases (e.g., "twin bed sheets" or "bath towels"). Fitted sheets for extrathick mattresses use a term such as "deep pocket" to identify this sizing. Where dimensions are given, they are in centimetres.

Metric in Miscellaneous Textile Articles

Other textile articles are generally sized as follows:

Twine, cord, rope, surgical dressings. Length in metres; weight (mass) in grams; linear density in tex; width (bandages) in millimetres.

Tents. Length and width in metres and decimals; weight in g/m^2 .

Awnings, tarpaulins, canvas goods. Any one dimension more than 250 cm (8 ft.) in metres; dimensions less than 250 cm in centimetres.

Sleeping bags, recreational, sports, and outdoor equipment. Dimensions in centimetres.

Metric in Home Maintenance of Textile Articles

Washing Machines

Outside dimensions of washers (and dryers) may eventually conform to metric building modules. Toploading washers generally have a **capacity** of 50 L (approximately 12 gal.); front-loading machines use, on average, about half as much water. The amount of **detergent** (if powder) is measured using dry ingredient cooking measures; use 125 mL for ½ cup and 50 mL for just under ¼ cup.

The "benchmarks" for water **temperatures** are the intervals in degrees Celsius used on U.S. and Canadian Standard care labels for cool, lukewarm, warm, and hot water; see Table 9.4 (see also discussion of water temperatures under "U.S. Care Labeling Rule," Section Six).

Table 9.2 Knitting Needle Suggested Equivalent Chart

Canadian	000	00	0	1	2	3	4	5	6	7	8	9	10	11	12	13	14	15
American	15	13	12	11	$10\frac{1}{2}$	10	9	8	7	6	5	4	3	2	1	0	00	000
Continental (mm)	10	9	8	$7\frac{1}{2}$	7	61/2	6	$5\frac{1}{2}$	5	$41/_{2}$	4	33/4	31/4	3	23/4	21/4	2	13/4

Table 9.3 Crochet Hook Suggested Equivalent Chart

Milward Disc	000	00	0	2	4	5	6	7	8	9	11	12	14			
(Canadian and British)																
Milward Steel											2/0	1/0	1	2	3	4
Plastic (American)				10½	10	9	8	6	5	4	2	1				
				or K	or J	or I	or H	or G	or F	or E	or C	or B				
International (mm)	10.00	9.00	8.00	7.00	6.00	5.50	5.00	4.50	4.00	3.50	3.00	2.50	2.00	1.75	1.25	1.00

Table 9.4 Fabric Wash Water Temperatures

Water Temperature Description	°C*	°F*	Relationship to Water Heater Output
Cool	30	65–85	
Lukewarm/hand wash	40	105	
Warm (hand hot)	50	120	
Hot	60	140	As from hot tap in many homes.
Very hot	70	160	Very hot for home.
Very, very hot	85	185	Commercial laundry.
Boiling	100	212	Wash boiler, anyone?

^{*}Temperature conversion: $^{\circ}C \times 1.8 + 32 = ^{\circ}F$; $^{\circ}F - 32 \div 1.8 = ^{\circ}C$

Pressing and Ironing

Following are the temperatures that correspond to the care symbols given on U.S. and Canadian Standard care labels:

Optional Care Symbols	Iron Setting	$^{\circ}C$	° F
1 dot	low	110	230
2 dots	medium	150	300
3 dots	high	200	390

Home Tinting

Packages of dye are labeled in grams; water volume is given in litres.

Metric in Textiles Study or Laboratory Testing

Students of textiles, or testing laboratory personnel, will encounter all the metric units mentioned previously, plus a number of specialized ones.

Staple Fiber Length

This is given in millimetres. The shortest spinnable fiber (some cotton) is about 12 mm long (1/2 in.); the longest staple fiber (some flax) would be about 500 mm long (20 in.). (The length of cotton hairs is still given in thirty-seconds of an inch.)

Filament Fiber Length

This is given in metres.

Fiber "Thickness" (Diameter)

This is usually measured in micrometres (µm) or millionths of a metre. Note that micro- is a prefix to indicate multiplying by 10^{-6} and its symbol is μ ; this symbol in SI of itself, then, does not represent a micron or one millionth of a metre (1/1,000,000 m)as it does in the inch-pound system. In nanotechnology, fibre diameter is measured in nanometres (nm), or billionths of a metre.

Fiber Bale Weight (Mass)

This is measured in tonnes (t), or 103 kg (1 tonne [1,000 kg] = 2,000 lb.; 1 ton [2,000 lb.] = 907 kg. In spoken English, it is clearer to speak of a tonne as a "metric ton."

Fiber Tenacity (Tensile Strength)

This is strictly given as newtons per tex (N/tex); centinewtons per decitex (cN/dtex) is often a more convenient measure and is close to the familiar grams per denier figure. The newton is a derived unit of force in the SI system, used instead of the gram since it will not vary according to gravitational force on a body. To convert g/denier to cN/tex, multiply by 8.83, or to cN/dtex, multiply by 0.883. However, breaking tenacity of fibers, filaments, yarns, and such is often measured and expressed as grams-force per tex or grams-force per denier4 (for details see reference given in endnote).

Linear Density of Fibers (Hair Weight per Centimetre)

This is given in mg/cm \times 10 5 . For notation of fibers in the tex system, the small unit of millitex (mtex) can be used (equal to mg/1,000 m).

Yarn Linear Density (Yarn Count)

This is based on tex (g/1,000 m); tex = denier \times 0.111 (or dtex = denier \times 1.11). Some relationships with familiar or traditional examples follow:

59 tex = cotton count 10 16.5 dtex = 15 denier 7.5 tex = cotton count 80 33 dtex = 30 denier15 tex = worsted count 60 111 dtex = 100 denier

Yarn or Fabric Thickness

This is given in millimetres.

Woven Fabric Thread Count

Warp count is given as ends per centimetre; filling as picks per centimetre (possibly per 10 centimetres for a coarse fabric).

Knitted Fabric Stitch Density

This is given as wales per centimetre or courses per centimetre.

(**Note:** Two knitting terms in common use are difficult to convert to metric: *cut* and *gauge*. The metric unit suggested is needles per one hundred millimetres.)

Fabric Area

Conversion factors between metric and English systems are as follows:

 $1 \text{ m}^2 = 1.196 \text{ sq. yd.}$ $1 \text{ sq. yd.} = 0.836 \text{ m}^2$

Fabric Weight (Mass)

This is given in grams per square metre (g/m²) or per running metre (g/m). Note the distinction between the two: weight per running unit will be proportionately greater than weight per square unit

as the fabric width is greater than the unit. Today, most fabrics are wider than a metre or yard, while interior furnishing fabrics and those from the wool family have always been made wide. (See Fabric Glossary, Range of Fabric Weights.) Conversion factors between metric and English systems are as follows:

 $1 \text{ g/m}^2 = 0.0295 \text{ oz./sq. yd.}$ $1 \text{ oz./sq. yd.} = 33.9 \text{ g/m}^2$

Here is a "rule of thumb" for conversion: 100 g/m^2 is close to 3 oz./sq. yd.

Momme is a unit of weight used for silk; it is equal to 4.33 g/m² (see discussion under "Silk Quality" in Section Two).

Carpet Pile Height and Density

Pile height is measured in millimetres. Pile density is expressed as the closeness of the tufts. In woven carpets this is *pitch*: warp yarns per 10 centimetres of width (traditionally warps per 27 inches); and *wires*: tufts per 10 centimetres of length (traditionally rows per inch).

Thermal Insulation

Two values are used:

Tog value measures the thermal resistance of a textile, which is ten times the temperature difference between two faces of a textile, when the flow of heat is one watt per square metre.⁵

Clo value measures insulating efficiency, or resistance to heat loss; this value is similar to the more familiar "R-value" used to rate housing insulation, with R-value equal to 0.88 Clo.⁶ Calculations for the two values are as follows:

 $1 \ Clo = (0.18^{\circ} \ C \times m^2 \times h) \div kcal$ R-value = (°F × ft.² × h) ÷ BTU

(Note: the space before symbol "°C" is retained in this section only—see "SI Usage" earlier.)

Clo values can be related to consumer products as follows:7

1 Clo is the value of business clothing worn indoors (about 20° C or 68° F).

2 Clo is the value needed for skiwear for use in about −5° C (23°F).

4 Clo is the value needed in clothing for −20° C $(-4^{\circ} F)$; if the person is not moving, this should include long underwear and insulated outerwear. It is also the insulation value of a sleeping bag for ordinary camping conditions.

8–9 Clo is the value needed in a sleeping bag for Arctic survival.

REVIEW QUESTIONS SECTION NINE

- 1. What is the origin of the yard as a measurement? What is the standard for it? (You will have to do research outside Fabric Reference for the answers to these.) What is the origin of the metre (or U.S. spelling meter)? What is the standard for the metre? How do the metre and yard compare in length?
- 2. For North American metric SI usage, which of the following are not correct, and what is the correct form: 250ml, 19 mm, 25cm, 50°c, 120g. per sq. m., 2,25 m?
- 3. How long a tape do you need for body measurements?
- 4. Do you (would you) encounter metric measurements in such bedding as sheets and pillowcases?
- 5. What is body temperature in °F? in °C? This (rounded off) gives you the lukewarm/hand

Color; Dyeing, Color Matching

Wavelengths of light are expressed in nanometres, which in SI replaces the Angström Unit.

1 nanometre (nm) = 10^{-9} m (1 Ångström unit [1 $Al = 10^{-10} \text{ m}$

Size of drops of ink from piezo heads of some inkjet printing machines is measured in picolitres (pL).

- wash temperature meant in symbols labeling for laundering. What are these temperatures for warm (hand hot), hot (for home washing), and commercial laundry temperatures?
- 6. What are Low, Medium, and High settings on irons in °F and °C? (Can you relate these to any better-known temperature settings at home?)
- 7. What is the relationship between denier and tex? What tex submultiple is close to being equivalent to denier?
- 8. What is a momme? What fabric might you find described as being of x momme?
- 9. What does the Clo value represent? For what clothing is a rating of 2 Clo satisfactory? For what article and conditions would you need at least an 8 Clo value?

INVESTIGATIONS TO DO WITH METRIC MEASUREMENT

- 1. Find a relationship with an approximate length well-known in inch/pound measure (such as body parts, dining table size, lumber, or walking/driving distance) for a millimetre, centimetre, metre, kilometre. Do the same for volume measures: what is the metric equivalent of a shot glass, a measuring cup, a pint, a guart, a gallon? In weight, what is the metric equivalent of an ounce, a pound, 100 pounds? What is an approximation in metric for ounces/square yard weight? (See Range of Fabric Weights in Fabric Glossary.)
- 2. What is the average width of polyester crepe piece goods? What is the metric equivalent? What is the width of narrow fabric such as hair canvas interlining, and what is the metric equivalent? What is the width of wool fabric you buy at retail. with metric equivalent? What is the widest material in a retail fabric store, and what is the metric equivalent? For what purposes are the widest fabrics used?
- 3. Do comparison calculations in metric and inch/foot/vard measurement of carpet needed for a room $12' \times 18'$. Do the same for curtaining

- needed for a window of a certain size, specifying also the depth of hems, and how many times in width of fullness you want, starting with inch/foot/yard measures, and then calculating the same in metric. Which was easier to work with?
- 4. Gather samples of fabric from lightest (airiest) to heaviest you can find. If possible, weigh a 10 cm square in grams, and mark the weight in g/m² on each. If you cannot weigh the samples, estimate
- their likely weight range by consulting Range of Fabric Weights in *Fabric Glossary*.
- Calculate the detergent you need for a wash load in metric units, by finding how many mL your usual measure represents.
- Consult packages of home dyes, and if instructions are not in metric units, convert ounces and gallons to grams and litres.

NOTES SECTION NINE

- 1. "European Union Metric-Only Labeling Requirement," *Metric Today*, Sept.–Oct. 2006, Vol. 41, No. 5: 2, 6.
- 2. William B. Penzes. "Time Line for the Definition of the Meter," Precision Engineering, Manufacturing Engineering Laboratory, www.mel.nist .gov/div821/museum/timeline.htm.
- 3. "What's in a Thread?" The Technology of Thread and Seams, J & P Coats Ltd., Glasgow.
- 4. "Vocabulary of fiber & textile technology," *The Textile Journal*, November/December 2004: 11.

- 5. C. Cooper, "Textiles as Protection against Extreme Wintry Weather, Part 1—Fabrics," *Textiles*, 8/3, 1979: 74.
- Technical data and testing report, Thinsulate[™] Lite-Loft, 3M, 1994.
- Work done on sleeping bags for Woods, Inc., makers of camping and survival equipment, at Ontario Research Foundation (now Bodycote Ortech Inc.), 1983; values for 4 Clo clothing value derived from brochure "From the Inside Out," DuPont Canada Inc., 1995.

References and Resources

References

- AATCC Technical Manual (annual edition, see Associations for address).
- Ashelford, Jane. Care of Clothes (U.K., National Trust, 1997). Describes historical methods for clothes care, but includes a few tips on looking after old and valued items today.
- ASTM Standards, Section 7—Textiles (annual edition, Vol. 07.01/Textiles (I): D76-D3218, Vol. 07.02/Textiles (II) D3333-latest, see Associations for address).
- Braddock Clarke, Sarah E., and Marie O'Mahony. *Techno Textiles 2.* (London: Thames & Hudson, 2005.) Updating of 1998 look at "confluence of textiles in art, design, and technology."
- Brown, P., and K. Stevens, editors. *Nanofibers and Nanotechnology in Textiles*. (Clemson University: Autumn 2007.)
- Brunnschweiler, D., and J.W.S. Hearle, editors. Polyester: Fifty Years of Achievement: Tomorrow's Ideas and Profits (Manchester: the Textile Institute, 1993).
- Collier, Billie J., and Phyllis G. Tortora. *Understanding Textiles*, 6th ed. (Upper Saddle River, NJ: Prentice-Hall, Inc., 2001). Sound presentation of basic coverage of textiles, although many technical advances since this edition. Good illustrations; includes summaries, questions, and at most stages adds Consumer Briefs, which focus on a particular aspect of practical application. Good record of legislation, standards.
- Davis, Rebecca, and Carol Tuntland. *The Textiles Handbook* (information *via* www.fabriclink.com).
- Davison's Textile Blue Book (Concord, NC: Davison Publishing Co., Inc.). Directory for all of North America for companies that produce or market textile products.

- Dyeing Primer, reprinted from Textile Chemist & Colorist (Research Triangle Park, NC: AATCC, 1981).
- Earnshaw, Pat. A Dictionary of Lace (Aylesbury, U.K.: Shire Publications Ltd., 1982).
- ———. The Identification of Lace (Aylesbury, U.K.: Shire Publications Ltd., 1984).
- Elsasser, Virginia. Textiles: Concepts and Principles (Albany: Delmar Publishers, 2005). Sketchy, simple experiments or records offered as "laboratory assignments." Inverse relation between content and price (it is soft cover); center insert of eight color pages of fabric pieces may contribute to relatively high cost.
- Encyclopedia of Textiles, American Fabrics, 3rd ed. (Englewood Cliffs, NJ: Prentice Hall, 1980).
- Hardingham, Martin. *The Fabric Catalog* (New York: Pocket Books, 1978). Sadly, out of print; a uniquely useful fabric dictionary.
- Harrison, E. P. Scottish Estate Tweeds (Elgin, Johnstons of Elgin, 1995). History (200 years), 185 color photos of checks by name, cashmere information—unique reference. Johnstons, Newmill, Elgin, Morayshire, Scotland 1V30 2AF.
- Hatch, Kathryn L. Textile Science (St. Paul, MN: West Publishing Co., 1993). An astonishingly detailed, complete (for its date), clearly written and well-illustrated reference.
- Hearle, John. Creativity in the Textile Industries: A Story from Pre-History to the 21st Century. (Manchester, U.K.: The Textile Institute, The Mather Lecture, 2000.) CD-ROM showing over 80 slides, voice-over by Prof. Hearle. Textiles Magazine, 2004, no. 3, recommends it as "interesting and instructive both to textile experts and to a general audience. . . . of particular value to schools with courses in textiles or technology." www.textileinstitute.com

Hearle, J. W. S., editor. *High-performance Fibres*. Cambridge: Woodhead Publishing Ltd., 2001.

Hongu, Tatsuya, Glyn O. Phillips, and Machiko Takigami. New Millennium Fibers. (Cambridge, U.K.: Woodhead Publishing, 2005.) New fibers, especially from renewable resources, and advantages fiber textile technology can deliver in the 21st century.

Humphries, Mary. Fabric Glossary, 4th ed. (Upper Saddle River, NJ: Prentice Hall, 2009). A fabric dictionary that is designed to be a "companion book" to Fabric Reference, but may be used on its own. On the principle that the best outcome of textiles study is a meaningful connection with specific fabrics, Fabric Glossary gives detailed descriptions of major "name fabrics" or categories, plus comprehensive listings of which fabrics are suitable for many end uses, in clothing as well as for interiors. One hundred twenty-six main and secondary Fabric Files define or explain. describe, and provide illustrations for some 600 fabric names and terms. The selection has been designed so that fabrics known by name illustrate all aspects of textile production and behavior: major fiber types; most kinds of yarns including novelty yarns; all categories of weaves, knits, other constructions such as tufted, lace, felt, nonwoven. stitchbonded, and others, plus leather and fur, and whose character is made by finishing, including examples related to dyeing, plus printing and other applied design.

However, Fabric Glossary can be enjoyed simply as a unique presentation of the characteristics, uses, and background (including origin of names) of materials that fascinate most people. For this Fourth Edition, names have been added from current fashion use. Almost all of the blackand-white illustrations are photos or computer scans of actual fabrics selected by the author, with many unraveled or arranged to reveal structure. But there is nothing to equal an actual swatch of fabric for "illustration"—fabric that can be examined, dissected or tested during textiles study or just for curiosity in self-learning. Fabric Glossary as published by Prentice Hall provides templates to aid the mounting of samples for each File, and includes thorough discussion of sampling and mounting techniques. Although the individual will almost certainly mount a personal selection of fabric samples in the ample space available, there is a

Swatch Set available designed to provide a valid, accurately cut and packed sample for each of 115 Files; for order information, see page at the back of this book.

Hunter, L. *Mohair: A Comprehensive Review* (Manchester, U.K.: the Textile Institute, 1993).

Issenman, Betty Kobayashi. Sinews of Survival: The Living Legacy of Inuit Clothing (Vancouver: University of British Columbia Press, 1997). Marvelously detailed examination in words, drawings, and photographs of this unique clothing of the Arctic.

Jerde, Judith. *Encyclopedia of Textiles* (New York: Facts on File, Inc.: 1992). Considerably lacking in completeness or quality of information, although the illustrations are ravishing.

Kadolph, Sara J. Textiles, 10th ed. (Upper Saddle River, NJ: Prentice Hall, 2007). This standard and always solid text has been redesigned, with lists, tables, summaries, and comparisons made highly effective in visual impact from layout and color as well as data. It is aimed to acquaint students with their possible graduate roles, and gives a good grounding. However, some directions of development generally judged to be highly significant are either not discussed or not clarified (e.g., nanotechnology).

Kurella, Elizabeth. Guide to Lace and Linens (Dubuque, IA: Antique Trader Books, 1998). This is a superbly illustrated book, but just as importantly, the information on a complex yet fascinating textile is first organized rationally and meticulously to guide anyone through examination and identification of lace. Then there are 136 pages on individual laces, alphabetically arranged. The Lace Merchant, PO Box 244, Whiting, IN 46394. The author has other books as well; consult www.elizabethkurella.com

Landi, Sheila. The Textile Conservator's Manual, 2nd ed. (Oxford: Butterworth/Heinemann, 1997).

Lebeau, Caroline. Fabrics: The Decorative Art of Textiles (New York: Clarkson Potter, 1994). Sumptuous book explores textiles for interior designers, with glossary of terms and source listings.

Linton, G. E. *The Modern Textile and Apparel Dictionary* (Plainfield, NJ: Textile Book Service, 1973). Quite out of date in many respects, but still encyclopedic in coverage.

McQuaid, Matilda, editor. Extreme Textiles (NY: Princeton Architectural Press, 2006). The result of

- an exhibition curated by M. McQuaid at the Smithsonian Cooper-Hewitt Design Museum, where she is Head of the Textiles Department. The book is a landmark, with headings of the collection of essays being enough to tantalize: "Stronger," "Faster," "Lighter," "Safer," "Smarter," and the illustrations and text satisfy. It must have been a blockbuster exhibition, which McQuaig says in her Acknowledgments took thirteen years to accomplish, with great collaboration among experts in many disciplines, and that is exactly what has been pushing (or pulling) so many "high technology" developments; that they turn out as works of art in design is a corollary she recognized and acted on. Her summing up: Textiles can be anything. A preview of the exhibition by John W. S. Hearle can be found in Textiles Magazine, 2005, No. 1: 25-27, and a review by him in 2005, No. 3/4: 31-33.
- Miles, Leslie W. C., editor. Textile Printing, 2nd ed. (Bradford, U.K.: Society of Dyers & Colourists, 1994). Historical overview added, processes and machines described and explained; new chapters include growing role of computers.
- Peigler, Dr. Richard S. "Wild Silks of the World." American Entomologist, 39/3, Fall 1993: 151– 161. Everything you ever wanted to know about wild silks; lucid, fascinating.
- Perkins, Warren S., Textile Coloration and Finishing (Durham, NC: Carolina Academic Press, 1996). Clear introductory text covering theory and practice.
- Price, Arthur, Allen C. Cohen, and Ingrid Johnson. J. J. Pizzuto's Fabric Science (NY: Fairchild Publications, 2006); www.fairchildbooks.com. Still the most industrially oriented text, includes good reference directories and textile laws/regulations. This edition focuses also on the shift of production to developing countries, and major technological advances; however, rather briefly, as are most updates, including emphasis on interiors but not in depth. Good practical assignments. Very basic coverage, but comes in ring binder and with swatch set; see listing under "Swatch Sets."
- Russell, Stephen, editor. Handbook of Nonwovens (Cambridge, U.K., Woodhead Publishing Ltd., 2006. Thorough coverage of a diverse market that has developed rapidly, beginning with the industrial sector.
- Scott, P. The Book of Silk (London: Thames & Hudson, 1993). History of silk worldwide.

- Slater, Keith. "Comfort Properties of Textiles." Textile Progress, Vol. 9, No. 4 (Manchester, U.K.: the Textile Institute, 1977). Literature review.
- -. "Textile Degradation." Textile Progress, Vol. 21, No. 1/2 (Manchester, U.K.: the Textile Institute, 1991). Literature review.
- Spencer, David J. Knitting Technology, 3rd ed. (Cambridge: Woodhead Publishing Ltd., 2002). Definitive text updated re knitted garment design and manufacture.
- Storey, Joyce. Manual of Textile Printing, 2nd ed. (London: Thames & Hudson Ltd., 1992).
- Storey, Joyce. The Thames and Hudson Manual of Dyes and Fabrics (London: Thames & Hudson Ltd., 1992).
- Tao, Xiaoming, editor. Smart Fibres, Fabrics and Clothing (Cambridge: Woodhead Publishing Ltd., in association with the Textile Institute, 2001). Research on new materials and their ability to sense and react to the environment. Chapters by various international experts.
- Textile Terms and Definitions, 11th ed. (Manchester: The Textile Institute, 2002). Standard terminology reference worldwide; includes many line drawings.
- Textile test methods. See Section Eight for names.
- Textile World Blue Book (Billian Publishing, Inc., 2002). Nearly 5,000 verified listings of mills throughout North America, plus international Buyers' Guide; www.textileindustries.com
- Tortora, Phyllis G., author, Robert S. Merkel, consultant. Fairchild's Dictionary of Textiles, 7th ed. (New York: Fairchild Books & Visuals, 1996). Over 14,000 entries in this updated standard.
- Trotman, E. R. Dyeing and Chemical Technology of Textile Fibres, 6th ed. (New York: John Wiley & Sons, Ltd., 1984, reprinted Hodder & Stoughton, 1991). Solid reference that first presents fibers and their reactions, then dyes and dyeing methods; significant developments, however, since this edition.
- Wilson, Jacquie. Handbook of Textile Design: Principles, Processes and Practice (Cambridge: Woodhead Publishing Ltd. in association with the Textile Institute: 2001).
- Yates, Marypaul. Fabrics: A Guide for Interior Designers and Architects. (New York: W. W. Norton, 2002.)
- Yeager, Jan, and Lura Teter-Justice, Textiles for Residential and Commercial Interiors, 2nd ed. (New

York: Fairchild Publications, Inc., 2000). Contents listed on Fairchild website; I have not reviewed the part on fibers and textiles *per se*, but the book seems to offer much useful information on the interior design process.

References of Historical Importance

Of interest mainly historically, a book of photomicrographic images of fibers (a landmark of its time) can be seen on the internet, thanks to The Smithsonian Libraries:

Von Bergen, Werner, and Walter Krauss. Textile Fiber Atlas: A Collection of Photomicrographs of Common Textile Fibers (New York: American Wool Handbook Company, 1942). There is a good deal of text dealing especially with wool. Shown are other animal fibers; silks; cotton; flax; other plant and mineral fibers; rayon; MF protein fibers (called "prolons"); two synthetics (called "synthons"), nylon and vinyon. www.sil.si.edu.digitalcollections/hstcollections/HST_title.cfm?bib_id=SIL7-236

I found two other older references useful in trying to simplify the workings of the jacquard mechanism:

Clarke, Leslie J. The Craftsman in Textiles (New York: Frederick A. Praeger, 1968).

Nisbet, H. Grammar of Textile Design, 2nd ed. (London: Scott, Greenwood & Son, 1919).

Another older book, William Watson's *Textile Design and Colour* (Burrow Green, Sevenoaks, Kent: Butterworth & Co. Publishers Ltd., 1946) is cited as reference for a diagram illustrating the principle of the jacquard mechanism that appears in the article "Jacquards for Weaving," *Textiles*, 10/1, 1981.

Publications—Catalogs or Online

ASTM Publications, Products, & Services, annual listing of standards, books, journals, and software. (See ASTM under "Associations" for address, including website.

Blackwell's Bookshops carry books on many subjects, including clothing design and production, and all aspects of fiber and fabric production. Details or order online: www.blackwell.co.uk

Canadian General Standards Board (CGSB), Sales Centre, Ottawa, ON, K1A 1G6, Canada; standards on care labeling, clothing sizing.

Fairchild Books & Visuals, focus on publications and aids for fashion, apparel, retailing, textiles, and latterly, interior design. Printed catalog does not always specify date of each publication; 7 West 34th Street, New York, NY 10001; www.fairchildbooks.com/textiles.cfm

Textile Technology Catalogue (Cambridge: Woodhead Publishing Ltd.). Revised annually, excellent coverage; www.woodhead-publishing.com

World Textile Publications Ltd., www.textilebook store.com.

Periodicals

- AATCC Review (see AATCC under "Associations" for address).
- Canadian Apparel Magazine (see Canadian Apparel Federation under "Associations" for address).
- Clothing and Textiles Research Journal, from ITAA (see "Associations" for address).
- Fabricare Canada, P.O. Box 968, Oakville, ON, Canada L6J 5E8.
- Home Textiles Today, online from Reed Business Information, www.hometextilestoday.com
- Journal of Family and Consumer Sciences, quarterly (see American Association of Family and Consumer Sciences under "Associations" for address).
- Journal of Interior Design, Interior Design Educators Council, 7150 Winton Drive, Suite 300, Indianapolis, IN 46268.
- Journal of Textile & Apparel, Technology and Management (JTATM), College of Textiles, North Carolina State University, quarterly. P.O. Box 8301, Raleigh, NC 27695–8301; www.tx.ncsu.edu/jtatm
- Journal of the Textile Institute (see The Textile Institute under "Associations" for address).
- Just-Style, daily news headlines free, in-depth articles to subscribers, covers all aspects from textile and apparel manufacture to marketing: http:// just-style.com.
- Textile Chemist & Colorist (see AATCC Review).

 Textile Journal, CTT Group, 3000 Boullé, St.-Hyacinthe, QC J2S 1H9; www.textilejournal.ca

- Textile Progress (see The Textile Institute under "Associations" for address).
- Textile Research Journal, P.O. Box 625, Princeton, NJ 08542.
- textiles, the quarterly magazine of The Textile Institute (see under "Associations" for address).
- Textile Technology Digest (see Institute of Textile Technology under "Associations" for address).
- Textile Technology International, Sterling Publications Limited, Brunel House, 55-57 North Wharf Road, London W2 1LA
- Textile World, published by TextileIndustries Media Group, 2100 Powers Ferry Road, Suite 300, Atlanta, GA 30339-5014. Buyers Guide for worldwide textile suppliers: http://textileindustries .com/buyersearch.com

Associations

- American Apparel and Footwear Manufacturers Association, 2500 Wilson Blvd., Ste. 301, Arlington, VA 22201.
- American Association of Family and Consumer Sciences, 400 North Columbus Street, Suite 202, Alexandria, VA 22314; www.aafcs.org.
- American Association of Textile Chemists and Colorist (AATCC), P.O. Box 12215, One Davis Drive, Research Triangle Park, NC 27709-2215; www.aatcc.org.
- American Fiber Manufacturers Association (AFMA), 1530 Wilson Blvd., Suite 690, Arlington, VA 22209. See Fibersource under "Teaching Aids and Resources: Printed and Internet" for AFMA consumer information, including Fiber Economics Bureau material.
- American Sheep Industry Association, 9785 Maroon Circle, Suite 360, Centennial, CO 80112.
- ASTM International, 100 Barr Harbor Drive, P.O. Box 6700, West Conshohocken, PA 19428-2959; www.astm.org.
- Canadian Apparel Federation, #504–124 O'Connor Street, Ottawa, ON Canada K1P 5M9.
- Canadian Carpet Institute, 647 Alesther, Ottawa, ON Canada K1K 1H8.
- Canadian Textiles Institute, 222 Somerset St. W., Suite 500, Ottawa, ON Canada K1P 5H1; www .textiles.ca.

- Carpet and Rug Institute, P.O. Box 2048, Dalton, GA 30722-2048.
- The Color Association of the United States, 315 West 39th Street, Studio 507, New York, NY 10018.
- Cotton Incorporated, 6399 Weston Parkway, Cary, NC 27513-2314.
- Fiber Economics Bureau, Inc. (a division of AFMA), 1530 Wilson Blvd., Suite 690, Arlington, VA 22209.
- The Fiber Society, c/o College of Textiles, North Carolina State University, Raleigh, NC 27695-8301.
- Hosiery Association, 7421 Carmel Executive Park, Suite 200, Charlotte, NC 28226.
- INDA, Association of the Nonwoven Fabrics Industry, P.O. Box 1288, Cary, NC 27512-1288; www.inda.org.
- Industrial Fabrics Association International, 1801 County Road B West, Roseville, MN 55113.
- Industry Canada, Office of Consumer Affairs, www .strategis.gc.ca.
- Institute of Textile Technology (ITT) (with Roger Milliken Library), 2551 Ivy Road, Charlottesville, VA 22903-4614.
- Interior Design Educators Council, 7150 Winton Drive, Suite 300, Indianapolis, IN 46268; www. idec.org.
- International Fabricare Institute (IFI), 14700 Sweitzer Lane, Laurel, MD 20707.
- International Furnishings and Design Association, 191 Clarksville Road, Princeton Junction, NJ 08550.
- International Textile and Apparel Association (ITAA), P.O. Box 1360, Monument, CO 80132-1360.
- National Cotton Council of America, 1030 Fifteenth Street NW, Washington, DC 20036.
- National Home Furnishings Association, P.O. Box 2396, High Point, NC 27261-2396.
- National Textile Association, 6 Beacon Street, Suite 1125, Boston, MA 02108; www.nationaltextile.org.
- Neighborhood Cleaners Association, 116 East 27th St., New York, NY 10016. Consumer information available:www.ncaclean.com/consumer/index.cfm.
- Soap and Detergent Association, 1500 K Street NW. Suite 300, Washington, DC 20005. Excellent single page graphics and explanation regarding symbol care labeling system, ASTM D5489-966; www.cleaning101.com.

- Supima Association of America, 4141 East Broadway Road, Phoenix, AZ 85040.
- Textile Human Resources Council (see Canadian Textiles Institute for address).
- The Textile Institute, 4th Floor, St. James Buildings, Oxford Street, Manchester MI 6FQ, U.K.
- U.S. Metric Association, Inc., 10245 Andasol Avenue, Northridge, CA 91325-1504.
- The Woolmark Company, 156 Avenue of the Americas, Suite 701, New York, NY 10036. (Addresses worldwide at www.wool.com/contact.php?id=32)

Teaching Aids and Resources

Printed and Internet

- Ask the Expert—Consumer Information, International Fabricare Institute, consult www.ifi.org/consumer/index.html.
- Carpet and rug information on buying, installation, and care from: The Carpet and Rug Institute, www.carpet-rug.com; Canadian Carpet Institute, www.canadiancarpet.org.
- Dictionary of Textile Terms. Order: Attn. Rowena, Dan River Inc., 1325 Sixth Avenue, 14th Floor, New York, NY 10019. US\$2.50 each, prepaid (includes postage to U.S. or to Canada). Not always accurate, but a good deal of information for students for the low price.
- Fabric Link at www.fabriclink.com offers a "Fabriclink University," with information that is definitely shaped by its sponsor companies (e.g., trademark names mentioned). However, there are sections on care, stain removal, and some coverage of new textiles. The dictionaries section gives surprisingly wide and accurate definitions for many terms.
- Fibersource offers educational content from the American Fiber Manufacturers Association (AFMA) on the internet through: www.fibersource.com. This covers information under Fiberworld Classroom, a video on carpets from the (spotty) selection of books on Amazon.com, and other items. The Fiber Economics Bureau's publications are listed here as well. Besides their major statistical reports, such as Fiber Organon, they offer the Manufactured Fibers Fact Book (description follows).
- Manufactured Fibers Fact Book, US\$5 per copy plus \$5 S&H (25% discount, 10 or more). This booklet can provide some very helpful pages. The graphics of production of a number of MF fibers and the table of physical properties of some MF

- fibers are worthwhile, although the booklet dates from 1988. The address in the booklet is outdated; here is the correct address: 1530 Wilson Blvd., Suite 690, Arlington, VA 22314.
- Guide to the Use of the Metric System (SI Version), 16th ed. (U.S. Metric Association, Inc., 2006) (see U.S. Metric Association under "Associations" for address) 34 pp., pbk. Clear and complete on basics (more detail on textile applications in Section Nine, Fabric Reference), \$15 + \$5 shipping & handling (1–9 copies; for price on larger numbers, see website). Order online or from the U.S. Metric Association address (see "Associations"). A list of other Metric Supplies and Training Aids available is included. A website comes courtesy of the University of Colorado, with pages maintained by Dr. Don Hillger. It is notable for the wealth of linkages to other sources of related material, besides being easy on the eyes and to get around in: http://lamar.colostate.edu/hillger.
- Wood, Errol J., Ed., *Tangling With Wool*, Christchurch, NZ, Canesis Network Ltd. (formerly WRONZ), 2000. A lively, if meandering resource book written by physicists and such experts bent on making their country's outstanding product known to schools; there is a Teachers' Guide as well. Many experiments would require access to raw wool, but the explanations of many scientific terms are so solid and clear that it could be valuable to any instructor (static; wool "grease" [wax]; warmth of wool when wet; color; prickle of [coarser] wool; genetics). However, be warned that there is no index, and the paging is somewhat erratic. Consult www.canesis.com.

Storage and Conservation of Textiles and Vintage Articles

- Ashleigh, Caroline, Antiques Roadshow, "Tips of the Trade," How to Care for Your Vintage Fabrics, www.pbs.org/wgbh/pages/roadshow/tips/vin tagefabrics. Records advice for care of rugs, quilts, vintage fabrics, and other textile items.
- Finch, Karen, and Greta Putnam. The Care and Preservation of Textiles (London: Batsford, 1985).
- Mailand, Harold F. Considerations for the Care of Textiles and Costumes, A Handbook for the Non-Specialist, Indianapolis Museum of Art, 1980, ISBN B0006CYZLC. Small paperback with excellent information.

Mété, Esther. "Conservation Notes: Preserving Your Child's Heirloom Garments," Rotunda. The Magazine of the Royal Ontario Museum, Fall/Winter 1998: 41.

Ordonez, Margaret T. Your Vintage Keepsake: A CSA Guide to Costume Storage and Display. 32 Pbk., www.costumesocietyamerica.com; bookstore with link to Amazon.com.

Ryder, Michael L., "The Conservation of Textiles," Textiles Magazine, 3, 1996: 15-20.

Talas, source of information and links concerning basic conservation techniques. Index of products, books list. 20 West 20th St., 5th Floor, New York, NY 10011; www.talas.online.com.

Timar-Balazsy, and Dinah Eastop. Chemical Principles of Textile Conservation (Butterworth-Heinemann Series in Conservation and Museology, 1998).

Resources Including Fabrics

Multifiber Cloth.

Sources, see Section Eight.

Swatch Sets

Fabric Glossary Swatch Set (115 swatches), has been designed to be mounted in Fabric Glossary, also published by Prentice Hall. For a description of this book, see earlier "References and Resources" entry under Humphries, which explains how it offers a rich collection of "name fabrics" but can also greatly illuminate a course of textiles study. For order information see page at the back of this book.

Fabric Science Swatch Kit, 8th ed. (101 swatches), 20 mounting pages, three-ring binder. Fairchild Books & Visuals, 2006 (see "Publications—Catalogs or Online" for address).

Textile Fabric Consultants, Inc. offer a variety of sets: Basic, Interior Design, Textile Identification Manual with Textile Collection, plus Fabric Exam Swatch Book (developed by Dr. Sara March and Dr. Sara Kadolph; www.textilefabric.com.

Fabric for Historical Reproductions

Traditional Fabrics, Inc., can make fabrics especially for reenactors and others wanting authentic fabrics such as linsey-woolsey; www.traditionalfabrics. com.

Equipment Helpful in Textiles Study

The following equipment will be useful in studying and identifying fabric samples. Many items can be obtained from a laboratory supply house or special hobby or college store.

Edmund Scientific's, U.S. customers only, online; 60 Pearce Avenue, Tonawanda, NY 14150; www.scientificsonline.com.

Scissors. Sharp; *not* the pinking type.

Tweezers.

Invisible or double-sided tape. For mounting samples.

Magnifier. A most useful item. Magnification of as little as four times $(4\times)$ will bring out features of fabrics and yarns in startling clarity. The best magnifiers incorporate a battery-operated light. Anyone involved with fabrics will find one handy. Available from laboratory supply companies, but also in optical stores and departments. (See Figure R.1.)

Pick (dissecting) needle. You also could use a hat pin or a darning needle with the eye in a cork. (See Figure R.1[a].)

Figure R.1 (a) Magnifier and dissecting needle; (b) optical department magnifier.

Pick or thread counter. Also called a loop, counting, or piece glass, linen tester, or prover. It gives some magnification and allows a count of the number of yarns or knit loops in a centimeter or inch. (See Figure R.2)

Microscope. Need not be high quality; the type sold for children's hobby use is quite adequate. You will also need some slides and cover slips,

Figure R.2 Pick counter.

and a dropper bottle for water is useful. (See Figure R.3) (See detailed instructions under "Microscopic Fiber Examination," Section Two.)

Figure R.3 (a) Microscope; (b) dropper bottle.

Appendix

Generic Names for Manufactured Fibers with Definitions

Generic names for manufactured fibers, with definitions for each, have been set by the Federal Trade Commission as *Rules and Regulations Under the Textile Fiber Products Identification Act (Textile Rules)*, following provisions of section 7(c) of the Act: 16 CFR Part 303.7.

A manufactured fiber in which the fiber-forming substance is any long chain synthetic polymer composed of

(a) Acrylic. A manufactured fiber in which the fiberforming substance is any long chain synthetic polymer composed of at least 85% by weight of acrylonitrile units

$$\begin{array}{c|c} (CH_2-CH-). \\ & | \\ CN \end{array}$$

(b) Modacrylic. A manufactured fiber in which the fiber-forming substance is any long chain synthetic polymer composed of less than 85% but at least 35% by weight of acrylonitrile units

except fibers qualifying under paragraph (j)(2) of this section and fibers qualifying under paragraph (q) of this section.

(c) Polyester. A manufactured fiber in which the fiber-forming substance is any long chain synthetic polymer composed of at least 85% by weight of an ester of a substituted aromatic carboxylic acid, including but not restricted to substituted terephthalate units,

and para substituted hydroxy-benzoate units,

$$p(-R-O-C_6H_4-C-O-)$$

Elasterell-p. Where the fiber is formed by the interaction of two or more chemically distinct polymers (of which none exceeds 85% by weight), and contains ester groups as the dominant functional unit (at least 85% by weight of the total polymer content of the fiber), and which, if stretched at least 100%, durably and rapidly reverts substantially to its unstretched length when the tension is removed, the term elasterell-p may be used as a generic description of the fiber.

- (d) Rayon. A manufactured fiber composed of regenerated cellulose, as well as manufactured fibers composed of regenerated cellulose in which substituents have replaced not more than 15% of the hydrogens of the hydroxyl groups. Lyocell. Where the fiber is composed of cellulose precipitated from an organic solution in which no substitution of the hydroxyl groups takes place and no chemical intermediates are formed, the term lyocell may be used as a generic description of the fiber.
- (e) Acetate. A manufactured fiber in which the fiberforming substance is cellulose acetate. Where not

less than 92% of the hydroxyl groups are acetylated, the term *triacetate* may be used as a generic description of the fiber.

(f) Saran. A manufactured fiber in which the fiberforming substance is any long chain synthetic polymer composed of at least 80% by weight of vinylidene chloride units (—CH₂—CCl₂—).

(g) Azlon. A manufactured fiber in which the fiberforming substance is composed of any regener-

ated naturally occurring proteins.

(h) Nytril. A manufactured fiber containing at least 85% of a long chain polymer of vinylidene dinitrile (—CH₂—C(CN)₂—) where the vinylidene dinitrile content is no less than every other unit in the polymer chain.

(i) Nylon. A manufactured fiber in which the fiberforming substance is a long chain synthetic polyamide in which less than 85% of the amide

linkages are attached directly to two aromatic rings.

- (j) Rubber. A manufactured fiber in which the fiberforming substance is comprised of natural or synthetic rubber, including the following categories:
 - (1) A manufactured fiber in which the fiber-forming substance is a hydrocarbon such as natural rubber, polyisoprene, polybutadiene, copolymers of dienes and hydrocarbons, or amorphous (noncrystalline) polyolefins.
 - (2) A manufactured fiber in which the fiber-forming substance is a copolymer of acrylonitrile and a diene (such as butadiene) composed of not more than 50% but at least 10% by weight of acrylonitrile units

The term *lastrile* may be used as a generic description for fibers falling within this category.

(3) A manufactured fiber in which the fiberforming substance is a polychloroprene or a copolymer of chloroprene in which at least 35% by weight of the fiber-forming substance is composed of chloroprene units

$$(-CH_2-C=CH-CH_2-)$$

- (k) Spandex. A manufactured fiber in which the fiberforming substance is a long chain synthetic polymer comprised of at least 85% of a segmented polyurethane.
- (l) Vinal. A manufactured fiber in which the fiber-forming substance is any long chain synthetic polymer composed of at least 50% by weight of vinyl alcohol units (—CH2—CHOH—), and in which the total of the vinyl alcohol units and any one or more of the various acetal units is at least 85% by weight of the fiber.
- (m) Olefin. A manufactured fiber in which the fiber-forming substance is any long chain synthetic polymer composed of at least 85% by weight of ethylene, propylene, or other olefin units, except amorphous (noncrystalline) polyolefins qualifying under pragraph (j)(1) of this section.
 - Lastol. Where the fiber-forming substance is a cross-linked synthetic polymer, with low but significant crystallinity, composed of at least 95% by weight of ethylene and at least one other olefin unit, and the fiber is substantially elastic and heat resistant, the term *lastol* may be used as a generic description of the fiber.
- (n) Vinyon. A manufactured fiber in which the fiberforming substance is any long chain synthetic polymer composed of at least 85% by weight of vinyl chloride units (—CH2—CHCI—).
- (o) Metallic. A manufactured fiber composed of metal, plastic-coated metal, metal-coated plastic, or a core completely covered by metal.
- (p) *Glass*. A manufactured fiber in which the fiber-forming substance is glass.
- (q) Anidex. A manufactured fiber in which the fiberforming substance is any long chain synthetic polymer composed of at least 50% by weight of one or more esters of a monohydric alcohol and acrylic acid (—CH2——CH—COOH).
- (r) Novoloid. A manufactured fiber containing at least 85% by weight of a cross-linked novolac.

(s) Aramid. A manufactured fiber in which the fiberforming substance is a long chain synthetic polyamide in which at least 85% of the amide

linkages are attached directly to two aromatic rings.

- (t) Sulfar. A manufactured fiber in which the fiberforming substance is a long chain synthetic polysulfide in which at least 85% of the sulfide (—S—) linkages are attached directly to two (2) aromatic rings.
- (u) PBI. A manufactured fiber in which the fiber-forming substance is a long chain aromatic

- polymer having reocurring imidazole groups as an integral part of the polymer chain.
- (v) Elastoester. A manufactured fiber in which the fiber-forming substance is a long chain synthetic polymer composed of at least 50% by weight of aliphatic polyether and at least 35% by weight of polyester, as defined in § 303.7(c).
- (w) Melamine. A manufactured fiber in which the fiber-forming substance is a synthetic polymer composed of at least 50% by weight of a cross-linked melamine polymer.
- (x) Fluoropolymer. A manufactured fiber containing at least 95% of a long chain polymer synthesized from aliphatic fluorocarbon monomers.
- (y) PLA. A manufactured fiber in which the fiberforming substance is composed of at least 85% by weight of lactic acid ester units derived from naturally occurring sugars.

INDEX

This Index covers both the Fabric Reference and its companion book Fabric Glossary. Page numbers in **boldface** indicate pages with illustrations. Words capitalized, if not proper names, are usually trademark names.

	Reference	Glossary	l .	Reference	Glossary
abaca	16, 18, 35		alkali	304	
abbot's cloth		21, 22	all over joining	190	
abrasion resistance	9, 20, 305–306		allover lace		137, 139, 141
absorbency	9, 20, 71, 286, 305		allover pattern	172	107, 103, 111
abused	205		alpaca	43, 45, 46	
accordion knits	158		alpaca fiber	13, 13, 13	2, 177
accordion rib	le le	207	alpha-helix	37, 39	_, _, _,
acetate	62, 240, 263		AlphaSan	85, 213	
acid	304		amauti	283	
acid dyes	220		Amicor Pure	85	
acid effect	275		amide linkages	37, 65	
acid metallized dyes	221		amino acids	37	
acid pollution	249		amorphous	10	
acid rain	294		angora	46, 97	
acid-washed	205		Angora goats	43, 44	
acrylic	16–19, 20, 22,		Angora rabbits	46	
	69–70, 239, 263,		anion	304	
	266		antifelting	214, 215	
acrylonitrile unit	70		anti-microbial action	,	
Actifresh	213		anti-microbial—		
Actigard	213		see bacteriostatic		217, 225
Actionbac	175		antique taffeta		261
actionwear			antique textile		
acivewear		8	storage	275	
Active Protection			antiquing	186	
System	191, 192, 298		antistatic fibers	84	
active stretch	72		Antron	99, 296	
"added value"			appearance test	307	
finishes	208– 217		applied design	227	V I
adsorbency	9		appliqué	233	
Aerocor	116		appliqué lace	171	133
aetz lace		137	Aquajet	181	
after five fabrics		8, 9	Arachne		251
Agilon	116		aramid	74–75	
aida cloth		85	Arctic clothing	283, 284, 285	
air-capture principle	283, 286		Argyle	165, 166	
air, air-jet textured		155	Argyle knit		195
air-jet looms	127, 128, 129,		armure	142	83
	144–145, 146		Arnel	62	
air-jet spinning	112		aromatic polyester	68, 253	
air-jet texturing	116		artery replacements	4	
air pollution	294–295		artillery cloth, cord		281, 282
ariplanecloth		239, 240	art linen	1	7, 151
air spaces	80–81, 286		Artistri	229 -230	
air texturing	116		asbestos	16, 18, 36	
air-trapping			assessment	302-312	
principle	283, 286		interiors fabrics	305–306	
à jour,	126		nontechnical tests	307, 308, 309	
Alcantara	83, 179	165	standard tests		
Alençon lace	170–171	133, 141	and ratings	303-305, 306	
alginate	16, 18, 64		astrakhan		155

	Reference	Glossary	ı	Reference	Glossary
automatic looms	131		beaver cloth		177, 178
automotive interior	131		beaver fur	47	1//, 1/8
fabrics	296			47	67
Avora FR	85		beaverteen beck	224	67
awnings	318		bed "linens"	224	5
awnings cloth,	310		bedding fabrics		5, 6
awnings cloth,		37	bedford cord		87
Axminster carpet	150	37	bedspreads		6
azlon	63–64		beetling	200	77
azoic dyes	221		begger's lace	171	135
azoic ayes			belfry cloth	1/1	21, 22
back of fabric		13 + photos in	Belima X	83, 86	21, 22
oden or idone		many Files	Bemberg	60	153
back side of fabric	124	many rics	bengaline	134	209 , 210
bacteria, harmful	249	l x	berber	151	109
bacterial rot	274		bias	125	103
Bactrian camel	44-45		bibulous paper	96	
Badenoch check	11 10	45, 47	bicomponent fibers	70	254
bagging	309	10, 17	bicomponent fibers,		204
bagheera velvet		287	biconstituent		
baize		103	fibers, bigeneric		
balance	129–130, 131, 134	100	fibers	39, 86	
balanced plain	100, 101, 101		billiard cloth	33,00	103
weave	29, 130, 134, 135		Bi-Loft	113	103
balbriggan	158	131	binary selection	145	
ball fringe	175		Binche lace	171	135
Ballindaloch check		45	bioactive agents	85. 212– 213	100
bamboo	36, 62, 293		bio-based synthetic	00, 212 210	
bandana, bandanna		193 , 194	fibers	76–77	
bannigan		67, 70	biodegradable	249	
Bannockburn tweed		277	biometric		297
bantamweight		4, 279	biopolishing		
barathea		209, 211, 303,	bioscouring	205	
		304	biotechnology	4, 296–297	
bark cloth, fiber		165	birdseye	160	
bark crepe	204	71, 75	birdseye knit back		93
bark fiber cloth	16, 36		birdseye piqué		87 , 88
Barmen	169		birdseye woven		303, 304
barmen warp lace		141	birefringence	233	161
barré, barriness	104		bishop's cloth		21, 22
base (alkali)	304		blades	317	T.
basket weave			blanket	244	
and effect	132, 134–135, 143		blanket cloth, fabrics		10, 175
basket weave & look	16 10 00 04 06	17, 19, 21, 23	blanket fabrics		157
bast fibers	16, 18, 30–34, 36	100 101	blanks (knitting)	157	
batik	219	193, 194	blazer cloth, fabrics		9, 10, 173
bating	184	0.5	bleach	251–252, 267	
batiste		25	bleaching	188, 198, 200	133
batt	105 150	63 , 165	bleeding dye	263	157
batten	125, 178	100	blending	86–89	
Battenburg lace	172	133	Blister Guard socks	76 , 86	
bave	48	, ,	blistered look	004	159
BCF	114		block printing	231	
bead edge	170		blood circulation	283	
beading	172, 173, 247		"blooming" (yarn)	173	
beam (dyeing) beam yarns	224 170		blotch print	231	
beam yarns beard needles	Total Control		blouse fabrics	100	8,9
beard needles beaten up	156, 157 125		boa babbin	188	
	125		bobbin babbin	125	141 160
ocutei	1120	,	bobbinet	169	141, 163

	Reference	Glossary	1	Reference	Glossary
bobbin lace	170, 171	133, 135, 141	bunting		117, 118
bobbin (loom)	126, 149		Burano lace		133
boiled wool		109, 171	burlap	175	33, 243, 275
BodyClimate	166	269	burling	206	00, 210, 270
body hoods	178		burned-out	232	185 , 186
body interactive	N N		burning behavior	93, 94, 95	100, 100
encapsulations	210		burning test	91, 94, 95	
body temperature	34-3300340000		butcher cloth, linen	, , , , , , ,	149, 150
regulation	287-288		Bute tweed		279
bolting cloth		117	buttonholes	120	
bonded fiber web	178 –179	165	buttons	248, 317	
bonded thread	120		BUZZ OFF Insect	,	
bonding	190, 248		Shield	213, 246	
book muslin		117			
botany wool	41		cable knits	158	207
bottom weight		4	cables	121, 175	
bouclé, bouclette	117 , 135	15, 155	cable yarn	105	
bouclette yarns,	117		CAD/CAM	144, 159	
bourette yarns	117, 118		Calcutta cloth		157
bourrelet	160	93	calendering	204	
box loom	125		calendered		57, 299
braid	175		calico	135	35
braid(ed), "braid"		27, 119	Cambrelle	180	
brand names,	19		cambric		25
break spinning	112, 113	4 111	camel, camelid		2
brick	185, 189		camel hair	43, 44–45	
bridal fabrics		8	camelids	45–46	
brides	170, 173		cams	142	
brides (lace)		134, 135, 137	candlewick	152, 173, 174, 175	275, 276
brighteners	265–266		canekudsm	43	
bright fiber	84, 98		Canton crepe		71, 73
brins	48		Canton flannel		105
broadcloth	131, 132, 134		canvas	135, 318	37, 85
broadcloth			canvas, hair or		
cotton, silk		16, 29, 211	tailor's		39
wool	145 446 045	177	cape net		163
brocade	145, 146, 247	31, 129, 130	caprolactam	65, 296	
épingle brocade		129, 130	cap spinning	108	
brocaded satin		217	carbon	18, 76	
brocaded velvet		287	carbonized,	00.100	
brocatelle		31	carbonizing	38, 198	
broché coutil,		100 070	carbon nanofiber	83	
figured broderie anglaise		129, 270 97	carded (yarn)	108, 109, 110	most spun yarn
broken twill	135, 136	97	aoua labalina	264 , 267–272	fabrics
Bruges lace	171	135	care labeling Care Labeling Rule	267- 268 , 270	
brushed	204	257	care labeling Rule	207-200, 270	
brushed-back satin	204	217, 221	symbols	269, 271	
Brussels carpet	150	217, 221	care of fabrics	239–275	
Brussels lace	130	135	caribou hair	46	
buckram		117	carpet	40	6, 247 , 275
buffalo check		45, 179	carpet	242–243, 257	0, 241, 275
buffalo hair	47	10, 117	machine woven	149–150	
buffing	186		pile height and	147-100	
builders	250–251		density	320	
bulked continuous	200 201		quality	150–151	
filament	114		recycling	296	
bulked filament			shading	270	
thread	120		prevention	215, 217	
bullseye piqué	-30	87, 88	stain-resistant	246	
7 1 1-1		,			•

	Reference	Glossary	r der	Reference	Glossary
carpet beetle larvae	274 –275		China grass	34	
Carrickmacross lace	171	133	China silk		239 , 240
carriers	265		chinchilla,	185, 189	
carved design	232	r we' j	chinchilla cloth		177 , 178
carving	188		chiné	224, 227	
Case History form	311-312		chiné effect	,	191 , 192
casement cloth,		al I	chino	2 1	53
fabric		5, 25, 51	chintz	135	55, 56
casein	64		chirimen		71
cashgora	44		chitin	64, 294	
cashmere	43-44, 97 , 243	2, 183, 184	chitosan	64, 294	de gr
cashmere goats	43, 44		chlorinated solvent	257–258	
cation	304		chlorine bleach	251	
cavalry twill		281	chlorofibre	14, 70, 182	
cationic dyes	221		chlorofluorocarbons	294	
cellophane	60, 182		chroma	219	
cellulases	205		Chromalon	84	
cellulose	27		Chromasensor CS-5,		
cellulose acetate	16, 19, 62–63		chrome dyes	220, 221	
cellulose fibers	14, 263–264, 266		chrome tanning	184	
cellulosic	11, 200 201, 200		Cidega	164	
manufactured			CIJ	229	49.
fibers	24, 26, 27–36,		circle (care labeling)	270	
noers	59–63		circular knitting	157	1 4
certification marks	19		ciré	204	57, 261, 297
CFCs	294		ciselé velvet	149	287
chafed silk	52		Clean & Green	259	207
chain warp	150		cleaning	239	
challie, challinet,	150		commercial	257–262	
challis, challys		41, 42	dry cleaning	257–259, 267, 308	
chambray		43, 181	home care	239–256	
chameleon		61, 261	self-cleaning	239-230	
chameleon effect	224	01, 201	clothing	298	
chamois	184	105, 145, 257	ultrasonic	259	
changeable dye,		100, 110, 207	wet cleaning	259	
changeant	E	61 , 62	"clever clothes,"	2, 3, 297–298	
changeant,	224	01, 02	clip-spot, clip-dot	146–147, 148	91
channels in fibers	79–81, 86		clokay, cloqué	140-147, 146	71, 159
Chantilly lace	171	135, 141	cloister cloth		21, 22
charge system	257	100, 111	cloqué	247	21, 22
charmeuse	207	71, 218, 223	closed-loop	247	
check, plain weave		45, 121, 157,	novelty yarn,	117	
orroom, plant would		187	closeness of	117	
check, twill weave	n ,	45, 47, 48	construction test	307	
cheesecloth	35 - 45	117	cloth of gold, silver	307	143
chemicals, toxic		117	cloth—see fabrics		140
or unpleasant	249		cloth count	130–132, 320	
chemical spinning	58	10.20	clothes moth,	274 –275	
chemical test	91, 99		clothing	2.1 270	
chenille	118, 151, 152,		cold weather	283, 284, 285,	
	175		cold weather	286– 287	
chenille (tufted)	1,0	275, 276	as environment	279–291	
chenille (yarn) &			self-cleaning	298	
mock		49, 205	warm weather	288	
Cheviot tweed		277	clo value	320–321	
chevron		123	Cluny lace	169, 171	135
chiffon	204, 247	51, 71, 295	CMF	27–36, 59–63	133
chiffon velvet	201, 21/	287	CO ₂ -based solvent	258	11 %
children's wear		20,	coachman cloth	200	175
fabrics		8, 9	coat fabrics		9, 10
	•	, ,	cour raories		, 10

	Reference	Glossary	l seg	Reference	Glossary
coated fabrics,	1 19		composite,		
coatings	186, 208-209	59, 189, 297,	compound fabrics		63, 64, 101
	3	298	composite materials	83	, , , , , , , , , , , , , , , , , , , ,
coil stretch	115, 116		composite		
Coigach check		45	technology	178, 181	
coir	16, 18,30		compound fabrics,	190-192 , 298	
cold weather			compound needles	156	y 22
clothing	283, 284, 285,	No. of	compound weave		87, 89
	286- 287	1,	compression		
collagen	37, 183, 184		garments		8, 255, 256
collodion	96		compressive		
color	219–226, 321		preshrinking	214–215, 216	
application dyes			computer-assisted		
& print	219–226		design and		
definition	219		manufacturing	144, 159	
printing	227–231		conditioned (leather)	184	
colorblending		"	conjugated	86	
thread	120		Connemara tweed		279
color decision	222		Consumer		
colored nubs	223		Products		
colored pigment	85		Safety Act	92	2
colorfastness	222, 263–266,		continuous filament		
	303 -304, 307,		yarn	104, 114	
	308		continuous ink jet	229	
colorfastness to		1 4	contour fabrics		8
perspiration tests	304 -305	A 4	contract textiles	2	
Colorganic	292–293	4	converters	198	
color matching	321		Coolmax	19, 79, 88–89	
color remover	251	F0 64 60	copolymer	10	
color variable	007	59, 61, 62	cordage	121, 175	12
colorway	227	22	cordonnet	171	
Com4 combed	111, 112		cordovan	184	
combinations	31, 32, 110 76, 86		cords	134, 318	
ComforSpun	111, 112		corduroy	148, 151, 242	07
comfort	111, 112	1	cord weave cord yarn	105	87
blends	87–89		cord yarn corded look	105	93, 251
characteristics	9		cordonet		133-135, 139,
in clothing	279–283		Cordoner		141
knits versus	277 200		corduroy (& uncut)		65, 67, 69, 70
wovens	155		core	86. 117	05, 07, 05, 70
physiological	5		corespun thread	120	
psychological	5		corium,	183	
thermal	209- 210		corkscrew yarns	118	
thermophysio-			Corriedale wool	38	
logical	305		corset fabrics		255, 259
yarn	104		Corterra	68, 253	
Comfortemp	210		cortex	39	
comforter covers	10,000	5	cotton	12-14, 27-30	
commercial			care	240, 242	
cleaning	257–262		features,	97	
commercial wet			finishing	200, 201	
cleaning	259		natural colors	292-293	
commingled yarn	104		production	25, 27–30	
commodity			properties	30	
fibers/goods	19		quality	30	
comonomers	65		cotton duvetyn		105
compact spinning	111, 112		cotton family		
complex-ply yarns	117–119		fabrics		2, 3
complex weaves	142–152	l 199	cotton flannel	[105

	Reference	Glossary		Reference	Glossary
cotton satin		217, 219	cultivated silk waste	52	
cotton sheeting	239–240	217, 213	cuprammonium	02	4
cotton thread	120		rayon, cupro	16, 18, 60–61	
cotton velvet	148	287, 289	cured (leather)	184	
cotton yarn	107	201, 201	curl yarns	117	155
counting glass	130–131, 330		curtain, cushion		
coupe de velours	100 101, 000	185, 186	fabrics		5, 6, 147
course	154	1 2 3 5 7 2 3 7	curtain grenadine,		, , ,
coutil		269	curtain madras		147
covered yarns	118		cuticle	39	
cover (opacity)	8	2 1	cut (knitting)	156, 320	
covert (cloth)		281 , 282	cut pile	149	
cow hair	46		cut-resistant		4
cowhide	184		particles	85–86	
crabbing	199		cutting (fur)	188, 189	2
craft yarn	317		cutting (knits)	155	*
Craiganputtach			cutting (wool)	204	
tweed		279	cutwork		97 , 133
crash	175	149			
crater fibers	81		Dacron	68	
crease recovery	213-214, 307		damaging out	188	
crepe—all types		71	damask	= ,	77, 78, 129, 130
crepe de Chine	145, 146	71, 73	darned lace	171	133
crepe marocain		71, 73	daywear, women's		9
crepe twist	106		decating	199	1
crepe twist yarn		51, 73, 159, 223	decitex	107	1
crepe weave		71, 72	decorticating	34	
creping	204		découpé	232	185, 186
crepon	204	71, 75	"deep dye nylon,"	65	
cretonne	135	55, 56, 301	degumming	199	
crimp	9		dehumidifying unit	245	
crimpknit	116, 160	93	delavé	205	"
Crimplene	116		delustering agent	84–85	4
crimp texturing	116	-	denier	107	70 00
"crinkle crepe,"	232		denim	205, 221, 264	79, 80
crinkle crepe		71 107 999	density desertification	92, 283, 320 294	
crinkled crinkle sheeting	205	71, 187, 233	Designtex	71	
crinoline	203	117	detergents	249, 250, 251, 318	
crisp finish	205, 247	117	dévoré velvet	247, 230, 231, 318	185, 186
crochet	164		dew bleaching	200	100, 100
crochet hooks	318		dew retted	31	
crochet hooks, sizes	318		DF 2000	258	
crochet & -look		133, 205	diacetate	62	
crochet lace	172	100, 200	dialysis	80–81	
crocking	263, 307		diaper cloth		83
cropping	204		diapers	296	L.
cross dyeing	89, 225		diapers, cloth vs		
crossbar dimity		213	disposable	296	
cross section	201		differential dyeing	89, 225	
crosswise grain	125		digital printing	229	
crushed, crush			dilatant	191	
resistant		189	dimensional stability	10, 214 –215	
crushing	233		dimity	134	213
crush resistance	214		dioxin	294	
"crystal acetate,"	80		direct developed		
crystalline	10		dyes	221	
C-Tex	290		direct dyes	221	
cultivated silk	16, 18, 47, 48, 98,		direct spinning	112–113	
	242	l .	direct yarn number	107	

	Reference	Glossary		Reference	Glossary
discharge print		41, 193, 194	druid's cloth		21, 22
discharge printing	231	41, 193, 194	dry (care labeling)	267	21, 22
disinfectants	252		dry cleaning	257–259, 267, 308	
disoriented	202		Dryel	252–253	
arrangement	59, 62		dry goods—	202 200	
disperse dyes	221		see fabrics		
dissecting needle,	329		drying (leather)	184	
distressed	205		Drysdale wool	38	
district check		45, 47, 48	Drysolve	259	
dobbie, dobby	125, 142-143	15, 81, 83, 85,	dry spinning	56	
		87, 89, 303, 304	dtex	107	
doeskin		175, 257	duchesse lace	171	135
dogtooth	S.	47	duchesse satin		217
doctor blade	228		duck		37
Dolly (cloned sheep)	296– 297		duffel		173
domestic fabrics	2		dulling agent	84–85, 98	
Donegal tweed		277, 279	dungaree	NO. 10. 10. 10. 10. 10. 10. 10. 10. 10. 10	79, 80
dope-dyed	85, 222		dupion silk	52	
dotted muslin, Swiss		91 , 92	duplex printing	231	
dotted Swiss	146, 147	00	Durable Press	214, 240–241,	
double cloth, woven	142, 149	89	D	242, 288	
double damask		77	Duratherm	191	
double face	224	89	Duvelle	80	5
double ikat double ikat—see	224		duvet care, covers		175
ikat "double			duvetyn duvets, down-filled	244	175
jersey"	f .	125	dyeing	89, 220– 226, 321	
doubleknits	160-161	193	Dyneema	84	
double piqué	160	170	Dynoonia		
double piqué knit		93	E3		284, 285
doubling	106, 108		Earthtex	71, 295	,
doupion, douppioni		245	eco concerns	5, 292–298	
douppioni silk	52		Eco Fibre	295, 296	
doup weave	145–146, 147 ,		economy—see price		
	152, 175		Eco-Ordinates	293	
Dow Corning Active			EcoSolv	258	
Protection	101 100 000		EcoSpun	295	041 040
System	191, 192 , 298	104	ecru color	170	241, 243
"down" (fiber, "fur") down (plumage)	37, 189 47, 48, 98, 244	184	Ecsaine	179 116	
draft chain	142		edge-crimp stretch, edging (lace)	172	141
drafting	59, 108		effect fiber	37, 117	277, 279
drapability	307		effect ply (novelty	37, 117	211, 219
drapery fabrics	007	5, 6	yarn)		155
drapes	208	0, 0	Effortless Wool	214	100
drawing,	59, 108		elastane	18, 72–74	
drawing in	128		elasterell-p	68, 74, 87	
drawn-thread work	172, 173	131	elastic, elasticity		253-256
dress fabrics		8, 9	elasticity	9	
dress shirt		237	élastique		281, 282
dressing (fur)	183, 188		elastic thread	120, 233	
dressing gown			elastodiene	18	
fabrics		7	elastoester	74	
dressy wear fabrics		8, 9	elastomers	72–74	
drill	041 067	95	"electronic	0 007 000	
drip drying	241, 267		clothing,"	3 , 297–298	100
Dri-release Dri-release FR	36, 62, 87, 88, 246		electronic control	144–145, 146, 159	129
drop-on-demand	88 229		electrospinning Elite Fibre spinning	58	
dropping (fur)	189		factory	46	
aropping (iui)	1 107	•	lactory	10	'

	Reference	Glossary	9.0	Reference	Glossary
elongation	9		defined	6	
elysian		177. 178	engineering	89	
embellished	234	1, 1,0	functions	5	
emboss(ed)	186, 232, 247	59, 61, 71,	guides	3	15
cmooss(ea)	100, 202, 247	189, 287	metrics	320	13
embroidery	4, 120, 135,	189, 287	production and	320	
emoroidery	176– 177, 233			7	14
embroidery, -ery	170-177, 233	97	use flowchart,		
embroidery, -ery	7.		sides	124	
		136, 137	without fibers	181–182	
embroidery crash,		151	without yarns	178–181	
linen		151	fabric softeners	252	
emerized, -ing	004	257	face	124	
emerizing	204		façonné velvet		185, 186
Encapsulated			factory cotton		235
Protection inside			fagoting	170, 172, 173	Part to a
Clothing	211	z 8,	faille	232	161, 209, 210,
encapsulation			\ \		261, 262
technology	209–211		Fair Isle design	165	
end-by-end control	145, 146		false-twist	115	
ends	125, 128–130	1	fancy yarns	117–119	
energy	285–291		farmer's satin	,	217
engineered blend	89		fashion	87–89	
engineered prints	231		fashioning marks	157, 158	
English Angora			fasteners	156, 287, 317	pil.
rabbits,	46		fat liguoring	184	
English Romney			feathering	188	
sheep	38		feathers	47 , 244	
environmental			featherwale		
concerns	5, 292–298		corduroy		67, 69
enzymes	252		featherweight tweed		4, 279
enzyme-washing	205		fell	125	1, 27
EPIC	211		felt & felting	10, 39, 178, 308	99, 109, 178
épingle		213	felting shrinkage	214, 215	33, 103, 170
épingle brocade		129, 213	fiber identification	211, 210	
epitropic	84	123, 213	burning test	91, 94, 95	
éponge		155	fiber mix dyeing	89, 225	
ePTFE	182, 190–191	100	fiber-reactive dyes	221	
eri silk	52		fiber (textile)	221	
estate tweed		45	families		2, 3
étamine		41 , 42	fibers	18–99	2, 3
etched		185, 186	blending	86–89	
ethylenevinylalcohol	181	100, 100	content labeling	16, 19	
eutrophication	249		density	92	
EVAL	181	1		222 -223	
even twill	135, 136		dyeing		
evening wear fabrics	155, 150	8	family tree,	15-16	
Evolon	180, 289	165	flowcharts of	10 10	
expanded polytetra-	100, 209	165	generic names	18, 19	
	100 100 101	1	general	6 , 14	
fluoroethylene	182, 190–191		identification	91–99	
expense—see price	F.C		melting point	92	
extrusion	56	0.1	metrics	319	
eyelash effect,	147,148	91	production	23, 25–26	-1
eyelet	135, 233	97 , 133	properties		
eyepiece	94		and care	20–24, 25,	
F1 . 0		,		239–240	
Fabric Case History	011 015		tenacity	9, 306, 319	
form	311–312		fibranne	16	
fabrics			fibrillation	61–62	, ,
assessment	302–312	a)	fibril/matrix	86, 179	<i>V</i>
cover	290		Fibrilon	114	7

	Reference	Glossary		Reference	Glossary
fibroin	37, 48, 52	Olossary	flock yarn	118	Glossary
figured	145, 146	129, 130, 217	floss	52	
filament	14, 47, 319	129, 130, 217	flouncing	172	
filament microfibers	82		fluorescers	252	
filament threads	120		fluorinated solvent	258	
filament yarn	104, 114–119, 134		fluorocarbon,	256	
fil continu	171	133	finish		299
filet lace	171	133	fluorofibre,		299
filling	125, 129–130,	133	fluropolymer	18, 75–76	
iming	157–162		fluted, -ing	10, 75-70	189
film	181- 182	101, 297	fluting	233	109
Finesse	8, 82	101, 257	flyer	108, 109	
finishing	186, 198–234,		fly shuttle	125, 126	
miormig	260, 261		foam	173, 182, 241	59, 101
firebrats	275		folded yarn	105	33, 101
fixing	221		folds, sharp	275	
flake yarns	118		fond	170	
flameproof	10, 98		fond simple	170	
flame resistant,	10, 50		footwear	281	
retardant	10, 21, 85, 89,		form finishers	260	
retardant	93, 213		form pleating	233	
flammability	10, 92–94, 306		Fortrel	68, 295	
Flammable Fabrics	10, 72 71, 000		foulard	135	259
Act	92		Foxfibre	292-293	203
flannel	135, 203	103	freize		173, 174
flannel-back satin	100, 200	221	"freshening,"	252-253	170, 171
flannelette	135, 203	105	FreshGuard	87, 88	
flash spinning	180		friar's cloth		21, 22
flatbed printing	228, 229		friction calendering	204	50
flat filament	80		fringe		6
flat knitting	157		frisé	149	
flat crepe		71, 72	frison	52	
flat screen printing	228, 229	E * 1	front-loading		
flax family fabrics		2, 3	washing machine	240	
flax fiber—see also			frosted	205	
linen fabric	16–18		fugi, fuji		249
care	240	19 18	fugitive dye/tint	263	
comfort	9		full cardigan stitch	161, 162	
features,	97		full-fashioned knits	157	
finishing	200		full grain	186	
production	31, 32		fulling	198– 199	109, 173, 175
properties	32		full skin (fur)	185, 189	
quality	32–33		fully let-out	189	
flechage	156, 157		fume fading	263, 304	
fleece	37, 158, 165–166,		fur		
	203		care	245–246	
fleece knit, single			cold weather		
face		15, 107	clothing,	287	
fleece knit, two face		109 , 110	garment	125 122	
fleece stitch-knit	: 1	250, 251	construction	186, 188	is the second se
fleece (wool)		107, 109, 178	general	183	
fleece (woven)	101	177 , 178	quality/price	186, 187–188	
fleshing	184		terminology	185 , 188–189	
flexibility	8		types		145
flexible looms	126, 127–128		fur fibers	47, 97	
flex strength	9		fur-like	113, 158, 165	15, 49, 113
float stitch	161	015		167 , 239	
float (weaving)	000 045	217	furnishings	287, 288–289,	
flocked	232, 247	00 111		318—see also	
flock, -ed, -ing	I	99, 111		upholstery fabrics	I

	Reference	Glossary	1503	Reference	Glossary
fused selvage	128, 130	229	grain, woven fabric	125	
fusible interfacing	178	165	grain leather,	183	145
fusing	190		gram	314	
fustian		67, 79	granite cloth, weave		71, 72
			grass bleaching	200	
gabardine	135, 137		gravure	228	
gabardine,		1	gray goods,	198	
gaberdine		115, 116	gray, greige goods		235
gaiting	156		Green Earth	258	
Galashiels tweed		277	greenhouse gas	294	
galatea		79, 80	greige	198	
galloon	172	139	grenadine	OF SERVICE SEA	147
gas chromatography	92		griffe bar	144	4
gassing	204		grinning,		
gating	156		grin-through	148, 150–151	
gauffered, -ing		189	groetzen	185, 188	
gauffering	233		gros de Londres	134	
gauge (film		1	gros de Londres,		
thickness)	181-182	101	Paris		209, 210
gauge (knit)	156, 320		gros de Paris	134	
gauges (implements)	317		grosgrain	134	209, 210
gauze weave	145–146, 147 ,		ground(lace)		133-135, 141
	152, 175		gros point lace	170	134
gauze & weave	2	117 , 147	grötzen	185, 188	
gazar, gaze		295	guanaco	45, 46	
gel spinning	56		guardhair	37, 188	
generic names	14- 16,17-18, 22		guard's check		45, 47, 48
Genesis Silver	213		guide bars	163–164, 165	, , , , , , , , , , , , , , , , , , , ,
Genoa back	147		guipure lace	171, 173	134, 135, 137
Genoa velvet		287, 289	gum, in the	48	
georgette		51, 71, 191	gun club check	Tel topic	45, 47 , 48
geotextiles	2, 180		Gunma silk		193, 194
Ghiordes knots	150, 151		gunny		33
gigging	203–204		2		
gimp "braid,"	175	119, 205	habutae, habutai		239, 240
gimp yarn	117	155	hackled	31, 32	
GINETEX care			hair fibers	37-47, 243-244	
labeling symbols	269 , 271	17.7	hair-side (fur)	245	
gingham	135	121, 213	hair-up (fur)	188	
givrene	134	209, 211	hair weight	320	
glacé	120		half-basket weave	135	
glacial	62		half cardigan stitch	161	
glass	77		hammered on	234	
glass fiber	14, 17, 20, 21, 77	_	hammered satin		217, 219
glass curtains		5	hand	8, 20, 104	
glaze, glazed	100	55, 56, 117	handbag fabrics		8
glazing	186		handkerchief linen		149
glen checks	135, 222	45 45 40	handmade lace	170–172	
glen check, plaid		45, 47, 48	hand protection	281	4
Glengarry tweed		279	hand washable wool	243	
glove fabrics	050 050	11, 271	handwoven carpets	150, 151	
glycol ether solvents	258–259	060	hang to dry (care	0.5	
Goblin	110	263	abeling)	267	
Golden Bale	110		hank-dyed	223	
Gore-Tex	4, 190-191, 246,		hard twist	106	
C T (1)	272, 280, 281	(0.101.22-	harness (loom)	125, 131,	
Gore-Tex fabric	100 101	63, 101, 297		142-143	
Gore-Tex PacLite	182, 191	,	Harris tweed	108	277, 279
Gorix	76		hat, headgear		
graft polymer	86	1	fabrics		8, 11, 27, 99

	Reference	Glossary		Reference	Glossary
hawsers	121, 175		horsehair & braid		2, 3, 27, 39, 117
hawser yarn	105		houndstooth & look		45, 47
Hazardous Products	= =		household science	239	10, 11
Act	92		house names	19	
head protection	281, 287		housewrap	180	
heat	239–240, 275		HTP	230	_
heat-flow barrier	209		huck, huckaback		83
heather effect	222-223		huckaback	142	
heat loss	281-283		hue	219	
heat resistance	21		HWM rayon	60, 61	
heat sensitive	9, 21, 239		hybrid needles	156	
heat set durable	21		hydrocarbon		
heat set permanent	21		solvents	258	
heat setting	214		hydroentangled		
heat stitched		63	fabrics	180-181	
heat transfer			hydrophilic	9	
printing	230	. 4	hydrophobic	9	
heather effect		277, 279	hygiene	89	
heddle, heddle eyes	128, 144		hygral expansion	9	
Helanca	115	7.5	hygroscopic	9, 39	
hem markers	317		hypothermia	285	
hemp	33-34, 293	2, 3, 33			1
henequen	35		ice dyes	221	
herringbone	136, 161, 162		identification, fiber	91–99	
herringbone & look		123 , 203 , 277	ikat	224	191 , 192
hessian		33	illusion net		
heterofil	86		immature cotton	97	
hide	184	(7.70	impermeable	208–209, 281	
high-low corduroy hide-out	188	67, 70	Impress	258–259	040
high-strength fibers,	100		Indian silk	53 304	243
high-tenacity			indicator papers	221, 264	79
fibers	84		indigo indirect yarn	221, 204	19
high twist	106		number	106–107	
High Wet Modulus	100		industrial	100-107	
rayon	60, 61		Revolution		2
hole count (net)	00, 01	163	industrial textiles	2	-
holland		233–235	infrared spectropho-	_	
Hollofil	80		tometry	92	
hollow fibers	80-81		Ingeo	76	
hollow viscose	80		ingrain	224	
hologram	1	61	ink jet printing	229	203
home care	239–256, 318– 319		inlaid, inlay	156, 166	
home dyes	265, 319		Innova	71	
Home Laundering			inorganic manu-		
Consultative			factured fibers	77	
Council	271		inorganic natural		
homespun		277	fibers	36	
home tinting	265, 319	2.12	INPRO	259	
honan	50	243	insensible per-	000 007	
honan silk	53	00	spiration	280, 287	
honeycomb Honiton lace	142	83 123	insertion (lace)	172	
	171, 172	99	inside split	184 206	
hood (hat) hoods	178, 283	77	inspection, final insulation	Dec 2007 Control Control	
hopsacking	135		ii isulatiOi i	80, 81, 83, 89, 282, 320	
hopsack,	100		intaglio printing	202, 320	35
hopsacking		17, 19, 20	intaglo	228	
horse blanket check		46, 47, 181	intarsia	165, 166, 224	ŷ.
horsehair	42			2, 3, 297–298	

Intersity (color) Interfacings Interiors fabrics Interiors		Reference	Glossary	1	Reference	Glossary
178-179, 248 178-179, 248 178-179, 248 178-179, 248 178-179, 248 178-179, 248 178-179, 248 178-179, 248 178-179, 248 178-179, 248 178-179, 248 178-179, 248 178-179, 248 178-179, 248 178-179, 248 178-179, 248 178-179, 248 188-189, 249 189-189, 249 189-189, 249 189-189, 249 189-189, 249 179-180, 248-189, 249 179-180, 248-189, 249 179-180, 248-189, 249 179-180, 249 277, 279 279-180, 249-180, 249 279-180, 249-180,	intersia knitting		195	kemn kemny wool	X X	
Interfacings Interfacings Interfacings Interfacings Interfacings Interfacing Interfaci	_	219	150		3/1	277, 273
Interfacings Interiors fabrics Interiors Interiors fabrics Interiors I						
Interinings Interior fabries		170 175, 248		The same of the sa	The state of the s	
Interlock 156, 160, 161 158 158, 165 1	0 /		7 107 165		/4	172 174
116 125 125 126 126 125 125 126 125 126 125 126 125 126 125 126		205 206		,	164	173, 174
International care labeling symbols into a care labeling symbols in the care labeli		and the same and	5, 6		200000 300	
International care labeling symbols international Organization for Standardization 14 15 169 175 181 169 181 169 181 160 165 181 161 165 181 161 165 181 165 181 161 165 181 181 165 181 181 165 181 181 165 181		A STATE OF THE STA	105			
Section Sect		156, 160, 161	125			
International Organization for Standardization interstices 204 135 135 124 125 136 139 140 165 158 165 175 176 179 180 190 158 165 175 176 179 180 190 188 179 188 180		060 071		ACAMAMAN INFORMATION SOMEONIA SOMEONIA CONSTRUMENTAL	Contract V Contract C	
Standardization Standardiz					1.50.50.00.00.00	
Standardization interstates 135 146 135 136 135 136 135 136 135 136		•			33.4.000	136, 139, 140
interselices interval (weave) interval (weave) interval (weave) interval (weave) interval (weave) intimate blends finuit clothing care 283, 284, 285 and indicescence, indescence, indescent indesce					2000-0001000	-
135 136 138						
Intimate blends Nutl clothing S6 Nutl clothing S3, 284, 285 Sin Nutl clothing S3, 284, 285 Sin S4, 285 S4, 285 Sin S4, 285 S4, 285 Sin S4, 285 Sin S4, 285 S4, 285 Sin S4, 28		100000000000000000000000000000000000000		knits, knitting	154– 168 —see also	
Internation Continue Contin		1777.000.000		1		
156		2000,000		care	247	
174 175	Inuit clothing			terms, action,		1
Tridescent Iridescent Iri		304		needles		
179-180, 190 179-180, 190 179-180, 190 179-180, 190 179-180, 190 188 180 1	iridescence,		Short	versus wovens	154–156	
Irish Linen Guild Irish tweed Ironing 267, 319 247, 279 277, 279 Irish Linen Guild Irish tweed Ironing Iro	iridescent		61 , 62	knit-sew	175–176,	
Acc Irish Line Guild Irish tweed Iri	iridescent	224			179-180 , 190	
Irish Linen Guild Irish tweed 156, 319 249 2	Irish Carrickmacros	SS S		knitted fabric stitch	,-2.	
Prish tweed Proning 267, 319 249	lace	171		density	320	
Irish tweed	Irish Linen Guild	32		knit terry	158, 165	
Internation in water Image: Provided Fraction Internation Intern	Irish tweed		277, 279	knitting (fur)	188	
International color	ironing	267, 319		knitting needles	318	
Salands-in-the-sea Italian quilting 233 283	iron in water	249		knop yarns	117, 118	
Italian quilting 233 283	irregular twill	135, 136		knots, carpet	150, 151	i i
Secretary Secr	islands-in-the-sea	86, 179		knotting	169–173	
179 30	Italian quilting	233		knot yarns	117, 118	
179 9, 10 10 10 10 10 10 10 10	ivalu	283				
jacket fabrics jacob sheep jaconet jac				Galileo jacket	297–298	100
Sacob sheep	jac cloth		179	Kodofill	80	
jaconet jacquard knit jacquard knit jacquard woven 125, 144–145, 146 jaspé java canvas, cloth J-Cloth jean(s) jersey "double" jersey tricot jet blasts jet dye 224 joined fabrics jude 33, 175 kamiks & 283 kapok kasha satin kashmir kasuri kasuri jacquard woven 165, 224 129, 130 191, 192 lace 169–173 242, 247 242, 242 242, 243, 243 243, 244, 244, 244, 244, 244, 244, 244,	jacket fabrics		9, 10	koha	47	
jaconet jacquard knit jacquard woven 165, 224 127 129, 130 labeling, care laboratory testing metrics 319–321 lace 169–173 242, 247 forms and terminology 172–173 lace machine-made machine types lig dye jet printing 228–230 jid ve joined fabrics jute 33, 175 2, 3, 33, 275 lace laboratory testing metrics 319–321 lace 169–173 242, 247 forms and terminology 172–173 handmade machine-made machine types lace-like fabrics 170–172 lace-like fabrics 172 lace-like fabrics 173 lace-like fabrics 174 lamb's wool "lamb's wool" almb's wool "lamb's wool" fabric lame', Lame' laminating lampas l	jacob sheep		277	Kunit	179-180	165, 251
125, 144-145, 146	jaconet		25			
jacquard woven 125, 144-145, 146	jacquard knit	165, 224	127	labeling, care	264, 267–272	
jaspé java canvas, cloth J-Cloth jean(s) jersey "double" jersey tricot jet blasts jet dye joined fabrics jute 33, 175 kamiks kapok kasha flannel kasha satin kashmir kasuri 191, 192 85 165 79, 80 158, 163 131, 132 132 131, 132 125 271, 272 133-135, 136 172-173 170-172 172-173 170-172 173-173 170-172 172-173 173-135, 136 172 172, 173 184 184 184 184 184 184 184 184 184 188 186 187 188 189 188 189 190 188 189 190 190 190 190 190 190 190 190 190 19	jacquard woven	125, 144-145 ,	129 , 130	laboratory testing		
java canvas, cloth J-Cloth jean(s) jersey jersey "double" jersey tricot jet dye jet printing jig dye joined fabrics jute 33, 175 kamiks kapok kasha flannel kasha satin kashmir kasuri 135, 163 158, 163 131, 132 125 271, 272 133-135, 136 terminology terminology 172-173 handmade 170-172 machine-made machine-made machine-made machine-made machine-made machine-work 169-170 137, 139, 140, 141, 205 137, 139, 140, 141, 205 137, 139, 140, 141, 205 137, 139, 140, 141, 205 107 lamb's wool "lamb's wool "lamb's wool" fabric lame, Lame laminating lampas lampas lampas lampshade fabrics lanolin Lansmere 210, 110		146		metrics	319–321	
J-Cloth jean(s) jersey jersey "double" jersey tricot jet blasts jet dye joined fabrics jute JOHON 192, 298 jute JOHON 283 Amiks kapok kasha flannel kasha satin kashmir kasuri John 192, 193 165 79, 80 131, 132 133, 132 133, 132 133, 132 133, 132 133, 135 136 170-172 133-135, 136 170-172 137, 139, 140, 141, 205 137, 139, 140, 141, 205	jaspé		191, 192	lace	169–173	
jean(s) jersey jersey "double" jersey tricot jet blasts jet dye joined fabrics jute 133, 175 kamiks kapok kasha flannel kasha satin kashmir kasuri 158, 163 79, 80 131, 132 131, 132 133-135, 136 terminology handmade machine-made machine-made machine types 169-170 137, 139, 140, 141, 205 137, 139, 140, 141, 205 137, 139, 140, 141, 205 137, 139, 140, 141, 205 137, 139, 140, 141, 205 137, 139, 140, 141, 205 137, 139, 140, 141, 205 137, 139, 140, 141, 205 142 158, 163 158, 163 158, 163 159, 143 150, 150, 150, 143 150, 150, 150, 150, 150, 150, 150, 150,	java canvas, cloth		85	care	242, 247	
jersey "double" jersey tricot jet blasts jet dye joined fabrics jute 33, 175 2, 33, 33, 275 136 131, 132 handmade machine-made machine types 128 283 kapok kasha flannel kashmir kasuri 158, 163 131, 132 125 271, 272 handmade machine-made machine types 169–170 133–135, 136 140, 141, 205 137, 139, 140, 141, 205 137, 139, 140, 141, 205 14	J-Cloth		165	forms and		
jersey "double" jersey tricot jet blasts jet dye joined fabrics jute 33, 175 283 kapok kasha flannel kashmir kasuri 158, 163 131, 132 125 271, 272 125 271, 272 125 271, 272 125 271, 272 125 271, 272 125 271, 272 125 271, 272 125 271, 272 133-135, 136 139-140, 141, 205 137, 139, 140, 141, 205 137, 139, 140, 141, 205 1	jean(s)		79, 80	terminology	172-173	
jersey "double" jersey tricot jet blasts 181 224 lace-like fabrics 172 137, 139, 140, 141, 205 141	jersey	158, 163	131, 132	handmade	170–172	133-135. 136
jersey tricot jet blasts jet dye jet printing jig dye joined fabrics jute 283 kapok kasha flannel kasha satin kashmir kasuri 271, 272 machine types machine types lace-like fabrics "ladder" work lambskin "lamb suede," lamb's wool "lamb's wool" fabric lamé, Lamé lampshade fabrics lampshade fabrics lampshade fabrics lampshade fabrics lanolin Lansmere 210, 110 machine types 137, 139, 140, 141, 205 141, 205 141, 205 141, 205 141, 205 141, 205 141, 205 141, 205 141, 205 141, 205 141, 205 141, 205 141, 205 141, 205	jersey "double"		125	machine-made	169–170	,
jet blasts jet dye jet printing jig dye joined fabrics jute 190-192, 298 jute 283 kapok kasha flannel kasha satin kashmir kasuri 181 jet dye 224 jet printing jig dye 224 joined fabrics jute 190-192, 298 jute 2, 3, 33, 275 107 lamb's wool "lamb's wool" fabric lamé, Lamé laminating lampas lampas lampas lampshade fabrics lanolin Lansmere 210, 110 141, 205 141, 205 141, 205 141, 205 141, 205 141, 205 141, 205 141, 205	jersey tricot		271 , 272			137, 139, 140.
jet dye jet printing jig dye joined fabrics jute 228-230 224 joined fabrics jute 33, 175 2, 3, 33, 275 lace-like fabrics "ladder" work lambskin lambskin lamb suede," lamb's wool "lamb's wool" lamé, Lamé laminating lampas lampas lampas lampas lampas lampshade fabrics lanolin Lansmere 210, 110	jet blasts	181				
jet printing jig dye joined fabrics jute 33, 175 228-230 224 190-192, 298 jute 33, 175 2, 3, 33, 275 2, 3, 33, 275 2, 3, 33, 275 2, 3, 33, 275 2, 3, 33, 275 2, 3, 33, 275 2, 3, 33, 275 2, 3, 33, 275 2, 3, 33, 275 2, 3, 33, 275 2, 3, 33, 275 2, 3, 33, 275 2, 3, 33, 275 2, 3, 33, 275 2, 3, 33, 275 2, 3, 33, 275 245 245 245 245 245 247 107 15, 59, 143 15, 59, 143 184 184 184 184 191 184 191 198 198	jet dye	224		lace-like fabrics	172	
joined fabrics jute 33, 175 2, 3, 33, 275 "amb suede," 245 42 107 107 107 107 108 kamiks kapok kasha flannel kasha satin kashmir kasuri 191 Lansmere 210, 110 108 108 109 108 109 108 109 109 109 109 109 109 109 109 109 109	jet printing	228 -230		"ladder" work	172 , 173	
jute 33, 175 2, 3, 33, 275 lamb's wool "lamb's wool" fabric lamé, Lamé laminating lampas lampas lampshade fabrics kashmir kasuri 107 kamiks kapok kapok kasha flannel kasha satin kasuri 105 lampas lampas lampshade fabrics lanolin Lansmere 210, 110 31 Lansmere 210, 110 198	jig dye	224	1 20	lambskin	184	
107 15, 59, 143 143 15, 59, 143 15	joined fabrics	190-192 , 298		"lamb suede,"	245	
kamiks 283 kapok 30 lamé, Lamé 15, 59, 143 laminating 190 lampas 31 lampshade fabrics 6 lampshade fabrics 6 lanolin 198 Lansmere 210, 110 198	jute	33, 175	2, 3, 33, 275	lamb's wool	42	
kapok 30 kasha flannel 105 kasha satin 221 kashmir 184 kasuri 198 Lansmere 210, 110				"lamb's wool" fabric		107
kapok kasha flannel kasha satin kashmir kasuri 191 laminating lampas lampas lampshade fabrics lanolin lansmere 210, 110 laminating lampas 31 lampshade fabrics lanolin lansmere 210, 110 laminating lampas 31 lampas lampshade fabrics lanolin lansmere 210, 110 laminating lampas 31 laminating lampas lampas 31 laminating lampas lampas 31 laminating lampas	kamiks	283	, 5 %			
kasha flannel kasha satin kasha satin kashmir kasuri 105 lampas lampas lampshade fabrics lanolin Lansmere 210, 110 31 6	kapok				190	,,
kasha satin kashmir kasuri 221 lampshade fabrics lanolin 198 Lansmere 210, 110			105			31
kashmir 184 lanolin 198 lansmere 210, 110	kasha satin		221			6.00
kasuri 191 Lansmere 210, 110	kashmir		184		198	
	kasuri		191	Lansmere 210, 110		
	kemp	137	1		287	

	Reference	Glossary	•	Defenen	
lammet		Glossary	(1)	Reference	Glossary
lappet	147,148	0.1	"linens," household		5
lappet figured	001	91	linen tester	130–131, 330	
laser printing	231		lingerie fabrics		7
Lastex	72		lingo	144	
lastol	71, 74, 87	253	lining	155	
latch needles	156,157		lining fabrics		7, 153
lateral	86		links and links	158	
Latitude 15 shirt	88		lint	241	
latticed	126, 146, 147,	85	Linton tweed		279
	172, 173		liquid detergents	250, 251	
laundering	248–253		liseré		31
lawn		25	lisle	158, 200, 201	131 , 132
layered/joined			litmus	304	,
fabrics	190-192 , 298	7	llama	45	
laying-in	156, 166		loaded silk	52	
layout	155		lobal cross section	79, 98	
leaf fibers	34–36		lochmore check	23,30	45
leather	0.00	145, 146, 165	lock weave	145–146, 147 ,	43
care	244–245, 247, 259	110, 110, 100	lock weave	152, 175	
general	183-184, 186		loden	132, 173	175 176
properties	186		loft	9, 20	175, 176
sources	184			,	
leatherette, leather-	104		logo	19	
like		59	LOI	93	
leathering	189	59	London shrinking	215	
3			long-staple cotton	30	
leather-like fabrics	182, 208		looms	125–128, 131, 150	
Leavers lace	160 170 171	141	looms, action,		
Leavers machine	169, 170 –171		selvage		
left hand	133		shuttle, shuttleless,		
left-hand twill	133, 136		speeds		229
leish	144		loop-bonded	175–176,	
lengthwise grain	125			179-180 , 190	
leno selvage	128, 130	229	loop glass	130–131, 330	
leno weave	145–146, 147 ,	49, 117, 147,	looping	169–173	
	152, 175	229	loop-textured—see		
Lenzing Modal	61		air-textured		15, 155
letters (care			loop texturing	116	
labeling)	270		loop yarns	117	
letting-down	189	1	lotus stems	36	
letting-out	185, 189		loungewear fabrics		7
leuco	221		Lovat tweed		279
lifting knife	144		low labeling	270	
light	219, 275, 297		low-pilling fibers	84, 85	
light resistance	21		luggage fabrics		8
light stabilized	85		lumberjack cloth		179
lignin	27		lumen	97	
liming	184		luminescent	224	61, 62
Limiting Oxygen			Lurex	118	
Index	93		luster	8	
Lincoln Longwool		5	Lycra	19, 73, 98	253, 255
sheep	38		Lycra Body Care	210	200, 200
linear density			Lycra Power	74	
of fibers	320		lyocell	16, 17, 19, 61–62,	
linedry (care labeling)	267	2	.yocon	240	
line (flax)	31, 32		lyons velvet	270	287, 289
linen fabric	9, 16, 18, 205,		iyons verver		201, 209
mien idone	242–see also flax		"Mace" test	309	
	fiber		machine-made lace	169–170	
linen fabric linen-	noei	an .	Machine Washable	107-170	
like		149, 150, 151	Wool	214 215 242	
line	,	149, 100, 131	VVOOI	214, 215, 243	

	Reference	Glossary	F 1	Reference	Glossary
machine washing,		9	medium micron	41	
home	240-241		medium-staple		
machine woven		64.1	cotton	30	
carpet	149-150		medium twist	106	
mackinac,			medulla	39, 97	
mackinaw	135	179	melamine	76	
macramé	170		mélange	224, 227	277
macromolecule	10		melding	180	
madras	135		meltblown	180	
Madeira work		97	melting point, fiber	92	
madras		157, 191	melton	199	
madras gauze,			melt spinning	56, 57	14
muslin		147	mending	206	
madras shirting	142	83	mercerized cotton	97, 200, 201	
magnifier	329		mercerized cotton		l H
Mali	175		thread	120	6
Malimo, Malivlies		165, 251, 252	Merino sheep	38	
Malimo	166, 175, 176, 179	, , , , , , , , , , , , , , , , , , , ,	Merino wool	37, 38, 110, 111	
Malines lace	171	135, 163	meta-aramids	74	
Maliwatt see Malimo			metal-complex dyes	221	ji.
manila, Manila			metallic	18, 77, 118, 186,	
"hemp,"	35		5 2 5	247	
manufactured fibers-			metamerism	219	
see also specific			Metlon	118	171, 173, 174
fibers			mesh-like		85
additions before			metrics	314-321	14
spinning	84–86		home furnishings	318	
advantages	23-24		home main-	4	
air spaces in	80-81		tenance of		
features	98–99	9	textile articles	318- 319	2
flowchart	18		miscellaneous	, Ann. (1865)	7
general	14, 15		textile articles	318	
modifications	79–86		sewing	316-318	
production	25–26		SI system	107, 314–315	
spinning	56–59		textiles study or		
Manx tweed		279	laboratory		
marking	155	t U	testing	319–321	
marl	223	277, 279	MF fibers general		2
marocain crepe	20.0	71, 73	MF—see manu-		
Marquesa	71, 295	2 1	factured fibers		
marquisette	and the same of the same of	147	micro-encapsulation	209–210	
mass	319, 320		micro, microfiber		165, 257
Masters of Linen	32	75	microfiber		
matching (fur)	189		care	247	
matelassé	247	71, 159	cold weather		
matelassé effect		63	clothing	286	
matmee		191	defined	8, 10	
matress covers, pads	06 470	5	general	81–83	
matrix/fibril	86, 179		spinnerets for	58	
matt, matte	84	8 50	thread for	121	
measuring tapes	317	71 1	microfibrils	39	
measuring tape		050 040	micrometer	10, 40	
fabric		259, 240	micron	40	
mechanical action in	040		Micronesse	82	
fabric care	240		microporous		297
mechanically	000 004		microporous film,		
applied design	232–234		microporous	100	
mechanical spinning	58	105	polymer laminate	182	
Mechlin lace	171	135	microporous	000	
medallion	I	137	polyurethane	209	I

	Reference	Glossary		Reference	Glossary
microscopes	91, 94, 95, 330		mudmee		191
microscopic exam-	, , , , , , , , , , , , , , , , , , , ,		Moygashel	32	171
ination, fiber			mud-washed	205	
examination	91, 94–99		muga, muggah	52, 53	243
midwale corduroy		67, 69	mulberry silk	48	
milanese	164		mule spinning	108	
mildew	273–274		mull		25
millinery braid,			multicomponent		
fabrics		11, 27	fabric	190-192 , 298	
Millennium dyeing			multifiber cloth	304	
system	219, 224, 225		multifilament		
milling	198		thread	120	
mill washing	205		multifilament yarn	104	
mineral natural			multiknit	179, 190	
fibers	36	1 0	multilayer fabric	190-192 , 298	
miss stitch	161		multi-linear action	128	
mission cloth		21, 22	multiphase looms	128, 129	9
mixture cloths	76 , 86		multiplex fabric	190–192, 298	
mixture effects	222–223		musk ox	46	
mock chenille yarns	119	49	muslin	132, 198	63, 147, 193,
mock leno	142, 143	85			233 –235
mock matelassé	5 0.000	63	Mylar	118	
modacrylic	70, 239		19		
modal	18, 60, 61		nacre velvet		87, 289
modulus	9	0 0 07 00 155	nailhead	100	45, 47, 303, 304
mohair	43, 44,97	2, 3, 27, 39, 155	nailing	189	0.5
moiré	124 020 022 047	177	nainsook	170	25
moire	134, 232–233, 247	121, 161, 209 261	nanduti lace nanofibers	172	
moisture		201	nanonoers	10–11, 81, 83 10	
management	212		nanoparticles	11, 83	
moldable	212	39	nanoscience, nan-	11, 65	
moleskin		69, 70	otechnology	10–11, 211– 212	
molleton		173, 174, 252	Nano-Tex	4, 5 , 211, 212 , 246	
momie cloth,		170, 171, 202	Nano-Tex Coolest	1, 0, 211, 212, 240	
weave		71, 72	Comfort	211	
momme, mommie	52	,	Nano-Tex Repels		
Mongolian lamp			and Releases		
look		113	Stains	211	
monk's cloth	135	17, 21, 22	Nano-Tex Resists		
monofilament		27	Spills	5, 211	
monofilament		, 1	Nano-Tex Resists	1	
thread	120		Static	211	
monofilament yarn	104		nanotubes	83	
monomers	10		nanowhiskers	10–11, 211, 212	
moquette	149	287, 289	nap, napped,		
mordant dyes	220, 221	F)	napping	199, 203 –204,	
morpho-structured				247, 308	9
fiber	79, 80		nap (-ped), (-ping)		17, 85, 86
mosquito netting	. 10	147	naphthol dyes	221	
moss crepe	100 000	71	National Standard		
motes	198 , 200		for Care Labeling	070	
moth, clothes	274 –275	(1	of Textiles	270	10
mother-of-pearl	100	61	natté	143	10
mothproofing	199	145	natural fibers	27–54—see also	
mouflon		145	- 1 6	specific fibers	
mounting swatches mousers	203–204	14–16	advantages	21, 23	
mousseline de laine	203-204	41	features flowchart	97–98 17	
mousseline de laine mousseline de soie	-91-	169, 295	general	18, 15	
moussemile de soile		109, 290	general	110, 13	

	Reference	Glossary		Reference	Glossary
Natural Technology	293		off-grain	206	
Natureworks PLA	76		offset (weave)	135	
neck cord	144		oilcloth		59
neckwear fabrics		10	oil fasteners	317	
needled, "needle			oil oxidation	254–255	
felt,"	179		oilskin	201 200	297
needle looms	128		olefin fiber	9, 71, 239—see also	
needled.	120		olelli ileei	polypropylene	
needle "felt"	- B	165	oleophilic	8	
needlepoint lace	170 –171	133, 134, 135,	oligomer	10	19
neediepoint lace	1,0 1,1	141	ombré, ombred		61 , 62
needle-punched	179		one-way lie	130	01, 02
needlework fabrics	1.7	7	on-loom inspection	206	
needles		'	opacity	8	
knitting	318		opalescent	0	61, 62
machine knitting	156, 157		open-end spinning	112, 113	01, 02
sewing machine	316, 317		openwork	112, 110	85 + Lace
needle-woven	179		opossum hair	47	OO + Lace
nep yarns	117, 118		optical bleach	252, 265–266	
net	169	133, 134, 141	Optim (Fine, Max)	111	
net	100	163	organic fibers	292-293	
net silk	48, 51	103	organdie, organdy	272-273	167 , 168
nettle fiber	293		organza	247	107, 100
nett silk	48, 51		organza, organzine	247	167, 168, 295
NewCell	62		Oriental carpets	150, 151	107, 100, 293
new wool	42		orientation	10, 59	
New Zealand "flax"	42		Orlon	98	
or "hemp,"	35		ortho-cortex	39	4
nightwear fabrics	33	7	osnaburg	198	233, 234
ninon		111, 167, 295	ottoman	134	
noil, noile, noils		249		318	209, 213
noils	52, 178	249	outdoor equipment Outlast	209- 210	,
Nomex	74		outing flannel	209-210	105
nonflammable,	/4		oven	239	105
noncombustible	10, 98		overcoat fabrics	239	10, 171, 173-179
nonwoven	178-181	165	overdrying	239–240	10, 1/1, 1/3-1/9
notation	170 101	103	over-wire method	149–150	
weaves	132–133		oxford cloth	147-150	43, 181
yarn	107		oxford cloth shirting	135	45, 101
Nottingham lace	169	141	oxidation	189	
novelty yarn	117–119	119, 155	oxygen bleach	251	
novoloid	75	1 1 1 1 1 1 1 1 1 1 1 1 1 1 1 1 1 1 1 1	onygon olodon	201	4
Novolon	180–181		package-dyed	223	
NPB solvents	259	1	PacLite	182, 191	297
n-propyl bromide-		1	padding	233	271
based solvents	259	I	paddle machines	226	
nub (varn)	117, 118	277, 279	pad dve	224, 225	
"Numdah" rugs	178	277, 273	painted on	234	
NuMetrex	298		painted off	234	183, 184
nun's veiling	250	293	pajama fabrics		8
nylon		2,3	palace satin		217
care	264–265, 266	1	PAN	16	217
production	65–66	1	panama	10	17, 23, 24, 85,
properties	66, 67	I	pariama		273
types (including	33, 3.	I	panne satin		217
6 and 6, 6)	65, 296	I	panne velvet knit,		41/
nytril	71	 	woven		287, 289
		 	pants fabrics		9
objective lens	94		pants laurics paper tafetta		261
ocular lens	94		paper taletta para-aramids	74	201
oculai lelis	1ノゴ	· •	para-aramus	172	

	Reference	Glossary		Reference	Classom
mana abusta alath	neierence				Glossary
parachute cloth	00	239, 240	picker stick	125	
para-cortex	39		pickled	184	
Paraguay lace	172	133	pick needle	329	
parchmentizing	205		picks	125, 129–130,	× ,
parkas	283, 284 –285			157–162	
partially oriented			picot edge, picot		133, 134, 135,
yarn	10, 114				141
party dress fabrics		8	picots	170	
pashmina	43–44	184	piece dyeing	224- 225	
passementerie	175	27	piece glass	130–131, 330	
patola	N N	191, 192	piece goods	316	
pattern	155, 172		pigment "dyes,"	222	
pattern, applied	* A	170	pigment-printed		
chemical, pressure		185, 186, 187	fabrics	247	
color (print)		59, 189, 190	pigskin	184	
pattern chain	142		pile fabrics	208, 242–243, 247	
pattern in yarns		191 , 192	pile weaves	147–152	
pattern on			pillar-and-inlay	163	205
dyed ground		193, 194	pilling	8, 306	
PBI	75		pillow lace	170, 171	
PCMs	209- 210		pillows	244	
PCT polyester	68		Pil-Trol	84	
peached		175, 257	pin check, pinhead	04	45, 47, 303, 304
pearlescent	224	61, 62	piña	35	45, 47, 505, 504
peau de pêche		175, 257	Pinsonic	190	63
peau de soie		219	pinwale corduroy	190	67. 69
pebbled pebbly		71, 72, 73	piqué	142, 143	07, 09
pelt, peltry	189	71, 72, 73	pique piqué woven	142, 143	87, 88
PEN polyester	68	1	pitch	151	67,00
peptide linkages	37		PLA	76–77	
perc	257–258		plaid	135, 136	
percale	131, 132	233 –235	plaid	133, 130	
perching	206	233-233	•		195
perchloroethylene	257–258		any plain stitch	150 160	193
performance	9–10, 89		plain stitch knit	158, 160	15 107 101
permanent)-10, 69		•	132, 134–135	15, 127, 131
hardness	248	1	plain weave	138–139, 287	15, 127, 131,
permanent heat set	203			130-139, 207	also see basket, rib,
permanent stains	254–255	1	back, pile woven		+ many! more 67, 287
perma-press	214, 240–241, 242,		plain weave sheeting	131-132	07, 207
perma-press	288		plain weave sneeting plait, plaited	131-132	27
permeable	280–281, 287		plaiting	156	21
Persian knots	150, 151	1	plangi	136	100
Persian lamp look	150, 151	49	plangi plasma	10	193
	275, 280, 281,	49	•	l	
perspiration	287–288, 304– 305		plate, fur or leather	184, 185, 186, 189	
petal-shaped	83, 86		plating (knit)	156	100
	1000 1000	1	pleated, -ing	000	189
PET polyester	66–68, 295		pleating	233	
pH	304		plied yarn	105	71 10-
Phase Change	000 010		plissé	135, 232	71, 187
Materials	209- 210		plucking	189	
Photofabric	230		plumage	47	
photographic			plush knit		283
printing	230–231	1	plush stitch-knit		251 , 252
photoluminescent	209	 	plush woven		285
physiological			pneumatic looms	127, 128	
comfort	5	I	pocket cloth,		
pick-and-pick		47, 304	double face		89
pick counter	130–131, 330		pocket fabric		95
picker lap	108	l I	point de gaze lace	170	

point de neige lace point de rose lace point d'esprit point diagrams pointelle pointing point laces 170 163 163 porous fibers poult de soie pount de soie pounded fibers powernet power stretch POY point laces 132–133 165, 166 189 133, 134, 135, PPS 76 precut warp pile product de soie pounded fibers powernet power stretch POY precut warp pile precut warp pile precut warp pile product de soie pounded fibers pounded fibers powernet power stretch POY power stretch power stretch product warp pile precut warp pile precut warp pile product de soie pounded fibers pounded fibers powernet power stretch power stretch power stretch product warp pile precut warp pile product	
point d'esprit point diagrams point diagrams point laces 132–133 165, 166 point laces 132–133 pounded fibers powernet power stretch POY PPS 76 precut warp pile 150	
point diagrams pointelle pointing point laces 132–133 powernet power stretch POY 10, 114 pPPS 76 precut warp pile 150 255	
pointelle pointing point laces 165, 166 189 power stretch POY 10, 114 PPS 76 precut warp pile 150	
pointing point laces 189 133, 134, 135, PPS 76 precut warp pile 150	
point laces 133, 134, 135, PPS 76 150 150	
precut warp pile 150	
precut warp pile 150	
point plat lace 170 premetallized dyes 221	
Polarfleece 161, 167 preshrinking,	
Polarguard HV 81 compressive 214–215, 216	
Polartec & recycled 109, 269 pressing 319	
Polartec Recycled price 21, 87, 104, 186,	
Series 295 187–188	
Polartec primary backing 173, 174, 175	
Technologies 166 primary backing	
polished cotton 55 carpet 247	
pollution 249, 293–295 prince of wales	
polo cloth 175 check 43, 47	
polyacrylonitrile 16 printing 220, 222 ,	
polyamide— 227–231 , 232	
see nylon producer-dyed 85, 222	
Polybac/AS 175 product dyeing 226	
polybenzimidazole 75 progression (weave) 135	
polychromatic 81 projectile looms 127	
polychromatic protein 18, 63–64	
dyeing, printing 228 protein natural	
polyester fibers 36–54	
care 265, 266 prover 130–131, 330	
general 66–67 psychological	
production 67 comfort 5	
properties 67–68 PTFE 18, 75–76	
types 66–67, 68 –69, 120, PTT polyester 68, 253	
253, 295 PU 208, 209 297	
polyethylene 18, 71, 182 puckered 63, 93, 19	59 . 187.
polyimide 18	, 10,
polylactate 76–77 puckering, seam 303	
polymer, polymerize 10, 27, 65, 66 puffed 63, 93, 1	59
polymer-dyed 85, 222 puff presses 260	
polynosic 16, 61 pulled wool 37	
polypeptides 37 pumice 205	
polyphenylene puppytooth check 45	
sulfide 76 pure dye silk 52, 200	
polypropylene 18, 71, 174, 175, purl gating 156	
182, 295 247, 275 purl stitch 158– 159, 160 131	
polysaccharide 27 PVA 16, 18, 70–71	
polytetrafluo- PVC 16, 208, 294	
roethylene 18, 75–76	
polyurethane 208, 209 Qiviuq, qiviut 46	
polyvinyl alcohol 18, 16, 70–71 quality	
polyvinyl chloride 16, 208, 294 blends 87–89	
pongee 243 carpet 150-151	
pongee silk 53 cotton 30	
ponte di Roma 160 93 flax 32–33	
poodle cloth, knit 155 fur 186, 187–188	
poor boy 207 silk 52	
poor boy knits 158 wool 40–42	
popcorn knir 253 Quallofil 80	
poplin 134 29, 197 , 211 quilting 190, 233	
275 quitting & effect 63, 64	

	Reference	Glossary	l	Reference	Glossary
rack stitch	161		Rhodia	74	
radiator	239		rib	134	
radzimir		209, 211	rib gating	156	
raffia	35	205, 211	rib knit	100	207
ragg (wool)	223	277, 280	rib knits	161	207
rainwear fabrics	220	8, 297 , 299, 301	rib (plain weave)	101	200 010 011
Rambouillet wool	38	0, 251, 255, 301	110 (plain weave)		209, 210, 211,
ramie	34		rib stitch	150 150 160	213
random	04		ribbon	158, 159, 160	010
arrangement	59		Cocca services conserved		210
rapier looms	126 , 127–128		ric-rac, rickrack		0.7
•	134		braid	104 100	27
rapp raschel			right hand	124, 133	
	163- 164, 165	40 110 107	right-hand twill	133, 136	
raschel knit		49, 119, 137,	right side of fabric	124	15
		139, 140, 205,	rigid looms	126, 127–128	
		255	ring spinning	108–109, 112	
ratiné		155, 177, 178	ring-spun		235
raveling, seam	309		rip-stop		57, 297
raw silk		241	rippling	31	
rayon	16–19, 60–61, 104,		Rit		250
	182, 240		Rit SunGuard	291	
reaching in	128		"rock wool,"	36	
reactive dyes	221		roller print		35
reclining twill	136, 137		roller printing	227-228	
Recoil Courtelle	113		rope	121, 175, 318	
reconstituted			rope form	224	
cellulose fibers	60–62		rosaline, rose point		121, 123
recreational			roselle	34	
equipment	318		rosepoint lace	170	
recycled wool	42		Rosner MP3Blue		
recycling	294 –296		jacket	3	
reducing bleach	251-252		rotary screen		
reed	125	122, 123, 127	printing	228, 229	
reeled silk	47, 48, 98, 242		rotor spinning	112, 113	
re-embroidered lace	171		round cross section	79, 98	
reflective coatings	209	59	round (stitch)	158	
reflective film	182		roving	108	
registered			rubber	72	
trademarks	19		rubber, -ized	. –	233, 275
regular twill	136, 137		ruching	233	200, 270
reindeer hair	46	277, 279	ruedas pattern	172	
relaxation shrinkage	214	,	Rynex	258–259	
renaissance lace		133		250 207	
repeat of design,		100	sackcloth		17
pattern		199, 202	safety	5, 89	1
repp		209, 211	sag in use, wear	0,00	21
reprocessed wool	42	203, 211	sagging	309	21
réseau	170		sailcloth	309	37
residential fabrics	2		salt and pepper	223	277
resiliency	9, 20, 286		salt and pepper salt bridge	39	211
resin	214		0	39	71
resist print	214	102 104	sand crepe	007 040	71
	021	193, 194	sand-washed silk	205, 242	
resist printing	231		Sanforized	214–215, 216, 272	
retan	184		Sanfor-Set	272	
reticella	170		Sanitized	213	38
retting	31, 33		saran	18, 70, 182	
reused wool	42		sateen	100 617	215
reversible	222	15 00 000	satin	138 , 247	217, 219-225
reversible fabric	0.4	15, 8 9, 223	satin, brushed-back		221
rhea	34	·	satin/crepe	I	71, 217, 223

185, 186, 219 115, 219 49 197, 269 247 247 251 248 247 247 251 248 247 247 251 248 247 247 248 247 248 247 248		Reference	Glossary	190	Reference	Glossary
satin jabardine satinized	satin découpé		185 , 186, 219	Sensory Percention	210	
Satinized	•				210	
Satin stripes, types satinesque satin stripes, types satinesque statin stripes, types satinesque statin wave 132, 133, 137-138, 139 204 132, 133, 137-138, 139 278, 279 117 Schriffil lace Schriefier calendar scissors 211, 245 291, 245 295	_		·		128	
Satinsex types sating types						
Satin weave 132, 133 137-138, 139 278, 279 11 12 135 serge suiting sericulture 47-8, 50 serciful out 184 170, 171, 233 271, 245 299 277, 279 277, 279 278, 289 278, 279 277, 279 279, 280, 280, 280, 280, 280, 280, 280, 280	_		Service and Market State 1995			¥
Saxony 137-138, 139 278, 279 137 38, 139 278, 279 137 38, 139 278, 279 137 38, 139 204 317, 38, 139 316, 317 316-318 317 318 319 317 318 319 317 318 319 317 318 319 317 318 319 317 318 319 317 318 319 317 318 319 317 318 319 317 318 319 317 318 319 317 318 319 317 318 319 318 3		204	219	CS-201/#0000000	247	921
137-138, 139 278, 279 278,		AND LOS TOO SECURE AND ADDRESS OF THE PARTY			135	231
Saxony	satiii weave				2007000001	
Scart fidurics Scart filing Schriffline Schreiner calendar Sch	Savonu	107-100, 107	278 270		47-0, 30	
Schriffline 204 204 207 316-318 316-318 316-	•				00	
Schriftliace 4, 170, 171, 233 317 316, 317 316, 318 316, 317 316, 318 31		190	11			
Schreiner calendar scissors Sacissors Scotchgard 211, 245 182 299 299 211, 245 211, 245 211, 245 211, 245 211, 245 211, 245 211, 245 211, 245 211, 245 211, 245 211, 245 212, 247 213, 213, 213, 213, 213, 213, 213, 213,	, ,	T0.00.00	07 127	9	184	
Scotchard 211, 245 299 Sewing mertes Sewing thread length Shaft			97, 137		016 017	
Scotchigard Scotching Sc		1000000 MM				
Scottishil Blackface Sheep Scottish Blackface Sheep Scottish district Check, estate tweed Scottish district Check, estate tweed Scottish twee			000	_		V5 * -
Scottish Blackface sheep 38 38 38 38 38 38 38 3			299			
Sheep Scottish district check, estate tweed Scottish tweed Scottis		182				
Scottish district check, estate tweed Scottish three Scottish tweed Scottish three						
Check, estate tweed Scottish tweed	1	38			100000000000000000000000000000000000000	
Scottish tweed Scot				shagbark	135	
Scottish tweed scouring scouring scouring scouring screen print screen printing screen printing scrim scroop (silk) sculptured design scutching stutching statisting seam sulcouring seam allowance seamles garament knitting seam puckering seam pruckering seam stretch test seawed sea scetate seed there seed there seed there seed there seed yarns self-cleaning clothing self-cleaning clothing self-cleaning clothing self-cleaning clothing seemi-permeable 278, 130 277, 279 279, 279 38, 204 303, 304 304, 303, 304 303, 304 303, 304 303, 304 303, 304 303, 304 303, 304 303, 304 303, 304 303, 304 303, 304 303, 304 303, 304 303, 304 303, 304 303, 304 303, 304 304, 304, 304 303, 304 303, 304 304, 304, 304, 304, 304, 304,	,			shahtoosh		
Scouring screen print Screen printing scre				shaker knits	158	207
203, 204 Shantung Sape (fur) Sapage (fur) Sharkskin worsted shawing Sharkskin worsted shawing Shear, fabric finish Shear (finish shear) Shear (finish shear (finish shear (finish shear) S	Scottish tweed		277, 279	shammy	184	
Scrien printing scrim scrim scrim scrim scrim scrim scroop scroop (silk) sculptured sculptured design sculcthing scall for scaled less and allowance seamless garment knitting seam ravelling seam ravelling seam raveling seam stretch test seam stertch test seam stertch test seam stertch test seam stertch test seam seed fiber seed fiber seed fiber seed fiber seed seed fiber seer sucker seer sucker seer sucker look segmented-pie fiber Sehnal knots self-cleaning clothing self-cleaning clothing self-cleaning clothing self-geam-let-out semi-permeable 189 117 117 117 118 114 117 117 118 114 117 118 119 118 119 118 119 119 119 110 118 119 118 11	scouring	38, 198, 198, 200		shank	158	
Scriom Scroop (silk) Sculptured sesign Sculptured design Scale Care Care	screen print		203, 204	shantung	53, 135	243
Scroop S	screen printing	228, 229		shape (fur)	189	
Scroop (silk) scrop (silk) sheer, (shearing shearling look shearling look shearling look sheath/core shedding 125, 131 sheep (shearing seam slowance seamless garment knitting seam raveling seam raveling seam stratch test seam stretch test seam stretch test seawed secondary backing secondary cellulose acctate seed fibers seed fibers seer sucker look segmented-pie fiber (shearing clothing selvage, selvage semi-let-out semi-permeable semi-let-out semi-permeable 189 18	scrim		117	sharkskin worsted		303. 304
sculptured sculptured design scutching 232, 247 47 45, 177 45, 177 45, 177 145, 177 145, 177 145, 177 145, 177 145, 177 113, 114 145, 177 113, 114 145, 177 113, 114 145, 177 113, 114 145, 177 113, 114 145 177 184 145 177 184 145	scroop	200		shaving	184	
Sculptured Scu	scroop (silk)		261	shear, fabric finish		173, 175, 267.
Sculptured design Scutching Stack Sea	sculptured		67, 70, 287, 289			
Sacace Sead Sea	sculptured design	232, 247		shearing	189. 204	
SeaCell SeaCell Active Seal Cotton Seal Cotton Seam allowance seamless garment knitting seam puckering seam raveling seam stretch test seaweed secondary backing secondary backing seed fibers seed fibers seed yarns seed yarns segmented-pie fiber Berni-let-out semi-let-out semi-let seam stretch search and some process and seed size of the search s	scutching		(884)	3		145, 177
SeaCell Active Seal Cotton 62, 85 19 sheath/core shedding sheep	SeaCell	62		<u> </u>		
Seal Cotton Seam allowance Seamless garment Knitting 161–162 303 309 300	SeaCell Active	62, 85		0	86	
seam allowance seamless garment knitting 317 sheep sheepskin look sheepskin look sheer; "sheers" fabrics 184 145 113,114 145 145 113,114 145 <td>Seal Cotton</td> <td></td> <td></td> <td>100-000-000-00-00-00-00-00-00-00-00-00-0</td> <td></td> <td></td>	Seal Cotton			100-000-000-00-00-00-00-00-00-00-00-00-0		
Seamless garment knitting Seam puckering Seam raveling Seam raveling Seam raveling Seam raveling Seam slippage test Seamed seawed Seamed seaved Seamondary backing Secondary backing Seam stretch test Seaved Secondary cellulose Acetate Seafibers Seaved Seed fibers Seavesucker Saa, 86 Sehna knots Self-cleaning Clothing Seavesucker Seavesucker Seavesucker Saa, 86 Sehna knots Self-cleaning Clothing Seavesucker Seavesucker Seavesucker Saa, 86 Sehna knots Self-cleaning Clothing Seavesucker Seavesucker Saa, 86 Saa, 86 Seavesucker Saa, 86 Seavesucker Saa, 86 Saa, 86 Seavesucker Saa, 86	seam allowance	317	1.1	-	ACCORDING TO A STATE OF THE STA	
Rhitting Seam puckering Seam raveling Seam raveling Seam (lace) Seam (lace) Seam slippage test Seam stretch test Seawed Seam stretch test Seam stertch test Seam s	seamless garment					145
seam puckering seam raveling seam raveling seam raveling seam raveling seam raveling seam subspace test seam stretch test seam stretch test seawed 309 sheer, "sheers" fabrics 5 5, 131, 233, 239-240 5, 131, 233, 239-240 234, 235 234, 235 239-240 234, 235 234, 235 239-240 234, 235 239-240 233, 239-240 233, 239-240 233, 239-240 233, 239-240 233, 239-240 233, 239-240 233, 239-240 233, 239-240 233, 239-240 233, 239-240 233, 239-240 233, 239-240 237, 279 277, 279 277, 279 135, 114, 145 277, 279 193, 194 277, 279 193, 194 277, 279 193, 194 287 239 233 239-240 237, 279 277, 279 193, 194 287 277, 279 193, 194 287 287 287 287 287 287 287 287 287 287 288 283, 86 296 288 283 296 296 296 296 296 296 299 296 299 296 299 296 299 211 299 <td< td=""><td></td><td>161-162</td><td></td><td></td><td>10.</td><td></td></td<>		161-162			10.	
seam raveling seams (lace) 309 fabrics 5 5, 131, 233, 235, 239-240 5, 131, 233, 235, 239-240 5, 131, 233, 235, 239-240 234, 235, 239-240 234, 235, 239-240 234, 235, 239-240 234, 235, 239-240 234, 235, 239-240 234, 235, 239-240 234, 235, 239-240 234, 235, 239-240 234, 235, 239-240 234, 235, 239-240 234, 235, 239-240 233, 234, 235, 239-240 237, 279, 279, 279, 279, 279, 279, 279, 27						110,114
seams (lace) 170 seam slippage test 306, 308, 309 seam stretch test 308 seawed 62, 293 secondary backing 173, 175 seed fibers 27-30 seed yarns 118 seersucker look 135 segmented-pie 150, 151 fiber 83, 86 Sehna knots 150, 151 selvage 128, 130 selvage, selvadge 128, 130 semi-let-out 189 sheeting 131-132, 205, 234, 235 shepherd's check shepherd's check sherpa 135 shetland tweed shibtor shift (weave) 135 Shirley Cloth 287 shirting fabrics 8, 237, 238 shirting madras 83 shoody 296 shoody 296 shot skill, taffet 224 showerproof 211 showerproof 211 shrinkage 214-215, 308-309 shuttle 125		The second of				5
seam slippage test seam stretch test seam stretch test seam stretch test seam stretch test seamed 306, 308, 309 308 309 308 308 308 308 308 308 308 308 308 308	_	Account to the contract of the	1.100		131-132 205	
seam stretch test seaweed 308 shepherd's check sherpa 45 113, 114, 145 45 113, 114, 145 277, 279 193, 194		and the second second second		onceing	, , , , , , , , , , , , , , , , , , , ,	l
seaweed 62, 293 secondary backing 173, 175 secondary cellulose shetland tweed secondary cellulose shift (weave) seed fibers 27-30 seed yarns 118 seersucker 135 seersucker look shirting fabrics seersucker look shivs segmented-pie shivs fiber 83, 86 Sehna knots 150, 151 self-cleaning shoe satin clothing 298 selvage 128, 130 selvage, selvadge showerproof semi-let-out 189 229 shuttle 129 113, 114, 145 277, 279 135 Shift (weave) 287 shirring 83 8, 237, 238 83 1219 1219 1210 2224 30 31 40 50 50 50	11 0	The second secon		shenherd's check	207 240	,
secondary backing secondary cellulose acetate 173, 175 shetland tweed shibori 277, 279 seed fibers seed fibers 27–30 shift (weave) 135 seer yarns seer yarns 118 233 seer seer yarns shirting fabrics shirting madras shivs shoddy shoe satin short-staple cotton short effect yarns short yarns seer yarns seer yarns shirting fabrics shirting madras short staple cotton short effect short skill, taffeta show yarns yarns seer yarns yarns seer yarns yarns seer yarns yarn				-		
secondary cellulose acetate 62 shibori shift (weave) 135 seed fibers 27–30 Shift (weave) 135 seed yarns 118 shirring 233 seersucker 135 71, 227 shirting fabrics 8, 237, 238 seersucker look segmented-pie shivs 31 fiber 83, 86 shoddy 296 Sehna knots 150, 151 shoe satin 296 self-cleaning short-staple cotton 30 219 selvage 128, 130 shot skill, taffeta 61, 62, 261 semi-let-out 189 shrinkage 214-215, 308-309 shuttle 125		productive or the rec	,	•		
acetate 62 seed fibers 27–30 seed yarns 118 seersucker 135 seersucker look 135 seersucker look 187 segmented-pie fiber 83, 86 Sehna knots 150, 151 self-cleaning clothing 298 selvage 128, 130 selvage, selvadge semi-let-out 189 229 shift (weave) Shirley Cloth shirring shirting fabrics shirting madras 83 shirting madras shirting madras 31 shoddy shoe satin short-staple cotton shot effect 30 shot skill, taffeta showerproof shirinkage shirinkage shuttle 211 semi-permeable 214-215, 308-309	, ,	170, 110		The same of the sa		
seed fibers 27–30 seed yarns 118 seersucker 135 seersucker look shirting segmented-pie shirting madras fiber 83, 86 Sehna knots 150, 151 self-cleaning shoe satin clothing 298 selvage 128, 130 selvage, selvadge semi-let-out semi-let-out 189 Shirley Cloth 287 shirting fabrics 83 shivs 31 shoddy 296 shoe satin 30 shot effect 224 showerproof 211 semi-let-out 189 383 31 61, 62, 261 229 30 31 61, 62, 261 299 214-215, 308-309 shuttle 125		62			125	193, 194
seed yarns 118 seersucker 135 seersucker look 187 segmented-pie fiber 83, 86 Sehna knots 150, 151 self-cleaning clothing 298 selvage 128, 130 selvage, selvadge semi-let-out 189 229 233 shirring shirring shirring shirring shirring shirring shirring shirring shirring shirring shirring shirring shirring shirring shirring 31 shoddy shoe satin shot skill, taffeta showerproof shirring shirring 31 shoddy 296 shot skill, taffeta showerproof shiring madras shot skill, taffeta showerproof shiring abrics showerproof shiring fabrics showerproof shiring showerproof shiring showerproof shiring showerproof showerproof shiring showerproof shiring showerproof shiring				,		
seersucker 135 71, 227 shirting fabrics 8, 237, 238 seersucker look seersucker look shirting madras 83 seegmented-pie fiber 83, 86 shoddy 296 Sehna knots 150, 151 shoe satin 219 self-cleaning clothing 298 shot effect 224 selvage 128, 130 shot skill, taffeta 61, 62, 261 selvage, selvadge semi-let-out 189 shrinkage 214-215, 308-309 semi-permeable shuttle 125	Part II and the contraction of t	(1771.19) (PROPER		,		
seersucker look segmented-pie shirting madras 83 fiber 83, 86 shoddy 296 Sehna knots 150, 151 shoe satin 219 self-cleaning short-staple cotton 30 219 selvage 128, 130 shot skill, taffeta 61, 62, 261 selvage, selvadge semi-let-out showerproof 211 semi-permeable shot skill, taffeta 214-215, 308-309 shuttle 125			71 227	0	233	0.007.000
segmented-pie shivs 31 fiber 83, 86 shoddy 296 Sehna knots 150, 151 shoe satin 219 self-cleaning short-staple cotton 30 clothing 298 shot effect 224 selvage 128, 130 shot skill, taffeta 61, 62, 261 semi-let-out 189 shrinkage 214-215, 308-309 semi-permeable shuttle 125		133				
fiber 83, 86 shoddy 296 Sehna knots 150, 151 shoe satin 219 self-cleaning clothing 298 30 224 selvage 128, 130 shot skill, taffeta 61, 62, 261 selvage, selvadge semi-let-out 189 shrinkage 214-215, 308-309 semi-permeable shuttle 125			107		0.1	83
Sehna knots 150, 151 self-cleaning clothing 298 selvage selvage semi-let-out semi-permeable 128, 130 229 229 298 30 shot effect shot skill, taffeta showerproof shrinkage shuttle 211 299 214-215, 308-309 shuttle		00 06		100 900 900 900 900	U. 200-01-0040	
self-cleaning clothing 298 selvage 128, 130 selvage, selvadge semi-let-out semi-permeable 298 self-cleaning 30 short-staple cotton shot effect 224 shot skill, taffeta showerproof 211 299					296	0.1.0
clothing 298 selvage 128, 130 selvage, selvadge semi-let-out semi-permeable 299 selvage, selvadge semi-let-out semi-permeable 299 shot effect shot effect shot skill, taffeta showerproof 211 299 shot effect shot skill, taffeta showerproof 211 299 shuttle 125		150, 151				219
selvage 128, 130 selvage, selvadge semi-let-out semi-permeable 189 229 shot skill, taffeta showerproof 211 shrinkage 214-215, 308-309 shuttle 125	_	000				
selvage, selvadge semi-let-out 189 showerproof shrinkage shuttle 125 299 299					224	
semi-let-out 189 shrinkage shuttle shuttle 125		128, 130				
semi-permeable shuttle 125		100	229			299
		189				
membrane 191 shuttleless looms 126, 127–128		101				
	membrane	191	I	shuttleless looms	126, 127–128	

	Reference	Glossary		Reference	Glossary
shuttleless loom selvage	128, 130		slipper satin		219
shuttle looms	125, 126		sliver-knit pile		15, 113
shuttle loom selvage	128, 130		slub yarn	108, 118	149, 150, 241,
side-by-side	86		oldo yarri	100, 110	243, 245
side (leather)	184		"smart fabrics,"	2, 3, 297–298	243, 243
sighting colour	263		SmartSilver	213	
silicon-based solvent	258		smocking	233	
silk burlap		243	snag resistance	309	
silk, cultivated		239, 240	snakeskin look	309	59
care	241-242, 265	102, 110	snarl yarn		155
family fabrics		2,3	snarl yarns	117	133
features	98	2,0	soap	250	
finishing	199 –200, 205		soft cotton thread	120	
production	47–52		softeners	205	
properties	52		soil release	211	299, 301
quality	52		Solarmax	85	255, 301
spun, waste		227	solar reactive thread	121	
silk linen		245	Solarweave	290	
silk, wild,	52–53, 98, 242	241 –245	Solospun	111	
silk screen printing	228, 229		sol pattern	172	
silk thread	121		solubility test	91. 99	
"silkworm,"	47–48, 49, 50		Solumbra	290	
Silpure	212- 213		solution-dyed	85, 222	
silver	212–213		solution-dye(d)	00, 222	113
SilverClear	213		solvents	257–259, 270	113
silverfish	274 , 275		solvent spinning	56, 61	
silver printing	227		Sophista	181	
SI metric system	107, 314–315		Sorona	68–69, 87, 292	
simplex	164	271	souffle	00 05, 07, 252	271, 272
simple yarns	105		sound	8	271, 272
singeing	204		soutache braid		27
single damask		77	South American		
single weft knits	157- 160		lace	172	
single yarn	105		soybeans	64	
Sirospun	111		"soy silk," 64		
sisal	34–35		space-dyed	224	
"sisal hemp,"	35		space-dye(d)	Section (Section Control of Section Control of Sect	191
sizing	129		spandex	14, 72–74	253, 255, 256
skein-dyed	223		Spanish moss	36	
skin irritation	9	×	special purpose		
skin (leather)	184		finishes	208- 217	
skin-on-skin (fur)	185 , 189		specialty hair fibers	42-47, 265	37 , 177, 183 ,
skin-side (fur)	245			, and a second	255
skin stretch	72		Spectra	84	
skip-dent	126		spectrum	219	1
skirt fabrics		9, 10	speed in weaving	125	
slack mercerization	200	254	Spider lace	172	
slack tension warp		227, 267	spider silk	53, 297	
slack tension warp			spike yarn		155
method	149, 150		spike yarns	117	
slacks fabrics		9, 10	spindle	108	
slasher rods	129		spinneret	48, 56, 58–59	
slashing	129		spinning	56-59, 108-109	
sleeping bags	318		spiral yarn		119
sley	125		spiral yarns	118	
slicker fabric		297	split-film		247
slide fasteners	317	4 1	split selvage,		
slipcover fabrics		5, 6	selvege		229
slippage, seam or			split skin	185, 189	
yarn		209	splitting	184	

	Reference	Glossary	greg 5	Reference	Glossary
sports equipment	318		stitching (compound		
sportswear fabrics		8	fabrics)	190	
spot-dot	146–147, 148		stitching (knits)	154, 155–156	
spots	253 –256		stitchbonded,	9.	
spot yarns	117, 118		stitch-knit	175–176,	165, 247, 251
spring beard				179–180 , 190	252
needles	156,157		stitched		
spunbond(ed)		165	(compound)		63
spunbonding	180		stitch length	316–317	
spun-dyed	85, 222		stitch side	124	
Spunjet	181		stock dyeing	222- 223	
spunlaced	180–181		Stoddard solvent	258	
spunlace(d)		249	stole	189	
spun-like effect	116		stone washing	205	
spun polyester	120		storage of textile		
spun rayon	104		articles	273, 274, 275	
spun rayon, silk		227	strength	9, 20, 104	П
spun silk	51, 52–53,		stretch and		
	104, 107		recovery test	307	
spun yarn	104, 108–113		stretch, comfort		
square (care			or fit		109 , 253 , 254
labeling)	267	1	power		8, 255, 256
square construction	129–130	1	stretch texturing	114–116	
square cut (fur)	185, 189		structural design	227, 232	
staining test	91, 92		structureless fiber	98	
Stainmaster	79		stuff—see fabrics		
stain removal	260		stuffer box	116	
stain repellent,			stuffer yarns	142, 143, 150	
resistant	4, 5 , 211, 213 ,		S twist	105	
	246	299, 301	sublime	230	1
stains	253 –256		sublistatic transfer	230	
StainSmart	211		submicron	58	
StainSmart	011		substantive dyes	220	
Comfort Zone staking	211 184		suede	183, 244–245, 247	
standard coatings	208		suedelike fabrics	83, 179, 204	
standard MF	200		sugar	055	
filament yarns	114		caramelization	255 198	
standard silk	52		suint suiting fabrics	241	
standing	204		sulfar	76	
staple fiber	14, 319		sulfur dyes	221–222	
staple microfibers	82–83		sun hazards	289, 290, 291	
staple silk	52-53		sunn	34, 35	
static electricity	9. 24. 25		SunScreen	289	
steamed fibers	178		SunSense	290	
steam heat	181		Super 100s wool	41	
steep twill	136, 137		Super 170s wool	41	
stem fibers	30–34, 36		supercontraction	53	
stenciling	189		Superfine wool	41	
stencil printing	231		Supplex	19, 116	
stenter frame	205- 206		supported film	182	
step-by-step stretch	115, 116		surah	135	259
step (weave)	135		surface designs	247	203
SteriPur AM	85		surface figure		
stiff finish	205, 247		weaves	146–147, 148	91, 92
stifled	48		surgical dressings,	,	,
stiffeners		117	stents	4, 318	
still air	282		swansdown	,	215
stinging nettle	36		"sweatshirt" fleece	203	
	-				

	Reference	Glossary	· ·	Reference	Glossary
Swedish			tendered	275	Olossury
"weaving"		83	Tenerife lace	172	133
sweep (fur)	189		tensile strength	9, 306, 319	133
swimwear fabrics	10)	8, 255	tensile strength tensioning	260, 261	
swivel	146, 147	0, 233	tenter frame	205- 206	
swivel figured	140, 147	91	tenter frame, holes	203-206	229
symbols, care		^1	tents	318	229
labeling	269, 271		terry	149, 150	
symbol with X over	205, 271		terry cloth knit	149, 130	283
it (care labeling)	267		terry cloth woven,		203
synthetic detergents,	207		incl terry/velour		267
syndets	250-251		Terylene	66–67	207
synthetic fibers	24, 25, 64–77,		testing—	00-07	
oynarede neers	240, 244—see also		see assessment		
	specific fibers		Tetoron	81	2
synthetic solvents	257–258		tex	107, 315	
by miletic solvents	207 200		textile—see fabrics;	107, 313	
tabby back	147		fibers		
tabby weave	132, 134–135,		textured filament		93, 155, 253
tuooy wouve	138–139, 287		Textile Fiber		93, 133, 233
table fabrics	100 100, 207	5, 141	Products Identific		
Tactel	116	0, 111	ation Act	16, 18	
Tactesse	79, 211		Textile Labelling	10, 10	
taffeta	134, 232, 247	57, 161, 210,	Act	18	
	101, 202, 217	261, 262	Textile Labelling	10	
taffeta weave	132, 134–135,	201, 202	and Advertising		
	138–139, 287		Regulations	18	
tailcoat fabrics	100 100, 207	9, 10	textured filament		
Tana All Protector	245	, 10	thread	120	
tannin	254		textured MF	120	
tanning	183, 184, 186	120	filament yarns	114–116	
tapa	36	165	textured set	116	
tape (bias)		253	Thai silk	53	245
tape lace	172		thermal cloth		83, 147
tapelike fiber	80		thermal comfort		
tapestry	150		management	209 -210	
tape selvage		229	thermal transfer	1	
tapestry		129, 130, 263	printing	230	
		264	thermochrome		61
tapestry velvet		287, 289	Thermolactyl	89	
tarlatan		117, 118	Thermolite	19, 83	
tarpaulin		37, 118	thermophysiological		
tarpaulins	318	- 1000	comfort	305	
tartan	135	45, 265, 266	thermoplastic	9, 20	
tasar silk	53		thermostatic	45	
tattersall check	2000-0000	45, 47, 181	thick & thin,		
tatting	172		thickest		
tear strength test	306		corduroy		69, 70
technical back	163	1 1 1 1 1	Thinsulate	83, 89, 99, 246	
technical textiles	2		Thinsulate Flex		
Teflon	75–76, 86, 211		Insulation	89	
Teflon(SP)		299	Thinsulate (Flex,		
temporary set (wool)		39	Life Loft Ultra)		63
temperature			Thinsulate Lite Loft	89, 246	
regulation	209 -210		thornproof tweed	10 May 201 10 May 201 10	277, 279
tenacity	9, 306, 319		thread	120–121	
Tencel	61, 62, 292		thread count	130–132, 320	
tender, loving care	044 045		thread counter	130–131, 330	a a
(TLC)	241–247		thread size	317	I

	Reference	Glossary		Reference	Glossary
three-dimensional			true grain	125	
surfaces	203–206	1	Trutac	215, 217	
throwing	48, 51		tsumugi		249
ticking	40, 01	269, 270	tucked-in selvage	128, 130	229
	224	191, 193, 194	tuck stitch	161	22)
tie-dye		191, 193, 194		172	
Tilley Endurables	89, 242, 290		Tucuman lace		047 075
tie fabrics		11	tufting	173 –175	247, 275
tissue cloth (lamé)		143	tulle 1		163
tissue gingham	134	121, 213	tumble drying	241, 267	
tissue linen		149, 150	Turkish knots	150, 151	
tissue taffeta		261	Turkish toweling		267
TLC	241–247		tussah		243
tog value	320		tussah silk	52, 53	
toile (fur)	186, 189		tuxedo fabrics	1	9, 10
toile de Jouy		199, 201, 202	tweed	117	45, 123, 155,
toilé (lace)	170	133, 202, 202			277, 279, 280
tooling	186		twill		277, 223, 200
_	223		angle		115, 281
top-dyed	223			F 8	67, 287, 291
top grain	100		back woven pile	ile l	
leather	183		steep	1.45	281, 282
top loading washing			twill back	147	
machine	240		twill line	124	
top printing	227		twill weave	132, 135–137,	
top-stitching	233			138–139	
top weight		4	twine	318	
torchon lace	169, 171	135	twist-heat set-		
Total Easy Care		4	untwist stretch	115, 116	
Wool	214, 215, 243		twisted lace		136, 141
tow	58		twisting	169–173	
towels		5, 83, 267	twist-on-twist	106	
trade association		3, 83, 207	twist-on-twist yarn	100	293
	272		two face fleece knit	165–166	273
care labeling	212	074 070		180	
trademark		274, 279	Typar		
trademarks, trade	10		Tyvek	180	
names	19			010.010	
Trade Marks Act	19		Ultra-Fresh Silpure	212 -213	l l
transfer printing	222, 230		ultra-microfibers	81, 83, 86	
transfer print		199, 203, 204	ultrasonic cleaning	259	
transparent velvet		287	ultrasonic sewing	190	
TrapTek	293		Ultrasuede	83, 179	165
trapunto	233	63, 64	Ultraviolet Protec-		1.
trash	198, 200		tion Factor	289, 290	
trash (cotton)			ultraviolet		
traveler	108		protective	213, 289,	
Trevira 350	84, 85		1	290, 305	
Trevira CS	85		ultraviolet rays	289–291	
Trevira Co Trevira Finesse	8, 82		ultraviolet resistant	21, 85	
Trevira Micronesse	82	2	umbrella fabrics	21,00	8
				047	0
triacetate	62–63, 265		unbalanced fabrics	247	
triangle (care	0.5	**	unbalanced plain	104 105	000
labeling)	267		weaves	134–135	209
triaxial looms	128		undercoat, underfur	37, 189	
tribocharging	24		undercoat, underfur		
triboelectric series	24, 25		& look		67
tricot	162-163		underlabeling	270	
tricot knit		101, 203, 255,	uneven twill	135, 136	1 1 1 1 1 1 1 1
grave u 1655		257, 271, 272	unhairing	184	
trim	248	, , , , , , , , , , , ,	uniform fabrics		10
trim fabrics		6	union cloths	76, 86	
tropical worsted		273, 274	union-dyed	224	
hopical worsted		210, 2/3	arnori ayea		

	Reference	Glossary	21	Reference	Glossary
union linen	86	151	vinyon	70, 182	
unserviceable		101	virgin wool	42	
merchandise	247–248		Virgin wooi Visa	211	301
UPF	289, 290			211	269
	243, 305–306—		visco	16 10 60 60 61	269
upholstery fabrics		5 6 21 40 50	viscose (rayon)	16–19, 60, 60–61,	
	see also furnishings	5, 6, 31, 49, 59	11.161	182	
		219	voided fibers	80	
urena	34		voided velvet		287, 289
use categories,			voile (cotton type)		293
fabric		5–11	voile decoupé		185, 186
Uster Fabricscan	206		voile (filament type)		167, 295
UV Index	291		voile (wool)		293
			Voltex		165, 251, 252
Val, Valenciennes	171	135, 136, 141	vortex spinning	112	
value (color)	219		VPWR	190-191 , 209	
vapor-permeable/					
water-resistant	190-191 , 209		Wadmala		173
vapor-phase	and the same of th		waffle cloth	142	
transfer	230		waffle cloth, pique	1.2	83
variable color effects			wale	135, 154	30
vat dyes	221		wale (corduroy)	100, 104	65, 67, 69, 70
"vegetable	221		wale (knit)		15
cashmere,"	64		warm weather		13
vegetable tanning	184		Care trace in the Care Care Care Care Care Care Care Car	000	
	10 April 10		clothing	288	
Velcro	151		warm weather	007 000	
Vellux	190	111	tactics	287–289	
velour	148, 149,		warp	125, 128–130	
1	158, 165		warp-face twill	135	
velour felt	κ.	99	warp insertion	166	
velour, velvet—knit			warp knit	154 , 162– 165	
pile		283	warp pile weaves	148–151	
velour woven,			warp piqué	142, 143	87
napped	9	175	warp print & look	City Projections	191, 192
velour, woven, pile		267, 285	warp printing	227	
velvet	148, 149, 150,		warp sateen		217
	152, 242		warp yarn	170	
velvet knit		283	warp yarn &	v	
velvet-like		111	compare to weft		16
velvet woven		185, 186, 287	washable silk	52, 241–242	
		289	wash cycles		
velveteen	148, 152, 242	70, 291	(care labeling)	267	
velveteen-like		111	washed silk	52	
Venetian cloth	7	115, 116, 219	washer silk	52, 241-242	
Venetian point lace	170		washing—see l	,	
Venetian point			aundering; mill		
Venise		133, 134	washing; scouring		
Verel	98	100, 101	washing machines	318-319	
very heat sensitive	10		Washpoint	258	
very low twist	105, 106		washtub symbol	200	
vicuña	45–46		(care labeling)	267	
vigoreaux printing	45-40	277		207	
0 1 0		211	waste silk, wool		045 040
vigoreaux,	204 207		fibers		245, 249
vigoureux	224, 227	165	water	040	
Vilence	16 10 50 51	165	fabric care	240	
vinal	16, 18, 70–71		hardness	248	
vintage textile			heat conduction	281	
storage	275		loss	294	
Vinterlacing	148		temperatures	267, 318–319	
vinylal	16, 18, 70–71		water conditioners	249, 251	
vinyl (vinyl chloride)	16, 182, 208, 294	297	water-jet looms	128	I

	Reference	Glossary	Laste et	Reference	Glossary
water pollution	249, 293–294		windchill chart	282	
water proof		59, 297, 298	windowpane		
water repellent	211, 287		check		45, 47
water repellent		, i	windproof fabric		297 , 298
resistant	1 1	57, 299, 301	wind resistance,		
water softeners	249, 251		resistant	286, 287, 307	
wax finish		57, 297, 299	Windstopper	282	
Weatherwize	213		windsurfer		
weave crimp	130		sail-fabric	3	
weaving	125-133		Winterlacing	148	
web	178		wiry fibers		2, 3, 27, 39
weft	125, 129–130,		Wood Material		
	157-162		Science Research		
weft-face twill	135		Project	62	
weft insertion	156, 166		woof	125, 129–130,	
weft knit	154			157–162	
weft piqué		87	wool	12-14	
weft pile weaves	151–152		care	240, 243–244,	
weft sateen		215		265, 266	
weft straighteners	206		features	97	
weight of fabrics		4, + most Files,	finishing	198 –199	
		+ 279	labeling	42	
weighted silk	52, 200	16	production	37–38	
Weirick test	305		properties	40	
Wellbond	86		quality	40–42	
Wellkey	81		structure	39	
Welsh Mountain			Wool Blend	42	
sheep	38		woolen yarn	109	
wet and melt			Woolmark	42, 272	
transfer	1.77		Woolmark Blend	42, 87, 272	
printing	230		Wool Products		
wet cleaning,	1 1		Labeling Act	42	
commercial	259		worsted yarn	107, 110	
wet modulus	9		workwear		10
wet press	10		fabrics		10
retention	10		worsted suiting		19, 303, 304
wet spinning	56		woven and look		many Files!
wet strength	20		woven fabric	320	
wetting agents	248, 250		thread count	Carry accounts	
weyers whiteners	151 252		wrapped yarns wrinkle resistant	118	
whipcord	232	281 , 282		213–214, 307	
whole skins	189	281, 282	wrong side of fabric	124	15
wicking	9, 20, 286, 305			184	15
Wicking Windows	212		wrung Wyzenbeek test	305–306	
widewale corduroy	212	61	wyzenoeek test	303-300	
widths typical in		01	XLA	71, 87	253
fabrics		4	X-Static	84, 85	200
wild silk	52–53, 98,	7	A Static	04, 00	
wild Silk	242	241, 243, 244	yak hair	46	
Wilton carpet	150	211, 210, 211	yamamau	10	243
winch	224		yarn	6, 104–121	240
windbreaker			classification	105–107	
fabrics		8	dyeing	222, 223-224	
1301103	•	. 0	ayenig	LLL, LLU LLT	

	Reference	Glossary		Reference	Glossary
metrics	320		zein	64	
notation	107		zephyr gingham		121
types and			zibeline		177,178
constructions	104		zero twist	105	
yarn count	106–107, 320		zippers	31	
yarn number	106-107		Z twist	105	
yucca	35	110			

Fabric Glossary Swatch Set

Set of 115 Swatches, selected as examples of major fabric names in *Fabric Glossary* and to provide samples for textile study in *Fabric Reference*.

More detailed description can be found in References and Resources under Swatch Sets.

To order go to: www.swatchsets.com

Of

www.maryhumphries.com

NOTE: Instructors whose students will be using the *Fabric Glossary* as a prescribed resource for a course are welcome to request a complimentary Swatch Set.

For more information please call or e-mail:

Susan Lichovnik 5694 Highway #7 East, suite 413 Markham, Ontario, L3P 1B4, Canada phone & fax: (905) 471-0569

swatch.sets@gmail.com

,				